The Cultural Studies Reader

Third Edition

The Cultural Studies Reader is the ideal introduction for students to this exciting discipline. A revised introduction explaining the history and key concerns of cultural studies brings together important articles by leading thinkers to provide an essential guide to the development, key issues and future directions of cultural studies.

This fully updated third edition includes:

- thirty-six essays including twenty-one new articles
- an editor's preface succinctly introducing each article with suggestions for further reading
- comprehensive coverage of every major cultural studies method and theory
- an updated account of recent developments in the field
- articles on new areas such as culture and nature and the cultures of globalization
- new key thinkers such as C.L.R. James, Gilles Deleuze, Antonio Negri and Edward Said, included for the first time
- a global appeal – *The Cultural Studies Reader* is designed to be read around the world and deals with issues relevant to each continent

Essays by: Theodor Adorno, Benedict Anderson, Arjun Appadurai, Roland Barthes, Simone de Beauvoir, Walter Benjamin, Tony Bennett, Pierre Bourdieu, Judith Butler, Michel de Certeau, Jodi Dean, Gilles Deleuze, Michel Foucault, Nancy Fraser, Paul Gilroy, Antonio Gramsci, Stuart Hall, Donna Haraway, Michael Hardt, Dick Hebdige, Max Horkheimer, C.L.R. James, Friedrich A. Kittler, Eve Kosofsky Sedgwick, Bruno Latour, Teresa de Lauretis, Henri Lefebvre, Justin Lewis, Hau Ling Cheng, Eric Ma, Meaghan Morris, Antonio Negri, Claire Parnet, Russell A. Potter, Janice A. Radway, Edward Said, Gayatri Spivak, Peter Stallybrass, Allon White, Raymond Williams.

Simon During is a Professor of English and Cultural Studies at Johns Hopkins University. He is the author of *Cultural Studies: A Critical Introduction* (2005); *Modern Enchantments: The Cultural Power of Secular Magic* (2004) and *Foucault and Literature* (1992).

The
Cultural Studies
Reader

Third Edition

Edited by

Simon During

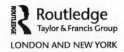
Routledge
Taylor & Francis Group

LONDON AND NEW YORK

First published 1993
by Routledge
2 Park Square, Milton Park, Abingdon, Oxon OX14 4RN

Simultaneously published in the USA and Canada
by Routledge
711 Third Avenue, New York, NY 10017

Second edition published 1999 by Routledge
Reprinted 2000, 2001, 2003 (twice), 2004, 2005

Routledge is an imprint of the Taylor & Francis Group, an informa business

Third edition published 2007 by Routledge

Editorial Selection and Material © 2007 Simon During
Chapters © 2007 The Contributors

Typeset in Perpetua and Bell Gothic by
HWA Text and Data Management, Tunbridge Wells

British Library Cataloguing in Publication Data
A catalogue record for this book is available from the British Library

Library of Congress Cataloging-in-Publication Data
A catalog record for this book has been requested

ISBN10: 0–415–37412–X (hbk)
ISBN10: 0–415–37413–8 (pbk)

ISBN13: 978–0–415–37412–5 (hbk)
ISBN13: 978–0–415–37413–2 (pbk)

Contents

Acknowledgments

The following were reproduced with kind permission. While every effort has been made to trace copyright holders and obtain permission, this has not been possible in all cases. Any omissions brought to our attention will be remedied in future editions.

Stuart Hall, 'Cultural studies and its theoretical legacies' from *Stuart Hall: Critical Dialogues in Cultural Studies*, ed. David Morley and Kuan-Hsing Chen, London: Routledge. Copyright © 1996. Reproduced by permission of the publisher, Stuart Hall and John Holmwood.

Antonio Gramsci, 'The organization of education and of culture' in *Selections from the Prison Notebooks*, eds Quintin Hoare and Geoffrey Nowell Smith. London: Lawrence & Wishart, 1971, pp. 26–33. Copyright © Quintin Hoare and Geoffrey Nowell Smith. Reproduced by permission of the publisher.

Walter Benjamin, excerpt from 'The work of art in the age of its mechanical reproduction' from *Illuminations* by Walter Benjamin, copyright © 1955 by Suhrkamp Verlag, Frankfurt a.M., English translation by Harry Zohn copyright © 1968 and renewed 1996 by Harcourt, Inc., reprinted by permission of Harcourt, Inc. Reprinted by permission of the publisher from 'The work of art in the age of its technological reproducibility' (third version) in *Walter Benjamin: Selected Writings, Volume 4, 1938–1940*, edited by Howard Eiland and Michael W. Jennings, pp. 270–1, Cambridge, MA: Harvard University Press, Copyright © 2000 by the President and Fellows of Harvard College.

Roland Barthes, 'From work to text' from *The Rustle of Language* by Roland Barthes, translated by Richard Howard. Translation copyright © 1986 by Farrar, Straus and Giroux, LLC. Reprinted by permission of Hill and Wang, a division of Farrar, Straus and Giroux, LLC.

Pierre Bourdieu, 'Field of power, literary field and habitus,' in Pierre Bourdieu, *The Field of Cultural Production*, Cambridge: Polity Press and Columbia University Press, 1993, pp. 161–76. Copyright © Pierre Bourdieu. English trans Copyright © Claud deVerlie. Reproduced by permission of the publishers.

Peter Stallybrass and Allon White, 'Bourgeois hysteria and the carnivalesque,' from *The Politics and Poetics of Transgression*, London: Routledge, Copyright © 1986 Peter Stallybrass and Allon White. Reproduced by permission of Peter Stallybrass and Taylor & Francis Books UK. Reprinted from 'Bourgeois Hysteria and the Carnivalesque,' from *The Politics and Poetics of Transgression*, by Peter Stallybrass and Allon White. Copyright © 1986 Peter Stallybrass and Allon White. Used by permission of the publisher, Cornell University Press.

Tony Bennett, 'Putting policy into cultural studies,' reprinted by permission from Sage Publications Ltd from *Culture: A Reformer's Science*, Copyright © Tony Bennett 1998.

Meaghan Morris, 'Banality in cultural studies in Discourse [USA],' *X/2* (Spring–Summer 1988). Reproduced by kind permission of the author. A longer version of this essay appears in *Logics of Television*, ed. Patricia Mellencamp. Bloomington, IN: Indiana University Press, 1990, pp. 14–43.

Henri Lefebvre, 'Notes on the new town,' in *Introduction to Modernity*, trans. John Moore. 1995. Reproduced by permission of Verso. The imprint of New Left Books Ltd. www.versobooks.com.

Michel de Certeau, 'Walking in the city' from *The Practice of Everyday Life*, copyright © 2002 The Regents of the University of California. Published by the University of California Press. Reproduced with permission.

Michel Foucault, 'Space, power and knowledge' from *The Foucault Reader* edited by Paul Rabinow. Copyright © 1984 by Paul Rabinow New York: Pantheon. Originally appeared in *Power/Knowledge: Selected and Other Writings by Michel Foucault 1972–1977*, edited by Colin Gordon. Copyright © 1972, 1975, 1976, 1977 by Michel Foucault. Reprinted by permission of Georges Borchardt, Inc. Michel Foucault, 'Space, power and knowledge', an interview with Paul Rabinow from *Dits et écrits*. Copyright © Editions Gallimard, Paris 1994. Reproduced with permission.

Gilles Deleuze and Claire Parnet, 'Politics'; from Gilles Deleuze and Felix Guattari, eds, *On the Line*, Semiotext(e), New York 1983.

Michael Hardt and Antonio Negri, 'Postmodernization, or the informatization of production' reprinted by permission of the publisher from *Empire* by Michael Hardt and Antonio Negri, pp. 280–300, Cambridge, MA: Harvard University Press, Copyright © 2000 by Presidents and Fellows of Harvard College.

Eric Ma and Hau Ling 'Helen' Cheng, '"Naked" bodies: experimenting with intimate relations among migrant workers in South China' reprinted by permission from Sage Publications Ltd from *International Journal of Cultural Studies*, Sept. 2005; 8: 307–28. Copyright © Sage Publications, 2005.

Arjun Appadurai, 'Disjuncture and difference in the global cultural economy,' reprinted by permission from Sage Publications Ltd from ed. Mike Featherstone, *Global Culture: Nationalism, Globalization and Modernity*. Copyright © Arjun Appadurai 1990.

Gayatri Spivak, 'The new subaltern: a silent interview,' in *Mapping Subaltern Studies and the Postcolonial*, ed. Vinayak Chaturvedi. London: Verso 2001, pp. 224–40. © Gayatri Spivak. Reproduced by permission of Verso and the author. The imprint of New Left Books Ltd. www.versobooks.com.

Edward Said, 'Traveling Theory Reconsidered,' in *Reflections on Exile and Other Essays*, 2002, Granta Books. Reproduced with permission.

Benedict Anderson, 'Imagined Communities,' extracted from *Imagined Communities: Reflections on the Origin and Spread of Nationalism*. Revised edition, London: Verso 1991, pp. 1–7 and 37–46. Copyright © Benedict Anderson. Reproduced by permission of Verso. The imprint of New Left Books Ltd. www.versobooks. com.

Paul Gilroy, 'The Crisis of "Race" and "Raciology"' reprinted by permission of the publisher from *Against Race: Imagining Political Culture Beyond the Color Line* by Paul Gilroy, pp. 11–32, Cambridge, MA: The Belknap Press of Harvard University Press, Copyright © 2000 by Paul Gilroy. Reprinted by kind permission of the author from *Between Camps: Nations, Culture and the Allure of Race* by Paul Gilroy, pp. 11–32, London: Routledge, Taylor & Francis Group, 2nd edition 2004, Copyright © 2000 by Paul Gilroy.

Raymond Williams, 'Ideas of Nature,' in *Problems in Materialism and Culture*, London: Verso 1980: pp. 67–85. Copyright © Raymond Williams 1980. Reproduced by permission of Verso. The imprint of New Left Books Ltd. www.versobooks. com.

Friedrich A. Kittler, 'Gramophone,' translated by Geoffrey Winthrop-Young and Michael Wutz, *Gramophone, Film, Typewriter*. English translation © 1999 by the Board of Trustees of the Leland Stanford University. Originally published in German © 1986 Brinkmann and Bose.

Bruno Latour, 'War of the worlds,' extracted from *War of the Worlds: What about Peace?* Chicago: Prickly Paradigm Press, 2002. Reproduced by kind permission of the author and publisher.

Donna Haraway, 'A cyborg manifesto' from *Simians, Cyborgs and Women*, RINC 1991. Reproduced by kind permission of the author.

Simone de Beauvoir, 'The independent woman' from *The Second Sex* by Simone de Beauvoir, translated by H.M. Parshley, copyright 1952 and renewed 1980 by Alfred A. Knopf, a division of Random House, Inc. Used by permission of Alfred A. Knopf, a division of Random House Inc. From the work: *The Second Sex* by Simone de Beauvoir. Copyright © 1949 by Editions Gallimard. Reprinted with permission.

Teresa de Lauretis, 'Upping the anti (sic) in feminist theory,' Copyright © 1990 from *Conflicts in Feminism*, eds Marianne Hirsch and Evelyn Fox Keller. Reproduced

by permission of Routledge/Taylor & Francis Group, LLC. Reproduced by permission of the author and publisher.

Judith Butler, 'Subversive bodily acts,' copyright © 1999, from *Gender Trouble* by Judith Butler. Reproduced by permission of Routledge/Taylor & Francis Group, LLC.

Eve Kosofsky Sedgwick, 'Axiomatic' from *Epistemology of the Closet*, copyright © 1990 The Regents of the University of California. Published by University of California Press. Reproduced with permission.

Theodor Adorno and Max Horkheimer, 'The culture industry: enlightenment as mass deception,' from *Dialectic of Enlightenment*, trans. John Cumming (1972 the Seabury Press), © S. Fischer Verlag 1969, trans. Herder & Herder 1972. Reproduced by permission of Verso, the imprint of New Left Books Ltd. www.versobooks.com.

C.L.R. James, 'What is art?' in *Beyond a Boundary*, Durham, NC: Duke University Press, 1993. Reproduced with permission of Curtis Brown Group Ltd, London on behalf of the Estate of C.L.R. James. Copyright © C.L.R. James 1993.

Dick Hebdige, 'Subculture and style,' from *Subculture: the Meaning of Style*, Routledge. Copyright © 1979 Dick Hebdige. Reproduced by permission of the author and Taylor & Francis Books UK.

Justin Lewis, 'Public arts funding: who benefits?' from *Art, Culture and Enterprise*, Routledge. Copyright © Justin Lewis 1990. Reproduced by permission of the author and Taylor & Francis Books UK.

Russell A. Potter, 'History – spectacle – resistance,' reprinted by permission from *Spectacular Vernaculars: Hip-Hop and the Politics of Postmodernism*, by Russell A. Potter, the State University of New York Press. © 1995, State University Press of New York. All rights reserved.

Stuart Hall, 'Encoding, Decoding,' Copyright © 1990 from *Cultural Studies*, ed. Lawrence Grossberg. Reproduced by permission of Stuart Hall, Lawrence Grossberg and the publisher.

Nancy Fraser, 'Rethinking the public sphere: a contribution to the critique of actually existing democracy,' from *Habermas and the Public Sphere*, ed. Craig Calhoun, Cambridge, MA: MIT Press, 1992. Copyright © 1992 Massachusetts Institute of Technology. Reproduced by permission of the publisher.

Janice A. Radway, 'The institutional matrix of romance' from *Reading the Romance: Women, Patriarchy and Popular Literature*, by Janice A. Radway. Copyright © 1984, new introduction © 1991 by the University of North Carolina Press. Used by permission of the publisher.

Introduction

■ Simon During

THIS BOOK COLLECTS SEMINAL and/or representative essays in cultural studies as an introduction to the discipline. Yet, as will become clearer after the essays have been read, cultural studies is not an academic discipline quite like others. It possesses neither a well-defined methodology nor clearly demarcated fields for investigation. Cultural studies is, of course, the study of culture, or, more particularly, the study of *contemporary* culture. But this does not take us very far. Even assuming that we know precisely what 'contemporary culture' is, it can be analysed in many ways – sociologically, for instance, by 'objectively' describing its institutions and functions as if they belong to a large, regulated system; or economically, by describing relations between markets and cultural production. More traditionally, it can be studied 'critically' by celebrating either large forms (like literature) or specific texts or images (like *Waiting for Godot* or an episode of *Sex in the City*). The question remains: does cultural studies bring its own orientation to these established forms of analysis?

There is no easy answer, but to introduce the forms of analysis developed by the discipline, we can point to two features that characterized it when it first appeared in Great Britain in the 1950s. It studied culture in relation to individual experiences and lives, breaking with social scientific positivism or 'objectivism'. The book that is often said to inaugurate the subject, Richard Hoggart's *The Uses of Literacy* (1957), is a very personal work. Hoggart wanted to show how changes in working-class life in post-war Britain affected an individual's 'whole way of life' which he did semi-autobiographically. For him, culture was an important category because it helps us recognize that one life-practice (like reading) cannot be torn out of a large network constituted by many other life-practices – working, sexual orientation, family life, say.

The second distinguishing characteristic of early cultural studies was that it was an engaged form of analysis. (It begins in what was called at the time 'the new left' – a Marxian but not communist movement, working towards forms of socialism outside of trade unions or formal political parties and aimed at emancipating lifestyles and not just at participating in the public world.) Early cultural studies did not flinch from the fact that societies are structured unequally, that individuals are not all born with the same access to education, money, healthcare etc., and it worked in the interests of those who have least resources, namely the working class (which in the US, where almost no one calls themselves 'working class', includes poorer members of the 'middle class' as well as a large proportion of the African-American community). In this it differed not only from the (apparently) objective social sciences but from the older forms of cultural criticism, especially literary criticism, which considered political questions as being of peripheral relevance to the appreciation of culture. For cultural studies, 'culture' was not an abbreviation of a 'high culture' assumed to have constant value across time and space. Another founding text of cultural studies, Raymond Williams's *The Long Revolution* (1961), criticized the consequences of uncoupling 'culture' from 'society', and 'high culture' from 'ordinary' culture, although Williams also conceded that it was through this uncoupling that modern culture acquires its particular energy, charm and capacity to inform.

These two defining features of early cultural studies were closely connected because it is at the level of experience that the cultural effects of social inequality are most apparent. Most individuals aspire and struggle the greater part of their lives and it is easier to forget this if one is just interpreting texts rather than thinking about reading as a life-practice, for instance. Cultural studies insists one cannot just ignore – or accept – division and struggle. We can ask, how did an engaged discipline of this kind emerge within higher education? This is the question that lets us approach cultural studies most effectively, so let us turn to the historical conditions which made the discipline possible.

A brief history of cultural studies

Cultural studies appears as a field of study in Great Britain in the 1950s out of left-Leavisism, a form of literary studies named after F.R. Leavis. Leavisism was an attempt to re-disseminate what is now commonly called, after Pierre Bourdieu, 'cultural capital' – though this is not how it saw itself. Leavis wanted to use the educational system to distribute literary knowledge and appreciation more widely. To achieve this, the Leavisites argued for a very restricted canon, discarding modern experimental works like those of James Joyce or Virginia Woolf, for instance. Instead they primarily celebrated works directed towards developing the moral sensibility of readers such as Jane Austen, Alexander Pope or George Eliot – the 'great tradition'. Leavisites fiercely insisted that culture was not simply a leisure activity; reading 'the great tradition' was, rather, a means of forming mature individuals with a concrete and balanced sense of 'life'. And the main

threat to this sense of life came from the pleasure offered by so-called 'mass culture'. In this, Leavisism was very much in tune with what cultural studies has come to call the 'social-democratic power bloc' which dominated post-war Britain. After the war, Britain was administered by a sequence of governments that intervened in the private sector both socially (in areas like health and housing) and culturally (in education and the arts). When the education system expanded radically through the 1950s and 1960s, it turned to Leavisism to form citizens' sensibilities.

Cultural studies developed out of Leavisism through Hoggart and Williams who (as I say) consciously wrote in the interests of the working class, striving for socialist forms of government, and whose writings were taken up in secondary schools and tertiary colleges soon after they were written. Both themselves came from working-class families; both had worked as teachers in post-compulsory education though, importantly, in workers' education. Thus they experienced Leavisism ambivalently. On the one hand, they accepted that its canonical texts were richer than contemporary so-called 'mass culture' and that culture ought to be measured in terms of its capacity to deepen and widen experiences; on the other, they recognized that Leavisism at worst erased, and at the very least did not fully come into contact with, the communal forms of life into which they had been born. So Hoggart's *The Uses of Literacy*, in particular, is a schizophrenic book. Its first half contains a heartfelt evocation of traditional industrial working-class communities, relatively untouched by commercial culture and educational institutions — this half tends towards sociology — while its second half mounts a practical-critical attack on modern mass culture. When Hoggart went on to found the Birmingham Centre for Contemporary Cultural Studies (henceforth CCCS), a postgraduate and research institute designed to further his work, it began by having to deal with this tension, which it hoped to overcome by bringing social analysis — sociology — into alignment with Leavisite literary criticism.

Hoggart was able to believe that the celebration of old high culture could fit alongside an evocation of the culture of his youth because both stood apart from contemporary commercial popular culture and, so, were under threat. The threat to, and final disappearance of, traditional British working-class life needs to be considered at a little length because it was crucial for the early development of cultural studies. (See Laing 1986 for a good account of this history.) Before the war, since the early 1920s, the British economy had been dominated by unemployment — there were never less than a million people unemployed over the period. This was the background of Hoggart's 'traditional' working class. By the end of the 1940s, however, Britain had a full employment economy, and by the end of the 1950s further shifts in the British economy were well under way. Jobs were moving into the state sector (in 1955 government expenditure had been 36.6 per cent of GDP as against 52.2 per cent in 1967 (Robbins 1983: 369)); small plants were being replaced by larger ones using 'Fordist' production techniques — that is, simplifying workers' tasks on assembly lines — which meant that labour became increasingly deskilled (between 1951 and 1973 the percentage of the workforce working in plants which employed over 1500 people increased by 50

per cent (Wright 1979: 40)). Simultaneously, the differential between lower-paid white collar and blue-collar workers was decreasing, and large-scale immigration from the colonies during the 1950s meant that many indigenous workers were no longer called upon to take the least desirable jobs. Workers, then, were becoming increasingly 'affluent' (to use a media term of the time) at least in so far as they were increasingly able to buy consumer goods, such as cars (numbers of which increased fivefold between 1950 and 1975), clothing, washing machines, refrigerators, record-players, telephone services (they increased fourfold between 1945 and 1970) and, most important of all, television sets (commercial television does not become widely available in Britain until 1957, the year Hoggart's book was published). Finally the large state rehousing programme, compulsory national service in the army (which ended in 1958) and, to a lesser extent, educational reform making higher education available to a fraction of the working class, also helped break up the culture that Hoggart described.

As the old working-class communal life fragmented, the cultural studies which followed Hoggart's *The Uses of Literacy* developed in two main ways. The old notion of culture as a whole way of life became increasingly difficult to sustain: attention moved from locally produced and often long-standing cultural forms (pub-life, group-singing, pigeon-fancying, attitudes to 'our mum', dances, holidays at camps and close-by seaside resorts etc.) to culture as organized from afar – both by the state through its educational system, and by what Theodor Adorno and Max Horkheimer (in the essay included here) called the 'culture industry', that is, highly-developed music, film and broadcasting businesses. This shift of focus could lead to a revision of older paradigms, as when Paddy Whannel and Stuart Hall in *The Popular Arts* (1964), gave the kind of status and attention reserved by the Leavisites for canonical literature to new forms (such as jazz and film) while devaluing others (especially television and rock music). Much more importantly, however, the logic by which culture was set apart from politics, already examined by Raymond Williams, was overturned. The historian E.P. Thompson, in his seminal book *The Making of the English Working Class* (1964) and elsewhere, had pointed out that the identity of the working class *as* working class had always had a strongly political and conflictual component – that identity was not just a matter of particular cultural interests and values. But the fragmentation of the old proletarian culture meant that a politics based on a strong working-class identity was less and less significant: people decreasingly identified themselves as workers (see Roberts *et al.* 1977). It was in this context that cultural studies theorists began seriously to explore culture's own political function and to offer a critique of the social-democratic power bloc which was drawing power into the state. From the early 1970s, culture came to be regarded as a form of 'hegemony' – a word associated with Antonio Gramsci, an Italian Marxist of the 1920s and 1930s, and widely circulated in new left circles in the early 1960s. (See his essay collected in this volume.) 'Hegemony' is a term to describe relations of domination which are not visible as such. It involves not coercion but consent on the part of the dominated (or 'subaltern'), in part by appealing to their real material interests. Gramsci himself elaborated the concept to explain why Mussolini's fascism was

so popular even though fascism curtailed the liberty of most Italians. For him, hegemonic forces constantly alter their content as social and cultural conditions change: they are improvised and negotiable, so that counter-hegemonic strategies must also be constantly revised. In the same spirit, if somewhat less subtly, culture could also be seen as what Michel Foucault was beginning to think of as a form of 'governmentality', that is a means to produce conforming or 'docile' citizens, most of all through the education system.

Perhaps the most sophisticated concept that emerged in cultural studies from out of its encounter with Gramsci and Foucault was that of 'articulation'. (See Grossberg 1992.) Here hegemony is thought of as the process within which particular discourses and images become bound to one another within particular institutional and governmental structures so as to create the conditions in which particular meanings and emotions are taken up or at least come to be preferred by individuals, or to put this slightly differently, come to seem and feel proper, right, natural. The key point about the concept of articulation is that it emphasizes how hegemony constantly mutates in terms of its elements and contents: it's a process of making alliances and connections, releasing energies rather than of presenting a static set of values and knowledges.

At any rate, as culture was thought about less as an expression of local communal lives and more as an apparatus within a large system of domination, cultural studies offered critiques of culture's hegemonic effects. At first such critique leant heavily on forms of semiotic analysis (represented in this collection in a sophisticated form by Stuart Hall's 'Encoding, decoding'). This meant in effect that culture was broken down into discrete messages, 'signifying practices' or 'discourses' which were distributed by particular institutions and media. To take a rather simplified example: a semiotic analysis of cigarette smoking among workers would analyse smoking not as a life-practice, that is, in terms of its importance as a rite of passage, its use in structuring the flow of time and so on, but in terms of its being a signifier produced by images like the 'Marlboro Man', which connote masculinity, freedom and transcendence of work-a-day life. Semiotics' capacity to extend its analysis beyond particular texts or signs is limited: it remained an analysis of 'codings' and 'recodings' not of uses, practices or feelings (though Stuart Hall's essay collected here has been influential because it articulates relations between uses and meanings).

It would be wrong to insist too strongly on what were called the 'culturalist' (emphasizing forms of life) and 'structuralist' (or semiotic) strands within the cultural studies of the period. But in the 1970s, a hard form of structuralism did emerge, one that called upon the work of Louis Althusser, backed up by psychoanalytic notions developed by Jacques Lacan. For this theory, individuals were constructs of ideology, where ideology means not beliefs we disapprove of (as in 'racist ideology') but the set of discourses and images which constitute the most widespread knowledge and values – 'common sense'. Ideology, so the argument went, is required so the state and capitalism can reproduce themselves without the threat of revolution. Here, as for Hoggart and Williams, the state's claim to neutrality is false, but this time for more classically Marxist reasons

— because it protects the exploitative 'relations of production' (i.e. Class differences) necessary to capitalism. For Althusser, dominant ideology turned what was in fact political, partial and open to change into something seemingly 'natural', universal and eternal. However, dominant ideology is not limited to politics or economics so, though it may present a particular view of economic relations (as in the common idea that trade unionism is a brake on economic competitiveness), its primary role is to construct an imaginary picture of civil life, especially the nuclear family as natural and, most of all, each individual as 'unique' and 'free'. Ideology fragments real connections and interdependencies, producing a picture of social relations which overemphasizes individual freedom and autonomy. For Althusser, individuals can be sucked into ideology so easily because it helps them make sense of the world, to enter the 'symbolic order' and ascribe power to themselves. They identify with ideology because they see themselves pictured as independent and strong in it — as an adolescent boy (or, indeed, adult) might picture himself, in a fantasy, as the Marlboro man. Dominant social values are internalized through this kind of identification. At this point, psychoanalysis was called upon to gird the theory. Once again to state the argument very simply: individuals see themselves mirrored in dominant ideology and identify with it as a way of 'taking the father's place' in a process which is fuelled by the 'fear of castration', that is, anxieties that true autonomy or unique individuality can never be reached. So ideology provides a false resolution to private, familial tensions, a resolution that is, for Lacan if not for Althusser, finally enabled by the fact that no symbolic structure can offer final meaning or security. Its lure is always imaginary: the promise of a full 'I-ness' which can exist only where 'I am not'.

But politico-psychoanalytical structuralism of this kind never made as much headway in cultural studies as it did in film studies, say. It did not concede enough space to the capacity of the individual or community to act on the world on their own terms, to generate their own meanings and effects. It was too theoretical in the sense that it offered truths which took little or no account of local differences; indeed, its claims to be scientifically true lacked support from scientific method. And it did not pay enough heed to the actual techniques and practices by which individuals form themselves and their lives. But another strand of semiotic thought was able to enter the culturalist tradition with more vigour. This emphasized the concept of polysemy. 'Polysemy' is a technical word for the way in which a particular signifier always has more than one meaning, because 'meaning' is an effect of differences within a larger system. This time the argument went: it is because meanings are not produced referentially (by pointing to specific objects in the world) but by one sign's difference from another, that signs are polysemous. One sign can always both be substituted for by another (in what is called the 'paradigmatic' relation), and enter a sequence of other signs (the 'syntagmatic' relation). More loosely, a sign can 'connote' any number of others: the Marlboro man, for instance, connoting 'toughness' in one context and 'cancer' in another.

The notion of polysemy, however, remains limited in that it still works at the level of individual signs as discrete signifying units. It did, however, lead to more

dynamic and complex theoretical concepts which help us describe how cultural products may be combined with new elements to produce different effects in different situations. In this way, cultural production is conceived of as a process of 'hybridization', 're-production', and 'negotiation'. For instance, the Marlboro Man might be made into a shiny, hard-edged polythene sculpture à la Jeff Koons to achieve a postmodern effect in an expensive Manhattan apartment; an ad using the image might be cut out of the magazine and used to furnish a poor dwelling in Lagos as an image of Western affluence and liberty, or parodied on a CD/album-cover. Concepts like hybridization, as they developed out of the notion of 'polysemy', return us to a renewed culturalism because they enable us to see how particular individuals and communities can actively create new meanings from signs and cultural products which come from afar. Yet a concept like 'hybridization' still does not account for the way that the meanings of particular signifiers or texts in a particular situation are, in part, ordered by material interests and power relations. The tobacco Industry, the medical profession and a certain stream within the women's movement might *struggle* over the meaning of 'Marlboro Man' for political and commercial reasons: one in order to sell more product; the other to promote health, as well as their own status and earning power; the last to reject an insensitive mode of masculinity. Cultural studies has been, as we might expect, most interested in how groups with least power practically develop their own readings of, and uses for, cultural products – in fun, in resistance, or to articulate their own identity.

This brief historical account of cultural studies' key concepts has not focussed on particular works at particular dates. The richness of the research promoted by the CCCS during the 1970s makes that research Impossible adequately to represent here. But three particularly influential texts, Paul Willis's *Learning to Labour* (1977), David Morley's *The 'Nationwide' Audience* (1980) and the collectively written *Resistance through Rituals: Youth Subcultures In Postwar Britain* (1976), each of which was written from a different space in the spectrum thrown open by the history I have just sketched, can rewardingly be described. First, Paul Willis's *Learning to Labour:* Willis used participant observer techniques to describe a group of disaffected boys in a working-class school (the 'lads'). He showed how they create a 'counter-school culture' in which they reject the official logic which legitimizes their education, that is, 'you obey the teachers because they teach you knowledge which will help you get a better job'. They reject this exchange for several reasons: partly because 'better jobs' (i.e. low-paid white-collar or apprentice jobs as against unskilled labouring jobs) involve moving out of the traditions of mateship, hard drinking, excitement and strong male bonding passed down in their families (it's a community well represented in Alan Sillitoe's novel *Saturday Night and Sunday Morning*); partly because those jobs were not necessarily 'better' financially at least in the short and medium term, and didn't require the kind of knowledge on offer at school anyway; and partly because the lads had a strong sense that the economic system ultimately required the exploitation of some people's labour power so that the 'shit jobs' they would take were in fact necessary rather than worthless. Willis's work

remains close to Hoggart's in that it involves a certain celebration of traditional working-class culture and it shows how that culture contains a quite accurate political understanding of the conditions of life, even though the lads have little conventional class consciousness and absolutely no interest in formal political institutions. What is striking about the study, though, is how important both sexism and racism remain to this segment of British working-class culture. Unfortunately, Willis does not address this head-on.

Whereas Willis's *Learning to Labour* is a culturalist book in the traditional sense, David Morley's *The 'Nationwide' Audience* is one of the first ethnographic studies not of a community (defined in terms of locale and class) but of an audience (defined as a group of viewers/readers), in this case the audience of *Nationwide*, a BBC news magazine programme widely watched through the late 1960s and 1970s, and which broadcasted mainly local, rather than national or international stories, somewhat like a US breakfast show. Morley's study was ethnographic in that he did not simply analyse the programme, he organized open-ended group discussions between viewers, with each group from a homogeneous class/gender/ work background (trade unionists, managers, students etc.). Indeed his book begins by contesting that image of a large audience as a 'mass' which had often been assumed by earlier sociological theorists of the media. His ethnographic approach was all the more a break within cultural studies work on media because, along with Charlotte Brunsdon, he had offered a conventional semiotic 'ideology-critique' of the programme in an earlier study, *Everyday Television: 'Nationwide'*. There, he and Brunsdon had argued that the programme presented an image of the world in which gender, class and ethnic differences were massively downgraded, and which assumed that 'we' (the programme's implied audience) possess a shared 'common sense' based on a practical view of the world, as against 'intellectual', political or culturally adventurous views. The programme's style or 'mode of address' was anchored in authoritarian but chatty presenters who embodied its values.

For Morley the textualist approach began to seem limited because it could not fully deal with polysemy. He had to go out into the field to discover what people actually thought about *Nationwide*. But this does not mean that, for him, the programme can be interpreted anyhow, precisely because its ideological orientation – that 'everyday life' view of the world – is the code which the programme itself presents as 'preferred'. To use Stuart Hall's phrase, the programme is 'structured in dominance' because it skews and restricts its audience's possibilities for interpreting the material it claims to present without bias. Though viewers need not accept the preferred code, they must respond to it in some way. Morley divides the possibilities of decoding *Nationwide* into three categories: 1) an acceptance of the preferred reading, 2) flat opposition to it (mainly, as it turned out, by being extremely bored by it) and 3) negotiation with it. His fieldwork findings were somewhat unexpected though: there was no clear correlation between the socio-cultural position of the groups and their response to the programme, although those, like a group of Caribbean young women, furthest away from the commonsense 'we' embodied in the white (and mainly male) presenters, were least able to respond to it. Also some groups (especially students and trainee managers)

understood that the programme was biased (or 'structured in dominance') but still accepted its dominant code. Knowing how it worked, not being 'cultural dupes', did not mean refusal of its values. And last, those groups with least social and cultural capital — like the Caribbean women — found the programme too distant from their own lives, preferring less newsy programmes with more 'human' stories — like those transmitted by the more market-orientated ITV companies. Though Morley makes little of it, for these groups it was the market rather than the state (through the state-funded BBC) that provided them with what they wanted. In a paradox that helps us understand certain problems at work at the heart of the social-democratic power bloc, those who are most vulnerable to market forces respond most positively to market-orientated cultural products.

The third, and earliest, book, *Resistance through Rituals: Youth Subcultures in Postwar Britain*, is a collection of essays, each by a different author, each of which comes to grips with the fragmentation of traditional working-class culture in a different way. In general, the authors accepted that the working class was being split: one section being drawn into skilled jobs that would enable them to live like certain elements of the middle classes, another into deskilled, low status, and often service jobs. However, they argued that jobs of this latter kind were especially taken by disadvantaged youth, who, inheriting neither a strong sense of communal identity nor values transmitted across generations in families, develop sub-cultures. These sub-cultures negotiate with, and hybridize certain hegemonic cultural forms as modes of expression and opposition. Dick Hebdige, for instance, shows how the Mods fetishized style itself as an element of life, borrowing elements from fashions old and new, turning cultural consumption (the crucial element in the life practices of the 'affluent' worker) to their own ends. These sub-cultures are much more creative than Willis's lads or Morley's audience, and, at least in some cases, they use commodities, the primary products of the system that disadvantages them, as forms of resistance and grounds on which to construct a communal identity. Yet while *Learning to Labour* allowed the 'lads'' voices a great deal of space in the text, and Morley too transcribed actual voices, *Resistance through Rituals* is primarily concerned to develop a *theory* of hegemony under the conditions it encounters. This more theoretical approach, characteristic of an earlier phase of cultural studies, has its limits. It means that the writers find resistance to 'hegemony' in sub-cultural styles rather too easily. The book does not emphasize the way in which newly developed 'youth markets' influenced and promoted sub-cultural systems — especially in the music and fashion businesses. It also underestimates the impact of the education system which streamed children after eleven and kept them at school until they were fifteen (sixteen after 1972), generating intense intergenerational bondings unknown before the war. Neither are the Mods, Teds, Hippies and so on seen as trying to have fun or to construct a mode of life for themselves; they are primarily viewed as being engaged in symbolic struggle with the larger social system. But as we are about to see, categories like 'struggle' and resistance against the 'dominant' become increasingly difficult for cultural studies to sustain.

Despite their use of semiotic and Gramscian concepts, *Learning to Labour*, *The 'Nationwide' Audience* and *Resistance through Rituals* remain within the tradition established by Hoggart's *The Uses of Literacy*. In the late 1970s things changed. Cultural studies came increasingly under the influence of forms of thought associated with French theorists, in particular Pierre Bourdieu, Michel de Certeau and Michel Foucault. I will present their work in a general model – though it is important to remember that this model is an abstraction and presents no specific individual's work. Indeed Bourdieu and Foucault, especially, had little time for each other's approach.

For French theory, individuals live in a setting constituted by various institutions or, what we can call, following Bourdieu, 'fields' – families, work, peer-groups, educational apparatuses, political parties, and so on. Each field takes a particular material form, most having a characteristic space and time attached to them (the private home for family life and most media-reception, weekdays for work etc.). The relation of space to social fields is the theme of the essay by Foucault collected here. Each field is future-directed and contains its own 'imaginary', its own promise and image of satisfaction and success, its own possibilities for pleasure. Family life, for instance, depends upon images of the perfect family (mum, dad and a new-born baby, say) and members may feel pleasure when they reproduce that image, even if only for a moment. This 'imaginary' *is* imaginary because of the limits and scarcities which organize fields – family life is constrained by finances, aging and intergenerational conflict for example. Because of these limits too, fields are suffused by power relations and tend to be structured hierarchically. After all, not everyone can have equal experience, knowledge, money or authority. Very hierarchical fields (like schools and offices) are most disciplined and rationalized: in them all activities are directed to a fixed purpose – education in a school, profit in a business. Further, each field has characteristic signifying practices more or less tightly attached to it: the same person may well talk, walk and dress differently at school (or work) than they do in the family, and differently again when socializing with their peers. These signifying practices are structured through scarcity as well. Dick Hebdige has pointed out that punks worked on their body rather than consumption as a means of expression because it was one of the few materials that they could afford.

Each field also contains a variety of styles of belonging: one can be this kind of student or that kind, for instance, a casual filmgoer or a film buff. These fields, then, contain choices of 'self-formation' or what Foucault called 'self-government', though in highly disciplined and rationalized fields like schools or businesses these choices are more directed from above than in others. Likewise individuals can work out strategies by which to advance in a field or to reconcile themselves to their current position: Bourdieu famously showed how members of the working class, unable to afford certain goods or tastes, made a virtue of necessity by saying that they didn't like them anyway. On the other hand, possibilities exist for 'transgressive' undermining or 'festive' overturning of routines and hierarchies through passive resistance, ironical mimicry, symbolic inversion, orgiastic letting-go, even daydreaming – as the essays by Peter Stallybrass and

Allon White and by Michel de Certeau here show. Especially in societies where hierarchies in many fields are rigid, these forms of transgression may themselves become institutionalized – as in Brazil today with its carnival samba schools, or early capitalist Europe with its pantomimes. Finally, each field, to some degree, both defines itself against and is suffused by others: for instance, relations in the workplace may be modelled on the family ('paternalism') though the family is simultaneously a 'haven' from work. However, highly rationalized fields (like schools and factories) interact least directly with other fields – they form their own 'world'. Nonetheless it is where fields are most rationalized and disciplined that positions held in one internal hierarchy may be converted into a position held in another. Reaching the 'top' of the education system helps you start 'higher' in the world of work.

What about individual identity and experience ('subjectivity') in this schema? The important point is that actual individuals are not 'subjects' wholly positioned by the system these fields constitute or the strategies the fields provide. There are several reasons for this: in theory at least individuals can always make choices which take into account, and thus avoid, the forces they know to be positioning them. Also, because human beings exist as 'embodied social subjects' (as Teresa de Lauretis puts it in her essay in this volume), an individual's relation to the fields continually incorporate and shift under the impact of contingent givens (skin colour, physical appearance and so on) and material events (weather, illness, technological breakdowns and so on) which are not simply determinants of social or cultural forces. Third, language itself intervenes between the individual and the socio-cultural fields that construct his or her positions. Our sense of uniqueness is ultimately grounded on our sense that we can *say* what we like – at least to ourselves, and we have that sense because language is both a resource that costs nothing (a basic but often ignored point) and complex enough to enable an infinite number of individual speech acts. As deconstructive theorists have pointed out, this is true because of, rather than in spite of, the fact that private discourse always comes from somewhere else and its meanings cannot be wholly mastered by those who use it. Last, given that individuals live a) in symbolic structures which let them (within limits) speak for themselves; b) in bodies that are their own but not wholly under control; c) in a temporality which flows towards the unknowable and uncontainable, they may find in themselves 'deep' selves which cannot be reduced either to the managerial self that chooses styles, strategies and techniques of self-formation or to the subject positioned by external fields and discourses. Modern Western culture in particular has given a great deal of value to this form of subjectivity – it's the kind of selfhood that the massive apparatus of therapy and new ageism is directed towards – and cultural studies' insistence that subjectivity primarily consists of practices and strategies has been partly targeted against it.

The French model breaks from earlier forms of cultural studies. To begin with, it downgrades the way that economic scarcities operate systematically across *many* fields. Because it conceives of social fields as 'partially autonomous', the

French model cannot affirm a central agency that might direct a number of fields to provide a more equitable distribution of resources. In this, it is remote from traditional social-democratic politics. Instead there is a drift to affirm both culture's utopian force and those forms of resistance (such as de Certeau's 'walking in the city' in this collection) only possible in the cracks and gaps of the larger, apparently impregnable, system. Somewhat paradoxically, that system is impregnable just because it is less centred around an isolatable and 'dominant' set of institutions or ideology. Why did cultural studies accept relatively depoliticized analyses of this kind? The reasons are to be found in the decline of the social-democratic power bloc from the mid-1970s onwards which enabled the so-called 'new right's' emergence – in the US under Ronald Reagan (1981) and in the UK under Margaret Thatcher (1979). Furthermore, it was in the context of the new right's emergence that (as we shall see), after absorbing French theory, the discipline orientated itself towards what Cornel West in his essay here calls the 'culture of difference' and became a genuinely global movement.

The new right (or Thatcherism as Stuart Hall dubbed it) countered the social democrats by arguing, first, that the state should intervene in citizens' lives to the minimum possible extent so that market forces can structure as many social relations and exchanges as possible, and, next, that internal differences (especially between classes, ethnic groups and genders) were threats to national unity. The nation was defined in terms of traditional and popular national-cultural images of 'Englishness' in Thatcher's case and 'Americanness' in Reagan's. This was a politics that appealed at least as much to the 'affluent worker' as to traditional conservative (in the US, Republican) voters. As long ago as 1957 Richard Hoggart had noted how, with increased spending power, the working class were increasingly evaluating the world in economic, rather than class, terms. Thatcherism was also the product of the social-democratic interventionist state's failure to manage the economy without playing inflation off against unemployment, a failure which itself followed increasing economic globalization (especially of the financial sector) and the appearance of economic powers outside the West. (The most prominent events in the process of economic globalization were the 1971 end of the postwar Bretton Wood agreement by which all major currencies had been pegged against the US dollar, itself convertible into gold; the 1973–74 OPEC cartel which led to unwonted price increases for oil; the radical increase of Japanese competitiveness in key consumer-durable markets; the increased movement of Western manufacturing 'offshore' through the 1970s and 1980s, and the immense increase of capacity for information about commodity and money markets to be disseminated quickly and globally, and, somewhat later, the 1989 end of the Cold War after the collapse of the old Soviet regime and empire.) In these terms, Thatcherism is the political reflex of an affluent, newly empowered but divided and threatened First-World society in a post-colonial world-order. As Hall pointed out (Hall 1988), it was able to counter a widespread sense of fragility by taking advantage of a mass of 'popular knowledge' which put the family, respectability, hard work, 'practicality' and order first – a 'popular knowledge' which, as Morley demonstrated, had been, for years, transmitted in shows like *Nationwide* and its

US equivalents. At this level at least, Thatcherism does not draw on the values of traditional high culture, instead it appeals to the social imaginary produced by the market-orientated media.

But Thatcherism contains an internal contradiction – between its economic rationalism and its consensual cultural nationalism. The more the market is freed from state intervention and trade and finance crosses national boundaries, the more the nation will be exposed to foreign influences and the greater the gap between rich and poor. New right appeals to popular values can be seen as an attempt to overcome this tension. In particular, the new right gives the family extraordinary value and aura just because a society organized by market forces is one in which economic life expectations are particularly insecure (as well as one in which, for some, rewards are large and life exciting). In the same way, a homogeneous image of national culture is celebrated and enforced to counter the dangers posed by the increasingly global nature of economic exchanges and widening national, economic divisions. The new right image of a mono-culture and hard-working family life (in the US often orientated towards active Judeo-Christianity), organized through traditional gender roles, requires a devaluation not just of other nations and their cultural identities but of 'enemies within': those who are 'other' racially, sexually, intellectually. It was in this situation that the Birmingham school focused more intensely, on the one hand, on feminist work (as by Charlotte Brunsdon, Angela McRobbie and Dorothy Hobson on the back of early work by Simone de Beauvoir (see her essay collected here)) as well as on the analysis of racism and a counter-celebration of black cultures (most painstakingly in Paul Gilroy's *Where's the Black in the Union Jack?*); and, on the other hand, to a more straightforward critique of the new right itself, as in the essays collected in Stuart Hall's *The Hard Road to Renewal* as well as the earlier collectively-written *Policing the Crisis*. This last book latches onto the mechanisms by which law-and-order issues and racism were gaining ground in the last days of the social-democratic power bloc, convincingly demonstrating that law-and-order panics in Britain in the 1970s were produced by tacit alliances between the media and the police – being, in that sense, organized.

As cultural studies responded to the conditions surrounding the new right's emergence, the discipline became internationalized. The main reasons for this are simple: analyses of racism, sexism and the culture industry possessed a wider appeal than analysis of the British working-class culture, particularly in the US or Australia ('New World' states who fancied themselves relatively 'classless' societies). But when cultural studies gave up its Marxian and classist approach, it began to approach, if in a different spirit and register, certain new right themes. After all, both movements were strongly anti-statist; both affirmed, within limits, a decentred view of social organization. What were the analogies between new right (or more particularly its neo-liberal side) and cultural studies, politically so opposed to one another? Perhaps most importantly, where new right discourse argued that no state institution could transcend particular interests and legitimately control individual choices best represented in the market, cultural studies criticized the notion that any theory could stand outside the field it claimed to tell the truth

about as if it were a 'meta-discourse'. For French theory, 'theory' itself was a discursive practice produced in a particular field with particular power effects: it offers, for instance, the ability rhetorically to master other people's values and 'common sense'. That there could be no transcendental 'meta-discourse' was a crucial thesis in what is sometimes also called theoretical 'postmodernism' — the end of any appeal to those 'grand narratives' by which institutions and discourses bearing the modernizing values of universal liberty, equality and progress were affirmed in the name of a trans-historical, meta-discursive subject.

The new mode of cultural studies no longer concentrated on reading culture as primarily directed against the state. Mainly under the impact of new feminist work at first, it began to affirm 'other' ways of life on their own terms. Emphasis shifted from communities positioned against large power blocs and bound together as classes or sub-cultures to ethnic and women's groups committed to maintaining and elaborating autonomous values, identities and ethics. This moment in cultural studies pictured society as much more de-centred than either the CCCS had in its earliest work or than the French theorists had, as they focused on discipline, rationalization and institutional fields. However an immediate problem confronted this new model as it broke society down into fractions united by sexuality, gender or ethnicity: how to conceive of relations between these dispersed communities? Two solutions were offered, both rather utopian and future-directed: first, new 'rainbow' alliances and cross-identifications could be worked out for particular and provisional social or 'micro-political' ends; second, relations between these groups would be 'dialogic' — a concept borrowed from Mikhail Bakhtin and in which the otherness of each interacting participant remains intact. Whatever the effectiveness of these solutions, celebrations of the 'other' sounded a powerful oppositional note where governments attempted to encourage or enforce mono-culturalism and traditional gender models on the nation. Nonetheless the affirmation of 'otherness' and 'difference' in what is sometimes called a 'politics of survival', belong to a looser, more pluralistic and postmodern, conceptual model than those which insist that capitalism and the free market produce interests that are *structurally* unequal and in conflict with each other. Unlike new left thought, the new cultural studies no longer aimed at a radical transfiguration of the whole system of social fields.

Cultural studies' affirmation of otherness and negation of meta-discourse must also be understood in terms of the accelerated globalizing of cultural production and distribution from the 1970s on. This is the theme of essays by Arjun Appadurai, and Michael Hardt and Antonio Negri in this volume, and they show how multidirectional the process of 'globalization' has been. In some areas, it has involved a breakdown of distinctions between 'First' and 'Third' World nations: new technologies (such as satellite broadcasting) produced international audiences as for Bob Geldoff's 'LiveAid' 1985 concert in the emergence of what might be called the 'global popular' and, most of all, by the internet as we will see. To similar ends, and on the back of the global popular, non-governmental agencies like Greenpeace established new transnational organizations. The globalization of the media had one especially important consequence: through the 1970s and

1980s it accelerated the concentration of the cultural industry largely because the global market requires increased investment in marketing and distribution. But in other ways globalization has produced new local 'vertical' differences – as where, for instance, First-World encouragement to modernize and develop led not just to massive Third-World indebtedness and an increase in poverty but to urbanization and de-culturalization around the world. In other ways still, however, globalization has generated diversity and autonomy – as when sophisticated cultural and media industries began to develop outside the West in places as different as Brazil and Hong Kong (increasing the amount of local news worldwide, for instance) or when non-Western communities were able creatively to commodify or museumify their cultures. One effect of the large and very various process of globalization has been especially important to cultural studies: Eurocentric concepts of 'primitive', 'underdeveloped' or superstitious peoples (that is, so-called 'Fourth-World' people) became difficult to sustain on a variety of registers. In his influential essay 'On Ethnographic Authority' (in Clifford 1988), James Clifford showed that anthropologists' 'native informants' could now speak for themselves to 'us' without the mediation of the anthropologists and their 'science'. To somewhat similar ends, Edward Said drew attention to 'Orientalism' – the history of those images of the 'Orient' produced to help the West dominate the East, and in which what non-Westerners said about themselves was systematically discounted. As cultural studies became the voice of the other, the 'marginal' in the academy, it absorbed a radical wing of anthropology, just as it had earlier absorbed a wing of sociology in Britain. The literary world threw up another case in which the processes of globalization were shown to trouble any simplistic or conventional analysis: in 1989 protests against Salman Rushdie's *The Satanic Verses* (started by migrant communities in Britain) undercut assumptions about the naturalness (or dominance) of Western notions of how particular cultural formations relate to one another. In particular the Western sense of literature's transcendence of religion and politics, and pointed the way to the politics of Islam versus the West which would emerge in full force after September 11. In sum, globalization meant that the role that sub-cultures and the working class played in earlier cultural studies began to be replaced and transformed by communities outside the West or migrant (or 'diasporic') communities within the West – in a move which involved new theoretical and political problems and intensities.

Conceiving of cultural studies as the academic site for marginal/minority discourses had another, very different but no less visible and globalizing consequence, one which took it further from its original attack on mass culture. The discipline began to celebrate commercial culture, in a move known as 'cultural populism'. Cultural populism became possible within the cultural studies anti-hegemonic tradition because, despite the new right's reliance on values disseminated through the cultural market, the right also buttressed its mono-culturalism by traditionalist appeals to the canon. (This play between popular knowledge and celebration of the canon marks another tension within the contemporary conservative thought.) In its turn, cultural populism helped cultural studies to become global just because, as we have seen, commercial culture has an increasingly transnational reach.

What form has cultural populism taken in cultural studies? It too turned away from the highly theoretical attacks on hegemony so important in the 1970s, this time by arguing that at least some popular cultural products themselves have positive quasi-political effects independently of education and critical discourse. For instance, in his 1987 essay, 'British Cultural Studies and Television', John Fiske, after reading *Magnum P.I.* (a TV cop show of the time) through the classic distinction between 'preferred', 'negotiated' and 'oppositional' readings developed by Hall and Morley, went on to claim that Madonna (circa 1986) offered fans her own form of feminist ideology critique. Madonna 'calls into question' 'binary oppositions as a way of conceptualizing women' (Fiske 1987a: 275). Elsewhere Fiske emphasized that popular culture provided 'pleasure in the processes of making meanings' (Fiske 1987b: 239) in a move that relied on Roland Barthes' later view that markedly polysemous texts generate particularly intense and liberating pleasures. (See the Barthes essay collected here.) Such work is refreshing because it rejects the hierarchies that support mono-cultures, as well as because, unlike the 'hegemony' theorists, it does not condescend to actual popular cultural practices. But it leaves many questions open. The theorist is still telling the 'popular' audience how their pleasure works in terms which owe much more to the history of theory than they do to what people actually say or think. It also passes over the question of co-option too rapidly. For instance, Madonna's later work showed us that 'needs of capital' (i.e. the requirement that investments make profits) has not been exactly irrelevant to her career. By calling herself a 'material girl', by daring to screen us some familial truths in *Truth or Dare/In Bed with Madonna* she once again went to show that what is daring and transgressive in the context of media-oligopolies, makes money. But as Madonna helped keep the industry in business through the 1980s and 1990s, her transgression becomes blander. That is what co-option is. In this light a comparison between Madonna and even a star as musically mainstream as Bruce Springsteen, who in the period of the 'War on Terror' participated more openly in anti-conservative politics, might be revealing. It would help show how a 'cultural populism' which can celebrate Madonna (whom the industry loves) as transgressive, is subtly, if unconsciously, connected to the new right with its promotion of market forces. This is not to say that we can equate entry into cultural markets with co-option in any rigid or formal manner. But cultural populism requires a very nuanced account of the relations between cultural markets and cultural products in order convincingly to celebrate (some) popular culture as 'progressive' – perhaps along the lines taken by Janice Radway in her essay in this collection.

Finally, another form of cultural studies, which emerged in the second half of the 1990s under the title 'cultural policy studies', responds to the decline of the social-democratic power bloc in yet other ways (see Tony Bennett's essay in this volume which mounts the case for this mode of cultural studies). Cultural policy studies itself takes two distinguishable forms, one economically orientated and pragmatic, the other more theoretical. The first, economic cultural policy analysis, starts from the recognition that much cultural production and distribution requires allocation of scarce resources – the limits to the number of stations that can

operate in the radio spectrum for instance. It also takes account of the fact that cultural labour and consumption are increasingly important to national economies, especially but not only those of highly 'advanced' post-industrial countries: indeed tourism is now the world's biggest industry. For reasons like this, governments are called upon to set parameters for cultural production and distribution – to provide public broadcasting for instance, or to protect tourist infrastructure. (See Collins, Garnham and Locksley 1988 for an excellent example of a policy document in this spirit aimed at the debate over UK public television.) At the micro level, local communities too may need policy advice, in order, for instance, to establish a museum that best provides for both local and tourist needs. Cultural policy studies helps us think about the frameworks and methods of articulating policy in such situations.

The other branch of cultural-policy theory derives from Michel Foucault's later work, though Foucault himself, despite advising a number of French governments, was ambivalent about this development of his thought. He encouraged intellectuals to be more critical than is possible when offering policy advice. (Ian Hunter's *Culture and Government* is the book which theorizes this form of neo-Foucauldianism in most detail; see Foucault's essay 'Practising Criticism' in Foucault 1988 for a rejection, in advance, of the position.) In its most radical guise, the neo-Foucauldian thesis argues that culture is neither an end in itself nor the product of autonomous agents – whether individuals or communities – but a mechanism for transmitting forms of 'governmentality', for ordering how we act, think, live. Indeed, so the argument goes, cultural work and effects only exist in relation to other governmental structures. Thus Tony Bennett argued that 'policy and governmental conditions and processes should be thought of as constitutive of different forms and fields of culture' (Bennett 1992: 25). The implication is that the least mystified task of the cultural studies analyst is to enter into alliances with, and attempt to influence, the processes of governmentality.

A number of strong arguments can be urged against neo-Foucauldian cultural policy theory. In particular, such theory possesses a rudimentary account of subjectivity. For it, the individual tends to be just a product of 'governmental' protocols or of 'techniques of self formation'. This matters because questions of pleasure, corporeality, fantasy, identification, affect, desire, critique, transgression and so on disappear – which is crippling to rich analysis of cultural work and reception. The theory also relies on a reductive sense of politics. 'Policy' becomes a word which, almost magically, neutralizes the more stubborn, conflictual and critical relations between the various individuals and groups which constitute the social fields in which culture is produced, disseminated and received.

Leaving these important theoretical difficulties aside for a minute, we can say that both forms of cultural policy studies mark an acceptance of the state hitherto unknown in cultural studies. It traditionally resisted the state's hegemony. There is, indeed, a sense in which cultural policy studies resists new right thinking by returning to statism. Cultural policy studies also breaks with the history of cultural studies in that the discipline has not traditionally produced neutral expertise. Here the difficulties just noted return. It is all the harder to

see how cultural studies might provide (apparently) neutral expertise when one considers the kinds of case that cultural policy characteristically address. How much 'local content' should a particular television industry have? What kind of museum should be constructed in this locality? From the bureaucratic point of view, questions like these require information to be gathered, costs and benefits to be projected, various economic models to be debated; a process of 'consultation' to be implemented. In this, individuals trained in cultural studies (and in other disciplines) might, of course, have a productive role to play. But apart from that, such questions are best argued over not by experts but by (representatives of) interested parties — that is, democratically and politically. As a transnational academic discipline cultural studies itself does not represent such an interest. And, in fact, policy advice does not uncover truths which can be immediately used and applied. On the contrary, outside the academy, it tends to become a pawn in wider political engagements between such interests. Policy is always contestable, that is to say, political — which means that cultural policy studies cannot trump politicized forms of cultural studies.

Cultural studies now: some directions and problems

So cultural studies is a discipline continuously shifting its interests and methods both because it is in constant and engaged interaction with its larger historical context and because it cannot be complacent about its authority. After all, it has taken the force of arguments against 'meta-discourses' and does not want the voice of the academic theorist to drown out other less often heard voices. As we have begun to see, the discipline's turn to ethnography in particular was motivated by the desire to move beyond theoretical discourses which, however insightful, have been restricted to higher education institutions. Ethnography of the kind developed by Willis and Morley was important to cultural studies because it provided a method by which the discipline could escape such restrictions, and it remains crucial to an understanding of the current and future directions of the discipline. It is crucial just because the turn to ethnography highlights the difficulty of *either* claiming *or* disclaiming academic and, more especially, ethnographic authority. For if we accept that the academic humanities are a field in which power and cultural capital are generated and transmitted and so do not simply articulate 'true' meta-discourses, we must also accept that non-academic or 'popular' cultural institutions require critique from a distance because they have their limits and power effects as well. To put it another way, cultural studies today is situated between its pressing need to question its own institutional and discursive legitimation and its fear that cultural practices outside the institution are becoming too organized and too dispersed to appeal to in the spirit it has hitherto appealed to sub-cultures, the women's movement and other 'others' in its (always somewhat compromised) repudiation of statism and the new right.

In this situation, we need to consider the question of ethnographic or academic authority a little more carefully. Of course ethnography has a long history in the

positive social sciences. Social scientists and market researchers have traditionally employed three modes of ethnographic investigation: 1) large-scale 'surveys' (or 'quantitative research') using formal questionnaires on a sample large enough to provide 'correlation coefficients' or measures to the degree one variable (like a taste for reading Charles Dickens) relates to another (like one's parents' jobs); 2) 'qualitative research' or in-depth or 'focus' interviews which claim no statistical validity (though they are often used alongside large-scale surveys) and do not rely on formal questionnaires but on (usually group) discussion; 3) 'participant observation' in which researchers live alongside their subjects – this having been most common in anthropology. Cultural studies ethnography, particularly of media audiences, has mainly used qualitative research in order to avoid the pitfalls of sociological objectivity and functionalism and to give room to voices other than the theorist's own. The problem of representativeness has been discounted. For cultural studies, knowledge based on statistical techniques belongs to the processes which 'normalize' society and stand in opposition to cultural studies' respect for the marginal subject.

In early cultural studies ethnographic work like Morley's The 'Nationwide' Audience, the researcher played the role of a neutral narrator – using research subjects as the basis upon which to elaborate theory. Later researchers, like Paul Willis, tried to articulate their subjects' perceptions into a more abstract and rigorous lexicon: for Willis good theory was continuous with the 'practical consciousness' of those he studied. The bonding between ethnographer and subject became even more crucial when women began working with women – of which Dorothy Hobson's work on the soap opera Crossroads is a well-known early instance (Hobson 1982). To think about the importance of the ethnographer's gender – consider how difficult it would have been for a woman to have had Willis's relation to the 'lads'! A sense of shared values, identities and purposes between the researcher and the researched often elicits richer responses and transactions in the field. When, in a well-known ethnographic study, Ien Ang invited letters from Dutch Dallas viewers, she positioned herself as a fan (as she was) so as to encourage engaged replies (Ang 1985). But – and here we strike a crucial problem – the ethnographer is not simply a fan; there is an irreducible rift between the position of being-a-researcher and that of being-a-fan, though of course a single individual can be both. There are two ways of dealing with this: one is to accept it and the ambivalence or contradiction it generates as productive; the other is for the researcher simultaneously to ethnographize herself in relation to her subjects and to allow her subjects as much exposure as possible to her own, more academic discourses. At which point ethnography can involve two-way transmission of information and maybe even passion.

With the category 'being a fan', the question of populism reappears. But now we need to draw a distinction between cultural populism and that form of academic populism which (like Paul Willis) argues that, in cultural studies, academic knowledge ought to formalize what is already popularly known. A difficulty for both these populisms is that when we think of either a 'culture of differences' engaged in a 'politics of survival' or a society as structured by various interacting

fields through which various discursive/cultural practices are transmitted then the *binary* opposition 'popular' versus 'elite' begins to fall away. The assault on this form of binary thinking has been all the stronger because recent historical research has shown that the separation between popular and elite culture has historically been more fluid than cultural historians have believed. (See Levine 1988 and Collins 1989.) Nevertheless the 'popular' as a category is unlikely to fall out of sight in cultural studies. To begin with, as we have seen, the distribution networks of concentrated cultural markets are increasingly gaining access to communities from different localities, ethnicities and cultural backgrounds to produce ever-larger popular audiences: now some stars and brands (Coke, Nike, McDonald's ...) belong to the global popular, at least for a while. At a more local level, notions of popular wants and desires are powerfully appealed to both by national politicians (nowhere more so than in Thatcherism) and by managers of large-scale cultural industries as they attempt to organize consumers' tastes, desires and pleasures. Politicians construct an imaginary through figures such as 'the silent majority', or the 'man (less often 'woman') in the street' or 'a real American'. These figures are sometimes literally fake: in the 1930s and 1940s, Hollywood habitually produced 'documentaries' using actors as supposedly 'real' interviewees. Fake or not, these figures become *embodied* in our national social imaginary. For the politicians, it is as if a certain kind of individual possesses the opinions, tastes and values which polls, charts, ratings and elections reveal to be popular. In the culture industries, the figure of the 'popular' mediates between producers and audiences. Using its own sophisticated ethnographic techniques, the industry attempts to produce what the public (or, at any rate the more affluent sections of it) want. But at the same time it generates public desire by marketing its products (both hardware and software) as if they were always already popular. That 'nothing sells like a hit' is more than a tautology, it is the most successful formula for cultural marketing. People will buy what other people love and desire. Through these political and commercial tactics and logics, the popular is constantly pushed towards the normal, even the universal.

Yet, as a concept like the global popular makes apparent, no single kind of person embodies the popular. Cultural studies can provide space for, and knowledge of, the multiple audiences and communities who, in various combinations, vote, buy records, watch television and films etc. without ever fitting the 'popular', 'ordinary' or 'normal'. This is another reason to examine the techniques by which social values, attitudes and desires are measured, as well as to demystify the political uses of representations like the 'silent majority' and 'ordinary American'. In this way, cultural studies can begin to intervene on the cultural market's failure to admit full cultural multiplicity – particularly if (going with cultural populism) it accepts that, in principle, cultural markets can provide a variety of products, pleasures and uses, including transgressive and avant-garde ones. Although cultural multiplicity is appealed to by many theoretical articles in this anthology, it is useful to cite a well-known recent example of how audience measurement affects cultural production and images of the 'popular' within a particular nation-state. When, in the USA in the early 1990s, *Billboard* stopped producing its charts

by measuring radio play and sales in an unrepresentative sample of shops and began using information based directly on bar-coded sales, it immediately became apparent that 'genre' music – country, rap, heavy metal – was selling much better than anyone had suspected. These music forms began to enter a redefined mainstream. The sense of what was 'popular' shifted. This is not to say that these new techniques perfectly represent public preferences: *Billboard*'s measurement of purchase doesn't measure real consumption, let alone tastes. For example, not all social groups have the same capacity to turn their taste into purchases, not all sold product is listened to as often as others, and some music genres are more often downloaded for free than others. Images of 'popular listening' based on *Billboard*'s information would still be awry – though this information will also allow the music business oligopolies to re-structure their production and hence (within limits) popular tastes and desires.

The deeper question that quantitative market research and ratings fail to answer is how cultural products are valued and used – this is especially important because this failure, too, has important effects on our construction of the popular. Take television for instance. Ratings are still mainly produced by measuring how many televisions are turned on each channel at any particular moment, though techniques to measure actual audience attention are also employed, including videoing viewers! But (leaving the question of recorders aside which have become much more disruptive of schedules since their digitalization) we know that television is watched in many ways: for information, for comforting background noise and flicker, as a neutral flow which helps to reduce (or increase) family tensions, for relaxation after working hours, for fans to watch a favourite programme intensely, to produce a sense of cultural superiority through a careful, but ironical and distanced, mode of viewing, as a medium for programmes which are received as great art and so on. At any one time any programme is available for many of these viewing practices. However at certain times of the week certain such practices dominate. 'Prime time' is the period in which most people watch for relaxation for instance. What the ratings measure then is not *one* kind of viewing: like is not being compared to like. Rather a good rating is a sign that a particular television use-value dominates at a particular moment within the larger rhythms of the working/schooling week. It is not the simple index of popular will or taste. Again, by turning a good rating into an expression of the 'popular', less widespread practices and preferences are marginalized as 'unpopular'.

Partly because the notion of the 'popular' carries with it these problems, cultural studies is increasingly drawing attention to another, closely connected, category, one which does not compound divisiveness for the simple reason that (at least apparently) no one, anywhere, can avoid it. This category is 'everyday life'. Ironically however, cultural studies (as in the essay by Michel de Certeau collected here) derives the notion from an avant-garde tradition which turned to everyday life not as a basis for reassuring consensus but as an arena capable of radical transformation just because it was being increasingly disciplined, commodified and rationalized in so-called 'modernity'. In particular, Henri Lefebvre believed that intellectuals could drive the 'organized passivity' and banality out of

everyday life, drawing attention to its tragedies, sublimity and magic (Lefebvre 1971 and 1991a). This was to be achieved by showing, first, that everyday life is *constructed* as the sphere in which, as the writer Maurice Blanchot put it, 'nothing happens' (Blanchot 1987: 15), and, then, by writing about it carefully and affectionately, to defamiliarize it and reaffirm its true value. Lefebvre's desire to play everyday life against modernity was elaborated by Michel de Certeau who found a dreamlike logic or 'grammar' in overlooked and habitual acts (like walking) which countered disciplining routines. Given de Certeau's essay collected here in particular, there can be little doubt that everyday life does provide an area where imaginative intellectual analysis and description may produce liberating effects. Partly by bringing academic analysis closer to the aims and techniques of older, non-academic essay writing, the textualizers of everyday life help us accept academic authority at the same time as they loosen and disseminate it. Nonetheless, theory which grounds itself on a sense of the everyday does not avoid the problems associated with populism. Most relevantly, within a discipline that has globalized itself through affirming otherness, it is important to remember the obvious point that everyday life is not everywhere the same, despite those modernizing effects of uniformity that Lefebvre was obsessed by. Think about walking in the city: doesn't it make a difference if one walks in Paris, downtown Detroit, Melbourne, Mexico City or Hong Kong just for starters? And, in each of these places, does a woman have the same experience as a man, a gay as a straight, a young person as an old one? The everyday, too, is produced and experienced at the intersection of many fields by embodied individuals; at times and in places it may also be a limit that cultural practices, especially those that attempt to move across cultures, aim to escape. And it does not possess a single history. It exists within multiple histories many of which escape the way the past is remembered and stored officially – in universities for instance. Here, perhaps more than elsewhere, cultural studies merges into cultural histories which re-connect us to the world in ways that cannot be taken for granted. So it is not as though appeal to everyday life can avoid the intractable questions as to relations between social differences, life practices and cultural expression which cultural studies began by addressing. But the fact that textualizing everyday life, with all its seduction, leads to these kinds of difficulties is another sign that the discipline has real vitality. There remains much work to do.

Barring minor modifications, the introduction above was written in 1992. Despite its now being about fifteen years old, it continues to provide a useful preface for the new essays added to this edition though many were written since. This is not to say, however, that cultural studies in 2006 is what it was in 1992. Not at all. To begin with, the topics it deals with have changed, or, at least, emphases have shifted, in part because, as a globalized field, it has felt the impact of two major events: September 11 and the rise of the internet. For instance, highly theorized work, especially from a structuralist/semiotic perspective, has moved to the background. So have topics like sub-cultures and media reception. However a few of the new areas, scattered across the field, are worth noticing in a little more detail.

First, sex. Sex has partly displaced gender as an area of debate and contestation. This has happened within queer theory which, in insisting that the regime of compulsory heterosexuality (or heteronormativity) shapes gender difference, has effectively rejected the earlier feminist bracketing off of sexual desire from critique of gender 'roles'. Notwithstanding its avowed political programme, and despite its capacity to help assemble a constituency ('queer nation'), queer theory tends to be more philosophical, and more distant from public culture as it happens in the media or official politics, than most previous work in cultural studies. At best the queer academic poststructuralist can be thought of as a vanguardist intellectual within queer nation (an 'organic' intellectual in Gramsci's sense even as she dismantles organicist thinking); at worst, unremittingly academic work in the poststructuralist vein can seem insensitive or irrelevant to the twists, wonders and shocks of lesbian, gay, queer life over the past decade – with its political wins and losses, the ongoing carnage of the AIDS epidemic; an increasing (popular-) cultural acceptance, confidence and inventiveness…

Indeed the function of the cultural studies teacher in relation to 'public culture' or the public sphere more generally has been much discussed. At least since Andrew Ross's pathbreaking book, *No Respect: Intellectuals and Popular Culture*, such discourse has often taken the form of arguments over intellectuals. What's an intellectual these days? Are they just professionalized voices within the academy or the media; are they spokespersons for specific interest groups or communities? Can the notion of the *critical* intellectual survive the fragmentation of culture into an assemblage of institutions, and the professionalization and specialization of academic knowledge? For instance, are Noam Chomsky and Stuart Hall both 'intellectuals', or is Hall, who rarely appears on TV, just an 'academic' or 'professor', with Chomsky, for all his fame, only a media intellectual because he's tied to old-left causes, having failed to attend to contemporary academic media/cultural/social theory as expressed in cultural studies? How about Judith Butler and Camilla Paglia? Cultural studies has increasingly concerned itself with such cases and questions (Robbins 1990 and 1993a).

Science has also become of more interest to cultural studies in response to the increasing technologization of nature and the human body as well as in response to global warming. As technology and nature merge, upholding a hard division between science and culture by insisting that science remains off-limits to non-scientists helps disenfranchise those whose lives are most affected by scientific and technological innovations (or, otherwise put, by science's colonization of the life world). On the other hand, leaving science to the experts may also allow too much scope amongst non-scientists for technophobes and those who fetishize a nature out of reach of human work and intervention. At the same time pressures are being brought to bear on the concept of the human itself, as medicalized bodies and reproductive techniques become more 'artificial' and as the species causes a crisis in its ecological niche (global warming). In this context, there has been an increased interest in the concept of the animal simultaneous to that in the 'posthuman' as conceptualized along the lines of Haraway's famous cyborg essay reproduced here.

But perhaps the most profound topical change in cultural studies has been its focusing on cultural *flow* or mobility. The field is much less focused on discrete, filiative national or ethnic cultures, or components of such cultures, than it was in its earlier history, in work by Raymond Williams and the early Birmingham school, say. Cultural studies' objects are decreasingly restricted or delimited by distance and locality at all. Rather they move across national borders (as in the global 'scapes' described by Arjun Appadurai in his essay collected here); or they belong to scattered, diasporic groups; or they are products of fluid, transnational regions like Paul Gilroy's Black Atlantic, peopled by men and women without 'pure' identities or traditions and all the more able to improvise within their situation for that reason; or they inhabit fault lines between global powers and processes like, for instance, citizens of urban China caught at the interface between a state tightly controlled by the Communist Party and global capitalism.

Cultural studies which addresses such cases is often called 'transnational cultural studies'. It is eroding so-called 'postcolonialism', first nurtured in literary studies, which was so important a feature of the late 1980s/early 1990s intellectual landscape. Much critiqued on the grounds that it prematurely celebrated the end of colonialist relations of exploitation and dependency, postcolonialism increasingly has had to come to terms with 'globalization' – a word often heard, rarely clearly understood. What is globalization, then? On one level it is best understood as the development of global markets and capital so as to skew highly capitalized national economies towards service, information and other high value-added products away from traditional primary commodities and mass production industries. Globalization also means more organized cross-national or 'diasporic' labour force movements, documented or undocumented. Globalization has created a new order of underclass: migrants without official papers disobeying the sovereignty of national borders, outside the processes of formal political representations in those countries where they labour, willing to risk extreme exploitation, and in reaction creating new forms of hyper-nationalism and xenophobia. At the same time, globalization means the accelerated development of digitalized communication technologies like the internet which escape the tyranny of distance, which drive contemporary systems of transportation, finance and surveillance (under which mass undocumented migration plays itself out) and which are profoundly and irrevocably altering the traditional media landscape in directions that are not yet clear.

In sum, globalization has undermined the autonomy of nation-states and reduced state intervention in society and the economy – sometimes as a cause, other times as an excuse. But it has also strengthened them partly in resistance to the insecurity it causes, partly because it has created new national elites and given them increasing capacity of social control. It has also drastically transformed and punctured the old metropolitan/colony, centre/periphery, North/South divisions, enabling new regions to invent themselves (notably 'Asia Pacific') as well as new cosmopolitanisms, elite and popular. (See Cheah and Robbins 1998 and the work being done in Asian Cultural Studies such as the essay by Ma and Cheng collected here.) At the same time it has created new forms of political resistance, of which by far the most important is the Islamic fundamentalist movement willing to

embrace terror and suicide bombing. I don't mean to say that the Islamic jihad groups are targeted solely against globalization (their primary enemy is US and Israeli domination of Islam's holy lands), but I am saying that global modernity is both their condition of possibility and their enemy, and there is a sense in which they too belong to the anti-globalization movement.

So this problem is not to be posed in the traditional fashion, that is: 'is globalization reducing global cultural differences?' The answer to that being increasingly clearly: 'no, at least not in any simple way' since globalization is articulating all cultures and communities to one another in a process which also makes for new fragmentations and mixes, new niche and local markets; new opportunities for self expression and alliance. Nor is the question: 'is globalization the same as Westernization?' To which again it is mainly agreed that the answer is, 'no, not in any simple way' – less because the technologies and capital driving globalization are not wholly owned in the West than because globalization brings benefits and power as well as costs to most localities around the world. The crucial questions are rather: 'is globalization creating new inequalities and depleting resources too unevenly and rapidly?' and, more complexly, 'is globalization depriving individuals and communities of the capacity to control and know their own interests as they are increasingly called upon to produce and consume for markets driven from afar?' And, 'is globalization creating a new politics of culture, which is setting the "secular" West against a faith-based Islam, committed to other forms of collectivity, social participation and political organization?' These questions have especial force for those – whether they live in rich or poor nations or regions – who have least capacity to direct or produce for global/national markets and flows, and hence are most likely to miss out on remunerative employment, becoming subject to demoralization and physical hardship, and objects of media stories, ethnographical research, touristic gazes and state, military or aid organization attention. Transnational cultural studies attempts to produce academic knowledge and testimony across political and cultural borders which are not complicit with these gazes, stories and attentions.

For all that, it is not cultural studies' *topics*, but its status in the education system, which has changed most radically. And in this process, cultural studies has become a soft target in the Western media. Risking academic self-absorption, I want to end this introduction by examining this crucial development a little more closely.

Since the early 1990s, there has been a gradual increase in cultural studies courses around the world. Or there seems to have been. In fact we need to distinguish between, on the one hand, a general 'turn to culture' (or 'cultural turn') in the social sciences and humanities, and, on the other, the expansion of cultural studies conceived of as a discrete mode of analysis as it is in this collection for instance – and which, for convenience's sake, I'll call 'engaged cultural studies'. (This is a topic I treat at more length in my *Cultural Studies: A Critical Introduction*, Routledge 2004.)

As to the cultural turn: most, maybe all, humanities/social science disciplines have increasingly emphasized culture over the past two decades. Cultural history has become the hot area in history; the cultural construction of space, in geography. Within criminology, representation of crime (i.e. crime's cultural face) has flourished. Cultural anthropologists are almost as likely to do fieldwork in urban, metropolitan communities (on shopping, say) as in the world's outposts, leaving them little space to distinguish them from cultural studies ethnographers. Books with titles like *From Sociology to Cultural Studies* raise few eyebrows. In many of the most exciting research areas of the last few years — the study of museums is a good example — historians, literary critics, anthropologists and geographers collaborate and compete with minimal disciplinary/methodological differences apparent — more often than not they are all doing 'cultural studies' as far as publishers and bookshops are concerned. Foreign language departments now routinely (if not uncontroversially) think of themselves as introducing students to cultures rather than languages and literatures. English departments around the world have developed courses in non-literary cultural forms.

This general turn to culture has helped disseminate cultural studies as a form of knowledge with its own histories, methods and programmes ('engaged cultural studies') but it also threatens to overwhelm and dilute it. In this situation, for those of us with a commitment to engaged cultural studies, it would seem that three tasks become particularly urgent: 1) clearly to articulate engaged cultural studies' specific project; 2) to analyse the conditions which underpin the general turn to culture just described; 3) to develop strategies to maintain engaged cultural studies as a discrete formation inside the larger cultural turn. These tasks are all the more compelling because, as I say, cultural studies, in becoming established in the academy, has been the object of public attacks — a player (and pawn) in the continuing 'culture wars' — on the grounds both that it fails to disseminate cultural value (for it, so it's alleged, Mickey Mouse is as good as Shakespeare), and that it disrupts cultural unity (conservatives complain that cultural studies is on a mission for a multiculturalism which will undermine national pride, heritage and consensus) and that it has a deep-seated and partisan commitment to the left which means that it cannot sustain proper academic disinterestedness and neutrality. Such attacks ring especially hollow when they fail to enquire into the reasons why cultural studies is expanding in the academy, both in its radical and more traditional forms.

This is not the place to begin working through these matters in any detail — that belongs to the ongoing work I spoke of at the end of my 1992 introduction. However a very brief (and partial) indication of directions to be taken is useful.

The first of these three tasks — addressing the issue of what is specific to engaged cultural studies — is probably the easiest to deal with. As this book hopes to persuade its readers, engaged cultural studies is academic work (teaching, research, dissemination etc.) on contemporary culture from non-elite or counter-hegemonic perspectives ('from below') with an openness to the culture's reception and production in everyday life, or, more generally, its impact on life trajectories. Engaged cultural studies encourages and takes notice of culture's capacity to

express and invoke less restricted (more 'other', counter-normative) ways of living. So it does not simply 'teach the conflicts' (Graff 1993) – that is, it does not neutrally present the debates over canons, cultural value, multiculturalism, identity-thinking and so on for students, rather it aims to produce knowledge from perspectives lost to and in dominant public culture, and to listen to far off or marginalized voices. This in itself need not commit it to a particular position in terms of traditional left/right politics. Yet, importantly, engaged cultural studies also examines its own constitutive borders and divisions – or more simply, the relation between what it includes and what it excludes. It examines its temporal border: the separation of past from present (asking, what is the role of history in contemporary cultural studies?). It examines the power barriers it assumes and contests: the division between hegemonic ('above') and counter-hegemonic ('below') – or, to swap terms, the borders between margins and centres. And it examines structural divisions: the boundaries between 'culture' on the one hand, and 'society' or the 'economy' on the other (asking, for instance, to what degree is culture shaped by economic structures?). We might add to these problems concerning boundaries, though it's been much less discussed, that cultural studies also addresses the basic distinction between the political (or the engaged) and the non-political (or the disengaged) where it touches culture – a topic to which I will return in a moment.

The second of my three tasks presents a more difficult challenge. Why has the study of culture recently become so popular across the whole range of the humanities, and even the social sciences? Summing up a very complicated situation in a couple of sentences: the turn to culture would seem to be best understood as an effect of three entangled events, each on a very different scale: first, the increasing importance of cultural industries to post-industrial national economies such as the USA and the UK; second, the rise in the use of cultural heritages and cultural consumption to maintain or stabilize identities by nations, ethnic groups and individuals (partly because socialism has been delegitimized somewhat as a result of globalization and the war on terror and because people increasingly don't identify with a class); and finally, at the micro-level of the education system, the downsizing of the academic humanities and the social sciences relative to other faculties inside a still expanding post-compulsory education sector.

To put the case in a nutshell: even in highly developed, post-industrial countries, more and more students are entering post-compulsory institutions without having, or wishing for, traditional European elite taste preferences and without the desire to form themselves ethically through their consumption or knowledge of canons. Their own everyday-life culture is increasingly that of popular culture or niches within it – this is their starting point for exploring the past, for instance. Many students from so-called 'minority' communities, often the first members of their family ever to attend university, wish to affirm and learn about their own neglected or repressed cultural heritages. At the same time, many students take humanities and social sciences courses in preparation for professional graduate training or (in the case of the humanities) to enter the broader cultural industries – in both cases, courses on culture, especially contemporary culture, provide especially efficient and

pertinent use-value or training. All this within an education system decreasingly supported by state funding and increasingly managed in business sector terms of 'efficiencies' and 'performance' so that areas of study without high student demand are gradually likely to be diminished or let go. These pressures finally have an impact even on rich institutions, especially at graduate school level, because such graduate schools train teachers, and, despite inertia, ultimately have to be responsive to projected student demand in the rest of the system. To move from the general to the particular, this is the larger logic within which books, articles and courses on, say, the politics of seventeenth-century France or monographs on canonical literary authors tend to decrease, while books, articles and courses on global media systems, or even, say, religious thinking in the construction of modernity, tend to increase. This logic is strongest in state-run university systems: in the USA where many universities are private, including many of the elite research schools, this logic has nothing like the same force.

The last of the three proposed tasks – the need to develop strategies to maintain engaged cultural studies as a specific field, as against the turn to culture in general – is perhaps the most contentious. A main reason for this is that it exposes anxieties over avowedly political knowledge and teaching within the supposedly 'objective' academy. In practice engaged cultural studies is rapidly becoming another area of speciality – a discipline, a field – able to be housed in any one of a number of departments, though most frequently in literature or communications departments. The tactic of adding speciality after speciality to departments, faculties or disciplines, and thereby avoiding dealing with controversial intellectual-pedagogical issues, has been well discussed by Gerald Graff in his *Professing Literature* (1987). But, as I say, because engaged cultural studies is expressly political, it does not settle easily into a pattern of accretion and liberal tolerance. So we need to spell out that there are compelling reasons why students, not least those from elite backgrounds, should be exposed to it. As a field, it accepts that studying culture is rarely value-free, and so, embracing clearly articulated, counter-hegemonic values, it seeks to extend and critique the relatively narrow range of norms, methods and practices embedded in the traditional, past-fixated, canon-forming humanities. It does so in order to provide students (in this case, especially elite students) with a point of entry into the contemporary world they are unlikely to have learned from their families, their secondary schooling or from the media, and it helps make a less blinkered and hierarchical, a fairer and more open culture for that very reason. Of course, it also often provides non-elite students and scholars with an approach they can recognize and own.

Nonetheless, I'd suggest that, for both practical and theoretical reasons, in the current situation, we need to think of cultural studies not as a traditional field or discipline, nor as a mode of interdisciplinarity, but as what I will call a field within multidisciplinarity. This means that cultural studies should aim to monopolize its students or, indeed, its teachers and intellectuals, as little as is possible within the academic-bureaucratic structures we have. Within the academy it is best regarded as an area to work in alongside others, usually more highly

institutionalized disciplines – Spanish, geography, politics, economics, literature ... whatever. The point is not so much to dismantle disciplinary boundaries as to be able to move across them; the aim is to transport methods and attitudes from cultural studies to other disciplines where they are appropriate, but also to be able to let them go where they are not. Pragmatically, thinking of cultural studies as a field within multidisciplinarity, increases its reach inside institutions committed, however problematically, to objectivity – institutions, I suspect, which are coming under mounting pressure to close down on cultural dissidence from community and media interests. We need also recognize that a great deal of the material studied in the humanities does not invite political engagement, let alone political engagement which can be easily translated into the current situation. To give just one cultural-historical example: amongst Elizabethan playwrights, if we have an interest in them at all, we may prefer Christopher Marlowe to Ben Jonson on political grounds because of the way that Marlowe rebels against the sexual and religious codes of his time. But what about debates between the Stoics and the Epicureans, so important for early modern Western political and philosophical thought? What's the current political valency there? And if these debates have little or no political valency now, is that a reason not to study them, alongside engaged cultural studies?

That kind of question is gaining force because the downsizing of the humanities is transforming the political force and meaning of the academic humanities. Let's put it like this: in a situation where globalized market forces and government policy are demanding that universities provide economically relevant practical training so as to increase productivity and efficiency, where calls for academics to make themselves over as 'public intellectuals' within the restricted parameters of the mainstream media are commonplace: is studying the Stoics and Epicureans, or, for that matter, technical aspects of the seventeenth-century English lyric, simply obscurantist or (in the case of the lyric) elitist? Such studies have a political charge, however faint, in their very incapacity to contribute to the market or media culture. (This is a version of the political charge that Theodor Adorno assigned to modernist art under industrial capitalism in his *Aesthetic Theory* and elsewhere.)

Multidisciplinarity, which thinks of engaged cultural studies less as an academic specialism than as a critical moment within a larger, dispersed, not wholly politicized field, is, then, a way of shoring up differences and counter-hegemony inside the humanities in an epoch of global managerialism. So I'm arguing that global managerialism underpins the academic turn to culture in ways which mean that engaged cultural studies best situates itself into the humanities and social sciences as a fluid and critical moment, neither weighted down by disciplinarity, nor blanded out into the interdisciplinarity of the wider cultural turn. And which has to work hard to maintain its critical, speculative and indeed radical spirit, since so much of contemporary cultural studies now serves the purposes of its funding bodies, whether the state or private industry, and national productivity in general. There are few traces of the anti-capitalism that motivated Raymond Williams and the young Stuart Hall. Nonetheless since the war on terror, the crisis

over immigration and the anti-globalization movement there are signs of renewed interest in a cultural studies radicalism: the amazing commercial success of Hardt and Negri's *Empire* (of which a chapter is reprinted here) and of Slavoj Žižek's work, with its nostalgia for Leninism, being a sign of that. (See also Denning 2004.) Whether or not engaged cultural studies reinvigorates the radicalism of its founders is up to readers of this book as much as anyone.

PART ONE

Theory and method

Stuart Hall

CULTURAL STUDIES AND ITS
THEORETICAL LEGACIES

EDITOR'S INTRODUCTION

THIS SHORT EXERCISE in intellectual autobiography by Stuart Hall, arguably
the most influential figure in contemporary cultural studies, is surprisingly
downbeat. That's because it was written at the moment when cultural studies was
taking off as an academic discipline in the US, attracting money and notoriety,
and triggering an extraordinary theoretical 'fluency' or textual 'ventriloquism' as
Hall puts it. Which called into question the discipline's seriousness – read its
political commitment – and its history. Here Hall reaffirms the first, using the
example of AIDS to argue for theory's 'deadly seriousness', and recapitulates a
personal version of the second.

While recognizing that cultural studies has many histories and legacies (he
has particular difficulty with the 'Britishness' of 'British cultural studies'), Hall
insists that, for him at least, the field emerges out of the 1950s disintegration of
classical Marxism in its Eurocentrism and its thesis that the economic base has
a determining effect on the cultural superstructure. (Hall does not mention the
decline of class as an identity forming category amongst the young in Britain at
that time.) Hall acknowledges that cultural studies has been, and must be, formed
in interruptions to its trajectories and perceived mission – notably, early on, by
feminism and anti-racism. Nevertheless, he argues, what is stable in cultural studies
is a Gramscian understanding of 'conjunctural knowledge' – knowledge situated
in, and applicable to, specific and immediate political/historical circumstances; as
well as an awareness that the structure of representations which form culture's
alphabet and grammar are instruments of social power, requiring critical and
activist examination. It is this kind of examination that is at jeopardy in a
professionalized cultural studies, Hall implies.

Further reading: Couldry 2000; During 2004; Dworkin 1997; Ferguson and Golding 1997; Hall *et al.* 2000; Jones 2004; Morley and Chen 1996; Proctor 2004.

My title suggests a look back to the past, to consult and think about the Now and the Future of cultural studies by way of a retrospective glance. It does seem necessary to do some genealogical and archaeological work on the archive. Now the question of the archives is extremely difficult for me because, where cultural studies is concerned, I sometimes feel like a *tableau vivant*, a spirit of the past resurrected, laying claim to the authority of an origin. After all, didn't cultural studies emerge somewhere at that moment when I first met Raymond Williams, or in the glance I exchanged with Richard Hoggart? In that moment, cultural studies was born; it emerged full-grown from the head! I do want to talk about the past, but definitely not in that way. I don't want to talk about British cultural studies (which is in any case a pretty awkward signifier for me) in a patriarchal way, as the keeper of the conscience of cultural studies, hoping to police you back into line with what it really was if only you knew. That is to say, I want to absolve myself of the many burdens of representation which people carry around – I carry around at least three: I'm expected to speak for the entire black race on all questions theoretical, critical, etc., and sometimes for British politics, as well as for cultural studies. This is what is known as the black person's burden, and I would like to absolve myself of it at this moment.

That means, paradoxically, speaking autobiographically. Autobiography is usually thought of as seizing the authority of authenticity. But in order not to be authoritative, I've got to speak autobiographically. I'm going to tell you about my own take on certain theoretical legacies and moments in cultural studies, not because it is the truth or the only way of telling the history. I myself have told it many other ways before; and I intend to tell it in a different way later. But just at this moment, for this conjecture, I want to take a position in relation to the 'grand narrative' of cultural studies for the purposes of opening up some reflections on cultural studies as a practice, on our institutional position, and on its project. I want to do that by referring to some theoretical legacies or theoretical moments, but in a very particular way. This is not a commentary on the success or effectiveness of different theoretical positions in cultural studies (that is for some other occasion). It is an attempt to say something about what certain theoretical moments in cultural studies have been like for me, and from that position, to take some bearings about the general question of the politics of theory.

Cultural studies is a discursive formation, in Foucault's sense. It has no simple origins, though some of us were present at some point when it first named itself in that way. Much of the work out of which it grew, in my own experience, was already present in the work of other people. Raymond Williams has made the same point, charting the roots of cultural studies in the early adult education movement in his essay on 'The future of cultural studies' (1989). 'The relation between a project and a formation is always decisive', he says, because they are 'different ways of materializing ... then of describing a common disposition of energy and direction.' Cultural studies has multiple discourses; it has a number of different histories. It is a whole set of formations; it has its own different conjunctures and

moments in the past. It included many different kinds of work. I want to insist on that! It always was a set of unstable formations. It was 'centres' only in quotation marks, in a particular kind of way which I want to define in a moment. It had many trajectories; many people had and have different trajectories through it; it was constructed by a number of different methodologies and theoretical positions, all of them in contention. Theoretical work in the Centre for Contemporary Cultural Studies was more appropriately called theoretical noise. It was accompanied by a great deal of bad feeling, argument, unstable anxieties, and angry silences.

Now, does it follow that cultural studies is not a policed disciplinary area? That it is whatever people do, if they choose to call or locate themselves within the project and practice of cultural studies? I am not happy with that formulation either. Although cultural studies as a project is open-ended, it can't be simply pluralist in that way. Yes, it refuses to be a master discourse or a meta-discourse of any kind. Yes, it is a project that is always open to that which it doesn't yet know, to that which it can't yet name. But it does have some will to connect; it does have some stake in the choices it makes. It does matter whether cultural studies is this or that. It can't be just any old thing which chooses to march under a particular banner. It is a serious enterprise, or project, and that is inscribed in what is sometimes called the 'political' aspect of cultural studies. Not that there's one politics already inscribed in it. But there is something *at stake* in cultural studies, in a way that I think, and hope, is not exactly true of many other very important intellectual and critical practices. Here one registers the tension between a refusal to close the field, to police it and, at the same time, a determination to stake out some positions within it and argue for them. That is the tension — the dialogic approach to theory — that I want to try to speak to in a number of different ways in the course of this paper. I don't believe knowledge is closed, but I do believe that politics is impossible without what I have called 'the arbitrary closure'; without what Homi Bhabha called social agency as an arbitrary closure. That is to say, I don't understand a practise which aims to make a difference in the world, which doesn't have some points of difference or distinction which it has to stake out, which really matter. It is a question of positionalities. Now, it is true that those positionalities are never final, they're never absolute. They can't be translated intact from one conjuncture to another; they cannot be depended on to remain in the same place. I want to go back to that moment of 'staking out a wager' in cultural studies, to those moments in which the positions began to matter.

This is a way of opening the questions of the 'wordliness' of cultural studies, to borrow a term from Edward Said. I am not dwelling on the secular connotations of the metaphor of worldliness here, but on the worldliness of cultural studies. I'm dwelling on the 'dirtiness' of it: the dirtiness of the semiotic game, if I can put it that way. I'm trying to return the project of cultural studies from the clean air of meaning and textuality and theory to the something nasty down below. This involves the difficult exercise of examining some of the key theoretical turns or moments in cultural studies.

The first trace that I want to deconstruct has to do with a view of British cultural studies which often distinguishes it by the fact that, at a certain moment, it became a Marxist critical practice. What exactly does that assignation of cultural studies as a Marxist critical theory mean? How can we think cultural studies at

that moment? What moment is it we are speaking of? What does that mean for the theoretical legacies, traces, and after-effects which Marxism continues to have in cultural studies? There are a number of ways of telling that history, and let me remind you that I'm not proposing this as the only story. But I do want to set it up in what I think may be a slightly surprising way to you.

I entered cultural studies from the New Left, and the New Left always regarded Marxism as a problem, as trouble, as danger, not as a solution. Why? It had nothing to do with theoretical questions as such or in isolation. It had to do with the fact that my own (and its own) political formation occurred in a moment historically very much like the one we are in now – which I am astonished that so few people have addressed – the moment of the disintegration of a certain kind of Marxism. In fact, the first British New Left emerged in 1956 at the moment of the disintegration of an entire historical/political project. In that sense I came into Marxism backwards: against the Soviet tanks in Budapest, as it were. What I mean by that is certainly not that I wasn't profoundly, and that cultural studies then wasn't from the beginning, proudly influenced by the questions that Marxism as a theoretical project put on the agenda: the power, the global reach and history-making capacities of capital; the question of class; the complex relationships between power, which is an easier term to establish in the discourses of culture than exploitation, and exploitation; the question of a general theory which could, in a critical way, connect together in a critical reflection different domains of life, politics and theory, theory and practice, economic, political, ideological questions and so on; the notion of critical knowledge itself and the production of critical knowledge as a practice. These important, central questions are what one meant by working within shouting distance of Marxism, working on Marxism, working against Marxism, working with it, working to try to develop Marxism.

There never was a prior moment when cultural studies and Marxism represented a perfect theoretical fit. From the beginning (to use this way of speaking for a moment) there was always-already the question of the great inadequacies, theoretically and politically, the resounding silences, the great evasions of Marxism – the things that Marx did not talk about or seem to understand which were our privileged object of study: culture, ideology, language, the symbolic. These were always-already, instead, the things which had imprisoned Marxism as a mode of thought, as an activity of critical practice – its orthodoxy, its doctrinal character, its determinism, its reductionism, its immutable law of history, its status as a metanarrative. That is to say, the encounter between British cultural studies and Marxism has first to be understood as the engagement with a problem – not a theory, not even a problematic. It begins, and develops through the critique of a certain reductionism and economism, which I think is not extrinsic but intrinsic to Marxism; a contestation with the model of base and superstructure, through which sophisticated and vulgar Marxism alike had tried to think the relationships between society, economy, and culture. It was located and sited in a necessary and prolonged and as yet unending contestation with the question of false consciousness. In my own case, it required a not-yet-completed contestation with the profound Eurocentrism of Marxist theory. I want to make this very precise. It is not just a matter of where Marx happened to be born, and of what he talked about, but of the model at the centre of the most developed parts of Marxist theory, which

suggested that capitalism evolved organically from within its own transformations. Whereas I came from a society where the profound integument of capitalist society, economy, and culture had been imposed by conquest and colonization. This is a theoretical, not a vulgar critique. I don't blame Marx because of where he was born; I'm questioning the theory for the model around which it is articulated: its Eurocentrism.

I want to suggest a different metaphor for theoretical work: the metaphor of struggle, of wrestling with the angels. The only theory worth having is that which you have to fight off, not that which you speak with profound fluency. I mean to say something later about the astonishing theoretical fluency of cultural studies now. But my own experience of theory – and Marxism is certainly a case in point – is of wrestling with the angels – a metaphor you can take as literally as you like. I remember wrestling with Althusser. I remember looking at the idea of 'theoretical practice' in *Reading Capital* and thinking, 'I've gone as far in this book as it is proper to go'. I felt, I will not give an inch to this profound misreading, this superstructuralist mistranslation, of classical Marxism, unless he beats me down, unless he defeats me in spirit. He'll have to march over to me to convince me. I warred with him, to the death. A long, rambling piece I wrote on Marx's 1857 'Introduction' to *The Grundrisse*, in which I tried to stake out the difference between structuralism in Marx's epistemology and Althusser's, was only the tip of the iceberg of this long engagement. And that is not simply a personal question. In the Centre for Contemporary Cultural Studies, for five or six years, long after the anti-theoreticism or resistance to theory of cultural studies had been overcome, and we decided, in a very un-British way, we had to take the plunge into theory, we walked right around the entire circumference of European thought, in order not to be, in any simple capitulation to the *Zeitgeist*, Marxists. We read German idealism, we read Weber upside down, we read Hegelian idealism, we read idealistic art criticism.

So the notion that Marxism and cultural studies slipped into place, recognised an immediate affinity, joined hands in some teleological or Hegelian moment of synthesis, and there was the founding moment of cultural studies, is entirely mistaken. It couldn't have been more different from that. And when, eventually, in the 1970s, British cultural studies did advance – in many different ways, it must be said – within the problematic of Marxism, you should hear the term problematic in a genuine way, not just in a formalist-theoretical way: as a problem; as much about struggling against the constraints and limits of that model as about necessary questions it required us to address. And when, in the end, in my own work, I tried to learn from and work with the theoretical gains of Gramsci, it was only because certain strategies of evasion had forced Gramsci's work, in a number of different ways, to respond to what I can only call (here's another metaphor for theoretical work) the conundrums of theory, the things which Marxist theory couldn't answer, the things about the modern world which Gramsci discovered remained unresolved within the theoretical framework of grand theory – Marxism – in which he continued to work. At a certain point, the questions I still wanted to address in short were inaccessible to me except via a detour through Gramsci. Not because Gramsci resolved them but because he at least addressed many of them. I don't want to go through what it is I personally think cultural studies in

the British context, in a certain period, learned from Gramsci: immense amounts about the nature of culture itself, about the discipline of the conjunctural, about the importance of historical specificity, about the enormously productive metaphor of hegemony, about the way in which one can think questions of class relations only by using the displaced notion of ensemble and blocs. These are the particular gains of the 'detour' via Gramsci, but I'm not trying to talk about that. I want to say, in this context, about Gramsci, that while Gramsci belonged and belongs to the problematic of Marxism, his importance for this moment of British cultural studies is precisely the degree to which he radically *displaced* some of the inheritances of Marxism in cultural studies. The radical character of Gramsci's 'displacement' of Marxism has not yet been understood and probably won't ever be reckoned with, now we are entering the era of post-Marxism. Such is the nature of the movement of history and of intellectual fashion. But Gramsci also did something else for cultural studies, and I want to say a little bit about that because it refers to what I call the need to reflect on our institutional position, and our intellectual practice.

I tried on many occasions, and other people in British cultural studies and at the Centre especially have tried, to describe what it is we thought we were doing with the kind of intellectual work we set in place in the Centre. I have to confess that, though I've read many, more elaborated and sophisticated accounts, Gramsci's account still seems to me to come closest to expressing what it is I think we were trying to do. Admittedly, there's a problem with his phrase 'the production of organic intellectuals'. But there is no doubt in my mind that we were trying to find an institutional practice in cultural studies that might produce an organic intellectual. We didn't know previously what that would mean, in the context of Britain in the 1970s, and we weren't sure we would recognize him or her if we managed to produce it. The problem about the concept of an organic intellectual is that it appears to align intellectuals with an emerging historic movement and we couldn't tell then, and can hardly tell now, where that emerging historical movement was to be found. We were organic intellectuals without any organic point of reference; organic intellectuals with a nostalgia or will or hope (to use Gramsci's phrase from another context) that at some point we would be prepared in intellectual work for that kind of relationship, if such a conjuncture ever appeared. More truthfully, we were prepared to imagine or model or simulate such a relationship in its absence: 'pessimism of the intellect, optimism of the will'.

But I think it is very important that Gramsci's thinking around these questions certainly captures part of what we were about. Because a second aspect of Gramsci's definition of intellectual work, which I think has always been lodged somewhere close to the notion of cultural studies as a project, has been his requirement that the 'organic intellectual' must work on two fronts at one and the same time. On the one hand, we had to be at the very forefront of intellectual theoretical work because, as Gramsci says, it is the job of the organic intellectual to know more than the traditional intellectuals do: really know, not just pretend to know, not just to have the facility of knowledge, but to know deeply and profoundly. So often knowledge for Marxism is pure recognition – the production again of what we have always known! If you are in the game of hegemony you have to be smarter than 'them'. Hence, there are no theoretical limits from which cultural

studies can turn back. But the second aspect is just as crucial: that the organic intellectual cannot absolve himself or herself from the responsibility of transmitting those ideas, that knowledge, through the intellectual function, to those who do not belong, professionally, in the intellectual class. And unless those two fronts are operating at the same time, or at least unless those two ambitions are part of the project of cultural studies, you can get enormous theoretical advance without any engagement at the level of the political project.

I'm extremely anxious that you should not decode what I'm saying as an anti-theoretical discourse. It is not anti-theory, but it does have something to do with the conditions and problems of developing intellectual and theoretical work as a political practice. It is an extremely difficult road, not resolving the tensions between those two requirements, but living with them. Gramsci never asked us to resolve them, but he gave us a practical example of how to live with them. We never produced organic intellectuals (would that we had) at the Centre. We never connected with that rising historic movement; it was a metaphoric exercise. Nevertheless, metaphors are serious things. They affect one's practice. I'm trying to redescribe cultural studies as theoretical work which must go on and on living with that tension.

I want to look at two other theoretical moments in cultural studies which interrupted the already interrupted history of its formation. Some of these developments came as it were from outer space: they were not all generated from the inside, they were not part of an inner-unfolding general theory of culture. Again and again, the so-called unfolding of cultural studies was interrupted by a break, by real ruptures, by exterior forces; the interruption, as it were, of new ideas, which decentred what looked like the accumulating practice of the work. There's another metaphor for theoretical work: theoretical work as interruption.

There were at least two interruptions in the work of the Centre for Contemporary Cultural Studies: the first around feminism, and the second around questions of race. This is not an attempt to sum up the theoretical and political advances and consequences for British cultural studies of the feminist intervention; that is for another time, another place. But I don't want, either, to invoke that moment in an open-ended and casual way. For cultural studies (in addition to many other theoretical projects), the intervention of feminism was specific and decisive. It was ruptural. It reorganized the field in quite concrete ways. First, the opening of the question of the personal as political, and its consequences for changing the object of study in cultural studies, was completely revolutionary in a theoretical and practical way. Second, the radical expansion of the notion of power, which had hitherto been very much developed within the framework of the notion of the public, the public domain, with the effect that we could not use the term power – so key to the earlier problematic of hegemony – in the same way. Third, the centrality of questions of gender and sexuality to the understanding of power itself. Fourth, the opening of many of the questions that we thought we had abolished around the dangerous area of the subjective and the subject, which lodged those questions at the centre of cultural studies as a theoretical practice. Fifth, 'the re-opening' of the closed frontier between social theory and the theory of the unconscious – psychoanalysis. It's hard to describe the import of the opening of that new continent in cultural studies, marked out by the relationship – or rather,

what Jacqueline Rose has called the as yet 'unsettled relations' – between feminism, psychoanalysis and cultural studies, or indeed how it was accomplished.

We know it was, but it's not known generally how and where feminism first broke in. I use the metaphor deliberately: as the thief in the night, it broke in; interrupted, made an unseemly noise, seized the time, crapped on the table of cultural studies. The title of the volume in which this dawn-raid was first accomplished – *Women Take Issue* – is instructive: for they 'took issue' in both senses – took over that year's book and initiated a quarrel. But I want to tell you something else about it. Because of the growing importance of feminist work and the early beginnings of the feminist movement outside in the very early 1970s, many of us in the Centre – mainly, of course, men – thought it was time there was good feminist work in cultural studies. And we indeed tried to buy it in, to import it, to attract good feminist scholars. As you might expect, many of the women in cultural studies weren't terribly interested in this benign project. We were opening the door to feminist studies, being good, transformed men. And yet, when it broke in through the window, every single unsuspected resistance rose to the surface – fully installed patriarchal power, which believed it had disavowed itself. There are no leaders here, we used to say; we are all graduate students and members of staff together, learning how to practise cultural studies. You can decide whatever you want to decide, etc. And yet, when it came to the question of the reading list … Now that's where I really discovered about the gendered nature of power. Long, long after I was able to pronounce the words, I encountered the reality of Foucault's profound insight into the individual reciprocity of knowledge and power. Talking about giving up power is a radically different experience from being silenced. That is another way of thinking, and another metaphor for theory: the way feminism broke, and broke into, cultural studies.

Then there is the question of race in cultural studies. I've talked about the important 'extrinsic' sources of the formation of cultural studies – for example, in what I called the moment of the New Left, and its original quarrel with Marxism – out of which cultural studies grew. And yet, of course, that was a profoundly English or British moment. Actually getting cultural studies to put on its own agenda the critical questions of race, the politics of race, the resistance to racism, the critical questions of cultural politics, was itself a profound theoretical struggle, a struggle of which *Policing the Crisis* was, curiously, the first and very late example. It represented a decisive turn in my own theoretical and intellectual work, as well as in that of the Centre. Again, it was accomplished only as the result of a long, and sometimes bitter – certainly bitterly contested – internal struggle against a resounding but unconscious silence. A struggle which continued in what has since come to be known, but only in the rewritten history, as one of the great seminal books of the Centre for Cultural Studies, *The Empire Strikes Back*. In actuality, Paul Gilroy and the group of people who produced the book found it extremely difficult to create the necessary theoretical and political space in the Centre in which to work on the project.

I want to hold to the notion, implicit in both these examples, that movements provoke theoretical moments. And historical conjunctures insist on theories: they are real moments in the evolution of theory. But here I have to stop and retrace my steps. Because I think you could hear, once again, in what I'm saying a kind

of invocation of a simple-minded anti-theoretical populism, which does not respect and acknowledge the crucial importance, at each point in the moves I'm trying to renarrativize, of what I would call the necessary delay or detour through theory. I want to talk about that 'necessary detour' for a moment. What decentred and dislocated the settled path of the Centre for Contemporary Cultural Studies certainly, and British cultural studies to some extent in general, is what is sometimes called 'the linguistic turn': the discovery of discursivity, of textuality. There are casualties in the Centre around those names as well. They were wrestled with, in exactly the same way I've tried to describe earlier. But the gains which were made through an engagement with them are crucially important in understanding how theory came to be advanced in that work. And yet, in my view, such theoretical 'gains' can never be a self-sufficient moment.

Again, there is no space here to do more than begin to list the theoretical advances which were made by the encounters with structuralist, semiotic, and post-structuralist work: the crucial importance of language and of the linguistic metaphor to *any* study of culture; the expansion of the notion of text and textuality, both as a source of meaning, and as that which escapes and postpones meaning; the recognition of the heterogeneity, of the multiplicity, of meanings, of the struggle to close arbitrarily the infinite semiosis beyond meaning; the acknowledgment of textuality and cultural power, of representation itself, as a site of power and regulation; of the symbolic as a source of identity. These are enormous theoretical advances, though of course, it had always attended to questions of language (Raymond Williams's work, long before the semiotic revolution, is central there). Nevertheless, the refiguring of theory, made as a result of having to think questions of culture through the metaphors of language and textuality, represents a point beyond which cultural studies must now always necessarily locate itself. The metaphor of the discursive, of textuality, instantiates a necessary delay, a displacement, which I think is *always* implied in the concept of culture. If you work on culture, or if you've tried to work on some other really important things and you find yourself driven back to culture, if culture happens to be what seizes hold of your soul, you have to recognize that you will always be working in an area of displacement. There's always something decentred about the medium of culture, about language, textuality, and signification, which always escapes and evades the attempt to link it, directly and immediately, with other structures. And yet, at the same time, the shadow, the imprint, the trace, of those other formations, of the intertextuality of texts in their institutional positions, of texts as sources of power, of textuality as a site of representation and resistance, all of those questions can never be erased from cultural studies.

The question is what happens when a field, which I've been trying to describe in a very punctuated, dispersed, and interrupted way, as constantly changing directions, and which is defined as a political project, tries to develop itself as some kind of coherent theoretical intervention? Or, to put the same question in reverse, what happens when an academic and theoretical enterprise tries to engage in pedagogies which enlist the active engagement of individuals and groups, tries to make a difference in the institutional world in which it is located? These are extremely difficult issues to resolve, because what is asked of us is to say 'yes' and 'no' at one and the same time. It asks us to assume that culture will always work

through its textualities — and at the same time that textuality is never enough. But never enough of what? Never enough for what? That is an extremely difficult question to answer because, philosophically, it has always been impossible in the theoretical field of cultural studies — whether it is conceived either in terms of texts and contexts, of intertextuality, or of the historical formations in which cultural practices are lodged — to get anything like an adequate theoretical account of culture's relations and its effects. Nevertheless I want to insist that until and unless cultural studies learns to live with this tension, a tension that all textual practices must assume — a tension which Said describes as the study of the text in its affiliations with 'institutions, offices, agencies, classes, academies, corporations, groups, ideologically defined parties and professions, nations, races, and genders' — it will have renounced its 'worldly' vocation. That is to say, unless and until one respects the necessary displacement of culture, and yet is always irritated by its failure to reconcile itself with other questions that matter, with other questions that cannot and can never be fully covered by critical textuality in its elaborations, cultural studies as a project, an intervention, remains incomplete. If you lose hold of the tension, you can do extremely fine intellectual work, but you will have lost intellectual practice as a politics. I offer this to you, not because that's what cultural studies ought to be, or because that's what the Centre managed to do well, but simply because I think that, overall, is what defines cultural studies as a project. Both in the British and the American context, cultural studies has drawn the attention itself, not just because of its sometimes dazzling internal theoretical development but because it holds theoretical and political questions in an ever irresolvable but permanent tension. It constantly allows the one to irritate, bother and disturb the other, without insisting on some final theoretical closure.

I've been talking very much in terms of a previous history. But I have been reminded of this tension very forcefully in the discussions on AIDS. AIDS is one of the questions which urgently brings before us our marginality as critical intellectuals in making real effects in the world. And yet it has often been represented for us in contradictory ways. Against the urgency of people dying in the streets, what in God's name is the point of cultural studies? What is the point of the study of representations, if there is no response to the question of what you say to someone who wants to know if they should take a drug and if that means they'll die two days later or a few months earlier? At that point, I think anybody who is into cultural studies seriously as an intellectual practice, must feel, on their pulse, its ephemerality, its insubstantiality, how little it registers, how little we've been able to change anything or get anybody to do anything. If you don't feel that as one tension in the work that you are doing, theory has let you off the hook. On the other hand, in the end, I don't agree with the way in which the dilemma is often posed for us, for it is indeed a more complex and displaced question than just people dying out there. The question of AIDS is an extremely important terrain of struggle and contestation. In addition to the people we know who are dying, or have died, or will, there are the many people dying who are never spoken of. How could we say that the question of AIDS is not also a question of who gets represented and who does not? AIDS is the site at which the advance of sexual politics is being rolled back. It's a site at which not only people will die, but desire and pleasure will also die if certain metaphors do not survive, or

survive in the wrong way. Unless we operate in this tension, we don't know what cultural studies can do, can't, can never do; but also, what it has to do, what it alone has a privileged capacity to do. It has to analyse certain things about the constitutive and political nature of representation itself, about its complexities, about the effects of language, about textuality as a site of life and death. Those are the things cultural studies can address.

I've used that example, not because it's a perfect example, but because it's a specific example, because it has a concrete meaning, because it challenges us in its complexity, and in so doing has things to teach us about the future of serious theoretical work. It preserves the essential nature of intellectual work and critical reflection, the irreducibility of the insights which theory can bring to political practice, insights which cannot be arrived at in any other way. And at the same time, it rivets us to the necessary modesty of theory, the necessary modesty of cultural studies as an intellectual project.

I want to end in two ways. First I want to address the problem of the institutionalization of these two constructions: British cultural studies and American cultural studies. And then, drawing on the metaphors about theoretical work which I tried to launch (not I hope by claiming authority or authenticity but in what inevitably has to be a polemical, positional, political way), to say something about how the field of cultural studies has to be defined.

I don't know what to say about American cultural studies. I am completely dumbfounded by it. I think of the struggles to get cultural studies into the institution in the British context, to squeeze three or four jobs for anybody under some heavy disguise, compared with the rapid institutionalization which is going on in the United States. The comparison is not valid only for cultural studies. If you think of the important work which has been done in feminist history or theory in Britain and ask how many of those women have ever had full-time academic jobs in their lives or are likely to, you get a sense of what marginality is really about. So the enormous explosion of cultural studies in the United States, its rapid professionalization and institutionalization, is not a moment which any of us who tried to set up a marginalized Centre in a university like Birmingham could, in any simple way, regret. And yet I have to say, in the strongest sense, that it reminds me of the ways in which, in Britain, we are always aware of institutionalization as a moment of profound danger. Now, I've been saying that dangers are not places you run away from but places that you go towards. So I simply want you to know that my own feeling is that the explosion of cultural studies along with other forms of critical theory in the academy represents a moment of extraordinarily profound danger.

Why? Well, it would be excessively vulgar to talk about such things as how many jobs there are, how much money there is around, and how much pressure that puts on people to do what they think of as critical political work and intellectual work of a critical kind, while also looking over their shoulders at the promotions stakes and the publication stakes, and so on. Let me instead return to the point that I made before: my astonishment at what I called the theoretical fluency of cultural studies in the United States.

Now, the question of theoretical fluency is a difficult and provoking metaphor, and I want only to say one word about it. Some time ago, looking at what one

can only call the deconstructive deluge (as opposed to deconstructive turn) which had overtaken American literary studies, in its formalist mode, I tried to distinguish the extremely important theoretical and intellectual work which it had made possible in cultural studies from a mere repetition, a sort of mimicry or deconstructive ventriloquism which sometimes passes as a serious intellectual exercise. My fear at that moment was that if cultural studies gained an equivalent institutionalization in the American context, it would, in rather the same way, formalize out of existence the critical questions of power, history, and politics. Paradoxically, what I mean by theoretical fluency is exactly the reverse. There is no moment now, in American cultural studies, where we are *not* able, extensively and without end, to theorize power – politics, race, class and gender, subjugation, domination, exclusion, marginality, Otherness, etc. There is hardly anything in cultural studies which isn't so theorized. And yet, there is the nagging doubt that this overwhelming textualization of cultural studies' own discourses somehow constitutes power and politics as exclusively matters of language and textuality itself. Now, this is not to say that I don't think that questions of power and the political have to be and are always lodged within representations, that they are always discursive questions. Nevertheless, there are ways of constituting power as an easy floating signifier which just leaves the crude exercise and connections of power and culture altogether emptied of any signification. That is what I take to be the moment of danger in the institutionalization of cultural studies in this highly rarified and enormously elaborated and well-funded professional world of American academic life. It has nothing whatever to do with cultural studies making itself more like British cultural studies, which is, I think, an entirely false and empty cause to try to propound. I have specifically tried not to speak of the past in an attempt to police the present and the future. But I do want to extract, finally, from the narrative I have constructed of the past some guidelines for my own work and perhaps for some of yours.

I come back to the deadly seriousness of intellectual work. It is a deadly serious matter. I come back to the critical distinctions between intellectual work and academic work: they overlap, they abut with one another, they feed off one another, the one provides you with the means to do the other. But they are not the same thing. I come back to the difficulty of instituting a genuine cultural and critical practice, which is intended to produce some kind of organic intellectual political work, which does not try to inscribe itself in the overarching meta-narrative of achieved knowledges, within the institutions. I come back to theory and politics, the politics of theory. Not theory as the will to truth, but theory as a set of contested, localized, conjunctural knowledges, which have to be debated in a dialogical way. But also as a practice which always thinks about its intervention in a world in which it would make some difference, in which it would have some effect. Finally, a practice which understands the need for intellectual modesty. I do think there is all the difference in the world between understanding the politics of intellectual work and substituting intellectual work for politics.

Antonio Gramsci

THE ORGANIZATION OF EDUCATION AND OF CULTURE

EDITOR'S INTRODUCTION

THIS SELECTION FROM GRAMSCI'S *PRISON NOTEBOOKS* may surprise readers who know of Gramsci only that he was a leader of the Italian Communist Party in the era just prior to, and in the early days of, Mussolini. For, in notes that speak directly to current educational policy as well as to the problematic relation between cultural studies and the academic system that I addressed in the last part of the 'Introduction' to this anthology, Gramsci goes so far as to defend the study of Latin and Greek and to argue that 'instruction' (the more or less by rote teaching of methods and information) is a crucial component of education.

What is at stake here for Gramsci was how to create an education system which caters to all members of a radically materially and intellectually unequal society such as Italy then was (and as, for instance, China and the US remain today). It needs state rather than private funding. It needs to provide sufficient discipline for those who come from families who inherit little cultural capital or formal learning interests and skills to succeed (and this is one of the reasons why he defends rote learning). And it needs to aim at nurturing autonomous, knowledgeable, reflective and critical citizens with a strong sense of collectivity. The study of Latin helps fulfil this since it familiarizes students with other ways of thinking than their own and with a tradition and culture which, though dead, has an often proved capacity to be brought back to life.

Gramsci's remarks should be read in context: they are written in response to the educational philosophy taken up by Mussolini's Minister of Education, Giovanni Gentile, under the inspiration of the idealist philosopher, Benedetto Croce. Gentile was radically scornful of utilitarian, specialized and practical education,

regarding it as a component of that industrialized civilization leading us back to barbarism. Gramsci is subtly polemicizing against this point of view, pointing out that education is a long process, different kinds of students will move out of it at different times, but that if we no longer have an education system that provides one kind of schooling for members of the 'ruling class' and another for everyone else, then it is possible to break out of the vocational/traditional divide and provide all citizens with the skills both require to live and to 'govern' (that is, practise social responsibility). But this requires not 'rhetoric' à la the idealist philosophers but (to use our lexicon) careful curriculum and policy development and a pedagogical method that allows all students to learn, whatever cultural capital they bring to the classroom.

Further reading: Borg *et al.* 2003; Entwistle 1979; Gramsci 1971 and 1978; Harris 1992; Holub 1992; Mouffe 1979.

It may be observed in general that in modern civilisation all practical activities have become so complex, and the sciences[1] so interwoven with everyday life, that each practical activity tends to create a new type of school for its own executives and specialists and hence to create a body of specialist intellectuals at a higher level to teach in these schools. Thus, side by side with the type of school which may be called "humanistic"—the oldest form of traditional school, designed to develop in each individual human being an as yet undifferentiated general culture, the fundamental power to think and ability to find one's way in life—a whole system of specialised schools, at varying levels, has been being created to serve entire professional sectors, or professions which are already specialised and defined within precise boundaries. It may be said, indeed, that the educational crisis raging today is precisely linked to the fact that this process of differentiation and particularisation is taking place chaotically, without clear and precise principles, without a well-studied and consciously established plan. The crisis of the curriculum and organisation of the schools, i.e. of the overall framework of a policy for forming modern intellectual cadres, is to a great extent an aspect and a ramification of the more comprehensive and general organic crisis.

The fundamental division into classical and vocational (professional) schools was a rational formula: the vocational school for the instrumental classes,[2] the classical school for the dominant classes and the intellectuals. The development of an industrial base both in the cities and in the countryside meant a growing need for the new type of urban intellectual. Side by side with the classical school there developed the technical school (vocational, but not manual), and this placed a question-mark over the very principle of a concrete programme of general culture, a humanistic programme of general culture based on the Graeco-Roman tradition. This programme, once questioned, can be said to be doomed, since its formative capacity was to a great extent based on the general and traditionally unquestioned prestige of a particular form of civilisation.

The tendency today is to abolish every type of schooling that is "disinterested" (not serving immediate interests) or "formative"—keeping at most only a small-

scale version to serve a tiny elite of ladies and gentlemen who do not have to worry about assuring themselves of a future career. Instead, there is a steady growth of specialised vocational schools, in which the pupil's destiny and future activity are determined in advance. A rational solution to the crisis ought to adopt the following lines. First, a common basic education, imparting a general, humanistic, formative culture; this would strike the right balance between development of the capacity for working manually (technically, industrially) and development of the capacities required for intellectual work. From this type of common schooling, via repeated experiments in vocational orientation, pupils would pass on to one of the specialised schools or to productive work.

One must bear in mind the developing tendency for every practical activity to create for itself its own specialised school, just as every intellectual activity tends to create for itself cultural associations of its own; the latter take on the function of post-scholastic institutions, specialised in organising the conditions in which it is possible to keep abreast of whatever progress is being made in the given scientific field.

It may also be observed that deliberative bodies tend to an ever-increasing extent to distinguish their activity into two "organic" aspects: into the deliberative activity which is their essence, and into technical-cultural activity in which the questions upon which they have to take decisions are first examined by experts and analysed scientifically. This latter activity has already created a whole bureaucratic body, with a new structure; for apart from the specialised departments of experts who prepare the technical material for the deliberative bodies, a second body of functionaries is created—more or less disinterested "volunteers", selected variously from industry, from the banks, from finance houses. This is one of the mechanisms by means of which the career bureaucracy eventually came to control the democratic regimes and parliaments; now the mechanism is being organically extended, and is absorbing into its sphere the great specialists of private enterprise, which thus comes to control both regimes and bureaucracies. What is involved is a necessary, organic development which tends to integrate the personnel specialised in the technique of politics with personnel specialised in the concrete problems of administering the essential practical activities of the great and complex national societies of today. Hence every attempt to exorcise these tendencies from the outside produces no result other than moralistic sermons and rhetorical lamentations.

The question is thus raised of modifying the training of technical-political personnel, completing their culture in accordance with the new necessities, and of creating specialised functionaries of a new kind, who as a body will complement deliberative activity. The traditional type of political "leader", prepared only for formal-juridical activities, is becoming anachronistic and represents a danger for the life of the State: the leader must have that minimum of general technical culture which will permit him, if not to "create" autonomously the correct solution, at least to know how to adjudicate between the solutions put forward by the experts, and hence to choose the correct one from the "synthetic" viewpoint of political technique.

A type of deliberative body which seeks to incorporate the technical expertise necessary for it to operate realistically has been described elsewhere in an account

of what happens on the editorial committees of some reviews, when these function at the same time both as editorial committees and as cultural groups. The group criticises as a body, and thus helps to define the tasks of the individual editors, whose activity is organised according to a plan and a division of labour which are rationally arranged in advance. By means of collective discussion and criticism (made up of suggestions, advice, comments on method, and criticism which is constructive and aimed at mutual education) in which each individual functions as a specialist in his own field and helps to complete the expertise of the collectivity, the average level of the individual editors is in fact successfully raised so that it reaches the altitude or capacity of the most highly-skilled—thus not merely ensuring an ever more select and organic collaboration for the review, but also creating the conditions for the emergence of a homogeneous group of intellectuals, trained to produce a regular and methodical "writing" activity (not only in terms of occasional publications or short articles, but also of organic, synthetic studies).

Undoubtedly, in this kind of collective activity, each task produces new capacities and possibilities of work, since it creates ever more organic conditions of work: files, bibliographical digests, a library of basic specialised works, etc. Such activity requires an unyielding struggle against habits of dilettantism, of improvisation, of "rhetorical" solutions or those proposed for effect. The work has to be done particularly in written form, just as it is in written form that criticisms have to be made—in the form of terse, succinct notes: this can be achieved if the material is distributed in time, etc.; the writing down of notes and criticisms is a didactic principle rendered necessary by the need to combat the habits formed in public speaking—prolixity, demagogy and paralogism. This type of intellectual work is necessary in order to impart to autodidacts the discipline in study which an orthodox scholastic career provides, in order to Taylorise intellectual work. Hence the usefulness of the principle of the "old men of Santa Zita" of whom De Sanctis speaks in his memoirs of the Neapolitan school of Basilio Puoti:[3] i.e. the usefulness of a certain "stratification" of capabilities and attitudes, and of the formation of work-groups under the guidance of the most highly-skilled and highly-developed, who can accelerate the training of the most backward and untrained.

When one comes to study the practical organisation of the common school, one problem of importance is that of the various phases of the educational process, phases which correspond to the age and intellectual-moral development of the pupils and to the aims which the school sets itself. The common school, or school of humanistic formation (taking the term "humanism" in a broad sense rather than simply in the traditional one) or general culture, should aim to insert young men and women into social activity after bringing them to a certain level of maturity, of capacity for intellectual and practical creativity, and of autonomy of orientation and initiative. The fixing of an age for compulsory school attendance depends on the general economic conditions, since the latter may make it necessary to demand of young men and women, or even of children, a certain immediate productive contribution. The common school necessitates the State's being able to take on the expenditure which at present falls on the family for the maintenance of children at school; in other words, it transforms

the budget of the national department from top to bottom, expanding it to an unheard of extent and making it more complex. The entire function of educating and forming the new generations ceases to be private and becomes public; for only thus can it involve them in their entirety, without divisions of group or caste. But this transformation of scholastic activity requires an unprecedented expansion of the practical organisation of the school, i.e. of buildings, scientific material, of the teaching body, etc. The teaching body in particular would have to be increased, since the smaller the ratio between teachers and pupils the greater will be the efficiency of the school—and this presents other problems neither easy nor quick to solve. The question of school buildings is not simple either, since this type of school should be a college, with dormitories, refectories, specialised libraries, rooms designed for seminar work, etc. Hence initially the new type of school will have to be, cannot help being, only for restricted groups, made up of young people selected through competition or recommended by similar institutions.

The common school ought to correspond to the period represented today by the primary and secondary schools, reorganised not only as regards the content and the method of teaching, but also as regards the arrangement of the various phases of the educational process. The first, primary grade should not last longer than three or four years, and in addition to imparting the first "instrumental" notions of schooling—reading, writing, sums, geography, history—ought in particular to deal with an aspect of education that is now neglected—i.e. with "rights and duties", with the first notions of the State and society as primordial elements of a new conception of the world which challenges the conceptions that are imparted by the various traditional social environments, i.e. those conceptions which can be termed folkloristic. The didactic problem is one of mitigating and rendering more fertile the dogmatic approach which must inevitably characterise these first years. The rest of the course should not last more than six years, so that by the age of fifteen or sixteen it should be possible to complete all the grades of the common school.

One may object that such a course is too exhausting because too rapid, if the aim is to attain in effect the results which the present organisation of the classical school aims at but does not attain. Yet the new organisation as a whole will have to contain within itself the general elements which in fact make the course too slow today, at least for a part of the pupils. Which are these elements? In a whole series of families, especially in the intellectual strata, the children find in their family life a preparation, a prolongation and a completion of school life; they "breathe in", as the expression goes, a whole quantity of notions and attitudes which facilitate the educational process properly speaking. They already know and develop their knowledge of the literary language, i.e. the means of expression and of knowledge, which is technically superior to the means possessed by the average member of the school population between the ages of six and twelve. Thus city children, by the very fact of living in a city, have already absorbed by the age of six a quantity of notions and attitudes which make their school careers easier, more profitable, and more rapid. In the basic organisation of the common school, at least the essentials of these conditions must be created—not to speak of the fact, which goes without saying, that parallel to the common

school a network of kindergartens and other institutions would develop, in which, even before the school age, children would be habituated to a certain collective discipline and acquire pre-scholastic notions and attitudes. In fact, the common school should be organised like a college, with a collective life by day and by night, freed from the present forms of hypocritical and mechanical discipline; studies should be carried on collectively, with the assistance of the teachers and the best pupils, even during periods of so-called individual study, etc.

The fundamental problem is posed by that phase of the existing school career which is today represented by the *liceo*,[4] and which today does not differ at all, as far as the kind of education is concerned, from the preceding grades—except by the abstract presumption of a greater intellectual and moral maturity of the pupil, matching his greater age and the experience he has already accumulated.

In fact between *liceo* and university, i.e. between the school properly speaking and life, there is now a jump, a real break in continuity, and not a rational passage from quantity (age) to quality (intellectual and moral maturity). From an almost purely dogmatic education, in which learning by heart plays a great part, the pupil passes to the creative phase, the phase of autonomous, independent work. From the school, where his studies are subjected to a discipline that is imposed and controlled by authority, the pupil passes on to a phase of study or of professional work in which intellectual self-discipline and moral independence are theoretically unlimited. And this happens immediately after the crisis of puberty, when the ardour of the instinctive and elementary passions has not yet resolved its struggle with the fetters of the character and of moral conscience which are in the process of being formed. Moreover, in Italy, where the principle of 'seminar' work is not widespread in the universities, this passage is even more brusque and mechanical.

By contrast, therefore, the last phase of the common school must be conceived and structured as the decisive phase, whose aim is to create the fundamental values of "humanism", the intellectual self-discipline and the moral independence which are necessary for subsequent specialisation—whether it be of a scientific character (university studies) or of an immediately practical-productive character (industry, civil service, organisation of commerce, etc.). The study and learning of creative methods in science and in life must begin in this last phase of the school, and no longer be a monopoly of the university or be left to chance in practical life. This phase of the school must already contribute to developing the element of independent responsibility in each individual, must be a creative school. A distinction must be made between creative school and active school, even in the form given to the latter by the Dalton method.[5] The entire common school is an active school, although it is necessary to place limits on libertarian ideologies in this field and to stress with some energy the duty of the adult generations, i.e. of the State, to "mould" the new generations. The active school is still in its romantic phase, in which the elements of struggle against the mechanical and Jesuitical school have become unhealthily exaggerated—through a desire to distinguish themselves sharply from the latter, and for polemical reasons. It is necessary to enter the "classical", rational phase, and to find in the ends to be attained the natural source for developing the appropriate methods and forms.

The creative school is the culmination of the active school. In the first phase the aim is to discipline, hence also to level out—to obtain a certain kind of "conformism" which may be called "dynamic". In the creative phase, on the basis that has been achieved of "collectivisation" of the social type, the aim is to expand the personality—by now autonomous and responsible, but with a solid and homogeneous moral and social conscience. Thus creative school does not mean school of "inventors and discoverers"; it indicates a phase and a method of research and of knowledge, and not a predetermined "programme" with an obligation to originality and innovation at all costs. It indicates that learning takes place especially through a spontaneous and autonomous effort of the pupil, with the teacher only exercising a function of friendly guide—as happens or should happen in the university. To discover a truth oneself, without external suggestions or assistance, is to create—even if the truth is an old one. It demonstrates a mastery of the method, and indicates that in any case one has entered the phase of intellectual maturity in which one may discover new truths. Hence in this phase the fundamental scholastic activity will be carried on in seminars, in libraries, in experimental laboratories; during it, the organic data will be collected for a professional orientation.

The advent of the common school means the beginning of new relations between intellectual and industrial work, not only in the school but in the whole of social life. The comprehensive principle will therefore be reflected in all the organisms of culture, transforming them and giving them a new content.

In search of the educational principle

In the old primary school, there used to be two elements in the educational formation of the children. They were taught the rudiments of natural science, and the idea of civic rights and duties. Scientific ideas were intended to insert the child into the *societas rerum*, the world of things, while lessons in rights and duties were intended to insert him into the State and into civil society. The scientific ideas the children learnt conflicted with the magical conception of the world and nature which they absorbed from an environment steeped in folklore;[6] while the idea of civic rights and duties conflicted with tendencies towards individualistic and localistic barbarism—another dimension of folklore. The school combated folklore, indeed every residue of traditional conceptions of the world. It taught a more modern outlook based essentially on an awareness of the simple and fundamental fact that there exist objective, intractable natural laws to which man must adapt himself if he is to master them in his turn—and that there exist social and state laws which are the product of human activity, which are established by men and can be altered by men in the interests of their collective development. These laws of the State and of society create that human order which historically best enables men to dominate the laws of nature, that is to say which most facilitates their *work*. For work is the specific mode by which man actively participates in natural life in order to transform and socialise it more and more deeply and extensively.

Thus one can say that the educational principle which was the basis of the old primary school was the idea of work. Human work cannot be realised in all

its power of expansion and productivity without an exact and realistic knowledge of natural laws and without a legal order which organically regulates men's life in common. Men must respect this legal order through spontaneous assent, and not merely as an external imposition—it must be a necessity recognised and proposed to themselves as freedom, and not simply the result of coercion. The idea and the fact of work (of theoretical and practical activity) was the educational principle latent in the primary school, since it is by means of work that the social and State order (rights and duties) is introduced and identified within the natural order. The discovery that the relations between the social and natural orders are mediated by work, by man's theoretical and practical activity, creates the first elements of an intuition of the world free from all magic and superstition. It provides a basis for the subsequent development of an historical, dialectical conception of the world, which understands movement and change, which appreciates the sum of effort and sacrifice which the present has cost the past and which the future is costing the present, and which conceives the contemporary world as a synthesis of the past, of all past generations, which projects itself into the future. This was the real basis of the primary school. Whether it yielded all its fruits, and whether the actual teachers were aware of the nature and philosophical content of their task, is another question. This requires an analysis of the degree of civic consciousness of the entire nation, of which the teaching body was merely an expression, and rather a poor expression—certainly not an *avant-garde*.

It is not entirely true that "instruction" is something quite different from "education". An excessive emphasis on this distinction has been a serious error of idealist educationalists and its effects can already be seen in the school system as they have reorganised it. For instruction to be wholly distinct from education, the pupil would have to be pure passivity, a "mechanical receiver" of abstract notions—which is absurd and is anyway "abstractly" denied by the supporters of pure educativity precisely in their opposition to mere mechanistic instruction. The "certain" becomes "true" in the child's consciousness.[7] But the child's consciousness is not something "individual" (still less individuated), it reflects the sector of civil society in which the child participates, and the social relations which are formed within his family, his neighbourhood, his village, etc. The individual consciousness of the overwhelming majority of children reflects social and cultural relations which are different from and antagonistic to those which are represented in the school curricula: thus the "certain" of an advanced culture becomes "true" in the framework of a fossilised and anachronistic culture. There is no unity between school and life, and so there is no automatic unity between instruction and education. In the school, the nexus between instruction and education can only be realised by the living work of the teacher. For this he must be aware of the contrast between the type of culture and society which he represents and the type of culture and society represented by his pupils, and conscious of his obligation to accelerate and regulate the child's formation in conformity with the former and in conflict with the latter. If the teaching body is not adequate and the nexus between instruction and education is dissolved, while the problem of teaching is conjured away by cardboard schemata exalting educativity, the teacher's work will as a result become yet more inadequate. We

will have rhetorical schools, quite unserious, because the material solidity of what is "certain" will be missing, and what is "true" will be a truth only of words: that is to say, precisely, rhetoric.

This degeneration is even clearer in the secondary school, in the literature and philosophy syllabus. Previously, the pupils at least acquired a certain "baggage" or "equipment" (according to taste) of concrete facts. Now that the teacher must be specifically a philosopher and aesthete, the pupil does not bother with concrete facts and fills his head with formulae and words which usually mean nothing to him, and which are forgotten at once. It was right to struggle against the old school, but reforming it was not so simple as it seemed. The problem was not one of model curricula but of men, and not just of the men who are actually teachers themselves but of the entire social complex which they express. In reality a mediocre teacher may manage to see to it that his pupils become more *informed*, although he will not succeed in making them better educated; he can devote a scrupulous and bureaucratic conscientiousness to the mechanical part of teaching—and the pupil, if he has an active intelligence, will give an order of his own, with the aid of his social background, to the "baggage" he accumulates. With the new curricula, which coincide with a general lowering of the level of the teaching profession, there will no longer be any "baggage" to put in order. The new curricula should have abolished examinations entirely; for to take an examination now must be fearfully more chancy than before. A date is always a date, whoever the examiner is, and a definition is always a definition. But an aesthetic judgement or a philosophical analysis?

The educational efficacy of the old Italian secondary school, as organised by the Casati Act,[8] was not to be sought (or rejected) in its explicit aim as an "educative" system, but in the fact that its structure and its curriculum were the expression of a traditional mode of intellectual and moral life, of a cultural climate diffused throughout Italian society by ancient tradition. It was the fact that this climate and way of life were in their death-throes, and that the school had become cut off from life, which brought about the crisis in education. A criticism of the curricula and disciplinary structure of the old system means less than nothing if one does not keep this situation in mind. Thus we come back to the truly active participation of the pupil in the school, which can only exist if the school is related to life. The more the new curricula nominally affirm and theorise the pupil's activity and working collaboration with the teacher, the more they are actually designed as if the pupil were purely passive.

In the old school the grammatical study of Latin and Greek, together with the study of their respective literatures and political histories, was an educational principle—for the humanistic ideal, symbolised by Athens and Rome, was diffused throughout society, and was an essential element of national life and culture. Even the mechanical character of the study of grammar was enlivened by this cultural perspective. Individual facts were not learnt for an immediate practical or professional end. The end seemed disinterested, because the real interest was the interior development of personality, the formation of character by means of the absorption and assimilation of the whole cultural past of modern European civilisation. Pupils did not learn Latin and Greek in order to speak them, to become waiters, interpreters or commercial letter-writers. They learnt them in

order to know at first hand the civilisation of Greece and of Rome—a civilisation that was a necessary precondition of our modern civilisation: in other words, they learnt them in order to be themselves and know themselves consciously. Latin and Greek were learnt through their grammar, mechanically; but the accusation of formalism and aridity is very unjust and inappropriate. In education one is dealing with children in whom one has to inculcate certain habits of diligence, precision, poise (even physical poise), ability to concentrate on specific subjects, which cannot be acquired without the mechanical repetition of disciplined and methodical acts. Would a scholar at the age of forty be able to sit for sixteen hours on end at his work-table if he had not, as a child, compulsorily, through mechanical coercion, acquired the appropriate psycho-physical habits? If one wishes to produce great scholars, one still has to start at this point and apply pressure throughout the educational system in order to succeed in creating those thousands or hundreds or even only dozens of scholars of the highest quality which are necessary to every civilisation. (Of course, one can improve a great deal in this field by the provision of adequate funds for research, without going back to the educational methods of the Jesuits.)

Latin is learnt (or rather studied) by analysing it down to its smallest parts—analysing it like a dead thing, it is true, but all analyses made by children can only be of dead things. Besides, one must not forget that the life of the Romans is a myth which to some extent has already interested the child and continues to interest him, so that in the dead object there is always present a greater living being. Thus, the language is dead, it is analysed as an inert object, as a corpse on the dissecting table, but it continually comes to life again in examples and in stories. Could one study Italian in the same way? Impossible. No living language could be studied like Latin: it would be and *would seem* absurd. No child knows Latin when he starts to study it by these analytical methods. But a living language can be known and it would be enough for a single child to know it, and the spell would be broken: everybody would be off to the Berlitz school at once. Latin (like Greek) appears to the imagination as a myth, even for the teacher. One does not study Latin in order to learn the language. For a long time, as a result of a cultural and scholarly tradition whose origin and development one might investigate, Latin has been studied as an element in an ideal curriculum, an element which combines and satisfies a whole series of pedagogic and psychological requirements. It has been studied in order to accustom children to studying in a specific manner, and to analysing an historical body which can be treated as a corpse which returns continually to life; in order to accustom them to reason, to think abstractly and schematically while remaining able to plunge back from abstraction into real and immediate life, to see in each fact or datum what is general and what is particular, to distinguish the concept from the specific instance.

For what after all is the educational significance of the constant comparison between Latin and the language one speaks? It involves the distinction and the identification of words and concepts; suggests the whole of formal logic, from the contradiction between opposites to the analysis of distincts;[9] reveals the historical movement of the entire language, modified through time, developing and not static. In the eight years of *ginnasio* and *liceo*[10] the entire history of the

real language is studied, after it has first been photographed in one abstract moment in the form of grammar. It is studied from Ennius (or rather from the words of the fragments of the twelve tablets) right up to Phaedrus and the Christian writers in Latin: an historical process is analysed from its source until its death in time—or seeming death, since we know that Italian, with which Latin is continually contrasted in school, is modern Latin. Not only the grammar of a certain epoch (which is an abstraction) or its vocabulary are studied, but also, for comparison, the grammar and the vocabulary of each individual author and the meaning of each term in each particular stylistic "period". Thus the child discovers that the grammar and the vocabulary of Phaedrus are not those of Cicero, nor those of Plautus, nor of Lactantius or Tertullian, and that the same nexus of sounds does not have the same meaning in different periods and for different authors. Latin and Italian are continually compared; but each word is a concept, a symbol, which takes on different shades of meaning according to the period and the writer in each of the two languages under comparison. The child studies the literary history of the books written in that language, the political history, the achievements of the men who spoke that language. His education is determined by the whole of this organic complex, by the fact that he has followed that itinerary, if only in a purely literal sense, he has passed through those various stages, etc. He has plunged into history and acquired a historicising understanding of the world and of life, which becomes a second— nearly spontaneous—nature, since it is not inculcated pedantically with an openly educational intention. These studies educated without an explicitly declared aim of doing so, with a minimal "educative" intervention on the part of the teacher: they educated because they gave instruction. Logical, artistic, psychological experience was gained unawares, without a continual self-consciousness. Above all a profound "synthetic", philosophical experience was gained, of an actual historical development. This does not mean—it would be stupid to think so—that Latin and Greek, as such, have intrinsically thaumaturgical qualities in the educational field. It is the whole cultural tradition, which also and particularly lives outside the school, which in a given ambience produces such results. In any case one can see today, with the changes in the traditional idea of culture, the way in which the school is in crisis and with it the study of Latin and Greek.

It will be necessary to replace Latin and Greek as the fulcrum of the formative school, and they will be replaced. But it will not be easy to deploy the new subject or subjects in a didactic form which gives equivalent results in terms of education and general personality-formation, from early childhood to the threshold of the adult choice of career. For in this period what is learnt, or the greater part of it, must be—or appear to the pupils to be—disinterested, i.e. not have immediate or too immediate practical purposes. It must be formative, while being "instructive"—in other words rich in concrete facts. In the present school, the profound crisis in the traditional culture and its conception of life and of man has resulted in a progressive degeneration. Schools of the vocational type, i.e. those designed to satisfy immediate, practical interests, are beginning to predominate over the formative school, which is not immediately "interested". The most paradoxical aspect of it all is that this new type of school appears and is advocated as being democratic, while in fact it is destined not merely to perpetuate social differences but to crystallise them in Chinese complexities.

The traditional school was oligarchic because it was intended for the new generation of the ruling class, destined to rule in its turn: but it was not oligarchic in its mode of teaching. It is not the fact that the pupils learn how to rule there, nor the fact that it tends to produce gifted men, which gives a particular type of school its social character. This social character is determined by the fact that each social group has its own type of school, intended to perpetuate a specific traditional function, ruling or subordinate. If one wishes to break this pattern one needs, instead of multiplying and grading different types of vocational school, to create a single type of formative school (primary-secondary) which would take the child up to the threshold of his choice of job, forming him during this time as a person capable of thinking, studying, and ruling—or controlling those who rule.

The multiplication of types of vocational school thus tends to perpetuate traditional social differences; but since, within these differences, it tends to encourage internal diversification, it gives the impression of being democratic in tendency. The labourer can become a skilled worker, for instance, the peasant a surveyor or petty agronomist. But democracy, by definition, cannot mean merely that an unskilled worker can become skilled. It must mean that every "citizen" can "govern" and that society places him, even if only abstractly, in a general condition to achieve this. Political democracy tends towards a coincidence of the rulers and the ruled (in the sense of government with the consent of the governed), ensuring for each non-ruler a free training in the skills and general technical preparation necessary to that end. But the type of school which is now developing as the school for the people does not tend even to keep up this illusion. For it is organised ever more fully in such a way as to restrict recruitment to the technically qualified governing stratum, in a social and political context which makes it increasingly difficult for "personal initiative" to acquire such skills and technical-political preparation. Thus we are really going back to a division into juridically fixed and crystallised estates rather than moving towards the transcendence of class divisions. The multiplication of vocational schools which specialise increasingly from the very beginning of the child's educational career is one of the most notable manifestations of this tendency. It is noticeable that the new pedagogy has concentrated its fire on "dogmatism" in the field of instruction and the learning of concrete facts—i.e. precisely in the field in which a certain dogmatism is practically indispensable and can be reabsorbed and dissolved only in the whole cycle of the educational process (historical grammar could not be taught in *liceo* classes). On the other hand, it has been forced to accept the introduction of dogmatism *par excellence* in the field of religious thought, with the result that the whole history of philosophy is now implicitly seen as a succession of ravings and delusions.[10] In the philosophy course, the new curriculum impoverishes the teaching and in practice lowers its level (at least for the overwhelming majority of pupils who do not receive intellectual help outside the school from their family or home environment, and who have to form themselves solely by means of the knowledge they receive in the class-room)—in spite of seeming very rational and fine, fine as any Utopia. The traditional descriptive philosophy, backed by a course in the history of philosophy and by the reading of a certain number of philosophers, in practice

seems the best thing. Descriptive, definitional philosophy may be a dogmatic abstraction, just as grammar and mathematics are, but it is an educational and didactive necessity. "One equals one" is an abstraction, but it leads nobody to think that one fly equals one elephant. The rules of formal logic are abstractions of the same kind, they are like the grammar of normal thought; but they still need to be studied, since they are not something innate, but have to be acquired through work and reflection. The new curriculum presupposes that formal logic is something you already possess when you think, but does not explain how it is to be acquired, so that in practice it is assumed to be innate. Formal logic is like grammar: it is assimilated in a "living" way even if the actual learning process has been necessarily schematic and abstract. For the learner is not a passive and mechanical recipient, a gramophone record—even if the liturgical conformity of examinations sometimes makes him appear so. The relation between these educational forms and the child's psychology is always active and creative, just as the relation of the worker to his tools is active and creative. A calibre is likewise a complex of abstractions, but without calibration it is not possible to produce real objects—real objects which are social relations, and which implicitly embody ideas.

The child who sweats at *Barbara, Baralipton*[11] is certainly performing a tiring task, and it is important that he does only what is absolutely necessary and no more. But it is also true that it will always be an effort to learn physical self-discipline and self-control; the pupil has, in effect, to undergo a psycho-physical training. Many people have to be persuaded that studying too is a job, and a very tiring one, with its own particular apprenticeship—involving muscles and nerves as well as intellect. It is a process of adaptation, a habit acquired with effort, tedium and even suffering. Wider participation in secondary education brings with it a tendency to ease off the discipline of studies, and to ask for "relaxations". Many even think that the difficulties of learning are artificial, since they are accustomed to think only of manual work as sweat and toil. The question is a complex one. Undoubtedly the child of a traditionally intellectual family acquires this psycho-physical adaptation more easily. Before he ever enters the class-room he has numerous advantages over his comrades, and is already in possession of attitudes learnt from his family environment: he concentrates more easily, since he is used to "sitting still", etc. Similarly, the son of a city worker suffers less when he goes to work in a factory than does a peasant's child or a young peasant already formed by country life. (Even diet has its importance, etc.) This is why many people think that the difficulty of study conceals some "trick" which handicaps them—that is, when they do not simply believe that they are stupid by nature. They see the "gentleman"[12]—and for many, especially in the country, "gentleman" means intellectual—complete, speedily and with apparent ease, work which costs their sons tears and blood, and they think there is a "trick". In the future, these questions may become extremely acute and it will be necessary to resist the tendency to render easy that which cannot become easy without being distorted. If our aim is to produce a new stratum of intellectuals, including those capable of the highest degree of specialisation, from a social group which has not traditionally developed the appropriate attitudes, then we have unprecedented difficulties to overcome.

Notes

1 "Sciences" in the sense of branches of human knowledge, rather than in the more restricted meaning which the word has taken on since the industrial revolution.

2 *Classi strumentali* is a term used by Gramsci interchangeably with the terms *classi subalterne* or *classi subordinate*, and there seems no alternative to a literal translation of each which leaves the reader free to decide whether there is any different nuance of stress between them. See too the final paragraph of "History of the Subaltern Classes".

3 De Sanctis in his memoirs recounts how as a child in Naples he was taken to be taught literary Italian at a school for the aristocracy of the city run in his home by the Marchese Puoti. Puoti used to refer to the elder boys, whose "judgement carried great weight, and when one of them spoke everyone fell silent, the marquis soonest of all, and was filled with admiration", as *gli anziani di Santa Zita*, in reference to Dante, *Inferno* XXI, 38. The *"anziani"* were the magistrates of the city of Lucca, whose patron saint was Zita.

4 Perhaps the nearest English-language equivalents of *ginnasio* and *liceo* are the American junior high school and high school, though in the Italian system they are selective schools (like English grammar schools) leading to a university education.

5 The Dalton Method, a development of Montessori's ideas, is described elsewhere by Gramsci (Int., p. 122): "the pupils are free to attend whichever lessons (whether practical or theoretical) they please, provided that by the end of each month they have completed the programme set for them; discipline is entrusted to the pupils themselves. The system has a serious defect: the pupils generally postpone doing their work until the last days of the month, and this detracts from the seriousness of the education and represents a major difficulty for the teachers who are supposed to help them but are overwhelmed with work—whereas in the first weeks of the month they have little or nothing to do. (The Dalton system is simply an extension to the secondary schools of the methods of study which obtain in the Italian universities, methods which leave the student complete freedom in his studies: in certain faculties the students sit twenty examinations and their final degree in the fourth and last year, and the lecturer never so much as knows the student.)"

6 See above for Gramsci's use of the term "folklore".

7 This distinction was made by Vico, in his *Scienza Nuova* of 1725. Para. 321: "The 'certain' in the laws is an obscurity of judgement backed only by authority, so that we find them harsh in application, yet are obliged to apply them just because they are certain. In good Latin *certum* means particularised, or, as the schools say, individuated; so that, in over-elegant Latin, *certum* and *commune*, the certain and the common, are opposed to each other." Para. 324: "The true in the laws is a certain light and splendour with which natural reason illuminates them; so that jurisconsults are often in the habit of saying *verum est* for *aequum est*." Para. 137: "Men who do not know what is true of things take care to hold fast to what is certain, so that, if they cannot satisfy their intellects by knowledge (*scienza*), their wills at least may rest on consciousness (*coscienza*)." Vico (1968).

8 The Casati Act, passed in 1859, remained the basis of the Italian educational system until the Gentile Reform of 1923.

9 For Croce's concept of the "analysis of distincts" see Introduction, p. xxiii.

10 The Gentile Reform provided for compulsory religious education in Italian schools, and Gentile's justifications of this are criticised by Gramsci in Int., pp. 116–18: "… Gentile's thinking … is nothing more than an extension of the idea that 'religion is good for the people' (people = child = primitive phase of thought to which religion corresponds, etc.), i.e. a (tendentious) abandonment of the aim of educating the people … Gentile's historicism is of a very degenerate kind: it is the historicism of those jurists for whom the knout is not a knout when it is an 'historical' knout. Moreover, its ideas are extremely vague and confused. The fact that a 'dogmatic' exposition of scientific ideas and a certain 'mythology' are necessary in the primary school does not mean that the dogma and the mythology have to be precisely those of religion."

11 *Barbara, Baralipton*, were mnemonic words used to memorise syllogisms in classical logic.

12 *Signore*. On this term, not of course an exact equivalent of "gentleman", see below p. 272.

Walter Benjamin

THE WORK OF ART IN THE AGE OF ITS TECHNOLOGICAL REPRODUCTION
Third version

EDITOR'S INTRODUCTION

WALTER BENJAMIN has been the most discussed and influential cultural theorist of the twentieth century, and this is his most famous essay. Benjamin wrote it in the late 1930s and this version remained unpublished in his lifetime. As is the case for the Gramsci piece in this anthology, it needs to be contextualized. Benjamin was a Jewish intellectual, a colleague of Theodor Adorno and Max Horkheimer of the so-called 'Frankfurt School', a group of Marxist theorists who were at the centre of Western Marxism. At this stage of his career, he was confronted with the appalling reality of the Nazi state which, pretty much for the first time, had drawn upon the whole apparatus of modern communication technology – film, radio, photography – for its purposes of total social domination of the nation-state by a political party, and he was also well aware of American industrialized mass culture. It was this situation, of course, that caused Adorno and Horkheimer to believe that commodified culture was closing all possibilities for genuine cultural experience.

Benjamin's intellectual orientations continually shifted and are extremely difficult to interpret but this essay belongs to the most clearly communist phase of his career. To put it simply: Benjamin was torn between, on the one side, a materialist Marxism which saw capitalism and commodity culture as a totality and, on the other, a fundamentally religious point of view, in which he examined experience for redemptive signs (so-called dialectical images), believing that revolutionary hope needed energies and motive force that could not be found on history's surface (history was, for him, wreckage, trash) but which existed, as it were, in capitalism's unconscious depths.

This ambivalence can be found in this essay, if it is read carefully. Benjamin departed from his colleague, Theodor Adorno, in arguing that film contained emancipatory potential. To put the case simply, it provided for a dreamlike disorientation in which dialectic images could emerge, particularly in its use of montage. And yet film, with its capacity to distract and shock (by which Benjamin means something like 'to take control of the audience's mental processes') can be used either for fascism or for communism – that's the argument in the wonderful last section of this essay. Which is more likely, he wonders, on the cusp of World War II?

Further reading: Buck-Morss 1989; Caygill 1998; Ferris 2004; Gunster 2004; Pensky 1993; Smith 1988; Weigel 1996.

I

In principle, the work of art has always been reproducible. Objects made by humans could always be copied by humans. Replicas were made by pupils in practicing for their craft, by masters in disseminating their works, and, finally, by third parties in pursuit of profit. But the technological reproduction of artworks is something new. Having appeared intermittently in history, at widely spaced intervals, it is now being adopted with ever-increasing intensity. The Greeks had only two ways of technologically reproducing works of art: casting and stamping. Bronzes, terracottas, and coins were the only artworks they could produce in large numbers. All others were unique and could not be technologically reproduced. Graphic art was first made technologically reproducible by the woodcut, long before written language became reproducible by movable type. The enormous changes brought about in literature by movable type, the technological reproducibility of writing, are well known. But they are only a special case, though an important one, of the phenomenon considered here from the perspective of world history. In the course of the Middle Ages the woodcut was supplemented by engraving and etching, and at the beginning of the nineteenth century by lithography.

Lithography marked a fundamentally new stage in the technology of reproduction. This much more direct process – distinguished by the fact that the drawing is traced on a stone, rather than incised on a block of wood or etched on a copper plate – first made it possible for graphic art to market its products not only in large numbers, as previously, but in daily changing variations. Lithography enabled graphic art to provide an illustrated accompaniment to everyday life. It began to keep pace with movable-type printing. But only a few decades after the invention of lithography, graphic art was surpassed by photography. For the first time, photography freed the hand from the most important artistic tasks in the process of pictorial reproduction – tasks that now devolved solely upon the eye looking into a lens. And since the eye perceives more swiftly than the hand can draw, the process of pictorial reproduction was enormously accelerated, so that it could now keep pace with speech. A cinematographer shooting a scene in the studio captures the images at the speed of an actor's speech. Just as the illustrated newspaper

virtually lay hidden within lithography, so the sound film was latent in photography. The technological reproduction of sound was tackled at the end of the last century. These convergent endeavors made it possible to conceive of the situation that Paul Valéry describes in this sentence: "Just as water, gas, and electricity are brought into our houses from far off to satisfy our needs with minimal effort, so we shall be supplied with visual or auditory images, which will appear and disappear at a simple movement of the hand, hardly more than a sign." *Around 1900, technological reproduction not only had reached a standard that permitted it to reproduce all known works of art, profoundly modifying their effect, but it also had captured a place of its own among the artistic processes.* In gauging this standard, we would do well to study the impact which its two different manifestations – the reproduction of artworks and the art of film – are having on art in its traditional form.

II

In even the most perfect reproduction, *one* thing is lacking: the here and now of the work of art – its unique existence in a particular place. It is this unique existence – and nothing else – that bears the mark of the history to which the work has been subject. This history includes changes to the physical structure of the work over time, together with any changes in ownership. Traces of the former can be detected only by chemical or physical analyses (which cannot be performed on a reproduction), while changes of ownership are part of a tradition which can be traced only from the standpoint of the original in its present location.

The here and now of the original underlies the concept of its authenticity. Chemical analyses of the patina of a bronze can help to establish its authenticity, just as the proof that a given manuscript of the Middle Ages came from an archive of the fifteenth century helps to establish its authenticity. *The whole sphere of authenticity eludes technological – and, of course, not only technological – reproducibility.*[1] But whereas the authentic work retains its full authority in the face of a reproduction made by hand, which it generally brands a forgery, this is not the case with technological reproduction. The reason is twofold. First, technological reproduction is more independent of the original than is manual reproduction. For example, in photography it can bring out aspects of the original that are accessible only to the lens (which is adjustable and can easily change viewpoint) but not to the human eye; or it can use certain processes, such as enlargement or slow motion, to record images which escape natural optics altogether. This is the first reason. Second, technological reproduction can place the copy of the original in situations which the original itself cannot attain. Above all, it enables the original to meet the recipient halfway, whether in the form of a photograph or in that of a gramophone record. The cathedral leaves its site to be received in the studio of an art lover; the choral work performed in an auditorium or in the open air is enjoyed in a private room.

The situations into which the product of technological reproduction can be brought may leave the artwork's other properties untouched, but they certainly devalue the here and now of the artwork. And although this can apply not only to art but (say) to a landscape moving past the spectator in a film, in the work of art this process touches on a highly sensitive core, more vulnerable than that

of any natural object. That core is its authenticity. The authenticity of a thing is the quintessence of all that is transmissible in it from its origin on, ranging from its physical duration to the historical testimony relating to it. Since the historical testimony is founded on the physical duration, the former, too, is jeopardized by reproduction, in which the physical duration plays no part. And what is really jeopardized when the historical testimony is affected is the authority of the object.[2]

One might encompass the eliminated element within the concept of the aura, and go on to say: what withers in the age of the technological reproducibility of the work of art is the latter's aura. The process is symptomatic; its significance extends far beyond the realm of art. *It might be stated as a general formula that the technology of reproduction detaches the reproduced object from the sphere of tradition. By replicating the work many times over, it substitutes a mass existence for a unique existence. And in permitting the reproduction to reach the recipient in his or her own situation, it actualizes that which is reproduced.* These two processes lead to a massive upheaval in the domain of objects handed down from the past – a shattering of tradition which is the reverse side of the present crisis and renewal of humanity. Both processes are intimately related to the mass movements of our day. Their most powerful agent is film. The social significance of film, even – and especially – in its most positive form, is inconceivable without its destructive, cathartic side: the liquidation of the value of tradition in the cultural heritage. This phenomenon is most apparent in the great historical films. It is assimilating ever more advanced positions in its spread. When Abel Gance fervently proclaimed in 1927, "Shakespeare, Rembrandt, Beethoven will make films. ... All legends, all mythologies, and all myths, all the founders of religions, indeed, all religions, ... await their celluloid resurrection, and the heroes are pressing at the gates," he was inviting the reader, no doubt unawares, to witness a comprehensive liquidation.[3]

III

Just as the entire mode of existence of human collectives changes over long historical periods, so too does their mode of perception. The way in which human perception is organized – the medium in which it occurs – is conditioned not only by nature but by history. The era of the migration of peoples, an era which saw the rise of the late-Roman art industry and the Vienna Genesis, developed not only an art different from that of antiquity but also a different perception. The scholars of the Viennese school Riegl and Wickhoff, resisting the weight of the classical tradition beneath which this art had been buried, were the first to think of using such art to draw conclusions about the organization of perception at the time the art was produced.[4] However far-reaching their insight, it was limited by the fact that these scholars were content to highlight the formal signature which characterized perception in late-Roman times. They did not attempt to show the social upheavals manifested in these changes of perception – and perhaps could not have hoped to do so at that time. Today, the conditions for an analogous insight are more favorable. And if changes in the medium of present-day perception can be understood as a decay of the aura, it is possible to demonstrate the social determinants of that decay.

The concept of the aura which was proposed above with reference to historical objects can be usefully illustrated with reference to an aura of natural objects. We define the aura of the latter as the unique apparition of a distance, however near it may be.[5] To follow with the eye – while resting on a summer afternoon – a mountain range on the horizon or a branch that casts its shadow on the beholder is to breathe the aura of those mountains, of that branch. In the light of this description, we can readily grasp the social basis of the aura's present decay. It rests on two circumstances, both linked to the increasing significance of the masses in contemporary life. Namely: *the desire of the present-day masses to "get closer" to things spatially and humanly, and their equally passionate concern for overcoming each thing's uniqueness [Überwindung des Einmaligen jeder Gegebenheit] by assimilating it as a reproduction.*[6] Every day the urge grows stronger to get hold of an object at close range in an image [*Bild*], or better, in a facsimile [*Abbild*], a reproduction. And the reproduction [*Reproduktion*], as offered by illustrated magazines and newsreels, differs unmistakably from the image. Uniqueness and permanence are as closely entwined in the latter as are transitoriness and repeatability in the former. The stripping of the veil from the object, the destruction of the aura, is the signature of a perception whose "sense for sameness in the world"[7] has so increased that, by means of reproduction, it extracts sameness even from what is unique. Thus is manifested in the field of perception what in the theoretical sphere is noticeable in the increasing significance of statistics. The alignment of reality with the masses and of the masses with reality is a process of immeasurable importance for both thinking and perception.

IV

The uniqueness of the work of art is identical to its embeddedness in the context of tradition. Of course, this tradition itself is thoroughly alive and extremely changeable. An ancient statue of Venus, for instance, existed in a traditional context for the Greeks (who made it an object of worship) that was different from the context in which it existed for medieval clerics (who viewed it as a sinister idol). But what was equally evident to both was its uniqueness – that is, its aura. Originally, the embeddedness of an artwork in the context of tradition found expression in a cult. As we know, the earliest artworks originated in the service of rituals – first magical, then religious. And it is highly significant that the artwork's auratic mode of existence is never entirely severed from its ritual function.[8] In other words: *the unique value of the "authentic" work of art has its basis in ritual, the source of its original use value.* This ritualistic basis, however mediated it may be, is still recognizable as secularized ritual in even the most profane forms of the cult of beauty.[9] The secular worship of beauty, which developed during the Renaissance and prevailed for three centuries, clearly displayed that ritualistic basis in its subsequent decline and in the first severe crisis which befell it. For when, with the advent of the first truly revolutionary means of reproduction (namely, photography, which emerged at the same time as socialism), art felt the approach of that crisis which a century later has become unmistakable, it reacted with the doctrine of *l'art pour l'art* – that is, with a theology of art. This in turn gave rise to a negative theology, in the

form of an idea of "pure" art, which rejects not only any social function but any definition in terms of a representational content. (In poetry, Mallarmé was the first to adopt this standpoint.[10]

No investigation of the work of art in the age of its technological reproducibility can overlook these connections. They lead to a crucial insight: for the first time in world history, technological reproducibility emancipates the work of art from its parasitic subservience to ritual. To an ever-increasing degree, the work reproduced becomes the reproduction of a work designed for reproducibility.[11] From a photographic plate, for example, one can make any number of prints; to ask for the "authentic" print makes no sense. *But as soon as the criterion of authenticity ceases to be applied to artistic production, the whole social function of art is revolutionized. Instead of being founded on ritual, it is based on a different practice: politics.*

V

The reception of works of art varies in character, but in general two polar types stand out: one accentuates the artwork's cult value; the other, its exhibition value. Artistic production begins with figures in the service of a cult. One may assume that it was more important for these figures to be present than to be seen. The elk depicted by Stone Age man on the walls of his cave is an instrument of magic. He exhibits it to his fellow men, to be sure, but in the main it is meant for the spirits. Cult value as such tends today, it would seem, to keep the artwork out of sight: certain statues of gods are accessible only to the priest in the cella; certain images of the Madonna remain covered nearly all year round; certain sculptures on medieval cathedrals are not visible to the viewer at ground level. *With the emancipation of specific artistic practices from the service of ritual, the opportunities for exhibiting their products increase.* It is easier to exhibit a portrait bust that can be sent here and there than to exhibit the statue of a divinity that has a fixed place in the interior of a temple. A panel painting can be exhibited more easily than the mosaic or fresco which preceded it. And although a Mass may have been no less suited to public presentation than a symphony, the symphony came into being at a time when the possibility of such presentation promised to be greater.

The scope for exhibiting the work of art has increased so enormously with the various methods of technologically reproducing it that, as happened in prehistoric times, a quantitative shift between the two poles of the artwork has led to a qualitative transformation in its nature. Just as the work of art in prehistoric times, through the absolute emphasis placed on its cult value, became first and foremost an instrument of magic which only later came to be recognized as a work of art, so today, through the absolute emphasis placed on its exhibition value, the work of art becomes a construct [Gebilde] with quite new functions. Among these, the one we are conscious of – the artistic function – may subsequently be seen as incidental.[12] This much is certain: today, photography and film are the most serviceable vehicles of this new understanding.

VI

In photography, exhibition value begins to drive back cult value on all fronts. But cult value does not give way without resistance. It falls back to a last entrenchment: the human countenance. It is no accident that the portrait is central to early photography. In the cult of remembrance of dead or absent loved ones, the cult value of the image finds its last refuge. In the fleeting expression of a human face, the aura beckons from early photographs for the last time. This is what gives them their melancholy and incomparable beauty. But as the human being withdraws from the photographic image, exhibition value for the first time shows its superiority to cult value. To have given this development its local habitation constitutes the unique significance of Atget, who, around 1900, took photographs of deserted Paris streets.[13] It has justly been said that he photographed them like scenes of crimes. A crime scene, too, is deserted; it is photographed for the purpose of establishing evidence. With Atget, photographic records begin to be evidence in the historical trial [*Prozess*]. This constitutes their hidden political significance. They demand a specific kind of reception. Free-floating contemplation is no longer appropriate to them. They unsettle the viewer; he feels challenged to find a particular way to approach them. At the same time, illustrated magazines begin to put up signposts for him – whether these are right or wrong is irrelevant. For the first time, captions become obligatory. And it is clear that they have a character altogether different from the titles of paintings. The directives given by captions to those looking at images in illustrated magazines soon become even more precise and commanding in films, where the way each single image is understood appears prescribed by the sequence of all the preceding images.

VII

The nineteenth-century dispute over the relative artistic merits of painting and photography seems misguided and confused today. But this does not diminish its importance, and may even underscore it. The dispute was in fact an expression of a world-historical upheaval whose true nature was concealed from both parties. Insofar as the age of technological reproducibility separated art from its basis in cult, all semblance of art's autonomy disappeared forever. But the resulting change in the function of art lay beyond the horizon of the nineteenth century. And even the twentieth, which saw the development of film, was slow to perceive it.

Though commentators had earlier expended much fruitless ingenuity on the question of whether photography was an art – without asking the more fundamental question of whether the invention of photography had not transformed the entire character of art – film theorists quickly adopted the same ill-considered standpoint. But the difficulties which photography caused for traditional aesthetics were child's play compared to those presented by film. Hence the obtuse and hyperbolic character of early film theory. Abel Gance, for instance, compares film to hieroglyphs: "By a remarkable regression, we are transported back to the expressive level of the Egyptians.... Pictorial language has not matured, because our eyes are not yet adapted to it. There is not yet enough respect, not enough *cult*, for what it expresses." Or, in the words of Séverin-Mars:

"What other art has been granted a dream ... at once more poetic and more real? Seen in this light, film might represent an incomparable means of expression, and only the noblest minds should move within its atmosphere, in the most perfect and mysterious moments of their lives." Alexandre Arnoux, for his part, concludes a fantasy about the silent film with the question: "Do not all the bold descriptions we have given amount to a definition of prayer?" It is instructive to see how the desire to annex film to "art" impels these theoreticians to attribute elements of cult to film – with a striking lack of discretion. Yet when these speculations were published, works like *A Woman of Paris* and *The Gold Rush* had already appeared. This did not deter Abel Gance from making the comparison with hieroglyphs, while Séverin-Mars speaks of film as one might speak of paintings by Fra Angelico. It is revealing that even today especially reactionary authors look in the same direction for the significance of film – finding, if not actually a sacred significance, then at least a supernatural one. In connection with Max Reinhardt's film version of *A Midsummer Night's Dream*, Werfel comments that it was undoubtedly the sterile copying of the external world – with its streets, interiors, railroad stations, restaurants, automobiles, and beaches – that had prevented film up to now from ascending to the realm of art. "Film has not yet realized its true purpose, its real possibilities. ... These consist in its unique ability to use natural means to give incomparably convincing expression to the fairylike, the marvelous, the supernatural."

VIII

The artistic performance of a stage actor is directly presented to the public by the actor in person; that of a screen actor, however, is presented through a camera, with two consequences. The recording apparatus that brings the film actor's performance to the public need not respect the performance as an integral whole. Guided by the cameraman, the camera continually changes its position with respect to the performance. The sequence of positional views which the editor composes from the material supplied him constitutes the completed film. It comprises a certain number of movements, of various kinds and duration, which must be apprehended as such through the camera, not to mention special camera angles, close-ups, and so on. Hence, the performance of the actor is subjected to a series of optical tests. This is the first consequence of the fact that the actor's performance is presented by means of a camera. The second consequence is that the film actor lacks the opportunity of the stage actor to adjust to the audience during his performance, since he does not present his performance to the audience in person. This permits the audience to take the position of a critic, without experiencing any personal contact with the actor. *The audience's empathy with the actor is really an empathy with the camera. Consequently, the audience takes the position of the camera; its approach is that of testing.*[14] This is not an approach compatible with cult value.

IX

In the case of film, the fact that the actor represents someone else before the audience matters much less than the fact that he represents himself before the apparatus. One of the first to sense this transformation of the actor by the test performance was Pirandello. That his remarks on the subject in his novel *Si gira* [Shoot!] are confined to the negative aspects of this change, and to silent film only, does little to diminish their relevance. For in this respect, the sound film changed nothing essential. What matters is that the actor is performing for a piece of equipment – or, in the case of sound film, for two pieces of equipment. "The film actor," Pirandello writes, "feels as if exiled. Exiled not only from the stage but from his own person. With a vague unease, he senses an inexplicable void, stemming from the fact that his body has lost its substance, that he has been volatilized, stripped of his reality, his life, his voice, the noises he makes when moving about, and has been turned into a mute image that flickers for a moment on the screen, then vanishes into silence. ... The little apparatus will play with his shadow before the audience, and he himself must be content to play before the apparatus."[15] The situation can also be characterized as follows: for the first time – and this is the effect of film – the human being is placed in a position where he must operate with his whole living person, while forgoing its aura. For the aura is bound to his presence in the here and now. There is no facsimile of the aura. The aura surrounding Macbeth on the stage cannot be divorced from the aura which, for the living spectators, surrounds the actor who plays him. What distinguishes the shot in the film studio, however, is that the camera is substituted for the audience. As a result, the aura surrounding the actor is dispelled – and, with it, the aura of the figure he portrays.

It is not surprising that it should be a dramatist such as Pirandello who, in reflecting on the special character of film acting, inadvertently touches on the crisis now affecting the theater. Indeed, nothing contrasts more starkly with a work of art completely subject to (or, like film, founded in) technological reproduction than a stage play. Any thorough consideration will confirm this. Expert observers have long recognized that, in film, "the best effects are almost always achieved by 'acting' as little as possible.... The development," according to Rudolf Arnheim, writing in 1932, has been toward "using the actor as one of the 'props,' chosen for his typicalness and ... introduced in the proper context."[16] Closely bound up with this development is something else. *The stage actor identifies himself with a role. The film actor very often is denied this opportunity.* His performance is by no means a unified whole, but is assembled from many individual performances. Apart from incidental concerns about studio rental, availability of other actors, scenery, and so on, there are elementary necessities of the machinery that split the actor's performance into a series of episodes capable of being assembled. In particular, lighting and its installation require the representation of an action – which on the screen appears as a swift, unified sequence – to be filmed in a series of separate takes, which may be spread over hours in the studio. Not to mention the more obvious effects of montage. A leap from a window, for example, can be shot in the studio as a leap from a scaffold, while the ensuing fall may be filmed weeks later at an outdoor location. And far more paradoxical cases can easily be imagined. Let

us assume that an actor is supposed to be startled by a knock at the door. If his reaction is not satisfactory, the director can resort to an expedient: he could have a shot fired without warning behind the actor's back on some other occasion when he happens to be in the studio. The actor's frightened reaction at that moment could be recorded and then edited into the film. Nothing shows more graphically that art has escaped the realm of "beautiful semblance," which for so long was regarded as the only sphere in which it could thrive.

X

The film actor's feeling of estrangement in the face of the apparatus, as Pirandello describes this experience, is basically of the same kind as the estrangement felt before one's appearance [*Erscheinung*] in a mirror. But now the mirror image [*Bild*] has become detachable from the person mirrored, and is transportable. And where is it transported? To a site in front of the public.[17] The screen actor never for a moment ceases to be aware of this. *While he stands before the apparatus, the screen actor knows that in the end he is confronting the public, the consumers who constitute the market*. This market, where he offers not only his labor but his entire self, his heart and soul, is beyond his reach. During the shooting, he has as little contact with it as would any article being made in a factory. This may contribute to that oppression, that new anxiety which, according to Pirandello, grips the actor before the camera. Film responds to the shriveling of the aura by artificially building up the "personality" outside the studio. The cult of the movie star, fostered by the money of the film industry, preserves that magic of the personality which has long been no more than the putrid magic of its own commodity character. So long as moviemakers' capital sets the fashion, as a rule the only revolutionary merit that can be ascribed to today's cinema is the promotion of a revolutionary criticism of traditional concepts of art. We do not deny that in some cases today's films can also foster revolutionary criticism of social conditions, even of property relations. But the present study is no more specifically concerned with this than is western European film production.

It is inherent in the technology of film, as of sports, that everyone who witnesses these performances does so as a quasi-expert. This is obvious to anyone who has listened to a group of newspaper boys leaning on their bicycles and discussing the outcome of a bicycle race. It is no accident that newspaper publishers arrange races for their delivery boys. These arouse great interest among the participants, for the winner has a chance to rise from delivery boy to professional racer. Similarly, the newsreel offers everyone the chance to rise from passer-by to movie extra. In this way, a person might even see himself becoming part of a work of art: think of Vertov's *Three Songs of Lenin* or Ivens' *Borinage*. *Any person today can lay claim to being filmed*. This claim can best be clarified by considering the historical situation of literature today.

For centuries it was in the nature of literature that a small number of writers confronted many thousands of readers. This began to change toward the end of the past century. With the growth and extension of the press, which constantly made new political, religious, scientific, professional, and local journals available

to readers, an increasing number of readers – in isolated cases, at first – turned into writers. It began with the space set aside for "letters to the editor" in the daily press, and has now reached a point where there is hardly a European engaged in the work process who could not, in principle, find an opportunity to publish somewhere or other an account of a work experience, a complaint, a report, or something of the kind. Thus, the distinction between author and public is about to lose its axiomatic character. The difference becomes functional; it may vary from case to case. At any moment, the reader is ready to become a writer. As an expert – which he has had to become in any case in a highly specialized work process, even if only in some minor capacity – the reader gains access to authorship. In the Soviet Union, work itself is given a voice. And the ability to describe a job in words now forms part of the expertise needed to carry it out. Literary competence is no longer founded on specialized higher education but on polytechnic training, and thus is common property.[18]

All this can readily be applied to film, where shifts that in literature took place over centuries have occurred in a decade. In cinematic practice – above all, in Russia – this shift has already been partly realized. Some of the actors taking part in Russian films are not actors in our sense but people who portray *themselves* – and primarily in their own work process. In western Europe today, the capitalist exploitation of film obstructs the human being's legitimate claim to being reproduced. Under these circumstances, the film industry has an overriding interest in stimulating the involvement of the masses through illusionary displays and ambiguous speculations.

XI

The shooting of a film, especially a sound film, offers a hitherto unimaginable spectacle. It presents a process in which it is impossible to assign to the spectator a single viewpoint which would exclude from his or her field of vision the equipment not directly involved in the action being filmed – the camera, the lighting units, the technical crew, and so forth (unless the alignment of the spectator's pupil coincided with that of the camera). This circumstance, more than any other, makes any resemblance between a scene in a film studio and one onstage superficial and irrelevant. In principle, the theater includes a position from which the action on the stage cannot easily be detected as an illusion. There is no such position where a film is being shot. The illusory nature of film is of the second degree; it is the result of editing. That is to say: *In the film studio the apparatus has penetrated so deeply into reality that a pure view of that reality, free of the foreign body of equipment, is the result of a special procedure, namely, the shooting by the specially adjusted photographic device and the assembly of that shot with others of the same kind*. The equipment-free aspect of reality has here become the height of artifice, and the vision of immediate reality the Blue Flower in the land of technology.[19]

This state of affairs, which contrasts so sharply with that which obtains in the theater, can be compared even more instructively to the situation in painting. Here we have to pose the question: How does the camera operator compare with the painter? In answer to this, it will be helpful to consider the concept of the

operator as it is familiar to us from surgery. The surgeon represents the polar opposite of the magician. The attitude of the magician, who heals a sick person by a laying-on of hands, differs from that of the surgeon, who makes an intervention in the patient. The magician maintains the natural distance between himself and the person treated; more precisely, he reduces it slightly by laying on his hands, but increases it greatly by his authority. The surgeon does exactly the reverse; he greatly diminishes the distance from the patient by penetrating the patient's body, and increases it only slightly by the caution with which his hand moves among the organs. In short: unlike the magician (traces of whom are still found in the medical practitioner), the surgeon abstains at the decisive moment from confronting his patient person to person; instead, he penetrates the patient by operating. – Magician is to surgeon as painter is to cinematographer. The painter maintains in his work a natural distance from reality, whereas the cinematographer penetrates deeply into its tissue. The images obtained by each differ enormously. The painter's is a total image, whereas that of the cinematographer is piecemeal, its manifold parts being assembled according to a new law. *Hence, the presentation of reality in film is incomparably the more significant for people of today, since it provides the equipment-free aspect of reality they are entitled to demand from a work of art, and does so precisely on the basis of the most intensive interpenetration of reality with equipment.*

XII

The technological reproducibility of the artwork changes the relation of the masses to art. The extremely backward attitude toward a Picasso painting changes into a highly progressive reaction to a Chaplin film. The progressive reaction is characterized by an immediate, intimate fusion of pleasure – pleasure in seeing and experiencing – with an attitude of expert appraisal. Such a fusion is an important social index. As is clearly seen in the case of painting, the more reduced the social impact of an art form, the more widely criticism and enjoyment of it diverge in the public. The conventional is uncritically enjoyed, while the truly new is criticized with aversion. With regard to the cinema, the critical and uncritical attitudes of the public coincide. The decisive reason for this is that nowhere more than in the cinema are the reactions of individuals, which together make up the massive reaction of the audience, determined by the imminent concentration of reactions into a mass. No sooner are these reactions manifest than they regulate one another. Again, the comparison with painting is fruitful. A painting has always exerted a claim to be viewed primarily by a single person or by a few. The simultaneous viewing of paintings by a large audience, as happens in the nineteenth century, is an early symptom of the crisis in painting, a crisis triggered not only by photography but, in a relatively independent way, by the artwork's claim to the attention of the masses.

Painting, by its nature, cannot provide an object of simultaneous collective reception, as architecture has always been able to do, as the epic poem could do at one time, and as film is able to do today. And although direct conclusions about the social role of painting cannot be drawn from this fact alone, it does have a strongly adverse effect whenever painting is led by special circumstances, as if against its nature, to confront the masses directly. In the churches and monasteries of the

Middle Ages, and at the princely courts up to about the end of the eighteenth century, the collective reception of paintings took place not simultaneously but in a manifoldly graduated and hierarchically mediated way. If that has changed, the change testifies to the special conflict in which painting has become enmeshed by the technological reproducibility of the image. And while efforts have been made to present paintings to the masses in galleries and salons, this mode of reception gives the masses no means of organizing and regulating their response.[20] Thus, the same public which reacts progressively to a slapstick comedy inevitably displays a backward attitude toward Surrealism.[21]

[…]

XIV

It has always been one of the primary tasks of art to create a demand whose hour of full satisfaction has not yet come.[22] The history of every art form has critical periods in which the particular form strains after effects which can be easily achieved only with a changed technical standard — that is to say, in a new art form. The excesses and crudities of art which thus result, particularly in periods of so-called decadence, actually emerge from the core of its richest historical energies. In recent years, Dadaism has abounded in such barbarisms. Only now is its impulse recognizable: *Dadaism attempted to produce with the means of painting (or literature) the effects which the public today seeks in film.*

Every fundamentally new, pioneering creation of demand will overshoot its target. Dadaism did so to the extent that it sacrificed the market values so characteristic of film in favor of more significant aspirations — of which, to be sure, it was unaware in the form described here. The Dadaists attached much less importance to the commercial usefulness of their artworks than to the uselessness of those works as objects of contemplative immersion. They sought to achieve this uselessness not least by thorough degradation of their material. Their poems are "word-salad" containing obscene expressions and every imaginable kind of linguistic refuse. It is not otherwise with their paintings, on which they mounted buttons or train tickets. What they achieved by such means was a ruthless annihilation of the aura in every object they produced, which they branded as a reproduction through the very means of production. Before a painting by Arp or a poem by August Stramm, it is impossible to take time for concentration and evaluation, as one can before a painting by Derain or a poem by Rilke. Contemplative immersion — which, as the bourgeoisie degenerated, became a breeding ground for asocial behavior — is here opposed by distraction [*Ablenkung*] as a variant of social behavior.[23] Dadaist manifestations actually guaranteed a quite vehement distraction by making artworks the center of scandal. One requirement was paramount: to outrage the public.

From an alluring visual composition or an enchanting fabric of sound, the Dadaists turned the artwork into a missile. It jolted the viewer, taking on a tactile [*taktisch*] quality. It thereby fostered the demand for film, since the distracting element in film is also primarily tactile, being based on successive changes of scene and focus which have a percussive effect on the spectator. Let us compare the screen [*Leinwand*] on which a film unfolds with the canvas [*Leinwand*] of a painting. The

painting invites the viewer to contemplation; before it, he can give himself up to his train of associations. Before a film image, he cannot do so. No sooner has he seen it than it has already changed. It cannot be fixed on. Duhamel, who detests the cinema and knows nothing of its significance, though he does know something about its structure, describes the situation as follows: "I can no longer think what I want to think. My thoughts have been replaced by moving images." Indeed, the train of associations in the person contemplating these images is immediately interrupted by new images. This constitutes the shock effect of film, which, like all shock effects, seeks to induce heightened attention.[24] *By means of its technological structure, film has freed the physical shock effect — which Dadaism had kept wrapped, as it were, inside the moral shock effect — from this wrapping.*[25]

XV

The masses are a matrix from which all customary behavior toward works of art is today emerging newborn. Quantity has been transformed into quality: *the greatly increased mass of participants has produced a different kind of participation*. The fact that the new mode of participation first appeared in a disreputable form should not mislead the observer. Yet some people have launched spirited attacks against precisely this superficial aspect of the matter. Among these critics, Duhamel has expressed himself most radically. What he objects to most is the kind of participation which the movie elicits from the masses. Duhamel calls the movie "a pastime for helots, a diversion for uneducated, wretched, worn-out creatures who are consumed by their worries ..., a spectacle which requires no concentration and presupposes no intelligence ..., which kindles no light in the heart and awakens no hope other than the ridiculous one of someday becoming a 'star' in Los Angeles." Clearly, this is in essence the ancient lament that the masses seek distraction, whereas art demands concentration from the spectator. That is a commonplace. The question remains whether it provides a basis for the analysis of film. This calls for closer examination. Distraction and concentration [*Zerstreuung und Sammlung*] form an antithesis, which may be formulated as follows. A person who concentrates before a work of art is absorbed by it; he enters into the work, just as, according to legend, a Chinese painter entered his completed painting while beholding it. By contrast, the distracted masses absorb the work of art into themselves. This is most obvious with regard to buildings. Architecture has always offered the prototype of an artwork that is received in a state of distraction and through the collective. The laws of architecture's reception are highly instructive.

Buildings have accompanied human existence since primeval times. Many art forms have come into being and passed away. Tragedy begins with the Greeks, is extinguished along with them, and is revived centuries later, though only according to its "rules." The epic, which originates in the early days of peoples, dies out in Europe at the end of the Renaissance. Panel painting is a creation of the Middle Ages, and nothing guarantees its uninterrupted existence. But the human need for shelter is permanent. Architecture has never had fallow periods. Its history is longer than that of any other art, and its effect ought to be recognized in any attempt to account for the relationship of the masses to the work of art. Buildings are received

in a twofold manner: by use and by perception. Or, better: tactilely and optically. Such reception cannot be understood in terms of the concentrated attention of a traveler before a famous building. On the tactile side, there is no counterpart to what contemplation is on the optical side. Tactile reception comes about not so much by way of attention as by way of habit. The latter largely determines even the optical reception of architecture, which spontaneously takes the form of casual noticing, rather than attentive observation. Under certain circumstances, this form of reception shaped by architecture acquires canonical value. *For the tasks which face the human apparatus of perception at historical turning points cannot be performed solely by optical means — that is, by way of contemplation. They are mastered gradually — taking their cue from tactile reception — through habit.*

Even the distracted person can form habits. What is more, the ability to master certain tasks in a state of distraction proves that their performance has become habitual. The sort of distraction that is provided by art represents a covert measure of the extent to which it has become possible to perform new tasks of apperception. Since, moreover, individuals are tempted to evade such tasks, art will tackle the most difficult and most important tasks wherever it is able to mobilize the masses. It does so currently in film. *Reception in distraction — the sort of reception which is increasingly noticeable in all areas of art and is a symptom of profound changes in apperception — finds in film its true training ground.* Film, by virtue of its shock effects, is predisposed to this form of reception. It makes cult value recede into the background, not only because it encourages an evaluating attitude in the audience but also because, at the movies, the evaluating attitude requires no attention. The audience is an examiner, but a distracted one.

Epilogue

The increasing proletarianization of modern man and the increasing formation of masses are two sides of the same process. Fascism attempts to organize the newly proletarianized masses while leaving intact the property relations which they strive to abolish. It sees its salvation in granting expression to the masses — but on no account granting them rights.[26] The masses have a right to changed property relations; fascism seeks to give them *expression* in keeping these relations unchanged. *The logical outcome of fascism is an aestheticizing of political life.* The violation of the masses, whom fascism, with its *Führer* cult, forces to their knees, has its counterpart in the violation of an apparatus which is pressed into serving the production of ritual values.

All efforts to aestheticize politics culminate in one point. That one point is war. War, and only war, makes it possible to set a goal for mass movements on the grandest scale while preserving traditional property relations. That is how the situation presents itself in political terms. In technological terms it can be formulated as follows: only war makes it possible to mobilize all of today's technological resources while maintaining property relations. It goes without saying that the fascist glorification of war does not make use of *these* arguments. Nevertheless, a glance at such glorification is instructive. In Marinetti's manifesto for the colonial war in Ethiopia, we read:

For twenty-seven years we Futurists have rebelled against the idea that war is anti-aesthetic.... We therefore state: ... War is beautiful because — thanks to its gas masks, its terrifying megaphones, its flame throwers, and light tanks — it establishes man's dominion over the subjugated machine. War is beautiful because it inaugurates the dreamed-of metallization of the human body. War is beautiful because it enriches a flowering meadow with the fiery orchids of machine-guns. War is beautiful because it combines gunfire, barrages, cease-fires, scents, and the fragrance of putrefaction into a symphony. War is beautiful because it creates new architectures, like those of armored tanks, geometric squadrons of aircraft, spirals of smoke from burning villages, and much more. ... Poets and artists of Futurism, ... remember these principles of an aesthetic of war, that they may illuminate ... your struggles for a new poetry and a new sculpture![27]

This manifesto has the merit of clarity. The question it poses deserves to be taken up by the dialectician. To him, the aesthetic of modern warfare appears as follows: if the natural use of productive forces is impeded by the property system, then the increase in technological means, in speed, in sources of energy will press toward an unnatural use. This is found in war, and the destruction caused by war furnishes proof that society was not mature enough to make technology its organ, that technology was not sufficiently developed to master the elemental forces of society. The most horrifying features of imperialist war are determined by the discrepancy between the enormous means of production and their inadequate use in the process of production (in other words, by unemployment and the lack of markets). *Imperialist war is an uprising on the part of technology, which demands repayment in "human material" for the natural material society has denied it*. Instead of draining rivers, society directs a human stream into a bed of trenches; instead of dropping seeds from airplanes, it drops incendiary bombs over cities; and in gas warfare it has found a new means of abolishing the aura.

"Fiat ars — pereat mundus,"[28] says fascism, expecting from war, as Marinetti admits, the artistic gratification of a sense perception altered by technology. This is evidently the consummation of *l'art pour l'art*. Humankind, which once, in Homer, was an object of contemplation for the Olympian gods, has now become one for itself. Its self-alienation has reached the point where it can experience its own annihilation as a supreme aesthetic pleasure. *Such is the aestheticizing of politics, as practiced by fascism. Communism replies by politicizing art.*

Notes

1 Precisely because authenticity is not reproducible, the intensive penetration of certain (technological) processes of reproduction was instrumental in differentiating and gradating authenticity. To develop such differentiations was an important function of the trade in works of art. Such trade had a manifest interest in distinguishing among various prints of a woodblock engraving (those before and those after inscription), of a copperplate engraving, and so on. The invention of the woodcut may be said to have struck at the root of the quality of authenticity even before its late flowering. To be sure, a medieval picture of the Madonna at the time it was created could not yet be said

to be "authentic." It became "authentic" only during the succeeding centuries, and perhaps most strikingly so during the nineteenth.

2 The poorest provincial staging of Goethe's *Faust* is superior to a film of *Faust*, in that, ideally, it competes with the first performance at Weimar. The viewer in front of a movie screen derives no benefit from recalling bits of tradition which might come to mind in front of a stage – for instance, that the character of Mephisto is based on Goethe's friend Johann Heinrich Merck, and the like. [Benjamin's note. The first performance of Parts I and II of Goethe's *Faust* took place in Weimar in 1876. Johann Heinrich Merck (1741–1791), a German writer, critic, and translator, as well as a professional pharmacist, helped found the periodical *Frankfurter gelehrte Anzeigen* (1722), in which some of Goethe's earliest pieces were published. For his portrait of Mephisto in *Faust*, Goethe drew on certain personality traits of this friend of his youth (who later committed suicide) – namely, his cool analytic mind, his unconstrained love of mockery and derision, and his destructive, nihilistic view of human affairs. – *Trans.*]

3 Abel Gance, "Le Temps de l'image est venue!" ("It is time for the image!"), in Leon Pierre-Quint, Germaine Dulac, Lionel Landry and Abel Gance, *L'Art cinématographique*, vol. 2 (Paris, 1927), pp. 94–96. [Benjamin's note. Gance (1889–1981) was a leading French film director, whose epic films *J'Accuse* (1919), *La Roue* (1922), and *Napoléon* (1927) made innovative use of such devices as superimposition, rapid intercutting, and split screen. – *Trans.*]

4 Alois Riegl (1858–1905) was an Austrian art historian who argued that different formal orderings of art emerge as expressions of different historical epochs.

5 "Einmalige Erscheinung einer Ferne, so nah sie sein mag." In Greek, *aura* means "air," "breath."

6 Getting closer (in terms of human interest) to the masses may involve having one's social function removed from the field of vision. Nothing guarantees that a portraitist of today, when painting a famous surgeon at the breakfast table with his family, depicts his social function more precisely than a painter of the seventeenth century who showed the viewer doctors representing their profession, as Rembrandt did in his *Anatomy Lesson*. [Benjamin's note]

7 Benjamin is quoting Johannes V. Jensen, *Exotische Novellen*, trans. Julia Koppel (Berlin: S. Fischer, 1919), pp. 41–42. Jensen (1873–1950) was a Danish novelist, poet, and essayist who won the Nobel Prize for Literature in 1944. See "Hashish in Marseilles," in Benjamin, *Selected Writings, Volume 2: 1927–1934* (Cambridge, Mass.: Harvard University Press, 1999), p. 677.

8 The definition of the aura as the "unique apparition of a distance, however near it may be," represents nothing more than a formulation of the cult value of the work of art in categories of spatiotemporal perception. Distance is the opposite of nearness. The *essentially* distant is the unapproachable. Unapproachability is, indeed, a primary quality of the cult image; true to its nature, the cult image remains "distant, however near it may be." The nearness one may gain from its substance [*Materie*] does not impair the distance it retains in its apparition. [Benjamin's note.]

9 To the extent that the cult value of a painting is secularized, the impressions of its fundamental uniqueness become less distinct. In the viewer's imagination, the uniqueness of the phenomena holding sway in the cult image is more and more displaced by the empirical uniqueness of the artist or of his creative achievement. To be sure, never completely so – the concept of authenticity always transcends that of proper attribution. (This is particularly apparent in the collector, who always displays some traits of the fetishist and who, through his possession of the artwork, shares in its cultic power.) Nevertheless, the concept of authenticity still functions as a determining factor in the evaluation of art; as art becomes secularized, authenticity displaces the cult value of the work. [Benjamin's note.]

10 Stéphane Mallarmé (1842–1898), French poet, translator, and editor, was an originator and leader of the Symbolist movement, which sought an incantatory language cut off from all referential function. Among his works are *L'Après-midi d'un faune* (Afternoon of a Faun; 1876) and *Vers et prose* (Poetry and Prose; 1893).

11 In film, the technological reproducibility of the product is not an externally imposed condition of its mass dissemination, as it is, say, in literature or painting. *The technological reproducibility of films is based directly on the technology of their production. This not only makes possible the mass dissemination of films in the most direct way, but actually enforces it.* It does so because the process of producing a film is so costly that an individual who could afford to buy a painting, for example, could not afford to buy a [master print of a] film. It was calculated in 1927 that, in order to make a profit, a major film needed to reach an audience of nine million. Of course, the advent of sound film [in that year] initially caused a movement in the opposite direction: its audience was restricted by language boundaries. And that coincided with the emphasis placed on national interests by fascism. But it is less important to note this setback (which in any case was mitigated by dubbing) than to observe its connection with fascism. The simultaneity of the two phenomena results from the economic crisis. The same disorders which led, in the world at large, to an attempt to maintain existing property relations by brute force induced film capital, under the threat of crisis, to speed up the development of sound film. Its introduction brought temporary relief, not only because sound film attracted the masses back into the cinema but because it consolidated new capital from the electricity industry with that of film. Thus, considered from the outside, sound film promoted national interests; but seen from the inside, it helped internationalize film production even more than before. [Benjamin's note. By "the economic crisis," Benjamin refers to the devastating consequences, in the United States and Europe, of the stock market crash of October 1929.]

12 Bertolt Brecht, on a different level, engaged in analogous reflections: "If the concept of 'work of art' can no longer be applied to the thing that emerges once the work is transformed into a commodity, we have to eliminate this concept with due caution but without fear, lest we liquidate the function of the very thing as well. For it has to go through this phase unswervingly; there is no viable detour from the straight path. Rather, what happens here with the work of art will change it fundamentally, will erase its past to such an extent that – should the old concept be taken up again (and it will be; why not?) – it will no longer evoke any memory of the thing it once designated." [Benjamin's note. The German poet and playwright Bertolt or Bert (Eugen Berthold Friedrich) Brecht (1898–1956) was the author of *Die Dreigroschenoper* (The Threepenny Opera; 1928), with music by Kurt Weill, *Mutter Courage und ihre Kinder* (Mother Courage and Her Children; 1941), and *Der kaukasische Kreidekreis* (The Caucasian Chalk Circle; 1948). Benjamin became friends with Brecht in 1929 and, during the Thirties, was considerably influenced by the younger man's thinking on the subject of politics and art.]

13 Eugène Atget (1857–1927), recognized today as one of the leading photographers of the twentieth century, spent his career in obscurity making pictures of Paris and its environs.

14 "Film ... provides – or could provide – useful insight into the details of human actions. ... Character is never used as a source of motivation; the inner life of the persons represented never supplies the principal cause of the plot and seldom is its main result" (Bertolt Brecht, "Der Dreigroschenprozess," *Versuche*, p. 268). The expansion of the field of the testable which the filming apparatus brings about for the actor corresponds to the extraordinary expansion of the field of the testable brought about for the individual through economic conditions. Thus, vocational aptitude tests become constantly more important. What matters in these tests are segmental performances of the individual. The final cut of a film and the vocational aptitude test are both taken before a panel of experts. The director in the studio occupies a position identical to that of the examiner during aptitude tests. [Benjamin's note.]

15 Pirandello (1867–1936) was an Italian playwright and novelist who achieved a series of successes on the stage that made him world famous in the 1920s. He is best known for his plays *Sei personaggi in cerca d'autore* (Six Characters in Search of an Author; 1921) and *Enrico IV* (Henry IV; 1922). – *Trans.*

16 In this context, certain apparently incidental details of film directing which diverge from practices on the stage take on added interest. For example, the attempt to let the actor perform without makeup, as in Dreyer's *Jeanne d'Arc*. Dreyer spent months seeking the forty actors who constitute

the Inquisitors' tribunal. Searching for these actors was like hunting for rare props. Dreyer made every effort to avoid resemblances of age, build, and physiognomy in the actors. If the actor thus becomes a prop, the prop, in its turn, not infrequently functions as actor. At any rate, it is not unusual for films to allocate a role to a prop. Rather than selecting examples at random from the infinite number available, let us take just one especially revealing case. A clock that is running will always be a disturbance on the stage, where it cannot be permitted its role of measuring time. Even in a naturalistic play, real-life time would conflict with theatrical time. In view of this, it is very revealing that film – where appropriate – can readily make use of time as measured by a clock. This feature, more than many others, makes it clear that – circumstances permitting – each and every prop in a film may perform decisive functions. From here it is but a step to Pudovkin's principle, which states that "to connect the performance of an actor with an object, and to build that performance around the object, ... is always one of the most powerful methods of cinematic construction." Film is thus the first artistic medium which is able to show how matter plays havoc with human beings [*wie die Materie dem Menschen mitspielt*]. It follows that films can be an excellent means of materialist exposition. [Benjamin's note.]

17 The change noted here in the mode of exhibition – a change brought about by reproduction technology – is also noticeable in politics. The present crisis of the bourgeois democracies involves a crisis in the conditions governing the public presentation of leaders. Democracies exhibit the leader directly, in person, before elected representatives. The parliament is his public. But innovations in recording equipment now enable the speaker to be heard by an unlimited number of people while he is speaking, and to be seen by an unlimited number shortly afterward. This means that priority is given to presenting the politician before the recording equipment. Parliaments are becoming depopulated at the same time as theaters. Radio and film are changing not only the function of the professional actor but, equally, the function of those who, like the leaders, present themselves before these media. The direction of this change is the same for the film actor and for the leader, regardless of their different tasks. It tends toward the exhibition of controllable, transferable skills under certain social conditions. This results in a new form of selection – selection before an apparatus – from which the star and the dictator emerge as victors. [Benjamin's note.]

18 The privileged character of the respective techniques is lost. Aldous Huxley writes: "Advances in technology have led ... to vulgarity. ... Process reproduction and the rotary press have made possible the indefinite multiplication of writing and pictures. Universal education and relatively high wages have created an enormous public who know how to read and can afford to buy reading and pictorial matter. A great industry has been called into existence in order to supply these commodities. Now, artistic talent is a very rare phenomenon; whence it follows ... that, at every epoch and in all countries, most art has been bad. But the proportion of trash in the total artistic output is greater now than at any other period. That it must be so is a matter of simple arithmetic. The population of Western Europe has a little more than doubled during the last century. But the amount of reading – and seeing – matter has increased, I should imagine, at least twenty and possibly fifty or even a hundred times. If there were n men of talent in a population of x millions, there will presumably be $2n$ men of talent among $2x$ millions. The situation may be summed up thus. For every page of print and pictures published a century ago, twenty or perhaps even a hundred pages are published today. But for every man of talent then living, there are now only two men of talent. It may be of course that, thanks to universal education, many potential talents which in the past would have been stillborn are now enabled to realize themselves. Let us assume, then, that there are now three or even four men of talent to every one of earlier times. It still remains true to say that the consumption of reading – and seeing – matter has far outstripped the natural production of gifted writers and draftsmen. It is the same with hearing-matter. Prosperity, the gramophone and the radio have created an audience of hearers who consume an amount of hearing-matter that has increased out of all proportion to the increase of population and the consequent natural increase of talented musicians. It follows from all this that in all the arts the output of trash is both absolutely and relatively greater than

it was in the past; and that it must remain greater for just so long as the world continues to consume the present inordinate quantities of reading-matter, seeing-matter, and hearing-matter." (Aldous Huxley, *Beyond the Mexique Bay: A Traveller's Journal* [1934; rpt. London, 1949], pp. 274ff.) This mode of observation is obviously not progressive.

19 Benjamin alludes here to *Heinrich von Ofterdingen*, an unfinished novel by the German Romantic writer Novalis (Friedrich, Freiherr von Hardenberg; 1772–1801) first published in 1802. Von Ofterdingen is a medieval poet in search of the mysterious Blue Flower, which bears the face of his unknown beloved.

20 This mode of observation may seem crude [*plump*]; but as the great theoretician Leonardo has shown, crude modes of observation may at times prove useful. Leonardo compares painting and music as follows: "Painting is superior to music because, unlike unfortunate music, it does not have to die as soon as it is born.... Music, which is consumed in the very act of its birth, is inferior to painting, which the use of varnish has rendered eternal." [Benjamin's note.]

21 Surrealism was an influential movement in art, literature, and film which flourished in Europe between World Wars I and II. Rooted most immediately in the ideas of the Dadaists (see note 39 below), it represented a protest against the rationalism that had guided European culture and politics in the past; it sought a reunification of conscious and unconscious realms of experience, such that the world of dream and fantasy would merge with the everyday world in "a surreality."

22 "The artwork," writes André Breton, "has value only insofar as it is alive to reverberations of the future." And indeed every highly developed art form stands at the intersection of three lines of development. First, technology is working toward a particular form of art. Before film appeared, there were little books of photos that could be made to flit past the viewer under the pressure of the thumb, presenting a boxing match or a tennis match; then there were coin-operated peepboxes in bazaars, with image sequences kept in motion by the turning of a handle. Second, traditional art forms, at certain stages in their development, strain laboriously for effects which later are effortlessly achieved by new art forms. Before film became established, Dadaist performances sought to stir in their audience reactions which Chaplin then elicited more naturally. Third, apparently insignificant social changes often foster a change in reception which benefits only the new art form. Before film had started to create its public, images (which were no longer motionless) were received by an assembled audience in the Kaiserpanorama. Here the audience faced a screen into which stereoscopes were fitted, one for each spectator. In front of these stereoscopes single images automatically appeared, remained briefly in view, and then gave way to others. Edison still had to work with similar means when he presented the first film strip – before the movie screen and projection were known; a small audience gazed into an apparatus in which a sequence of images was shown. Incidentally, the institution of the Kaiserpanorama very clearly manifests a dialectic of development. Shortly before film turned the viewing of images into a collective activity, image viewing by the individual, through the stereoscopes of these soon outmoded establishments, was briefly intensified, as it had been once before in the isolated contemplation of the divine image by the priest in the cella. [Benjamin's note: André Breton (1896–1966), French critic, poet, and editor, was the chief promoter and one of the founders of the Surrealist movement publishing his first *Manifeste du surréalisme* in 1924. His novel *Nadja* appeared in 1928. The Dada movement arose in Zurich, in 1916, as an anti-aesthetic engendered by disgust with bourgeois values and despair over World War I; it quickly spread to New York, Berlin, Cologne, Hannover, and Paris, recruiting many notable artists, writers, and performers who strove to shock their audiences at public gatherings. Dadaism began to lose steam after 1922, and the energies of the group turned toward Surrealism. Thomas Alva Edison (1847–1931) patented more than a thousand inventions over a sixty-year period, including the microphone, the phonograph, the incandescent electric lamp, and the alkaline storage battery. He supervised the invention of the Kinetoscope in 1891; this boxlike peep-show machine allowed individuals to view moving pictures on a film loop running on spools between an electric lamp and a shutter. He built the first film studio, the Black Maria, in 1893, and later founded his own company for the production of projected films.]

23 The theological archetype of this contemplation is the awareness of being alone with one's God. Such awareness, in the heyday of the bourgeoisie, fostered a readiness to shake off clerical tutelage. During the decline of the bourgeoisie, this same awareness had to take into account the hidden tendency to remove from public affairs those forces which the individual puts to work in his communion with God. [Benjamin's note. Hans Arp (1887–1966), Alsatian painter, sculptor, and poet, was a founder of the Zurich Dada group in 1916 and a collaborator with the Surrealists for a time after 1925. August Stramm (1874–1915) was an early Expressionist poet and dramatist, a member of the circle of artists gathered around the journal *Der Sturm* in Berlin. André Derain (1880–1954), French painter, was a leader of the Postimpressionist school and, later, one of the Fauvists. Rainer Maria Rilke (1875–1926), Austro-German writer born in Prague, was one of the great lyric poets in the German language. His *Duineser Elegien* (Duino Elegies) and *Sonette an Orpheus* (Sonnets to Orpheus) were published in 1923. – *Trans.*]

24 Film is the art form corresponding to the increased threat to life that faces people today. Humanity's need to expose itself to shock effects represents an adaptation to the dangers threatening it. Film corresponds to profound changes in the apparatus of apperception – changes that are experienced on the scale of private existence by each passerby in big-city traffic, and on a historical scale by every present-day citizen. [Benjamin's note.]

25 Film proves useful in illuminating Cubism and Futurism, as well as Dadaism. Both appear as deficient attempts on the part of art to take into account the pervasive interpenetration of reality by the apparatus [*Durchdringung der Wirklichkeit mit der Apparatur*]. Unlike film, these schools did not try to use the apparatus as such for the artistic representation of reality, but aimed at a sort of alloy of represented reality and represented apparatus. In Cubism, a premonition of the structure of this apparatus, which is based on optics, plays a dominant part; in Futurism, it is the premonition of the effects of the apparatus – effects which are brought out by the rapid coursing of the band of film. [Benjamin's note. Cubism, a movement in painting and sculpture that arose in Paris in the years 1907–1914, reduced and fragmented natural forms into abstract, often geometric structures, sometimes showing several sides of an object simultaneously. Futurism was an artistic movement originating in Italy in 1911 whose aim was to oppose traditionalism and to express the dynamic and violent quality of contemporary life, especially as embodied in the motion and force of modern machinery and modern warfare. – *Trans.*]

26 A technological factor is important here, especially with regard to the newsreel, whose significance for propaganda purposes can hardly be overstated. *Mass reproduction is especially favored by the reproduction of the masses*. In great ceremonial processions, giant rallies, and mass sporting events, and in war, all of which are now fed into the camera, the masses come face to face with themselves. This process, whose significance need not be emphasized, is closely bound up with the development of reproduction and recording technologies. In general, mass movements are more clearly apprehended by the camera than by the eye. A bird's-eye view best captures assemblies of hundreds of thousands. And even when this perspective is no less accessible to the human eye than to the camera, the image formed by the eye cannot be enlarged in the same way as a photograph. This is to say that mass movements, including war, are a form of human behavior especially suited to the camera. [Benjamin's note.]

27 Cited in *La Stampa Torino*. [Benjamin's note. The German editors of Benjamin's *Gesammelte Schriften* argue that this passage is more likely to have been excerpted from a French newspaper than from the Italian newspaper cited here. Futurism was founded by the Italian writer Emilio Filippo Tomaso Marinetti (1876–1944), whose "Manifeste de Futurisme," published in the Paris newspaper *Le Figaro* in 1909, called for a revolutionary art and total freedom of expression. Marinetti's ideas had a powerful influence in Italy and in Russia, though he himself, after serving as an officer in World War I, went on to join the Fascist party in 1919 and to become an enthusiastic supporter of Mussolini. Among his other works are a volume of poems, *Guerra sola igiene del mundo* (War the Only Hygiene of the World; 1915) and a political essay, *Futurismo e Fascismo* (1924), which argues that Fascism is the natural extension of Futurism – *Trans.*]

28 "Let art flourish – and the world pass away." This is a play on the motto of the sixteenth-century
Holy Roman emperor Ferdinand I: "Fiat iustitia et pereat mundus" ("Let justice be done and the
world pass away").

Roland Barthes

FROM WORK TO TEXT

EDITOR'S INTRODUCTION

FIRST PUBLISHED IN 1971, Roland Barthes' essay was one the most lucid and widely read expressions of what was to be called 'post-structuralism' in literary studies. But it had an influence on cultural studies too. Indeed two rather different implications can be drawn from Barthes' account of the 'text.' Barthes defines the text against the work: it is not as if some pieces of writing simply are texts and others are works. It depends, at least in part, on how they are approached: a novel by Balzac, for instance, or a film by D.W. Griffiths can be treated either as a work or as a text.

The work has true and proper meaning which interpretation uncovers; it is a contained thing (it exists in catalogues and chronologies); it is simply either canonical or not canonical. A text is none of these things: it has no fixed and true meaning, rather it has associations, connections. It exists as a combination of other texts: in other words, it is 'intertextual' through and through. It has effects. It only comes into existence through the work of reception that it solicits from its readers or viewers. It belongs to the play of language, or better, the play of the signifying system.

And yet, according to Barthes, texts are also subversive: they don't belong to the order of stereotypes, commonsense, banality. So we have a choice. Is he offering us a theory for reading, one which allows us to say that texts only have meaning in their effects on the world and their readers for instance? Or is he offering a celebration of a certain kind of aesthetic production in which some pieces are more 'textual' in his sense than others? Cultural studies has used Barthes basically as if he were saying the first: he became a father of the move towards understanding all texts as 'polysemic' (having different meanings) and as

having to be analysed in terms of their effects on the world, i.e. ethnographically. On the other hand, literary poststructuralism (which in this form is all but dead) understood him as saying the second, as if certain avant-garde writing and reading practices produce 'texts' which can subvert dominant ideology.

One challenge for cultural studies might be to see if there is any value in returning to the poststructuralist Barthes as against the Barthes of the semiotics of media reception.

Further reading: Barthes 1972 and 1977; Bennett and Woollacott 1988; Jensen 1995; Payne 1997; Stafford 2004; Williams 1977.

A change has lately occurred, or is occurring, in our idea of language and consequently of the (literary) work which owes to that language at least its phenomenal existence. This change is obviously linked to the present development of (among other disciplines) linguistics, anthropology, Marxism, psychoanalysis (the word *link* is used here in a deliberately neutral manner: no determination is being invoked, however multiple and dialectical). The transformation of the notion of the work does not necessarily derive from the internal renewal of each of these disciplines, but rather from their intersection at the level of an object which traditionally proceeds from none of them. We might say, as a matter of fact, that *interdisciplinary* activity, today so highly valued in research, cannot be achieved by the simple confrontation of specialized branches of knowledge; the interdisciplinary is not a comfortable affair: it begins *effectively* (and not by the simple utterance of a pious hope) when the solidarity of the old disciplines breaks down — perhaps even violently, through the shocks of fashion — to the advantage of a new object, a new language, neither of which is precisely this discomfort of classification which permits diagnosing a certain mutation. The mutation which seems to be affecting the notion of the work must not, however, be overestimated; it is part of an epistemological shift, more than of a real break of the kind which in fact occurred in the last century upon the appearance of Marxism and Freudianism; no new break has occurred since, and we might say that for the last hundred years we have been involved in a repetition. What History, our History, allows us today is merely to displace, to vary, to transcend, to repudiate. Just as Einsteinian science compels us to include within the object studied the *relativity of reference points*, so the combined action of Marxism, Freudianism, and structuralism compels us, in literature, to relativize the relations of *scriptor*, reader, and observer (critic). Confronting the *work* — a traditional notion, long since, and still today, conceived in what we might call a Newtonian fashion — there now occurs the demand for a new object, obtained by a shift or a reversal of previous categories. This object is the *Text*. I know that this word is fashionable (I myself am compelled to use it frequently), hence suspect in some quarters; but this is precisely why I should like to review the main propositions at whose intersection the Text is located, as I see it; the word *proposition* must here be understood more grammatically than logically: these are speech-acts, not arguments, "hints," approaches which agree to remain metaphorical. Here are these propositions: they concern method, genres, the sign, the plural, filiation, reading, pleasure.

1. The text must not be understood as a computable object. It would be futile to attempt a material separation of works from texts. In particular, we must not permit ourselves to say: the work is classical, the text is avant-garde; there is no question of establishing a trophy in modernity's name and declaring certain literary productions *in* and *out* by reason of their chronological situation: there can be "Text" in a very old work, and many products of contemporary literature are not texts at all. The difference is as follows: the work is a fragment of substance, it occupies a portion of the spaces of books (for example, in a library). The Text is a methodological field. The opposition may recall (though not reproduce term for term) a distinction proposed by Lacan: "reality" is shown [*se montre*], the "real" is proved [*se démontre*]; in the same way, the work is seen (in bookstores, in card catalogues, on examination syllabuses), the text is demonstrated, is spoken according to certain rules (or against certain rules); the work is held in the hand, the text is held in language: it exists only when caught up in a discourse (or rather it is Text for the very reason that it knows itself to be so); the Text is not the decomposition of the work, it is the work which is the Text's imaginary tail. Or again: *the Text is experienced only in an activity, in a production*. It follows that the Text cannot stop (for example, at a library shelf); its constitutive moment is *traversal* (notably, it can traverse the work, several works).

2. Similarly, the Text does not stop at (good) literature; it cannot be caught up in a hierarchy, or even in a simple distribution of genres. What constitutes it is on the contrary (or precisely) its force of subversion with regard to the old classifications. [...] If the Text raises problems of classification (moreover, this is one of its "social" functions), it is because it always implies a certain experience of limits: [...] the Text is what is situated at the limit of the rules of the speech-act (rationality, readability, etc.). This notion is not rhetorical, we do not resort to it for "heroic" postures: the Text attempts to locate itself very specifically *behind* the limit of the *doxa* (is not public opinion, constitutive of our democratic societies, powerfully aided by mass communications – is not public opinion defined by its limits, its energy of exclusion, its *censorship?*); taking the word literally, we might say that the Text is always *paradoxical*.

3. The text is approached and experienced in relation to the sign. The work closes upon a signified. We can attribute two modes of signification to this signified: either it is claimed to be apparent, and the work is then the object of a science of the letter, which is philology; or else this signified is said to be secret and final, and must be sought for, and then the work depends upon a hermeneutics, an interpretation (Marxist, psychoanalytic, thematic, etc.); in short, the work itself functions as a general sign, and it is natural that it should represent an institutional category of the civilization of the Sign. The Text, on the contrary, practices the infinite postponement of the signified, the Text is dilatory; its field is that of the signifier; the signifier must not be imagined as "the first part of the meaning," its material vestibule, but rather, on the contrary, as its *aftermath*; similarly, the signifier's *infinitude* does not refer to some notion of the ineffable (of an unnamable signified) but to a notion of *play*; the engendering of the perpetual signifier (in the fashion of a perpetual calendar) in the field of the Text is not

achieved by some organic process of maturation, or a hermeneutic process of "delving deeper," but rather by a serial movement of dislocations, overlappings, variations; the logic governing the Text is not comprehensive (trying to define what the work "means") but metonymic; the activity of associations, contiguities, cross-references coincides with a liberation of symbolic energy (if it failed him, man would die). The work (in the best of cases) is *moderately* symbolic (its symbolics runs short, i.e., stops); the Text is *radically* symbolic: *a work whose integrally symbolic nature one conceives, perceives, and receives is a text*. The Text is thus restored to language; like language, it is structured but decentered, without closure (let us note, to answer the scornful suspicion of "fashion" sometimes lodged against structuralism, that the epistemological privilege nowadays granted to language derives precisely from the fact that in it [language] we have discovered a paradoxical idea of structure: a system without end or center).

4. The Text is plural. This does not mean only that it has several meanings but that it fulfills the very plurality of meaning: an *irreducible* (and not just acceptable) plurality. The Text is not coexistence of meaning, but passage, traversal; hence, it depends not on an interpretation, however liberal, but on an explosion, on dissemination. The plurality of the Text depends, as a matter of fact, not on the ambiguity of its contents, but on what we might call the stereographic plurality of the signifiers which weave it (etymologically, the text is a fabric): the reader of the Text might be compared to an idle subject (who has relaxed his image-repertoire): this fairly empty subject strolls (this has happened to the author of these lines, and it is for this reason that he has come to an intense awareness of the Text) along a hillside at the bottom of which flows a wadi (I use the word to attest to a certain alienation); what he perceives is multiple, irreducible, issuing from heterogeneous, detached substances and levels: lights, colors, vegetation, heat, air, tenuous explosions of sound, tiny cries of birds, children's voices from the other side of the valley, paths, gestures, garments of inhabitants close by or very far away, all these incidents are half identifiable: they issue from known codes, but their combinative operation is unique, it grounds the stroll in a difference which cannot be repeated except *as difference*. This is what happens in the Text: it can be Text only in its difference (which does not mean its individuality); [...] and yet entirely woven of quotations, references, echoes: cultural languages (what language is not cultural?), antecedent or contemporary, which traverse it through and through, in a vast stereophony. The intertextuality in which any text is apprehended, since it is itself the intertext of another text, cannot be identified with some *origin* of the text: to seek out the "sources," the "influences" of a work is to satisfy the myth of filiation; the quotations a text is made of are anonymous, irrecoverable, and yet *already read:* they are quotations without quotation marks. The work disturbs no monistic philosophy (there are antagonistic ones, as we know); for such a philosophy, plurality is Evil. Hence, confronting the work, the Text might indeed take for its motto the words of the man possessed by devils: "My name is legion, for we are many" (Mark 5:9). The plural or demonic texture which sets the Text in opposition to the work may involve profound modifications of reading, precisely where monologism seems to be the law: certain "texts" of Scripture, traditionally adopted by theological (historical or anagogical) monism, may lend themselves to

a diffraction of meanings (i.e., finally, to a materialist reading), while the Marxist interpretation of the work, hitherto resolutely monistic, may become more materialist by pluralizing itself (if, of course, Marxist "institutions" permit this).

5. The work is caught up in a process of filiation. What is postulated are a *determination* of the world (of the race, then of History) over the work, a *consecution* of works among themselves, and an *appropriation* of the work to its author. The author is reputed to be the father and the owner of his work; literary science thus teaches us to *respect* the manuscript and the author's declared intentions, and society postulates a legality of the author's relation to his work (this is the "author's rights," actually a recent affair, not legalized in France until the time of the Revolution). The Text, on the other hand, is read without the Father's inscription. The metaphor of the Text is here again detached from the metaphor of the work; the latter refers to the image of an *organism* which grows by vital expansion, by "development" (a significantly ambiguous word: biological and rhetorical); the metaphor of the Text is that of the *network*; if the Text expands, it is by the effect of a combinative operation, of a systematics (an image, moreover, close to the views of contemporary biology concerning the living being); no vital "respect" is therefore due to the Text: it can be *broken* (moreover, this is what the Middle Ages did with two nonetheless authoritarian texts: Scripture and Aristotle); the Text can be read without its father's guarantee; the restoration of the intertext paradoxically abolishes inheritance. It is not that the Author cannot "return" in the Text, in his text, but he does so, one might say, as a guest; if he is a novelist, he inscribes himself there as one of his characters, drawn as a figure in the carpet; his inscription is no longer privileged, paternal, alethic, but ludic: he becomes, one can say, a paper author; his life is no longer the origin of his fables, but a fable concurrent with his life; there is a reversion of the work upon life (and no longer the contrary); the work of Proust and Genet permits us to read their lives as a text: the word *biography* regains a strong, etymological meaning; and thereby the sincerity of the speech-act, a veritable "cross" of literary ethics, becomes a false problem: the *I* that writes the text is never anything but a paper *I*.

6. The work is ordinarily the object of consumption; I intend no demagoguery by referring to what is called a consumer culture, but we must recognize that today it is the work's "quality" (which ultimately implies an appreciation of "taste") and not the actual operation of reading which can make differences between books: "cultivated" reading is not structurally different from reading on trains. The Text (if only by its frequent "unreadability") decants the work (if it permits it at all) from its consumption and recuperates it as play, task, production, practice. This means that the Text requires an attempt to abolish (or at least to diminish) the distance between writing and reading, not by intensifying the reader's projection into the work, but by linking the two together into one and the same signifying practice. The distance that separates reading from writing is historical. In the period of strongest social division (before the instauration of democratic cultures), reading and writing were *equally* class privileges: Rhetoric, the great literary code of that time, taught *writing* (even if what was ordinarily produced were discourses, not texts); it is significant that the advent of democracy reversed the watchword:

the (secondary) school prides itself on teaching *reading* and no longer writing. In fact, *reading*, in the sense of *consuming*, is not *playing* with the text. "Playing" must be taken here in all the polysemy of the term: the text itself "plays" (like a door that "plays" back and forth on its hinges; like a fishing rod in which there is some "play"); and the reader plays twice over: he *plays at* the Text (ludic meaning), he seeks a practice which reproduces it; but, so that this practice is not reduced to a passive, interior *mimesis* (the Text being precisely what resists this reduction), he *plays* the Text; we must not forget that *play* is also a musical term; the history of music (as practice, not as "art") is, moreover, quite parallel to that of the Text; there was a time when, active amateurs being numerous (at least within a certain class), "to play" and "to listen" constituted a virtually undifferentiated activity; then two roles successively appeared: first of all, that of the *interpreter*, to which the bourgeois public (though it could still play a little itself: this is the entire history of the piano) delegated its playing; then that of the (passive) amateur who listens to music without being able to play it (the piano has effectively been replaced by the record); we know that today post-serial music has disrupted the role of the "interpreter," who is asked to be in a sense the co-author of the score which he completes rather than "expresses." The Text is a little like a score of this new kind: it solicits from the reader a practical collaboration. A great [innovation] this, for who *executes* the work? (Mallarmé raised this question: he wanted the audience to *produce* the book.) Today only the critic executes the work (pun intended). The reduction of reading to consumption is obviously responsible for the "boredom" many feel in the presence of the modern ("unreadable") text, the avant-garde film or painting: to be bored means one cannot produce the text, play it, release it, *make it go*.

7. This suggests one final approach to the Text: that of pleasure. I do not know if a hedonist aesthetic ever existed [...]. Of course, a pleasure of the work (of certain works) exists; I can enjoy reading and rereading Proust, Flaubert, Balzac, and even – why not? – Alexandre Dumas; but this pleasure, however intense, and even when it is released from any prejudice, remains partly (unless there has been an exceptional critical effort) a pleasure of consumption: for, if I can read these authors, I also know that I cannot *rewrite* them (that one cannot, today, write "like that"); and this rather depressing knowledge suffices to separate me from the production of these works, at the very moment when their distancing founds my modernity (to be modern – is this not really to know that one cannot begin again?). The Text is linked to delectation, i.e., to pleasure without separation. Order of the signifier, the Text participates in its way in a social Utopia; before History (supposing that History does not choose barbarism), the Text fulfills if not the transparency of social relations, at least the transparency of language relations: it is the space in which no language prevails over any other, where the languages circulate (retaining the *circular* meaning of the word).

These few propositions do not necessarily constitute the articulation of a Theory of the Text. This is not merely the consequence of the presenter's inadequacies (moreover, in many points he has merely recapitulated what is being investigated and developed around him). This is a consequence of the fact that a Theory of

the Text cannot be satisfied with a metalinguistic exposition: the destruction of meta-language, or at least (for it may be necessary to resort to it provisionally) calling it into question, is part of the theory itself: discourse on the Text should itself be only text, research, textual activity, since the Text is that *social* space which leaves no language safe, outside, and no subject of the speech-act in a situation of judge, master, analyst, confessor, decoder: the theory of the Text can coincide only with a practice of writing.

Pierre Bourdieu

FIELD OF POWER, LITERARY FIELD AND HABITUS

EDITOR'S INTRODUCTION

THIS ESSAY CAN BE READ as taking something like the opposite line than Roland Barthes does in his 'From Work to Text'. Bourdieu is a loosely Marxian sociologist who is here describing the literary world, or as he calls it, the literary field of French literature in the middle of the nineteenth century. In particular he is concerned with Gustave Flaubert, author, most famously, of *Madame Bovary* and one of the progenitors of pure or autonomous literature, that is to say, literature written for its own sake rather than for any moral, social, or political purpose. One way of thinking about Bourdieu's project is to say that he wants to understand the institutional structure and logic within which literary autonomy emerged. And in doing so he comes up with a whole new theory of cultural production.

His key move is to insist that there is such a thing as the literary field, independent from other social fields. It works according to its own logics, that is to say it is not wholly determined by the logic of the market. Writers take position within this field which they don't control: that is, if you are a writer you can't write anything you like, you find yourself positioned in a field which structures your possibilities. And in the period Bourdieu was concerned with the French literary field was divided into three main positions: social art, bourgeois art and art for art's sake. He argues that the position that writers found themselves in depended largely on the class and financial position they brought with them to their literary vocation. And he argues that those with most cultural and financial capital tended to take the art for art's sake position which enabled them to fulfil their fantasies of living freely in effect by giving up the simpler, more materialist gains that control the rest of the literary field.

(That is the point of this essay's important but rather enigmatic last paragraph.) From this position: to lose in terms of the wider world is to win (and this has some relation to Barthes's understanding of the subversive power of the text as against the work).

Bourdieu has been important to cultural studies (and terms like 'field', and 'cultural capital' have become commonplace) because, for him, cultural production is neither the expression of a people or a nation, nor (in its canonical form) the store of the best that has been thought and said, nor does it exist in relation to ideology as it does for those who come out of Althusser, nor does it hold the possibility of emancipation from the commodity form as it does for the Frankfurt school. Rather it has particular functions and particular laws which can be rationally accounted for, and which, if understood properly, demystify the old opposition between 'high' and 'low' or, to put this more accurately, mean that high art has no more inherent value than other forms of cultural production. After Bourdieu, high art's cultural capital seems radically reduced, an outcome that can, of course, be either celebrated or rejected.

Further reading: Bourdieu 1986, 1990 and 1993; Garnham and Williams 1980; Guillory 1993; Swartz 1998; Thompson 1984; Wacquant and Bourdieu 2005.

What do I mean by 'field'? As I use the term, a field is a separate social universe having its own laws of functioning independent of those of politics and the economy. The existence of the writer, as fact and as value, is inseparable from the existence of the literary field as an autonomous universe endowed with specific principles of evaluation of practices and works. To understand Flaubert or Baudelaire, or any writer, major or minor, is first of all to understand what the status of writer consists of at the moment considered; that is, more precisely, the social conditions of the possibility of this social function, of this social personage. In fact, the invention of the writer, in the modern sense of the term, is inseparable from the progressive invention of a particular social game, which I term the *literary field* and which is constituted as it establishes its autonomy, that is to say, its specific laws of functioning, within the field of power.

To provide a preliminary idea of what I mean by that I will make use of the old notion of the 'Republic of Letters', of which Bayle, in his *Dictionnaire historique et critique*, had announced the fundamental law: 'Liberty is what reigns in the Republic of Letters. This Republic is an extremely free state. In it, the only empire is that of truth and reason; and under their auspices, war is naively waged against just about anybody. Friends must protect themselves from their friends, fathers from children, fathers-in-law from sons-in-law: it is a century of iron. In it everyone is both ruler and subject of everyone else.' Several fundamental properties of the field are enunciated in this text, in a partly normative, partly positive mode: the war of everyone against everyone, that is, universal competition, the closing of the field upon itself, which causes it to be its own market and makes each of the producers seek his customers among his competitors; the ambiguity, therefore, of this world where one may see, according to the adopted perspective, the paradise

of the ideal republic, where everyone is at once sovereign and subject, or the hell of the Hobbesian battle of everyone against everyone.

But it is necessary to make the definition somewhat more precise. The literary field (one may also speak of the artistic field, the philosophical field, etc.) is an independent social universe with its own laws of functioning, its specific relations of force, its dominants and its dominated, and so forth. Put another way, to speak of 'field' is to recall that literary works are produced in a particular social universe endowed with particular institutions and obeying specific laws. And yet this observation runs counter to both the tradition of internal reading, which considers works in themselves independently from the historical conditions in which they were produced, and the tradition of external explication, which one normally associates with sociology and which relates the works directly to the economic and social conditions of the moment.

This field is neither a vague social background nor even a *milieu artistique* like a universe of personal relations between artists and writers (perspectives adopted by those who study 'influences'). It is a veritable social universe where, in accordance with its particular laws, there accumulates a particular form of capital and where relations of force of a particular type are exerted. This universe is the place of entirely specific struggles, notably concerning the question of knowing who is part of the universe, who is a real writer and who is not. The important fact, for the interpretation of works, is that this autonomous social universe functions somewhat like a prism which *refracts* every external determination: demographic, economic or political events are always retranslated according to the specific logic of the field, and it is by this intermediary that they act on the logic of the development of works.

To know Flaubert (or Baudelaire or Feydeau), to understand his work, is thus to understand, first of all, what this entirely special social universe is, with customs as organized and mysterious as those of a primitive tribe. It is to understand, in the first place, how it is defined in relation to the field of power and, in particular, in relation to the fundamental law of this universe, which is that of economy and power. Without going into detail at this point in the analysis, I will merely say that the literary field is the economic world reversed; that is, the fundamental law of this specific universe, that of disinterestedness, which establishes a negative correlation between temporal (notably financial) success and properly artistic value, is the inverse of the law of economic exchange. The artistic field is a *universe of belief*. Cultural production distinguishes itself from the production of the most common objects in that it must produce not only the object in its materiality, but also the value of this object, that is, the recognition of artistic legitimacy. This is inseparable from the production of the artist or the writer as artist or writer, in other words, as a creator of value. A reflection on the meaning of the artist's signature would thus be in order.

In the second place, this autonomous field, a kind of *coin de folie* or corner of madness within the field of power, occupies a dominated position in the field. Those who enter this completely particular social game participate in domination, but as *dominated* agents: they are neither dominant, plain and simple, nor are they dominated (as they want to believe at certain moments of their history). Rather, they occupy a dominated position in the dominant class, they are owners of a

dominated form of power at the interior of the sphere of power. This structurally contradictory position is absolutely crucial for understanding the positions taken by writers and artists, notably in struggles in the social world.

Dominated among the dominant, writers and artists are placed in a precarious position which destines them to a kind of objective, therefore subjective, indetermination: the image which others, notably the dominants within the field of power, send back to them is marked by the ambivalence which is generated in all societies by beings defying common classifications. The writer — or the intellectual — is enjoined to a double status, which is a bit suspect: as possessor of a dominated weak power, he is obliged to situate himself somewhere between the two roles represented, in medieval tradition, by the *orator*, symbolic counterweight of the *bellator*, charged with preaching and praying, with saying the true and the good, with consecrating or condemning by speech, and by the *fool*, a character freed from convention and conformities to whom is accorded transgression without consequences, inspired by the pure pleasure of breaking the rule or of shocking. Every ambiguity of the modern intellectual is inscribed in the character of the fool: he is the ugly buffoon, ridiculous, a bit vile, but he is also the alerter who warns or the adviser who brings forth the lesson; and, above all, he is the demolisher of social illusions.

Significantly, all statistical inquiries show that the social properties of agents, thus their dispositions, correspond to the social properties of the position they occupy. The literary and artistic fields attract a particularly strong proportion of individuals who possess all the properties of the dominant class *minus one:* money. They are, if I may say, *parents pauvres* or 'poor relatives' of the great bourgeois dynasties, aristocrats already ruined or in decline, members of stigmatized minorities like Jews or foreigners. One thus discovers, from the first moment, that is, at the level even of the social position of the literary and artistic field in the field of power, a property which Sartre discovered within the domestic unit and in the particular case of Flaubert: the writer is the 'poor relative', the *idiot of the bourgeois family*.

The structural ambiguity of their position in the field of power leads writers and painters, these 'penniless bourgeois' in Pissarro's words, to maintain an ambivalent relationship with the dominant class within the field of power, those whom they call 'bourgeois', as well as with the dominated, the 'people'. In a similar way, they form an ambiguous image of their own position in social space and of their social function: this explains the fact that they are subject to great fluctuation, notably in the area of politics (for example, when the centre of gravity of the field shifted towards the left in 1848), one notes a general swing towards 'social art': Baudelaire, for instance, speaks of the childish or 'puerile Utopia of art for art's sake' and rises up in violent terms against pure art.

The characteristics of the positions occupied by intellectuals and artists in the field of power can be specified as a function of the positions they occupy in the literary or artistic field. In other words, the position of the literary field within the field of power affects everything that occurs within the latter. In order to understand what artists and writers can say or do, one must always take into account their membership of a dominated universe and the greater or lesser distance of this universe from that of the dominant class, an overall distance that varies with different periods and societies and also, at any given time, with various positions

within the literary field. One of the great principles of differentiation within the literary field, in fact, lies in the relationship towards the structural position of the field, and thus of the writer, that different positions within the literary field favour; or, if one prefers, in the different ways of realizing this fundamental relationship, that is, in the different relationships with economic or political power, and with the dominant fraction, that are associated with these different positions.

Thus the three positions around which the literary field is organized between 1830 and 1850, namely, to use the indigenous labels, 'social art', 'art for art's sake' and 'bourgeois art', must be understood first as so many particular forms of the generic relationship which unites writers, dominated-dominant, to the dominant-dominant. The partisans of social art, republican and democratic like Pierre Leroux, Louis Blanc or Proudhon, or liberal Catholics like Lamennais and many others who are now completely unknown, condemn the 'egotistical' art of the partisans of art for art's sake and demand that literature fulfil a social or political function. Their lower position within the literary field, at the intersection of the literary field with the political field, doubtless maintains a circular causal relationship with respect to their solidarity with the dominated, a relationship that certainly is based in part on hostility towards the dominant within the intellectual field.

The partisans of 'bourgeois art', who write in the main for the theatre, are closely and directly tied to the dominant class by their lifestyle and their system of values, and they receive, in addition to significant material benefits (the theatre is the most economically profitable of literary activities) all the symbols of bourgeois honour – notably the Academy. In painting, with Horace Vernet or Paul Delaroche, in literature with Paul de Kock or Scribe, the bourgeois public is presented with an attenuated, softened, watered-down version of Romanticism. The restoration of 'healthy and honest' art is the responsibility of what has been called the 'school of good sense': those like [...] Octave Feuillet, Murger, Cherubuliez, Alexandre Dumas fils, [...]. Émile Augier and Octave Feuillet, whom Jules de Goncourt called the 'family Musset', and whom Flaubert detested even more than Ponsard, subject the most frenzied Romanticism to the tastes and norms of the bourgeoisie, celebrating marriage, good management of property, the honourable placement of children in life. Thus, Émile Augier, in *L'Aventurière*, combines the sentimental reminiscences of Hugo and Musset with praise of morality and family life, a satire on courtesans and condemnation of love late in life.

Thus the defenders of art for art's sake occupy a central but structurally ambiguous position in the field which destines them to feel with doubled intensity the contradictions that are inherent in the ambiguous position of the field of cultural production in the field of power. Their position in the field compels them to think of themselves, on the aesthetic as well as the political level, in opposition to the 'bourgeois artists', homologous to the 'bourgeois' in the logic of the field, and in opposition to the 'social artists' and to the 'socialist boors', in Flaubert's words, or to the 'bohemians', homologous to the 'people'. Such conflicts are felt successively or simultaneously, according to the political climate. As a result, the members of this group are led to form contradictory images of the groups they oppose as well as of themselves. Dividing up the social world according to criteria that are first of all aesthetic, a process that leads them to cast the 'bourgeois', who are closed to art, and the 'people', imprisoned by the material problems of everyday existence,

into the same scorned class, they can simultaneously or successively identify with a glorified working class or with a new aristocracy of the spirit. A few examples: 'I include in the word *bourgeois*, the bourgeois in working smocks and the bourgeois in frock coats. We, and we alone, that is the cultured, are the people, or to put it better, the tradition of humanity' (letter to George Sand, May 1867). 'All must bow before the elite: the Academy of Sciences must replace the Pope.'

Brought back towards the 'bourgeois' when they feel threatened by the bohemians, they can be prompted by their disgust for the bourgeois or the bourgeois artist to proclaim their solidarity with all those whom the brutality of bourgeois interests and prejudices rejects or excludes: the bohemian, the young artist, the acrobat, the ruined noble, the 'good-hearted servant' and especially, perhaps, the prostitute, a figure who is symbolic of the artist's relationship to the market.

Their disgust for the bourgeois, a customer who is at the same time sought after and scorned, whom they reject as much as he rejects them, is fed, in the intellectual field, the first horizon of all aesthetic and political conflicts, by disgust for the bourgeois artist, that disloyal competitor who assures for himself immediate success and bourgeois honour by denying himself as a writer: 'There is something a thousand times more dangerous than the bourgeois,' says Baudelaire in his *Curiosités esthétiques*, 'and that is the bourgeois artist, who was created to come between the artist and genius, who hides each from the other.' (It is remarkable that all the partisans of art for art's sake, with the exception of Bouilhet and Banville, suffered resounding defeat in the theatre, like Flaubert and the Goncourts, or that, like Gautier and Baudelaire, they kept librettos or scripts in their portfolios.) Similarly, the scorn shown at other times by the professionals of artistic endeavour, the partisans of art for art's sake, towards the literary proletariat who are jealous of their success, inspires the image that they have of the 'populace'. The Goncourts, in their *Journal*, denounce 'the tyranny of the brasseries and of bohemian life over all real workers' and oppose Flaubert to the 'great bohemians', like Murger, in order to justify their conviction that 'one must be an honest man and an honourable bourgeois in order to be a man of talent'. Placed at the field's centre of gravity, they lean towards one pole or the other according to the state of the forces outside the field and their indirect consequences within the field, shifting towards political commitment or revolutionary sympathies in 1848 and towards indifference or conservatism under the Second Empire.

This double rejection of the two opposing poles of social space and of the literary field, rejection of the 'bourgeois' and of the 'people', at the same time a rejection of 'bourgeois art' and 'social art', is continually manifested in the purely literary domain of style. The task of writing is experienced as a permanent struggle against two opposing dangers: 'I alternate between the most extravagant grandiloquence and the most academic platitudes. This smacks alternatively of Petrus Borel and Jacques Delille' (to Ernest Feydeau, late November/early December 1857); 'I am afraid of falling into a sort of Paul de Kock or of producing Chateaubriandized Balzac' (to Louise Colet, 20 September 1851); 'What I am currently writing runs the risk of sounding like Paul de Kock if I don't impose some profoundly literary form on it' (to Louise Colet, 13 September 1852). In his efforts to distance himself from the two poles of the literary field, and by extension of the social field, Flaubert comes to refuse any mark, any distinctive sign, that could mean support, or,

worse, membership. Relentlessly hunting down *commonplaces*, that is, those places in discourse in which an entire group meets and recognizes itself, and *idées reçues*, generally accepted ideas that go without saying for all members of a group and that one cannot take up without affirming one's adhesion to the group, Flaubert seeks to produce a socially Utopian discourse, stripped of all social markers.

The need to distance oneself from all social universes goes hand in hand with the will to refute every kind of reference to the audience's expectations. Thus Flaubert writes to Renan about the 'Prayer on the Acropolis': I don't know whether there is a more beautiful page of prose in French! It's splendid and I am sure that the bourgeois won't understand a bit of it! So much the better!' The more artists affirm their autonomy and produce works which contain and impose their own norms of evaluation, the greater their chances of pushing the 'bourgeois' to the point where they are incapable of appropriating these works for themselves. As Ortega y Gasset observes: 'by its very existence new art compels the *bon bourgeois* to admit who he is: a *bon bourgeois*, a person unworthy of aesthetic feelings, deaf and blind to all pure beauty' (*The Dehumanization of Art*). The symbolic revolution through which artists free themselves from bourgeois demands and define themselves as the sole masters of their art while refusing to recognize any master other than their art – this is the very meaning of the expression 'art for art's sake' – has the effect of eliminating the market. The artist triumphs over the 'bourgeois' in the struggle to impose aesthetic criteria, but by the same token rejects him as a potential customer. As the autonomy of cultural production increases, so does the time-lag that is necessary for works to impose the norms of perceptions they bring along. This time-lag between supply and demand tends to become a structural characteristic of the restricted field of production, a very special economic world in which the producers' only customers tend to be their own competitors.

Thus the Christ-like mystique of the *artiste maudit*, sacrificed in this world and consecrated in the next, is nothing other than the retranslation of the logic of a new mode of production into ideal and ideology: in contrast to 'bourgeois artists', assured of immediate customers, the partisans of art for art's sake, compelled to produce their own market, are destined to deferred economic gratification. At the limit, pure art, like pure love, is not made to be consumed. Instant success is often seen, as with Leconte de Lisle, as 'the mark of intellectual inferiority'. We are indeed in the economic world reversed, a game in which the loser wins: the artist can triumph on the symbolic terrain only to the extent that he loses on the economic one, and vice versa. This fact can only reinforce the ambivalence of his relationship to the 'bourgeois', this unacceptable and unobtainable customer. To his friend Feydeau who is attending his dying wife, Flaubert writes: 'You have and will have some good paintings, and you will be able to do some good studies. You'll pay for them dearly. The bourgeois hardly realize that we are serving up our heart to them. The race of gladiators is not dead: every artist is one of them. He entertains the public with his death throes.' This is a case of not letting oneself become caught up in the mithridatizing effect created by our dependence on literary bombast. Gladiator or prostitute, the artist invents himself *in suffering*, in revolt, against the bourgeois, against money, by inventing a separate world where the laws of economic necessity are suspended, at least for a while, and where value is not measured by commercial success.

That being said, one cannot forget the economic conditions of that distancing of oneself from economic necessity that we call 'disinterestedness'. The 'heirs', as in *Sentimental Education*, hold a decisive advantage in a world which, as in the world of art and literature, does not provide immediate profits: the possibility that it offers for 'holding out' in the absence of a market and the freedom it assures in relation to urgent needs is one of the most important factors of the differential success of the avant-garde enterprise and of its unprofitable or, at least, very long-term investments. 'Flaubert', observed Théophile Gautier to Feydeau, 'was smarter than us. He had the wit to come into the world with money, something that is absolutely indispensable to anyone who wants to get anywhere in art.' In short, it is still (inherited) money that assures freedom from money. In painting as in literature, the most innovative enterprises are the privilege of those who have inherited both the boldness and the insurance that enable this freedom to grow ...

Thus we come back to the individual agents and to the personal characteristics which predispose them to realize the potentialities inscribed in a certain position. I have attempted to show that the partisans of art for art's sake were predisposed by their position in the intellectual field to experience and to express in a particularly acute way the contradictions inherent in the position of writers and artists in the field of power. Similarly, I believe that Flaubert was predisposed through a whole set of properties to express in exemplary fashion the potentialities inscribed in the camp of art for art's sake. Some of these characteristics are shared by the whole group. For example, the social and educational background: Bouilhet, Flaubert and Fromentin are sons of famous provincial doctors; Théodore de Banville, Barbey d'Aurevilly and the Goncourts are from the provincial nobility. Almost every one of them studied law, and their biographers observe that, for several, the fathers 'wanted a high social position for them' (this opposes them to the partisans of 'social art' who, especially after 1850, come in large part from the middle class and even the working classes, while the 'bourgeois artists' are more often from the business bourgeoisie).

In the position within social space of what was at the time termed *les capacités* – that is, the 'liberal professions' – one can see the principle of particular affinities between writers issuing from that position and art for art's sake which occupies, as we have seen, a central position in the literary field: *les capacités* occupy an intermediary position between economic power and intellectual prestige; this position, whose occupants are relatively well endowed with both economic and cultural capital, constitutes a kind of intersection from which one can continue, with roughly equal probabilities, towards the pole of business or the pole of art. And it is truly remarkable to see how Achille-Cléophas, Flaubert's father, invested simultaneously in the education of his children and in real estate.

The objective relation established between *les capacités* and the other fractions of the dominant class (not to mention the other classes) doubtless oriented the subconscious dispositions and the conscious representations of Flaubert's family and of Flaubert himself with respect to the various positions that could be explored. Therefore, in Flaubert's correspondence one can only be struck by the precocious appearance of the oratorical precautions, which are so characteristic of his relation to writing, and through which Flaubert, then ten years old, distances himself from commonplaces and pompous formulae: 'I shall answer your letter and, as some

practical jokers say, I am setting pen to paper to write to you' (to Ernest Chevalier, 18 September 1831); 'I am setting pen to paper (as the shopkeeper says) in order to answer your letter punctually (as the shopkeeper again says)' (to Ernest Chevalier, 18 July 1835); 'As the true shopkeeper says, I am sitting down and I am setting pen to paper to write to you' (to Ernest Chevalier, 25 August 1838).

The reader of *The Family Idiot* discovers, not without surprise, the same stereotyped horror of the stereotype in a letter from Dr Achille-Cléophas to his son in which the ritualistic considerations – here not devoid of intellectual pretension – on the virtues of travel suddenly take on a typically Flaubertian tone, with vituperation against the shopkeeper: 'Take advantage of your travel and remember your friend Montaigne who reminds us that we travel mainly to bring back the mood of nations and their mores, and to "rub and sharpen our wits against other brains". See, observe, and take notes; do not travel as a shopkeeper or a salesman' (29 August 1840). This programme for a literary journey, so extensively practised by writers and, in particular, by the partisans of art for art's sake, and perhaps the form of the reference to Montaigne ('your friend'), which suggests that Gustave shared his literary tastes with his father, attests that if, as hinted by Sartre, Flaubert's literary 'vocation' may have had its origin in the 'paternal curse' and in the relationship with his elder brother – that is, in a certain division of the work of reproduction – it met very early on with the understanding and the support of Dr Flaubert who, if one can believe this letter and, among other indications, the frequency of his references to poets in his thesis, must have been not insensitive to the prestige of the literary enterprise.

But this is not all. At the risk of seeming to push the search for an explanation a bit far, it is possible, starting from Sartre's analysis, to point out the homology between the objective relationship that tied the artist as 'poor relation' to the 'bourgeois' or 'bourgeois artist' and the relationship that tied Flaubert, as the 'family idiot', to his elder brother, and through him – the clear objectification of the most probable career for their category – to his class of origin and to the objective future implied by that class. We would therefore have an extraordinary superimposition of redundant determinations. When Sartre evokes the relationship that Flaubert maintains with his family milieu, the child's and the misunderstood student's resentment, he seems to describe the relationship that the segment of artists and writers maintains with the dominant fractions: 'He is outside and inside. He never ceases to demand that this bourgeoisie, in so far as it manifests itself to him as his family milieu, *recognize* and *integrate* him.' 'Excluded and compromised, victim and accomplice, he suffers from both his exclusion and his complicity.' [...]

One could ask what has been gained by proceeding as I have, from the opposite side of the most common approach: instead of starting from Flaubert, and his particular oeuvre, I went directly to the space in which he was inserted, I tried to open the biggest box, the field of power, in order to discover what the writer was about, what Flaubert was as a writer defined by a predetermined position in this space. Then, in opening the second box, I tried to reconstitute this dominated-dominant in the literary field, where I found a structure homologous to that of the field of power: on one side the 'bourgeois artists', dominated-dominants with the emphasis on the dominant, and on the other side 'social art', dominated-dominants with emphasis on the dominated; between the two, art for art's sake and Flaubert,

dominated-dominants with no emphasis on either side, in a state of equilibrium, unstable between the two poles. Finally, I examined the initial position of Gustave in social space and discovered, I believe, the immobile trajectory which, starting from the position of equilibrium between the two poles of the field of power that is represented by the position of the physician, directed him to occupy this position of equilibrium in the literary field. This long aside was not superfluous, I believe, since it permitted the observation that many properties which one could be tempted to attribute to the particular characteristics of Flaubert's history, as was done by Sartre, are inscribed in the position of 'pure' writer.

What we have learned through this analysis also accounts for Flaubert's quasi-miraculous lucidity. If Flaubert was able to produce a quasi-objective representation of social space of which he was himself the product, it is because the position he never ceased to occupy in this space *from the very outset*, and the tension, even the suffering associated with the *indetermination* which defines it, promotes a *painful lucidity*, since it is rooted in powerlessness, converted into a refusal to belong to one or the other group situated at one or the other of the poles of this space. The objectifying distance, close to Frédéric's contemplative indifference, which enables Flaubert to produce a global vision of the space in which he is situated, is inseparable from the obsession of powerlessness which is associated with the occupation of neutral positions where the forces of the field are neutralized.

[...]

This description of the space of the positions objectively offered to the bourgeois adolescent of the 1840s owes its objectivistic rigour to an indifference, a lack of satisfaction and, as Claudel used to say, an 'impatience with limits', which are hardly compatible with the magical experience of the 'vocation': 'I will pass my bar examination, but I scarcely think I shall ever plead in court about a party-wall or on behalf of some poor paterfamilias cheated by a rich upstart. When people speak to me about the bar, saying "This young fellow will make a fine trial lawyer", because I'm broad in the shoulders and have a booming voice, I confess it turns my stomach. I don't feel myself made for such a completely materialistic, trivial life'.

So, the status of the writer devoted to pure art, situated at equal distance from the two polar positions, also appears as a means of holding on to the refusal to belong, to hold and to be held, which characterized the young Gustave. Pure art transforms Frédéric's 'inactive passion' into a wilful position, a system: 'I no longer want to be associated with a review, or to be a member of a society, a club, or an academy, no more than to be a city counsellor or an officer in the national guard' (to Louise Colet, 31 March 1853); 'No, *sacré nom de Dieu!*, no!, I shall not attempt to publish in any review. It seems to me that, under present conditions, to be *a member of anything*, to join any official organization, any association or small club [*boutique*], or even to take a title no matter what it might be, is to lose one's honour, to debase oneself, since everything is so low' (to Louise Colet, 3–4 May 1853).

Again at the risk of seeming to push the analysis too far, I should like to describe finally what appears to be the true principle of the relationship between Flaubert and Frédéric, and the true function of the work of writing through which Flaubert projected himself, and projected a self through and beyond Frédéric's

character. What is at stake in this relationship is the inescapable social genesis of a sovereign position which proclaims itself free of any determination. And what if social determinations which encourage distance *vis-à-vis* all determinations did exist? What if the power that the writer appropriates for himself through writing were only the imaginary inversion of powerlessness? What if intellectual ambition were only the imaginary inversion of the failure of temporal ambitions? It is evident that Flaubert never ceased to ask himself whether the writer's scorn for the 'bourgeois' and the wordly possessions of which they are the prisoners does not owe something to the resentment of the failed 'bourgeois' who transforms his failure into elective renunciation; unless it is the 'bourgeois' who, by keeping him at a distance, enable the writer to distance himself from them.

Flaubert knew all too well that flights into the imaginary, just like revolutionary declarations, are also ways to seek refuge from powerlessness. One can return now to Frédéric who, at the apex of his trajectory, in the Dambreuses' salon, reveals, through his disdain for his failed revolutionary friends, his conviction that the artistic or revolutionary vocations are nothing but refuges from failure – the same Frédéric who never feels more intellectual than when his life goes wrong. It is when he is faced with Monsieur Dambreuse's reproach for his actions or by Madame Dambreuse's allusions to Rosanette's coach that, surrounded by bankers, he defends the positions of the intellectual in order to conclude: 'I don't give a damn about business!'

It would appear that Flaubert was not able to forget the negative determinations of his writer's 'vocation', free of all determination. The enchantment of writing enables him to abolish all determinations which are the constituent parts of social existence: 'This is why I love Art. It's because at least there, in the world of fictions, everything can happen; one is at the same time one's king and one's people, active and passive, victim and priest. No limits; humanity is a jokester with little bells that one jingles at the end of one's sentence, like a street performer at the end of his foot' (to Louise Colet, 15–16 May 1852); 'The only way to live in peace is to leap in one motion above humanity and to have nothing in common with it, except to gaze upon it.' Eternity and ubiquity are the divine attributes the pure observer appropriates for himself. 'I could see other people live, but a life different from mine: some believed, some denied, others doubted, and others finally were not at all concerned by these matters and went about their business, that is, selling in their shops, writing their books, or declaiming from their podiums.'

But *Sentimental Education* is there to prove that Flaubert never forgot that the idealist representation of the 'creator' as a 'pure' subject who is inscribed in the social definition of the writer's *métier* is rooted in the sterile dilettantism of the bourgeois adolescent, temporarily freed from social determinations, and is magically realized in the ambition, that Flaubert himself professed, to 'live like a bourgeois and think like a demigod'.

Peter Stallybrass and Allon White

BOURGEOIS HYSTERIA AND THE CARNIVALESQUE

EDITOR'S INTRODUCTION

STALLYBRASS AND WHITE'S ESSAY develops an account of carnival first put forward by the Russian theorist, Mikhail Bakhtin who wrote while Stalin was in power. Bakhtin tacitly opposed Stalinism's strictly modernizing program and rhetoric by arguing that carnivals and other 'survivals' of the pre-modern period expressed energies suppressed in modernized everyday life and also an alternative politics. For Bakhtin, carnival contained a utopian urge: it displaced, even inverted, the normal social hierarchies. Carnival was also a time which encouraged different bodily needs and pleasures than those called upon by the ordinary rhythm of labour and leisure.

Stallybrass and White here argue that in the modern era, carnival was 'sublimated'. On the one hand (as by Freud), the opposition between order and carnival was transposed into models of the psyche; on the other, carnival becomes spectacularized, the object of a large audience's remote and sentimental gaze. Theirs is a thesis which helps make sense of a number of seemingly disparate cultural formations, though it is important not to forget that, just as the carnivalesque does not die out in modernity, rigid social hierarchies and controls pre-date modernization and industrialization, and may be found, in some form or other, wherever carnival exists. If that is not recognized, the Bakhtinian thesis developed by Stallybrass and White settles back into nostalgia.

Further reading: Bakhtin 1981 and 1987; Emerson 2000; Fiske 1987b; Holquist 2002; Morson and Emerson 1991; Stallybrass and White 1986.

> While she was being massaged she told me only that the children's governess
> had brought her an ethnological atlas and that some of the pictures in it of
> American Indians dressed up as animals had given her a great shock. 'Only think,
> if they came to life' (she shuddered). I instructed her not to be frightened of
> the pictures of the Red Indians but to laugh heartily at them. And this did in
> fact happen after she had woken up: she looked at the book, asked whether I
> had seen it, opened it at the page and laughed at the grotesque figures, without
> a trace of fear and without any strain in her features.
>
> 'Studies on hysteria', Frau Emmy von N. (Freud 1974: 109–10)

Carnival debris spills out of the mouths of those terrified Viennese women in
Freud's 'Studies on hysteria'. 'Don't you hear the horses stamping in the circus?'
Frau Emmy von N. implores Freud at a moment of particularly abject horror.
It is striking how the broken fragments of carnival, terrifying and disconnected,
glide through the discourse of the hysteric. Occasionally, as in the extract quoted
above, it appears that Freud's therapeutic project was simply the reinflexion of
this grotesque material into comic form. When Frau Emmy can at last look at
the 'grotesque figures' and 'laugh without a trace of fear', it is as if Freud had
managed a singular restitution, salvaging torn shreds of carnival from their phobic
alienation in the bourgeois unconscious by making them once more the object
of cathartic laughter.

It is of course significant that the carnivalesque practice which produced the
phobic symptom in Frau Emmy is that of an alien, non-European culture. Not the
least significant element in the middle-class rejection of the indigenous carnival
tradition in the late nineteenth century in Europe was a compensatory plundering
of ethnographic material – masks, rituals, symbols – from colonized cultures. In
this respect Joseph Conrad was doing no more than Frau Emmy in placing 'savage
rites' at the heart of European darkness in the 1890s.

As we know, within a very few years Freud was to abandon the cathartic
approach which he used with his early hysterical patients and to lose interest in
the attempt to precipitate the abreactive rituals which might reinflect the grotesque
and the disgusting into a *comic* form. There is some contention that this was not
necessarily a positive move (Scheff 1979), but in any event it is a notable feature
of the early case histories that it is *the patients themselves* who, in their pastiche
appropriations of festive, carnival, religious and pantomimic gestures, suggest
kinds of alleviation to their own suffering. Anna O. is credited by Ernest Jones
as being the real discoverer of the cathartic method and Breuer developed and
formalized her practical notions in his own method (Scheff 1979: 28). Freud's
gradual move away from abreactive ritual of a cathartic kind towards associative
methods of self-consciousness is entirely consonant with his desire to produce a
professional, *scientific* psychology. This is because science, particularly in the late
nineteenth century, was deeply hostile to ritual. It even saw itself, on occasion, as
self-consciously improving upon those areas of social life which, once governed by
'irrational' rituals, could now be brought under scientific control.

Indeed science only emerged as an autonomous set of discursive values
after a prolonged struggle against ritual, and it marked out its own identity by
the distance which it established from 'mere superstition' – science's label for,

among other things, a large body of social practices of a therapeutic kind. Scheff has suggested that there is a strongly cognitive bias against ritual and catharsis in much recent work in psychology and anthropology. A re-reading of hysteria case studies (not only Freud's) in relation to the ritualistic and symbolic material of carnival suggests new ways of interpreting the hostility, the felt incompatibility, of rational knowledge to ritual behaviour.

In the 'Studies on hysteria' many of the images and symbols which were once the focus of various pleasures in European carnival have become transformed into the morbid symptoms of private terror. Again and again these patients suffer acute attacks of disgust, literally vomiting out horrors and obsessions which look surprisingly like the rotted residue of traditional carnival practices. At the same time the patients seem to be reaching out, in their highly stylized gestures and discourses, towards a repertoire of carnival material as both expression and support. They attempt to mediate their terrors by enacting private, made-up carnivals. In the absence of social forms they attempt to produce their own by pastiche and parody in an effort to embody semiotically their distress. Once noticed, it becomes apparent that there is a second narrative fragmented and marginalized, lodged within the emergent psychoanalytic discourse. It witnesses a complex interconnection between hints and scraps of parodic festive form and the body of the hysteric. In his general remarks on hysterical attacks (Freud 1963), Freud himself even makes this 'other narrative' part of his definition of hysteria, without, however, making anything of it: 'When one psychoanalyses a patient subject to hysterical attacks one soon gains the conviction that these attacks are nothing but phantasies projected and translated into motor activity and *represented in pantomime*' (Freud 1963: 153, our italics).

Freud goes on to talk about the distortion which 'the pantomimic representation of phantasy' undergoes as a result of censorship. Yet the semiotic encoding of the hysterical symptom in pantomime mimicry is given as the very form of representation of fantasy: Freud's definition of hysteria makes pantomime the *symptomatic* locus of the Imaginary, that second-order signifying system which 'translates' and 'represents' the anterior language of the unconscious. Thus when Julia Kristeva attempted to synthesize the Bakhtinian opposition between the classical and grotesque with the Lacanian terms of the symbolic and the Imaginary, there was warrant for the connection not only at the theoretical level but in this 'other narrative' of the hysteric. Yet such is the low status of popular ritual and dramatic representation that Freud never 'sees' his own reference to pantomime as anything other than metaphorical. Towards the end of a letter to Fliess written in 1896, Freud remarks on what Charcot had dubbed the 'clownism' phase of hysterical attacks. He writes of: 'the "clownism" in boys' hysteria, the imitation of animals and circus scenes . . . a compulsion to repeat dating from their youth [in which they] seek their satisfaction to the accompaniment of the craziest capers, somersaults and grimaces' (Freud 1954: 182).

Even though Charcot's typology of hysterical styles is unreliable and contrived, especially for the photographic representations, the 'clownism' was frequently attested to as a symptomatic aspect of hysteria. Freud, in the explanation which he offers to Fliess in the letter, refers to the 'perversion of the seducers' (the patients themselves) who, he says, 'connect up nursery games and sexual scenes'. This is

something we explored in the preceding chapter in relation to the nursemaid: here, offered as an explanation of the clownism, it does not take sufficient account of the whole range of festive material scattered through various studies on hysteria and which together create a subtext irreducible to nursery games. There are indeed deep connections between childhood rituals, games and carnivalesque practices (White 1983), but here Freud's insistence upon a purely sexual aetiology obscures a fundamental socio-historical matrix of the symptom.

The carnival material of the case studies witnesses an historical repression and return. The repression includes the gradual, relentless attack on the 'grotesque body' of carnival by the emergent middle and professional classes from the Renaissance onwards. Interestingly, scholars of European popular culture have occasionally wanted to connect up, backwards as it were, Renaissance festive form to Freud's ideas. Thus C. L. Barber claims that 'A saturnalian attitude, assumed by a clear-cut gesture toward liberty, brings mirth, an accession of wanton vitality. In terms of Freud's analysis of wit, the energy normally occupied in maintaining inhibition is freed for celebration'. But Barber's reference to Freud seems like a reaching after validation which confuses the historically complex relation of the discourse of psychoanalysis to festive practices. The demonization and the exclusion of the carnivalesque has to be related to the victorious emergence of specifically bourgeois practices and languages which reinflected and incorporated this material within a negative, individualist framework. In one way or another Freud's patients can be seen as enacting desperate ritual fragments salvaged from a festive tradition, *the self-exclusion from which* had been one of the identifying features of their social class. The language of bourgeois neurosis both disavows and appropriates the domain of calendrical festive practices. Thus the 'highly gifted lady' of the case studies celebrated a whole series of what she called 'festivals of remembrance', annually re-enacting the various scenes of her affliction.

It might at first seem plausible to view the discourses of neurosis as the *psychic* irruption of *social* practices which had been suppressed. Certainly, in the long-term history from the seventeenth to the twentieth century, as we have seen above, there were literally thousands of acts of legislation introduced which attempted to eliminate carnival and popular festivity from European life. In different areas of Europe the pace varied, depending upon religious, class and economic factors. But everywhere, against the periodic revival of local festivity and occasional reversals, a fundamental ritual order of Western culture came under attack – its feasting, violence, drinking, processions, fairs, wakes, rowdy spectacle and outrageous clamour were subject to surveillance and repressive control. We can briefly list some particular instances of this general process. In 1855 the Great Donnybrook Fair of Dublin was abolished in the very same year that Bartholomew Fair in London finally succumbed to the determined attack of the London City Missions Society. In the decade following the Fairs Act of 1871 over seven hundred fairs, mops and wakes were abolished in England. By the 1880s the Paris carnival was rapidly being transformed into a trade show cum civic/military parade (Faure 1978), and although the '*cortège du boeuf gras*' processed round the streets until 1914, 'little by little it was suppressed and restricted because it was said to cause a traffic problem' (Pillement 1972: 383). In 1873 the famous Nice carnival was taken over by a *comité des Fêtes*, brought under bureaucratic bourgeois control and reorganized quite self-consciously as a

tourist attraction for the increasing numbers who spent time on the Riviera and who were finding neighbouring San Remo's new casino a bigger draw (Sidro 1979: 57–62). As Wolfgang Hartmann has shown (1976), in Germany in the aftermath of the Franco-Prussian war traditional processions and festivities were rapidly militarized and incorporated into the symbolism and 'classical body' of the state. This dramatic transformation of the ritual calendar had implications not only for each stratum of the social formation, particularly for those which were disengaging *themselves* from ongoing practices, but for the basic structures of symbolic activity in Europe: carnival was now everywhere and nowhere.

Many social historians treat the attack on carnival as a victory over popular culture, first by the Absolutist state and then by the middle classes, a process which is viewed as the more or less complete destruction of popular festivity: the end of carnival. In this vision of the complete elimination of the ritual calendar there is the implicit assumption that, in so far as it was the culture of a rural population which was disappearing, the modernization of Europe led inevitably to the supersession of traditional festivity – it was simply one of the many casualties in the movement towards an urban, industrial society. On the other hand recent literary criticism, following Bakhtin, has found elements of the carnivalesque everywhere it has looked in *modern* as well as traditional literature. Critics now discover the forms, symbols, rituals and structures of carnival to be among the fundamental elements in the aesthetics of modernism (White 1982).

By and large literary critics have not connected with the work of social historians to ask how or why this carnivalesque material should persistently inform modern art because, busy with the task of textual analysis, they move too easily from social practice to textual composition. Yet the social historians who have charted the transformations of carnival as a social practice have not registered its *displacements* into bourgeois discourses like art and psychoanalysis: adopting a naïvely empirical view they have outlined a simple disappearance, the elimination of the carnivalesque.

But, as we have shown, carnival did not simply disappear. At least four different processes were involved in its ostensible break-up: fragmentation; marginalization; sublimation; repression.

Carnival had always been a loose amalgam of procession, feasting, competition, games and spectacle, combining diverse elements from a large repertoire and varying from place to place. Even the great carnivals of Venice, Naples, Nice, Paris and Nuremberg were fluid and changeable in their combination of practices. During the long and uneven process of suppression (we often find that a carnival is banned over and over again, only to re-emerge each time in a slightly altered fashion), there was a tendency for the basic mixture to break down, certain elements becoming separated from others. Feasting became separated from performances, spectacle from procession: the grotesque body was fragmented. At the same time it began to be marginalized both in terms of social class and geographical location. It is important to note that even as late as the nineteenth century, in some places, carnival remained a ritual involving most classes and sections of a community – the disengaging of the middle class from it was a slow and uneven matter. Part of that process was, as we have seen, the 'disowning' of carnival and its symbolic resources, a gradual reconstruction of the idea of carnival as the culture of the Other. This

act of disavowal on the part of the emergent bourgeoisie, with its sentimentalism and its disgust, *made* carnival into the festival of the Other. It encoded all that which the proper bourgeois must strive *not to be* in order to preserve a stable and 'correct' sense of self.

William Addison (1953) charts many of these geographical marginalizations in the English context in the seventeenth and eighteenth centuries. Within a town the fair, mop, wake or carnival, which had once taken over the whole of the town and permitted neither outside nor outsider to its rule, was confined to certain areas and gradually driven out from the well-to-do neighbourhoods. In the last years of the Bury St Edmunds Fair it was 'banished from the aristocratic quarter of Angel Hill and confined to St Mary's and St James's squares' (Addison 1953: 163). In and around London:

> Both regular and irregular fairs were being steadily pushed from the centre outwards as London grew and the open spaces were built over. Greenwich and Stepney were the most popular at one time. Others – Croydon's for example – came to the fore later when railways extended the range of pleasure as well as the range of boredom, until towards the end of the nineteenth century London was encircled by these country fairs, some of which were, in fact, ancient charter fairs made popular by easier transport. . . . Most of them were regarded by the magistrates as nuisances, and sooner or later most of those without charters were suppressed. Yet such was the popularity of these country fairs round London that to suppress them in one place led inevitably to an outbreak elsewhere, and often where control was more difficult. As the legal adviser to the City Corporation had said in the 1730's, 'It is at all times difficult by law to put down the ancient customs and practices of the multitude.'
>
> (Addison 1953: 100)

In England the sites of 'carnival' moved more and more to the coastal periphery, to the seaside. The development of Scarborough, Brighton, Blackpool, Clacton, Margate and other seaside resorts reflects a process of liminality which, in different ways, was taking place across Europe as a whole. The seaside was partially legitimated as a carnivalesque site of pleasure on the grounds of health, since it combined the (largely mythical) medicinal virtues of the spa resorts with tourism and the fairground. It can be argued that this marginalization is a *result* of other, anterior processes of bourgeois displacement and even repression. But even so, this historical process of marginalization must be seen as an historical tendency distinct from the actual elimination of carnival.

Bakhtin is right to suggest that post-romantic culture is, to a considerable extent, subjectivized and interiorized and on this account frequently related to private terrors, isolation and insanity rather than to robust kinds of social celebration and critique. Bakhtin however does not give us a convincing explanation of this *sublimation* of carnival. The social historians, on the other hand, tend not to consider processes of sublimation at all: for them carnival came to an end and that was that. They tend not to believe in the return of the repressed.

But a convincing map of the transformation of carnival involves tracing migrations, concealment, metamorphoses, fragmentations, internalization and

neurotic sublimations. The *disjecta membra* of the grotesque body of carnival found curious lodgement throughout the whole social order of late nineteenth- and early twentieth-century Europe. These dispersed carnivalesque elements represent more than the insignificant nomadic residues of the ritual tradition. In the long process of disowning carnival and rejecting its periodical inversions of the body and the social hierarchy, bourgeois society problematized its own relation to the power of the 'low', enclosing itself, indeed often defining itself, by its suppression of the 'base' languages of carnival.

As important as this was the fact that carnival was being marginalized *temporally* as well as spatially. The carnival calendar of oscillation between production and consumption which had once structured the whole year was displaced by the imposition of the working week under the pressure of capitalist industrial work regimes. The semiotic polarities, the symbolic clusters of classical and grotesque, were no longer *temporally* pinned into a calendrical or seasonal cycle, and this involved a degree of unpredictability in moment and surface of emergence. The 'carnivalesque' might erupt from the literary text, as in so much surrealist art, or from the advertisement hoarding, or from a pop festival or a jazz concert.

Carnival was too disgusting for bourgeois life to endure except as sentimental spectacle. Even then its specular identifications could only be momentary, fleeting and partial – voyeuristic glimpses of a promiscuous loss of status and decorum which the bourgeoisie had had to deny as abhorrent in order to emerge as a distinct and 'proper' class.

Tony Bennett

CULTURE AND POLICY

EDITOR'S INTRODUCTION

TONY BENNETT'S ESSAY ARGUES THE CASE for the defence in what has come to be called 'the cultural policy studies debate' – cultural policy studies being the study of, and training in, the formulation and provision of cultural policy. He's on cultural policy's side. It's a rather confusing debate though, because it drifts somewhat haphazardly over three levels. The question is not so much (level 1) 'should cultural policy be studied in universities', the answer to which is pretty clearly 'yes, where there is a demand for it'. The question is rather (level 2) 'should cultural studies as a whole move in the direction of cultural policy studies' – or to state it in a rather more nuanced fashion, should cultural studies' habitual modes of more or less radical theoretical and utopian critique, which do not have to account for their practicability, be marginalized in favour of forms of cultural analysis which can feed into policy-formation? Behind this question lies a more theoretical one (level 3), drawn from the work of Foucault, which we can pose very starkly like this: 'is the realm of modern culture independent of government, or is governmentality the condition of possibility for all modern culture?'

Tony Bennett takes the side of governmentality and policy at all three levels by arguing that it is wrong to believe that cultural policy studies are committed to a 'top down' rather than a 'bottom up' approach (i.e. are on the side of governments rather than communities) because in fact communities and their cultures are formed within governmental practices and (though Bennett emphasizes this less) vice-versa.

This essay was written in Australia, traditionally a highly governed nation, where, particularly under 1980's Labour party rule (an equivalent to Britain's 1990's New Labour), governments were committed to developing national and

regional cultural resources and institutions. Good pickings for left-leaning policy consultants. But this means that the hot issues on the American culture/government interface – censorship, withholding of public funding for so-called obscene or blasphemous works, the attack on multiculturalism, the questioning of the public funding of culture at all – do not really appear in Bennett's work. So, leaving theoretical questions aside, we can ask: what happens to left-ish cultural policy studies when a combination of right-wing, anti-statist, populist government and private/corporate patronage/sponsorship are in power? In those circumstances, presumably, free-wheeling dissident cultural studies absorbs most of cultural policy studies once more, however we theoretically interpret the relation between governmentality and culture.

Further reading: Bennett 1992b; Cunningham 1992; Jameson 1993; Miller and Yudice 2002; Morris 1992; O'Regan 1992; Yudice 2004.

In the first issue of *Text*, the newsletter of the Centre for Cultural and Media Studies at the University of Natal, Keyan Tomaselli describes the most important change of emphasis in the recent work of that Centre as being 'the dramatic shift from theories and strategies of resistance to policy research'. 'Where policy research prior to February 1990 was seen by some academics, as negatively "idealist" or pejoratively "utopian",' Tomaselli continues, 'policy research has now assumed major significance as the country desperately attempts to address vital problems' (Tomaselli 1992: 2). It is easy to see, given the changing political context of South Africa, why this shift 'from resistance to policy' should have taken place. It is also easy to see why, internationally, few intellectuals would object to the adoption of such a position in the contemporary South African context or, if they did, that they would be prepared to say so. To do so would be to place oneself on the wrong side in relation to the democratic process that has delivered the South African state into the new and, for the moment, benign form of an ANC government.

The response to similar suggestions in the Australian context – where the political conditions which make them intelligible can claim a longer history – has, by contrast, been a quite vexatious one. John Frow and Meaghan Morris have argued that the so-called 'policy debate' conducted in a range of fora – conferences, journals, the media – in the late 1980s and early 1990s, mainly in Australia but occasionally spilling over into the international circuits of cultural studies debate, 'produced much heat and less light' (Frow and Morris 1993: xxix). Perhaps so. My own assessment, though, is both that the debate was a necessary one and that it has proved productive.

It was necessary in the sense that it was not possible, in the mid-1980s, to connect policy work to the concerns of cultural studies except, more or less apologetically, as an aside from 'the real' theoretical and political issues which, it was assumed, lay elsewhere. This is not to say that policy concerns had not figured in earlier stages in the development of cultural studies. To the contrary, they were and remained central to the concerns of Raymond Williams. This was largely a personal commitment, however, and one which had relatively little impact on debates

within cultural studies. The most significant exception to this was comprised by the interest that was shown in the cultural policies of the Greater London Council as an important bulwark against the early phases of Thatcherism until, of course, the GLC was itself dismantled. In Australia, similarly, the only synthesising engagement with cultural policy was Tim Rowse's *Arguing the Arts* (1985), although there had been important work done in the field of media policy from at least the late 1970s. Policy issues, however, were not effectively knitted into the fabric of debate within Australian cultural studies during these early years of its emergence as a discipline. They did not figure prominently within conferences and were seldom aired in the pages of the *Australian Journal of Cultural Studies* or its successor, *Cultural Studies*, when it went international. In these circumstances, as Tom O'Regan describes them, those who wanted to engage with policy issues had found it necessary to 'set up shop somewhere else' by describing their work in other terms – as, in his case, variously that of 'cultural historian, film critic, sociologist and political scientist' (O'Regan 1992: 415–16). Policy issues, in short, had not been given in either the Australian or British contexts, any principled rationale or justification that defined a clearly articulated role for them within cultural studies. The same was true in the United States, where the disconnection of cultural studies from any effective socialist traditions has minimized the significance it accords the relations between culture and government. As a consequence, policy work could be, and too often clearly was, seen in all of those national contexts as a narrowly pragmatic activity lacking any broader theoretical or political interest. It also reeked of a politically unpalatable compromise with 'the state'. Against this background, the development of an argument which insisted on the need to locate a policy horizon within cultural studies as a necessary part of its theorization of, and effective practical engagement with, relations of culture and power was a necessary step if such concerns were to be placed effectively on the agendas of cultural studies.

I suggest that the debate has proved productive for two reasons. The first is that, at least in the Australian context, it has played a role in facilitating the development of new forms of collaboration between intellectuals working in the field of cultural studies as teachers and researchers and other cultural workers and intellectuals working within specific cultural institutions or in the branches of government responsible for the management of those institutions. Of course, more systemic tendencies have driven these developments which are best viewed as local manifestations of a more general response within the humanities academy to the requirement for greater relevance to contemporary practical needs and circumstances that governments now typically press for in return for the taxpayers' dollar. To recognize these new realities is not, of course, to idealize them as if every response for greater relevance were clearly formulated. Nor does it entail an overestimation of the kinds of contributions intellectuals can be expected to make to policy, as if these could – or, indeed, should – override the imperfect and compromised nature of any policy-making or political process. However, being sensibly cautious on these matters is a far cry from the kinds of wholesale regret with which some sections of the cultural left have responded to demands for the greater 'practicalization' of the academy unless those demands can meet the measure of some ideal critical calculus of their own making. While such views

still have their advocates, it can now confidently be expected that such advocacy will prove increasingly inconsequential, just as it can be expected that the locus of productively critical work will shift to the interface between pragmatically orientated theoretical tendencies and actually existing policy agendas.

This brings me to my second point, for, while the propositions I have just advanced would not recruit the support of the majority of those who locate their work within cultural studies, they would recruit *some* support and, if my antennae are reading the changing environment correctly, are likely to prove more successful in this regard. However, this is less to say that the advocates of cultural policy studies have proved successful in winning new converts to their case than it is to suggest that the 'policy debate' was itself a symptom of what was already a clearly emerging division between revisionist tendencies within cultural studies – tendencies, that is, wishing to embrace reformist rhetorics and programs – and tendencies still committed to the earlier rhetorics of revolution or resistance. The 'policy debate', viewed in this light, served a catalysing function in serving as a means of clarifying options which were already evident as emerging tensions within cultural studies. Be this as it may, policy-related arguments now occupy a recognizable position within the landscape of cultural studies debates, a position in which it is clear that the references to policy serve to flag a more general set of issues concerning the kinds of political stances, programs, styles of intellectual work and relations of intellectual production that can now cogently be claimed for cultural studies work.

These are the issues with which I want to engage here. However much heat or light it may once have generated, the 'policy debate' has been 'off the boil' for some time now and I have no wish to heat the topic up again by reviving the controversies which characterized it. There is some value, however, in looking beneath the surface of those controversies to identify some of the discursive antagonisms which the debate activated. For these have a longer history and, if we can identify the historical provenance of the discursive grid which places culture on one side of a discursive divide and policy on the other, we shall have gone a good way towards undermining the logic of this antagonism and the related oppositions which are frequently articulated to it.

This is not, I should stress, a matter of pointing an accusing finger at those who criticized the proponents of the 'policy case'. To the contrary, I want to take my initial bearings from two such critics – Meaghan Morris and, although he had earlier seen himself as a proponent of the 'cultural-policy push' (O'Regan 1992: 415), Tom O'Regan – both of whom, while supporting the view that cultural studies should concern itself with policy issues, registered their main concern (with some justice) as being with the polarized options which policy advocates seemed to be posing. Morris thus objected that 'the big dichotomy of "Criticism and Policy"' had proved unable to focus debate in a fruitful and realistic way and saw 'policy polemic' as 'haunted by phantom *tendencies* that never quite settle into a mundane human shape' (Morris 1992a: 548). Tom O'Regan's nuanced and challenging discussion of the 'policy moment' led in a similar direction. Objecting to the over-polarized option of 'criticism or policy', O'Regan rightly points out that the relations between these are both permeable and variable:

As far as intervention and self-conduct are concerned, the very issue of choosing between policy and cultural criticism – which to write for, which to inhabit – must turn out to be a question admitting no general answer. There are no *a priori* principles for choosing policy over cultural criticism. Nor can any presumption be made about social utility and effectiveness as necessarily belonging to one or the other. Cultural policy and criticism are not hermetically sealed but are porous systems; open enough to permit transformation, incorporation and translation, fluid enough to permit a great range of practices and priorities. To put this crudely: words like 'social class' and 'oppression' (and their attendant rhetorics) may not enter the vocabulary of government policy, but without their social presence in credible explanatory systems, any policy directed towards securing equality and equal opportunity would be diminished in scope and power. The recognition of oppression informs the policy goal of access, the persistence of social class underwrites the goal of social equality. Cultural policy and criticism are different forms of life, but they often need each other, they use each other's discourses, borrowing them shamelessly and redisposing them.

(O'Regan 1992: 418)

Given this, O'Regan argues, the call to change cultural critics into cultural bureaucrats reflects a failure to identify correctly the often indirect, but none the less real and consequential, contribution which cultural criticism makes to the policy process in, through time, shifting the discursive grounds on which policy options are posed and resolved.

I can find little to quarrel with here except to suggest the need for more clearly stressing the two-way nature of this traffic if we are also to understand how the discursive terms in which some forms of cultural criticism are themselves conducted – those which speak in terms of cultural rights, for example – are often a by-product of specific forms of governmental involvement in the sphere of culture. Where I think O'Regan is mistaken is when, in the light of considerations of this kind, he suggests that those who have argued that cultural studies should reorient its concerns so as to accord policy issues a greater centrality have been 'attacking phantom targets' in supposing that such concerns could not simply be accommodated within existing traditions of work within cultural studies. Notwithstanding his own good sense in stressing the permeability of the relations between cultural policy and cultural criticism, there are versions of cultural criticism which *do* rest on a principled rejection of any engagement with the mundane calculations of bureaucratic procedures and policy processes. Fredric Jameson offered one version of this position in his unqualified rejection of policy questions as of no possible relevance to the critical intellectual. Nor was this an isolated instance: indeed, a veritable cacophony of voices was raised in principled condemnation of the policy option as such.

The difficulty which O'Regan's arguments tend to gloss over, then, is that there have been influential traditions within cultural studies which have sought to render criticism and policy constitutively impermeable to one another. The grounds invoked for this have been variable, ranging from the anti-reformist heritage of some traditions of Marxist thought to radical-feminist perceptions of the state

as essentially patriarchal and, therefore, beyond the reach of useful engagement. These are, however, variants of more general positions which have been applied to justify the adoption of a position of critical exteriority in relation to other policy fields – those of economic or social policy, for example. Objections of this kind have usually been based on the grounds that any policies emerging from the state are bound to reflect the interests of a ruling class or of patriarchy rather than because of any intrinsic properties that are attributed to the economy or to the field of the social as such. The more distinctive reasons that have been advanced in opposition to an engagement with cultural policy, by contrast, have rested on a view of culture which is in some way intrinsically at odds with, and essentially beyond the reach of, the mundane processes of policy formation.

This, then, is one of the issues I want to look at: the respects in which the shape of the criticism–policy polarity has been configured by a unique constellation of issues, pertaining solely to the field of culture, which are the legacy, broadly speaking, of Romanticism. I shall broach these issues by reviewing what Theodor Adorno had to say about cultural policy in the context of his broader discussion of the relationships between culture and administration. The discussion in question has been referred to by a number of contributors to 'the cultural policy debate', mainly to suggest that we should view Adorno's account as exemplary in its refusal to dissolve the contradictory tensions between culture and administration (see, for example, Jones 1994: 410). I shall suggest, to the contrary, that the historical limitations of Adorno's account are only too apparent and that it is, accordingly, now possible to see beyond the rims of the polarities which sustained it.

I shall take my bearings for the second issue I want to discuss from a related polarity, and one O'Regan introduces in contrasting a 'bottom-up' concern with policy, which he argues has always characterized cultural studies, with the 'top-down' approach which he attributes to advocates of the 'cultural-policy push'. In the 'bottom-up' approach, policy is 'understood in terms of its consequences and outcomes, and in terms of the actions of those affected by it, as they exert some measure of influence upon the process' (O'Regan 1992: 409). The 'top-down' approach, by contrast, recommends that cultural studies 'should reorient its concerns so as to coincide with top-down programs and public procedures, become bureaucratically and administratively minded in the process' (412). In the course of his discussion, O'Regan draws on a term I had proposed in suggesting that intellectuals working in the cultural field should think of themselves as 'cultural technicians' – a concept which O'Regan interprets as being about 'securing policy resources, consultancies and engagements' (413). This is an unfortunate representation of the concept, since the context in which I had introduced it was as part of an argument that was intended to call into question the very construction of the kind of bottom-up–top-down polarity O'Regan proposes. For such polarities lose their coherence if the relations between the kinds of politics cultural studies has supported and modern forms of government can be seen as relations of mutual dependency to the degree that the former ('bottom-up' politics) often depend on, and are generated by, the latter ('top-down' forms of government).

'How cultural forms and activities are politicized and the manner in which their politicization is expressed and pursued: these,' I argued, 'are matters which emerge from, and have their conditions of existence within, the ways in which those

forms and activities have been instrumentally fashioned as a consequence of their governmental deployment for specific social, cultural or political ends' (Bennett 1992b: 405). It was in this context that I proposed the term 'cultural technicians' as a description of the political role of intellectuals which, rather than seeing government and cultural politics as the *vis-à-vis* of one another, would locate the work of intellectuals within the field of government in seeing it as being committed 'to modifying the functioning of culture by means of technical adjustments to its governmental deployment' (1992b: 406).

This is not, of course, a matter of 'working for the government' (although it may include that) or of formulating policy in a 'top-down' fashion. To the contrary, my concern was with the ways in which the practice of intellectual workers both is, and is usefully thought of, as a matter of 'tinkering with practical arrangements' within the sphere of government – that is, the vast array of cultural institutions, public and private, that are involved in the cultural shaping and regulation of the population – in ways that reflect the genesis of cultural politics from within the processes of government, rather than viewing these in the form of a 'bottom-up' opposition to policy imposed from the top down. By way of making this argument clearer, I shall review a contemporary example of radical political engagement represented by those who argue that museums should be transformed into instruments of community empowerment and dialogue. I shall do so with a view to illustrating how this politics involves, precisely, a series of adjustments to the functioning of museums which, far from changing their nature fundamentally reconnects them to a new form of governmental program and does so – as any effective engagement with the sphere of culture must – precisely by tinkering with the routines and practices through which they operate.

The aesthetic personality and administration of culture

It is useful to recall that recent debates regarding the relations between culture and policy are not without historical precedent. Their closest analogue, perhaps, was the debate between the Frankfurt school and the American traditions of applied social research represented by Paul Lazarsfeld during the period when Lazarsfeld was seeking to involve the Frankfurt theorists, particularly Adorno, more closely in the work of the Office for Radio Research which he directed. The tensions this engendered were perhaps best summarized by Adorno's testy remark, recalling his rebuttal of a request from Lazarsfeld that he (Adorno) should aspire to greater empirical precision, that 'culture might be precisely that condition that excludes a mentality capable of measuring it' (cited in Jay 1973: 222). This tension between the aesthetic realm and the requirements of bureaucratic calculation and measurement was one to which Adorno returned in a later essay on the relations between culture and administration which, if its limitation is that its diagnosis is ultimately caught and defined by the terms of this antinomy, identifies its historical basis with unparalleled acuity. Adorno characteristically insists on retaining both aspects of this antinomy, refusing both an easy resolution that would side, unequivocally, with the one against the other as well as the temptation to project their overcoming

through the historical production of a higher point of dialectical synthesis. For Adorno, culture and administration, however much they might be opposites, are also systemically tangled up with one another in historically specific patterns of interaction from which there can be no escape.

The terms in which the tensions between the two are to be described are made clear in the opening moves of the essay:

> Whoever speaks of culture speaks of administration as well, whether this is his intention or not. The combination of so many things lacking a common denomination – such as philosophy and religion, science and art, forms of conduct and mores – and finally the inclusion of the objective spirit of an age in the single word 'culture' betrays from the outset the administrative view, the task of which, looking down from on high, is to assemble, distribute, evaluate and organize ...
>
> At the same time, however – according to German concepts – culture is opposed to administration. Culture would like to be higher and more pure, something untouchable which cannot be tailored according to any tactical or technical considerations. In educated language, this line of thought makes reference to the autonomy of culture. Popular opinion even takes pleasure in associating the concept of personality with it. Culture is viewed as the manifestation of pure humanity without regard for its functional relationships within society.
>
> (Adorno 1991: 93)

This sense of a constitutive and inescapable tension ('culture suffers damage when it is planned and administered' but equally, culture, 'when it is left to itself ... threatens to not only lose its possibility of effect, but its very existence as well' – 1991: 94) suffuses the essay, gaining in layers of complexity as the analysis develops. The two realms, Adorno argues, rest on antithetical norms:

> The demand made by administration upon culture is essentially heteronomous: culture – no matter what form it takes – is to be measured by norms not inherent to it and which have nothing to do with the quality of the object, but rather with some type of abstract standards imposed from without, while at the same time the administrative instance – according to its own prescriptions and nature – must for the most part refuse to become involved in questions of immanent quality which regard the truth of the thing itself or its objective bases in general. Such expansion of administrative competence into a region, the idea of which contradicts every kind of average generality inherent to the concept of administrative norms, is itself irrational, alien to the immanent ratio of the object – for example, to the quality of a work of art – and a matter of coincidence as far as culture is concerned.
>
> (1991: 98)

In a situation in which 'the usefulness of the useful is so dubious a matter', a line drawn 'strictly in ideology', the 'enthronement of culture as an entity unto itself' mirrors and mocks 'the faith in the pure usefulness of the useful' in being looked

on 'as thoroughly useless and for that reason as something beyond the planning and administrative methods of material production' (99). At the same time, there can be no withdrawal from administration which, in the past as in the present, persists as a condition of art's possibility:

> The appeal to the creators of culture to withdraw from the process of administration and keep distant from it has a hollow ring. Not only would this deprive them of the possibility of earning a living, but also of every effect, every contact between work of art and society, something which the work of greatest integrity cannot do without, if it is not to perish.
>
> (1991: 103)

At the same time that art 'denounces everything institutional and official' (102), it is dependent on official and institutional support, just as administration invades the inner life as with the 'UNESCO poets' who 'inscribe the international slogans of high administration with their very hearts' blood' (107).

While thoroughly aware that the system he describes is historically specific, Adorno can see no way beyond it, no set of relations in which culture will not be, at the same time, critical of, while dependent on, an administrative and bureaucratic rationality, no way in which culture can escape the gravitational pull of the everyday forms of usefulness to which it presents itself as an alternative. The best that can be hoped for, Adorno argues, is the development, in the cultural sphere, of 'an administrative praxis' which, in being 'mature and enlightened in the Kantian sense', will exhibit a 'self-consciousness of this antinomy and the consequences thereof' (98). What Adorno has in mind here becomes clearer towards the end of his essay when he articulates his vision for a cultural policy. A cultural policy that is worthy of the name, that would respect the specific content of the activities it would administer, Adorno argues, must be based on a self-conscious recognition of the contradictions inherent in applying planning to a field of practices which stand opposed to planning in their innermost substance, and it must develop this awareness into a critical acknowledgment of its own limits. Practically speaking, this means that such a policy must recognize the points at which administration 'must renounce itself' in recognizing its need for 'the ignominious figure of the expert' (111). Adorno is, of course, fully aware of the objections this position might court and he rehearses them fully, particularly the 'notorious accusation ... that ... the judgement of an expert remains a judgement for experts and as such ignores the community from which, according to popular phraseology, public institutions receive their mandate' (111). Even so, the expert is the only person who can represent the objective discipline of culture in the world of administration where his (for such experts, Adorno assures us [113], are 'men of insight') expertise serves as the only force capable of protecting cultural matters from the market ('which today unhesitatingly mutilates culture' [112]) and democracy (in upholding 'the interest of the public against the public itself' [112]). It is from this perspective that Adorno concludes his account of the relations between culture and administration in suggesting that there is still room for individuals in liberal-democratic societies to unfreeze the existing historical relations between the two. 'Whoever makes critically and unflinchingly conscious use of the means of administration and its

institutions,' he suggests, in the slim ray of hope he allows himself, 'is still in a position to realise something which would be different from merely administered culture' (113). 'Whoever', in this context, however, is not quite so open a category as it seems, for Adorno has in fact already closed this down to the expert, the aesthetic personality who alone is able to act in the sphere of administration in the name of values which exceed it, a lonely historical actor destined to be lacerated by the contradictions he seeks to quell in culture's favour.

It is easy to see why, in terms of both his intellectual formation and historical experience, Adorno would be driven to a conclusion of this kind. It is equally clear, however, that the position is no longer – if ever it was – tenable. For, in its practical effects, it amounts to an advocacy of precisely those forms of arts administration that have been, in varying degrees, successfully challenged over the postwar period because of the aesthetic, and therefore social, bias they entail. The criticisms that have been made of the rhetorics of 'excellence', as interpreted by expert forms of peer evaluation, within the evaluative criteria and processes of the Australia Council are a case in point. The grounds for such criticisms, moreover, have typically been provided by a commitment to those democratic principles of access, distribution and cultural entitlement whose force, in Adorno's perspective, the enlightened administrator was to mute and qualify in a cultural policy worthy of the name. What has happened over the intervening period to make Adorno's position pretty well uninhabitable, except for a few retro-aesthetes, has been that culture has since been relativized – in policy procedures and discourses just as much as in academic debate – and, except in the perspective of cultural conservatives, relativized without any of the dire consequences Adorno predicted coming true.

In the course of his essay, Adorno signals his awareness that the ground of culture on which he takes his stand is giving way beneath him. 'The negation of the concept of the cultural,' he writes, 'is itself under preparation' (106). He suggests that this entails the death of criticism as well as the loss of culture's autonomy.

> And finally, criticism is dying out because the critical spirit is as disturbing as sand in a machine to that smoothly-running operation which is becoming more and more the model of the cultural. The critical spirit now seems antiquated, irresponsible and unworthy, much like 'armchair' thinking.
>
> (1991: 107)

The truth is the opposite. It is precisely because we can now, without regret, treat culture as an industry and, in so doing, recognize that the aesthetic disposition forms merely a particular market segment within that industry, that it is a particular form of life like any other, that it is possible for questions of cultural policy to be posed, and pursued, in ways which allow competing patterns of expenditure, forms of administration and support to be debated and assessed in terms of their consequences for different publics, their relations to competing political values and their implications for particular policy objectives – and all without lacerating ourselves as lonely subjects caught in the grip of the contradictory pincers of culture and administration. There are no signs, either, that this has entailed the death of criticism if by this is meant taking particular policy and administrative arrangements to task because – from a stated perspective – they fail to meet specified political

or cultural objectives, or because they are contradictory or technically flawed. If, by contrast, it means the death of criticism as an activity that proceeds from a position – Adorno's culture – that is located in a position of transcendence in relation to its object, we should not mourn its passing. That critics have had to forsake such high ground in recognizing 'the professional conditions they share, for the most part, with millions of other knowledge workers', Andrew Ross has argued (Ross 1990), is no cause for lament. To the contrary, the less academic intellectuals working in the cultural sphere are able to take refuge in antinomies of this kind, the less likely it is that their analyses will be eviscerated by a stance which, in their own minds, gives them a special licence never to engage with other intellectuals except on their own terms.

Community, culture and government

Let me go back to O'Regan and the role that he accords the concept of community in illustrating the differences between the 'bottom-up' and 'top-down' approaches to policy. From the former perspective, 'cultural studies engaged with the policy development of the state, from the point of view of disadvantaged recipients or those who are excluded from such policies altogether, and it sought to defend or to restore community' (O'Regan 1992: 410). For the latter, by contrast, the goal 'is no longer to celebrate and help restore the community which survives and resists manipulative social and cultural programs; it is rather to accept the necessary lot of intervention and to recognize that such communities are themselves the by-product of policy' (412). What this polarized construction misses, I think, are the more interesting issues, which O'Regan glimpses in his concluding formulations, concerning the respects in which what, at first sight, appear to be autochthonous forms of 'bottom-up' advocacy of community so often turn out to be generated from within, and as a part of, particular governmental constructions of community. Yet the antinomy is not, of course, of O'Regan's making. To the contrary, it is inscribed within the history of the concept of community which, as Raymond Williams has noted, is such a 'warmly persuasive' word that whatever is cast in the role of 'not community' is thereby, so to speak, linguistically hung, drawn and quartered by the simple force of the comparison. The state, in being portrayed as the realm of formal, abstract and instrumental relationships in contrast to 'the more direct, more total and therefore more significant relationships of community' (Williams 1985: 92) has fared particularly badly in this respect.

Whenever 'community' is drawn into the debate, then, we need to be alert to the fact that it brings with it layers of historical meaning that have become sedimented in contemporary usage – the common people as opposed to people of rank or station; the quality of holding something in common; a sense of shared identity emerging from common conditions of life – which imply a condemnation of whatever has been constructed as its opposite. A few examples drawn from contemporary debates regarding the relations between museums and communities will show how this, the rhetorical force of the term, operates. Advocates of the community perspective within these debates typically speak of museums as means of empowering communities by encouraging their participation in, and

control over, museum programmes. This perspective of museums as vehicles for discovering and shaping a sense of community, of a shared identity and purpose, has been developed as a criticism of earlier views of museums which saw their roles primarily in didactic terms. The ideals of the ecomuseum thus constitute an explicit break with, and critique of, the 'top-down' model of museums which sees museums as having a responsibility to instruct their publics in favour of a more interactive model through which the public, transformed into an active community, becomes the co-author of the museum in a collaborative enterprise 'designed to ensure "mutual learning" and the participation of all', whose ultimate goal is 'the development of the community' (Hubert, cited in Poulot 1994: 66). From this perspective, the administrative vocabulary which speaks of museums in terms of their relations to audiences, citizens or publics appears abstract and alienated, just as the realms of government or of the state stand condemned as external and impositional forms which are either indifferent or antagonistic to the creative cultural life of communities.

Yet it is also the case that it is precisely from within the practices of government that 'community' acquires this paradoxical value of something that is both to be nurtured into existence by government while at the same time standing opposed to it as its antithesis. The points Poulot makes in his discussion of the ecomuseum movement provide a telling example of this paradox. The distinguishing feature of the ecomuseum movement, Poulot argues, consists in the way it connects the concern with the preservation and exhibition of marginalized cultures which had characterized the earlier folk-museum and outdoor-museum movements to notions of community development, community empowerment and community control. The ecomuseum, as Poulot puts it, is 'concerned with promoting the self-discovery and development of the community' (Poulot 1994: 75); 'it aims not to attain knowledge but to achieve communication' (76); it is concerned less with representation than with involvement – 'the ecomuseum searches, above all, to engage (voir faire) its audience in the social process' (78); and its focus is on everyday rather than on extraordinary culture. And yet, Poulot argues, no matter how radically different the programme of the ecomuseum may seem from that of more traditional museum forms, it is one which, at bottom, is motivated by similar civic aspirations, albeit ones that are applied not universally to a general public but in a more focused way related to the needs of a particularly regionally defined community. The ecomuseum, he argues, embodies a form of 'civic pedagogy' which aims to foster self-knowledge on the part of a community by providing it with the resources through which it can come to know and participate in its culture in a more organized and self-conscious way. Viewed in this light, Poulot suggests, the ecomuseum is best seen as a 'kind of state-sponsored public works project' which seeks to offer 'a program of "cultural development" of the citizen' (79).

This identifies precisely why equations which place museums and communities on one side of a divide as parts of creative, 'bottom-up' processes of cultural development and the state or government on another as the agents of external and imposed forms of 'top-down' cultural policy formation are misleading. However much the language of community might imply a critique of the more abstract relationships of government or of a state, what stands behind the ecomuseum are the activities of government which, in establishing such museums and training

their staff, developing new principles for the exhibition of cultural materials and a host of related tinkerings with practical arrangements, organize and constitute the community of a region in a form that equips it to be able to develop itself as a community through acquiring a greater knowledge and say in the management of its shared culture. This is not to deny the reality of the existence of regions or, more generally, particular social groups outside and independently of particular governmental programmes – whether these are those of museums, programmes of community development or community arts programmes. Nor is it to suggest that the ways in which communities might be constructed and envisaged are restricted to such governmental practices – far from it. What it is to suggest, though, is that community can no more function as an outside to government than government can be construed as community's hostile 'other'. When, in the language of contemporary cultural debates, 'community' is at issue, then so also is government as parts of complex fields in which the perspectives of social movements, and of intellectuals allied to those movements, and shifts in the institutional and discursive fields of policy, interact in ways that elude entirely those theorizations which construct the relations between the fields of culture and politics and culture and policy in terms of a 'bottom-up'–'top-down' polarity. An adequate analytical perspective on cultural policy needs, then, to be alert to the patterns of these interactions. But then so, too, does an adequate practical engagement with cultural policy need to be alert to the fact that being 'for community' may also mean working through and by governmental means.

Meaghan Morris

BANALITY IN CULTURAL STUDIES

EDITOR'S INTRODUCTION

THIS IS AN EXCEPTIONALLY SUBTLE and theoretically informed essay about the relations between cultural studies and the popular. It plays the work of the French sociologist, Jean Baudrillard off against the more reductive modes of cultural studies populism by turning to theoretical concepts articulated by Michel de Certeau of which it finally offers a critique.

For Baudrillard, as Morris argues, the media machinery of contemporary capitalism has allowed the endless flow of images to destroy the real, in a turn in which banality (the ceaseless undiscriminating pursuit by the media of events in the world) combines with fatality (the death of the real). For cultural studies populists, the popular subject always knows best and the means by which cultural studies academics ventriloquize the popular and ordinary are ignored.

In both cases, aggressive, critical voices embedded in the grit and hardness of day to day life get left out. That's not true in Michel de Certeau's work which historicizes and theorizes the relation between the theorist and the popular by demonstrating that there has been a long history in which those in control of the written record cite and contain the 'voice' of the people. De Certeau, Morris tells us, argues that another relation between the theorist and the popular, one in which the academic strives to locate the place of the ordinary in herself and thereby find means to give those other to herself the capacity to articulate themselves.

I say 'herself' of the theorist here but as Morris argues de Certeau equates the popular and ordinary with the 'other' in ways that too easily pass over differences in the ordinary world, differences that feminists are long attuned to noticing.

Further reading: Baudrillard 1995; de Certeau 1986; McGuigan 1992; Morris 1988 and 1998; Nava 1987.

This paper takes a rather circuitous route to get to the point. I'm not sure that banality can have a point, any more than cultural studies can properly constitute its theoretical object. My argument *does* have a point, but one that takes the form of pursuing an aim rather than reaching a conclusion. Quite simply, I wanted to come to terms with my own irritation about two developments in recent cultural studies.

One was Jean Baudrillard's revival of the term "banality" to frame theory of media. It is an interesting theory that establishes a tension between everyday life and catastrophic events, banality and "fatality"—using television as a metonym of the problems that result. Yet why should such a classically dismissive term as "banality" appear to establish, yet again, a frame of reference for discussing popular culture?

The other development has occurred in the quite different context that John Fiske calls "British Cultural Studies," and is much more difficult to specify. Judith Williamson, however, has bluntly described something that also bothers me: "left-wing academics … picking out strands of 'subversion' in every piece of pop culture from Street Style to Soap Opera." In this kind of analysis of everyday life, it seems to be *criticism* that actively strives to achieve "banality," rather than investing it negatively in the object of study.

These developments are not *a priori* related, let alone opposed (as, say, pessimistic and optimistic approaches to popular culture). They also involve different kinds of events. "Baudrillard" is an author, British Cultural Studies is a complex historical and political movement as well as a library of texts. But irritation may create relations where none need necessarily exist. To attempt to do so is the real point of this paper.

I want to begin with a couple of anecdotes about banality, fatality, and television. But since storytelling itself is a popular practice that varies from culture to culture, I shall again define my terms. My impression is that American culture easily encourages people to assume that a first-person anecdote is primarily oriented toward the emotive and conative functions, in Jakobson's terms, of communication: that is, toward speaker-expressive and addressee-connective activity, or an I/you axis in discourse. However, I take anecdotes, or yarns, to be primarily referential. They are oriented futuristically towards the construction of a precise, local, and *social* discursive context, of which the anecdote then functions as a *mise en abyme*. That is to say, anecdotes for me are not expressions of personal experience but allegorical expositions of a model of the way the world can be said to be working. So anecdotes need not be true stories, but they must be functional in a given exchange.

My first anecdote is a fable of origin.

TV came rather late to Australia: 1956 in the cities, later still in the country regions where the distance between towns was immense for the technology of that time. So it was in the early 1960s that in a remote mountain village—where

few sounds disturbed the peace except for the mist rolling down to the valley, the murmur of the wireless, the laugh of the kookaburra, the call of the bellbird, the humming of chainsaws and lawnmowers, and the occasional rustle of a snake in the grass—the pervasive silence was shattered by the voice of Lucille Ball. In the memory of many Australians, television came as Lucy, and Lucy *was* television. There's a joke in *Crocodile Dundee* where the last white frontiersman (Paul Hogan) is making first contact with modernity in his New York hotel, and he's introduced to the TV set. But he already knows TV: "I saw that twenty years ago at so-and-so's place." He sees the title, "*I Love Lucy*," and says, "Yeah, that's what I saw." It's a throwaway line that at one level works as a formal definition of the "media-recycle" genre of the film itself. But in terms of the dense cultural punning that characterizes the film, it's also, for Australians, a very precise historical joke. Hogan was himself one of the first major Australian TV stars, finding instant stardom in the late 1960s by faking his way onto a talent-quest show, and then abusing the judges. Subsequently, he took on the Marlboro Man in a massive, cigarette-advertising battle that lasted long enough to convert the slogan of Hogan's commercials ("Anyhow, have a Winfield") into a proverb inscrutable to foreigners. So Hogan's persona already incarnates a populist myth of indigenous Australian response to Lucy as synecdoche of all American media culture.

But in the beginning was Lucy, and I think she is singled out in memory—since obviously it was not the only program available—because of the impact of her voice. The introduction of TV in Australia led not only to the usual debates about the restructuring of family life and domestic space, and to predictable fears that the Australian "accent" in language and culture might be abolished, but also to a specific local version of anxiety about the effects of TV on children. In "Situation Comedy, Feminism, and Freud: Discourses of Gracie and Lucy," Patricia Mellencamp discusses the spectacle of female comedians in the American 1950s "being out of control via language (Gracie) or body (Lucy)." In my memory, Lucy herself combines both functions. Lucy was heard by many Australians as a screaming hysteric: as "voice," she was "seen" to be a woman out of control in both language *and* body. So there was concern that Lucy-television would, by some mimesis or contagion of the voice, metabolically transform Australian children from the cheeky little larrikins we were expected to be into ragingly hyperactive little psychopaths.

My own memory of this lived theoretical debate goes something like this. My mother and I loved Lucy, my father loathed "that noise." So once a week, there would be a small domestic catastrophe, which soon became routinized, repetitive, banal. I'd turn Lucy on, my father would start grumbling, Mum would be washing dishes in the next room, ask me to raise the volume, I'd do it, Dad would start yelling, Mum would yell back, I'd creep closer to the screen to hear, until finally Lucy couldn't make herself heard, and I'd retire in disgust to my bedroom, to the second-best of reading a novel. On one of the rare occasions when all this noise had led to a serious quarrel, I went up later as the timid little voice of reason, asking my father why, since it was only half an hour, did *he* make such a lot of noise. He said that the American voices (never then heard "live" in our small town) reminded him of the Pacific war. And that surely, after all these years, there were some things that, in the quiet of his own home, a man had a right to try to forget.

Looking back from the contradictions of the present, I can define from this story a contradiction which persists in different forms today. On the one hand, Lucy had a galvanizing and emancipating effect because of her loquacity and her relentless tonal insistence. Especially for Australian women and children, in a society where women were talkative with each other and laconic with men, men were laconic with each other and catatonic with women, and children were seen but not heard. Lucy was one of the first signs of a growing sense that women making a lot of noise did not need to be confined to the haremlike rituals of morning and afternoon tea or the washing up. On the other hand, my father's response appears, retrospectively, as prescient as well as understandable. The coming of Lucy, and of American TV, was among the first explicit announcements to a general public still vaguely imagining itself as having been "British" that Australia was now (as it had, in fact, been anyway since 1942) hooked into the media network of a different war machine.

My second anecdote follows logically from that, but is set in another world. Ten years later, after a whole cultural revolution in Australia and another war with the Americans in Asia, I saw a TV catastrophe one banal Christmas Eve. There we were in Sydney, couch-potatoing away, when the evening was shattered by that sentence which takes different forms in different cultures but is still perhaps the one sentence always capable of reminding people everywhere within reach of TV of a common and vulnerable humanity—"We interrupt this transmission for a special news flash."

Usually on hearing that, you get an adrenaline rush, you freeze, you wait to hear what's happened, then the mechanisms of bodily habituation to crisis take over to see you through the time ahead. This occasion was alarmingly different. The announcer actually stammered: "Er ... um ... something's happened to Darwin." Darwin is the capital of Australia's far north. Most Australians know nothing about it, and live thousands of miles away. It takes days to get into by land or sea, and in a well-entrenched national imaginary it is the "gateway" to Asia, and in its remoteness and "vulnerability," the likely port of a conventional invasion. This has usually been a racist nightmare about the "yellow peril" sweeping down, but it does also have a basis in flat-map logic. There's no one south of Australia but penguins.

So people panicked, and waited anxiously for details. But the catastrophe was that there was *no information*. Now, this was not catastrophe *on* TV— like the explosion of the space shuttle *Challenger*—but a catastrophe of and *for* TV. There were no pictures, no reports, just *silence*—which had long ceased to be coded as paradisal, as it was in my fable of origin, but was now the very definition of a state of total emergency. The announcer's stammer was devastating. He had lost control of all the mechanisms for assuring credibility; his palpable personal distress had exposed us, unbelievably, to something like a *truth*. When those of us who could sleep woke up the next day to find everyday life going on as usual, we realized it couldn't have been World War III. But it took another twenty-four hours for "true" news to be reestablished, and to reassure us that Darwin had merely been wiped out by a cyclone. Whereupon we went into the "natural disaster" genre of TV living, and banality, except for the victims, resumed. But in the aftermath, a

question surfaced. Why had such a cyclone-sensitive city not been forewarned? It was a very big cyclone—someone should have seen it coming.

Two rumors did the rounds. One was an oral rumor, or a folk legend. The cyclone took Darwin by surprise because it was a Russian weather warfare experiment that had either gone wrong or—in the more menacing variant—actually found its target. The other rumor made its way into writing in the odd newspaper. There had been foreknowledge: indeed, even after the cyclone there was a functioning radio tower and an airstrip which might have sent news out straight away. But these belonged to an American military installation near Darwin, which was not supposed to be there. And in the embarrassment of realizing the scale of the disaster to come, someone somewhere had made a decision to say nothing in the hope of averting discovery. If this was true, "they" needn't have worried. The story was never, to my knowledge, pursued further. We didn't really care. If there had been such an installation, it wasn't newsworthy; true or false, it wasn't catastrophic; true or false, it merged with the routine stories of conspiracy and paranoia in urban everyday life; and, true or false, it was—compared with the Darwin fatality count and the human interest stories to be had from cyclone survivors—just too banal to be of interest.

My anecdotes are also banal, in that they mark out a televisual contradiction which is overfamiliar as both a theoretical dilemma and an everyday experience. It is the contradiction between one's pleasure, fascination, thrill, and sense of "life," even birth, in popular culture and the deathly shadows of war, invasion, emergency, crisis, and terror that perpetually haunt the networks. Sometimes there seems to be nothing more to say about that "contradiction," in theory, yet as a phase of collective experience it does keep coming back around. So I want to use these two anecdotes now to frame a comparison between the late work of Baudrillard and some aspects of "British" (or Anglo-Australian) cultural studies—two theoretical projects that have had something to say about the problem. I begin with Baudrillard, because "banality" is a working concept in his lexicon, whereas it is not a significant term for the cultural studies that today increasingly cite him.

In Baudrillard's terms, my anecdotes marked out a historical shift between a period of concern about TV's effects on the real—which is thereby assumed to be distinct from its representation (the *Lucy* moment)—and a time in which TV *generates* the real to the extent that any interruption in its processes of doing so is experienced as more catastrophic in the lounge room than a "real" catastrophe elsewhere. So I have simply defined a shift between a regime of production and a regime of simulation. This would also correspond to a shift between a more or less real Cold War ethos, where American military presence in your country could be construed as friendly or hostile, but you thought you should have a choice, and that the choice mattered; and a pure war (or, simulated chronic cold war) ethos, in which Russian cyclones or American missiles are completely interchangeable in a local imaginary of terror, and the choice between them is meaningless.

This analysis could be generated from Baudrillard's major thesis in *L'échange symbolique et la mort* (1976). The later Baudrillard would have little further interest in my story about Lucy's voice and domestic squabbles in an Australian country town, but might still be mildly amused by the story of a city disappearing for thirty-

six hours because of a breakdown in communications. However, where I would want to say that this event was for participants a real, if mediated, experience of catastrophe, he could say that it was just a final flicker of real reality. With the subsequent installation of a global surveillance regime through the satellization of the world, the disappearance of Darwin could never occur again.

So Baudrillard would collapse the "contradiction" that I want to maintain: and he would make each polar term of my stories (the everyday and the catastrophic, the exhilarating and the frightful, the emancipatory and the terroristic) invade and contaminate its other in a process of mutual exacerbation. This is a viral, rather than an atomic, model of crisis in everyday life. If, for Andreas Huyssen, modernism as an adversary culture constitutes itself in an "anxiety of contamination" by its Other (mass culture), the Baudrillardian text on (or of) mass culture is constituted by perpetually *intensifying* the contamination of one of any two terms by its other (Huyssen 1986).

So like all pairs of terms in Baudrillard's work, the values "banality" and "fatality" chase each other around his pages following the rule of dyadic reversibility. Any one term can be hyperbolically intensified until it turns into its opposite. Superbanality, for example, becomes fatal, and a superfatality would be banal. It's a very simple but, when well done, dizzying logico-semantic game which makes Baudrillard's books very easy to understand, but any one term most difficult to define. A complication in this case is that "banality" and "fatality" chase each other around two books, *De la séduction* (1979) and *Les stratégies fatales* (1983).

One way to elucidate such a system is to imagine a distinction between two sets of two terms—for example, "fatal charm" and "banal seduction." Fatal charm can be seductive in the old sense of an irresistible force, exerted by someone who desires nothing except to play the game in order to capture and to immolate the desire of the other. That's what's fatal about it. Banal seduction, on the other hand, does involve desire: desire for, perhaps, an immovable object to overcome. That's what's fatal for it. Baudrillard's next move is to claim that both of these strategies are finished. The only irresistible force today is that of the moving *object* as it flees and evades the subject. This is the "force" of the sex-object, of the silent zombie-masses, and of femininity (not necessarily detached by Baudrillard from real women, but certainly detached from feminists).

This structure is, I think, a "fatal" travesty, or a "seduction" of the terms of Althusserian epistemology and *its* theory of moving objects. In *Les stratégies fatales*, the travesty is rewritten in terms of a theory of global catastrophe. The human species has passed the dead point of history: we are living out the ecstasy of permanent catastrophe, which slows down as it becomes more and more intense (*une catastrophe au ralenti*, slow-motion, or slowing-motion catastrophe), until the supereventfulness of the event approaches the uneventfulness of absolute inertia, and we begin to live everyday catastrophe as an endless dead point, or a perpetual freeze frame.

This is the kind of general scenario produced in Baudrillard's work by the logic of mutual contamination. However, an examination of the local occurrences of the terms "banal" and "fatal" in both books suggests that "banality" is associated, quite clearly and conventionally, with negative aspects of media—overrepresentation,

excessive visibility, information overload, an obscene plenitude of images, a gross platitudinousness of the all-pervasive present.

On the other hand, and even though there is strictly no past and no future in Baudrillard's system, he uses "fatality" as both a nostalgic and a futuristic term for invoking a classical critical value, *discrimination* (redefined as a senseless but still rule-governed principle of selectiveness). "Fatality" is nostalgic in the sense that it invokes in the text, for the present, an "aristocratic" ideal of maintaining an elite, arbitrary, and avowedly artificial order. It is futuristic because Baudrillard suggests that in an age of overload, rampant banality, and catastrophe (which have become at this stage equivalents of each other), the last Pascalian wager may be to bet on the return, in the present, of what can only be a simulacrum of the past. When fatal charm can simulate seducing banal seduction, you have a fatal strategy. The animating myth of this return is to be, in opposition to critical philosophies of Difference (which have now become identical), a myth of *Fatum*—that is, Destiny.

So read in one sense, Baudrillard's theory merely calls for an aesthetic order (fatality) to deal with mass cultural anarchy (banality). What makes his appeal more charming than most other tirades about the decay of standards is that it can be read in the opposite sense. The "order" being called for is radically decadent, superbanal. However, there is a point at which the play stops.

In one of Baudrillard's anecdotes (an enunciative *mise en abyme* of his theory), set in some vague courtly context with the ambience of a mid-eighteenth-century French epistolary novel, a man is trying to seduce a woman. She asks, "Which part of me do you find most seductive?" He replies, "Your eyes." Next day, he receives an envelope. Inside, instead of the letter, he finds a bloody eye. Analyzing his own fable, Baudrillard points out that in the obviousness, the literalness of her gesture, the woman has purloined the place of her seducer.

The man is the banal seducer. She, the fatal seducer, sets him a trap with her question as he moves to entrap her. In the platitudinous logic of courtliness, he can only reply "Your eyes"—rather than naming some more vital organ which she might not have been able to post—since the eye is the window of the soul. Baudrillard concludes that the woman's literalness is fatal to the man's banal figuration: she loses an eye, but he loses *face*. He can never again "cast an eye" on another woman without thinking literally of the bloody eye that replaced the letter. So Baudrillard's final resolution of the play between banality and fatality is this: a banal theory assumes, like the platitudinous seducer, that the subject is more powerful than the object. A fatal theory knows, like the woman, that the object is always *worse* than the subject ("*je ne suis pas belle, je suis pire ...*").

Nonetheless, in making the pun "she loses an eye, but he loses face," Baudrillard in fact enunciatively reoccupies the place of control of meaning by *de*-literalizing the woman's gesture, and returning it to figuration. Only the pun makes the story work as a fable of seduction, by draining the "blood" from the eye. Without it, we would merely be reading a horror story (or a feminist moral tale). So it follows that Baudrillard's figuration is, in fact, "fatal" to the woman's literality, and to a literal feminist reading of her story that might presumably ensue. In the process, the privilege of "knowing" the significance of the woman's fatal-banal gesture is securely restored to metalanguage, and to the subject of exegesis.

Recent cultural studies offers something completely different. It speaks not of restoring discrimination but of encouraging cultural democracy. It respects difference and sees mass culture not as a vast banality machine but as raw material made available for a variety of popular practices.

In saying "it," I am treating a range of quite different texts and arguments as a single entity. This is always imprecise, polemically "unifying," and unfair to any individual item. But sometimes, when distractedly reading magazines such as *New Socialist* or *Marxism Today* from the last couple of years, flipping through *Cultural Studies*, or scanning the pop-theory pile in the bookstore, I get the feeling that somewhere in some English publisher's vault there is a master disk from which thousands of versions of the same article about pleasure, resistance, and the politics of consumption are being run off under different names with minor variations. Americans and Australians are recycling this basic pop-theory article, too: with the perhaps major variation that English pop theory still derives at least nominally from a Left populism attempting to salvage a sense of life from the catastrophe of Thatcherism. Once cut free from that context, as commodities always are, and recycled in quite different political cultures, the vestigial *critical* force of that populism tends to disappear or mutate.

This imaginary pop-theory article might respond to my television anecdotes by bracketing the bits about war and death as a sign of paranoia about popular culture, by pointing out that it's a mistake to confuse conditions of production with the subsequent effects of images, and by noting that with TV one may always be "ambivalent." It would certainly stress, with the Lucy story, the subversive pleasure of the female spectators. (My father could perhaps represent an Enlightenment paternalism of reason trying to make everything cohere in a model of social totality.) With the Darwin story, it would insist on the creativity of the consumer/ spectator, and maybe have us distractedly zapping from channel to channel during the catastrophe instead of being passively hooked into the screen, and then resisting the war machine with our local legends and readings. The article would then restate, using a mix of different materials as illustration, the enabling theses of contemporary cultural studies.

In order to move away now from reliance on imaginary bad objects, I'll refer to an excellent real article which gives a summary of these theses— Mica Nava's "Consumerism and Its Contradictions." Among the enabling theses—and they *have* been enabling—are these: consumers are not "cultural dopes" but active, critical users of mass culture; consumption practices cannot be derived from or reduced to a mirror of production; consumer practice is "far more than just economic activity: it is also about dreams and consolation, communication and confrontation, image and identity. Like sexuality, it consists of a multiplicity of fragmented and contradictory discourses" (Nava 1987).

I'm not now concerned to contest these theses. For the moment, I'll buy the lot. What I'm interested in is first, the sheer proliferation of the restatements, and second, the emergence in some of them of a *restrictive definition* of the ideal knowing subject of cultural studies.

John Fiske's historical account in "British Cultural Studies and Television" produces one such restatement and restriction. The social terrain of the beginning of his article is occupied by a version of the awesomely complex Althusserian subject-

in-ideology, and by a summary of Gramsci on hegemony. Blending these produces a notion of subjectivity as a dynamic field, in which all sorts of permutations are possible at different moments in an endless process of production, contestation, and reproduction of social identities. By the end of the article, the field has been vastly simplified: there are "the dominant classes" (exerting hegemonic force) and "the people" (making their own meanings and constructing their own culture "within, and sometimes against," the culture provided for them) (Fiske 1987a, 286).

Cultural studies for Fiske aims to understand and encourage cultural democracy. One way of understanding the *demos* is "*ethnographyi*—finding out what the people say and think about their culture. But the methods cited are "voxpop" techniques common to journalism and empirical sociology—interviewing, collecting background, analyzing statements made spontaneously by, or solicited from, informants. So the choice of the term "ethnography" for these practices emphasizes a possible "ethnic" gap between the cultural student and the culture studied. The "understanding" and "encouraging" subject may share some aspects of that culture, but *in the process of interrogation and analysis* is momentarily located outside it. "The people" is a voice, or a *figure of* a voice, cited in a discourse of exegesis. For example, Fiske cites "Lucy," a fourteen year old fan of Madonna ("She's tarty and seductive ... but it looks alright when she does it, you know, what I mean ..."); and then goes on to translate, and diagnose, what she means: "Lucy's problems probably stem from her recognition that marriage is a patriarchal institution and, as such, is threatened by Madonna's sexuality" (273).

If this is again a process of embedding in metadiscourse a sample of raw female speech, it is also a perfectly honest approach for any academic analyst of culture to take. It differs from a discourse that simply appeals to "experience" to validate and universalize its own conclusions. However, such honesty should also require some analysis of the analyst's own institutional and "disciplinary" position—perhaps some recognition, too, of the double play of transference. (Lucy tells him her pleasure in Madonna: but what is his pleasure in Lucy's?) This kind of recognition is rarely made in populist polemics. What takes its place is first, a citing of popular voices (the informants), an act of translation and commentary, and then a play of *identification* between the knowing subject of cultural studies and a collective subject, "the people."

In Fiske's text, however, "the people" have no necessary defining characteristics— except an indomitable capacity to "negotiate" readings, generate new interpretations, and remake the materials of culture. This is also, of course, the function of cultural studies itself (and in Fiske's version, the study does include a "semiotic analysis of the text" to explore *how* meanings are made [272]). So against the hegemonic force of the dominant classes, "the people" in fact represent the most creative energies and functions of critical reading. In the end they are not simply the cultural student's object of study and his native informants. The people are also the textually delegated, allegorical emblem of the critic's own activity. Their *ethnos* may be constructed as other, but it is used as the ethnographer's mask.

Once "the people" are both a source of authority for a text and a figure of its own critical activity, the populist enterprise is not only circular but (like most empirical sociology) narcissistic in structure. Theorizing the problems that ensue is one way—in my view, an important way—to break out of the circuit of repetition.

Another is to project elsewhere a misunderstanding or discouraging Other figure (often that feminist or Marxist Echo, the blast from the past) to necessitate and enable more repetition.

The opening chapter of Iain Chambers's *Popular Culture* provides an example of this, as well as a definition of what counts as "popular" knowledge that is considerably more restrictive than John Fiske's. Chambers argues that in looking at popular culture, we should not subject individual signs and single texts to the "contemplative stare of official culture." Instead, it is a practice of "distracted reception" that really characterizes the subject of "popular epistemology." For Chambers, this distraction has consequences for the practice of writing. Writing can imitate popular culture (life) by, for example, "writing through quotations," and refusing to "explain … references fully." To explain would be to reimpose the contemplative stare and adopt the authority of the "academic mind."

Chambers's argument emerges from an interpretation of the history of subcultural practices, especially in music. I've argued elsewhere my disagreement with his attempt to use that history to generalize about popular culture in The Present. Here, I want to suggest that an image of the subject of pop epistemology as casual and "distracted" obliquely entails a revival of the figure that Andreas Huyssen, Tania Modleski, and Patrice Petro have described in various contexts as "mass culture as woman." Petro, in particular, further points out that the contemplation/distraction opposition is historically implicated in the construction of the "female spectator" as site, and target, of a theorization of modernity by male intellectuals in Weimar.

There are many versions of a "distraction" model available in cultural studies today: there are housewives phasing in and out of TV or flipping through magazines in laundromats as well as pop intellectuals playing with quotes. In Chambers's text, which is barely concerned with women at all, distraction is not presented as a female characteristic. Yet today's recycling of Weimar's distraction nonetheless has the "contours," in Petro's phrase, of a familiar female stereotype—distracted, absent-minded, insouciant, vague, flighty, skimming from image to image. The rush of associations runs irresistibly toward a figure of mass culture not as woman but, more specifically, as bimbo.

In the texts Petro analyzes, "contemplation" (of distraction in the cinema) is assumed to be the prerogative of male intellectual audiences. In pop epistemology, a complication is introduced via the procedures of projection and identification that Elaine Showalter describes in "Critical Cross-Dressing." The knowing subject of popular epistemology no longer contemplates "mass culture" as bimbo, but takes on the assumed mass cultural characteristics in the writing of his own text. Since the object of projection and identification in post-subcultural theory tends to be black music and "style" rather than the European (and literary) feminine, we find an actantial hero of knowledge emerging in the form of the *white male theorist* as bimbo.

However, I think the problem with the notion of pop epistemology is not really, in this case, a vestigial antifeminism in the concept of distraction. The problem is that in antiacademic pop-theory writing (much of which, like Chambers's book, circulates as textbooks with exam and essay topics at the end of each chapter), a stylistic enactment of the "popular" as *essentially* distracted, scanning the surface,

and short on attention span, performs a retrieval, at the level of *enunciative* practice, of the thesis of "cultural dopes." In the critique of which—going right back to the early work of Stuart Hall, not to mention Raymond Williams—the project of cultural studies effectively and rightly began.

One could claim that this interpretation is possible only if one continues to assume that the academic traditions of "contemplation" really do define intelligence, and that to be "distracted" can therefore only mean being dopey. I would reply that as long as we accept to restate the alternatives in those terms, that is precisely the assumption we continue to recycle. No matter which of the terms we validate, the contemplation/distraction, academic/popular oppositions can serve only to limit and distort the possibilities of popular practice. Furthermore, I think that this return to the postulate of cultural dopism in the *practice* of writing may be one reason why pop theory is now generating over and over again the same article. If a cultural dopism is being enunciatively performed (and valorized) in a discourse that tries to contest it, then the argument in fact *cannot* move on, but can only retrieve its point of departure as "banality" (a word pop theorists don't normally use) in the negative sense.

For the thesis of cultural studies as Fiske and Chambers present it runs perilously close to this kind of formulation: people in modern mediatized societies are complex and contradictory, mass cultural texts are complex and contradictory, therefore people using them produce complex and contradictory culture. To add that this popular culture has critical and resistant elements is tautological—unless one (or a predicated someone, that Other who needs to be told) has a concept of culture so rudimentary that it excludes criticism and resistance from the practice of everyday life.

Given the different values ascribed to mass culture in Baudrillard's work and in pop theory, it is tempting to make a distracted contrast between them in terms of elitism and populism. However, they are not symmetrical opposites.

Cultural studies posits a "popular" subject "supposed to know" in a certain manner, which the subject of populist theory then claims to understand (Fiske) or mimic (Chambers). Baudrillard's elitism, however, is not an elitism of a knowing subject of theory but an elitism of the *object*—which is forever, and actively, evasive. There is a hint of "distraction" here, an echo between the problematics of woman and literalness and mass culture as bimbo which deserves further contemplation. A final twist is that for Baudrillard, the worst (that is, most effective) elitism of the object can be called, precisely, "theory." Theory is understood as an objectified and objectifying (never "objective") force strategically engaged in an ever more intense process of commodification. Like "distraction" it is distinguished by the rapidity of its *flight*, rather than by a concentrated pursuit.

However, it is remarkable, given the differences between them and the crisis-ridden society that each in its own way addresses, that neither of the projects I've discussed leaves much place for an unequivocally pained, unambivalently discontented, or momentarily *aggressive* subject. It isn't just negligence. There is an active process going on in both of discrediting—by direct dismissal (Baudrillard) or covert inscription as Other (cultural studies)—the voices of grumpy feminists and cranky leftists ("Frankfurt School" can do duty for both). To discredit such voices

is, as I understand it, one of the immediate political functions of the current boom in cultural studies (as distinct from the intentionality of projects invested by it). To discredit a voice is something very different from displacing an analysis which has become outdated, or revising a strategy which no longer serves its purpose. It is to characterize a fictive position from which anything said can be dismissed as already heard.

Baudrillard's hostility to the discourses of political radicalism is perfectly clear and brilliantly played out. It is a little too aggressive to accuse cultural studies of playing much the same game. Cultural studies is a humane and optimistic discourse, trying to derive its values from materials and conditions already available to people. On the other hand, it can become an apologetic "yes, but..." discourse that most often proceeds *from* admitting class, racial, and sexual oppressions *to* finding the inevitable saving grace—when its theoretical presuppositions should require it at least to do both simultaneously, even "dialectically." And in practice the "but..."—that is to say, the argumentative rhetoric—has been increasingly addressing not the hegemonic force of the "dominant classes" but other critical theories (vulgar feminism, the Frankfurt School) inscribed as misunderstanding popular culture.[1]

Both discourses share a tendency toward reductionism—political as well as theoretical. To simplify matters myself, I'd say that where the fatal strategies of Baudrillard keep returning us to his famous Black Hole—a scenario that is so grim, obsessive, and, in its enunciative strategies, maniacally overcoherent that instead of speaking, a woman must *tear out her eye* to be heard—the voxpop style of cultural studies is on the contrary offering us the sanitized world of a deodorant commercial where there's always a way to redemption. There's something sad about that, because cultural studies emerged from a real attempt to give voice to much grittier experiences of class, race, and gender.

Yet the sense of frustration that some of us who would inscribe our own work as cultural studies feel with the terms of present debate can be disabling. If one is equally uneasy about fatalistic theory on the one hand and about cheerily "making the best of things" on the other, then it is a poor solution to consent to confine oneself to (and in) the dour position of rebuking both.

In *The Practice of Everyday Life*, Michel de Certeau provides a more positive approach to the politics of theorizing popular culture, and to the particular problems I have discussed. One of the pleasures of this text for me is the range of moods that it admits to a field of study which—surprisingly, since "everyday life" is at issue—often seems to be occupied only by cheerleaders and prophets of doom. So from it I shall borrow—in a contemplative rather than a distracted spirit—two quotations to modify the sharp oppositions I've created, before discussing his work in more detail.

The first quotation is in fact from Jacques Sojcher's *La Démarche poétique*. De Certeau cites Sojcher after arguing for a double process of mobilizing the "weighty apparatus" of theories of ordinary language to analyze everyday practices, *and* seeking to restore to those practices their logical and cultural legitimacy. He then uses the Sojcher quotation to insist that in this kind of research, everyday practices will "alternately exacerbate *and disrupt* our logics. Its regrets are like those of the

poet, and like him, it struggles against oblivion." So I will use his quotation in turn as a response to the terrifying and unrelenting coherence of Baudrillard's fatal strategies. Sojcher:

> And I forgot the elements of chance introduced by circumstances, calm or haste, sun or cold, dawn or dusk, the taste of strawberries or abandonment, the half-understood message, the front page of newspapers, the voice on the telephone, the most anodyne conversation, the most anonymous man or woman, everything that speaks, makes noise, passes by, touches us lightly, meets us head on. (xvi)

The second quotation comes from a discussion of "Freud and the Ordinary Man," and the difficult problems that arise when "elitist writing uses the 'vulgar' [or, I would add, the 'feminine'] speaker as a disguise for a metalanguage about itself." For de Certeau, a recognition that the "ordinary" and the "popular" can act as a mask in analytical discourse does *not* imply that the study of popular culture is impossible except as recuperation. Instead, it demands that we show *how* the ordinary introduces itself into analytical techniques, and this requires a displacement in the institutional practice of knowledge:

> Far from arbitrarily assuming the privilege of speaking in the name of the ordinary (it cannot *be* spoken), or claiming to be in that general place (that would be a false "mysticism"), or, worse, offering up a hagiographic everydayness for its edifying value, it is a matter of restoring historicity to the movement which leads analytical procedures back to their frontiers, to the point where they are changed, indeed disturbed, by the ironic and mad banality that speaks in "Everyman" in the sixteenth century, and that has returned in the final stages of Freud's knowledge.... (5)

In this way, he suggests, the ordinary "can reorganize the place from which discourse is produced." I think that this includes being very careful about our enunciative and "anecdotal" strategies—more careful than much cultural studies has been in its mimesis of a popular voice—and their relation to the institutional *places* we may occupy as we speak.

In spirit, de Certeau's work is much more in sympathy with the *bricoleur* impulse of cultural studies than with apocalyptic thinking. The motto of his book could be the sentence "People have to make do with what they have" (18). Its French title is *Arts de faire:* arts of making, arts of doing, arts of making do. Its project, however, is not a theory of popular culture but "a science of singularity": a science of the relationship that links "everyday pursuits to particular circumstances." So the study of how people use mass media, for example, is defined not in opposition *to* "high" or "elite" cultural analysis, but in connection *with* a general study of *activities*—cooking, walking, reading, talking, shopping. A basic operation in the "science" is an incessant movement between what de Certeau calls "polemological" and "utopian" spaces of making do (15–18): a movement which involves, as my quotations may suggest, both a poetics and a politics of practice.

The basic assumption of a polemological space is summed up by a quotation from a Maghrebian syndicalist at Billancourt: "They always fuck us over." This is

a sentence that seems inadmissible in contemporary cultural studies: it defines a space of struggle, and mendacity ("the strong always win, and words always deceive"). For the peasants of the Pernambuco region of Brazil, in de Certeau's main example, it is a socioeconomic space of innumerable conflicts in which the rich and the police are constantly victorious. But at the same time and in the same place, a Utopian space is reproduced in the popular legends of *miracles* that circulate and intensify as repression becomes more absolute and apparently successful. De Certeau mentions the story of Frei Damiao, the charismatic hero of the region.

I would cite, as a parable of both kinds of space, a television anecdote about the Sydney Birthday Cake Scandal. In 1988, governments in Australia spent lavish sums of money on bicentenary celebrations. But it was really the bicentenary of Sydney as the original penal colony. In 1988 "Australia" was in fact only eighty-seven years old, and so the event was widely understood to be a costly effort at simulating, rather than celebrating, a unified national history. It promoted as our fable of origin not the federation of the colonies and the beginnings of independence (1901) but the invasion of Aboriginal Australia by the British penal system—and the catastrophe that, for Aborigines, ensued.

A benevolent Sydney real-estate baron proposed to build a giant birthday cake above an expressway tunnel in the most famous social wastage-and-devastation zone of the city, so we could know we were having a party. The project was unveiled on a TV current affairs show, and there was an uproar—not only from exponents of good taste against kitsch. The network switchboards were jammed by people pointing out that, above the area that belongs to junkies, runaways, homeless people, and the child as well as adult prostitution trade, a giant cake would invoke a late eighteenth-century voice quite different from that of our first prison governor saying, "Here we are in Botany Bay." It would be Marie Antoinette saying, "Let them eat cake." There was nothing casual or distracted about *that* voxpop observation.

The baron then proposed a public competition, again via TV, to find an alternative design. There were lots of proposals: a few of us wanted to build Kafka's writing machine from "In the Penal Colony." Others proposed an echidna, a water tower, a hypodermic, or a giant condom. The winner was a suburban rotary clothesline: Australia's major contribution to twentieth-century technology, and thus something of a symbol for the current decline in our economy. But in the end, the general verdict was that we'd rather make do with the cake. As one person said in a voxpop segment, "At least with the cake, the truth about the party is all now out in the open." So had the cake been built, it would have been, after all that polemological narrativity, a wildly Utopian popular monument.

No monument materialized, and the story died down. However, it reappeared in a different form when an extravagant birthday party was duly held on January 26, 1988. Two and a half million people converged on a few square kilometers of harbor foreshore on a glorious summer's day to watch the ships, to splash about, to eat and drink and fall asleep in the sun during speeches. The largest gathering of Aboriginal people since the original Invasion Day was also held, to protest the proceedings. The party ended with a fabulous display of fireworks, choreographed to music progressing "historically" from the eighteenth century to the present. The

climax was "Power and the Passion," a famous song by Midnight Oil (Australia's favorite polemological rock band), which is utterly scathing about public as well as "popular" chauvinist culture in urban white Australia. Only those watching the celebrations on TV were able to hear it and to admire the fireworks dancing to its tune. The day after, a slogan surfaced in the streets and on the walls of the city and in press cartoons: "Let them eat fireworks."

For de Certeau, a polemological analysis is entailed by "the relation of procedures to the fields of force in which they act" (de Certeau 1984: xvii). It maps the terrain and the strategies of what he loosely calls "established powers" (in opposition not to the "powerless" but to the nonestablished, to powers and possibilities not in stable possession of a singular *place* of their own). This analysis is an accompaniment, and not an alternative or a rival, to Utopian tactics and stories. Polemological and Utopian spaces are distinct, but in proximity: they are "alongside" each other, not in contradiction.

These terms need clarification, since it is not just a matter of opposing major to minor, strong to weak, and romantically validating the latter. A strategy is "the calculus of force-relationships which becomes possible when a subject of will and power (a proprietor, an enterprise, a city, a scientific institution) can be isolated from an 'environment'" (xix). Strategy presupposes a place of its own, one circumscribed as "proper," and so predicates an exterior, an "outside," an excluded Other (and technologies to manage this relationship). Tactics, however, are localized ways of using what is made available—materials, opportunities, time and space for action—by the strategy of the other, and in "his" place. They depend on arts of *timing*, a seizing of propitious moments, rather than on arts of colonizing space. They use "the place of the other," in a mode of *insinuation*—like the street slogans in my example, of course, but more exactly like the mysterious appearance of "Power and the Passion" in the festive choreography of State.

The "miracle" created by the appearance of this heretical song did not necessarily derive, unlike the graffiti, from a deliberate act of debunking—although it's nice to think it did. While Midnight Oil's public image in Australia is unambiguously political, it is just possible that for the ceremony planners, the reference may have been more like Ronald Reagan's "Born in the USA": a usage crucially inattentive to detail, but functional, and not inaccurate, in mobilizing parts of a resonant myth of how Sydney feels as a *place*. But the intention didn't matter: the flash of hilarity and encouragement the song gave viewers otherwise mortified by the Invasion festival would be, in de Certeau's terms, a product of *their* "tactical" use of the show, their insinuation of polemical significance into the place of programmed pleasure.

It is in this sense of popular practice as a fleeting appropriation, one which diverts the purposive rationality of an established power, that de Certeau's theory associates consumer "reading" with oral culture, and with the survival skills of colonized people: like dancers, travelers, poachers, and short-term tenants, or "voices" in written texts, "they move about ... passing lightly through the field of the other" (131). In this movement, polemological space is created by an "analysis of facts": not facts as objectively validated by a regime of place, but facts produced by *experience* of another place, and time spent on the other's terrain. Polemological analysis in this sense accords no legitimacy to "facts." "They always fuck us over" may be a fact but not a law: Utopian spaces deny the immutability and authority

of facts, and together both spaces refuse the fatality (the *fatum*, "what has been spoken," destiny decreed) of an established order.

This general definition of popular culture as a *way of operating*—rather than as a set of contents, a marketing category, a reflected expression of social position, or even a "terrain" of struggle—is at once in affinity with the thematics of recent cultural studies and also, I think, inflected away from some of its problems.

Like most theories of popular culture today, it does not use "folk," "primitive" or "indigenous" cultures as a lost origin or ideal model for considering "mass" cultural experience. Unlike some of those theories, it does not thereby cease to think connections between them. Global structures of power and forces of occupation (rationalizing time and establishing place) do not drop out of the analytical field. On the contrary, imperialism and its knowledges—ethnology, travel writing, "communications"—*establish* a field in which analysis of popular culture becomes a tactical way of operating.

De Certeau shares with many others a taste for "reading" as privileged metaphor of a *modus operandi*. However, the reading he theorizes is not a figure of "writerly" freedom, subjective mastery, interpretive control, or caprice. To read is to "wander through an imposed system" (169)—a text, a city street, a supermarket, a State festivity. It is not a passive activity, but it is not independent of the system it uses. Nor does the figure of reading assert the primacy of a scriptural model for understanding popular culture. To read is not to write and rewrite but to travel: reading borrows, without establishing a "place" of its own. As a schooled activity, reading happens at the point where "*social* stratification (class relationships) and *poetic* operations (the practitioner's construction of a text) intersect." So a reader's autonomy would depend on a transformation of the social relationships that overdetermine her relation to texts. But in order not to be another normative imposition, any "politics" of reading would also have to be articulated on an analysis of poetic practices already in operation.

In this framework, popular culture does not provide a space of exemption from socioeconomic constraints, although it may circulate stories of exemption denying the fatality of socioeconomic systems. At the same time, it is not idealized as a reservoir or counterplace for inversions of "propriety" (distraction vs. contemplation, for example). As a way of operating, the practice of everyday life has no place, no borders, no hierarchy of materials forbidden or privileged for use: "Barthes reads Proust in Stendhal's text: the viewer reads the landscape of his childhood in the evening news" (xxi).

De Certeau's insistence on the movement *between* polemological and Utopian practices of making do makes it possible to say that if cultural studies is losing its polemological edge—its capacity to articulate loss, despair, disillusion, anger, and thus to learn from failure—Baudrillard's work has not lost its utopianism but has rather produced too much *convergence* between polemological and (nightmare) Utopian spaces: his stories are negative miracles, working only to intensify the fatality of his "facts."

Yet de Certeau's formulations draw heavily on a distinction between having and not having a place (and on a "fleeting appropriation" of Derrida's critique of *le propre*) which can in turn pose difficulties for feminists, or indeed anyone today

for whom "a room of one's own" is a Utopian aspiration rather than a securely established premise, and for whom a stint of "short-term tenancy" in someone else's place seems less like denying fatality, and more like one's usual fate.

There are serious problems here (and not only for a feminist appropriation of de Certeau's work). Another is the way that any rhetoric of otherness may slide, by association or analogy between historically "othered" terms, toward assimilating its figures of displacement in an ever-expanding exoticism: peasants in Brazil, Maghrebian workers in Billancourt, Barthes in the library, and television viewers in Sydney can come into equivalence in a paradigm of *exempla* of desirably transient practice. And the political question of "positioning" in relation to "practice" in cultural studies is clearly not eliminated by a rhetorical shift from "having" words to "doing" words, from values of propriety to modes of operativity—or from territorializing to technicist frames of reference.

The Practice of Everyday Life doesn't eliminate or avoid these problems, although its solutions may not satisfy feminists. It deals with them through a historical critique of the "logics" of cultural analysis, the objects of study they constitute, and the limits they construct and confront. I need to refer briefly to this critique in order to consider the relation between place, storytelling, and a politics of "banality" in his theory.

There is an insistent "we" structuring de Certeau's discourse, which is not a humanist universal but an (otherwise undifferentiated) marker of a class position in knowledge. It locates the text's project (and the writer and reader of cultural analysis) in a "place"—the scholarly enterprise, the research institution. Whether or not de Certeau's reader is prepared to go along with his tenured (masculine) "we," its placing works to interrupt rather than facilitate any slide toward exoticism. It also creates intervals, or spaces, of polemological reflection on that Utopia for analysis, the non-place of the other. For as Wlad Godzich points out in a foreword to de Certeau's collection of essays *Heterologies*, his "other" "is not a magical or a transcendental entity; it is the discourse's mode of relation to its own historicity in the moment of its utterance" (de Certeau 1986: xx).

In the quotations with which I began my discussion of *The Practice of Everyday Life*, the "regrets" of research involve a moment of remembering "the element of chance introduced by circumstances … everything that speaks, makes noises, passes by, touches us lightly, meets us head on." Since these fugitive encounters with the other are also the very object of analysis, remembering entails not only a poetics of regret but also a history of forgetting, a "struggle against oblivion." If the taste of strawberries or abandonment can "alternately exacerbate and disrupt our logics," it is not because of some essential inadequacy of "thought" (analysis) in relation to "feeling" (the popular), as Iain Chambers's mind/body dualism implies; nor is it because of a tantalizing gap in *being* founding the subject's pursuit of its objects (that famous "lack" still assumed, if parodied, by Baudrillard's theory of fatality). It is, rather, that what may transform analytical procedures at their frontiers is precisely a "banality" of which the repression has constituted *historically* an enabling, even empowering, condition for the study of popular culture.

This is a large thesis, which rests on several distinct arguments. I can mention only two, in drastically simplified form. One is a historical account of how French scholarly interest in popular culture emerged during the nineteenth century

from projects to destroy or "police" it, and how this primary "murder" inflects procedures still used today: for example, thatplaak of identification which leads cultural historians into writing, in the name of the "popular," other-effacing forms of intellectual autobiography (de Certeau 1986, 119–36). The second argument takes the form of an allegory of the relationship between European writing and "orality" since the seventeenth century. It combines a history of a socioeconomic and technological space ("the scriptural economy") with an interpretation of the emergence of modern disciplines, and of the birth-in-death of "the other." The work of Charles Nisard (*Histoire des livres populaires*, 1954) is the focus for the first account, and Defoe's *Robinson Crusoe* (1719) is read as an inaugural text for the second.

They are linked by a claim that the scriptural economy entailed for intellectuals a "double isolation" from the "people" (in opposition to the "bourgeoisie") and from the "*voice*" (in opposition to the "written"): "Hence the conviction that far, too far away from economic and administrative powers, 'the People speaks'" (131–32). This new "voxpop" (my term, not his) becomes both an object of nostalgic longing and a source of disturbance. Thus Robinson Crusoe, master of the island, the white page, the blank space (*espace propre*) of production and progress, finds his scriptural empire haunted by the "crack" or the "smudge" of Man Friday's footprint on the sand—a "silent marking" of the text by what *will* intervene *as voice* ("a marking of language by the body") in the field of writing (154–55).[2] With the figure of Man Friday appears a new and long-lasting form of alterity defined *in relation to* writing: he is the other who must either cry out (a "wild" outbreak requiring treatment) or make his body the vehicle of the dominant language—becoming "his master's voice," his ventriloquist's dummy, his mask in enunciation.

If this is a large thesis, it is also today a familiar one, not least with respect to its form. Defining the "other" (with whatever value we invest in this term in different contexts) as the repressed-and-returning in discourse has become one of the moves most tried and trusted to (re)generate writing, remotivate scriptural enterprise, inscribe signs, maybe myths, of critical difference. De Certeau admits as much, describing the "problematics of repression" as a type of ideological criticism that doesn't change the workings of a system but endows the critic with an appearance of distance from it (41). However, his own emphasis is on "restoring historicity" in order to think the critic's *involvement* in the system, and thus the operations that may reorganize his place.

If the other figures mythically as "voice" in the scriptural economy, the voice in turn discursively figures in the primary form of quotation—a mark or trace of the other. Two ways of quoting have historically defined this voice: quotation as *pretext*, using oral "relics" to fabricate texts, and quotation-*reminiscence*, marking "the fragmented and unexpected return ... of oral relationships that are structuring but repressed by the written" (156). De Certeau gives the first an eighteenth-century name, "the *science of fables*"; the second he calls "returns and turns of voices" ("*retours et tours de voix*"), or "sounds of the body."

The science of fables involves all "learned" hermeneutics of speech— ethnology, psychiatry, pedagogy, and political or historiographical procedures which try to "introduce the 'voice of the people' into the authorized language." As "heterologies,"

or "sciences of the different," their common characteristic is to try to *write* the voice, transforming it into readable products. In the process, the position of the other (the primitive, the child, the mad, the popular, the feminine ...) is defined not only as a "fable," identical with "what speaks" (*fari*), but as a fable that "does not know" what it says. The technique enabling this positioning of the other (and thus the dominance of scriptural labor over the "fable" it cites) is *translation*: the oral is transcribed as writing, a model is constructed to read the fable as a system, and a meaning is produced. John Fiske's "ethnographic" fable of Lucy's response to Madonna provides a step-by-step example of this procedure.[3]

The "sounds of the body" marked in language by quotation-reminiscence are invoked by de Certeau in terms strongly reminiscent of a thematics of Woman— resonances, rhythms, wounds, pleasures, "solitary erections" (the *inaccessibility* of the voice, says de Certeau, makes "people" write), fragmentary cries and whispers, "aphasic enunciation"—"everything that speaks, makes noise, passes by, touches us lightly, meets us head on." Necessarily more difficult to describe than the science of fables, these returns and turns of voices are suggested, rather than represented, by examples: opera (a "space for voices" that emerged at the same time as the scriptural economy), *Nathalie Granger*, Marguerite Duras's "film of voices," but also the stammers, voice-gaps, vague rhythms, unexpectedly moving or memorable turns of phrase that mark our most mundane activities and haunt our everyday prose (162–63).

Perhaps these are the sounds that are banished from Baudrillard's story of the eye—or rather by the "scriptural labor" of his subsequent exegesis. Baudrillard finds a triumph of *literalness* in the woman's substitution of an eye for the letter. So, in the manner of the science of fables, he specifies a meaning for the fable that suits the antifemi*nist* discourse for which it acts as a pretext. However, he does this not by trying to "write" the woman's voice (body) but, on the contrary, by rephrasing an extremist bodily gesture as an urbane triumph of writing.

But we could say instead that a rejection of *writing* is the primary reversal on which the story of the eye depends. The "translation" of the letter as body is precisely a refusal of "literal-ness." The woman sends the eye as commentary (metadiscourse): as Baudrillard notes, her gesture cites and mocks the seducer's courtly platitude. But the "blood" in the envelope is also a reminder of the gap between the rhetorical promise of seduction and its material consequences, in this social code, for women.

In the epistolary novels to which Baudrillard's fable refers (see, for example, *Les lettres de la Marquise de M*** au Comte de R****, by Crébillon fils), the usual outcome is death, often by suicide, for the female co(r)respondent. So the eye sliding out of the envelope cheats death, as well as cheating the seducer of his pleasures. He loses face, but she merely gives him the eye. And it cheats on literary narrative; the eye in this fable is the mark of a high-speed, fast-forward reader who tears to the end of the story without submitting to the rituals of "writing." Something in this fable—perhaps a shudder—leaps from a woman to man in the circuit reserved for the letter, but it doesn't take the form of a pun. It has a historically resonant *eloquence* to which Baudrillard's discourse, even as it tells the story, remains resolutely deaf.

It is crucial to say, however, that in de Certeau's framework both of the major forms of quoting are understood positively as capable (when their history is not forgotten and the position of the "scribe" not denied) of leaving ways for the other to speak. It is precisely this capacity which makes possible a feminist reading of Fiske's and Baudrillard's stories, and which can enable feminist cultural criticism to resist, in turn, its own enclosure as a self-perpetuating, self-reiterating academic practice.

The science of fables uses voices to proliferate discourse: in the detour through difference, quotation alters the voice that it desires and fails to reproduce, but is also altered by it. However, unlike an exoticism which multiplies anecdotes of the same, a "heterological" science will try to admit the alteration provoked by difference. Its reflexivity is not reinvested in a narcissistic economy of pleasure, but works to transform the conditions that make its practices possible, and the positioning of the other these entail.

Quotation-reminiscence "lets voices out": rather than generating discourse, the sounds of the body interrupt it from an "other" scene. As "letting out," this kind of quotation seems to be involuntary: memories rush from that nonplace conveniently cast beyond the citing subject's "domain" of responsibility. However, it is in a "*labor*" of reminiscence that the body's sounds can interrupt discourse not only in the mode of event but as practice. De Certeau sees this "struggle against oblivion" in philosophies which (like Deleuze and Guattari's *Anti-Oedipus*, Lyotard's *Libidinal Economy*) strive to create "auditory space"; and in the "reversal" that has taken psychoanalysis from a "science of dreams" toward "the experience of what speaking voices *change* in the dark grotto of the bodies that hear them" (162, emphasis mine).

So while both of these "ways of quoting" belong to the strategy of the institution, and define the scholarly place, each therefore can be borrowed by tactical operations that—like the recognition of alterity, the labor of reminiscence—change analytical procedures by "returning" them to their limits, and insinuating the ordinary into "established scientific fields." The event of this change is what de Certeau calls "banality": the arrival at a *common* "place," which is not (as it may be for populism) an initial state of grace, and not (as it is in Baudrillard) an indiscriminate, inchoate condition, but on the contrary, the outcome of a practice, something that "comes into being" at the end of a trajectory. This is the banality that speaks in *Everyman*, and in the late work of Freud—where the ordinary is no longer the object of analysis but the *place* from which discourse is produced.

It is at this final point, however, that my reading can fellow-travel no further, and parts company with de Certeau's "we."

A feminist critique of *The Practice of Everyday Life* would find ample material to work with. De Certeau's Muse—the silent other to whom his writing would strive to give voice—is unmistakably The Ordinary Man.[4]

My problem here, however, is specifically with the characteristics of the *scholarly* "place" of enunciation from which the notion of banality is constructed, and for which it can work as a myth of transformation. For to invoke with de Certeau an "ironic and mad banality" that can insinuate itself into our techniques, and reorganize the place from which discourse is produced, is immediately to posit

an awkward position for "scholarly" subjects for whom *Everyman* might not serve as well as "*I Love Lucy*" as a fable of origin, or indeed as a myth of "voice." For me as a feminist, as a distracted media baby, and also, to some extent, as an Australian, the reference to *Everyman* (and, for that matter, to Freud) is rather a reminder of the problems of disengaging my own thinking from patriarchal (and Eurocentric) cultural norms.

The analytical scene for de Certeau occurs in a highly specialized, professional place. Yet in contrast to most real academic institutions today, it is not already *occupied* (rather than nomadically "crossed") by the sexual, racial, ethnic, and popular differences that it constitutes as "other." Nor is it squarely *founded*, rather than "disrupted," by the ordinary experience encountered at its frontiers. It is a place of knowledge secured, in fact, by precisely those historic exclusions which have made it so difficult to imagine or *admit* the possibility of a scholarship "proper" to the other's "own" experience—except in the form of an error (essentialism), or apocalyptic fantasy (rupture, revolution). Construed from de Certeau's "here," the other as narrator, rather than object, of scholarly discourse remains, as a general rule, a promising myth of the future, a fable of changes to come. In other words: in this place, the citing of alterity and the analytical labor of reminiscence promise something like the practice of a "writing cure" for the latter-day Robinson Crusoe.

This is a "fate" all the more awkward for me to assume in that for de Certeau, "place," "the proper," and even "closure" are not always necessarily *bad values*, but modes of spatial and narrative organization everywhere at work in everyday social life. It is the primary function of any *story*, for example, to found a place, or create a field that authorizes practical actions (125). So there is no suggestion in his work that those who have been most intimately marked in history by Man Friday's Alternative (the cry, the impersonation) should not now, in writing their stories, thereby lay claim to a place. The Utopian deferral of an "other" narration in de Certeau's theory occurs, like the apotheosis of banality as the Ordinary *Man*, because the "place" of the other may never coincide with that of any subject of a discourse (nor, of course, the subject's with that of an actual speaker). To dream otherwise is a "false mysticism"—longing for Presence, denial of History, nostalgia for God.

Unfortunately, since the other here is also "the discourse's mode of relation to *its own* historicity in the moment of its utterance" (emphasis mine), this argument encourages us to conclude that scholarly knowledge in the present must continue to be written, and transformed, from Crusoe's place. In practice, of course, de Certeau drew no such conclusion, writing that "the history of women, of blacks, of Jews, of cultural minorities, *etc.*" (my emphasis) puts into question "the subject-producer" of history and *therefore* "the particularity of the place where discourse is produced." But the "*etc.*" points to a problem with the rhetoric of otherness that lingers when the epistemology that sustained it is apparently revised. "Etc." is Man Friday's footprint: a unifying myth of a *common* otherness—Black, Primitive, Woman, Child, People, "Voice," Banality—deriving its value only from its function as negation (polemological challenge, Utopian hope) for that same singular writing subject of historical production.

I am skeptical that a theory grounded on (rather than tactically using) the category of otherness can ever end up anywhere else. However, in the context of cultural studies, the immediate practical disadvantage of this construction of analysis is to reinscribe *alienation* from everyday life as a constitutive rather than contingent feature of the scholar's enunciative place. An old pathos of separation creeps back in here, of which the polarities (elite/popular, special/general, singular/"banal") mark not only the semantic organization of de Certeau's discourse but the narrative thrust of his text. The main line of *The Practice of Everyday Life* moves from its beginnings in "A Common Place: Ordinary Language" to "The Unnamable," a meditation on that absolute other, ultimate frontier, and final banality, Death.

Rather than venturing any further on to that forbidding theoretical terrain, I shall shift the scene of my own analysis to a more congenial place.

One of the enduring lounge-room "institutions" of Australian TV is Bill Collins, host of an ancient show that was once *The Golden Years of Hollywood*, but is now just a time-slot for *Movies*. A former teacher, Collins has spent twenty years using his "place" to define what counts on television as knowledge of cinema history. He now has many competitors and probably not much power, but for years he had a monopoly—years when there were no old films in theaters, no video chains, and no systematic study of media in schools. So it is no exaggeration to say that Collins was one of the founders of Australian screen education.

His pedagogy has changed little with time. Collins is a trivia expert, respectful rather than mocking in his relentless pursuit of the detail. His address to the audience is avuncular, his construction of film auratic. Never raucous or unkind, rarely "critical," his scholarship is a perpetual effusion of an undemanding love. Usually placed in a "home study" decor with posters, magazines, and books, Collins represents knowledge as a universally accessible domestic hobby. It is from his enthusiasms, rather than any formal training (which in this "place" is rather despised), that his authority derives. His "history" is a labyrinthine network of minuscule anecdotes: its grand theme is less the rise and fall of famous careers than the ebb and flow of fortune in the lives of the humbler figures near the bottom of the credits, or toward the edge of the frame. His own image expounds his theme: plump, owlish, chronically middle-aged, unpretentiously dressed, Collins has one eccentricity, a voice just a little bit pompous and prissy.

While I was working on this essay, he showed two films that seemed chosen to stimulate my thinking. Both were fables about "proper" places (malign in one case, benign in the other) and a principle of fatality at work in everyday life.

David Green's *The Guardian* (1984) could have been subtitled *Man Friday's Revenge*. Martin Sheen plays the white husband and father worried about the security of his apartment block, invaded by junkies from the street. After a murder and a rape inside, he persuades the other residents to hire a guardian (Louis Gossett, Jr.). Tough, streetwise, and black, the solitary "John" moves in and makes the place his own. A sinister conflict emerges. Sheen wants a flexible frontier: residents inside, desperados outside, ordinary peaceful neighbors moving in and out as before. Gossett demands strict closure, total control: he bashes visitors, kills intruders, and polices not only the building but the residents' everyday lives.

At last, the sleeping liberal awakens in the would-be white vigilante. Too late: charging off into the night to tackle Gossett *chez lui*, Sheen falls afoul of a ghetto gang. Pulverized by terror, he is saved at last by Gossett—to suffer the ignominy of his own abject gratitude for the guardian's greater violence. Back at the ranch, the two men lock gazes in the final scene of the film: black guardian standing triumphantly inside, undisputed master of the place; white resident creeping furtively outside, insecure and afraid between the zones of home and street—in each of which he will henceforth be but a tenant without authority.

The structural reversal is complete, the moral ambiguity of the moment absolute. Was Sheen's first mistake to accept violence by inviting Gossett in, or was it to deny the implications of this action and, by dithering, lose control? Either way, *The Guardian* dramatizes with white-and-black simplicity a problem besetting any thematics of place primarily articulated by binary oppositions between "haves" and "have-nots," self and other, propriety and mobility. In such a schema, the drifter's desire is colonized as the settler's worst nightmare. The *other's* desire for a place can be represented only in terms of a choice between the *status quo* (critique of property, romance of dispossession) or as a violent reversal of roles that intensifies the prevailing structuration of powers. Totalitarian violence is in the end the true successor to Sheen's liberal paranoia—and it is the only image that the film can admit of what "a room of one's own" for the (black) urban poor might mean.

If *The Practice of Everyday Life* provides a sophisticated attempt to undermine the fatality of this kind of system by introducing nonsymmetry to its terms—theorizing difference rather than contradiction between them, refusing to assign *a priori* a negative value to either side—it nevertheless leaves us stranded when it comes to developing, rather than arriving at, the critical practice of a feminism (for example) already situated *both* by knowledge and social experience of insecurity and dispossession, *and* by a politics of exercising established institutional powers. Similarly, this aspect of de Certeau's work may not be of much help with the problems of an emerging cultural criticism which is equally—though not indifferently— "at home" in a number of sometimes conflicting social sites (academy, media, community group as well as "home" and "street"), moving between them with an agility which may well owe more to imperatives derived from technological changes, and from shifts in employment patterns, than it does to transient desire.

Bill Collins introduced *The Guardian* with a promise that it would unsettle anybody who lived in an apartment. Screening Alfred Hitchcock's *The Trouble with Harry* (1955) for the first time on TV, he saved his lesson till last.

The Trouble with Harry provided the perfect counterpart to the pure polemological message ("they always fuck us over") of *The Guardian*. Subtle, elusive, hilariously amoral in its Utopian treatment of death, it also promised a perfect ending for my essay. For in this film, one day in a quiet mountain village—where few sounds disturb the silence except for the drifting of autumn leaves, the bird song in the valley, the honking of an antique car horn, the popping of a shotgun, the call of an excited child, and the occasional rustle of a rabbit in the grass—the pervasive calm is shattered by the appearance of a corpse.

Harry is a strange body, in more ways than one. He is a foreigner to the valley: the curious insignificance of his death, the incongruity of his presence there, is

established by repeated shots of his feet sticking up as he sprawls headfirst down the hillside. But as the locals begin to arrive, it seems that there may be more trouble in paradise than the mere apparition of Harry. One by one, the adults respond with astounding banality: they talk of blueberry muffins, coffee, elderberry wine, lemonade; a reader trips on the corpse and ignores it, going straight on with his book; a tramp steals Harry's shoes; an artist sketches the scene. The initial suspect, watching from the bushes, mutters: "Next thing you know they'll be televising the whole thing!"

As the mystery of these responses begins to be dispelled, another takes its place. The inhabitants of this tiny village barely know each other, and coexist in an anomic isolation far exceeding small-town discretion. This may be a not-quite-innocent paradise, but it isn't really a *place*; a Utopia, but not a community. But when the truth of Harry's death starts to emerge from a casual chat about destiny, new relationships swiftly develop. During the ensuing narrative play between deception and detection, the corpse shifts repeatedly between temporary homes—in the ground, on the hillside, in the bathtub. Only when the full story has been told does Harry find his proper location (where he was in the beginning) and identity (as a banal victim of a fatal heart attack); couples are formed, first names exchanged, histories shared, community established; and, when the founding of a place is complete, "the trouble with Harry is over."

Grasping something like this in my first viewing, thrilling in an allegorical sensitivity to each phrase, every scene, that echoes *The Practice of Everyday Life*, I resolved to do a reading of the film—forgetting that to retrieve a given theory of popular culture from a text framed as an *exemplum* of both would be to produce, at the end of my trajectory, precisely the kind of "banality" I was setting out to question.

I did not long enjoy the contemplation of my intention. "Did you notice," asked Bill Collins in his meditative moment, "how everyone in this film seems to *want* to feel guilty?" "*That's not the point!*" I told the television, ready with my counterthesis. "Well," declared that irritating voice, "there's a Ph.D. in that!"

In a fascinating essay on the figure of the speaking voice in the work of Rousseau and Plato, Michèle Le Doeuff points out that this voice (indefinite, uncertain, irrational in its effects, "*celle dont on aurait pu penser qu'elle était la banalité même*") may function in philosophy not only as an emblem of the other but, therefore, as an instrument of demarcation whereby a theory can speak obliquely not of voices but of philosophy itself—its limits, its failures, and its problems of legitimacy.

I suspect that in cultural studies, its function is rather the opposite. Parasitic on philosophy as cultural studies has been, it is perhaps today the discipline most at odds with the historic, self-legitimating dream of philosophical autonomy analyzed by Le Doeuff in *L'imaginaire philosophique*. Careless about its own epistemological grounding, its theoretical integrity, and its difference from "other" discourses, cultural studies has been more concerned (and, I think, rightly so) with analyzing and achieving political effects. It may be for this reason, then, and along with the historical determinations that de Certeau describes, that the "banality" of the speaking voice becomes in cultural studies a way of *suspending* the question of legitimation, and all the problems that question entails.

"Banality," after all, is one of the group of words—including "trivial" and "mundane"—whose modern history inscribes the disintegration of old European ideals about the common people, the common place, the common culture. In medieval French, the "banal" fields, mills, and ovens were those used communally. It is only in the late eighteenth century (and within the "scriptural economy") that these words begin to acquire their modern sense of the trite, the platitudinous, the unoriginal.

So if banality is an irritant that repeatedly returns to trouble cultural theory, it is because the very concept is part of the modern history of taste, value, and critique of judgment that constitutes the polemical field within which cultural studies now takes issue with classical aesthetics. "Banality" as mythic signifier is thus always a mask for questions of value, of value judgment, and "discrimination"—especially in the sense of how we distinguish and evaluate *problems* (rather than cultural "products"), legitimate our priorities, and defend our choice of what matters.

This is a debate which has barely begun, and which is all the more complex in that the professional protocols inherited by cultural studies from established disciplines—sociology, literary criticism, philosophy—may well be either irrelevant or contentious. If I find myself, for example, in the contradictory position of wanting polemically to reject Baudrillard's use of "banality" as a framing *aesthetic* concept to discuss mass media, yet go on to complain myself of a syllogistic "banality" in British cultural studies, the dilemma can arise because the repertoire of critical strategies available to people wanting to theorize the discriminations that they make in relation to their experience of popular culture—without needing to defend the validity of that experience, still less that of culture *as a whole*—is still extraordinarily depleted.

And there is an extra twist to the history of banality. In the Oxford version of this history, it has a double heritage in, on the one hand, old English, *bannan*—to summon, or to curse—and a Germanic *bannan*: to proclaim *under penalty*. So banality is related to banishing, and also to wedding *bans*. In other words, it is a figure inscribing power in an act of *enunciation*. In medieval times it could mean two things besides "common place." It could mean to issue an edict or a summons (usually to war). That was the enunciative privilege of the feudal lord. Or it could mean to proclaim under orders: to line the streets, and cheer, in the manner required by the call "*un ban pour le vanqueur!*" To obediently voice a rhythmic applause is the "banal" enunciative duty of the common people, the popular chorus.

This two-sided historical function of banality—lordly pronouncement, mimetic popular performance—is not yet banished from the practice of theorizing the popular today. It's very hard, perhaps impossible, not to make the invoked "voice" of the popular perform itself obediently in just that medieval way in our writing. However, when the voice of that which academic discourses—including cultural studies—constitute *as* popular begins in turn to theorize its speech, then you have an interesting possibility. That theorization may well go round by way of the procedures that Homi Bhabha has theorized as "colonial mimicry," for example, but may also come around eventually in a different, and as yet Utopian, mode of enunciative practice. However, I think that this can happen only if the complexity of social experience investing our "place" as intellectuals today— including the proliferation of different places in and between which we may learn and teach

and write—becomes a presupposition of, and not an anecdotal adjunct to, our practice.

For this reason, I think that feminists have to work quite hard in cultural studies *not* to become subjects of banality in that old double sense: not to formulate edicts and proclamations, yet to keep theorizing, not to become supermimics in the Baudrillardian sense of becoming, by reversal, the same as that which is mimicked, yet to refuse to subside either into silence or into a posture of reified difference. Through some such effort, pained and disgruntled subjects, who are also joyous and inventive practitioners, can begin to articulate our critique of everyday life.

Notes

1 This sectarianism may be partly a result of the notions of "negotiated," "resistant," and "oppositional" *readings* that still play such a large part in our analyses. In the end, the aim of analysis becomes to generate one of these, thus repeatedly proving it possible to do so. Since there is little point in regenerating a "dominant" reading of a text (the features of which are usually presupposed by the social theory that frames the reading in the first place), the figure of a misguided but onside Other is necessary as a structural support to justify the exercise and guarantee the "difference" of the reading.

2 De Certeau restricts the use of a writing/orality opposition in several important ways. First, there can be no *quest* for this voice "that has been simultaneously colonized and mythified" (132). There is no origin, authenticity, or spontaneity of presence to be found in a mythic voxpop, and no "pure" voice independent either of the scriptural systems that it inhabits or of the ways of "hearing"/receiving by which it is codified.

 Second, "writing" and "orality" should not be construed as terms *that always* found a metaphysical opposition, the recurrence of which analysis can perpetually retrace. If "writing" and "orality" can function now as imaginary unities, they do so as a result of reciprocal distinctions made "within successive and interconnected historical configurations," from which they cannot be isolated (133). (Cf. *L'écriture de l'histoire*, Part III, "Systèmes de sens: l'écrit et l'oral.")

 Third, the orality in question is one *changed* by three or four centuries of Western fashioning. It cannot be "heard" except as insinuation in the text of the scriptural economy. In Defoe's "theoretical fiction," Man Friday's footprint is not another local trace of an eternal illusion of presence. It represents the emergence of something *novel* in Defoe's text, outlining "a *form* of alterity in relation to writing that will also impose its identity on the voice ... " (155).

3 In this perspective, "pop epistemology" works in a slightly different way. It "writes the voice" by effacing scriptural labor, as well as the translation that makes "distraction" readable, thus producing a fable of the coincidence of its own writing with "what speaks" in popular culture. The problem here is not that the "materiality" of writing is effaced but that the relationship of this practice to the disciplinary history from which it emerges (and which it claims to contest) is simply ignored.

4 Certainly, he is a Man now marked as Woman, Child, or Savage (and the text is sensitive to the problem of assimilating any one of these terms to the bodies of people they have been used to represent). However, de Certeau's history of this marking presupposes the indifference of the primary figure.

PART TWO

Culture in space

Henri Lefebvre

NOTES ON THE NEW TOWN

EDITOR'S INTRODUCTION

THIS ESSAY NEEDS TO BE READ alongside Michel de Certeau's 'Walking in the City'. Lefebvre was one of the most widely read Marxist intellectuals of the postwar period and was a major influence on Guy Debord and the Situationists. Within cultural studies he is mainly remembered as a theorist of everyday life, alongside de Certeau and Debord. 'Notes on the New Town' is a late essay in his career and has a strangely baroque structure, almost as if it could have been written in the eighteenth century — much of it consists of a monologue by a philosopher on a hill overlooking a 'new town', namely a state-organized high rise development aimed at replacing the old slum-dwellings of the working class. Such developments were commonplace across Western Europe during the late 1950s and 1960s and it's safe to say that they are generally regarded as a planning/housing fiasco.

Lefebvre's piece begins in what seems a straightforward lament for the end of the old organic working-class community (a note struck for instance by Richard Hoggart in *The Uses of Literacy*) but in fact among the boredom, abstraction and alienation of the new high rises he sees the potential for emancipation. In a way, this analysis shares something with that of Walter Benjamin in the essay anthologized here. It's not their methods or philosophical background that are similar (Lefebvre's piece is conceptually much simpler than Benjamin's), rather it's their contempt for modern life and desire for emancipation from it and then their will to find emancipatory moments within the forms of life that they see as empty and reducing the meaning of existence.

Further reading: Couldry 2004; Harvey 2001; Highmore 2001 and 2005; Plant 1992; Shields 1999.

A few kilometres away from the tower blocks of the new town lies the sleepy old village where I live. Just a few minutes from my timeworn house, and I am surrounded by the derricks of a building estate without a past.

N. is medieval, but not obviously so (it was built to a fairly regular plan in the fourteenth century, by a bridge over the Gave on the road from Le Puy to Santiago de Compostela, and on the site of a much older hamlet; in its time it was a new town, and an even newer one two centuries later when it was rebuilt on an even more geometric groundplan, and ringed with Italianate ramparts). I know every stone of Navarrenx. In these stones I can read the centuries, rather as botanists can tell the age of a tree by the number of rings in its trunk. But for Navarrenx — as for many other places, villages and towns — a different analogy springs to mind: the image of the seashell. A living creature has slowly secreted a structure; take this living creature in isolation, separate it from the form it has given itself according to the laws of its species, and you are left with something soft, slimy and shapeless; what can it possibly have in common with this delicate structure, its ridges, its grooves, its symmetries, its every detail revealing smaller, more delicate details as you examine it more closely? But it is precisely this link, between the animal and its shell, that one must try to understand. It summarizes the immense life of an entire species, and the immense effort this life has made to stay alive and to maintain its own characteristics. History and civilization in a seashell, this town embodies the forms and actions of a thousand-year-old community which was itself part of a wider society and culture, ever more distant from us as the years pass by. This community has shaped its shell, building and rebuilding it, modifying it again and again according to its needs. Look closely, and within every house you will see the slow, mucous trace of this animal which transforms the chalk in the soil around it into something delicate and structured: a family. Every house has its own particular face. It is amazing the diversity which can be obtained spontaneously from the same unchanging (or 'structural') regional elements, like the gallery used for drying corncobs which also served as a passageway from room to room, or the big covered entrance for the carts on their way to the barns where corn and barley were threshed with a flail. On the inside and the outside of these old houses the functionally practical and the ornamentally superfluous live side by side in a matter-of-fact way, often (but not always) attractive, as charming as they are understated. The word 'charm' suits them better than 'beauty' or 'style', even if they indubitably express a certain taste and lifestyle. Vividly coloured roughcast adorns each dwelling; it protects the walls from the weather, as well as offering a traditional protection against evil spirits. Each village is a construct in its own right, and so is each house. Everything about them forms a kind of unity: goals, functions, forms, pleasures, activities. Although the different neighbourhoods in N. have their own vague sort of individuality (around the cattle market, around the church and in the outskirts beyond the walls), none of them has a separate identity; there are no residential areas separated from the places where people work or enjoy themselves (sometimes). There is no clear-cut difference, yet no confusion between the countryside, the streets and the houses; you walk from the fields into the heart of the town and the buildings, through an uninterrupted chain of trees, gardens, gateways, courtyards and animals. In the town, the street is not a wasteland, nor is it the only place where — for good or ill — things happen. It is

not the only human place. Spontaneous and transitionary, it is not simply there so that people can get from A to B, nor does it lay traps for them with lighting effects and displays of objects. It is a place to stroll, to chinwag, to be alive in. Nothing can happen in the street without it being noticed from inside the houses, and to sit watching at the window is a legitimate pleasure. But the passers-by get their own back by staring down the corridors and into the courtyards. The street is not an overprivileged means of communication, but neither has ill fortune emasculated it. The street is something integrated. Listen to the song of the craftsmen and their hammers, listen to the shrilling of the carpenters' planes and the children crying and the mothers scolding. There may be nicer and more picturesque places, but there were not many – in times gone by – which were more evenly balanced. They were never without their hidden conflicts, but that is another story.

But none of this really obtains any more. This small town, with its craftsmen and shopkeepers, in its well-established context of peasantry and countryside, is vegetating and emptying, like so many other dying villages and towns. The expiring seashell lies shattered and open to the skies. The surviving shopkeepers are little more than managers. The craftsmen? You could count them on the fingers of one hand. Market day has been the same since the fourteenth century, but the market itself is tiny compared with what it used to be. The street is filled with cars and lorries; it is getting more and more noisy, more and more like a wasteland. N. is boring, like everywhere else is boring, and more and more so. It always was boring, but in times gone by that boredom had something soft and cosy about it, like Sundays with the family, comforting and carefree. There was always something to talk about, always something to do. Life was lived in slow motion, life was *lived* there. Now it is just boring, the pure essence of boredom....

Whenever I step foot in Mourenx I am filled with dread. Yet the new town has a lot going for it. The overall plan (the master blueprint) has a certain attractiveness: the lines of the tower blocks alternate horizontals and verticals. The break between the landscape – wooded hills, moorland, vineyards – and the city may be rather abrupt, but it is bearable; it is relatively easy on the eye. The blocks of flats look well planned and properly built; we know that they are very inexpensive, and offer their residents bathrooms or showers, drying rooms, well-lit accommodation where they can sit with their radios and television sets and contemplate the world from the comfort of their own homes.... Over here, state capitalism does things rather well. Our technicists and technocrats have their hearts in the right place, even if it is what they have in their minds which is given priority. It is difficult to see where or how state socialism could do any differently and any better.

Yet every time I see these 'machines for living in' I feel terrified. When the technologues and 'mechanologues' of today describe the latest machines, they present them as being less inert and closed-off than perhaps we had thought. They are supposedly less fragmenting for work; they constitute a 'milieu' with an existence and life of its own, and act as a mediator between nature and human beings, both as individuals and as groups. Such descriptions are of the greatest interest. When they review the question of machines, it is in the light of the most recent developments in science and technology. But if proof for what they say is to be found, it is not here in Mourenx but a short walk away, in the dazzling and gigantic factory at Lacq. Here in Mourenx, what do I see? These blocks of flats

are also 'technological objects' and machines. Will they be able to provide a new humanism? Are they already providing it? Can they mediate between man and nature, between one man and another? Are they bringing individuals, families and groups together, or are they forcing them apart? Will people be compliant and do what the plan expects them to do, shopping in the shopping centre, asking for advice at the advice bureau, doing everything the civic centre offices demand of them like good, reliable citizens? (We should not overlook the fact that as yet these centres exist only on paper, and of course they can only be an improvement – as and when they materialize!) Can spontaneity be revitalized here, can a community be created? Is the functional being integrated into an organic reality – a life – in a way which will give that reality a structure it will be able to modify and adapt? As yet I cannot give a firm answer. The hypothesis is plausible, and it produces a whole new string of questions. Here, in Mourenx, what are we on the threshold of? Socialism or supercapitalism? Are we entering the city of joy or the world of unredeemable boredom?

Mourenx has taught me many things. Here, objects wear their social credentials: their function. Every object has its use, and declares it. Every object has a distinct and specific function. In the best diagnosis, when the new town has been successfully completed, everything in it will be functional, and every object in it will have a specific function: its own. Every object indicates what this function is, signifying it, proclaiming it to the neighbourhood. It repeats itself endlessly. When an object is reduced to nothing but its own function, it is also reduced to signifying itself and nothing else; there is virtually no difference between it and a signal, and to all intents and purposes a group of these objects becomes a signalling system. As yet there are not many traffic lights in Mourenx. But in a sense the place is already nothing but traffic lights: do this, don't do that. When objects are reduced to the basic level of a signifier they become indistinguishable from things *per se*, they are left naked, stripped bare, robbed of meaning. With signals as with signs (in language), the final element which signifiers adhere to and separate from is a basic fact, a thing: the red light, the phoneme. Here nothing noticeable happens (or apparently not). Only one event is possible: total explosion, total collapse. To put it in terms of information theory: everything is almost a hundred per cent redundant. Everything is clear and intelligible. Everything is trivial. Everything is closure and materialized system. The text of the town is totally legible, as impoverished as it is clear, despite the architects' efforts to vary the lines. Surprise? Possibilities? From this place, which should have been the home of all that is possible, they have vanished without trace.

In Mourenx, modernity opens its pages to me. It is just like a 'novel of objects' (no, I must ask contemporary novelists to excuse me, that is not right – I mean just like a propaganda leaflet). Here I cannot read the centuries, not time, nor the past, nor what is possible. Instead I read the fears modernity can arouse: the abstraction which rides roughshod over everyday life – the debilitating analysis which divides, cuts up, separates – the illusory synthesis which has lost all ability to reconstruct anything active – the fossilized structures, powerless to produce or reproduce anything living, but still capable of suppressing it – the father figures who feel they have to be cruel to be kind: the state, the police, the Church, God

(and the absence of God), the *gendarmerie*, caretakers, offices and bureaucracy, organization (and lack of organization), politics (and all its shortcomings).

The bourgeoisie had an indisputable genius for analysis and analytical reasoning, the evil genius of abstraction and separation. It still has it – or at least, its most intelligent members, the technocrats, still have it. The bourgeoisie did not create this genius (it was born with the beginnings of logic), nor have they exhausted it. It has survived them. For all we know, socialism will have to undergo the same process. To use 'class perspective' to deny this would be one-sided, and grossly partisan. Syntheses, totalities, the total man, supersessions – all have been sadly lacking; the only course open to us is to wait patiently for a higher unity to emerge. As for the bourgeoisie, it adopted analytical reasoning and made it its own specific mentality. With all its effectiveness, theoretical and practical, material and non-material, the bourgeois mentality has dismembered everything which had hitherto been organically united: nature and the social man, being and thought, work, actions, activities, generations, ideas, feelings, functions, forms. Nowadays it is even dislocating words and discourse, the elements of discourse, 'structures'. It has taken the technical division of labour to such extremes that it seems that the rediscovery of unity and totality must be just around the corner, so intolerable is the sense of separation.

From this perspective the bourgeois era was characterized by a colossal analysis – indispensable, effective, terrifying – which has been turned into objective reality and projected on to the new towns. Everything which could be has been separated and differentiated: not only specific spheres and types of behaviour, but also places and people. All those things which have made up the interwoven texture of the spontaneous places of social living since the neolithic village have been hurled one by one into time and space. Consequently, the intermediaries between these disjointed elements (when there are any, which is always a good thing: means of communication, streets and roads, signals and codes, commercial agents, etc.) take on an exaggerated importance. The links become more important than the 'beings' who are being linked. But in no way does this importance endow these intermediaries with active life. Streets and highways are becoming more necessary, but their incessant, unchanging, ever-repeated traffic is turning them into wastelands. Retail is becoming more important than production, exchange more important than activity, intermediaries more important than makers, means more important than ends. And everything is subsiding into boredom.

This is not the result of some demonic intervention or the consequence of bourgeois stupidity alone. A more objective necessity is in operation. Maybe it was necessary to push distance and separation to their utmost limits. Knowledge and action can function effectively only on distinct and separate elements. Analysis must be taken to its logical conclusion – which entails the death and dismemberment of what is being analysed – before thinking and living can be reunited. For praxis to become whole again, it has to have been fragmented and disjointed. Finally, in the course of man's increasing control over nature – in economic and social development – there comes a moment when all the forces begin growing for themselves, almost as though they were autonomous: technology, demography, art, science, etc. Everything becomes disjointed, yet everything becomes a totality.

Everything becomes reified, yet everything starts disintegrating. The aleatory is triumphant.

These are paradoxes. We are offered the 'world' as though it were a Meccano set, broken up into thousands of little 'worlds'. At the same time, this dislocation – which is undermining the very foundations of praxis, of consciousness, of activity – is underpinned by an increasingly vigorous integration. On this vast field of human fragments, the state has built its watchtower. Society is becoming increasingly socialized, at a time when socialism has failed to offer any convincing solutions to the problems left hanging in midair by bourgeois society – except for one, which no longer concerns us directly: the problem of accumulation and economic growth without internal checks. This may guarantee the victory of socialism in the long term, but it still leaves us with all the other questions unanswered.

One of these aspects constantly makes us forget the other. On the one hand, the tendency towards totalization and 'integration' (in the social system as a whole – in other words, in the state) prevents us from seeing how disjointed everything is becoming. On the other hand, the fragmentation of everyday life is now much more extensive than the fragmentation of labour (something which may disappear in the not-too-distant future), and it prevents us from realizing that unification is being imposed from above, and that all original differences are being eliminated. The truth is to be found in the movement of totalization and fragmentation taken as a whole. This is the truth we read in that obscure and legible text: the new town.

When I come to Mourenx by road, I always climb a small hill which overlooks the brand-new housing estate, where the water tower is being built. As an intellectual of the Left and a philosopher (or ex-philosopher), I am not afraid of looking ridiculous; it is obvious that any gentleman who sits on a hilltop to meditate on the destiny of the housing estate below is perfectly ridiculous – or almost. And here are the things I have told myself so many times during my hilltop meditation:

'It is impossible for you not to be reminded here of what Marx wrote when he was still a young man: "Big industry ... took from the division of labour the last semblance of its natural character. It destroyed natural growth in general ... and resolved all natural relationships into money relationships. In place of naturally grown towns it created the modern, large industrial cities which have sprung up overnight." So think back to the medieval towns, swarming with activities and natural life. Nothing was disjointed, and everything opened out on to everything else: work and passing-through places, house and street, countryside and buildings, exchange and production, private life and public life. There, as Marx said, the life of the people and the life of the state coincided. It was democracy, it was lack of freedom – vitality and poverty, splendour and derision. You have seen something like it in the medinas of Islam. There is still a trace of it in the village where you live.

'Above all, think of the polycentric cities of Greece. The agora, the temple and the stadium regulated not only the way the inhabitants moved about, but also their interests and their passions, in an organic way. The way the city was structured coincided almost entirely with its way of life. Passions and rhythms, cycles in time and space – all was in harmony. There, the feeling of personal dignity and freedom was a part of social living. Civil society – in other words, the overall system of

social relations which constituted men as individuals – was in harmony with the state, in so far as there was a state. The state coincided with the city and civil society to form a whole, and private life was subservient to it.

'Here, up until now, in comparable towns, everything has failed. You have seen the proof for yourself. You have seen the people who live in the new town, you have spoken to them. You call yourself a sociologist, but you haven't even come up with any useful concepts for understanding them. Of what relevance to them are theories on adaptation and non-adaptation? For them, to adapt means being forced into a pre-existing context which has been built without them in mind. It means ceasing to exist. And not adapting is like suffering a vague, nagging pain. No doubt this is what they have chosen (is 'choose' really the right word?): protest and pain. That is their way of adapting. There they are. When they arrived, they were hoping for a radiant life. They thought the new estate would be like a holiday camp. That was what they had been promised. Then came the shock. The initial disappointment may lose its edge, but it is as tenacious as the scar left by a deep wound. People are only too aware of the shortcomings of this society to which they do not belong. And despite being keenly conscious of this, their everyday life becomes gradually numb. They sink into the stupor of indifference. The day will come when they will insist that they are satisfied. What will that insistence conceal? What can life really be like for the couples who live in this town knowing that it cannot last more than twenty to twenty-five years, since its energy sources are dwindling? One thing this means is that they have no hope of growing old with their children close at hand.

'Don't forget that many of them have already been transplanted at least once before. Most of them have already been uprooted. Their happiness and their solace is also the bane of their lives: children. Shortly you will go to see some people you know in that tower block down there. You will ask them if the noise the kids make is as unbearable as ever. Just a minute, that would be a useful statistic: the threshold beyond which the number of kids per floor makes life unbearable. Just the sort of thing a good, honest sociologist should be working on. The trouble with you is that you're too concerned with large-scale ideas. What is surprising here is that everything is disjointed, and yet all these separated people are governed by a strict hierarchy. As soon as they get together the hierarchy comes to the fore, fiercely, furiously, through pride. In each building and tower block, everyone is like everyone else, everyone is the same; so everyone does all they can to be different from everyone else. It becomes enormously important to boost one's pride and prestige no matter how petty the means. Pride is poisoning life.

'Before, elsewhere, everyday life existed. It was alive. The slimy creature secreted its beautiful shell. Everyday life was apparent only through its metamorphoses: art, culture, monuments, or quite simply discourse, a naive rhetoric, symbols. Yet it existed, with its dual dimension of platitude and profundity. You used to think that an autocritique of everyday life through its own transpositions was possible: a critique of the slimy animal by its delicate shell and vice versa – a critique of the everyday by festivals, or of trivial instants by moments, and vice versa – a critique of life by art and of art by life, of the real by its double and its reverse image: dreams, imagination, fiction. Then times changed. Technology began penetrating everyday life; there were new problems. And now, what can you see? Everyday

life like a massive weight, reduced to its essence, to its trivial functions, and at the same time almost disintegrated, nothing but fragmented gestures and repeated actions. There it is at your feet, almost entirely alienated and reified, and maybe willingly so, but perhaps also trying to take control again. And you say (as Marx did, but how bitter and uncertain the 'must' is!) we must strip human life of everything natural and define it as pure power over nature, so that finally men will come together and reunite to discover their own nature and join forces with external nature once more. Here in Mourenx this stripping process has been accomplished. So what now? What is to be done with this human sand, in which individuals and their gestures are stuck together in implacable, abstract blocks and dumped on the edge of the moors which have not changed at all, not far from ancestral villages, like a brand-new knife blade piercing the ancient soil? Our task now is to construct everyday life, to produce it, consciously to create it. There it is, in all its crushing boredom, a single, monolithic platitude. Yet it is not there any more, it has been reduced to a thin, opaque human material deprived of its games and spontaneous pleasures.... Will you try to find the crack for freedom to slip through, silently filling up the empty spaces, sliding through the interstices? Good old freedom, you know it well. It needs a "world", neither a completely empty one nor a completely full one. But what about that "world" down there? It looks empty, yet it looks full, "as full as an egg and as empty as an abyss ...". So it really is a question of creating things over again. It is obvious that working-class towns and proletarian neighbourhoods must be rebuilt. You might even go so far as to call for a dictatorship by the proletariat which would transform all the old slums into new towns. But in the end, what would that solve? The proof is there at your feet. Socialism cannot work magic, even if for many people the word has magic powers. Socialism has to find its own style too. As for you, what right have you to set yourself up as a specialist and an expert in ennui? Because that's what you seem to be doing. Like a gourmet at a wine-tasting, you sample different varieties of boredom. The boredom of Nav. has kept its aroma of things gone by — good things, often beautiful things. It smells of the land. The passing years have tarnished its splendours, but the bouquet lingers on. It is a modest and often complacent boredom, the boredom of long winter nights and summer Sundays. Here, in the new town, boredom is pregnant with desires, frustrated frenzies, unrealized possibilities. A magnificent life is waiting just around the corner, and far, far away. It is waiting like the cake is waiting when there's butter, milk, flour and sugar. This is the realm of freedom. It is an empty realm. Here man's magnificent power over nature has left him alone with himself, powerless. It is the boredom of youth without a future.

'And will you be content simply to pick your ironic and philosophical way through all these boredoms? Or perhaps to invent a new one, just right for the occasion, the exquisite boredom of the never-ending dinner party with its overpolite host, the boredom of shattered pride, tinged with the subtle hues of intellectuality? The boredom of the intellectual of the Left? No. There are other things to be done. There are things to be created. And let no one say that it is impossible. Men have always created, in a life-enhancing way, with the vitality of animals. Every father produces a living being. Every artist, every era, has produced their works of art. Wasn't your own village a new town once? It was built on the

banks of the Gave, like this one, and because it was alive, it evolved a form. It is precisely because you reject aestheticism that you should take art as your model: art transformed into the art of living. The new town is a challenge to men to create human life! ... But no one should say that it's an easy task! These days it is extraordinary how analogous the various spheres of knowledge and praxis are. Mathematicians are trying to measure the perceivable and the concrete; it seems they have reached their goal – and then suddenly concrete reality vanishes; the gap seemed to be narrowing, but up close it appears wider than ever. The same surprise (and a fruitful one) awaits the biochemist who attempts to understand and produce human tissue. The thing is that men have two different ways of creating and producing, and as yet these have not intersected: spontaneous vitality, and abstraction. On the one hand, in pleasure and in play; on the other, in seriousness, patience and painful consciousness, in toil. Might not the same be true of towns, those products of social living? Perhaps. And here we are facing the same problem as before: how to reproduce what was once created spontaneously, how to create it from the abstract. Possible? Impossible? If the concept of what is possible is separated from the concept of what is not possible, both become meaningless. If we aim at what is impossible today, it will become tomorrow's possibility. And no matter how immense the gap between the possible and the impossible, the aim and the goal, abstraction and living, may appear, you must make every effort to bridge it. So read the text of the new town, like the mathematician, the physicist and the biochemist read theirs. Use it as an experiment, as a laboratory, as a test tube if you like, but not in the sense in which some clumsy lab assistant might handle inert materials. Think of it as a place of privileged experiment where at last men are about to conquer and control their everyday lives, through trial and error, successive approximations, abstractions superseded and concrete reality achieved, which is the path knowledge must follow towards predictable and unpredictable totality.

'No, we will not find a style for our age in a place like this. But we will find the way towards it. For it is here that our age must face up to the challenge. And if one day, by luck or by judgement, it does find its style in everyday life, and if it does manage to resolve the duality between the "technical object" and the "aesthetic object", then surely the success will be all the more dazzling because of the setbacks, and the tremendous efforts involved. "Transform the world" – all well and good. It is being transformed. But into what? Here, at your feet, is one small but crucial element in that mutation.'

Michel de Certeau

WALKING IN THE CITY

IN THIS REMARKABLE ESSAY, carefully poised between poetry and semiotics, Michel de Certeau analyses an aspect of daily urban life. He presents a theory of the city, or rather an ideal for the city, against the theories and ideals of urban planners and managers, and to do so, he does not look down at the city as if from a high-rise building – he walks in it.

Walking in the city turns out to have its own logic – or, as de Certeau puts it, its own 'rhetoric'. The walker individuates and makes ambiguous the 'legible' order given to cities by planners, a little like waking life is displaced and ambiguated by dreaming – to take one of de Certeau's several analogies.

This is a utopian essay: it conceives of the 'everyday' as different from the official in the same way that poetry is other to a planning manual. And it grants twentieth-century urban experience, for which walking is a secondary form of locomotion (usually a kind of drifting), the glamour that a writer such as Walter Benjamin found in the nineteenth-century leisured observer or *flâneur*. 'Walking in the City' has been very influential in cultural studies just because of the way that it uses both imagination and technical semiotic analysis to show how everyday life has particular value when it takes place in the gaps of larger power-structures.

Further reading: Ahearne 1996; Bachelard 1969; de Certeau 1984; Harvey 1985; Highmore 2005 and 2006; Lefebvre 1971; Massey 1994; Morris 1990; Rigby 1991.

Seeing Manhattan from the 110th floor of the World Trade Center. Beneath the haze stirred up by the winds, the urban island, a sea in the middle of the sea, lifts up the skyscrapers over Wall Street, sinks down at Greenwich, then rises again to the crests of Midtown, quietly passes over Central Park and finally undulates off into the distance beyond Harlem. A wave of verticals. Its agitation is momentarily arrested by vision. The gigantic mass is immobilized before the eyes. It is transformed into a texturology in which extremes coincide – extremes of ambition and degradation, brutal oppositions of races and styles, contrasts between yesterday's buildings, already transformed into trash cans, and today's urban irruptions that block out its space. Unlike Rome, New York has never learned the art of growing old by playing on all its pasts. Its present invents itself, from hour to hour, in the act of throwing away its previous accomplishments and challenging the future. A city composed of paroxysmal places in monumental reliefs. The spectator can read in it a universe that is constantly exploding. In it are inscribed the architectural figures of the *coincidatio oppositorum* formerly drawn in miniatures and mystical textures. On this stage of concrete, steel and glass, cut out between two oceans (the Atlantic and the American) by a frigid body of water, the tallest letters in the world compose a gigantic rhetoric of excess in both expenditure and production.

Voyeurs or walkers

To what erotics of knowledge does the ecstasy of reading such a cosmos belong? Having taken a voluptuous pleasure in it, I wonder what is the source of this pleasure of 'seeing the whole', of looking down on, totalizing the most immoderate of human texts.

To be lifted to the summit of the World Trade Center is to be lifted out of the city's grasp. One's body is no longer clasped by the streets that turn and return it according to an anonymous law; nor is it possessed, whether as player or played, by the rumble of so many differences and by the nervousness of New York traffic. When one goes up there, he leaves behind the mass that carries off and mixes up in itself any identity of authors or spectators. An Icarus flying above these waters, he can ignore the devices of Daedalus in mobile and endless labyrinths far below. His elevation transfigures him into a voyeur. It puts him at a distance. It transforms the bewitching world by which one was 'possessed' into a text that lies before one's eyes. It allows one to read it, to be a solar Eye, looking down like a god. The exaltation of a scopic and gnostic drive: the fiction of knowledge is related to this lust to be a viewpoint and nothing more.

Must one finally fall back into the dark space where crowds move back and forth, crowds that, though visible from on high, are themselves unable to see down below? An Icarian fall. On the 110th floor, a poster, sphinx-like, addresses an enigmatic message to the pedestrian who is for an instant transformed into a visionary: *It's hard to be down when you're up.*

The desire to see the city preceded the means of satisfying it. Medieval or Renaissance painters represented the city as seen in a perspective that no eye had yet enjoyed. This fiction already made the medieval spectator into a celestial eye. It created gods. Have things changed since technical procedures have organized

an 'all-seeing power'? The totalizing eye imagined by the painters of earlier times lives on in our achievements. The same scopic drive haunts users of architectural productions by materializing today the utopia that yesterday was only painted. The 1370-foot-high tower that serves as a prow for Manhattan continues to construct the fiction that creates readers, makes the complexity of the city readable and immobilizes its opaque mobility in a transparent text.

Is the immense texturology spread out before one's eyes anything more than a representation, an optical artefact? It is the analogue of the facsimile produced, through a projection that is a way of keeping aloof, by the space planner urbanist, city planner or cartographer. The panorama-city is a 'theoretical' (that is, visual) simulacrum, in short a picture, whose condition of possibility is an oblivion and a misunderstanding of practices.

The ordinary practitioners of the city live 'down below', below the thresholds at which visibility begins. They walk – an elementary form of this experience of the city; they are walkers, *Wandersmänner*, whose bodies follow the thicks and thins of an urban 'text' they write without being able to read it. These practitioners make use of spaces that cannot be seen; their knowledge of them is as blind as that of lovers in each other's arms. The paths that correspond in this intertwining, unrecognized poems in which each body is an element signed by many others, elude legibility. It is as though the practices organizing a bustling city were characterized by their blindness. The networks of these moving, intersecting writings compose a manifold story that has neither author nor spectator, shaped out of fragments of trajectories and alterations of spaces: in relation to representations, it remains daily and indefinitely other.

Escaping the imaginary totalizations produced by the eye, the everyday has a certain strangeness that does not surface, or whose surface is only its upper limit, outlining itself against the visible. Within this ensemble, I shall try to locate the practices that are foreign to the 'geometrical' or 'geographical' space of visual, panoptic, or theoretical constructions. These practices of space refer to a specific form of *operations* ('ways of operating'), to 'another spatiality' (an 'anthropological', poetic and mythic experience of space), and to an *opaque and blind* mobility characteristic of the bustling city. A *migrational*, or metaphorical, city thus slips into the clear text of the planned and readable city.

From the concept of the city to urban practices

The World Trade Center is only the most monumental figure of Western urban development. The atopia—utopia of optical knowledge has long had the ambition of surmounting and articulating the contradictions arising from urban agglomeration. It is a question of managing a growth of human agglomeration or accumulation. 'The city is a huge monastery', said Erasmus. Perspective vision and prospective vision constitute the twofold projection of an opaque past and an uncertain future on to a surface that can be dealt with. They inaugurate (in the sixteenth century?) the transformation of the urban *fact* into the *concept* of a city. Long before the concept itself gives rise to a particular figure of history, it assumes that this fact can be dealt with as a unity determined by an urbanistic *ratio*. Linking the city to the concept

never makes them identical, but it plays on their progressive symbiosis: to plan a city is both to *think the very plurality* of the real and to make that way of thinking the plural *effective*; it is to know how to articulate it and be able to do it.

An operational concept?

The 'city' founded by utopian and urbanistic discourse is defined by the possibility of a threefold operation.

First, the production of its *own* space (*un espace propre*): rational organization must thus repress all the physical, mental and political pollutions that would compromise it;

Second, the substitution of a nowhen, or of a synchronic system, for the indeterminable and stubborn resistances offered by traditions; univocal scientific strategies, made possible by the flattening out of all the data in a plane projection, must replace the tactics of users who take advantage of 'opportunities' and who, through these trap-events, these lapses in visibility, reproduce the opacities of history everywhere;

Third and finally, the creation of a *universal* and anonymous *subject* which is the city itself: it gradually becomes possible to attribute to it, as to its political model, Hobbes's State, all the functions and predicates that were previously scattered and assigned to many different real subjects – groups, associations, or individuals. 'The city', like a proper name, thus provides a way of conceiving and constructing space on the basis of a finite number of stable, isolatable, and interconnected properties.

Administration is combined with a process of elimination in this place organized by 'speculative' and classificatory operations. On the one hand, there is a differentiation and redistribution of the parts and functions of the city, as a result of inversions, displacements, accumulations, etc.; on the other there is a rejection of everything that is not capable of being dealt with in this way and so constitutes the 'waste products' of a functionalist administration (abnormality, deviance, illness, death, etc.). To be sure, progress allows an increasing number of these waste products to be reintroduced into administrative circuits and transforms even deficiencies (in health, security etc.) into ways of making the networks of order denser. But in reality, it repeatedly produces effects contrary to those at which it aims: the profit system generates a loss which, in the multiple forms of wretchedness and poverty outside the system and of waste inside it, constantly turns production into 'expenditure'. Moreover, the rationalization of the city leads to its mythification in strategic discourses, which are calculations based on the hypothesis or the necessity of its destruction in order to arrive at a final decision. Finally, the functionalist organization, by privileging progress (i.e., time), causes the condition of its own possibility – space itself – to be forgotten; space thus becomes the blind spot in a scientific and political technology. This is the way in which the Concept-city functions; a place of transformations and appropriations, the object of various kinds of interference but also a subject that is constantly enriched by new attributes, it is simultaneously the machinery and the hero of modernity.

Today, whatever the avatars of this concept may have been, we have to acknowledge that if in discourse the city serves as a totalizing and almost mythical landmark for socio-economic and political strategies, urban life increasingly permits the re-emergence of the element that the urbanistic project excluded. The language of power is in itself 'urbanizing', but the city is left prey to contradictory movements that counterbalance and combine themselves outside the reach of panoptic power. The city becomes the dominant theme in political legends, but it is no longer a field of programmed and regulated operations. Beneath the discourses that ideologize the city, the ruses and combinations of powers that have no readable identity proliferate; without points where one can take hold of them, without rational transparency, they are impossible to administer.

The return of practices

The Concept-city is decaying. Does that mean that the illness afflicting both the rationality that founded it and its professionals afflicts the urban populations as well? Perhaps cities are deteriorating along with the procedures that organized them. But we must be careful here. The ministers of knowledge have always assumed that the whole universe was threatened by the very changes that affected their ideologies and their positions. They transmute the misfortune of their theories into theories of misfortune. When they transform their bewilderment into 'catastrophes', when they seek to enclose the people in the 'panic' of their discourses, are they once more necessarily right?

Rather than remaining within the field of a discourse that upholds its privilege by inverting its content (speaking of catastrophe and no longer of progress), one can try another path: one can analyse the microbe-like, singular and plural practices which an urbanistic system was supposed to administer or suppress, but which have outlived its decay; one can follow the swarming activity of these procedures that, far from being regulated or eliminated by panoptic administration, have reinforced themselves in a proliferating illegitimacy, developed and insinuated themselves into the networks of surveillance, and combined in accord with unreadable but stable tactics to the point of constituting everyday regulations and surreptitious creativities that are merely concealed by the frantic mechanisms and discourses of the observational organization.

This pathway could be inscribed as a consequence, but also as the reciprocal, of Foucault's analysis of the structures of power. He moved it in the direction of mechanisms and technical procedures, 'minor instrumentalities' capable, merely by their organization of 'details', of transforming a human multiplicity into a 'disciplinary' society and of managing, differentiating, classifying, and hierarchizing all deviances concerning apprenticeship, health, justice, the army or work. 'These often miniscule ruses of discipline', these 'minor but flawless' mechanisms, draw their efficacy from a relationship between procedures and the space that they redistribute in order to make an 'operator' out of it. But what *spatial practices* correspond, in the area where discipline is manipulated, to these apparatuses that produce a disciplinary space? In the present conjuncture, which is marked by a contradiction between the collective mode of administration and an individual

mode of reappropriation, this question is no less important, if one admits that spatial practices in fact secretly structure the determining conditions of social life. I would like to follow out a few of these multiform, resistant, tricky and stubborn procedures that elude discipline without being outside the field in which it is exercised, and which should lead us to a theory of everyday practices, of lived space, of the disquieting familiarity of the city.

The chorus of idle footsteps

> The goddess can be recognized by her step.
>
> Virgil, *Aeneid*, I, 405

Their story begins on ground level, with footsteps. They are myriad, but do not compose a series. They cannot be counted because each unit has a qualitative character: a style of tactile apprehension and kinesthetic appropriation. Their swarming mass is an innumerable collection of singularities. Their intertwined paths give their shape to spaces. They weave places together. In that respect, pedestrian movements form one of these 'real systems whose existence in fact makes up the city'. They are not localized; it is rather they that spatialize. They are no more inserted within a container than those Chinese characters speakers sketch out on their hands with their fingertips.

It is true that the operations of walking on can be traced on city maps in such a way as to transcribe their paths (here well-trodden, there very faint) and their trajectories (going this way and not that). But these thick or thin curves only refer, like words, to the absence of what has passed by. Surveys of routes miss what was: the act itself of passing by. The operation of walking, wandering, or 'window shopping', that is, the activity of passers-by, is transformed into points that draw a totalizing and reversible line on the map. They allow us to grasp only a relic set in the nowhen of a surface of projection. Itself visible, it has the effect of making invisible the operation that made it possible. These fixations constitute procedures for forgetting. The trace left behind is substituted for the practice. It exhibits the (voracious) property that the geographical system has of being able to transform action into legibility, but in doing so it causes a way of being in the world to be forgotten.

Walking rhetorics

The walking of passers-by offers a series of turns (*tours*) and detours that can be compared to 'turns of phrase' or 'stylistic figures'. There is a rhetoric of walking. The art of 'turning' phrases finds an equivalent in an art of composing a path (*tourner un parcours*). Like ordinary language, this art implies and combines styles and uses. *Style* specifies 'a linguistic structure that manifests on the symbolic level ... an individual's fundamental way of being in the world'; it connotes a singular. Use defines the social phenomenon through which a system of communication manifests itself in actual fact; it refers to a norm. Style and use both have to do

with a 'way of operating' (of speaking, walking, etc.), but style involves a peculiar processing of the symbolic, while use refers to elements of a code. They intersect to form a style of use, a way of being and a way of operating.

A friend who lives in the city of Sèvres drifts, when he is in Paris, toward the rue des Saints-*Pères* and the rue de *Sèvres*, even though he is going to see his mother in another part of town: these names articulate a sentence that his steps compose without his knowing it. Numbered streets and street numbers (112th St., or 9 rue Saint-Charles) orient the magnetic field of trajectories just as they can haunt dreams. Another friend unconsciously represses the streets which have names and, by this fact, transmit her — orders or identities in the same way as summonses and classifications; she goes instead along paths that have no name or signature. But her walking is thus still controlled negatively by proper names.

What is it then that they spell out? Disposed in constellations that hierarchize and semantically order the surface of the city, operating chronological arrangements and historical justifications, these words (*Borrégo, Botzaris, Bougainville ...*) slowly lose, like worn coins, the value engraved on them, but their ability to signify outlives its first definition. *Saint-Pères, Corentin Celton, Red Square ...* these names make themselves available to the diverse meanings given them by passers-by; they detach themselves from the places they were supposed to define and serve as imaginary meeting-points on itineraries which, as metaphors, they determine for reasons that are foreign to their original value but may be recognized or not by passers-by. A strange toponymy that is detached from actual places and flies high over the city like a foggy geography of 'meanings' held in suspension, directing the physical deambulations below: *Place de l'Étoile, Concorde, Poissonnière ...* These constellations of names provide traffic patterns: they are stars directing itineraries. 'The Place de la Concorde does not exist,' Malaparte said, 'it is an idea.' It is much more than an 'idea'. A whole series of comparisons would be necessary to account for the magical powers proper names enjoy. They seem to be carried as emblems by the travellers they direct and simultaneously decorate.

Linking acts and footsteps, opening meanings and directions, these words operate in the name of an emptying-out and wearing-away of their primary role. They become liberated spaces that can be occupied. A rich indetermination gives them, by means of a semantic rarefaction, the function of articulating a second, poetic geography on top of the geography of the literal, forbidden or permitted meaning. They insinuate other routes into the functionalist and historical order of movement. Walking follows them: 'I fill this great empty space with a beautiful name.' People are put in motion by the remaining relics of meaning, and sometimes by their waste products, the inverted remainders of great ambitions. Things that amount to nothing, or almost nothing, symbolize and orient walkers' steps: names that have ceased precisely to be 'proper'.

Ultimately, since proper names are already 'local authorities' or 'superstitions', they are replaced by numbers: on the telephone, one no longer dials *Opera*, but 073. The same is true of the stories and legends that haunt urban space like superfluous or additional inhabitants. They are the object of a witch-hunt, by the very logic of the techno-structure. But their extermination (like the extermination of trees, forests, and hidden places in which such legends live) makes the city a 'suspended symbolic order'. The habitable city is thereby annulled. Thus, as a

woman from Rouen put it, no, here 'there isn't any place special, except for my own home, that's all ... There isn't anything.' Nothing 'special': nothing that is marked, opened up by a memory or a story, signed by something or someone else. Only the cave of the home remains believable, still open for a certain time to legends, still full of shadows. Except for that, according to another city-dweller, there are only 'places in which one can no longer believe in anything'.

It is through the opportunity they offer to store up rich silences and wordless stories, or rather through their capacity to create cellars and garrets everywhere, that local legends (*legenda*: what is *to be read*, but also what *can be read*) permit exits, ways of going out and coming back in, and thus habitable spaces. Certainly walking about and travelling substitute for exits, for going away and coming back, which were formerly made available by a body of legends that places nowadays lack. Physical moving about has the itinerant function of yesterday's or today's 'superstitions'. Travel (like walking) is a substitute for the legends that used to open up space to something different. What does travel ultimately produce if it is not, by a sort of reversal, 'an exploration of the deserted places of my memory', the return to nearby exoticism by way of a detour through distant places, and the 'discovery' of relics and legends: 'fleeting visions of the French countryside', 'fragments of music and poetry', in short, something like an 'uprooting in one's origins' (Heidegger)? What this walking exile produces is precisely the body of legends that is currently lacking in one's own vicinity; it is a fiction, which moreover has the double characteristic, like dreams or pedestrian rhetoric, of being the effect of displacements and condensations. As a corollary, one can measure the importance of these signifying practices (to tell oneself legends) as practices that invent spaces.

From this point of view, their contents remain revelatory, and still more so is the principle that organizes them. Stories about places are makeshift things. They are composed with the world's debris. Even if the literary form and the actantial schema of 'superstitions' correspond to stable models whose structures and combinations have often been analysed over the past thirty years, the materials (all the rhetorical details of their 'manifestation') are furnished by the leftovers from nominations, taxonomies, heroic or comic predicates, etc., that is, by fragments of scattered semantic places. These heterogeneous and even contrary elements fill the homogeneous form of the story. Things *extra* and *other* (details and excesses coming from elsewhere) insert themselves into the accepted framework, the imposed order. One thus has the very relationship between spatial practices and the constructed order. The surface of this order is everywhere punched and torn open by ellipses, drifts, and leaks of meaning: it is a sieve-order.

Michel Foucault

SPACE, POWER AND KNOWLEDGE

EDITOR'S INTRODUCTION

THIS INTERVIEW, in which Michel Foucault talks to Paul Rabinow, makes its most general point last. Foucault argues that material changes cannot be used to explain changes in subjectivity. For instance, when, in the middle ages, chimneys were first walled and placed inside, rather than outside, houses, inter-personal relations were transformed. New interactions flourished around chimneys. But the building of chimneys is not enough to explain these changes – if, for instance, different discourses and values had been circulating at the time then chimneys would have produced different kinds of changes. Generalizing from this point, Foucault argues that abstract (and in the West highly valued) words like 'liberty' and 'rationality' refer neither simply to ideas nor to practices – but to sets of complex exchanges between the two. Nonetheless, it has been the 'practices' of liberty and reason that have been neglected by intellectual and cultural historians.

This line of thought has an important consequence. It means that architects and other social managers cannot guarantee that their designs will secure liberty or rationality. What matters is the fit between the material re-organization of space, life-practices, values and discourses: only if the fit is right will social managers be able to augment what Foucault calls 'practices of liberty'. In this light Foucault argues that intellectuals have a particular function when society is being modernized and rationalized by managers and experts: they are to remain critical of nostalgic, utopian and overly abstract thought.

Further reading: Dreyfus and Rabinow 1983; Foucault 1980b and 1988; Inda 2005; Mitchell 1988 (a book which uses Foucault's work to describe the construction of colonial space); Paras 2006.

Q. Do you see any particular architectural projects, either in the past or the present, as forces of liberation or resistance?

M.F. I do not think that it is possible to say that one thing is of the order of 'liberation' and another is of the order of 'oppression'. There are a certain number of things that one can say with some certainty about a concentration camp to the effect that it is not an instrument of liberation, but one should still take into account – and this is not generally acknowledged – that, aside from torture and execution, which preclude any resistance, no matter how terrifying a given system may be, there always remain the possibilities of resistance, disobedience, and oppositional groupings.

On the other hand, I do not think that there is anything that is functionally – by its very nature – absolutely liberating. Liberty is a *practice*. So there may, in fact, always be a certain number of projects whose aim is to modify some constraints, to loosen, or even to break them, but none of these projects can, simply by its nature, assure that people will have liberty automatically, that it will be established by the project itself. The liberty of men is never assured by the institutions and laws that are intended to guarantee them. This is why almost all of these laws and institutions are quite capable of being turned around. Not because they are ambiguous, but simply because 'liberty' is what must be exercised.

Q. Are there urban examples of this? Or examples where architects succeeded?

M.F. Well, up to a point there is Le Corbusier, who is described today – with a sort of cruelty that I find perfectly useless – as a sort of crypto-Stalinist. He was, I am sure, someone full of good intentions and what he did was in fact dedicated to liberating effects. Perhaps the means that he proposed were in the end less liberating than he thought, but, once again, I think that it can never be inherent in the structure of things to guarantee the exercise of freedom. The guarantee of freedom is freedom.

Q. So you do not think of Le Corbusier as an example of success. You are simply saying that his intention was liberating. Can you give us a successful example?

M.F. No. It *cannot* succeed. If one were to find a place, and perhaps there are some, where liberty is effectively exercised, one would find that this is not owing to the order of objects, but, once again, owing to the practice of liberty. Which is not to say that, after all, one may as well leave people in slums, thinking that they can simply exercise their rights there.

Q. Meaning that architecture in itself cannot resolve social problems?

M.F. I think that it can and does produce positive effects when the liberating intentions of the architect coincide with the real practice of people in the exercise of their freedom.

Q. But the same architecture can serve other ends?

M.F. Absolutely. Let me bring up another example: the *Familistère* of Jean-Baptiste Godin at Guise [1859]. The architecture of Godin was clearly intended for the freedom of people. Here was something that manifested the power of ordinary workers to participate in the exercise of their trade. It was a rather important sign and instrument of autonomy for a group of workers. Yet no one could enter or leave the place without being seen by everyone – an aspect of the architecture that could be totally oppressive. But it could only be oppressive if people were prepared to use their own presence in order to watch over others. Let's imagine a community of unlimited sexual practices that might be established there. It would once again become a place of freedom. I think it is somewhat arbitrary to dissociate the effective practice of freedom by people, the practice of social relations, and the spatial distributions in which they find themselves. If they are separated, they become impossible to understand. Each can only be understood through the other.

Q. Yet people have often attempted to find utopian schemes to liberate people, or to oppress them.

M.F. Men have dreamed of liberating machines. But there are no machines of freedom, by definition. This is not to say that the exercise of freedom is completely indifferent to spatial distribution, but it can only function when there is a certain convergence; in the case of divergence or distortion, it immediately becomes the opposite of that which had been intended. The panoptic qualities of Guise could perfectly well have allowed it to be used as a prison. Nothing could be simpler. It is clear that, in fact, the *Familistère* may well have served as an instrument for discipline and a rather unbearable group pressure.

Q. So, once again, the intention of the architect is not the fundamental determining factor.

M.F. Nothing is fundamental. That is what is interesting in the analysis of society. That is why nothing irritates me as much as these enquiries – which are by definition metaphysical – on the foundations of power in a society or the self-institution of a society, etc. These are not fundamental phenomena. There are only reciprocal relations, and the perpetual gaps between intentions in relation to one another.

Q. You have singled out doctors, prison wardens, priests, judges, and psychiatrists as key figures in the political configurations that involve domination. Would you put architects on this list?

M.F. You know, I was not really attempting to describe figures of domination when I referred to doctors and people like that, but rather to describe people through whom power passed or who are important in the fields of power relations. A patient in a mental institution is placed within a field of fairly complicated power relations, which Erving Goffman analysed very well. The pastor in a Christian or Catholic church (in Protestant churches it is somewhat different) is an important link in a set of power relations. The architect is not an individual of that sort.

After all, the architect has no power over me. If I want to tear down or change a house he built for me, put up new partitions, add a chimney, the architect has no control. So the architect should be placed in another category – which is not to say that he is not totally foreign to the organization, the implementation, and all the techniques of power that are exercised in a society. I would say that one must take *him* – his mentality, his attitude – into account as well as his projects, in order to understand a certain number of the techniques of power that are invested in architecture, but he is not comparable to a doctor, a priest, a psychiatrist, or a prison warden.

Q. 'Postmodernism' has received a great deal of attention recently in architectural circles. It is also being talked about in philosophy, notably by Jean-François Lyotard and Jürgen Habermas. Clearly, historical reference and language play an important role in the modern episteme. How do you see postmodernism, both as architecture and in terms of the historical and philosophical questions that are posed by it?

M.F. I think that there is a widespread and facile tendency, which one should combat, to designate that which has just occurred as the primary enemy, as if this were always the principal form of oppression from which one had to liberate oneself. Now this simple attitude entails a number of dangerous consequences: first, an inclination to seek out some cheap form of archaism or some imaginary past forms of happiness that people did not, in fact, have at all. For instance, in the areas that interest me, it is very amusing to see how contemporary sexuality is described as something absolutely terrible. To think that it is only possible now to make love after turning off the television! and in mass-produced beds! 'Not like that wonderful time when ...' Well, what about those wonderful times when people worked eighteen hours a day and there were six people in a bed, if one was lucky enough to have a bed! There is in this hatred of the present or the immediate past a dangerous tendency to invoke a completely mythical past. Second, there is the problem raised by Habermas: if one abandons the work of Kant or Weber, for example, one runs the risk of lapsing into irrationality.

I am completely in agreement with this, but at the same time, our question is quite different: I think that the central issue of philosophy and critical thought since the eighteenth century has always been, still is, and will, I hope, remain the question: *What* is this Reason that we use? What are its historical effects? What are its limits, and what are its dangers? How can we exist as rational beings, fortunately committed to practising a rationality that is unfortunately crisscrossed by intrinsic dangers? One should remain as close to this question as possible, keeping in mind that it is both central and extremely difficult to resolve. In addition, if it is extremely dangerous to say that Reason is the enemy that should be eliminated, it is just as dangerous to say that any critical questioning of this rationality risks sending us into irrationality. One should not forget – and I'm saying this not in order to criticize rationality, but in order to show how ambiguous things are – it was on the basis of the flamboyant rationality of social Darwinism that racism was formulated, becoming one of the most enduring and powerful ingredients of Nazism. This was, of course, an irrationality, but an irrationality that was at the same time, after all, a certain form of rationality....

This is the situation that we are in and that we must combat. If intellectuals in general are to have a function, if critical thought itself has a function, and, even more specifically, if philosophy has a function within critical thought, it is precisely to accept this sort of spiral, this sort of revolving door of rationality that refers us to its necessity, to its indispensability, and at the same time, to its intrinsic dangers.

Q. All that being said, it would be fair to say that you are much less afraid of historicism and the play of historical references than someone like Habermas is; also, that this issue has been posed in architecture as almost a crisis of civilization by the defenders of modernism, who contend that if we abandon modern architecture for a frivolous return to decoration and motifs, we are somehow abandoning civilization. On the other hand, some postmodernists have claimed that historical references per se are somehow meaningful and are going to protect us from the dangers of an overly rationalized world.

M.F. Although it may not answer your question, I would say this: one should totally and absolutely suspect anything that claims to be a return. One reason is a logical one; there is in fact no such thing as a return. History, and the meticulous interest applied to history, is certainly one of the best defences against this theme of the return. For me, the history of madness or the studies of the prison ... were done in that precise manner because I knew full well – this is in fact what aggravated many people – that I was carrying out a historical analysis in such a manner that people *could* criticize the present, but it was impossible for them to say, 'Let's go back to the good old days when madmen in the eighteenth century ...' or, 'Let's go back to the days when the prison was not one of the principal instruments ...' No; I think that history preserves us from that sort of ideology of the return.

Q. Hence, the simple opposition between reason and history is rather silly ... choosing sides between the two....

M.F. Yes. Well, the problem for Habermas is, after all, to make a transcendental mode of thought spring forth against any historicism. I am, indeed, far more historicist and Nietzschean. I do not think that there is a proper usage of history or a proper usage of intrahistorical analysis – which is fairly lucid, by the way – that works precisely against this ideology of the return. A good study of peasant architecture in Europe, for example, would show the utter vanity of wanting to return to the little individual house with its thatched roof. History protects us from historicism – from a historicism that calls on the past to resolve the questions of the present.

Q. It also reminds us that there is always a history; that those modernists who wanted to suppress any reference to the past were making a mistake.

M.F. Of course.

Q. Your next two books deal with sexuality among the Greeks and the early Christians. Are there any particular architectural dimensions to the issues you discuss?

M.F. I didn't find any; absolutely none. But what is interesting is that in imperial Rome there were, in fact, brothels, pleasure quarters, criminal areas, etc., and there was also one sort of quasi-public place of pleasure: the baths, the *thermes*. The baths were a very important place of pleasure and encounter, which slowly disappeared in Europe. In the Middle Ages, the baths were still a place of encounter between men and women as well as of men with men and women with women, although that is rarely talked about. What were referred to and condemned, as well as practised, were the encounters between men and women, which disappeared over the course of the sixteenth and seventeenth centuries.

Q. In the Arab world it continues.

M.F. Yes; but in France it has largely ceased. It still existed in the nineteenth century. One sees it in *Les Enfants du Paradis*, and it is historically exact. One of the characters, Lacenaire, was – no one mentions it – a swine and a pimp who used young boys to attract older men and then blackmailed them; there is a scene that refers to this. It required all the *naïveté* and anti-homosexuality of the Surrealists to overlook that fact. So the baths continued to exist, as a place of sexual encounters. The bath was a sort of cathedral of pleasure at the heart of the city, where people could go as often as they want, where they walked about, picked each other up, met each other, took their pleasure, ate, drank, discussed. ...

Q. So sex was not separated from the other pleasures. It was inscribed in the centre of the cities. It was public; it served a purpose....

M.F. That's right. Sexuality was obviously considered a social pleasure for the Greeks and the Romans. What is interesting about male homosexuality today – this has apparently been the case of female homosexuals for some time – is that their sexual relations are immediately translated into social relations and the social relations are understood as sexual relations. For the Greeks and the Romans, in a different fashion, sexual relations were located within social relations in the widest sense of the term. The baths were a place of sociality that included sexual relations.

One can directly compare the bath and the brothel. The brothel is in fact a place, and an architecture, of pleasure. There is, in fact, a very interesting form of sociality that was studied by Alain Corbin in *Les Filles de Noces*. The men of the city met at the brothel; they were tied to one another by the fact that the same women passed through their hands, that the same diseases and infections were communicated to them. There was a sociality of the brothel, but the sociality of the baths as it existed among the ancients – a new version of which could perhaps exist again – was completely different from the sociality of the brothel.

Q. We now know a great deal about disciplinary architecture. What about confessional architecture – the kind of architecture that would be associated with a confessional technology?

M.F. You mean religious architecture? I think that it has been studied. There is the whole problem of a monastery as xenophobic. There one finds precise regulations concerning life in common; affecting sleeping, eating, prayer, the place of each individual in all of that, the cells. All of this was programmed from very early on.

Q. In a technology of power, of confession as opposed to discipline, space seems to play a central role as well.

M.F. Yes. Space is fundamental in any form of communal life; space is fundamental in any exercise of power. To make a parenthetical remark, I recall having been invited, in 1966, by a group of architects to do a study of space, of something that I called at that time 'heterotopias', those singular spaces to be found in some given social spaces whose functions are different or even the opposite of others. The architects worked on this, and at the end of the study someone spoke up – a Sartrean psychologist – who firebombed me, saying that *space* is reactionary and capitalist, but *history* and *becoming* are revolutionary. This absurd discourse was not at all unusual at the time. Today everyone would be convulsed with laughter at such a pronouncement, but not then.

Q. Architects in particular, if they do choose to analyse an institutional building such as a hospital or a school in terms of its disciplinary function, would tend to focus primarily on the walls. After all, that is what they design. Your approach is perhaps more concerned with space, rather than architecture, in that the physical walls are only one aspect of the institution. How would you characterize the difference between these two approaches, between the building itself and space?

M.F. I think there is a difference in method and approach. It is true that for me, architecture, in the very vague analyses of it that I have been able to conduct, is only taken as an element of support, to ensure a certain allocation of people in space, a *canalization* of their circulation, as well as the coding of their reciprocal relations. So it is not only considered as an element in space, but is especially thought of as a plunge into a field of social relations in which it brings about some specific effects.

For example, I know that there is a historian who is carrying out some interesting studies of the archaeology of the Middle Ages, in which he takes up the problem of architecture, of houses in the Middle Ages, in terms of the problem of the chimney. I think that he is in the process of showing that beginning at a certain moment it was possible to build a chimney inside the house – a chimney with a hearth, not simply an open room or a chimney outside the house; that at that moment all sorts of things changed and relations between individuals became possible. All of this seems very interesting to me, but the conclusion that he presented in an article was that the history of ideas and thoughts is useless.

What is, in fact, interesting is that the two are rigorously indivisible. Why did people struggle to find the way to put a chimney inside a house? Or why did they put their techniques to this use? So often in the history of techniques it takes years or even centuries to implement them. It is certain, and of capital importance,

that this technique was a formative influence on new human relations, but it is impossible to think that it would have been developed and adapted had there not been in the play and strategy of human relations something which tended in that direction. What is interesting is always interconnection, not the primacy of this over that, which never has any meaning.

Gilles Deleuze and Claire Parnet

POLITICS

EDITOR'S INTRODUCTION

THIS SHORT PIECE OFFERS A TASTE of Gilles Deleuze's unforgettable and unique approach to social analysis which has influenced a whole generation of social theorists working around cultural studies. This essay exists somewhere between a prose poem, a disquisition of analytical method, an outline for a psycho-metaphysics and an anarchistic political intervention. It is much closer in spirit to the Barthes of 'From Work to Text' than Bourdieu on the literary field, since it turns the globe's social spaces into something like a Barthesian 'text'.

The social world is described in a battery of metaphors: it becomes a disorganized, multi-levelled scene of flows, lines, segments, speeds, codes, assemblages, machines, apparatuses. But the basic structure is quite clear: social and experiential units come together and enter into larger flows either through 'molar' or through 'molecular' forces: the first being the large or macro tendencies and structures (or 'lines') which Deleuze is suspicious of and which are related to the State and market apparatuses (schools, professions, factories, histories); the second are the more temporary, small scale and looser joinings of particularities (becomings).

It's a matter of the continual overcoding of micro level flows and segments, and the equally continual 'irruption of the Amazons' in which molar forces are disrupted by the molecular. In 'Politics' Deleuze and Parnet gesture towards relations between the molar and molecular at the level of the individual life, before (in a breathtaking change of perspective) describing relations between the globe's North (developed regions) and South (underdeveloped regions).

Further reading: Colebrook 2000; Patton 1996; Rajchman 2000.

As individuals and groups we are made of lines, lines that are very diverse in nature. The first type of line (there are many of this type) that forms us is segmentary or rigidly segmented: family/profession; work/vacation; family/then school/then army/then factory/and then retirement. Each time, from one segment to another, we are told, "Now you are no longer a child"; then at school, "Now you are no longer at home"; then in the army, "This isn't school anymore...." In short, all kinds of well-defined segments, going in every direction, which carve us up in every sense, these bundles of segmented lines. At the same time there are segmented lines that are much more supple, that are somehow molecular. Not that they are more intimate or more personal, for they traverse groups and societies as well as individuals. They trace out small modifications, cause detours, suggest "highs" or periods of depression; yet they are just as well defined, and even govern many irreversible processes. Rather than being segmented molar lines, these are molecular flows (*flux*) with thresholds or quanta. *A threshold is crossed that doesn't necessarily coincide with a segment of more visible lines.* Many things happen along this second type of line—becomings, micro-becomings—that don't have the same rhythm as our "history." This is why family problems, readjustments, and recollection seem so painful, while our real changes are happening elsewhere—another politics, another time, another individuation. A profession is a rigid segment, but what goes on underneath? What connections, attractions, and repulsions which don't coincide with the segments, what secret follies nevertheless linked to public power! A professor, for example, or a judge, lawyer, accountant and a cleaning woman.

At the same time again, there is a third type of line, even stranger still, as if something were carrying us away, through our segments but also across our thresholds, toward an unknown destination, neither foreseeable nor pre-existent. This line, though simple and abstract, is the most complicated and tortuous of all: it is the line of gravity or celerity, the line of flight with the steepest gradient. ("The line that has to describe the center of gravity is certainly very simple, and believed to be straight in most cases...but from another point of view this line possesses something exceedingly mysterious, for it is nothing other than the path of the dancer's soul.") This line seems to surge up afterwards, detaching itself from the other two, if indeed it ever does. For perhaps there are people who do not have this line, who have only the other two, or who have only the one, who live only along it. Yet, in another way, this line has been there from time immemorial, although it is the opposite of destiny: it need not detach itself from the others but may be primary, with the others deriving from it. In any case these three lines are immanent and caught up in each other. We have as many entangled lines in our lives as there are in the palm of a hand. But we are complicated in a different way. The pursuits that Guattari and I call by various names—schizo-analysis, micro-politics, pragmatism, diagrammatics, rhizomatics, cartography—have no other goal than the study of these lines, in groups or in individuals.

In his admirable autobiographical piece *The Crack-up*, F. Scott Fitzgerald explains how a life always proceeds at several rhythms and at several speeds. Since Fitzgerald is a living drama, and defines life as a process of demolition, the text is bleak, though no less exemplary for that, and inspires love with every sentence. Never has

there been so much genius at work as when he speaks of the loss of his genius. Thus, he says, for him there are first the large segments: rich/poor, young/old, success/failure, health/sickness, love/indifference, creativity/sterility, all in relation to social events (economic crises, the stock market crash, the cinema replacing the novel, the development of fascism—all kinds of necessarily heterogeneous events, to which these segments respond and by which they are precipitated). Fitzgerald refers to all this as a *break*; each segment marks or is capable of marking a break. This type of segmented line is what concerns us at a particular time, in a particular place. Whether it moves toward degradation or advancement doesn't really matter. (A successful life built on this model is no better for that. Whether one starts out a street sweeper and ends up a millionaire or the reverse, it's the American Dream, the segments are the same.) At the same time Fitzgerald is also saying something else: there are lines of crack-up that don't coincide with the lines having large, segmentary breaks, as one might say of a plate which is cracked. It is when everything is going well, or everything is going better on the other line, that the crack occurs on this new line; secretly, imperceptibly, it marks a threshold of diminishing resistance, or a rising threshold of demand. We can no longer put up with things the way we used to, even as we did yesterday. The distribution of desire within us has changed, our relationships of speed and slowness have been modified; a new kind of anguish, but also a new serenity, have come upon us. When the flows subside, and your health is improved, your wealth more assured, your talent more affirmed, that's when the little crack occurs that will cause the line to go oblique. Or perhaps the reverse: you set about improving things when everything is cracking apart on the other line. It's an immense relief, for no longer being able to put up with something can be a way to progress. It can also be a senile fear or the development of paranoia. Or a perfectly accurate emotional or political evaluation. We don't change or grow old in the same way, from one line to another. The supple line is not, however, more personal or more intimate. The micro-cracks are collective also, just as the macro-breaks are personal.

Fitzgerald goes on to speak of still another line, a third line which he calls a *rupture*. It might be said that nothing has changed, and yet everything has changed. Assuredly, the large segments, changes or even voyages are not what make this line, but neither do the most secret mutations, nor the mobile and fluent thresholds, although the latter come close to it. Instead, we would say that an "absolute" threshold has been attained. There's no longer any secret. We have become just like everyone else, or more exactly, we have made of everyone else a *becoming*. We have become clandestine, imperceptible. We have made a strange, stationary trip.

In spite of the difference in tone, it is a little like Kierkegaard's description of the knight of faith: *I Look Only at the Movements*; the knight no longer has segments of resignation, but he doesn't have the suppleness of the poet or dancer either; he doesn't look unusual, but rather resembles an ordinary bourgeois gentleman, a tax collector, or a shopkeeper; he dances with such precision that one would say he's only walking or even resting immobile; he blends into the wall, but the wall has come alive; he has painted himself grey on grey, or like the Pink Panther he has painted the world in his own color; he has acquired something invulnerable, and he knows that, even in loving and in order to love, one must be self-sufficient,

abandon love and the self... (it is curious that D.H. Lawrence wrote similar pages).
He is no more than an abstract line, a pure movement difficult to discover; he
never begins, but takes up things in the middle; he is always in the middle. In
the middle of the other two lines? "I look only at movements."

Consider the cartography proposed by Fernand Deligny when he follows the course
of autistic children: the customary lines, and also the supple lines, where the child
makes a curl, finds something, slaps his hands, hums a tune, retraces his steps,
and then makes "meandering lines" intertwined with the other two. All these lines
are tangled. Deligny makes a geo-analysis, an analysis of lines that follows its own
path away from psychoanalysis, and that concerns not merely autistic children, but
all children and all adults. (Watch someone walking in the street, if he is not too
caught up in his rigid segmentation. What little inventions he puts into his gaits,
gestures, affects, language, and style.)

These three lines ought to be defined more precisely. For the molar lines of
rigid segmentation, one can indicate a number of characteristics that account for
their arrangement (*agencement*), or rather their functioning in the arrangements
they are a part of. (There are no arrangements not made up of them.) Here then
roughly are the characteristics of the first type of line.

1. The segments stem from binary machines, which are necessarily very diverse.
Binary machines of social classes, sexes (men/women), ages (child/adult), races
(black/white), sectors (public/private), and subjectivizations (ours/not ours). These
binary machines grow more complex as they intersect or collide with one another,
confront each other, and cut us up in every direction. They are dichotomizing rather
than dualistic, and they can work diachronically. If you are neither *a* nor *b*, then
you are *c*; the dualism has been transposed, and no longer concerns simultaneous
elements to be chosen, but successive choices; if you are neither black nor white,
you are a mulatto; if you are neither a man nor a woman, you are a transvestite.
Each time the machine with binary elements will produce choices between elements
that don't fall into either category.

2. The segments also imply power set-ups, also very diverse, with each one fixing
the code and the territory of the corresponding segment. These are the set-ups
analyzed by Michel Foucault, who has gone so far in his analysis by refusing to
see in them simple emanations of a pre-existing State apparatus. Each power set-
up is a code-territory complex ("Don't come near my territory, I'm the one in
command here..."). Proust's character Charlus fails at Madame Verdurin's because
he has ventured out of his own territory and his code no longer functions. Think
of the segmentation of the contiguous offices in Kafka's work. By discovering this
segmentation and this heterogeneity of modern power, Foucault was able to break
with the hollow abstractions of the State and of "the law," and to rethink all the
givens of political analysis. Not that the State apparatus has no meaning: it has a
very particular function, insofar as it overcodes all segments, simultaneously both
those it takes for itself at a particular moment and those it leaves outside itself.
Or rather the State apparatus is a concrete arrangement that puts a society's
overcoding machine into effect. This machine in its turn is thus not the State itself,

but the abstract machine that organizes the dominant statements (*énoncés*) and the established order of a society, the languages and dominant forms of knowledge, and the segments that win out over the others. The abstract overcoding machine assures the homogenization of different segments, their convertibility and translatability; it rules the passages between them and establishes the conditions of passage. It is not dependent on the State as such but its efficacy depends on the State as the arrangement that effectuates it in the social field. For example, the different monetary segments and the different kinds of currency have rules of convertibility, both within the system and externally with goods, which refer to a central bank as State apparatus. Greek geometry functioned as an abstract machine organizing the social space, under conditions provided by the concrete arrangement of the city's power. We would like to ask what are the abstract machines of overcoding exercised today by means of the modern State in all its forms. We can even conceive of "knowledge" being offered in service to the State, offering its own implementation, and aspiring to furnish the best machines according to the tasks and ends of the State. Is it today the computer? And also the human sciences? There are no sciences of the State, but there are abstract machines which have relationships of interdependence with the State. This is why, on a line of rigid segmentation, one must distinguish between the *power set-ups* that code the diverse segments, the *abstract machine* that overcodes them and regulates their relationships, and the *State apparatus* that effectuates this machine.

3. Finally, the whole rigid segmentation and all the lines of rigid segmentation envelop a certain plane, which simultaneously concerns forms and their development, subjects and their formation. This *plane of organization* always utilizes a supplementary dimension (overcoding). The education of the subject and the harmonization of form have never ceased to haunt our culture, and to inspire the segmentations, planifications and the binary machines that cut them up and the abstract machines that support them. [...]

For the other type of line, the status seems completely different. Its segments are not the same, but proceed by means of thresholds, constitute becomings and blocks of becoming, mark continuums of intensity and unions of flow (*flux*). The abstract machines in this realm are not the same; they mutate without overcoding and mark their mutations at each threshold and at each union. The plane is not the same, the *plane of consistence or of immanence*. From forms it tears away particles, among which there are now only relationships of speed or slowness, and from subjects it tears away affects, which now only produce individuations through "haecceities." The binary machines no longer have a bite on the real, not because the dominant segment (a particular social class or sex, etc.) has changed, nor because mixtures of a bisexual type or a mixture of classes have been imposed, but on the contrary, because the molecular lines make the flows of deterritorialization run between the segments, flows that no longer belong to one nor the other but constitute the asymmetrical becoming of the two, a molecular sexuality that is no longer that of a man or a woman, molecular masses that no longer have the outlines of a class, molecular groups like little lineages that no longer respond to the large molar oppositions. It's certainly not a question of a synthesis of the two, a synthesis

of 1 and 2, but of a third which always comes from elsewhere and disrupts the binary nature of the two, no more inscribing itself in their opposition than in their complementarity. It's not a matter of adding a new segment on the line to preceding segments (a third sex, a third class, a third age), but of tracing another line in the middle of the segmentary line, in the middle of its segments, a line that carries them away according to variable speeds in a movement of flight or flow.

Speaking always as geographers, let's suppose that between the *East and the West* a certain segmentation is established, opposed in a binary machine, arranged in the apparatuses of State, and overcoded by an abstract machine as outline of a new world Order. It is then from the *North to the South* that a "de-stabilization" occurs, as Giscard d'Estaing says with melancholy, and that a stream hollows out a channel, even a fairly deep one, which puts everything at stake again and upsets the plane of organization. A Corsica here, elsewhere a Palestine, a hijacked airplane, a tribal push, a feminist movement, a protest from ecologists, a Russian dissident—there will always be some insurgence in the south. Imagine the Greeks and Trojans as two opposed segments, face to face; then the Amazons arrive on the scene and begin to overthrow the Trojans, so well that the Greeks cry out, "The Amazons are with us!" But then the Amazons suddenly turn against the Greeks, and sweep through them like a torrent. So begins Kleist's *Penthesilus*.

The great ruptures and oppositions are always negotiable, but not the little cracks and imperceptible ruptures that come from the south. We say "from the south" merely as illustration, to mark a direction that is no longer one of a segmented line. Each one has his own south, situated anywhere, his own line of inclination or flight. Nations, classes, sexes have their south. As Godard says, what counts are not only the two opposed camps on the great line where they confront each other, but also the frontier along which everything passes and runs on a broken molecular line with a different orientation. May '68 was the explosion of such a molecular line, the irruption of the Amazons, the frontier that traced its unexpected line, dragging along segments like no longer recognizable blocks that have been torn away.

We can be reproached for remaining within a dualism, with two type of lines that are cut up, planified and "machined" differently. But what defines a dualism is not the number of terms, just as one doesn't escape from one by adding more terms $(x > 2)$. One only really escapes by displacing the dualism as one would a burden, when one discovers between the terms, whether two or more, a narrow pass like a border or frontier which will make of the ensemble a multiplicity, independently of the number of particles. What we call an *arrangement* (*agencement*) is precisely such a multiplicity. Yet any arrangement consists necessarily of lines of rigid and binary segmentation, no less than of molecular lines, or border lines, or of lines of inclination and flight. To us, power set-ups do not seem constitutive of arrangements, but form part of them in a dimension where the whole arrangement can teeter or fold back on itself. But even though the dualisms belong to this dimension, another dimension of the arrangement does not form a dualism with it. Thus there is no dualism between the abstract overcoding machines and the

abstract machines of mutation: the latter appear to be segmented, organized, and overcoded by the others, at the same time that they undermine them, the two working on each other within the arrangement. Similarly, there is no dualism between the two planes, the plane of transcendent organization and the plane of immanent consistency: it is rather from the forms and subjects of the first plane that the second ceaselessly tears away particles among which there are now only relationships of speed and slowness. It is also on the plane of immanence that the other rises up, working from within to block movements, fix affects, and organize forms and subjects. The indicators of speed presuppose the forms that they dissolve, no less than the organizations presuppose the material in fusion that they put into order. Thus we are not talking then about a dualism between two kinds of "things," but of a multiplicity of dimensions, lines, and directions within an arrangement.

To the question how can desire desire its own repression, how can it desire its own enslavement, we answer that the powers that crush desire, or subjugate it are already part of the arrangements of desire themselves: it suffices that desire follow that line, that it be caught, like a sailboat, in that wind. There is no more desire *for* revolution than there is desire *for* power, desire *to* oppress or *to be* oppressed; but revolution, oppression, power, etc. are the lines today composing a given arrangement. Not that these lines pre-exist; they are traced and composed, immanent in one another, entwined in one another, at the same time that the arrangement of desire is formed, with its entangled machines and intersecting planes.

We don't know in advance what will function as a line of inclination, nor the form an obstacle to it will take. This is true of a musical arrangement, for example, with its codes and territories, its constraints and power apparatuses, its dichotomized measures, its developing melodic and harmonic forms, its plan of transcendent organization, and also with its transformers of speed between sonorous molecules, its "off-beat" rhythm, its proliferations and dissolutions, its various becomings—child, woman, animal—its plane of immanent consistence. Consider the role of the church's power, for a long time, in the musical arrangements, and what the musicians succeeded in doing within them, in their midst. The same is true of every arrangement.

What must be compared in each case are the movements of deterritorialization and the processes of reterritorialization that appear in an arrangement. What do these words mean, words Guattari invents in order to make variable coefficient of them? One might again consider the commonplaces of humanity's evolution: man, *the deterritorialized animal*. When we hear that the hominid raised up its front paws from the ground, and that the hand is first locomotive, then prehensile, we say these are the thresholds or quanta of deterritorialization, but each time with a complementary reterritorialization: the locomotive hand as deterritorialized claw is reterritorialized on the branches used to swing from tree to tree; the prehensile hand as deterritorialized locomotor is reterritorialized on elements torn away or borrowed and called tools that it will brandish or throw. Note too that the "stick" as tool is itself a deterritorialized branch, and that the great inventions of man imply a passage to the steppe as a deterritorialized forest.

At the same time man reterritorializes himself on the steppe. It is said that the breast is a deterritorialized mammary gland, because of its vertical stature, and that the mouth is a deterritorialized muzzle, because of the turning up of the exterior mucous membranes (the lips): but a correlative reterritorialization of the lips occurs on the breast and inversely, so much that bodies and environments are traversed by very different speeds of deterritorialization, or by differential speeds whose complementaries will form continuums of intensity, but will also yield to processes of reterritorialization. At the limit, there is the earth itself, the deterritorialized ("the desert grows..."), and the nomad, the man of the earth, the man of deterritorialization—although he is also the one who doesn't move, who remains fixed in the middle, desert or steppe.

The comparative movements of deterritorialization, the continuums of intensity and the unions of flux that they form must be studied in the concrete social fields, at particular moments in time. Take, for example, events from around the 11th century: the sudden movement of masses of money; the great deterritorialization of the peasant masses, under the influence of the last invasions, and the increased demands of the feudal lords; the deterritorialization of the masses of mobility, which took forms as diverse as the Crusades, settling in towns, and new kinds of exploitation of the land (leasing or piece-work); the new configuration of the cities, whose fitting out is less and less territorial; the deterritorialization of the church, with the dispossession of its land, its "God's peace," its organization of the Crusades; the deterritorialization of woman with chivalric love, then with courtly love. The Crusades (the children's crusades included) can be seen as a threshold of the union of all these movements.

In some ways, these lines, the movements of flight, are what appear first in a society. Far from being a flight outside the social, or from being Utopian or even ideological, these lines actually constitute the social field, tracing its shapes and its borders, its entire state of becoming. Basically, a Marxist is recognized by his assertion that a society contradicts itself, that it is defined by its contradictions, notably its class contradictions. We say rather that in a society everything flees, and that a society is defined by its lines of flight, which affect masses of every kind (once again, "mass" is a molecular notion). A society, or any collective arrangement, is defined first by its points or flows (*flux*) of deterritorialization. History's greatest geographic adventures are lines of flight: the long marches by foot, horse, or boat; the Hebrews in the desert, Genseric the Vandal crossing the Mediterranean, the nomads across the steppes, the Great March of the Chinese—it's always along a line of flight that we create because there we are tracing the real and composing a plane of consistency, not simply imagining or dreaming. Flee, but while fleeing, pick up a weapon.

This primacy of the lines of flight must not be understood in a chronological sense, nor in the sense of an eternal generality. Rather, it points toward the "untimely" as fact and principle: a time without rhythm, a haecceity like a wind that stirs at midnight, or at noon. Yet reterritorializations occur at the same time: monetary reterritorializations on the new circuits, rural reterritorializations on the new modes of exploitation, urban reterritorializations along the new functions, etc.

Insofar as all of these reterritorializations begin to accumulate, there arises a new class that derives particular benefits from it, and that is capable of homogenizing and overcoding all its segments. At the very uppermost, one would have to distinguish between every kind of mass movement, with their coefficients of respective speeds, and class stabilization, with their segments distributed in the reterritorialization of the totality. The same thing acts as mass and class, but on two different entwined lines, whose contours do not coincide. We can now better understand why I said that sometimes there are at least three different lines, sometimes only two, and sometimes only one, all very entangled. Sometimes there are actually three lines, because the line of flight or of rupture combines all the movements of deterritorialization, precipitates quanta, tears off accelerated particles that cross into each other's territories, and carries them onto a plane of consistency or a mutating machine. And then there is a second, molecular line, where the deterritorializations are now only relative, always compensated for by reterritorializations which impose on them so many loops and detours, equilibria and stabilizations. Finally there is the molar line, with well-defined segments, where the reterritorializations accumulate in order to constitute a plane of organization and to pass into an overcoding machine.

Three lines: the nomad line, the migrant line, and the sedentary line (the migrant and nomad lines are not at all the same). Or there might only be two lines, because the molecular line would only appear in oscillation between the two extremes, sometimes swept away by the combination of deterritorializations, and sometimes contributing to the accumulation of reterritorializations (sometimes the migrant allies himself with the nomad, sometimes with the mercenary or confederate of an empire: the Ostrogoths and the Visigoths). Or perhaps there is only a single line, the primary line of flight, the border or edge that is relativized in the second line, and allows itself to be stopped or cut in the third. But even then, it can be conveniently presented as *the* line born from the explosion of the other two. Nothing is more complicated than a line or lines. This is what Melville is concerned with: the dinghys tied together in their organized segmentation, Captain Ahab on his molecular line, becoming animal, and the white whale in its mad flight.

Let's return to the realm of signs we were discussing earlier: how the line of flight, allotted a negative sign, is blocked in despotic regimes; how it discovers in the Hebrew regime a positive value, relative to be sure, and split up in successive trials...These are only two summary illustrations; there are so many others, each one revealing the essence of politics. Because one never knows in advance how a line will turn, politics is an experimental activity. Make the line break through, says the accountant: but that's just it, the line can break through *anywhere*.

There are so many dangers, and each line poses its own. The danger of a rigid segmentation or a break appears everywhere. For this danger concerns not only our relationships with the State, but with all the power set-ups that work on our bodies, all the binary machines that cut us up, and the abstract machines that overcode us; it concerns our way of perceiving, acting, feeling—our entire realm of signs. Clearly the nation States oscillate between two poles: the liberal one, where the State is only a mechanism that orients the operation of the abstract machine,

and the totalitarian one, where the State takes the abstract machine upon itself, and tends to blend with it. In any case, the segments traversing us and through which we pass are marked with a rigidity that reassures us, all while making us the most fearful, merciless, and bitterest of creatures. The danger is so widespread and so evident that we ought rather to wonder why we need such segmentation at all. Even if we had the power to get rid of it, could we do so without destroying ourselves, so much is it a part of the conditions of life, including both the human organism and our rational faculties? The prudence required to guide this line, the precautions needed to soften, suspend, divert or undermine it, all point to a long process of labor directed not only against the State, but against itself as well.

All the more so since the second line poses its own dangers. Rest assured that it is not enough to attain or trace a molecular line, or to be carried away on a supple line. For there again, everything—our perception, our actions and passions, our whole system of signs—is involved. Not only can we encounter on the supple line the same dangers met with on the rigid line—only miniaturized, disseminated or rather molecularized—but also the little Oedipi of the community have replaced the family Oedipus; changing relationships of force have become the relays of power set-ups; and cracks have replaced segregations. But worse still, the supple lines themselves produce or meet with their own dangers: a threshold crossed too quickly or an intensity become dangerous because no longer bearable. You didn't take enough precautions. This is the "black hole" phenomenon: a supple line rushes into a black hole from which it cannot emerge. Guattari speaks of micro-fascisms that exist in a social field without necessarily being centralized in a particular State apparatus. We have left the shores of rigid segmentation, and entered a realm that is no less organized, where each one plumbs his own black hole, thereby becoming dangerous, confident about his own situation, his role and his mission. This is even more disturbing than the certitudes of the first line: Stalins of little groups, neighborhood dispensers of justice, the micro-fascisms of gangs, etc.... We have been interpreted as saying that for us the schizophrenic is the true revolutionary. We believe rather that schizophrenia is the collapse of a molecular process into a black hole. Marginal groups have always been the object of fear, and sometimes of horror. They are not so clandestine.

(N.B.: In any case, they have given me fear. There is a molecular speech "in vivo" of the madman, the addict or the delinquent, but it's worth no more than the discourse of a psychiatrist "in vitro." There is as much assurance on the one side as certitude on the other. The marginals are not the ones who create the lines; they install themselves on them, and make of them their property. It's perfect when they have the curious modesty of "men of the line," and the prudence of an experimenter, but a catastrophe when they slide into a black hole, from which emerges only the micro-fascist speech of their eddying dependency: "We are the avant-garde!" or "We are the marginals!")

It may even happen that the two lines nourish each other, and that the organization of an increasingly rigid segmentation, at the level of the great molar ensembles, connects with the administration of little fears and black holes where each one plunges into a molecular network. Paul Virilio has sketched the outlines of the

world State such as it appears today: a State of absolute peace more terrifying still than one of total war, having fully realized its identification with the abstract machine, where the equilibrium of spheres of influence and the great segments communicate with a "secret capillarity," where the illuminated and totally cross-sectioned city now provides shelter only for nocturnal troglodytes, each one buried in his black hole, the "social swamp." Thus "the plainly visible and over-organized society" is completed.

It would be a mistake to believe finally that taking the line of flight or rupture is enough. First it is necessary to trace it, to know where and how to trace it. Then it has its own danger, perhaps the worst of all. Not only do the lines of flight, the lines of steepest gradient, carry the risk of being blocked, segmented, or rushing into black holes, but they carry an additional, particular risk: of turning into lines of abolition and destruction, both of others and of themselves. The passion of abolition. Even music, why does it make us feel so much like dying? Marie's death cry, so drawn out along the water, or Lulu's death cry, vertical and celestial (in Berg's two pieces). Does all music enter into these cries?

All the examples of lines of flight that we have given, though taken only from works of writers we love, have turned out badly. Why? Lines of flight turn out badly not because they are imaginary but precisely because they are real and move within reality. They turn out badly, not only because they are short-circuited by the two other lines, but because they themselves secrete a danger: Kleist and his double suicide, Hölderlin and his madness, Fitzgerald and his self-destruction, Virginia Woolf's drowning herself. One can imagine some of these deaths as being calm or even happy, the haecceity of a death no longer personal, the release of a pure event, at its hour, on its own plane. But can only the plane of immanence or consistency bring us a death that is relatively worthy and not bitter? It wasn't made for that. Even if all creation ends in a destruction at work, from the very beginning, even if all music is a pursuit of silence, they cannot be judged according to their end nor assumed purpose, for they exceed them in every way. When they lead to death, it's the result of a danger peculiar to them, not to their destination. Here is what we mean: Why does the "metaphor" of war turn up so often, even at the most personal or individual level, on these lines of flight that we take to be real? Hölderlin and the battlefield, Hyperion. Kleist, whose work contains throughout the idea of a war machine against the State apparatuses; and in his life too, the idea of waging a war that ultimately will lead to suicide. Fitzgerald: "I felt as though I were standing alone at twilight on a deserted shooting range." The "critique" and the "clinic" are the same thing, just as life and art are the same when they join the line of flight that makes them pieces of the same war machine. Under these conditions, life ceased being personal and the work of art ceased being literary or textual a long time ago.

Surely war is not a metaphor. We think that the nature and origin of the war machine is completely different from that of the State apparatus. The war machine probably arose in the conflict between the nomadic shepherds and the imperial sedentary peoples. It implies an arithmetic organization in an open space where

men and animals are distributed, as opposed to the geometric organization of the State, which divides up a closed space. Even when the war machine is related to a geometry, it's a very different one from that of the State, a kind of Archimedian geometry consisting of "problems" and not of "theorems" like Euclid's. Inversely, the power of the State does not rest on the war machine, but on the functioning of the binary machines that traverse us and the abstract machine that overcodes us: a whole "police force."

The war machine, on the contrary, is traversed by the warrior's states of "becoming": becoming-animal, becoming-woman, becoming-imperceptible. (Think of the secret as the invention of the war machine, in opposition to the "publicity" of the despot or the statesman.) Georges Dumézil has often insisted on this eccentric position of the warrior in relation to the State, and Luc de Heusch shows how the war machine comes from the exterior and throws itself upon an already developed State which doesn't include it. Pierre Clastres, in a definitive text, explains that the function of war in primitive societies was precisely to conjure away the formation of a State apparatus. We would say that the State apparatus and the war machine do not belong to the same lines, or are not constructed along the same lines. Whereas the State apparatus belongs to lines of rigid segmentation, and even conditions them insofar as it brings about their overcoding, the war machine follows the lines of flight and of steepest gradient, as it comes from the heart of the steppes or the desert and penetrates into the empire. Ghengis Khan and the Emperor of China. The military organization is one of flight (even the one that Moses gave to his people), not only because it is made to flee something, or even to make the enemy take flight, but because wherever it goes it traces a line of flight or of deterritorialization which is only part of its own politics and its own strategy. Under these conditions, one of the most difficult problems facing the State will be to integrate the war machine into an institutionalized army, and to make it a part of its general police (Tamerlane is perhaps the most striking example of such a conversion). The army is always a compromise. It may happen that the war machine becomes mercenary, or even that it allows itself to be appropriated by the State in its very attempt to conquer it. Yet there will always be a tension between the State apparatus, with its demand for self-preservation, and the war machine, with its project to destroy the State and its subjects, and even to destroy or dissolve itself along the line of flight.

If there is no history from the point of view of the nomads (even though everything happens through them), to the extent that they are like the "noumena" or unknowables of history, it is because they are inseparable from this enterprise of abolition that makes nomadic empires vanish like the nomads themselves, at the same time that the war machine either destroys itself or passes into the service of the State. In short, the line of flight converts into a line of abolition, destroying itself and others, each time it is traced by a war machine. And that is the special danger of this type of line, which is entwined with but not to be confused with the preceding dangers. To the point that, every time a line of flight turns into a line of death, we don't invoke an internal drive like the death instinct, but again an arrangement of desire that puts into play an objectively or extrinsically definable

machine. It is not being metaphorical, therefore, to say that every time someone destroys both himself and others that he has invented his own war machine on the line of flight: the conjugal war machine of Strindberg, the alcoholic war machine of Fitzgerald The entire work of Kleist rests on the following: there is no longer any war machine on the scale of that of the Amazons; the war machine is no longer but a dream that vanishes and gives way to national armies (the Prince of Homburg); how can a new type of war machine be invented (Michael Kohlhass); how can a line of flight be traced when we know very well that it leads to destruction and double suicide? Lead one's own war? Or rather, how evade this last trap?

The differences do not lie between the individual and the collective, for we see no duality between the two types of problems. There is no subject of enunciation; every proper noun is collective, every arrangement is already collective. The differences do not lie between the natural and the artificial, as long as the two belong to the same machine and are interchangeable within it. Nor between the spontaneous and the organized, as long as the only question concerns the modes of organization. Nor between the segmentary and the centralized, as long as centralization is itself an organization resting on a form of rigid segmentation. The effective differences occur between the lines, although they are all immanent in each other, and entangled with each other. This is why the question of schizo-analysis or of pragmatism or of micro-politics is never one of interpretation, but only of asking: which are your lines, as an individual or group, and what are their dangers? (1.) Which are your rigid segments, your binary machines and their overcodings? For even the latter are not given ready made; we are not only divided up by binary machines of class, sex or age; there are others that we never cease displacing and inventing without knowing it. And what would be the dangers if we got rid of these segments too quickly? The human organism itself would not die, even though it too possesses binary machines, in its nerves and brain. (2.) Which are your supple lines, your fluxes and your thresholds? What is the aggregate of your relative deterritorializations, and the correlative reterritorializations? And the distribution of your black holes? And what do they contain, a little beast hiding itself or a growing micro-fascism? (3.) Which are your lines of flight, where the fluxes add to one another, and where the thresholds attain a point of adjacency and rupture? Are they still viable, or have they already been caught in a machine of destruction and self-destruction which would recompose a molar fascism?

It can happen that an arrangement of desire and of enunciation may be reduced to the most rigid lines, and to power set-ups. There are some arrangements that only have these lines. Yet other dangers, more supple and more sticky, lie in wait for each of us. We alone are the judge, as long as it is not too late. The question "How can desire desire its own repression?" presents no real theoretical difficulty, but many practical problems each time it is posed. There is desire as soon as there is a machine or a "body without organs." But there are bodies without organs that are empty, hardened envelopes because their organic components have been eliminated too quickly and forcefully, as in an "overdose." There are cancerous or fascist bodies without organs, in black holes or in machines of abolition. How

can desire thwart all that, all while confronting these dangers on its own plane of immanence and of consistency?

There is no general recipe. We are finished with all globalizing concepts. Even concepts are haecceities and events in themselves. What is interesting about concepts like "desire," "machine," or "arrangement," is that they are valuable only as variables, and as they permit a maximum number of variables. We are not in favor of such gross concepts as The law, The master, or The rebel, which are like hollow teeth. It's not our function to account for the dead, the victims of history, the martyrs of the Gulag, in order to conclude: "Though the revolution is impossible, we thinkers must think the impossible, since this impossibility only exists in our minds!" It appears to us that the Gulag would never have existed if the victims had spoken out the way those who mourn them do today. The victims would have had to think and live very differently, in order to provide subject matter for those who cry in their name, who think in their name, and who give lessons in their name. It's the life force that pushed them, and not their sourness; their sobriety, not their ambition; their anorexia, and not, as Zola would say, their gross appetites. We would have liked to write a book about life, not about accountability or dispensing justice, even in regard to people or pure thought.

The question of revolution has never been one of Utopian spontaneity or State organization. When we challenge the model of the State apparatus or of a party organization modeled to take over this apparatus, we are not falling back on the grotesque alternatives of either calling for a state of nature with a dynamic spontaneity or becoming the so-called lucid thinker of an impossible revolution, who derives pleasure from its impossibility. The question has always been organizational, never ideological: Is an organization not modeled on the State apparatus possible, even one meant to prefigure the State to come? What about a war machine, with its lines of flight? In every arrangement, even musical or literary, the war machine and the State apparatus are opposed, and the degree of proximity to one pole or the other must be determined. But how can a war machine, in whatever domain, become modern? How can it keep its own fascist dangers at bay, as it confronts the totalitarian dangers of the State, or its own dangers of self-destruction, as it faces the conservation of the State?

In some ways it's very simple; it happens by itself, everyday. It would be a mistake to say that there is a globalizing State that is master of its plans and that sets its own traps; and then that there is a form of resistance that will assume the same form, even if it means betraying us, or that it will become enmeshed in local and spontaneous struggles, even if it means being stifled and beaten. The most centralized State is not at all master of its plans. It too is experimental: it makes injections here and there, yet never succeeds at predicting anything. State economists even declare that they are incapable of predicting an increase in the money supply. American politics, for example, is obviously obliged to proceed by empirical injections, and not at all by demonstrable programs. Those who speak of a supremely wicked master in order to present themselves as rigorous thinkers, "incorruptible" and pessimistic, are sadly deceived. The powers of State conduct

their experiments along different lines of complex arrangements, but these lead to experiments of another sort, experiments that baffle expectations, trace active lines of flight, seek out lines that are bunching, accelerating or decreasing in speed, and little by little create the plane of consistency with a war machine that at each step measures the dangers to be encountered.

What characterizes our situation is both beyond and on this side of the State. *Beyond* the nation States: the development of the world market, the power of multinational corporations, the outline of a "planetary" organization, and the extension of capitalism throughout the entire social body are forming a huge abstract machine that overcodes the monetary, industrial and technological flux. At the same time, the means of exploitation, control, and surveillance are becoming more and more subtle and diffused, in some way more molecular. The workers of the wealthy countries participate necessarily in the looting of the Third World, and men in the over-exploitation of women, etc. But the abstract machine, with its dysfunctions, is no more infallible than the nation States, which couldn't regulate it on their own or another's territory. The State no longer possesses the political, institutional or even financial means that would enable it to parry the social counterattacks of the machine. It is doubtful it can rely forever upon older forms such as the police, the army, the bureaucracy (even unionized), collective equipment, schools and families. Enormous landslides are occurring *on this side of* the State, following lines of gradience or flight, that principally affect the following: (1.) territorial divisions; (2.) the mechanisms of economic subjugation (new aspects of unemployment and inflation); (3.) basic structures of regulation (crisis in the schools, unions, army, among women, etc.); (4.) social claims and demands, which are becoming qualitative as much as quantitative ("quality of life" instead of "standard of living"). All of these things constitute what can be called the *right to desire*. It is not surprising that all sorts of questions—minority, linguistic, ethnic, regional, sexual, and juvenile—are re-emerging not only by way of archaisms, but also in contemporary revolutionary forms that throw into question in a totally immanent way the global economy of the machine and the arrangements of the nation States. Instead of betting on the eternal impossibility of the revolution and on the fascist return of the war machine in general, why not think that *a new type of revolution is becoming possible*, and that all kinds of mutant machines are alive, engaged in warfare, joining one another, and tracing a plane of consistency that undermines the organizational plan of the World State?

For, once again, the world and its States are no more masters of their plan than are revolutionaries condemned to deform their own. Everyone plays a very uncertain part, "face to face/back to back, back to face...." The question of the revolution's future is a bad one, because, as long as it is posed, there are going to be those who will not *become* revolutionaries. Which is precisely why it is done: to prevent the becoming-revolutionary of people everywhere and at every level.

Globalization/postmodernism

Michael Hardt and Antonio Negri

POSTMODERNIZATION, OR THE INFORMATIZATION OF PRODUCTION

EDITOR'S INTRODUCTION

THE SUCCESS OF HARDT AND NEGRI'S *Empire* after its publication in 2000 came as a complete surprise to almost everyone. Writings by Antonio Negri, a long time theorist and activist within the lively and theoretically innovative Italian radical scene, and in particular the Autonomia movement, were already available in English, although admittedly *Empire* does mark a break from his earlier more 'workerist' theory which argued that radicalism had to start at the factory floor and in which labour was thought of as under exploitation in more classically Marxist terms. Yet *Empire*'s theoretical approach had already been outlined in broad terms in collections such as the journal *Semiotext(e)*'s 1980 issue on Italian political theory.

But *Empire* took off because it moves on from the characteristically Italian mix of Deleuzianism, anarchist radicalism and a sense that if capitalism were let really rip it would explode itself in wholly non-Marxist terms. They apply this understanding to the new networked globe (the infrastructure of the internet and the 'information highway'), to the accelerating technologization of nature and to a military-based American imperialism which for them (controversially) contains seeds of a truly open future to come. It's as if a pragmatic even realist American radical democratic optimism joins with a European poststructuralist, postmarxist and wholly utopian understanding of the emancipatory project as a permanent revolution, enabled by capitalism itself, in which the docile populations of nation-states will be replaced by a 'multitude', that is, a collectivity of different, mutating identities (or 'singularities') on a global 'commons'.

Further reading: Balakrishnan and Aronowitz 2003, Brennan 2006; Hardt and Negri 2004; Hardt and Virno 1996; Virno 2004; Wallerstein 1979.

It has now become common to view the succession of economic paradigms since the Middle Ages in three distinct moments, each defined by the dominant sector of the economy: a first paradigm in which agriculture and the extraction of raw materials dominated the economy, a second in which industry and the manufacture of durable goods occupied the privileged position, and a third and current paradigm in which providing services and manipulating information are at the heart of economic production (Bell 1973, Touraine 1971). The dominant position has thus passed from primary to secondary to tertiary production. Economic *modernization* involves the passage from the first paradigm to the second, from the dominance of agriculture to that of industry. Modernization means industrialization. We might call the passage from the second paradigm to the third, from the domination of industry to that of services and information, a process of economic *postmodernization*, or better, *informatization*.

The most obvious definition and index of the shifts among these three paradigms appear first in quantitative terms, in reference either to the percentage of the population engaged in each of these productive domains or to the percentage of the total value produced by the various sectors of production. The changes in employment statistics in the dominant capitalist countries during the past one hundred years do indeed indicate dramatic shifts. This quantitative view, however, can lead to serious misunderstandings of these economic paradigms. Quantitative indicators cannot grasp either the *qualitative* transformation in the progression from one paradigm to another or the *hierarchy* among the economic sectors in the context of each paradigm. In the process of modernization and the passage toward the paradigm of industrial dominance, not only did agricultural production decline quantitatively (both in percentage of workers employed and in proportion of the total value produced), but also, more important, agriculture itself was transformed. When agriculture came under the domination of industry, even when agriculture was still predominant in quantitative terms, it became subject to the social and financial pressures of industry, and moreover agricultural production itself was industrialized. Agriculture, of course, did not disappear; it remained an essential component of modern industrial economies, but it was now a transformed, industrialized agriculture.

The quantitative perspective also fails to recognize hierarchies among national or regional economies in the global system, which leads to all kinds of historical misrecognitions, posing analogies where none exist. From a quantitative perspective, for example, one might assume a twentieth-century society with the majority of its labor force occupied in agriculture or mining and the majority of its value produced in these sectors (such as India or Nigeria) to be in a position analogous to a society that existed sometime in the past with the same percentage of workers or value produced in those sectors (such as France or England). The historical illusion casts the analogy in a dynamic sequence so that one economic system occupies the same position or stage in a sequence of development that another had held in a previous period, as if all were on the same track moving forward in line. From the qualitative perspective, that is, in terms of their position in global power relationships, however, the economies of these societies occupy entirely incomparable positions. In the earlier case (France or England of the past), the agricultural production existed as the dominant sector in its economic sphere, and

in the later (twentieth-century India or Nigeria), it is subordinated to industry in the world system. The two economies are not on the same track but in radically different and even divergent situations—of dominance and subordination. In these different positions of hierarchy, a host of economic factors is completely different—exchange relationships, credit and debt relationships, and so forth. In order for the latter economy to realize a position analogous to that of the former, it would have to invert the power relationship and achieve a position of dominance in its contemporary economic sphere, as Europe did, for example, in the medieval economy of the Mediterranean world. Historical change, in other words, has to be recognized in terms of the power relationships throughout the economic sphere.

The discourse of economic *development*, which was imposed under U.S. hegemony in coordination with the New Deal model in the postwar period, uses such false historical analogies as the foundation for economic policies. This discourse conceives the economic history of all countries as following one single pattern of development, each at different times and according to different speeds. Countries whose economic production is not presently at the level of the dominant countries are thus seen as developing countries, with the idea that if they continue on the path followed previously by the dominant countries and repeat their economic policies and strategies, they will eventually enjoy an analogous position or stage. The developmental view fails to recognize, however, that the economies of the so-called developed countries are defined not only by certain quantitative factors or by their internal structures, but also and more important by *their dominant position in the global system*.

[…]

Informatization

The processes of modernization and industrialization transformed and redefined all the elements of the social plane. When agriculture was modernized as industry, the farm progressively became a factory, with all of the factory's discipline, technology, wage relations, and so forth. Agriculture was modernized as industry. More generally, society itself slowly became industrialized even to the point of transforming human relations and human nature. Society became a factory. In the early twentieth century, Robert Musil reflected beautifully on the transformation of humanity in the passage from the pastoral agricultural world to the social factory: "There was a time when people grew naturally into the conditions they found waiting for them and that was a very sound way of becoming oneself. But nowadays, with all this shaking up of things, when everything is becoming detached from the soil it grew in, even where the production of soul is concerned one really ought, as it were, to replace the traditional handicrafts by the sort of intelligence that goes with the machine and the factory." The processes of becoming human and the nature of the human itself were fundamentally transformed in the passage defined by modernization.

In our times, however, *modernization has come to an end*. In other words, industrial production is no longer expanding its dominance over other economic forms and social phenomena. A symptom of this shift is manifest in the quantitative changes in employment. Whereas the process of modernization was indicated by a

migration of labor from agriculture and mining (the primary sector) to industry (the secondary), the process of postmodernization or informatization has been demonstrated through the migration from industry to service jobs (the tertiary), a shift that has taken place in the dominant capitalist countries, and particularly in the United States, since the early 1970s. Services cover a wide range of activities from health care, education, and finance to transportation, entertainment, and advertising. The jobs for the most part are highly mobile and involve flexible skills. More important, they are characterized in general by the central role played by knowledge, information, affect, and communication. In this sense many call the postindustrial economy an informational economy.

The claim that modernization is over and that the global economy is today undergoing a process of postmodernization toward an informational economy does not mean that industrial production will be done away with or even that it will cease to play an important role, even in the most dominant regions of the globe. Just as the processes of industrialization transformed agriculture and made it more productive, so too the informational revolution will transform industry by redefining and rejuvenating manufacturing processes. The new managerial imperative operative here is, "Treat manufacturing as a service." In effect, as industries are transformed, the division between manufacturing and services is becoming blurred. Just as through the process of modernization all production tended to become industrialized, so too through the process of postmodernization all production tends toward the production of services, toward becoming informationalized.

Not all countries, of course, even among the dominant capitalist countries, have embarked on the project of postmodernization along the same path. On the basis of the change of employment statistics in the G-7 countries since 1970, Manuel Castells and Yuko Aoyama have discerned two basic models or paths of informatization. Both models involve the increase of employment in postindustrial services, but they emphasize different kinds of services and different relations between services and manufacturing. The first path tends toward a *service economy model* and is led by the United States, the United Kingdom, and Canada. This model involves a rapid decline in industrial jobs and a corresponding rise in service-sector jobs. In particular, the financial services that manage capital come to dominate the other service sectors. In the second model, the *info-industrial model*, typified by Japan and Germany, industrial employment declines more slowly than it does in the first model, and, more important, the process of informatization is closely integrated into and serves to reinforce the strength of existing industrial production. Services related directly to industrial production thus remain more important in this model relative to other services. The two models represent two strategies to manage and gain an advantage in the economic transition, but it should be clear that they both move resolutely in the direction of the informatization of the economy and the heightened importance of productive flows and networks.

Although the subordinated countries and regions of the world are not capable of implementing such strategies, the processes of postmodernization nonetheless impose irreversible changes on them. The fact that informatization and the shift toward services have taken place thus far primarily in the dominant capitalist countries and not elsewhere should not lead us back to an understanding of the contemporary global economic situation in terms of linear stages of development. It is true

that as industrial production has declined in the dominant countries, it has been effectively exported to subordinated countries, from the United States and Japan, for example, to Mexico and Malaysia. Such geographical shifts and displacements might lead some to believe that there is a new global organization of economic stages whereby the dominant countries are informational service economies, their first subordinates are industrial economies, and those further subordinated are agricultural. From the perspective of stages of development, for example, one might think that through the contemporary export of industrial production, an auto factory built by Ford in Brazil in the 1990s might be comparable to a Ford factory in Detroit in the 1930s because both instances of production belong to the same industrial stage.

When we look more closely, however, we can see that the two factories are not comparable, and the differences are extremely important. First of all, the two factories are radically different in terms of technology and productive practices. When fixed capital is exported, it is exported generally at its highest level of productivity. The Ford factory in 1990s Brazil, then, would not be built with the technology of the Ford factory of 1930s Detroit, but would be based on the most advanced and most productive computer and informational technologies available. The technological infrastructure of the factory itself would locate it squarely within the informational economy. Second, and perhaps more important, the two factories stand in different relations of dominance with respect to the global economy as a whole. The Detroit auto factory of the 1930s stood at the pinnacle of the global economy in the dominant position and producing the highest value; the 1990s auto factory, whether in São Paulo, Kentucky, or Vladivostok, occupies a subordinate position in the global economy—subordinated to the high-value production of services. Today all economic activity tends to come under the dominance of the informational economy and to be qualitatively transformed by it. The geographical differences in the global economy are not signs of the co-presence of different stages of development but lines of the new global hierarchy of production.

It is becoming increasingly clear from the perspective of subordinated regions that modernization is no longer the key to economic advancement and competition. The most subordinated regions, such as areas of sub-Saharan Africa, are effectively excluded from capital flows and new technologies, and they thus find themselves on the verge of starvation. Competition for the middle-level positions in the global hierarchy is conducted not through the industrialization but through the informatization of production. Large countries with varied economies, such as India and Brazil, can support simultaneously all levels of productive processes: information-based production of services, modern industrial production of goods, and traditional handicraft, agricultural, and mining production. There does not need to be an orderly historical progression among these forms, but rather they mix and coexist. All of the forms of production exist within the networks of the world market and under the domination of the informational production of services.

[...]

Just as modernization did in a previous era, postmodernization or informatization today marks a new mode of becoming human. Where the production of soul is concerned, as Musil would say, one really ought to replace the traditional techniques of industrial machines with the cybernetic intelligence of information

and communication technologies. We must invent what Pierre Levy calls an anthropology of cyberspace (Levy 1997). This shift of metaphors gives us a first glimpse of the transformation, but we need to look more closely to see clearly the changes in our notion of the human and in humanity itself that emerge in the passage toward an informational economy.

The sociology of immaterial labor

The passage toward an informational economy necessarily involves a change in the quality and nature of labor. This is the most immediate sociological and anthropological implication of the passage of economic paradigms. Today information and communication have come to play a foundational role in production processes.

A first aspect of this transformation is recognized by many in terms of the change in factory labor—using the auto industry as a central point of reference—from the Fordist model to the Toyotist model. The primary structural change between these models involves the system of communication between the production and the consumption of commodities, that is, the passage of information between the factory and the market. The Fordist model constructed a relatively "mute" relationship between production and consumption. The mass production of standardized commodities in the Fordist era could count on an adequate demand and thus had little need to "listen" to the market. A feedback circuit from consumption to production did allow changes in the market to spur changes in productive engineering, but this communication circuit was restricted (owing to the fixed and compartmentalized channels of planning and design structures) and slow (owing to the rigidity of the technologies and procedures of mass production).

Toyotism is based on an inversion of the Fordist structure of communication between production and consumption. Ideally, according to this model, production planning will communicate with markets constantly and immediately. Factories will maintain zero stock, and commodities will be produced just in time according to the present demand of the existing markets. This model thus involves not simply a more rapid feedback loop but an inversion of the relationship because, at least in theory, the production decision actually comes after and in reaction to the market decision. In the most extreme cases the commodity is not produced until the consumer has already chosen and purchased it. In general, however, it would be more accurate to conceive the model as striving toward a continual interactivity or rapid communication between production and consumption. This industrial context provides a first sense in which communication and information have come to play a newly central role in production. One might say that instrumental action and communicative action have become intimately interwoven in the informationalized industrial process, but one should quickly add that this is an impoverished notion of communication as the mere transmission of market data.

The service sectors of the economy present a richer model of productive communication. Most services indeed are based on the continual exchange of information and knowledges. Since the production of services results in no material and durable good, we define the labor involved in this production as

immaterial labor—that is, labor that produces an immaterial good, such as a service, a cultural product, knowledge, or communication. One face of immaterial labor can be recognized in analogy to the functioning of a computer. The increasingly extensive use of computers has tended progressively to redefine laboring practices and relations, along with, indeed, all social practices and relations. Familiarity and facility with computer technology is becoming an increasingly general primary qualification for work in the dominant countries. Even when direct contact with computers is not involved, the manipulation of symbols and information along the model of computer operation is extremely widespread. In an earlier era workers learned how to act like machines both inside and outside the factory. We even learned (with the help of Muybridge's photos, for example) to recognize human activity in general as mechanical. Today we increasingly think like computers, while communication technologies and their model of interaction are becoming more and more central to laboring activities. One novel aspect of the computer is that it can continually modify its own operation through its use. Even the most rudimentary forms of artificial intelligence allow the computer to expand and perfect its operation based on its interaction with its user and its environment. The same kind of continual interactivity characterizes a wide range of contemporary productive activities, whether computer hardware is directly involved or not. The computer and communication revolution of production has transformed laboring practices in such a way that they all tend toward the model of information and communication technologies. Interactive and cybernetic machines become a new prosthesis integrated into our bodies and minds and a lens through which to redefine our bodies and minds themselves. The anthropology of cyberspace is really a recognition of the new human condition.

Robert Reich calls the kind of immaterial labor involved in computer and communication work "symbolic-analytical services"—tasks that involve "problem-solving, problem-identifying, and strategic brokering activities" (Reich 1991: 177). This type of labor claims the highest value, and thus Reich identifies it as the key to competition in the new global economy. He recognizes, however, that the growth of these knowledge-based jobs of creative symbolic manipulation implies a corresponding growth of low-value and low-skill jobs of routine symbol manipulation, such as data entry and word processing. Here begins to emerge a fundamental division of labor within the realm of immaterial production.

We should note that one consequence of the informatization of production and the emergence of immaterial labor has been a real homogenization of laboring processes. From Marx's perspective in the nineteenth century, the concrete practices of various laboring activities were radically heterogeneous: tailoring and weaving involved incommensurable concrete actions. Only when abstracted from their concrete practices could different laboring activities be brought together and seen in a homogeneous way, no longer as tailoring and weaving but as the expenditure of human labor power in general, as *abstract labor*. With the computerization of production today, however, the heterogeneity of concrete labor has tended to be reduced, and the worker is increasingly further removed from the object of his or her labor. The labor of computerized tailoring and the labor of computerized weaving may involve exactly the same concrete practices—that is, manipulation of symbols and information. Tools, of course, have always abstracted labor power

from the object of labor to a certain degree. In previous periods, however, the tools generally were related in a relatively inflexible way to certain tasks or certain groups of tasks; different tools corresponded to different activities—the tailor's tools, the weaver's tools, or later a sewing machine and a power loom. The computer proposes itself, in contrast, as the universal tool, or rather as the central tool, through which all activities might pass. Through the computerization of production, then, labor tends toward the position of abstract labor.

The model of the computer, however, can account for only one face of the communicational and immaterial labor involved in the production of services. The other face of immaterial labor is the *affective labor* of human contact and interaction. Health services, for example, rely centrally on caring and affective labor, and the entertainment industry is likewise focused on the creation and manipulation of affect. This labor is immaterial, even if it is corporeal and affective, in the sense that its products are intangible, a feeling of ease, well-being, satisfaction, excitement, or passion. Categories such as "in-person services" or services of proximity are often used to identify this kind of labor, but what is really essential to it are the creation and manipulation of affect. Such affective production, exchange, and communication are generally associated with human contact, but that contact can be either actual or virtual, as it is in the entertainment industry.

This second face of immaterial labor, its affective face, extends well beyond the model of intelligence and communication defined by the computer. Affective labor is better understood by beginning from what feminist analyses of "women's work" have called "labor in the bodily mode." Caring labor is certainly entirely immersed in the corporeal, the somatic, but the affects it produces are nonetheless immaterial. What affective labor produces are social networks, forms of community, biopower. Here one might recognize once again that the instrumental action of economic production has been united with the communicative action of human relations; in this case, however, communication has not been impoverished, but production has been enriched to the level of complexity of human interaction.

In short, we can distinguish three types of immaterial labor that drive the service sector at the top of the informational economy. The first is involved in an industrial production that has been informationalized and has incorporated communication technologies in a way that transforms the production process itself. Manufacturing is regarded as a service, and the material labor of the production of durable goods mixes with and tends toward immaterial labor. Second is the immaterial labor of analytical and symbolic tasks, which itself breaks down into creative and intelligent manipulation on the one hand and routine symbolic tasks on the other. Finally, a third type of immaterial labor involves the production and manipulation of affect and requires (virtual or actual) human contact, labor in the bodily mode. These are the three types of labor that drive the postmodernization of the global economy.

We should point out before moving on that in each of these forms of immaterial labor, cooperation is completely inherent in the labor itself. Immaterial labor immediately involves social interaction and cooperation. In other words, the cooperative aspect of immaterial labor is not imposed or organized from the outside, as it was in previous forms of labor, but rather, *cooperation is completely immanent to the laboring activity itself*. This fact calls into question the old notion (common

to classical and Marxian political economics) by which labor power is conceived as "variable capital," that is, a force that is activated and made coherent only by capital, because the cooperative powers of labor power (particularly immaterial labor power) afford labor the possibility of valorizing itself. Brains and bodies still need others to produce value, but the others they need are not necessarily provided by capital and its capacities to orchestrate production. Today productivity, wealth, and the creation of social surpluses take the form of cooperative interactivity through linguistic, communicational, and affective networks. In the expression of its own creative energies, immaterial labor thus seems to provide the potential for a kind of spontaneous and elementary communism.

Network production

The first geographical consequence of the passage from an industrial to an informational economy is a dramatic decentralization of production. The processes of modernization and the passage to the industrial paradigm provoked the intense aggregation of productive forces and mass migrations of labor power toward centers that became factory cities, such as Manchester, Osaka, and Detroit. Efficiency of mass industrial production depended on the concentration and proximity of elements in order to create the factory site and facilitate transportation and communication. The informatization of industry and the rising dominance of service production, however, have made such concentration of production no longer necessary. Size and efficiency are no longer linearly related; in fact, large scale has in many cases become a hindrance. Advances in telecommunications and information technologies have made possible a deterritorialization of production that has effectively dispersed the mass factories and evacuated the factory cities. Communication and control can be exercised efficiently at a distance, and in some cases immaterial products can be transported across the world with minimal delay and expense. Several different production facilities can be coordinated in the simultaneous production of a single commodity in such a way that factories can be dispersed to various locations. In some sectors even the factory site itself can be done away with as its workers communicate exclusively through new information technologies.

In the passage to the informational economy, the assembly line has been replaced by *the network* as the organizational model of production, transforming the forms of cooperation and communication within each productive site and among productive sites. The mass industrial factory defined the circuits of laboring cooperation primarily through the physical deployments of workers on the shop floor. Individual workers communicated with their neighboring workers, and communication was generally limited to physical proximity. Cooperation among productive sites also required physical proximity both to coordinate the productive cycles and to minimize the transportation costs and time of the commodities being produced. For example, the distance between the coal mine and the steel mill, and the efficiency of the lines of transportation and communication between them, are significant factors in the overall efficiency of steel production. Similarly, for automobile production the efficiency of communication and transportation among the series of subcontractors involved is crucial in the overall efficiency of the system. The passage toward

informational production and the network structure of organization, in contrast, make productive cooperation and efficiency no longer dependent to such a degree on proximity and centralization. Information technologies tend to make distances less relevant. Workers involved in a single process can effectively communicate and cooperate from remote locations without consideration to proximity. In effect, the network of laboring cooperation requires no territorial or physical center.

The tendency toward the deterritorialization of production is even more pronounced in the processes of immaterial labor that involve the manipulation of knowledge and information. Laboring processes can be conducted in a form almost entirely compatible with communication networks, for which location and distance have very limited importance. Workers can even stay at home and log on to the network. The labor of informational production (of both services and durable goods) relies on what we can call *abstract cooperation*. Such labor dedicates an ever more central role to communication of knowledges and information among workers, but those cooperating workers need not be present and can even be relatively unknown to one another, or known only through the productive information exchanged. The circuit of cooperation is consolidated in the network and the commodity at an abstract level. Production sites can thus be deterritorialized and tend toward a virtual existence, as coordinates in the communication network. As opposed to the old vertical industrial and corporate model, production now tends to be organized in horizontal network enterprises.

The information networks also release production from territorial constraints insofar as they tend to put the producer in direct contact with the consumer regardless of the distance between them. Bill Gates, the co-founder of the Microsoft Corporation, takes this tendency to an extreme when he predicts a future in which networks will overcome entirely the barriers to circulation and allow an ideal, "friction-free" capitalism to emerge: "The information highway will extend the electronic marketplace and make it the ultimate go-between, the universal middleman." If Gates's vision were to be realized, the networks would tend to reduce all distance and make transactions immediate. Sites of production and sites of consumption would then be present to one another, regardless of geographical location.

These tendencies toward the deterritorialization of production and the increased mobility of capital are not absolute, and there are significant countervailing tendencies, but to the extent that they do proceed, they place labor in a weakened bargaining position. In the era of the Fordist organization of industrial mass production, capital was bound to a specific territory and thus to dealing contractually with a limited laboring population. The informatization of production and the increasing importance of immaterial production have tended to free capital from the constraints of territory and bargaining. Capital can withdraw from negotiation with a given local population by moving its site to another point in the global network—or merely by using the potential to move as a weapon in negotiations. Entire laboring populations, which had enjoyed a certain stability and contractual power, have thus found themselves in increasingly precarious employment situations. Once the bargaining position of labor has been weakened, network production can accommodate various old forms of non-guaranteed labor, such as freelance work, home work, part-time labor, and piecework.

The decentralization and global dispersal of productive processes and sites, which is characteristic of the postmodernization or informatization of the economy, provokes a corresponding centralization of the control over production. The centrifugal movement of production is balanced by the centripetal trend of command. From the local perspective, the computer networks and communications technologies internal to production systems allow for more extensive monitoring of workers from a central, remote location. Control of laboring activity can potentially be individualized and continuous in the virtual panopticon of network production. The centralization of control, however, is even more clear from a global perspective. The geographical dispersal of manufacturing has created a demand for increasingly centralized management and planning, and also for a new centralization of specialized producer services, especially financial services. Financial and trade-related services in a few key cities (such as New York, London, and Tokyo) manage and direct the global networks of production. As a mass demographic shift, then, the decline and evacuation of industrial cities has corresponded to the rise of global cities, or really cities of control.

Information highways

The structure and management of communication networks are essential conditions for production in the informational economy. These global networks must be constructed and policed in such a way as to guarantee order and profits. It should come as no surprise, then, that the U.S. government poses the establishment and regulation of a global information infrastructure as one of its highest priorities, and that communications networks have become the most active terrain of mergers and competition for the most powerful transnational corporations.

An adviser to the Federal Communications Commission, Peter Cowhey, provides an interesting analogy for the role these networks play in the new paradigm of production and power. The construction of the new information infrastructure, he says, provides the conditions and terms of global production and government just as road construction did for the Roman Empire. The wide distribution of Roman engineering and technology was indeed both the most lasting gift to the imperial territories and the fundamental condition for exercising control over them. Roman roads, however, did not play a central role in the imperial production processes but only facilitated the circulation of goods and technologies. Perhaps a better analogy for the global information infrastructure might be the construction of railways to further the interests of nineteenth- and twentieth-century imperialist economies. Railways in the dominant countries consolidated their national industrial economies, and the construction of railroads in colonized and economically dominated regions opened those territories to penetration by capitalist enterprises, allowing for their incorporation into imperialist economic systems. Like Roman roads, however, railways played only an external role in imperialist and industrial production, extending its lines of communication and transportation to new raw materials, markets, and labor power. *The novelty of the new information infrastructure is the fact that it is embedded within and completely immanent to the new production processes.* At the pinnacle of contemporary production, information and communication are

the very commodities produced; the network itself is the site of both production and circulation.

In political terms, the global information infrastructure might be characterized as the combination of a *democratic* mechanism and an *oligopolistic* mechanism, which operate along different models of network systems. The democratic network is a completely horizontal and deterritorialized model. The Internet, which began as a project of DARPA (the U.S. Defense Department Advanced Research Projects Agency), but has now expanded to points throughout the world, is the prime example of this democratic network structure. An indeterminate and potentially unlimited number of interconnected nodes communicate with no central point of control; all nodes regardless of territorial location connect to all others through a myriad of potential paths and relays. The Internet thus resembles the structure of telephone networks, and indeed it generally incorporates them as its own paths of communication, just as it relies on computer technology for its points of communication. The development of cellular telephony and portable computers, unmooring in an even more radical way the communicating points in the network, has intensified the process of deterritorialization. The original design of the Internet was intended to withstand military attack. Since it has no center and almost any portion can operate as an autonomous whole, the network can continue to function even when part of it has been destroyed. The same design element that ensures survival, the decentralization, is also what makes control of the network so difficult. Since no one point in the network is necessary for communication among others, it is difficult for it to regulate or prohibit their communication. This democratic model is what Deleuze and Guattari call a rhizome, a nonhierarchical and noncentered network structure (Deleuze and Guattari 1988: 3–25).

The oligopolistic network model is characterized by broadcast systems. According to this model, for example in television or radio systems, there is a unique and relatively fixed point of emission, but the points of reception are potentially infinite and territorially indefinite, although developments such as cable television networks fix these paths to a certain extent. The broadcast network is defined by its centralized production, mass distribution, and one-way communication. The entire culture industry—from the distribution of newspapers and books to films and video cassettes—has traditionally operated along this model. A relatively small number of corporations (or in some regions a single entrepreneur, such as Rupert Murdoch) can effectively dominate all of these networks. This oligopolistic model is not a rhizome but a tree structure that subordinates all of the branches to the central root.

The networks of the new information infrastructure are a hybrid of these two models. Just as in a previous era Lenin and other critics of imperialism recognized a consolidation of international corporations into quasi-monopolies (over railways, banking, electric power, and the like), today we are witnessing a competition among transnational corporations to establish and consolidate quasi-monopolies over the new information infrastructure. The various telecommunication corporations, computer hardware and software manufacturers, and information and entertainment corporations are merging and expanding their operations, scrambling to partition and control the new continents of productive networks. There will, of course,

remain democratic portions or aspects of this consolidated web that will resist control owing to the web's interactive and decentralized structure; but there is already under way a massive centralization of control through the (de facto or de jure) unification of the major elements of the information and communication power structure: Hollywood, Microsoft, IBM, AT&T, and so forth. The new communication technologies, which hold out the promise of a new democracy and a new social equality, have in fact created new lines of inequality and exclusion, both within the dominant countries and especially outside them.

Eric Ma and Hau Ling 'Helen' Cheng

'NAKED BODIES'
Experimenting with intimate relations among migrant workers in South China

EDITOR'S INTRODUCTION

ERIC MA AND HAU LING CHENG here provide a participant observer's account of life for young women working in a factory in China's newly industrialized South – effectively what Manchester was said to be in the nineteenth century, 'the workshop of the world'. They move from their collectivized peasant holdings in the north in order to earn considerably higher wages than those on the farm back home. In the process their world is wholly transformed: they are placed without support of family and village in a world where modern media and communications technologies are available to them. But, under China's strict internal migration laws, in six years while they are still in their early twenties they must return home. They are, in effect, a kind of guest worker.

Ma and Cheng's metaphor for their situation is 'nakedness' – which on one level refers to these young factory workers' lack of protection from the social forces they encounter – they are neither 'modern/urban' nor 'traditional/rural' yet exposed to pressures from both sides. On another level it refers to the way in which they use eroticism and intimacy to deal with their situation, finding a space for a certain self-expression between the discipline of the factory, the (relative) affluence of the wage earner and the strict marriage codes of the rural districts they come from and will return to. Ma and Cheng loosely draw on both Michel Foucault's notion of biopower and Erving Goffmann's sociology of self-presentation but they find that neither theorist quite accounts for the situation of these young women, a situation which is more common around the globe than contemporary cultural/social theory admits.

Further reading: Chen 1998; Chen *et al.* 2001; Giddens 1992; Goffman 1973; Ong 1999 and 2003; Thomas and Ahmed 2004.

Introduction

This is an ethnographic study of how migrant workers in South China are experimenting with love, intimacy and marriage. More than just a record of talk and gossip, it is also a mapping of the negotiation between traditional norms, modern lifestyles and unspeakable desires. Between 2001 and 2003, our research team regularly visited factories in South China. The main research site in this study was a medium-sized factory called Gogo Ltd that produced American toys with heavily regulated manual labour. One of Eric's research assistants served as a factory worker for three months, while Eric worked more closely with the managers of the factory, interviewing migrant workers befriended by the research assistants. Helen worked as an English tutor in the factory and interviewed female workers. From this research site, Eric branched out to other social networks for interviews and participant observations.

Our informants, both male and female, were born in rural farming villages and grew up there before coming to work in South China. Although they hailed from different regions of rural China with diverse linguistic backgrounds, they shared a lot of similarities in terms of socioeconomic status. Because most of the informants were 'country kids' with a junior high school education and little urban experience, we were interested in how rural migrant workers negotiated intimate relations, considering their rural upbringing and their newfound freedom in urban settings. Although we were deeply interested in the impact that the urban experience would have on these migrant workers, the question of 'long-term impact' lies outside the scope of this article. In other words, we made our observations in the factory where the informants worked – the 'inbetween' space of modern China and of their own lives. The scope of this article is limited to describing their experiences in a transitory state of existence.

Rural-to-urban migration has been a key feature of industrialization and modernization for many decades. However, internal migration in China has been squeezed into the recent decades rather than spread over centuries as in Europe. Since the mid-1980s, as transnational corporations have been rushing into mainland China to take advantage of its larger markets and lower costs, bringing with them overseas capital, ideas, information and technology, many Chinese have also been pursuing their version of modern life in the cities. Massive migration from rural areas to urban areas, from the North to the South and from the inner cities to the coastal lands has been one of the most significant social changes in China in the past two decades. Migrant workers, accustomed to a relatively stable set of language and the practice of early marriage, are thrown into a fluid set of discourses about dating, love, romance, choices and desires. In their detraditionalized and deterritorialized lifeworlds, migrant workers find themselves in a ruptured discursive space where new intimate experiences require new hybrid vocabularies to express themselves. We want to map out this sociocultural condition in which migrant workers are transforming previously unspeakable intimate experiences into communicable forms. What are the discourses available to them? How do they manage different sets of discourse on love and marriage? Is the leap into modernity for Chinese migrant workers similar to the relatively linear transformation of intimacy in developed western countries or is it an erratic trajectory of compression and confusion?

Negotiating nakedness in South China

In China, a primitive production line economy coexists with what Lash and Urry (1994) term the 'sign/space economy'. This Chinese compressed modernity features multiple sociocultural layers juxtaposed with each other. In spatial terms, factory zones are layered with agricultural communities. In cultural terms, traditional practices are mixed with consumer lifestyles. In social terms, the working class comes into close contact with the increasingly affluent middle class, creating an astonishing social inequality. These local social helixes, themselves multilayered, are also revolving around the push and pull of global and transnational dynamics.

In South China, compressed and multilayered modernity means the pluralization of life choices in which various forms of individuality are imagined and practised. This pluralization is particularly conspicuous when contrasted with the collectivity that had been engineered by socialist China for more than three decades. As socialist comradeship gives way to a capitalist individualism saturated with the ironies of sex and money, intimate relations have been reworked. New lifestyle choices are not only available to urbanites, but also to rural Chinese. Yan (2003) charts the transformation of private life in a Chinese village and reports the rise of the private family and individualistic ideas about love and intimacy. Indeed, one of the goals of the 4 May movement in China was to end the practice of arranged marriages so that people could have autonomy over personal happiness. Common rhetoric and academic attention on the transition of China from a traditional society to a modern nation also fall back upon the dichotomy of arranged marriage versus the personal pursuit of love affairs. This dichotomy is mapped upon another rural/urban dichotomy in which rural people are seen as more traditional and urbanites as modern and individualistic. However, by employing ethnographic data from South China, we argue that the transformation of intimacy among rural migrant workers is never a one way process, but instead a dialectic dangling from both the passive acceptance of traditional moral codes and the active pursuit of modern notions of choice. Bubbling up in China's market economy are new ways of engaging in intimate relations, which require new sets of vocabulary to speak about emotions, desires and conflicts.

As Giddens (1990, 1992) points out, modernity is reconstructing everyday life at very personal and intimate levels. He argues that one of the features that differentiates modernity from tradition is the transformation of intimacy from one of economic consideration/institutional arrangement into pure relationship. Previously fixed life patterns are now becoming 'life projects' of reflexive individuals. In fact, Beck and Beck-Gernscheim (2002) go further by saying that modernity is a process of 'forced' individualization. To have a life of one's own is not a choice, but an inevitability of modernity (Bauman 2001).

A few recent studies on Chinese migrants have focused on these changes of lifestyles as experienced by the migrant themselves. Jacka (2005) traces the contradictory narratives used by female migrant workers to describe their home village and their new urban experiences in Beijing. Gaetano (2004) describes how migrant workers are caught between the discourses of filial daughters and modern women. Beynon's (2004) stories of migrants 'living one day at a time' point to the transitory nature of migrant life and their situation as outsiders in the city.

Similar to these studies, this article examines the inbetween-ness of migrant experiences. We try to go beyond narrative analyses by exploring the materiality and corporality of migrants' experiences. For Giddens, Beck, Jacka, Gaetano and Beynon, life projects are cognitive, emotive and discursive. In this ethnographic study, the reconstruction of our informants' intimate relations has a more bodily component. These intimate bodies are not mere products of discourse in the Foucauldian sense. Migrant workers are deterritorialized and are thus detached from the traditional rural institution of early marriage. At the same time, they have yet to be disciplined into the strong discursive system of individualistic and consumerist romance in capitalism. The migrant bodies are not locked inside the Foucauldian panopticon of either traditional marriage or capitalized romance. In the conflicting and overlapping discursive systems of rurality and urbanity, the desires for intimacy are somehow led by a corporal logic. They are sensing and testing intimate relationships in the absence of a fully systematized or enforced discourse on love and romance. Goffman's (1973) theory places the body in a more active role of negotiating situational interaction (i.e. it is the physical body that is actively presenting itself as an acceptable social body). The body is not only a receptor and manifestation of social meaning, but also a generator of meaning itself. Goffman's interactionist bodies are generating meaning and negotiating a socially acceptable presentation of self in relatively patterned norms of social behaviour. However, in our case study, the migrant bodies are relating in an unstable social world where the norms are still in the making or unable to effectively discipline social actions. How can migrant bodies experiment with urban casual sex while still subscribing to the moral codes of traditional marriage? How does a female worker manage the stigma of the 'old maid' that accompanies her first taste of a successful career? Here we have elusive bodies in the practical sense; migrant workers are temporarily following the embodied self in their newfound intimate relations in the city without a fully developed way of speaking about their experiences. To use a theoretical metaphor, they are 'naked' – bodies caught between two discourses and embraced by neither. As we discuss the particular 'nakedness' of rural migrant bodies in South China, we may also see in it a remarkable similarity to the momentary 'nakedness' of other modern bodies caught up in pluralistic modern discourses about sex, love, romance, intimacy and marriage. The following ethnographic descriptions are an attempt to answer the empirical question of how migrants negotiate conflicting intimate relationships and the theoretical question of how intimate bodies negotiate 'nakedness'.

The 'geographical site' for this study is a factory in Zhang'an, a highly industrialized, but slowly urbanizing, township in the Pearl River Delta region. In the six industrial zones of Zhang'an, factory buildings stand row upon row. Like most industrial towns that have mushroomed during the rapid economic development, Zhang'an has several particularities not found in fully urbanized cities. Having changed from a set of farming and fishing villages into an industrial town in less than five years, Zhang'an consists mostly of industries based on labour-intensive Fordist production houses. The majority of migrant workers are young females from rural areas whose migration to the Pearl River Delta is temporary. Every migrant worker has a temporary residence document that requires the factory to apply for its renewal every year. The migrant workers are not eligible for any

social welfare programmes provided by the local government. If the worker does not belong to any factory, he or she will be considered an illegal resident and sent back home. The population of migrant workers outnumbers the locals by 10 or even 20 times and the economic gap between migrant workers and locals is gigantic. The average monthly wage for a migrant worker working 60 hours per week is 500 RMB. The average local household can earn a monthly income of 5000 RMB by merely renting their land to factory owners. It was in this rapidly changing migrant town that our ethnographic journey began.

Speaking of love

In traditional society, marriage is an institution of economic and social partnership between families and kinship groups. However, modern notions of romance and love centre on personal pursuit and what Giddens describes as 'pure relationship', in which partnership and commitment are relatively free from institutional bondage. Factory women learn about these ideas of modern love by consuming novels, popular music and television programmes that celebrate romance and passion. In the factory where we did our participant observation, there is a library from which factory workers could borrow books to read at their leisure. According to the library records, romances are the most popular genre. In the nearby flea markets, there are small mobile stalls selling dated romance novels and magazines that serve as practical guides on courtship. Factory workers can also buy current magazines that cater specifically to their needs. In these magazines, they can read fictional and 'real' love stories of workers. They can even place pen pal advertisements to find a potential partner. These magazines offer workers a vicarious taste of romance and sometimes serve as a survival guide to building new relationships. In the dormitory, workers are allocated a small private space on their bunk beds where one can easily find these novels and magazines. The vocabularies of romantic love are eagerly acquired by these workers to articulate their yearning for intimacy, previously unspeakable under traditional norms. However, these mediated stories are filled with the ironies of eroticism and free choice, in that they foreground moral lessons denouncing promiscuity and affirming traditional virtues. Explicit content is framed by warnings of failed love and betrayal; the pursuit of true love is often wrapped up in the ideal of stable and committed marriage.

'Finding a friend' is one of the most common topics of gossip among factory workers. The girls often told Helen the latest news: who had received a love letter from her boyfriend or who had been out on a date recently. When a girl successfully found a boyfriend, she had to celebrate by treating her fellow workers with 'dating candies'. When the factory women learned that Helen did not have a boyfriend, they encouraged her to pursue Sing, our project's male research assistant. 'It is the 21st century already. Don't be shy', they said. Moreover, Helen wore her hair very short and favoured loose t-shirts while working in the factory. Telling Helen that she was too 'boyish' to attract attention, the factory girls taught Helen some 'tactics' for becoming more feminine, such as wearing v-necks and growing her hair long. These tactics were not only tips from popular magazines,

but were mediated by the advertising images that saturate the lifeworld of these factory workers.

Other tips are widely circulated via mobile phone text messaging (also known as SMS). The usage rate of mobile phones among workers is high, not only because it is fashionably modern, but also because it serves as a supplementary support system in a social setting that lacks formal communication networks for migrants. Since sending text messages is much cheaper than making an actual cell phone call, it is a very popular mode of electronic communication. We were quite surprised to discover compilations of popular erotic text messages circulating widely in the factory zones. While romantic novels serve as a guide for female workers, these erotic booklets are highly sought after by male workers, who read them for entertainment, but also for practical advice. When male workers sent these text messages to male friends, it was to affirm a shared body of new knowledge; when they addressed these messages to female friends, it was to express intimacy. Since their ability to write flowery sentences was limited, copying the examples in the booklets helped them please their girlfriends. These 'new vocabularies', likely to be written by cultural brokers outside the rural migrant community, help migrant workers articulate and contemplate their new urban experiences, rendering previously forbidden desires both imaginable and communicable. The majority of text messages from the booklets legitimatize male sexual fantasies. For instance, one text reads: 'A man's four big dreams: banknotes fall from the sky; handsome men get sick; sexy women are brain dead, and they all become loose chicks.' These texts also render extramarital affairs thinkable and even admirable: 'Wife stays home; your lover stays in your bed; send salary home; share bonus with your lover; when sick, go home; when you feel great, go to your lover.' Serving as an alternative to the discourse of traditional marriage, they tie together capitalism, individualism and romance, for example: 'Break your long-term contract with your wife; bring in the free market of lovers' rights.' A large number of these texts talk explicitly about the migrants' sexualized bodies: 'Women fall in love with men's ears; men fall in love with women's eyes'; and, 'When I caress your hair, it makes me feel so nice; when I touch your face, I will be feeling alright; when I embrace your body, you look really delighted; when I stroke your back, I am ready to bring you to my bed.' These texts are woven into the fabric of the workers' everyday intimate relationships; they make sense of, and constitute, new sexual and bodily experiences.

Learning to love

Traditional values are the conventional mechanism for protecting the institution of marriage. However, when rural labourers move to a town far away from home, traditional moral values are also uprooted, creating a space for new discourses and practices of intimacy to emerge. For example, cohabitation is common among lovers working in the factory. Quan, a clerk at Gogo, moved out of the dormitory and rented a room with her boyfriend two months ago. She said, 'No one says anything bad about me. It is very acceptable.' One 18-year-old Gogo worker brought his

pregnant girlfriend home to visit his parents. However, the parents were against their union. The couple went back to the factory and terminated the pregnancy in the street corner clinic. In the streets of Zhang'an, signs reading 'affordable abortion' and 'treatment for sexually transmitted disease' are commonplace. One security guard at Gogo had more than half a dozen girlfriends. He told us the secret of his success: 'It is so lonely to be alone. They want to be touched. It is easy. If you give them some care and comfort, you can touch these girls.' He went on to describe the softness of their skin and how pleasurable and comfortable it felt to hold the hands of his girlfriends. When asked how he handled multiple relationships without getting into trouble, he said: 'We all understand that the relationship won't last long. It comes. It goes.' In fact, it is not uncommon for a married male worker to have a girlfriend in the factory while maintaining a relationship with his wife back home.

Partners can express their intimate relationships in public without fear of being labelled immoral and promiscuous. Young lovers go to the Golden Lion, a nearby entertainment centre for factory workers, to embrace and kiss in the dim light. We saw one couple sitting together on a swing. In fact, the woman was suggestively straddling the man's lap. We asked them whether they were comfortable with us taking their photo. They replied with a definite yes, without any sense of embarrassment. Workers are learning from each other by watching. One young boy told us: 'When I first arrived here, I found it terrible when I saw people kissing each other in public. Now I do it too and I feel terrific.' The restraints on the body levied by the traditional sense of moral correctness are lifting. Through imitation, the body is loosening up and reacting to the new intimate possibilities heavily promoted by consumerist media and conspicuously displayed in social encounters. Mobility breaks the force of moral values and encourages alternative relationships. Bodies adjust and learn; desires are acquired and unleashed; references to non-monogamy are abundant.

Another site in which the individualized and sexualized bodies are socially displayed is the dancing space in public squares. In Zhang'an, the biggest dancing space is the central town square. In the evenings, the town authority broadcasts two hours of popular dance music on a big open air stage set up on the corner of the town square. Workers are free to dance there. When night falls, workers from different factories flock in. Some of them have transformed themselves into party girls, wearing tight t-shirts with long skirts or bell-bottom jeans. We attended the dances many times with a few groups of workers whom we had befriended. During the day, they wore the factory uniform; on the dance floor, they used fancy clothes to display their personal styles. In rural settings, the physical body is worked on by the collectivity of the extended family and worn down by the hardship of manual farming. In urban settings, the workers' bodies are reworked and 'refreshed' by bodily care products and services. On the dance floor, workers are learning to experience the newfound capacity to manipulate their looks and gestures, which are exposed to the penetrating gaze of friends and strangers, especially of the opposite sex. The line between friends and strangers is blurred. People dance hand in hand. They learn the latest steps from each other. They come here to watch and to be watched, to enjoy the scene and to constitute the scene. Some experienced dancers took delight in teaching us the basic steps.

Goffman's idea of the active body is relevant here. The body is not emptied out by Foucauldian discourse, but rather by actively improvising along with the dynamic of contingent social interaction. To avoid embarrassment by mastering the techniques and joking about clumsy moves, to blend into the group by following steps and to assert one's uniqueness by creating new gestures, this is how the body actively generates meaning in this public dancing.

For us urban researchers, disco dancing and clubbing carry fuzzy associations of enchantment, escape, social distinctions, flirtation and self-absorption in a transnational youth culture. However, these representations do not fit nicely into the Zhang'an scene, which is more of a hybridized space of rural communality and urbanized individuality, where mutual learning, relating, communicating and confirming figure much more strongly. In Frank's typology (1991), these are 'communicative bodies' that are struggling to create themselves. Frank considers dance as a site for communicative bodies because dancers are associating expressiveness with their bodies in the dialectic between inscribed patterns and improvisations. On the Zhang'an dance stage, dancers are communicative since their dances are less rigidly patterned into institutional gender constraints than in established dance halls, and the migrant workers are left with ample room to create their own bodily gestures. Presented 'naked' to the public gaze is a collective of rural-turned-urban bodies in the prolonged liminal state of expressing individuality, impressing others and toying with sexualized visual pleasures. Although the traditional desire of locating a marriage partner is still a hidden agenda, the overwhelming social demands on these dancing bodies are carnival, visual, communal and sexual. As Frank notes: 'Dance may be no more a metaphor for the sexual joining of bodies than sex may be a metaphor for dance' (1991: 80). Through their communicative bodies, migrant workers are releasing and realizing their sexual and urban fantasies in the disguise of socially acceptable dance steps.

Dangling between rurality and urbanity

As Zhang'an's migrant workers are exposed to a new set of discourses about intimacy, they are eager to experiment with new relationships in their everyday life. However, the unique biographical condition of these migrant bodies is that they are aware of the need to return to their rural home villages, where traditional marriage is still the prevailing discourse. The Zhang'an migrant workers do not fit into Giddens's gradual but linear transition to urbanity, in which the rural bodies are learning the language of modern life and settling down. Even as rural bodies are exposed to the stimulating and tantalizing discipline of individualized romances and recreational sex, there is always a perceived inevitability of returning to the familiar and seemingly secure institution of the extended family. The migrant bodies exist in a prolonged state of transient 'nakedness', caught between yearning for the modern and returning to the traditional.

In this 'naked' period, migrant workers are eager to find comfort and excitement. Since the majority of Gogo factory workers are young females, which makes it unlikely for them to find a potential boyfriend at work, they turn to other avenues. Thus, in the 'pen pal' ad column in magazines targeted at factory workers, one

can read sentences such as: 'Feelings are dancing in the letters. At that moment, there's only you and me'; 'Maple leaves turn red, plum blossoms smell good. Are you willing to explore the mystery of life with a young woman from Guilin?'; and, 'Fate will bring us together. Please reply to this letter.' Hung, one of the girls who advertised in the pen pal column, told us: 'I really want to taste love.' However, when a long-term pen pal sent Hung a box of chocolates and asked her to be his girlfriend, she hesitated. 'I am so worried that he is a playboy and I will be hurt. Also, whenever I call home, my mother always reminds me not to date any boys.' After six years working in factories, she finally decided to go home for matchmaking. Although romance is an important theme of everyday gossip and new forms of relationship do exist, the final destination for most factory women is still their hometown, where they will find a husband through a matchmaker. This unique social configuration is compressing contradictory discourses upon the migrant bodies, prolonging and heightening the condition of 'nakedness'.

In this prolonged liminal stage, the body is transformed such that it may not fit easily into both rural and urban discourses. The massive migration of rural female labourers to Zhang'an began in 1993. Prior to this, village girls usually got married at the age of 18, after graduating from junior high school. Working life has pushed the average age of marriage to 22 (most factories only recruit workers between the ages of 18 and 22). On the surface, most young women still follow the traditional path of going back to their villages for an arranged marriage. Ching, a woman from Jiangxi, told Helen:

> When girls in our village reach 20, the family will arrange a 'matching interview' for their visit home at New Year. Usually, you meet the man recommended by the matchmaker on the fourth day of New Year. Then you get engaged on the seventh day. Then you go back to work in the factory. Then, by the end of that year, you come home and get married.

This pattern of working for a few years and returning home to get married is the typical life trajectory for factory workers. It would seem that years of living away from home have not fundamentally challenged the institution of marriage. However, the stories of the factory workers reveal that mobility has brought challenges to the traditional practices of marriage.

Fang told Helen the story of a friend who did not like the man she was engaged to. During her week-long visit home, the girl dared not say anything to her parents and the matchmaker, worried that her parents would accuse her of bringing shame to the family. When she went back to the factory, she reconsidered the marriage over and over again. After six months, she decided to make a long-distance call home to ask her parents to break off the engagement. When asked why the girl suddenly got the courage to do so, Fang replied:

> When she is far away from home, if the parents start scolding her, she can always hang up the phone immediately. If she were at home, the parents might force her to have the wedding ceremony at once. But she is at the factory and they can do nothing. And the next time she goes home again for New Year, it will have been six months. The parents will no longer be that angry at that time.

In this sense, working away from home empowers some girls with the courage to challenge parental authority.

From these stories, we can see that the mobility bestowed by modern capitalism sometimes empowers female workers to deal with the authority of tradition. However, mobility is never a simple story of liberation. It also brings new problems for the young women. Working away from home can be an escape from tradition, but in South China, it is never an easy way out. As we will discuss in the next section, the strong pull to return home persists.

Conditioning 'nakedness'

The heightened condition of 'nakedness' is structured by the very specific sociocultural constraints that the migrant workers face. Discursive forces from rural and urban social networks interpenetrate the lifeworld of migrants, disciplining the bodies with contradictory stimulations and punishments. Without a stable set of rules and norms, social roles and expectations about decency and vulgarity, the body cannot improvise in social encounters and is somehow left in its 'nakedness' to test out tactics for surviving everyday challenges. Modern and urban discourses about intimacy might be transforming traditional gender roles. However, tradition defends its territory by employing gossip to exercise the power of moral values. In other studies, jokes and gossip are said to serve as a safety valve to blur the lines of acceptable and unacceptable sexual behaviours; they are considered ways to accommodate unconventional intimate relations. However, in our study, gossip was a powerful means of 'wrapping up' the 'naked' bodies in a traditional morality. Although they have travelled far away from home and tradition, disciplining gossip can travel through extended social networks to reach and capture the runaway migrants.

Mui's story is a good example. Mui is a 27-year-old married woman whose monthly wage of 500 RMB is higher than that of her husband, who works as a cook in their home village. Although she prefers living in Zhang'an and working at Gogo to staying at home as a housewife, she decided to quit her job half a year after she arrived. A rumour that she had had an affair with a man at the factory began to spread in her village three months after she left. In order to prove her 'innocence', she felt she had no choice but to return home and stay there. She had also felt guilty leaving her 4-year-old son at home. More than once, she told Helen, crying, 'People must have called me a terrible mother'. However, the discourse of guilt seldom applies to male factory workers. When we asked the male workers if they missed home, most of them would reply, 'This is life. What can I do?' It is understood that a good father has to leave home in order to support his family. But if a woman leaves home to support her household, she comes under suspicion as being both a bad mother and an unfaithful wife.

Xu's story is another illustration of a farm girl experiencing confusion at the crossroads of modernity and tradition. Xu is the supervisor of Gogo's packing department. At the age of 27, with three years of primary school education, she is an excellent example of how women can miraculously change their own lives in a modern society. Nine years ago, a drought ruined the crops in her village and forced

her to seek work in the factory. Now, with a monthly income of about 1000 RMB, she can afford to go home by aeroplane. In terms of economic development, Xu has completely discarded the traditional norm of a housewife, embracing instead the modern ideal of earning her success. 'How could I go back home to grow rice under the scorching sun and earn 200 RMB a year?', she asked. However, she is trapped in the dilemma that her unmarried status creates among her gossiping relatives. Starting six years ago, Xu has gone home for matchmaking every New Year holiday. But no man in the neighbouring villages can match her financial status or ambitions. They are either farmers or factory workers.

If modernity is about making choices, Xu does not have the privilege of a modern woman who can choose to remain single. Financially speaking, she is able to live on her own. Ideologically speaking, she also knows that there is such a thing as career women. When other girls urged Helen to get a boyfriend, Xu sometimes lectured them, 'It is okay for a modern woman to remain single'. However, she does not consider remaining single to be a viable option for herself. Tradition employs gossip, discrimination, myth and moral values to discipline its subjects and perpetuate its influences. Xu told Helen that the people of her village call her an 'old monster'. Although she is financially successful, the gossip of her hometown has labelled her a failure. Ching quoted us a common saying: 'Even the retarded one can find a husband.' In other words, in the discourse of the village, remaining single is not a choice, but a failure. The story of 'old maid ghosts' also manifests this discrimination against single women. Chun and Lian told us:

> In our village, if a woman cannot find a husband by 40, she will be driven out of her home and the village because she will become an 'old maid ghost' after death. You know, the 'old maid ghost' is very horrible.

Myths such as these construe single women as vengeful spirits who have not merely failed in their own lives, but also bring harm to others. When challenged by liberal ideas, traditional institutions employ moral codes to discipline people into marriage and the web of social relationships that both bind and exclude.

Returning home

The essential contradiction of the stories of migrant workers whom we witnessed and heard cannot be described fully without a discussion of the strong urge to return to conventional marriage. Increasingly, migrant workers, especially male workers, are staying in the city for good, but as of the time of writing, there is still a high percentage of workers who are facing, sometimes willingly, the inevitable return to their home communities. In fact, returning to traditional marriage is not a bad option for some. Some working girls willingly go back to their hometowns to find a husband in the neighbouring villages. For them, matchmaking is considered a pragmatic strategy of self-protection. As we have discussed previously, the mushrooming of alternative discourses and practices of intimacy among migrant workers is the result of mobility, which weakens the authority of traditional moral codes. However, in South China, such mobility is nearly always temporary for the

migrant workers. It is not easy for a migrant worker to settle down permanently in the city. When they are no longer employed in factories or restaurants, they must go home. One of the practical challenges faced by lovers who have met in Zhang'an is to decide in whose hometown they should settle permanently. For example, Ying is from Jiangxi and her boyfriend is from Hunan. They met and fell in love when working in Gogo. Ying told Helen that although they love each other deeply, she does not see a bright future for their relationship. 'We are fine here in Zhang'an. But we cannot live here forever. I was my parents' beloved daughter. He is the eldest son of the family. We will be so torn between both families wanting us to live with them.' During the past New Year, in order to visit both families, Ying and her boyfriend spent six days out of their 13-day holiday on the road travelling between the factory and their two families. In fact, many lovers break up when it is time for one of them to go home.

Mobility creates the space and opportunity to form the modern notion of an intimate relationship. Mobility also uproots migrant workers from their social networks and the web of security. Most workers send most of their wages home to support their family and the remainder would barely suffice for them to live self-sufficiently in South China. With little education, lack of financial independence and a lack of political and legal protection such as unions or a labour department, the migrant workers are subjected to various sorts of exploitation and can only employ the protective mechanism of traditional social networks. Intimacy is no exception. Ching told Helen a story:

> There is a playboy in our village. He met and married a Sichuan girl in the factory. The girl followed him back to our village. Later, the boy abused the girl. Since she was so far away from home, no one from her family could defend her. The boy divorced the girl. She was alone and broke, without any help. My parents always use this story to remind me not to marry a man from another province.

Xu also explained why she would never consider marrying somebody from the factory management level who might share her financial status and experience: 'What if he didn't like me anymore? Who could I ask for help?'

Traditional social networks can provide a web of security, especially for working girls. The factory girls do think that falling in love is romantic, yet most of them still opt for matchmaking. Hung, the girl who had received the chocolates from her pen pal, refused to indulge in modern romantic love in real life, saying: 'What if he deceives me? Where shall I go if he dumped me?' As a result, she and many other girls see traditional arranged marriage as a protective rather than an oppressive institution. For the workers, provincialism is a guide to survival rather than a narrow-minded worldview. As Man (2001) puts it, for the migrant workers, 'the folks back home [lao xiang]' means not just familiarity, but also solidarity.

Therefore, for female migrant workers, marrying somebody from outside the local community is not a romantic journey, but a risky gamble. With the lack of legal/civic support, these rural females still rely heavily on family and kinship to minimize potential conflicts and handle future friction in marriage. Moreover, it is difficult to find a partner in the work environment.

First of all, work hours are long and there is a lack of privacy. Second, the ratio of female to male workers is highly skewed. Finding a prospective husband at home only becomes possible during the 10-day annual Chinese New Year holiday, when migrant workers visit home. Therefore, the matchmaker is still the most common means of finding a marriage partner. As the girls told Helen, there are two main advantages to matchmaking: 1) the family can investigate the personal and family history of the man to gain a better understanding of his personality and background; and, 2) the girl can remain close to her own family.

In this article, we have told the stories of how the intimate lives of migrant workers are being transformed by the macroeconomic restructuring of South China. Traditional conventions and modern experiences overlap with each other, creating spaces for new practices and forms of discourse, but also trapping migrant workers at the crossroads. After six years of working in the factory, Hung could not imagine going back home and spending her life farming in the rice paddies. She repeatedly told Helen that she hoped to find a husband who would come to work in the Pearl River Delta with her. A lot of workers are contemplating opening their own small businesses when they return home. They came to Zhang'an as farmers' children. They cannot go back to become farmers. If the journey for these migrant workers is not a one-way ticket because they cannot become totally 'modern', it is also never a round-trip journey because they cannot return to being totally 'traditional'.

Our ethnographic studies show that although women migrant workers succumb more easily to the disciplinary force of traditional values, such as the threat of becoming an 'old maid ghost' or the gossip about extramarital affairs, our argument of 'naked bodies' applies to both genders facing the more-than-rural/less-than-urban dilemma.

Naked bodies: a concluding note

Migrant workers in South China are thrown into conflicting discourses of sex, love, intimacy and marriage. Their experience of individualized intimacy has to be folded back into their traditional rural networks when they return home. Indeed, the detraditionalized and deterritorialized migrant workers are deskilling their rural bodies and reskilling themselves into urban bodies that celebrate individualized intimate relationships. However, this deskilling and reskilling are often reworked in the opposite direction. Migrant workers are trading their vitality and youthfulness for a temporary urban experience. With new waves of migration flooding South China every year, mature workers are usually discarded by the labour market when they enter their early thirties. All along, they have been fully aware of the need to return home. The migrants are 'naked' in this very peculiar reflexive trajectory; they leave the protective shelter of traditional marriage norms and transform their bodies to fit the new individualized discursive shell of urbanity, but their transformations are half-finished and transitional, leaving the migrant bodies in naked contradiction. The 'naked' bodies of migrant workers problematize the rural/urban dichotomy in which the urban is considered more modern. In fact, some Chinese urbanites hold strong traditional family values. The migrants, in

their inbetween existence, may sometimes be more idiosyncratic than 'modern' city dwellers in their experiments with intimate relationships.

How do migrants negotiate these contradictions? What are the tactics of masking their nakedness? What kinds of change are they triggering in their home communities? Answering these questions would require empirical data that are beyond the scope of this project. In order to chart how modernized bodies fit into a traditional marriage, we would have to visit the rural homes of migrants and stay there for an extended period of time. For instance, Fan (2004) describes how returning female migrants contribute to rural social settings by bringing in new social ties and cultural capital acquired from the cities. This study does not claim to make these kinds of generalizations, but the empirical descriptions in this article are more than enough to present the complex sociocultural conditions of 'nakedness'. This is an article describing how migrant workers are left exposed to the contradictory regimes of rural and urban intimacy. The sensuous bodies of the workers have become the central stage for them to experience and perform competing sets of discourses about sex, love and marriage. It is neither a product of discursive discipline in the Foucauldian sense, nor is it an active body learning a socially acceptable presentation of self in the Goffmanian sense. Rather, it is similar to what Frank has proposed, a 'communicative body' that is in the process of making itself. The corporal is sensing itself outside the iron cage of rationality. We suggest that the specific and unique social conditions of 'nakedness' among these specific groups of social actors may not be case-specific. Their naked condition is a particular case that is unique to this time and place; it may also be a general case that informs us of our 'nakedness' under rapidly globalizing and pluralized discourses on intimacy. Most of us living in the transient condition of urban modernity experience similar forms of momentary 'nakedness', in which available discourses are contradictory and cannot give a public face to one's bodily experiences.

We end this article by telling the story of our last visit to a female worker. Her name was Hung and she was one of our informants, dance tutors, friends and pen pals at Gogo. She had already moved to another factory in Zhang'an when we paid her a surprise visit. It was our last trip to the site and Helen had bought her a necklace as a wedding gift. At lunchtime, we waited outside the gate of the factory. Hung came out during her lunch break, wearing a hearty smile. She was still in her uniform and a white worker's cap covered her long hair. It was the sixth and last year of her working life in Zhang'an. At the upcoming Chinese New Year holiday, she would go back home and settle into an arranged marriage, which she felt would provide her with a more secure life. We remembered Hung as a Cinderella figure because she had worn a silvery nightgown when we first saw her at the evening dance. She had a good time on the dance stage; she had had a dozen admirers; she posted pen pal ads on the *Working Sisters* magazine and fantasized about fairy tale romance. After experiencing these wonderful and eye-opening years, however, she finally decided to return home. We bade farewell at the intersection in front of her factory. It was a crossroads at which she had stood for six years between her home village and the modern town of Zhang'an. She embodied six years of urban experiences. The image of her waving goodbye at the crossroads will be a cherished memory as well as a theoretical metaphor of how modern bodies negotiate their existence in a maze of pluralistic discourses on modern love.

Arjun Appadurai

DISJUNCTURE AND DIFFERENCE IN THE GLOBAL CULTURAL ECONOMY

EDITOR'S INTRODUCTION

DOES GLOBALIZATION MEAN that local cultures are becoming more homogeneous? Firmly answering 'no' to the 'homogenization thesis', Arjun Appadurai goes on to make a series of path-breaking and exhilarating suggestions which have reconfigured theories of postcolonialism, postmodernism and globalization.

He argues that we need to let go the old oppositions like 'global/local', 'North/South', 'metropolitan/non-metropolitan' which divided the world in two. We need to think rather of distinct flows or 'scapes' which ceaselessly sweep through the globe carrying capital, information, images, people, ideas, technologies.

The content of these flows constantly mutates; their relation to one another is increasingly distant and antagonistic. As they pass through national boundaries, in each country they intensify the division between the nation (the country's cultural identity and unity) and the state (the country's public, governmental institutions).

Reading between the lines of this essay, I'd suggest that for Appadurai this globe of scapes contains much more possibility than the old world of colonies and centres, and of nations firmly bound to states. His is a celebratory globalism.

The question is: how utopic is it? Who is losing out in this mobile new world of mutating, disjunct flows? Gayatri Spivak's piece in this volume is one place to look for an answer.

Further reading: Abbas *et al.* 2004; Crane *et al.* 2002; Morley and Robins 1995; Tsing 2004; Virilio 1991a and 1991b; Wilson and Dissanayake 1996.

The central problem of today's global interactions is the tension between cultural homogenization and cultural heterogenization. A vast array of empirical facts could be brought to bear on the side of the 'homogenization' argument, and much of it has come from the left end of the spectrum of media studies. Most often, the homogenization argument subspeciates into either an argument about Americanization or an argument about 'commoditization', and very often the two arguments are closely linked. What these arguments fail to consider is that at least as rapidly as forces from various metropolises are brought into new societies they tend to become indigenized in one or other way: this is true of music and housing styles as much as it is true of science and terrorism, spectacles and constitutions. The dynamics of such indigenization have just begun to be explored in a sophisticated manner, and much more needs to be done. But it is worth noticing that for the people of Irian Jaya, Indonesianization may be more worrisome than Americanization, as Japanization may be for Koreans, Indianization for Sri Lankans, Vietnamization for the Cambodians, Russianization for the people of Soviet Armenia and the Baltic Republics. Such a list of alternative fears to Americanization could be greatly expanded, but it is not a shapeless inventory: for polities of smaller scale, there is always a fear of cultural absorption by polities of larger scale, especially those that are nearby. One man's imagined community (Anderson 1991) is another man's political prison.

This scalar dynamic, which has widespread global manifestations, is also tied to the relationship between nations and states, to which I shall return later in this essay. For the moment let us note that the simplification of these many forces (and fears) of homogenization can also be exploited by nation states in relation to their own minorities, by posing global commoditization (or capitalism, or some other such external enemy) as more 'real' than the threat of its own hegemonic strategies.

The new global cultural economy has to be understood as a complex, overlapping, disjunctive order, which cannot any longer be understood in terms of existing centre–periphery models (even those that might account for multiple centers and peripheries). Nor is it susceptible to simple models of push and pull (in terms of migration theory) or of surpluses and deficits (as in traditional models of balance of trade), or of consumers and producers (as in most neo-Marxist theories of development). Even the most complex and flexible theories of global development which have come out of the Marxist tradition (Mandel 1978; Wallerstein 1974; Wolf 1982) are inadequately quirky, and they have not come to terms with what Lash and Urry (1987) have recently called 'disorganized capitalism'. The complexity of the current global economy has to do with certain fundamental disjunctures between economy, culture and politics which we have barely begun to theorize.

I propose that an elementary framework of exploring such disjunctures is to look at the relationship between five dimensions of global cultural flow which can be termed: first, ethnoscapes; second, mediascapes; third, technoscapes; fourth, finanscapes; and fifth, ideoscapes. I use terms with the common suffix scape to indicate first of all that these are not objectively given relations which look the same from every angle of vision, but rather that they are deeply perspectival constructs, inflected very much by the historical, linguistic and political situatedness of different sorts of actors: nation states, multinationals, diasporic communities,

as well as sub-national groupings and movements (whether religious, political or economic), and even intimate face-to-face groups, such as villages, neighborhoods and families. Indeed, the individual actor is the last locus of this perspectival set of landscapes, for these landscapes are eventually navigated by agents who both experience and constitute larger formations, in part by their own sense of what these landscapes offer. These landscapes thus, are the building blocks of what, extending Benedict Anderson, I would like to call 'imagined worlds', that is, the multiple worlds which are constituted by the historically situated imaginations of persons and groups spread around the globe. An important fact of the world we live in today is that many persons on the globe live in such imagined 'worlds' and not just in imagined communities, and thus are able to contest and sometimes even subvert the 'imagined worlds' of the official mind and of the entrepreneurial mentality that surround them. The suffix scape also allows us to point to the fluid, irregular shapes of these landscapes, shapes which characterize international capital as deeply as they do international clothing styles.

By 'ethnoscape', I mean the landscape of persons who constitute the shifting world in which we live: tourists, immigrants, refugees, exiles, guestworkers and other moving groups and persons constitute an essential feature of the world, and appear to affect the politics of and between nations to a hitherto unprecedented degree. This is not to say that there are not anywhere relatively stable communities and networks, of kinship, of friendship, of work and of leisure, as well as of birth, residence and other filiative forms. But it is to say that the warp of these stabilities is everywhere shot through with the woof of human motion, as more persons and groups deal with the realities of having to move, or the fantasies of wanting to move. What is more, both these realities as well as these fantasies now function on larger scales, as men and women from villages in India think not just of moving to Poona or Madras, but of moving to Dubai and Houston, and refugees from Sri Lanka find themselves in South India as well as in Canada, just as the Hmong are driven to London as well as to Philadelphia. And as international capital shifts its needs, as production and technology generate different needs, as nation states shift their policies on refugee populations, these moving groups can never afford to let their imagination rest too long, even if they wished to.

By 'technoscape', I mean the global configuration, also ever fluid, of technology, and of the fact that technology, both high and low, both mechanical and informational, now moves at high speeds across various kinds of previously impervious boundaries. Many countries now are the roots of multinational enterprise: a huge steel complex in Libya may involve interests from India, China, Russia and Japan, providing different components of new technological configurations. The odd distribution of technologies, and thus the peculiarities of these technoscapes, are increasingly driven not by any obvious economies of scale, of political control, or of market rationality, but of increasingly complex relationships between money flows, political possibilities and the availability of both low- and highly skilled labor. So, while India exports waiters and chauffeurs to Dubai and Sharjah, it also exports software engineers to the United States (indentured briefly to Tata-Burroughs or the World Bank), then laundered through the State Department to become wealthy 'resident aliens', who are in turn objects of seductive messages to invest their money and know-how in federal and state projects in India. The global economy can still

be described in terms of traditional 'indicators' (as the World Bank continues to do) and studied in terms of traditional comparisons (as in Project Link at the University of Pennsylvania), but the complicated technoscapes (and the shifting ethnoscapes), which underlie these 'indicators' and 'comparisons' are further out of the reach of the 'queen of the social sciences' than ever before. How is one to make a meaningful comparison of wages in Japan and the United States, or of real estate costs in New York and Tokyo, without taking sophisticated account of the very complex fiscal and investment flows that link the two economies through a global grid of currency speculation and capital transfer?

Thus it is useful to speak as well of 'finanscapes', since the disposition of global capital is now a more mysterious, rapid and difficult landscape to follow than ever before, as currency markets, national stock exchanges, and commodity speculations move mega-money through national turnstiles at blinding speed, with vast absolute implications for small differences in percentage points and time units. But the critical point is that the global relationship between ethnoscapes, technoscapes and finanscapes is deeply disjunctive and profoundly unpredictable, since each of these landscapes is subject to its own constraints and incentives (some political, some informational and some techno-environmental), at the same time as each acts as a constraint and a parameter for movements in the other. Thus, even an elementary model of global political economy must take into account the shifting relationship between perspectives on human movement, technological flow and financial transfers, which can accommodate their deeply disjunctive relationships with one another.

Built upon these disjunctives (which hardly form a simple, mechanical global 'infrastructure' in any case) are what I have called 'mediascapes' and 'ideoscapes', though the latter two are closely related landscapes of images. 'Mediascapes' refer both to the distribution of the electronic capabilities to produce and disseminate information (newspapers, magazines, television stations, film production studios, etc.), which are now available to a growing number of private and public interests throughout the world; and to the images of the world created by these media. These images of the world involve many complicated inflections, depending on their mode (documentary or entertainment), their hardware (electronic or pre-electronic), their audiences (local, national or transnational) and the interests of those who own and control them. What is most important about these mediascapes is that they provide (especially in their television, film and cassette forms) large and complex repertoires of images, narratives and 'ethnoscapes' to viewers throughout the world, in which the world of commodities and the world of 'news' and politics are profoundly mixed. What this means is that many audiences throughout the world experience the media themselves as a complicated and interconnected repertoire of print, celluloid, electronic screens and billboards. The lines between the 'realistic' and the fictional landscapes they see are blurred, so that the further away these audiences are from the direct experiences of metropolitan life, the more likely they are to construct 'imagined worlds' which are chimerical, aesthetic, even fantastic objects, particularly if assessed by the criteria of some other perspective, some other 'imagined world'.

'Mediascapes', whether produced by private or state interests, tend to be image-centered, narrative-based accounts of strips of reality, and what they offer to those

who experience and transform them is a series of elements (such as characters, plots and textual forms) out of which scripts can be formed of imagined lives, their own as well as those of others living in other places. These scripts can and do get disaggregated into complex sets of metaphors by which people live as they help to constitute narratives of the 'other' and proto-narratives of possible lives, fantasies which could become prologemena to the desire for acquisition and movement.

'Ideoscapes' are also concatenations of images, but they are often directly political and frequently have to do with the ideologies of states and the counter-ideologies of movements explicitly oriented to capturing state power or a piece of it. These ideoscapes are composed of elements of the Enlightenment worldview, which consists of a concatenation of ideas, terms and images, including 'freedom', 'welfare', 'rights', 'sovereignty', 'representation' and the master-term 'democracy'. The master-narrative of the Enlightenment (and its many variants in England, France and the United States) was constructed with a certain internal logic and presupposed a certain relationship between reading, representation and the public sphere (for the dynamics of this process in the early history of the United States, see Warner 1990). But their diaspora across the world, especially since the nineteenth century, has loosened the internal coherence which held these terms and images together in a Euro-American master-narrative, and provided instead a loosely structured synopticon of politics, in which different nation states, as part of their evolution, have organized their political cultures around different 'keywords'.

As a result of the differential diaspora of these keywords, the political narratives that govern communication between elites and followings in different parts of the world involve problems of both a semantic and a pragmatic nature: semantic to the extent that words (and their lexical equivalents) require careful translation from context to context in their global movements; and pragmatic to the extent that the use of these words by political actors and their audiences may be subject to very different sets of contextual conventions that mediate their translation into public politics. Such conventions are not only matters of the nature of political rhetoric (viz. what does the aging Chinese leadership mean when it refers to the dangers of hooliganism? What does the South Korean leadership mean when it speaks of 'discipline' as the key to democratic industrial growth?).

These conventions also involve the far more subtle question of what sets of communicative genres are valued in what way (newspapers versus cinema for example) and what sorts of pragmatic genre conventions govern the collective 'readings' of different kinds of text. So, while an Indian audience may be attentive to the resonances of a political speech in terms of some key words and phrases reminiscent of Hindi cinema, a Korean audience may respond to the subtle codings of Buddhist or neo-Confucian rhetorical strategy encoded in a political document. The very relationship of reading to hearing and seeing may vary in important ways that determine the morphology of these different 'ideoscapes' as they shape themselves in different national and transnational contexts. This globally variable synaesthesia has hardly even been noted, but it demands urgent analysis. Thus 'democracy' has clearly become a master-term, with powerful echoes from Haiti and Poland to the Soviet Union and China, but it sits at the center of a variety of ideoscapes (composed of distinctive pragmatic configurations of rough 'translations' of other central terms from the vocabulary of the Enlightenment).

This creates ever new terminological kaleidoscopes, as states (and the groups that seek to capture them) seek to pacify populations whose own ethnoscapes are in motion, and whose mediascapes may create severe problems for the ideoscapes with which they are presented. The fluidity of ideoscapes is complicated in particular by the growing diasporas (both voluntary and involuntary) of intellectuals who continuously inject new meaning-streams into the discourse of democracy in different parts of the world.

This extended terminological discussion of the five terms I have coined sets the basis for a tentative formulation about the conditions under which current global flows occur: *they occur in and through the growing disjunctures between ethnoscapes, technoscapes, finanscapes, mediascapes and ideoscapes*. This formulation, the core of my model of global cultural flow, needs some explanation. First, people, machinery, money, images, and ideas now follow increasingly non-isomorphic paths: of course, at all periods in human history, there have been some disjunctures between the flows of these things, but the sheer speed, scale and volume of each of these flows is now so great that the disjunctures have become central to the politics of global culture. The Japanese are notoriously hospitable to ideas and are stereotyped as inclined to export (all) and import (some) goods, but they are also notoriously closed to immigration, like the Swiss, the Swedes and the Saudis. Yet the Swiss and Saudis accept populations of guestworkers, thus creating labor diasporas of Turks, Italians and other circum-Mediterranean groups. Some such guestworker groups maintain continuous contact with their home nations, like the Turks, but others, like high-level South Asian migrants, tend to desire lives in their new homes, raising anew the problem of reproduction in a deterritorialized context.

Deterritorialization, in general, is one of the central forces of the modern world, since it brings laboring populations into the lower-class sectors and spaces of relatively wealthy societies, while sometimes creating exaggerated and intensified senses of criticism or attachment to politics in the home state. Deterritorialization, whether of Hindus, Sikhs, Palestinians or Ukranians, is now at the core of a variety of global fundamentalisms, including Islamic and Hindu fundamentalism. In the Hindu case for example, it is clear that the overseas movement of Indians has been exploited by a variety of interests both within and outside India to create a complicated network of finances and religious identifications, in which the problems of cultural reproduction for Hindus abroad has become tied to the politics of Hindu fundamentalism at home.

At the same time, deterritorialization creates new markets for film companies, art impresarios and travel agencies, who thrive on the need of the deterritorialized population for contact with its homeland. Naturally, these invented homelands, which constitute the mediascapes of deterritorialized groups, can often become sufficiently fantastic and one-sided that they provide the material for new ideoscapes in which ethnic conflicts can begin to erupt. The creation of 'Khalistan', an invented homeland of the deterritorialized Sikh population of England, Canada and the United States, is one example of the bloody potential in such mediascapes, as they interact with the 'internal colonialisms' (Hechter 1974) of the nation state. The West Bank, Namibia and Eritrea are other theaters for the enactment of the bloody negotiation between existing nation states and various deterritorialized groupings.

The idea of deterritorialization may also be applied to money and finance, as money managers seek the best markets for their investments, independent of national boundaries. In turn, these movements of money are the basis of new kinds of conflict, as Los Angelenos worry about the Japanese buying up their city, and people in Bombay worry about the rich Arabs from the Gulf States who have not only transformed the prices of mangoes in Bombay, but have also substantially altered the profile of hotels, restaurants and other services in the eyes of the local population, just as they continue to do in London. Yet, most residents of Bombay are ambivalent about the Arab presence there, for the flip side of their presence is the absence of friends and kinsmen earning big money in the Middle East and bringing back both money and luxury commodities to Bombay and other cities in India. Such commodities transform consumer taste in these cities, and also often end up smuggled through air and sea ports and peddled in the gray markets of Bombay's streets. In these gray markets, some members of Bombay's middle classes and of its lumpenproletariat can buy some of these goods, ranging from cartons of Marlboro cigarettes to Old Spice shaving cream and tapes of Madonna. Similarly gray routes, often subsidized by the moonlighting activities of sailors, diplomats, and airline stewardesses who get to move in and out of the country regularly, keep the gray markets of Bombay, Madras and Calcutta filled with goods not only from the West but also from the Middle East, Hong Kong and Singapore.

It is this fertile ground of deterritorialization, in which money, commodities and persons are involved in ceaselessly chasing each other around the world, that the mediascapes and ideoscapes of the modern world find their fractured and fragmented counterpart. For the ideas and images produced by mass media often are only partial guides to the goods and experiences that deterritorialized populations transfer to one another. In Mira Nair's brilliant film, *India Cabaret*, we see the multiple loops of this fractured deterritorialization as young women, barely competent in Bombay's metropolitan glitz, come to seek their fortunes as cabaret dancers and prostitutes in Bombay, entertaining men in clubs with dance formats derived wholly from the prurient dance sequences of Hindi films. These scenes cater in turn to ideas about Western and foreign women and their 'looseness', while they provide tawdry career alibis for these women. Some of these women come from Kerala, where cabaret clubs and the pornographic film industry have blossomed, partly in response to the purses and tastes of Keralites returned from the Middle East, where their diasporic lives away from women distort their very sense of what the relations between men and women might be. These tragedies of displacement could certainly be replayed in a more detailed analysis of the relations between the Japanese and German sex tours to Thailand and the tragedies of the sex trade in Bangkok, and in other similar loops which tie together fantasies about the other, the conveniences and seductions of travel, the economics of global trade and the brutal mobility fantasies that dominate gender politics in many parts of Asia and the world at large.

While far more could be said about the cultural politics of deterritorialization and the larger sociology of displacement that it expresses, it is appropriate at this juncture to bring in the role of the nation state in the disjunctive global economy of culture today. The relationship between states and nations is everywhere an embattled one. It is possible to say that in many societies, the nation and the state

have become one another's projects. That is, while nations (or more properly groups with ideas about nationhood) seek to capture or co-opt states and state power, states simultaneously seek to capture and monopolize ideas about nationhood. In general, separatist, transnational movements, including those which have included terror in their methods, exemplify nations in search of states: Sikhs, Tamil Sri Lankans, Basques, Moros, Québécois, each of these represent imagined communities which seek to create states of their own or carve pieces out of existing states. States, on the other hand, are everywhere seeking to monopolize the moral resources of community, either by flatly claiming perfect coevality between nation and state or by systematically museumizing and representing all the groups within them in a variety of heritage politics that seems remarkably uniform throughout the world. Here, national and international mediascapes are exploited by nation states to pacify separatists or even the potential fissiparousness of all ideas of difference. Typically, contemporary nation states do this by exercising taxonomical control over difference; by creating various kinds of international spectacle to domesticate difference; and by seducing small groups with the fantasy of self-display on some sort of global or cosmopolitan stage. One important new feature of global cultural politics, tied to the disjunctive relationships between the various landscapes discussed earlier, is that state and nation are at each other's throats, and the hyphen that links them is now less an icon of conjuncture than an index of disjuncture. This disjunctive relationship between nation and state has two levels: at the level of any given nation state, it means that there is a battle of the imagination, with state and nation seeking to cannibalize one another. Here is the seedbed of brutal separatisms, majoritarianisms that seem to have appeared from nowhere, and micro-identities that have become political projects within the nation state. At another level, this disjunctive relationship is deeply entangled with the global disjunctures discussed throughout this essay: ideas of nationhood appear to be steadily increasing in scale and regularly crossing existing state boundaries: sometimes, as with the Kurds, because previous identities stretched across vast national spaces, or, as with the Tamils in Sri Lanka, the dormant threads of a transnational diaspora have been activated to ignite the micro-politics of a nation state.

In discussing the cultural politics that have subverted the hyphen that links the nation to the state, it is especially important not to forget its mooring in the irregularities that now characterize 'disorganized capital' (Lash and Urry 1987). It is because labor, finance and technology are now so widely separated that the volatilities that underlie movements for nationhood (as large as transnational Islam on the one hand, or as small as the movement of the Gurkhas for a separate state in the north-east of India) grind against the vulnerabilities which characterize the relationships between states. States find themselves pressed to stay 'open' by the forces of media, technology, and travel which had fueled consumerism throughout the world and have increased the craving, even in the non-Western world, for new commodities and spectacles. On the other hand, these very cravings can become caught up in new ethnoscapes, mediascapes, and eventually, ideoscapes, such as 'democracy' in China, that the state cannot tolerate as threats to its own control over ideas of nationhood and 'peoplehood'. States throughout the world are under siege, especially where contests over the ideoscapes of democracy are fierce and fundamental, and where there are radical disjunctures between ideoscapes

and technoscapes (as in the case of very small countries that lack contemporary technologies of production and information); or between ideoscapes and finanscapes (as in countries, such as Mexico or Brazil, where international lending influences national politics to a very large degree); or between ideoscapes and ethnoscapes (as in Beirut, where diasporic, local and translocal filiations are suicidally at battle); or between ideoscapes and mediascapes (as in many countries in the Middle East and Asia) where the lifestyles represented on both national and international television and cinema completely overwhelm and undermine the rhetoric of national politics: in the Indian case, the myth of the law-breaking hero has emerged to mediate this naked struggle between the pieties and the realities of Indian politics, which has grown increasingly brutalized and corrupt.

The transnational movement of the martial arts, particularly through Asia, as mediated by the Hollywood and Hong Kong film industries, is a rich illustration of the ways in which longstanding martial arts traditions, reformulated to meet the fantasies of contemporary (sometimes lumpen) youth populations, create new cultures of masculinity and violence, which are in turn the fuel for increased violence in national and international politics. Such violence is in turn the spur to an increasingly rapid and amoral arms trade which penetrates the entire world. The worldwide spread of the AK-47 and the Uzi, in films, in corporate and state security, in terror, and in police and military activity, is a reminder that apparently simple technical uniformities often conceal an increasingly complex set of loops, linking images of violence to aspirations for community in some 'imagined world'.

Returning then to the 'ethnoscapes' with which I began, the central paradox of ethnic politics in today's world is that primordia (whether of language or skin color or neighborhood or kinship) have become globalized. That is, sentiments whose greatest force is in their ability to ignite intimacy into a political sentiment and turn locality into a staging ground for identity, have become spread over vast and irregular spaces, as groups move, yet stay linked to one another through sophisticated media capabilities. This is not to deny that such primordia are often the product of invented traditions (Hobsbawm and Ranger 1983) or retrospective affiliations but to emphasize that because of the disjunctive and unstable interplay of commerce, media, national politics and consumer fantasies, ethnicity, once a genie contained in the bottle of some sort of locality (however large) has now become a global force, forever slipping in and through the cracks between states and borders.

But the relationship between the cultural and economic levels of this new set of global disjunctures is not a simple one-way street in which the terms of global cultural politics are set wholly by, or confined wholly within, the vicissitudes of international flows of technology, labor and finance, demanding only a modest modification of existing neo-Marxist models of uneven development and state formation. There is a deeper change, itself driven by the disjunctures between all the landscapes I have discussed, and constituted by their continuously fluid and uncertain interplay, which concerns the relationship between production and consumption in today's global economy. Here I begin with Marx's famous (and often mined) view of the fetishism of the commodity, and suggest that this fetishism has been replaced in the world at large (now seeing the world as one, large, interactive system, composed of many complex subsystems) by two mutually

supportive descendants, the first of which I call production fetishism, and the second of which I call the fetishism of the consumer.

By production fetishism I mean an illusion created by contemporary transnational production loci, which masks translocal capital, transnational earning flows, global management and often faraway workers (engaged in various kinds of high-tech putting out operations) in the idiom and spectacle of local (sometimes even worker) control, national productivity and territorial sovereignty. To the extent that various kinds of free trade zone have become the models for production at large, especially of high-tech commodities, production has itself become a fetish, masking not social relations as such but the relations of production, which are increasingly transnational. The locality (both in the sense of the local factory or site of production and in the extended sense of the nation state) becomes a fetish which disguises the globally dispersed forces that actually drive the production process. This generates alienation (in Marx's sense) twice intensified, for its social sense is now compounded by a complicated spatial dynamic which is increasingly global.

As for the fetishism of the consumer, I mean to indicate here that the consumer has been transformed, through commodity flows (and the mediascapes, especially of advertising, that accompany them) into a sign, both in Baudrillard's sense of a simulacrum which only asymptotically approaches the form of a real social agent; and in the sense of a mask for the real seat of agency, which is not the consumer but the producer and the many forces that constitute production. Global advertising is the key technology for the worldwide dissemination of a plethora of creative, and culturally well-chosen, ideas of consumer agency. These images of agency are increasingly distortions of a world of merchandising so subtle that the consumer is consistently helped to believe that he or she is an actor, where in fact he or she is at best a chooser.

The globalization of culture is not the same as its homogenization, but globalization involves the use of a variety of instruments of homogenization (armaments, advertising techniques, language hegemonies, clothing styles and the like), which are absorbed into local political and cultural economies, only to be repatriated as heterogeneous dialogues of national sovereignty, free enterprise, fundamentalism etc. in which the state plays an increasingly delicate role: too much openness to global flows and the nation state is threatened by revolt – the China syndrome; too little, and the state exits the international stage, as Burma, Albania and North Korea in various ways have done. In general, the state has become the arbiter of this *repatriation of difference* (in the form of goods, signs, slogans, styles etc.). But this repatriation or export of the designs and commodities of difference continuously exacerbates the 'internal' politics of majoritarianism and homogenization, which is most frequently played out in debates over heritage.

Thus the central feature of global culture today is the politics of the mutual effect of sameness and difference to cannibalize one another and thus to proclaim their successful hijacking of the twin Enlightenment ideas of the triumphantly universal and the resiliently particular. This mutual cannibalization shows its ugly face in riots, in refugee flows, in state-sponsored torture and in ethnocide (with or without state support). Its brighter side is in the expansion of many individual horizons of hope and fantasy, in the global spread of oral rehydration therapy and other low-tech instruments of well-being, in the susceptibility even of South Africa

to the force of global opinion, in the inability of the Polish state to repress its own working classes, and in the growth of a wide range of progressive, transnational alliances. Examples of both sorts could be multiplied. The critical point is that both sides of the coin of global cultural process today are products of the infinitely varied mutual contest of sameness and difference on a stage characterized by radical disjunctures between different sorts of global flows and the uncertain landscapes created in and through these disjunctures.

Nationalism/postcolonialism/ multiculturalism

Gayatri Spivak

THE NEW SUBALTERN
A silent interview

EDITOR'S INTRODUCTION

SUBALTERN STUDIES ATTEMPTS TO PLACE those left out by history (both as an academic discipline and as that segment of the past that is recorded in and sanctioned by the present) back into a history which is much more various, inclusive and tolerant of gaps and holes. As a movement it was in part inspired by the British Marxist historian E. P. Thompson and his *The Making of the English Working Class* which tried to tell the political history of the working class before there was such a category and identity as the working class. Thompson was part of the New Left movement which produced British Cultural Studies too. And like British cultural studies, subaltern studies quickly drew on the work of Antonio Gramsci. But it has been based in and focused on South Asia and then on Latin America, where Gramsci has long been a key intellectual presence.

Spivak's characteristically difficult piece moves beyond the original subaltern studies project. She poses a feminized 'new subaltern' subject who is unable to join or be represented in the new global order evoked in this volume by the selection from Hardt and Negri's *Empire*. What relation is the privileged class of metropolitan academics to have to *her*? Spivak insists that we need to 'learn to learn from below' at the same time as she tries to place theoretical concepts in a material setting while bringing empirical situations and events into a theoretical frame. It's the complexity and ambitiousness of her ambitions that make her so difficult to read: indeed her primary aim is not for consistency and lucidity but to rub theory against the real world so as to produce politically, ethically and pedagogically useful apothegms such as the one that enjoins us to learn to learn from below.

Further reading: Beverley 1999; Chakrabarty 2000; Chatterjee 1993a and 1993b; Chaturvedi 2000; Guha 1983.

How do you define contemporary Subaltern Studies in relationship to Marxism and feminism, speaking theoretically and politically, even when considering the enormous diversity concealed by these general labels?

Subaltern Studies considers the bottom layer of society, not necessarily put together by capital logic alone. This is its theoretical difference from Marxism. Its theoretical relationship to feminism is that the subaltern is gendered, and hence needs to be studied with the help of feminist theory.

The imprisoned Antonio Gramsci used the word to stand in for 'proletarian', to escape the prison censors. But the word soon cleared a space, as words will, and took on the task of analysing what 'proletarian', produced by capital logic, could not cover. Gramsci's politics were to situate Marxism upon his contemporary Italian scene, divided by what would come to be called 'internal colonization'. Marx's comments about Germany and Britain in the Postface to the second edition of *Capital* I make this consonant with the politics of Marxian theory. Gramsci was not attempting to define 'subaltern'. Although he insisted on the fragmentary nature of subaltern history in a well-known passage, in his own writings, based on fascist Italy, the line between subaltern and dominant is more retrievable than in the work of subcontinental Subaltern Studies. Gramsci's project is not specifically gender-sensitive in its detail but can be made so. In his *Prison Notebooks* he lays out that future programme in a passage, quaintly but conscientiously phrased in a 'male'-marked idiom, fully visible under his neat erasure: 'until woman has truly attained independence in relation to man, the sexual question will be full of morbid characteristics and one must exercise caution in dealing with it and in drawing legislative conclusions'.

Partha Chatterjee shows that Gramsci understood his own project as flexible when it came to the Indian colonial context (Chatterjee 1993a: 50–1). For the historians of South Asia who took the word from Gramsci, 'subaltern' came to mean persons and groups cut off from upward – and, in a sense, 'outward' – social mobility. This also meant that these persons and groups were cut off from the cultural lines that produced the colonial subject. If one follows the Gramscian line, this makes Subaltern Studies a more dynamic use of Marxian theory than the forced application of Marxian terminology upon the colonial scene. Marx's own remarks, not so much in the famously Eurocentric journalism, but in the few comments on 'foreign trade' in *Capital* III also imply that Marxist theory should be accommodated to the analysis of colonial history.

The value-form makes things commensurable. A mode of production is, strictly speaking, a mode of production of value. The colonial subject could be measured by colonial standards in his very subjectivity. To change Marx slightly, 'he carried the subject of colonialism'. Since 'subaltern' in the subcontinental use defines those who were cut off from the lines that produced the colonial mindset, s/he did not emerge in the colonial cultural value-form. Thus, considerations of cultural

problematics in Subaltern Studies are not a substitute for, but a supplement to, Marxist theory.

Except in the work of Susie Tharu, a relatively new member of the collective, Subaltern Studies is not informed by feminist theory as such. 'Chandra's Death', an exquisite piece by Ranajit Guha, still resonates with patriarchal benevolence and critique (Guha 1987). Chatterjee's scrupulous consideration of gender as one of the nation's fragments reads women's testimony as evidence at face value (Chatterjee 1993b: 135–57). Thus Subaltern Studies, though not inimical to a feminist politics, is not immediately useful for it.

The general political importance of Subaltern Studies is in the production of knowledge, to quote a Marxian phrase, in 'educating the educators' (Third Thesis on Feuerbach). Disciplinary inclusion – it is now a paper for the Master's degree in history at Delhi University, and perhaps at other Indian institutions – is a pyrrhic victory, of course. The subalternist politics of the production of knowledge was to undermine the monopoly credit rating of the progressive bourgeoisie and rethink the 'political' so that subaltern insurgency is not seen as invariably 'pre-political'. Further, the cultural space of subalternity, although cut off from the lines of mobility producing the class- and gender-differentiated colonial subject, was not seen as stagnant by the subcontinental subalternists. How religion (culture) is transformed into militancy, and thus produces tangents for the subaltern sphere, is one of the most interesting aspects of subalternist analysis in its subcontinental phase.

With the rise of Hindu-dominant nationalism in the Indian polity, however, Marxist secularists have suspected a sympathy for the religious in Subaltern Studies that may be counter-productive in the context of today's India. On the other hand, education in postcolonial India has not become more democratic. Hence, to ignore the increasing class difference between the urban and rural poor – the word 'subaltern' loses theoretical force here – and further, to ignore the potential of the history of, first, conflictual coexistence among subordinate groups and, second, of alternative movements of subaltern theology, is to make subaltern participation in secularism a matter of law enforcement rather than agency, in the active voice. The work of Shail Mayaram and Shahid Amin is particularly noteworthy here although, as is usual with most work involving the production of knowledge anywhere, the line that goes from case study to public policy is not, perhaps cannot be, drawn by the scholar as scholar.

Today the 'subaltern' must be rethought. S/he is no longer cut off from lines of access to the centre. The centre, as represented by the Bretton Woods agencies and the World Trade Organization, is altogether interested in the rural and indigenous subaltern as source of trade-related intellectual property or TRIPs. Many ways are being found to generate a subaltern subject asking to be used thus. Marxist theory best describes the manner in which such 'intellectual property' is made the basis of exploitation in the arenas of biopiracy and human genome engineering. (In so far as the remote origin of subalternist theory was Ranajit Guha's *A Rule of Property for Bengal*, the wheel may be said to have come full circle.) But 'the agent of production' here is no longer the working class as produced by industrial or post-industrial capitalism.

This new location of subalternity is being covered over by the sanctioned ignorance of elite theory. Recently, Foucault's 'bio-power' has been brought up for

revision. Paul Rabinow, the eminent Foucauldian, comments on genome engineering as a move from *zoë* to *bios* and commends Iceland – 'the oldest democracy in Europe' – for having a citizenry that voluntarily allows its DNA to be mapped. Giorgio Agamben, referring to bio-power, uses the *zoë–bios* argument and cites Rabinow, although in the last sentence of his *Homo Sacer* he does announce a disciplinary catastrophe as a result of 'a being that is only its own bare existence . . . seiz[ing] hold of the very *haplos* [bottom line] that constitutes both the task and the enigma of Western metaphysics' (Agamben 1998: 188). One cannot quarrel with this general pronouncement. But in a more particular sphere, voluntary acceptance of the transformation of *zoë* to *bios* does not seem to us to be the last instance. The issue is the difference between dieting and starving, when the dieters' episteme is produced by a system that produces the starvers' starvation. In other words, although the 'agent of production' is not the working class, we must still heed the social relations of production of value. The issue is that some own others' *bios*-beings – human, animal or natural (the impossibility of listing them together must be postponed for the moment, since they can be owned in their data-being by similar patents) – and secure ownership by patenting, often fining and punishing those others for not having followed patenting laws in their subaltern past and thus having put up 'illegal trade barriers'. The issue, in other words, is one of property – and the subaltern body as *bios* or subaltern knowledge as (agri-) or (herbi-) culture is its appropriative object. Not only property, but Trade Related Intellectual Property.

This new location of subalternity also requires a revision of feminist theory. The *genetically* reproductive body as the site of production questions feminist theories based only on the ownership of the phenomenal body as means of reproduction, and feminist psychological theories reactive to reproductive genital penetration as normality.

Politically, this new understanding of subalternity leads to global social movements supported by a Marxist analysis of exploitation, calling for an undoing of the systemic-antisystemic binary opposition. In the domain of a specifically feminist politics, such Subaltern Studies would require an engagement with global feminism. The subcontinental Subaltern Studies collective, of which I am a sometime member, does not necessarily endorse this understanding of the new subalternity. I am therefore taking the liberty of writing according to my own stereotype of 'myself' here, rather than describing Subaltern Studies as it is commonly understood.

The word 'woman' has been taken for granted by the United Nations ever since the beginning of the large-scale women's conferences. In the domain of gendered intervention, today's United Nations is indeed international. Within a certain broadly defined group of the world's women, with a certain degree of flexibility in class and politics, the assumptions of a sex-gender system, an unacknowledged biological determination of behaviour, and an object-choice scenario defining female life (children or public life? population control or 'development'?), are shared at least as common currency. I begin to think it is a discursive formation, and oppositions can be generated within it.

Although the subaltern is outside of this commonality there has been an attempt to access her within it by defining, not her way of acting, but her ways of suffering others' action. Its most overt tabulation was the six-point Platform of

Action of the Fourth World Women's Conference in Beijing. There was something grand in the effort to bring the world's women under one rule of law, one civil society, administered by the women of the internationally divided dominant.

Even as we understand the Encyclopedist grandeur of this design, we must also see that it is the exact impersonal structural replica of the grand design to bring the world's rural poor under one rule of finance, one global capital, again run by the internationally divided dominant. To use a technique from Michel Foucault, let us say this is the most 'rarefied' definition of globalization that we can grasp.

If the dominant is represented by the centreless centre of electronic finance capital, the subaltern woman is the target of credit-baiting without infrastructural involvement, thus opening a huge untapped market to the international commercial sector. Here a genuinely feminist politics would be a monitoring one, that forbids the ideological appropriation of much older self-employed women's undertakings and, further, requires and implements infrastructural change rather than practise cultural coercion in the name of feminism. Farida Akhter's intercession with Grameen Bank to cancel its agreement with Monsanto is a case in point. This is not the place to go into the connection between rural women as growers and managers of diversified seed and as chosen recipients of rural credit. I will expand upon the latter in my conclusion. This all too schematic answer is, I hope, flexible enough to suit the diversity of Marxisms and feminisms.

(One rider: With the break-up of the welfare state, the earlier definition of the subaltern as one cut off from lines of social mobility increasingly applies to the metropolitan homeless, although the cultural argument is subsumed under a class argument there.)

If Subaltern Studies can be identified with what Derrida calls 'a certain spirit of Marx', are there plausible Marxist and feminist rejoinders to the concepts of nation, class, caste, that is, political community, emerging within the work of those identified with Subaltern Studies?

Subaltern Studies has been more dynamically Marxist in its detail and in its presuppositions from its inception, than an 'identification with a certain spirit of Marx' would suggest, although, as I have suggested above, it has its differences from a more orthodox Marxist historiography. Derrida's *Specters of Marx*, from which your passage is taken, was originally published in 1993, after world-historical circumstances – not Derrida's words – obliged him to 're-read' Marx. When in the early 1980s, I connected the method of Subaltern Studies to 'deconstructing historiography', I was not engaging with the group's relationship to Marxism, but rather to the question of subalternity and subaltern consciousness. Thus I cannot grant the condition governing the question. I am hampered also by not being a scholar of subalternist work, but rather a sort of subalternist on the fringe of the main movement.

That said, here is an account of the possible implications of subalternist work for the concepts listed.

The notion of 'nation', as back-formation from the western European nationalisms that were at the helm of capitalist imperialism, informed and displaced the prevailing discourses of dominant proto-governmentalities – the Mughals, the Marathas – already in existence in 'India', as well as the emergent ground of colonial

subject-formation – most especially the *bhadralok* society of Bengal. Chatterjee
has prospectively narrativized the latter as departure-manoeuvre-arrival, giving it
an exceptionalist Indian scope, locating each stage by one prominent individual
– only the first of *bhadralok* origin. He has further suggested that the exceptionalist
narrative is an uneasy collection of fragments in its Bengali context. It can certainly
be concluded from his work that the notion of an Indian nation as a miraculating
ground of identity, thought and action, leading to a political community, was not
discursively available to the larger proportion of the immensely diverse inhabitants
of the subcontinent. To consider this in an evolutionist way is to consider European
enrichment as nothing but a result of the survival of the fittest. K.N. Chaudhuri
is not an avowed subalternist, but his *Asia Before Europe* is a good corrective for
methods of analysis based on such a view.

[...]

Since 1989, the state has withered away some, since barriers removed between
national economies and the functioning of global capital curtail redistribution
and constitutional redress. (Marx had quietly moved from 'national economy'
– *Economic and Philosophical Manuscripts* – to 'political economy' – *Capital* I – a fact
obliterated by English translations.) And the globalizing agencies directly confront
those to whom nation-think was not accessible – thus the subaltern – during
the colonial era. The work of the non-Eurocentric 'social movements', seeking
to turn globalization persistently towards that subaltern front (no longer merely
an arithmetical sum of 'local' movements), away from capitalist ends, provides,
however haphazardly, the goal of a loosely based 'regional' political agenda that
must remain, as I have already suggested, Marxist in its analysis of exploitation.
The Gramscian 'war of manoeuvre' – non-teleological and innovative – was
unaware of broader consequences in the Italy of the beginning of the century.
With full-scale globalized capitalism, this by-now subalternist alternative describes
the most viable way of constructive resistance. [...] The 'regional' focus is perhaps
less strong in the feminist aspects of these movements – reactive as they are to
population control by pharmaceutical dumping, to the undermining of women's
relationship to seed development and storage through biopiracy and monoculture,
and to credit-baiting. The 'rejoinder' to the state offered by 'the international
civil society' of powerful non-governmental organizations studies the subaltern in
the interest of global capital, and cannot be called subalternist, although it is, to
a very large extent, feminist in its professed interest in gender.[1]

Although the terrain of the colonial subaltern cannot be explained by capital logic
alone, this cannot mean jettisoning the concept of class formation as a descriptive
and analytical category. The new subaltern is produced by the logic of a global
capital that forms classes only instrumentally, in a separate urban sphere, because
commercial and finance capital cannot function without an industrial component.
Post-Fordism had taken away the organizational stability of the factory floor and thus
taken away the possibility of class consciousness, however imperfect. International
labour is racist and thus has no class solidarity as such. The union movement in
the United States is severely restricted and politically effective only in so far as it
serves managerial interests. This is not the moment to find a 'rejoinder' to class
– even as it must be recognized that not much can be done in its name, that it

cannot produce an account of subalternity. I have written elsewhere about the 'exceptionalist' class mobility among aboriginal subalterns.

Is caste a 'political community' today? The transmogrification of caste outlines in Hindu-majority nationalism is a subject beyond my scope, and perhaps beyond the scope of this discussion.

How do you define Subaltern Studies in the wider field of postcolonial studies? Is it simply an Indian-national sector in this wider field or is it a cluster of distinct theoretical positions in this wider field?

Subaltern Studies did not relate to identity politics at its inception. In the introduction to the first edition of *A Rule of Property*, Guha makes some allusion to his origins. But that was twenty years before the collective came into being. Their goal was to set the record straight, to revise historiography, and thus discover the nineteenth-century subaltern, largely from the text of the elite. Postcolonial criticism, in so far as it takes its inspiration from Fanon and Said, sees itself as *engagé*, on behalf of the colonized. Even in its metropolitan hybridist form, its challenge to the purity of origins relates, however implicitly, to its own diasporic location. The Subaltern Studies collective is certainly related to South Asian history, as Gramsci was related to Italy. Its theoretical position, of studying how the continuity of supposedly pre-political insurgency brings culture to crisis and confronts power would make postcolonial studies more conventionally political. One major difference is that the disciplinary connection of post-colonial studies is to literary criticism rather than history and the social sciences. Subaltern Studies has not pursued oral history as unmediated narrative, and its investigations of testimony have generally confined themselves to legal utterance. I shall expand upon this in my conclusion.

Is there a political-theoretical horizon beyond the existing discourse of postcoloniality?

The discourse of postcoloniality developed rather haphazardly in response to a felt need among minority groups. Its focus is, in its grounding presuppositions, metropolitan. Its language skills are rudimentary, though full of subcultural affect. [...] Postcolonial discourse should thus be 'situated' as much as any style of analysis. And any situation limits itself in terms, necessarily, of what is beyond itself. It is possible to situate, in turn, the versions of the 'beyond' that are chosen as its negation, its condition, its effect. Otherwise historiography would end. In conclusion, then, I choose my own version of the beyond of postcolonial discourse: the question of subaltern consciousness. But I choose it with the deconstructive caution; it is a step beyond in the French mode: *un pas au-delà*. In French, *pas* is both step and the enclitic adverb that most often completes the negative. Colloquially, it is a negation that can also be a prohibition – the step beyond (can be also) a restriction within. It is one of those happy idiomatic accidents, like *Aufhebung*, which conveniently means both to keep intact and destroy.

Opening the question of subaltern consciousness is my *pas au-delà* of postcolonial discourse.

In 'Deconstructing Historiography' I had suggested that the Subaltern Studies collective assumed a subaltern consciousness, however 'negative', by a 'strategic

use of essentialism'. Subaltern Studies had no need of such apologetics. But the theoretically inclined metropolitan identitarians did. In the name of their own groups, they argued identity, claimed strategy, and sometimes gave me credit. No one particularly noticed what I have already mentioned, that Subaltern Studies never presupposed a consciousness for 'their own group', but rather for their object of investigation, and for the sake of the investigation.

In the context of the emergence of the new subaltern, the question of subaltern consciousness has once again become important, now displaced to the global political sphere, so that a) knowledge can be made data, and b) a subaltern will for globalization can be put together as justification for policy. By contrast, the current writings of the collective no longer ponder that challenge.

It is around the issues of democratization and gender-and-development that the question of subaltern consciousness most urgently arises. This is because it is precisely those who were denied access to the lines leading to the European civil society mindset and to bourgeois-model female emancipation who must first be diagnosed today as culturally incapable of democracy and feminism, in the interest of the smooth global functioning of these issues. Thus 'democratization' – code name for the political restructuring entailed by the transformation of (efficient through inefficient to wild) state capitalisms and their colonies to tributary economies of rationalized global financialization – carries with it the aura of the civilizing mission accompanying transformative projects from imperialism to development. This aura carries over to the question of minority rights within developed civil societies, where it engages postcolonial radicalism of a more political sort. 'Consciousness' here does not engage subject-theory, deconstructive, psychoanalytic, or otherwise. We are here on the level of social agency – institutionally validated action. The institutions concerned are democracy and development – politics and economics.

Opposition to parliamentary democracy in the name of cultural origin (as advanced by Lee Kuan Yew, Senior Minister of Singapore, or, at the other end of the spectrum and in speech after speech, by Farid Zakaria, the editor of the influential conservative journal *Foreign Affairs*) is an obviously meretricious position. Opposition to female emancipation in the name of cultural sanctions is as onerous. But to produce a subject for democracy and development, must we then rely on crash courses in 'gender training' and 'election training' offered by the international civil society?

As an alternative I offer that double-edged *pas*. It is a narrative concerning a tiny group of one kind of subaltern. I have got to know them well in the last ten years, after I gave up my apologetic formula for Subaltern Studies (which the collective did not need anyway): strategic use of essentialism. I found instead a different one emerging from my own subaltern study: learning to learn from below. This one will have had few takers.

Let me first present a context that is remote from the new subalternity, for 'reasons' that are too complex for this broad-stroke silent interview. It is the context of the smallest groups among Indian Aboriginals, at last count roughly ninety million as a whole. I use 'Aboriginal' just this once for the general readership. Neither 'Aboriginal' nor 'tribal' fits the Indian case, because historically – and this invocation of history is to beg the question – there is apparently no certainty about

the authenticity of the Aryan settler/original inhabitants story. I will therefore use 'ST', short for 'Scheduled Tribe', as laid down in the Indian Constitution, and regularly used by the state and activists alike.

This much is provisionally noticeable in the history of the present. These are people occupying remnants of varieties of oral culture permeated by dominant Sanskritized literate cultures without benefit of literacy. This last not because of widely disseminated anthropological piety, but because these people are among the increasing numbers of the Indian poor. Upward class mobility is harder for these people because of long-standing patterns of prejudice and therefore low-level graft works even better upon this terrain, destroying the possibility or attractiveness of real education for the intelligent child, the prospective leader or, of course, the ordinary child, the backbone of the functioning future electorate. Votes are bought and sold here, *en bloc* and individually. The prevailing system of education is to memorize answers to antiquated questions relating to set books. The occasional human-interest story – of villagers establishing their own schools or NGOs joining a UN drive for schools must, first, be evaluated against this grid – if indeed it penetrates to the bottom layers of the diversified life of the Indian scheduled tribes.

There is something like an opening into 'women's history', even here. The sharp young girls, wading up through the muddy sluggish currents of gendered rural politics, can aim for the reserved seats on the various organs of state government, generally to become pawns in the hands of veteran mainstream players. When they enter UN statistics as 'women entering politics' (see the Declaration of Mexico, 1975), the aporia of exemplarity is rather brutally crossed. The single female out of the Lodha tribe who made it into university – studying, heartbreakingly, anthropology – hanged herself under mysterious circumstances some years ago. Various rumours about illicit love affairs circulate even as self-styled subalterns and oral history investigators assure each other in print that the subaltern can, indeed, speak.

I am not a historian. Here I am moving in an area – the task of writing the history of the Indian STs – which baffles the historian. I move upon this landscape in an attempt to learn to learn from below. I enter into yearly increasing intimacies with female and male children and adults. I bear witness to the storying of the vanishing present, the piecing together of characters (I might as well beg the question and call them 'historical agents') so that a detailed sequence may seem to pre-exist. At the same time, I try to disengage from the children and the teachers some pedagogic principles for teaching democratic habits. An electoral democracy is historical.

Are men and women different here? Only in so far as some indefinite thing called tribal 'culture' has started to resemble the class mobility patterns of the non-tribal poorer classes. The men get a greater opportunity to travel out and up through governmental and non-governmental possibilities, though they too are used. Our usual sex-gender system clichés work fine here.

But what about writing their history in the usual way? I see no difference between men and women for that project. Anti-colonial tribal insurgencies have occasionally been recorded. A handful of tribals get pensions as fighters for independence. Tribals emerge into history in the perspective of the drama of colonialism.

I should at once say that the ST communities in India are not everywhere equally deprived. Making allowances for very much larger numbers, a different position upon the grid of the global economic system, the relatively autonomous difference in its geopolitical standing, and its different place in the cultural politics of the dominant historical mythology of the so-called civilized world, the story of the *exceptional* ST has broad-stroke similarities to, say, the Aboriginal story in Japan – another non-European pre-colonial settler colony – the distance marked, let us say, between the stories recounted in Kayano Shigeru, *Our Land Was a Forest: An Ainu Memoir* at one end, and Richard Siddle's *Race, Resistance and the Ainu of Japan*, at the other – often a way for the exceptional Aboriginal(s) to reach the United Nations. The altogether exceptional Rigoberta Menchù, the Nobel Prize-winning Aboriginal woman from Guatemala, distances herself from the common woman in her testimony. My point is that we are not yet ready to grasp the challenge of gender upon this terrain. Gender consciousness here is in the detail of unglamorous teaching, by patiently learning *from* below, not in directly confronting the challenge of history by impatient 'gender training' from above. It remains to me interesting that the vanguard of the Japanese Ainu have looked to European settler colonies – Native American and Australian – for forming a collectivity. In this they may have duplicated the continental isolationism of their dominant culture.

I will now give the bare bones of a narrative. Activists from the institutionally educated classes of the general national culture have recently won a state-level legal victory against police brutality over the most deprived ST groups. They are trying to transform this into a national-level legal awareness campaign. (Like the United States, India has to be thought of, of course, in terms of national, state-level and local *politics*. On the other hand, like Japan, India represents itself as culturally homogeneous.)

In spite of the group's legal victory against the state, the ruling party, which notionally does not approve of police brutality, supports them on the state level. Nationally, since a different party is in power, the question is too complex to be discussed here. The ruling party on the local level, on the other hand, is trying to take its revenge against the group's victory over the police by taking advantage of three factors, one positive, two negative.

First, the relatively homogeneous dominant Hindu culture at the village level keeps the ST materially isolated through prejudice. Second, as a result of this material isolation, women's independence among the STs, in their daily in-house behaviour ('ontic idom') has remained intact. It has not been infected by the tradition of women's oppression within the general culture. Third, politically ('pre-politically?'), the general, supposedly homogeneous rural culture and the ST culture are united in their lack of democratic training. This is a result of poverty and class prejudice existing nationally. Therefore, as I have said above, votes can be bought and sold here as normal practice; and electoral conflict is treated by rural society in general like a competitive sport where violence is legitimate.

Locally, since the legal victory of the metropolitan activists against the police, the ruling party has taken advantage of these three things by rewriting women's conflict as party politics. An incidental quarrel among ST women has been used by the police to divide the ST community against itself. One side has been encouraged to press charges against the other. The defending faction has been wooed and

won by the opposition party. In the absence of education in the principles of democracy (not merely training in election control, which is also lacking) and *in the presence of women's power, however circumscribed*, police terror has been accepted as part of the party spirit by the ST community. This is a direct consequence of the educated activists' 'from above' effort at constitutional redress. If there should be a person holding the views that I am describing in this essay within this activist group – organized now as a tax-sheltered non-profit organization – who thinks, in other words, that the real effort should be to connect and activate the tribals' indigenous 'democratic' structures to *parliamentary* democracy by patient and sustained efforts to learn to learn from below, s/he would thus be both impractical and a consensus breaker. The consensually united vanguard is never patient. In my view, agency within rule-governed behaviour, a definition even more 'upstream' than Ronald Dworkin's 'democracy for hedgehogs', must be persistently reined in by engaging with the subject.

Given that it is woman power separated from the dominant culture that is being used here, and given that the ST community is *generally* separated from access to disciplinary history, to focus on gendered history as a less class-conscious feminist theory is liable to do, is irrelevant and counter-productive here.

The earliest work of the Subaltern Studies collective had met the general challenge of nationalist history by trying to deduce subaltern consciousness from the texts of the elite. Legal proceedings, where the subaltern gives witness or testimony, had been particularly productive for them. Are my interventions in subaltern education part of the documentation of Subaltern Studies? As resident teacher-trainer, I get into the grain of their lives. Yet is that a requirement for good history writing, after all? Could it not stand in the way?

Julia Kristeva quotes the eighteenth-century French thinker Montesquieu to steer a clear evolutionary path from family consciousness to state consciousness. In her book *Speaking through the Mask*, Norma Claire Moruzzi shows that such a story leaves out the postcolonial migrant, whose historical sequence and scenario are rather different. When we come to subaltern groups such as ST minorities within the postcolonial state, however, the lines become impossibly confused.

So far we have spoken only of society, of the outside world. If we come to the subaltern ST women's inner world – given our class, cultural and, yes, 'historical' difference – although I am so close to them, I can only dimly imagine the enormity of assuming that I could enter a continuity with their specific pattern of working with the mind, body divide, which is my understanding of an inner world. [...] A disciplinary anthropologist computes this from the outside, to make it understandable to other anthropologists. And yet I keep hoping that, while I work at my teacher training, understanding will perhaps have come to me in the way of fiction, a compromised way that history cannot challenge. I therefore think it is important that women of the international mainstream, such as we are, define and accept the challenge of women's history, again and again, in order to correct and deflect male domination. But where I am with the subaltern I cannot get a grip on it.

I must rather keep working at training half-educated rural teachers for the remote achievement of a living democratic culture in the classroom of subaltern children, protecting the girls by improvised tactics. This is to break subalternity not into hegemony but into a citizenship *without history*. If someone in my position and

with my interests accepts the challenge of women's history as a goal, the specific kind of historylessness of the Aboriginal falls into an evolutionist primitivism that I will not accept.

No, I must keep imagining and presuming a challenge *to* history. Training in disciplinary literary criticism will come to my help. I must, however provisionally, keep the binarity between history and fiction alive. Ever since 'Deconstructing Historiography' I have tried to undo it and historians have advised against it. I now see their point, partly and as follows: mainstream 'Indian' culture is as distant from the Aboriginal subaltern in India as is Aristotle. Echoing Aristotle, then, I must keep telling myself that history tells us what happened and fiction what may have happened and indeed may happen. The uneven entry of my pre-adult students' future children into the historical record will be along paths that I cannot make myself imagine. I have lost track here, in the interest of learning rather than knowing, using rather than remaining within the comfort of describing with coherence for disciplinary access alone. Paradoxically, a classroom where you teach the reading of fiction as such — learning from the singular and the unverifiable — is a training ground for this. Here, too, of course, the scholar cannot draw the direct line to social action as public policy.

Hopeless? Perhaps. But without this nothing can undo the divisions put in place in the colonies by the Enlightenment and still conserve the best legacy of the subaltern. The 'encounter with apartheid' made Mahmood Mamdani ask 'How to transcend the urban–rural divide' — but he wrote a book about it. That divide is the gap we live in, a gap which keeps apart the production of definitive and elite knowledge on the one hand and any hope of educating the subaltern educators on the other. To look into the gap is as hopeful as it is hopeless, at least. *Un pas au-delà.*

Acknowledgements

I thank Partha Chatterjee for a perceptive first reading of the essay. I thank Jamel Brinkley for research assistance.

Note

1 It is this basically post-state situation, ravaged by the 'passionate intensity' in the underbelly of nation-thinking, that calls up other kinds of 'rejoinders': NATO stepping in to preserve 'Western values', as debated in October 1998, with reference to the situation where the Albanians in Kosovo are being 'ethnically cleansed' by the Serbs. By contrast, Subaltern Studies cautions against vanguardist rationalist solutions imposed from above, right or left.

Edward Said

TRAVELING THEORY
RECONSIDERED

EDITOR'S INTRODUCTION

SAID'S ESSAY IS VALUABLE for cultural studies in a number of ways. First it offers a clear exposition of one of the twentieth century's most important cultural-theory moments, the founding moment of what was later to be called 'Western marxism': Georgy Lukács's articulation of the concept of 'reification' in *History and Class Consciousness*. Reification means (roughly) the way in which human relations tend to become objectified and humans tend to be treated as things under the pressures of capitalism. This notion, as Said notes, lies behind Adorno and Horkheimer's account of the fate of culture once it becomes commodified, an account which is still routinely referred to in cultural studies, usually as a point of departure. Second, Said's essay shows how Adorno revised and subverted Lukács's theory in his theory of aesthetics and in particular in his description of modernist art-music. Third, Said contends that Frantz Fanon, the great theorist of colonial subjectivity and liberation struggle is also using a version of Lukács's notion to spell out the effects of colonialism. In this section Said makes an original and imaginative contribution to postcolonial theory (although I would caution readers that he does not distinguish between different kinds and moments in colonialism, and the binary colonizer/colonized that he and Fanon use are way too simple). And last Said offers a striking picture of what happens to theory as it moves from context to context, from theorist to theorist, asking us to imagine that it forms a 'moral community' in the process.

Further reading: Clifford 1997; Fanon 1967a; Jarvis 1998; Löwy 1979; Lukács 1971; Said 2002 and 2003.

In an essay ("Traveling Theory") written several years ago, I discussed the ways in which theories sometimes "travel" to other times and situations, in the process of which they lose some of their original power and rebelliousness. The example I used was Georg Lukács's theory of reification, which is fully explained in the famous fourth chapter of his masterpiece, *History and Class Consciousness*. Underlying my analysis was a common enough bias that, even though I tried to guard against and mitigate its influence, remains in the essay. This bias can be put simply as follows: the first time a human experience is recorded and then given a theoretical formulation, its force comes from being directly connected to and organically provoked by real historical circumstances. Later versions of the theory cannot replicate its original power; because the situation has quieted down and changed, the theory is degraded and subdued, made into a relatively tame academic substitute for the real thing, whose purpose in the work I analyzed was political change.

As a revolutionary in early twentieth-century Hungary, Lukács was a participant in the dramatic social upheavals that in his work he linked to the whole social deformation of alienation, the radical separation of object and subject, the atomization of human life under bourgeois capitalism. To resolve the crisis represented by these things Lukács spoke about "the viewpoint of the proletariat," a dynamic theoretical reconciliation of subject with object that was enabled by getting beyond fragmentation and imagining a revolutionary vision of "totality." *History and Class Consciousness* is full of the agony of life in a brutally capitalist society: the way in which every human relationship and impulse is compelled into "alienated" labor, the bewildering rule of facts and figures with no bonds between people except those of the cash nexus, the loss of perspective, the fragmentation of every experience into saleable commodities, the absence of any image of community or wholeness. When he comes to the remedy for such diminishments and deprivations Lukács presses into service a Marxism that is principally the result of an alteration of consciousness. To be conscious of how widespread is reification—how everything is turned into a "thing"—is for the first time to be aware of the *general* problem of life under capitalism, and for the first time to be conscious of the class of individuals, the proletariat, who are capitalism's most numerous victims. Only in this way can subjectivity understand its objective situation, and this in turn makes possible an understanding of what kept subject and object apart, and how they can be rejoined.

The point I made about all this was that when they were picked up by late European students and readers of Lukács (Lucien Goldmann in Paris, Raymond Williams in Cambridge), the ideas of this theory had shed their insurrectionary force, had been tamed and domesticated somewhat, and became considerably less dramatic in their application and gist. What seemed almost inevitable was that when theories traveled and were used elsewhere they ironically acquired the prestige and authority of age, perhaps even becoming a kind of dogmatic orthodoxy. In the setting provided by revolutionary Budapest, Lukács's theory of the subject-object split and of reification was actually an inducement to insurrectionary action, with the hope that a proletarian perspective in his highly eccentric view of it would see "reality" as eminently changeable because largely a matter of perspective. His later readers regarded the theory as essentially an interpretive device, which is not to take away from their work some considerable and even very brilliant achievements.

What now seems to me incomplete and inadequate in such an account of Lukács's theory and its subsequent travels is that I stressed the reconciliatory and resolvable aspects of his diagnosis. Those who borrowed from Lukács—and for that matter Lukács himself—saw in the reifications imposed epistemologically on the split between subject and object something that could be remedied. For such a view Lukács of course was indebted to Marx and Hegel before him, in whose theories the dialectic between opposed factors was routinely to result in synthesis, resolution, transcendence, or *Aufhebung*. Lukács's particular elaboration (some would say improvement) on the Hegelian and Marxian dialectic was to stress both the extraordinarily widespread infection of all of human life by reification—from the family to professional pursuits, psychology, and moral concerns—as well as the almost aesthetic character of the reconciliation or healing process by which what was split asunder could be rejoined.

In this perhaps more comforting phase of the theory the work of several recent Lukács scholars, chief among them Michael Löwy, is useful. They have shown the powerful influence on the young Lukács, the romantic anticapitalist, of Dostoevsky and Kierkegaard, whose explorations of modern angst found so devastatingly thorough and analytic a realization not only in *History and Class Consciousness* but also in his earlier treatises, *Soul and Form* and *Theory of the Novel*. But, it can be argued, so too can the Kierkegaardian and Dostoevskian influences be found in Lukács's specifically Marxist resolution, or even redemption. As contained in subject-object reconciliation within the largely unreal, projected, or "putative" category of "totality," Lukács's leap from present misery to future healing recapitulates (if it does not actually repeat) the great nineteenth-century irrationalists' leaps of faith.

But what if some of Lukács's readers, totally influenced by his description of reification and the subject-object impasse, did not accept the reconciliatory denouement of his theory, and indeed deliberately, programmatically intransigently refused it? Would this not be an alternative mode of traveling theory, one that actually developed *away* from its original formulation, but instead of becoming domesticated in the terms enabled by Lukács's desire for respite and resolution, flames out, so to speak, restates and reaffirms its own inherent tensions by moving to another site? Is this different kind of dislocation so powerful as retrospectively to undermine Lukács's reconciliatory gesture when he settles the subject-object tensions into what he calls "the standpoint of the proletariat"? Might we then not call this surprising later development an instance of "transgressive theory," in the sense that it crosses over from and challenges the notion of a theory that begins with fierce contradiction and ends up promising a form of redemption?

Let us return briefly to the early Lukács. In the principally aesthetic works that anticipate *History and Class Consciousness* (1923) he brilliantly examines the relationship between different aesthetic forms on the one hand, and the concrete historical or existential experience from which they derive and to which they are a response. The most famous of these early works is *Theory of the Novel* (1920), premised on the notion that in a world abandoned by God the novel embodies the trajectory of an epic whose hero is either demonic or mad, whose constitutive element is a temporality basically disappointing and demystifying, and whose representative status as the art form of modernity is based on its tremendous constitutive ironies,

the irony of "errant souls [adventuring] in an inessential, empty reality," or that of speaking "of past gods and gods ... to come" but never of what is present, or "the irony [which] has to seek the only world that is adequate to it along the *via dolorosa* of interiority but is doomed never to find it there."

Before he becomes a Marxist, therefore, Lukács's overpowering sense of the disjunctions of modernity (which in his *Logos* essay of 1917 he abstracted into "the subject-object relationship") led him to regard the aesthetic as a site where their contradictions are manageable, and even pleasurable. For this view he is indebted to both Kant and Schiller, although his inflection of the thesis is largely original. Each art form, he says, is itself in a sense the incarnation of a particular phase in the subject-object relationship. The essay, for example, is about heralding a resolution but never giving it; the tragedy is the fatal clash between subjects, and so forth. That the novel has a special privilege in modernity is underscored by its scope, its hero, and (although Lukács never actually says this) by the fact that theoretical discourse (such as his) can express and by its sheer complexity represent the form's quintessential ironies. The transformation in Lukács's politics that occurs after *Theory of the Novel* and in *History and Class Consciousness* is that Marxism, as borne and reflected in "the class consciousness of the proletariat," is explicitly revealed to be the theoretical discourse resolving the subject-object relationship.

Nevertheless, Lukács actually says that that resolution is almost by nature postponed and thus hasn't happened yet. There is an unwonted certainty in his accents that, it must be said immediately, supplies his later work with its gruffly dogmatic authority and assertiveness. Clearly, however, not every reader of Lukács went as far in *that* direction, as the dogged stubbornness of Adorno quite plainly shows. Adorno, I believe, is virtually unthinkable without the majestic philosophical beacon provided by *History and Class Consciousness*, but he is also unthinkable without his own great resistance to its triumphalism and implied transcendence. If for Lukács the subject-object relationship, the fragmentation and lostness, the ironic perspectivism of modernity were supremely discerned, embodied, and consummated in *narrative* forms (the rewritten epics both of the novel and of the proletariat's class consciousness), for Adorno that particular choice was, he said in a famous anti-Lukács essay, a kind of false reconciliation under duress. Much more typical, more in keeping with the irremediably "fallen" character of modernity was "new" music, which, for Adorno, was Schoenberg, Berg, and Webern, *not* Stravinsky and Bartók.

Philosophie der neuen Musik (1948) is a quite spectacular instance of a traveling theory gone tougher, harder, more recalcitrant. In the first place its language is a good deal more difficult to decode even than Lukács's, which in the reification essay of *History and Class Consciousness* had already had a programmatically unattractive density and philosophical obscurity to it. Lukács's choice of the history of classical philosophy—here too the *narrative* of increasing desperation and abstraction was an illustration of subject-object tension unrelieved by reconciliation—was meant to show how deeply alienation had penetrated, and therefore where, in its most abstruse version, it could be analyzed as a pure symptom of the overall *anomie* of modern life. Adorno goes a step further. Modern music, he says, is so marginal,

so rarefied, so special an expression as to represent a total rejection of society and any of its palliatives. This is why Schoenberg is such a heroic figure to Adorno. No longer is the composer a figure like Beethoven, who stands for the newly triumphant bourgeoisie, or like Wagner, whose sorcererlike art camouflages the irreconcilability between the aesthetic and the commercial. The twentieth-century composer stands outside tonality itself, proclaiming an art of so totally, irrecusably rebarbative a mode as to reject listeners altogether. Why? Because according to Schoenberg as described by Adorno, "the middle road ... is the only one which does not lead to Rome."

For indeed the subject-object compromise enacted by Lukács does resemble a middle-of-the-road synthesis; whereas Schoenberg's twelve-tone theory was based upon and, more definitively than any other language, reasserted the impossibility of synthesis. Its premise was dissonance, the subject-object impasse raised to the level of an uncompromisable principle, "forced into complete isolation during the final stage of industrialism" (6). Standing apart from society with a uniquely brooding severity and a remorseless self-control, the new music's loneliness pitilessly showed how all other art had become kitsch, other music ruled by "the omni-present hit tune," "false interpretations and stereotyped audience reaction patterns." These, Adorno said sternly, needed to "be destroyed." Any illusions that the tonality rejected by Schoenberg was somehow natural are rejected: according to Adorno, tonality corresponds to "the closed and exclusive system [of] mercantile society," music submitting to the demands of trade, consumerism, administration. Not for nothing then in a later essay did Adorno attack Toscanini as the *maestro* of conventional music, with its limitless reproducibility, inauthentic perfection, and heartless rhythms contained in the conductor's ironlike dominance and precision.

For Lukács the atomized individual consciousness in surveying its alienation from the product of its own labor desired a kind of healing unity; this was afforded it by "class consciousness," made tenuous, it is true, because, in Lukács's rather circumspect description, consciousness was not empirical or actually and immediately experienceable but "imputable" (*zugerechnetes*). Such a deferral of the clubby gregariousness normally associated with class feeling undercuts the "vulgar Marxism" that Lukács was so polemically energetic in trying to discredit. But it also allowed him to reharness the aesthetic powers of imagination and projection that had been central to his work before he became a Marxist. "Imputable consciousness" was a daring composite made up not only of what was later to be called Marxist humanism, but in addition borrowing from Schiller's play instinct, Kant's aesthetic realm, and Hans Vaihinger's *als ob*. In all, then, it held a good deal of optimism and even enthusiasm for the promised re-connection of the subject with itself, other subjects, and objects.

None of this is permitted by Adorno in his stirringly bleak account of Schoenberg's emergence and rather repellent triumph. Instead of social relevance Schoenberg's aesthetic chooses irrelevance; instead of amiability the choice is intransigence; instead of antinomian problematics being overcome (a central notion in Lukács's history of classical philosophy) they are vindicated; instead of class consciousness there is the monad; instead of positive thinking there is "definitive negation":

In the process of pursuing its own inner logic, music is transformed more and more from something significant into something obscure—even to itself. No music today, for example, could possibly speak in the accents of "reward." Not only has the mere idea of humanity, or of a better world no longer any sway over mankind—though it is precisely this which lies at the heart of Beethoven's opera [*Fidelio*]. Rather the strictness of musical structure, wherein alone music can assert itself against the ubiquity of commercialism, has hardened music to the point that it is no longer affected by those external factors which caused absolute music to become what it is. ... Advanced music has no recourse but to insist upon its own ossification without concession to that would-be humanitarianism which it sees through, in all its attractive and alluring guises, as the mask of inhumanity. (19–20)

Music thus insistently becomes what Lukács's reconciled consciousness has given up—the very sign of alienation which, says Adorno, "preserves its social truth through the isolation resulting from its antithesis to society." Not that this isolation is something to be enjoyed as, say, an 1890s aesthete might have enjoyed the status of arty eccentric. No; in the awareness of an advanced composer that his work derives from such appalling "social roots" as this, there is consequently a recoil from them. So between that awareness and an attitude that "despises [the] ... illusion of reconciliation" stands new music. Precisely because its constitutive principle is the disjunctive twelve-note series, its harmony a mass of dissonances, its inspiration the remorseless "control" of the composer who is bound by the system's unbreakable laws, music aspires to the condition of theoretical knowledge. Of what? The contradiction.

With this clearly stated, Adorno proceeds resolutely to an account of Schoenberg's career or "progress" (the word is fairly loaded down with irony) from the early expressionist works to the late dodecaphonic masterpieces. As if affectionately recalling and then angrily refuting Lukács, Adorno describes the twelve-tone method in terms taken almost verbatim from the subject-object drama, but each time there is an opportunity for synthesis Adorno has Schoenberg turn it down.

The further irony is that very far from liberating him, Schoenberg's mastery of the atonal technique he invented for escaping "the blind domination of tonal material" ends up by dominating him. The severity, objectivity, and regulatory power of a technique that supplies itself with an alternative harmony, inflection, tonal color, rhythm—in short a new logic for music, the object of the subject's compositional skill—become "a second blind nature," and this "virtually extinguishes the subject" (68–69). In Adorno's descriptions here there is a breathtakingly regressive sequence, a sort of endgame procedure by which he threads his way back along the route taken by Lukács; all the laboriously constructed solutions devised by Lukács for pulling himself out of the slough of bourgeois despair—the various satisfactory totalities given by art, philosophy, Marxism—are just as laboriously dismantled and rendered useless. Fixated on music's absolute rejection of the commercial sphere, Adorno's words cut out the social ground from underneath art. For in fighting ornament, illusion, reconciliation, communication, humanism, and success, art becomes untenable:

Everything having no function in the work of art—and therefore everything transcending the law of mere existence—is withdrawn. The function of the work of art lies precisely in its transcendence beyond mere existence. Thus the height of justice becomes the height of injustice: the consummately functional work of art becomes consummately functionless. Since the work after all, cannot be reality, the elimination of all illusory features accentuates all the more glaringly the illusory character of its existence. This process is inescapable. (70)

An even more drastic statement comes later, when Adorno avers as how the fate of new music in its illusionless self-denial and ossified self-sacrifice is to remain unheard: "music which has not been heard falls into empty time like an impotent bullet" (133). Thus the subject-object antithesis simply disappears, because Adorno has Schoenberg rejecting even the ghost of achievement and experience. I say it this way to underscore Adorno's manipulation of Schoenberg, and also to contrast it with Mann's *Doctor Faustus* (based on Adorno's book), a tamer version of Adorno's Schoenberg. Mann's hero is an Adornian emanation, but the novel's technique, especially the presence of Serenus Zeitblom, the humanist narrator, recuperates and to a degree saves or domesticates Adrian by giving him the aura of a figure representative of modern Germany, now chastened and perhaps redeemed for postwar elegiac reflection.

But Lukács's theory has voyaged elsewhere too. Recall that between Lukács and Adorno there is first of all a common European culture and more particularly the affinity stemming from the Hegelian tradition to which they both belong. It is therefore quite startling to discover the subject-object dialectic deployed with devastating intellectual and political force in Frantz Fanon's last work, *The Wretched of the Earth*, written in 1961, the very year of its author's death. All of Fanon's books on colonialism show evidence of his indebtedness to Marx and Engels, as well as to Freud and Hegel. Yet the striking power that differentiates his last work from, say, the largely Caribbean setting *of Black Skins, White Masks* (1952) is evident from the unflagging mobilizing energy with which in the Algerian setting Fanon analyzes and situates the antinomy of the settler versus the native. There is a philosophical logic to the tension that is scarcely visible in his previous work, in which psychology, impressions, astute observation, and an almost novelistic technique of insight and vignette give Fanon's writing its ingratiatingly eloquent inflections.

Two things seem to have happened between *L'An V de la revolution algérienne* (1959), his first collection of essays after he changed his focus from the Caribbean to North Africa, and *The Wretched of the Earth*. One of them, obviously, is that the progress of the Algerian revolution had deepened and widened the gulf between France and its colony. There was a greater drive toward separation between them, the war had become uglier and more extensive, sides were being taken both in Algeria and in the metropolis, with rifts and internecine conflicts in both of the two great hostile encampments. Second—and here I speculate—Fanon seems to have read Lukács's book and taken from its reification chapter an understanding of how even in the most confusing and heterogeneous of situations, a rigorous analysis of one central problematic could be relied on to yield the most extensive understanding of the whole. The evidence I have is, to repeat, not firm, but it is

worth noting: a French version of Lukács's central work, *Histoire et conscience de classe*, appeared in 1961, in an excellent translation by Kostas Axelos and Jacqueline Bois, published by Editions de Minuit. Some of the chapters had already appeared in *Arguments* a few years earlier, but 1961 was the first time the entire book had made its appearance anywhere at all, ever since Lukács had recanted the book's most radical tenets a generation earlier. In his preface Axelos compared Lukács to Brecht's Galileo, associating him also with those other martyrs to truth, Socrates, Christ, and Giordano Bruno; according to Axelos, the main point for twentieth-century thought, however, was that Lukács's great treatise was expunged from both history and class consciousness, with no visible effects on those working people the book was designed to assist.

How strongly the subject-object dialectic resonated *outside* Europe, and for an audience made up of colonial subjects, is immediately apparent from the opening pages of *The Wretched of the Earth*. The Manicheanism Fanon describes as separating the clean, well-lighted colonial city and the vile, disease-ridden darkness of the *casbah* recalls the alienation of Lukács's reified world. And Fanon's whole project is first to illuminate and then to animate the separation between colonizer and colonized (subject and object) in order that what is false, brutalizing, and historically determined about the relationship might become clear, stimulate action, and lead to the overthrow of colonialism itself. As Lukács put it in his supremely Hegelian 1922 Preface to *History and Class Consciousness*: "It is of the essence of dialectical method that concepts which are false in their abstract onesidedness are later transcended." To this Fanon will answer that there is nothing abstract or conceptual about colonialism, which, as Conrad once said, "mostly means the taking it [land] away from those who have a different complexion or slightly flatter noses than ourselves." Thus, according to Fanon,

> for a colonized people the most essential value, because the most concrete, is first and foremost the land: the land which will bring them bread and, above all, dignity. But this dignity has nothing to do with the dignity of the human individual: for that human individual has never heard tell of it. All that the native has seen in his country is that they can freely arrest him, beat him, starve him: and no professor of ethics, no priest has ever come to be beaten in his place, nor to share their bread with him. As far as the native is concerned: morality is very concrete; it is to silence the settler's defiance, to break his flaunting violence—in a word, to put him out of the picture.

Lukács's dialectic is grounded in *The Wretched of the Earth*, actualized, given a kind of harsh presence nowhere to be found in his agonized rethinking of the classical philosophical antinomies. The issue for Lukács was the primacy of consciousness in history; for Fanon it is the primacy of geography in history, and then the primacy of history over consciousness and subjectivity. That there is subjectivity at all is because of colonialism—instituted by Europeans who like Odysseus came to the peripheries to exploit the land and its people, and thereafter to constitute a new aggressive selfhood—and once colonialism disappears the settler "has no longer any interest in remaining or in coexisting" (45). The subjective colonizer has turned the native into a dehumanized creature for whom zoological terms are the

most apt; for the settler the terms used to falsify and palliate his or her repressive presence are borrowed from "Western culture," which whenever it is mentioned "produces in the native a sort of stiffening or muscular lockjaw" (43).

At the same time that Fanon uses the subject-object dialectic most energetically he is quite deliberate about its limitations. Thus, to return to the relationship between the colonial enclave and the native quarter: these "two zones are opposed," says Fanon, "but not in the service of a higher unity. ... They both follow the principle of reciprocal exclusivity. No conciliation is possible, for of the two terms one is superfluous" (38–39). At the same time that he uses what is a patently Marxist analysis Fanon realizes explicitly that such "analysis should always be slightly stretched" in the colonial situation. For neither the colonist nor the colonized behaves as if subject and object might some day be reconciled. The former plunders and pillages; the latter dreams of revenge. When the natives rise in violent insurrection, it "is not a rational confrontation of points of view. It is not a treatise on the universal, but the untidy affirmation of an original idea propounded as an absolute" (41).

No one needs to be reminded that Fanon's recommended antidote for the cruelties of colonialism is violence: "the violence of the colonial regime and the counter-violence of the native balance each other and respond to each other in an extraordinary reciprocal homogeneity" (88). The logic of colonialism is opposed by the native's equally strict and implacable counterlogic. What operates throughout the war of national liberation is therefore a combative subject-object dialectic whose central term is violence which at brief moments appears to play a reconciling, transfiguring role. True, Fanon says there is no liberation without violence and certainly he admits that there is no "truthful behavior" in a colonial setting: "good is quite simply that which is evil for 'them'" (50). But does Fanon, like Lukács, suggest that the subject-object dialectic can be consummated, transcended, synthesized, and that violence in and of itself is that fulfillment, the dialectical tension resolved by violent upheaval into peace and harmony?

The by now conventional notion about Fanonist violence is exactly that, a received idea, and is a caricatural reduction more suited to the Cold War (Sidney Hook's attack on Fanon being a case in point) than to what Fanon actually says and to how he says it. In other words, Fanon can too easily be read as if what he was doing in *The Wretched of the Earth* was little more than a replication of Lukács, with the subject-object relationship replaced exactly by the colonizer-colonized relationship, the "new class-consciousness of the proletariat," Lukács's synthesizing term, replaced by revolutionary violence in Fanon's text. But that would be to miss Fanon's crucial reworking and critique of Lukács, in which the *national* element missing in *History and Class Consciousness*—the setting of that work, like Marx's, is entirely European—is given an absolute prominence by Fanon. For him, subject and object are European and non-European respectively; colonialism does not just *oppose* the terms and the people to each other. It obliterates and suppresses their presence, substituting instead the lifeless dehumanizing abstractions of two "masses" in absolute uncommunicating hostility with each other. Whereas Lukács saw the subject-object antinomy as integral to European culture, and as in fact its partial symbol, Fanon sees the antinomy as imported from Europe, a foreign intrusion that has completely distorted the native presence. "Thus the history

which he [the colonist] writes is not the history of the country which he plunders but the history of his own nation in regard to all that she skims off, all that she violates and starves" (51).

Fanon had made earlier use of the subject-object dialectic in an expressly Hegelian manner; this is most notably evident in *Black Skins*, where he uses the master-slave dialectic to show how the Negro had been turned by racism into an "existential deviation." Yet even there Fanon distinguished the dialectic as Hegel envisioned it for white Europe, and how it might be used by whites against Negroes: "here [in the colonial relationship between races] the master differs basically from the master described by Hegel. For Hegel there is reciprocity; here the master laughs at the consciousness of the slave. What he wants from the slave is not recognition but work." In *The Wretched of the Earth* existential racial relationships have been superseded, in a sense: they are now located and resituated geographically in the colonial setting. And from this derives that "world divided into compartments, a motionless Manicheistic world, a world of statues" (51).

In short, the colonial antinomy can now be reinterpreted as an antagonism between nations, one dominating the other, and in the process actually preventing the other from coming into being. The new complication therefore is nationalism, which Fanon introduces as follows:

> The immobility to which the native is condemned can only be called in question if the native decides to put an end to the history of colonization—the history of pillage—and to bring into existence the history of the nation—the history of decolonization. (51)

The unresolvable antinomy is the opposition between two nations which in the colonies cannot be brought to coexist. Fanon matches two sets of terms: pillage and colonization versus the nation and decolonization, and they emerge in the anticolonial struggle itself as absolutely opposed as they were before it began, before the liberation movement was born, before it started to fight, before it challenged the colonizer. The violence of decolonization is no more than an explicit fulfillment of the violence that lurks within colonialism, and instead of the natives being the object of colonial force, they wield it back *against* colonialism, as subjects reacting with pent-up violence to their own former passivity.

Were liberation therefore only to consist in the violence of nationalism, the process of decolonization might be seen as leading inevitably to it, one step along the way. But Fanon's essential point—and here he also rejects Lukács's own resolution—is that nationalism is a necessary but far from sufficient condition for liberation, perhaps even a sort of temporary illness that must be gone through. By the approximate terms of the subject-object antinomy, the natives who reject their reified status as negation and evil take on violence as a way of providing themselves with "a royal pardon" (86): since they stand outside the European class system about which Lukács wrote, colonized natives need an extra measure of rebelliousness to afford them the dubious position of antagonists (their dreams, Fanon remarks, are full of jumping, swimming, running, climbing, as if trying to imagine what it would be like *not* to stay in place). Once antagonists of the colonizers, however, they are only the *opposite* of colonialism: this is why Fanon says that only at an

initial stage can violence be used to organize a party. Colonial war is of the colonial dialectic, the replication of some of its mutually exclusive and antagonistic terms on a national level. The opposites reflect each other. For the Europeans this will lead to expulsion; for the native this will mean that national independence will be achieved. Yet both expulsion and independence belong essentially to the unforgiving dialectic of colonialism, enfolded within its unpromising script.

Thereafter Fanon is at pains to show that the tensions between colonizer and colonized will not end, since in effect the new nation will produce a new set of policemen, bureaucrats, and merchants to replace the departed Europeans. And indeed after his opening chapter on violence Fanon proceeds to show how nationalism is too heavily imprinted with the *unresolved* (and unresolvable) dialectic of colonialism for it to lead very far beyond it. The complexity of independence, which is so naturally desirable a goal for all colonized people, is that simultaneously it dramatized the discrepancy between colonizer and colonized so basic to colonialism, and also a discrepancy (*décalage*) between the people and their leaders, leaders who perforce are shaped by colonialism. Thus after the opening chapter on violence, Fanon proceeds to develop the new difficulties of nationalism as it continues the war against colonialism decreed by the subject-object antinomy, while at the same time an entirely new consciousness—that of liberation—is struggling to be born.

It is not until the chapter on "The Pitfalls of National Consciousness" that Fanon makes clear what he has been intending all along: national consciousness is undoubtedly going to be captured by the colonial bourgeois elite, the nationalistic leaders, and far from guaranteeing real independence this will perpetuate colonialism in a new form, a "sterile formalism." Thus, he says, if nationalism "is not enriched and deepened by a very rapid transformation into a consciousness of social and political needs, in other words, into humanism, it leads up a blind alley" (204). Borrowing from Aimé Césaire, Fanon suggests that the necessity is to "invent souls," not to reproduce the solutions and formulas either of colonialism or the tribal past. "The living expression of the nation is the moving consciousness of the whole of the people; it is the coherent, enlightened action of men and women" (204). A few sentences later he states that a national government (the only government ever known!) ought to cede its power back to the people, dissolve itself.

Fanon's radicalism, I think, is and has been since his death too strenuous for the new postcolonial states, Algeria included. The gist of his last work plainly indicts them for this insufficiently visionary response to the colonialist dialectic, from which they have never fully liberated themselves, satisfied as they have been with the imitations and simulacra of sovereignty that they have simply taken over from European masters. But even in this extraordinary turn Fanon relies to some degree on Lukács, although it is a Lukács that had been either rejected or toned down by Lukács himself. So that even for a colonial setting, as he criticized the subject-object reconciliation advocated by *History and Class Consciousness* as the "class consciousness of the proletariat," Fanon takes from Lukács the real dissatisfaction with that resolution that surfaces briefly near the end of the essay on "Class Consciousness," the short essay that precedes the reification chapter. "The proletariat," says Lukács, "only perfects itself by annihilating and transcending itself ... it is equally [therefore] the struggle of the proletariat against itself" (80).

There is concurrence here between Fanon and this more (and perhaps only momentarily) radical Lukács on the one hand, and between Lukács and Adorno on the other. The work of theory, criticism, de-mystification, deconsecration, and decentralization they imply is never finished. The point of theory therefore is to travel, always to move beyond its confinements, to emigrate, to remain in a sense in exile. Adorno and Fanon exemplify this profound restlessness in the way they refuse the emoluments offered by the Hegelian dialectic as stabilized into resolution by Lukács—or the Lukács who appeared to speak for class consciousness as something to be gained, possessed, held onto. There was of course the other Lukács which both his brilliant rereaders preferred, the theorist of permanent dissonance, as understood by Adorno, the critic of reactive nationalism as partially adopted by Fanon in colonial Algeria.

In all this we get a sense, I think, of the geographical dispersion of which the theoretical motor is capable. I mean that when Adorno uses Lukács to understand Schoenberg's place in the history of music, or when Fanon dramatized the colonial struggle in the language of the manifestly European subject-object dialectic, we think of them not simply as coming after Lukács, using him at a belated second degree, so to speak, but rather as pulling him from one sphere or region into another. This movement suggests the possibility of actively different locales, sites, situations for theory, without facile universalism or over-general totalizing. One would not, could not, want to assimilate Viennese twelve-tone music to the Algerian resistance to French colonialism: the disparities are too grotesque even to articulate. But in both situations, each so profoundly and concretely felt by Adorno and Fanon respectively, is the fascinating Lukácsian figure, present both as traveling theory and as intransigent practice. To speak here only of borrowing and adaptation is not adequate. There is in particular an intellectual, and perhaps moral, community of a remarkable kind, *affiliation* in the deepest and most interesting sense of the word. As a way of getting seriously past the weightlessness of one theory after another, the remorseless indignations of orthodoxy, and the expressions of tired advocacy to which we are often submitted, the exercise involved in figuring out where the theory went and how in getting there its fiery core was reignited is invigorating—and is also another voyage, one that is central to intellectual life in the late twentieth century.

Benedict Anderson

IMAGINED COMMUNITIES
Nationalism's cultural roots

EDITOR'S INTRODUCTION

FEW NOTIONS IN CONTEMPORARY CULTURAL STUDIES have as much
mileage as the 'imagined community', a concept that Benedict Anderson
developed in his pathbreaking account of nationalism. But it's a concept that
is often used in a more simplistic way than Anderson himself conceived. He set
himself the task of accounting for an important and neglected problem, namely,
why is it that today people have so much commitment to and passion for an
institution – the nation – which is such an abstract and dispersed form of
community? After all, people are willing to die for their nation just as they once
were for their religion, but why should their co-nationals matter so much to them?
And the answer, according to Anderson, is to be found in the cultural history of
nationalism, which he traces back to the encounter between 1) capitalism, 2)
printing technology, and 3) the diversity of natural languages over space. When
these three joined it became possible for large communities, peopled by individuals
who had no filiative or personal or even historical relation to one another to
imagine themselves as 'fraternally' joined.

What this account pushes somewhat aside of course in accounting for
nationalism's appeal are the benefits that nation-states have provided their citizens;
the relation between the development of nationalism and military power; and the
way that nationalism is not simply a product of capitalism but also a reaction
against it. Anderson's is also an account that needs to be considered in the light
of critiques of the relation between nationalism and monoculturalism, given that,
even if he is right about how nationalism developed as a form of monoculturalism,
today nation-states confront internally divisive policy issues in relation to cultural
diversity. These are matters to be carefully considered.

Further reading: Balibar 1991; Bhabha 1990; Chatterjee 1993a; Cheah and Robbins 1998; Hobsbawm and Ranger 1983; Nairn 1977; Seton-Watson 1977.

Perhaps without being much noticed yet, a fundamental transformation in the history of Marxism and Marxist movements is upon us. Its most visible signs are the recent wars between Vietnam, Cambodia and China. These wars are of world-historical importance because they are the first to occur between regimes whose independence and revolutionary credentials are undeniable, and because none of the belligerents has made more than the most perfunctory attempts to justify the bloodshed in terms of a recognizable *Marxist* theoretical perspective. While it was still just possible to interpret the Sino-Soviet border clashes of 1969, and the Soviet military interventions in Germany (1953), Hungary (1956), Czechoslovakia (1968), and Afghanistan (1980) in terms of – according to taste – 'social imperialism,' 'defending socialism,' etc., no one, I imagine, seriously believes that such vocabularies have much bearing on what has occurred in Indochina.

If the Vietnamese invasion and occupation of Cambodia in December 1978 and January 1979 represented the first *large-scale conventional war* waged by one revolutionary Marxist regime against another,[1] China's assault on Vietnam in February rapidly confirmed the precedent. Only the most trusting would dare wager that in the declining years of this century any significant outbreak of inter-state hostilities will necessarily find the USSR and the PRC – let alone the smaller socialist states – supporting, or fighting on, the same side. [...] Those variegated groups who seek a withdrawal of the Red Army from its encampments in Eastern Europe should remind themselves of the degree to which its overwhelming presence has, since 1945, ruled out armed conflict between the region's Marxist regimes.

Such considerations serve to underline the fact that since World War II every successful revolution has defined itself in *national* terms – the People's Republic of China, the Socialist Republic of Vietnam, and so forth – and, in so doing, has grounded itself firmly in a territorial and social space inherited from the prerevolutionary past. Conversely, the fact that the Soviet Union shares with the United Kingdom of Great Britain and Northern Ireland the rare distinction of refusing nationality in its naming suggests that it is as much the legatee of the prenational dynastic states of the nineteenth century as the precursor of a twenty-first century internationalist order.[2]

Eric Hobsbawm is perfectly correct in stating that 'Marxist movements and states have tended to become national not only in form but in substance, i.e., nationalist. There is nothing to suggest that this trend will not continue.' Nor is the tendency confined to the socialist world. Almost every year the United Nations admits new members. And many 'old nations,' once thought fully consolidated, find themselves challenged by 'sub'-nationalisms within their borders – nationalisms which, naturally, dream of shedding this sub-ness one happy day. The reality is quite plain: the 'end of the era of nationalism,' so long prophesied, is not remotely in sight. Indeed, nation-ness is the most universally legitimate value in the political life of our time.

But if the facts are clear, their explanation remains a matter of long-standing dispute. Nation, nationality, nationalism – all have proved notoriously difficult to

define, let alone to analyse. In contrast to the immense influence that nationalism has exerted on the modern world, plausible theory about it is conspicuously meagre. Hugh Seton-Watson, author of far the best and most comprehensive English-language text on nationalism, and heir to a vast tradition of liberal historiography and social science, sadly observes: 'Thus I am *driven* to the conclusion that no "scientific definition" of the nation can be devised; yet the phenomenon has existed and exists' (Seton-Watson 1977: 5). Tom Nairn, author of the path-breaking *The Break-up of Britain*, and heir to the scarcely less vast tradition of Marxist historiography and social science, candidly remarks: 'The theory of nationalism represents Marxism's great historical failure. But even this confession is somewhat misleading, insofar as it can be taken to imply the regrettable outcome of a long, self-conscious search for theoretical clarity. It would be more exact to say that nationalism has proved an uncomfortable *anomaly* for Marxist theory and, precisely for that reason, has been largely elided, rather than confronted. How else to explain Marx's failure to explicate the crucial adjective in his memorable formulation of 1848: 'The proletariat of each country must, of course, first of all settle matters with *its own* bourgeoisie'?[3] How else to account for the use, for over a century, of the concept 'national bourgeoisie' without any serious attempt to justify theoretically the relevance of the adjective? Why is *this* segmentation of the bourgeoisie – a world-class insofar as it is defined in terms of the relations of production – theoretically significant?

The aim of this book is to offer some tentative suggestions for a more satisfactory interpretation of the 'anomaly' of nationalism. My sense is that on this topic both Marxist and liberal theory have become etiolated in a late Ptolemaic effort to 'save the phenomena'; and that a reorientation of perspective in, as it were, a Copernican spirit is urgently required. My point of departure is that nationality, or, as one might prefer to put it in view of that word's multiple significations, nation-ness, as well as nationalism, are cultural artefacts of a particular kind. To understand them properly we need to consider carefully how they have come into historical being, in what ways their meanings have changed over time, and why, today, they command such profound emotional legitimacy. I will be trying to argue that the creation of these artefacts towards the end of the eighteenth century[4] was the spontaneous distillation of a complex 'crossing' of discrete historical forces; but that, once created, they became 'modular,' capable of being transplanted, with varying degrees of self-consciousness, to a great variety of social terrains, to merge and be merged with a correspondingly wide variety of political and ideological constellations. I will also attempt to show why these particular cultural artefacts have aroused such deep attachments.

Concepts and definitions

Before addressing the questions raised above, it seems advisable to consider briefly the concept of 'nation' and offer a workable definition. Theorists of nationalism have often been perplexed, not to say irritated, by these three paradoxes: (1) The objective modernity of nations to the historian's eye vs. their subjective antiquity in the eyes of nationalists. (2) The formal universality of nationality as a socio-cultural concept – in the modern world everyone can, should, will 'have' a

nationality, as he or she 'has' a gender – vs. the irremediable particularity of its concrete manifestations, such that, by definition, 'Greek' nationality is sui generis. (3) The 'political' power of nationalisms vs. their philosophical poverty and even incoherence. In other words, unlike most other isms, nationalism has never produced its own grand thinkers: no Hobbeses, Tocquevilles, Marxes, or Webers. This 'emptiness' easily gives rise, among cosmopolitan and polylingual intellectuals, to a certain condescension. Like Gertrude Stein in the face of Oakland, one can rather quickly conclude that there is 'no there there'. It is characteristic that even so sympathetic a student of nationalism as Tom Nairn can nonetheless write that: '"Nationalism" is the pathology of modern developmental history, as inescapable as "neurosis" in the individual, with much the same essential ambiguity attaching to it, a similar built-in capacity for descent into dementia, rooted in the dilemmas of helplessness thrust upon most of the world (the equivalent of infantilism for societies) and largely incurable' (Nairn 1977: 359).

Part of the difficulty is that one tends unconsciously to hypostasize the existence of Nationalism-with-a-big-N (rather as one might Age-with-a-capital-A) and then to classify 'it' as *an* ideology. (Note that if everyone has an age, Age is merely an analytical expression.) It would, I think, make things easier if one treated it as if it belonged with 'kinship' and 'religion', rather than with 'liberalism' or 'fascism'.

In an anthropological spirit, then, I propose the following definition of the nation: it is an imagined political community – and imagined as both inherently limited and sovereign.

It is *imagined* because the members of even the smallest nation will never know most of their fellow-members, meet them, or even hear of them, yet in the minds of each lives the image of their communion. Renan referred to this imagining in his suavely back-handed way when he wrote that 'Or l'essence d'une nation est que tous les individus aient beaucoup de choses en commun, et aussi que tous aient oublié bien des choses.' ['Now the essence of a nation is that all its subjects have much in common, and also that they have forgotten a great deal.'] With a certain ferocity Gellner makes a comparable point when he rules that 'Nationalism is not the awakening of nations to self-consciousness: it *invents* nations where they do not exist.' The drawback to this formulation, however, is that Gellner is so anxious to show that nationalism masquerades under false pretences that he assimilates 'invention' to 'fabrication' and 'falsity', rather than to 'imagining' and 'creation'. In this way he implies that 'true' communities exist which can be advantageously juxtaposed to nations. In fact, all communities larger than primordial villages of face-to-face contact (and perhaps even these) are imagined. Communities are to be distinguished, not by their falsity/genuineness, but by the style in which they are imagined. Javanese villagers have always known that they are connected to people they have never seen, but these ties were once imagined particularistically – as indefinitely stretchable nets of kinship and clientship. Until quite recently, the Javanese language had no word meaning the abstraction 'society'. We may today think of the French aristocracy of the *ancien régime* as a class; but surely it was imagined this way only very late.[5] To the question 'Who is the Comte de X?' the normal answer would have been, not 'a member of the aristocracy,' but 'the lord of X,' 'the uncle of the Baronne de Y,' or 'a client of the Duc de Z.'

The nation is imagined as *limited* because even the largest of them, encompassing perhaps a billion living human beings, has finite, if elastic, boundaries, beyond which lie other nations. No nation imagines itself coterminous with mankind. The most messianic nationalists do not dream of a day when all the members of the human race will join their nation in the way that it was possible, in certain epochs, for, say, Christians to dream of a wholly Christian planet.

It is imagined as *sovereign* because the concept was born in an age in which Enlightenment and Revolution were destroying the legitimacy of the divinely-ordained, hierarchical dynastic realm. Coming to maturity at a stage of human history when even the most devout adherents of any universal religion were inescapably confronted with the living *pluralism* of such religions, and the allomorphism between each faith's ontological claims and territorial stretch, nations dream of being free, and, if under God, directly so. The gage and emblem of this freedom is the sovereign state.

Finally, it is imagined as a *community*, because, regardless of the actual inequality and exploitation that may prevail in each, the nation is always conceived as a deep, horizontal comradeship. Ultimately it is this fraternity that makes it possible, over the past two centuries, for so many millions of people, not so much to kill, as willingly to die for such limited imaginings.

These deaths bring us abruptly face to face with the central problem posed by nationalism: what makes the shrunken imaginings of recent history (scarcely more than two centuries) generate such colossal sacrifices? I believe that the beginnings of an answer lie in the cultural roots of nationalism.

[...]

If the development of print-as-commodity is the key to the generation of wholly new ideas of simultaneity, still, we are simply at the point where communities of the type 'horizontal-secular, transverse-time' become possible. Why, within that type, did the nation become so popular? The factors involved are obviously complex and various. But a strong case can be made for the primacy of capitalism.

At least 20,000,000 books had already been printed by 1500 signalling the onset of Benjamin's 'age of mechanical reproduction.' If manuscript knowledge was scarce and arcane lore, print knowledge lived by reproducibility and dissemination.[6] If, as Febvre and Martin believe, possibly as many as 200,000,000 volumes had been manufactured by 1600, it is no wonder that Francis Bacon believed that print had changed 'the appearance and state of the world.'

One of the earlier forms of capitalist enterprise, book-publishing felt all of capitalism's restless search for markets. The early printers established branches all over Europe: 'in this way a veritable "international" of publishing houses, which ignored national [sic] frontiers, was created.' And since the years 1500–1550 were a period of exceptional European prosperity, publishing shared in the general boom. 'More than at any other time' it was 'a great industry under the control of wealthy capitalists.' Naturally, 'book-sellers were primarily concerned to make a profit and to sell their products, and consequently they sought out first and

foremost those works which were of interest to the largest possible number of their contemporaries'.

The initial market was literate Europe, a wide but thin stratum of Latin-readers. Saturation of this market took about a hundred and fifty years. The determinative fact about Latin – aside from its sacrality – was that it was a language of bilinguals. Relatively few were born to speak it and even fewer, one imagines, dreamed in it. In the sixteenth century the proportion of bilinguals within the total population of Europe was quite small; very likely no larger than the proportion in the world's population today, and – proletarian internationalism notwithstanding – in the centuries to come. Then and now the bulk of mankind is monoglot. The logic of capitalism thus meant that once the elite Latin market was saturated, the potentially huge markets represented by the monoglot masses would beckon. To be sure, the Counter-Reformation encouraged a temporary resurgence of Latin-publishing, but by the mid-seventeenth century the movement was in decay, and fervently Catholic libraries replete. Meantime, a Europe-wide shortage of money made printers think more and more of peddling cheap editions in the vernaculars.

The revolutionary vernacularizing thrust of capitalism was given further impetus by three extraneous factors, two of which contributed directly to the rise of national consciousness. The first, and ultimately the least important, was a change in the character of Latin itself. Thanks to the labours of the Humanists in reviving the broad literature of pre-Christian antiquity and spreading it through the print-market, a new appreciation of the sophisticated stylistic achievements of the ancients was apparent among the trans-European intelligentsia. The Latin they now aspired to write became more and more Ciceronian, and, by the same token, increasingly removed from ecclesiastical and everyday life. In this way it acquired an esoteric quality quite different from that of Church Latin in mediaeval times. For the older Latin was not arcane because of its subject matter or style, but simply because it was written at all, i.e. because of its status as *text*. Now it became arcane because of what was written, because of the language-in-itself.

Second was the impact of the Reformation, which, at the same time, owed much of its success to print-capitalism. Before the age of print, Rome easily won every war against heresy in Western Europe because it always had better internal lines of communication than its challengers. But when in 1517 Martin Luther nailed his theses to the chapel-door in Wittenberg, they were printed up in German translation, and 'within 15 days [had been] seen in every part of the country.' In the two decades 1520–1540 three times as many books were published in German as in the period 1500–1520, an astonishing transformation to which Luther was absolutely central. His works represented no less than one third of *all* German-language books sold between 1518 and 1525. Between 1522 and 1546, a total of 430 editions (whole or partial) of his Biblical translations appeared. 'We have here for the first time a truly mass readership and a popular literature within everybody's reach.' In effect, Luther became the first best-selling author *so known*. Or, to put it another way, the first writer who could 'sell' his *new* books on the basis of his name.

Where Luther led, others quickly followed, opening the colossal religious propaganda war that raged across Europe for the next century. In this titanic 'battle for men's minds', Protestantism was always fundamentally on the offensive,

precisely because it knew how to make use of the expanding vernacular print-market being created by capitalism, while the Counter-Reformation defended the citadel of Latin. The emblem for this is the Vatican's *Index Librorum Prohibitorum* – to which there was no Protestant counterpart – a novel catalogue made necessary by the sheer volume of printed subversion. Nothing gives a better sense of this siege mentality than François I's panicked 1535 ban on the printing of *any* books in his realm – on pain of death by hanging! The reason for both the ban and its unenforceability was that by then his realm's eastern borders were ringed with Protestant states and cities producing a massive stream of smugglable print. To take Calvin's Geneva alone: between 1533 and 1540 only 42 editions were published there, but the numbers swelled to 527 between 1550 and 1564, by which latter date no less than 40 separate printing-presses were working overtime.

The coalition between Protestantism and print-capitalism, exploiting cheap popular editions, quickly created large new reading publics – not least among merchants and women, who typically knew little or no Latin – and simultaneously mobilized them for politico-religious purposes. Inevitably, it was not merely the Church that was shaken to its core. The same earthquake produced Europe's first important non-dynastic, non-city states in the Dutch Republic and the Commonwealth of the Puritans. (François I's panic was as much political as religious.)

Third was the slow, geographically uneven, spread of particular vernaculars as instruments of administrative centralization by certain well-positioned would-be absolutist monarchs. Here it is useful to remember that the universality of Latin in mediaeval Western Europe never corresponded to a universal political system. The contrast with Imperial China, where the reach of the mandarinal bureaucracy and of painted characters largely coincided, is instructive. In effect, the political fragmentation of Western Europe after the collapse of the Western Empire meant that no sovereign could monopolize Latin and make it his-and-only-his language-of-state, and thus Latin's religious authority never had a true political analogue.

The birth of administrative vernaculars predated both print and the religious upheaval of the sixteenth century, and must therefore be regarded (at least initially) as an independent factor in the erosion of the sacred imagined community. At the same time, nothing suggests that any deep-seated ideological, let alone proto-national, impulses underlay this vernacularization where it occurred. The case of 'England' – on the northwestern periphery of Latin Europe – is here especially enlightening. Prior to the Norman Conquest, the language of the court, literary and administrative, was Anglo-Saxon. For the next century and a half virtually all royal documents were composed in Latin. Between about 1200 and 1350 this state-Latin was superseded by Norman French. In the meantime, a slow fusion between this language of a foreign ruling class and the Anglo-Saxon of the subject population produced Early English. The fusion made it possible for the new language to take its turn, after 1362, as the language of the courts – and for the opening of Parliament. Wycliffe's vernacular *manuscript* Bible followed in 1382 (Seton-Watson 1977: 28–9). It is essential to bear in mind that this sequence was a series of 'state,' not 'national,' languages; and that the state concern covered at various times not only today's England and Wales, but also portions of Ireland, Scotland *and France*. Obviously, huge elements of the subject populations knew little or nothing of Latin, Norman French, or Early English.[7] Not till almost a

century *after* Early English's political enthronement was London's power swept out of 'France'.

On the Seine, a similar movement took place, if at a slower pace. As Bloch wrily puts it, 'French, that is to say a language which, since it was regarded as merely a corrupt form of Latin, took several centuries to raise itself to literary dignity', only became the official language of the courts of justice in 1539, when François I issued the Edict of Villers-Cotterêts. In other dynastic realms Latin survived much longer – under the Habsburgs well into the nineteenth century. In still others, 'foreign' vernaculars took over: in the eighteenth century the languages of the Romanov court were French and German.

In every instance, the 'choice' of language appears as a gradual, unselfconscious, pragmatic, not to say haphazard development. As such, it was utterly different form the selfconscious language policies pursued by nineteenth-century dynasts confronted with the rise of hostile popular linguistic-nationalisms. (See below, Chapter 6.) One clear sign of the difference is that the old administrative languages were *just that:* languages used by and for officialdoms for their own inner convenience. There was no idea of systematically imposing the language on the dynasts' various subject populations.[8] Nonetheless, the elevation of these vernaculars to the status of languages-of-power, where, in one sense, they were competitors with Latin (French in Paris, [Early] English in London), made its own contribution to the decline of the imagined community of Christendom.

At bottom, it is likely that the esotericization of Latin, the Reformation, and the haphazard development of administrative vernaculars are significant, in the present context, primarily in a negative sense – in their contributions to the dethronement of Latin. It is quite possible to conceive of the emergence of the new imagined national communities without any one, perhaps all, of them being present. What, in a positive sense, made the new communities imaginable was a half-fortuitous, but explosive, interaction between a system of production and productive relations (capitalism), a technology of communications (print), and the fatality of human linguistic diversity.[9]

The element of fatality is essential. For whatever superhuman feats capitalism was capable of, it found in death and languages two tenacious adversaries.[10] Particular languages can die or be wiped out, but there was and is no possibility of humankind's general linguistic unification. Yet this mutual incomprehensibility was historically of only slight importance until capitalism and print created monoglot mass reading publics.

While it is essential to keep in mind an idea of fatality, in the sense of a *general* condition of irremediable linguistic diversity, it would be a mistake to equate this fatality with that common element in nationalist ideologies which stresses the primordial fatality of *particular* languages and their association with *particular* territorial units. The essential thing is the *interplay* between fatality, technology, and capitalism. In pre-print Europe, and, of course, elsewhere in the world, the diversity of spoken languages, those languages that for their speakers were (and are) the warp and woof of their lives, was immense; so immense, indeed, that had print-capitalism sought to exploit each potential oral vernacular market, it would have remained a capitalism of petty proportions. But these varied idiolects were capable of being assembled, within definite limits, into print-languages far fewer

in number. The very arbitrariness of any system of signs for sounds facilitated the assembling process.[11] (At the same time, the more ideographic the signs, the vaster the potential assembling zone. One can detect a sort of descending hierarchy here from algebra through Chinese and English, to the regular syllabaries of French or Indonesian.) Nothing served to 'assemble' related vernaculars more than capitalism, which, within the limits imposed by grammars and syntaxes, created mechanically reproduced print-languages capable of dissemination through the market.

These print-languages laid the bases for national consciousnesses in three distinct ways. First and foremost, they created unified fields of exchange and communication below Latin and above the spoken vernaculars. Speakers of the huge variety of Frenches, Englishes, or Spanishes, who might find it difficult or even impossible to understand one another in conversation, became capable of comprehending one another via print and paper. In the process, they gradually became aware of the hundreds of thousands, even millions, of people in their particular language-field, and at the same time that *only those* hundreds of thousands, or millions, so belonged. These fellow-readers, to whom they were connected through print, formed, in their secular, particular, visible invisibility, the embryo of the nationally imagined community.

Second, print-capitalism gave a new fixity to language, which in the long run helped to build that image of antiquity so central to the subjective idea of the nation. As Febvre and Martin remind us, the printed book kept a permanent form, capable of virtually infinite reproduction, temporally and spatially. It was no longer subject to the individualizing and 'unconsciously modernizing' habits of monastic scribes. Thus, while twelfth-century French differed markedly from that written by Villon in the fifteenth, the rate of change slowed decisively in the sixteenth. 'By the 17th century languages in Europe had generally assumed their modern forms.' To put it another way, for three centuries now these stabilized print-languages have been gathering a darkening varnish; the words of our seventeenth-century forebears are accessible to us in a way that to Villon his twelfth-century ancestors were not.

Third, print-capitalism created languages-of-power of a kind different from the older administrative vernaculars. Certain dialects inevitably were 'closer' to each print-language and dominated their final forms. Their disadvantaged cousins, still assimilable to the emerging print-language, lost caste, above all because they were unsuccessful (or only relatively successful) in insisting on their own print-form. 'Northwestern German' became Platt Deutsch, a largely spoken, thus sub-standard, German, because it was assimilable to print-German in a way that Bohemian spoken-Czech was not. High German, the King's English, and, later, Central Thai, were correspondingly elevated to a new politico-cultural eminence. (Hence the struggles in late-twentieth-century Europe by certain 'sub-'nationalities to change their subordinate status by breaking firmly into print – and radio.)

It remains only to emphasize that in their origins, the fixing of print-languages and the differentiation of status between them were largely unselfconscious processes resulting from the explosive interaction between capitalism, technology and human linguistic diversity. But as with so much else in the history of nationalism, once 'there,' they could become formal models to be imitated, and, where expedient, consciously exploited in a Machiavellian spirit. Today, the Thai government actively discourages attempts by foreign missionaries to provide its hill-tribe minorities with

their own transcription-systems and to develop publications in their own languages: the same government is largely indifferent to what these minorities *speak*. The fate of the Turkic-speaking peoples in the zones incorporated into today's Turkey, Iran, Iraq, and the USSR is especially exemplary. A family of spoken languages, once everywhere assemblable, thus comprehensible, within an Arabic orthography, has lost that unity as a result of conscious manipulations. To heighten Turkish-Turkey's national consciousness at the expense of any wider Islamic identification, Atatürk imposed compulsory romanization. The Soviet authorities followed suit, first with an anti-Islamic, anti-Persian compulsory romanization, then, in Stalin's 1930s, with a Russifying compulsory Cyrillicization.

We can summarize the conclusions to be drawn from the argument thus far by saying that the convergence of capitalism and print technology on the fatal diversity of human language created the possibility of a new form of imagined community, which in its basic morphology set the stage for the modern nation. The potential stretch of these communities was inherently limited, and, at the same time, bore none but the most fortuitous relationship to existing political boundaries (which were, on the whole, the highwater marks of dynastic expansionisms).

Yet it is obvious that while today almost all modern self-conceived nations – and also nation-states – have 'national print-languages', many of them have these languages in common, and in others only a tiny fraction of the population 'uses' the national language in conversation or on paper. The nation-states of Spanish America or those of the 'Anglo-Saxon family' are conspicuous examples of the first outcome; many ex-colonial states, particularly in Africa, of the second. In other words, the concrete formation of contemporary nation-states is by no means isomorphic with the determinate reach of particular print-languages.

Notes

1 This formulation is chosen simply to emphasize the scale and the style of the fighting, not to assign blame. To avoid possible misunderstanding, it should be said that the December 1978 invasion grew out of armed clashes between partisans of the two revolutionary movements going back possibly as far as 1971. After April 1977, border raids, initiated by the Cambodians, but quickly followed by the Vietnamese, grew in size and scope, culminating in the major Vietnamese incursion of December 1977. None of these raids, however, aimed at overthrowing enemy regimes or occupying large territories, nor were the numbers of troops involved comparable to those deployed in December 1978.

2 Anyone who has doubts about the UK's claims to such parity with the USSR should ask himself what nationality its name denotes: Great Brito-Irish?

3 Karl Marx and Friedrich Engels, *The Communist Manifesto*, in the *Selected Works*, I, p. 45. Emphasis added. In any theoretical exegesis, the words 'of course' should flash red lights before the transported reader.

4 As Aira Kemiläinen notes, the twin 'founding fathers' of academic scholarship on nationalism, Hans Kohn and Carleton Hayes, argued persuasively for this dating. Their conclusions have, I think, not been seriously disputed except by nationalist ideologues in particular countries. Kemiläinen also observes that the word 'nationalism' did not come into wide general use until the end of the nineteenth century. It did not occur, for example, in many standard nineteenth century lexicons. If

Adam Smith conjured with the wealth of 'nations,' he meant by the term no more than 'societies' or 'states.' Aira Kemiläinen, *Nationalism*, pp. 10, 33, and 48–49.

5 Hobsbawm, for example, 'fixes' it by saying that in 1789 it numbered about 400,000 in a population of 23,000,000. (See his *The Age of Revolution*, p. 78.) But would this statistical picture of the noblesse have been imaginable under the *ancien régime*?

6 Emblematic is Marco Polo's *Travels*, which remained largely unkown till its first printing in 1559 (Polo 1559).

7 We should not assume that administrative vernacular unification was immediately or fully achieved. It is unlikely that the Guyenne ruled from London was ever primarily administered in Early English.

8 An agreeable confirmation of this point is provided by François I, who, as we have seen, banned all printing of books in 1535 and made French the language of his courts four years later!

9 It was not the first 'accident' of its kind. Febvre and Martin note that while a visible bourgeoisie already existed in Europe by the late thirteenth century, paper did not come into general use until the end of the fourteenth. Only paper's smooth plane surface made the mass reproduction of texts and pictures possible – and this did not occur for still another seventy-five years. But paper was not a European invention. It floated in from another history – China's – through the Islamic world (Febvre and Martin 1984: 22–45).

10 We still have no giant multinationals in the world of publishing.

11 That the sign *ough* is pronounced differently in the words although, bough, lough, rough, cough, and hiccough, shows both the idiolectic variety out of which the now-standard spelling of English emerged, and the ideographic quality of the final product.

Paul Gilroy

THE CRISIS OF 'RACE' AND RACIOLOGY

EDITOR'S INTRODUCTION

FOR PAUL GILROY 'RACIOLOGY' (a term he invented) means the discourse of race-difference and all the stereotypes, prejudices, images, identities and knowledges it carries in its wake. He sometimes goes so far as to call raciology, 'compulsory raciality' in analogy to the 'compulsory heterosexuality' of queer theory. At any rate, Gilroy makes a bold argument that what is necessary is not some overturning of concepts of race and raciology but their total abandonment. We need to give up the idea of race altogether. And as he is well aware that is going to be hardest for many of those who have suffered most historically from racial prejudice, since they have invested so much in restoring and transvaluing their racial identities. He is thinking most of all of African-Americans, and the cult of a distinct, racially-thought African identity and culture.

But Gilroy is not recommending an end of raciology in the interests of an abstract disembodied humanism. And this is where his analysis becomes both very complex and very interesting. He is arguing that we can end raciology only by immersing ourselves more thoroughly into the human body and human-engagement-in-the-world as material practices, and in particular by fully considering the diasporic mobility of bodies, cultures and images. The sheer complexity of the lived world is the most effective antidote to raciology. Not the ideals of a rational and transcendent humanness but what he calls 'planetary humanism'. This is a truly original thought, and one whose implications have not been fully thought through yet in cultural studies, particularly where raciology affects different cases than the tragic one between blacks and whites which is Gilroy's main point of reference.

Further reading: Allen 1994; Berger 1996; CCCS 1982; Gilroy 1994; Hall 1996; Sarich and Miele 2004; Williams 1998.

> It is indeed the case that human social and political organization is a reflection of our biological being, for, after all, we are material biological objects developing under the influence of the interaction of our genes with the external world. It is certainly not the case that our biology is irrelevant to social organization. The question is, what part of our biology is relevant?
>
> Richard Lewontin

> A genuine revolution of values means in the final analysis that our loyalties must become ecumenical rather than sectional. Every nation must now develop an overriding loyalty to mankind as a whole in order to preserve the best in their individual societies.
>
> Martin Luther King, Jr.

It is impossible to deny that we are living through a profound transformation in the way the idea of "race" is understood and acted upon. Underlying it there is another, possibly deeper, problem that arises from the changing mechanisms that govern how racial differences are seen, how they appear to us and prompt specific identities. Together, these historic conditions have disrupted the observance of "race" and created a crisis for raciology, the lore that brings the virtual realities of "race" to dismal and destructive life.

Any opportunities for positive change that arise from this crisis are circumscribed by the enduring effects of past catastrophe. Raciology has saturated the discourses in which it circulates. It cannot be readily re-signified or de-signified, and to imagine that its dangerous meanings can be easily re-articulated into benign, democratic forms would be to exaggerate the power of critical and oppositional interests. In contrast, the creative acts involved in destroying raciology and transcending "race" are more than warranted by the goal of authentic democracy to which they point. The political will to liberate humankind from race-thinking must be complemented by precise historical reasons why these attempts are worth making. The first task is to suggest that the demise of "race" is not something to be feared. Even this may be a hard argument to win. On the one hand, the beneficiaries of racial hierarchy do not want to give up their privileges. On the other hand, people who have been subordinated by race-thinking and its distinctive social structures (not all of which come tidily color-coded) have for centuries employed the concepts and categories of their rulers, owners, and persecutors to resist the destiny that "race" has allocated to them and to dissent from the lowly value it placed upon their lives. Under the most difficult of conditions and from imperfect materials that they surely would not have selected if they had been able to choose, these oppressed groups have built complex traditions of politics, ethics, identity, and culture. The currency of "race" has marginalized these traditions from official histories of modernity and relegated them to the backwaters of the primitive and the prepolitical. They have involved elaborate, improvised constructions that have the primary function of absorbing and deflecting abuse. But they have gone far

beyond merely affording protection and reversed the polarities of insult, brutality, and contempt, which are unexpectedly turned into important sources of solidarity, joy, and collective strength. When ideas of racial particularity are inverted in this defensive manner so that they provide sources of pride rather than shame and humiliation, they become difficult to relinquish. For many racialized populations, "race" and the hard-won, oppositional identities it supports are not to be lightly or prematurely given up.

These groups will need to be persuaded very carefully that there is something worthwhile to be gained from a deliberate renunciation of "race" as the basis for belonging to one another and acting in concert. They will have to be reassured that the dramatic gestures involved in turning against racial observance can be accomplished without violating the precious forms of solidarity and community that have been created by their protracted subordination along racial lines. The idea that action against racial hierarchies can proceed more effectively when it has been purged of any lingering respect for the idea of "race" is one of the most persuasive cards in this political and ethical suit.

Historians, sociologists, and theorists of politics have not always appreciated the significance of these sometimes-hidden, modern countercultures formed by long and brutal experiences of racialized subordination through slavery and colonialism and since. The minor, dissident traditions that have been constituted against the odds amid suffering and dispossession have been overlooked by the ignorant and the indifferent as well as the actively hostile. Some initiates, who should certainly know better, have even rejected and despised these formations as insufficiently respectable, noble, or pure. Nonetheless, vernacular cultures and the stubborn social movements that were built upon their strengths and tactics have contributed important moral and political resources to modern struggles in pursuit of freedom, democracy, and justice. Their powerful influences have left their imprint on an increasingly globalized popular culture. Originally tempered by the ghastly extremities of racial slavery, these dissident cultures remained strong and supple long after the formalities of emancipation, but they are now in decline and their prospects cannot be good. They are already being transformed beyond recognition by the uneven effects of globalization and planetary commerce in blackness.

Where the dangers represented by this historic decline have been recognized, the defense of communal interests has often mobilized the fantasy of a frozen culture, of arrested cultural development. Particularity can be maintained and communal interests protected if they are fixed in their most authentic and glorious postures of resistance. This understandable but inadequate response to the prospect of losing one's identity reduces cultural traditions to the simple process of invariant repetition. It has helped to secure deeply conservative notions that supply real comfort in dismal times but do little justice either to the fortitude and the improvisational skills of the slaves and their embattled descendants or to the complexities of contemporary cultural life.

We need to understand the appeal of the idea of tradition in this context. Where it is understood as little more than a closed list of rigid rules that can be applied consciously without interpretation or attention to particular historical conditions, it is a ready alibi for authoritarianism rather than a sign of cultural viability or ethical confidence. Indeed, the defense of tradition on these grounds

can, as we shall see, open a door to ultraconservative forms of political culture and social regulation.

In identifying these problems and moving beyond them, I shall try to show that the comfort zone created in the fading aura of those wonderful cultures of dissidence is already shrinking and that the cultures themselves are not as strong, complex, or effective as they once were. They do still occasionally flicker into spectacular life, urging desperate people to stand up for their rights and giving them a potent political and moral language with which to do it. However, there is no reason to suppose that they will be able to withstand all the destructive effects of globalization and localization, let alone the corrosive power of substantive political disagreements that have arisen over the nature of black particularity and its significance relative to other contending identity-claims: religion, sexuality, generation, gender, and so on.

The dissident traditions inaugurated by the struggle against slavery, a struggle for recognition as human rather than chattel, agent and person rather than object, have already been changed by translocal forces, both political and economic, that bear heavily on the symbolic currency of "race." This situation is another fundamental part of the crisis of raciology. It provides further inducements to recognize that the current disruption of race-thinking presents an important opportunity. There is here a chance to break away from the dangerous and destructive patterns that were established when the rational absurdity of "race" was elevated into an essential concept and endowed with a unique power to both determine history and explain its selective unfolding.

If we are tempted to be too celebratory in assessing the positive possibilities created by these changes in race-thinking and the resulting confusion that has enveloped raciology, we need only remind ourselves that the effects of racial discourses have become more unpredictable as the quality of their claims upon the world have become more desperate. This is a delicate situation, and "race" remains fissile material.

A crisis of raciology

Any inventory of the elements that constitute this crisis of raciology must make special mention of the rise of gene-oriented or genomic constructions of "race." Their distance from the older versions of race-thinking that were produced in the eighteenth and nineteenth centuries underlines that the meaning of racial difference is itself being changed as the relationship between human beings and nature is reconstructed by the impact of the DNA revolution and of the technological developments that have energized it. This book is premised upon the idea that we must try to take possession of that profound transformation and somehow set it to work against the tainted logic that produced it. In other words, the argument here unfolds from the basic idea that this crisis of "race" and representation, of politics and ethics, offers a welcome cue to free ourselves from the bonds of all raciology in a novel and ambitious abolitionist project.

The pursuit of liberation from "race" is an especially urgent matter for those peoples who, like modern blacks in the period after transatlantic slavery, were

assigned an inferior position in the enduring hierarchies that raciology creates. However, this opportunity is not theirs alone. There are very good reasons why it should be enthusiastically embraced by others whose antipathy to race-thinking can be defined, not so much by the way it has subordinated them, but because in endowing them with the alchemical magic of racial mastery, it has distorted and delimited their experiences and consciousness in other ways. They may not have been animalized, reified, or exterminated, but they too have suffered something by being deprived of their individuality, their humanity, and thus alienated from species life. Black and white are bonded together by the mechanisms of "race" that estrange them from each other and amputate their common humanity. Frantz Fanon, the Martiniqean psychiatrist and anticolonial activist whose work frames these concerns, observed this dismal cycle through its effects on the lives of men: "the Negro enslaved by his inferiority, the white man enslaved by his superiority alike behave in accordance with a neurotic orientation." Dr. Martin Luther King, Jr., another influential pathologist of "race," whose work counterpoints Fanon's own, was fond of pointing out that race-thinking has the capacity to make its beneficiaries inhuman even as it deprives its victims of their humanity.

Here, drawing implicitly upon the combined legacies of King and Fanon, his sometime interlocutor, a rather different, postracial and postanthropological version of what it means to be human might begin to take shape. If this radically nonracial humanism is to be placed upon more stable foundations than those provided by King's open-minded and consistent Christianity or Fanon's phenomenological, existential, and psychoanalytic interests, it must be distinguished from earlier, less satisfactory attempts to refigure humankind. Its attempt at a comprehensive break from those traditions of reflection is signaled fundamentally by a refusal to be articulated exclusively in the male gender. From this angle, the precious, patient processes that culminate in community and democracy do not exist only in the fraternal patterns that have proved so durable and so attractive to so many. The ideal of fraternity need no longer compromise or embarrass the noble dreams of liberty and equality. This willfully ungendered humanism is not reducible to demands for equality between men and women or even for reciprocity between the sexes. Those revolutionary ideas are already alive and at large in the world. They can be complemented by a change of the conceptual scale on which essential human attributes are being calculated.

This change, in turn, entails the abolition of what is conventionally thought of as sexual division. Minor differences become essentially irrelevant. The forms of narcissism they support need not retain their grip upon the world. If that aim seems to be an unduly Utopian or radical aspiration, we would do well to recall the important practical example of these principles currently being pursued by the military organizations of the overdeveloped world. Forced by recruitment shortfalls and other demographic changes to accept the possibility that women are just as physically capable of front-line combat duties as their male counterparts, these organizations have undertaken a partial but nonetheless significant demasculinization of soldiery. While Demi Moore was being incarnated as GI Jane, Western military organizations were conducting a number of technical studies of exactly how the female body can be modified by exercise and training so that its physical potential for military activities can be optimized. Scientists at Britain's Ministry of Defence

Research Agency have, for example, outlined a form of basic training, cryptically known as "personnel selection standards," for their new female recruits. The British Army has emphasized that it cannot eliminate intrinsic physical differences such as hip size and varying proportions of fat and muscle; however, "initial results from the new training regime have, on average, added 2 lbs more muscle while removing 6 lbs of fat." One British officer said: "Brute strength is not a great part of military life in the 1990s." Comparable strategies are also being revealed on the other side of scarcity in the underdeveloped parts of the planet. The active and enthusiastic contribution of women to the genocide of Tutsi and the killing of Hutu political opponents that took place in Rwanda during 1994 provides one warning against any desire to celebrate these changes as inherently progressive.

Perhaps, pending the eventual sublation of governmental militarism, the ideal of military genderlessness can enhance our understanding of moral and civic agency. As a sign of transition, it hints at a universality that can exist in less belligerent forms. There need be no concessions to the flight from embodiment that has been associated with the consolidation of abstract, modern individuality. Here, the constraints of bodily existence (being in the world) are admitted and even welcomed, though there is a strong inducement to see and value them differently as sources of identification and empathy. The recurrence of pain, disease, humiliation and loss of dignity, grief, and care for those one loves can all contribute to an abstract sense of a human similarity powerful enough to make solidarities based on cultural particularity appear suddenly trivial.

Some other features of this pragmatic, planetary humanism can be tentatively enumerated. Though most political philosophers who consider these questions have ignored this possibility or failed to recognize its truly subversive force, I would suggest that a certain distinctiveness might also be seen to emerge through the deliberate and self-conscious renunciation of "race" as a means to categorize and divide humankind. This radically nonracial humanism exhibits a primary concern with the forms of human dignity that race-thinking strips away. Its counteranthropological and sometimes misanthropic orientation is most powerfully articulated where it has been accompanied by a belated return to consideration of the chronic tragedy, vulnerability, and frailty that have defined our species in the melancholic art of diverse poetic figures from Leopardi and Nietzsche to Esther Phillips and Donny Hathaway. Its signature is provided by a grim determination to make that predicament of fundamentally fragile, corporeal existence into the key to a version of humanism that contradicts the triumphal tones of the anthropological discourses that were enthusiastically supportive of race-thinking in earlier, imperial times.

This is not the humanism of existentialists and phenomenologists, short-sighted Protestants or complacent scientists. Indeed, mindful of raciological associations between past humanisms and the idea of progress, this humanism is as unfriendly toward the idea of "race" as it is ambivalent about claims to identify progress that do not take the de-civilizing effects of continuing racial division into account. I want to show that important insights can be acquired by systematically returning to the history of struggles over the limits of humanity in which the idea of "race" has been especially prominent. This humanism is conceived explicitly as a response to the sufferings that raciology has wrought. The most valuable resources for its elaboration derive from a principled, cross-cultural approach to the history and

literature of extreme situations in which the boundaries of what it means to be human were being negotiated and tested minute by minute, day by day. These studies of the inhumanity inspired by and associated with the idea of "race" are not, of course, confined to slavery or the brutal forms of segregation that followed it. They have arisen from numerous episodes in colonial history and from the genocidal activities that have proved to be raciology's finest, triumphant hours. They are especially worthwhile, not because the suffering of the victims of extreme evil offers easy lessons for the redemption of the more fortunate; indeed, we cannot know what acute ethical insights the victims of race-thinking may have taken with them in death. The victims of these terrors are necessarily mute, and if there are any survivors, they will be beset by guilt, shame, and unbearably painful and unreliable memories. They will not be the best guides to the moral and political lessons involved in histories of pointless suffering, but they may still be able to yield important insight into the moral dilemmas of the present. We should therefore pay attention to the doubts that the most eloquent and perceptive survivors of systematic inhumanity have thrown on the value of their own testimony. We must be alert to its unspoken conventions and genres, for there are tacit rules governing the expectations of the reading publics that have formed around these painful, moving words and texts.

However, in an unprecedented situation in which ambivalence reigns and general laws of ethical conduct are difficult to frame, this legacy of bearing witness should not be spurned as a distraction from the laborious tasks of documentation and historical reconstruction. It is far better to make this dubious testimony our compass and to seek our bearings in the words of witnesses than to try vainly to orient ourselves with the unreliable charts supplied by covertly race-coded liberal or even socialist humanisms, which, if they did not steer us into this lost position, have offered very few ideas about how we might extricate ourselves from it and find ourselves again without the benefit of racial categories or racial lore.

Genes and bodies in consumer culture

The contemporary focus on the largely hidden potency of genes promotes a fundamental change of scale in the perception and comprehension of the human body. This change is not an automatic product of only the most recent scientific developments and needs to be connected to an understanding of techno-science, particularly biotechnology, over a longer period of time. Its impact upon the status of old, that is, essentially eighteenth-century, racial typologies has been inexcusably neglected by most writers on "race."

The tragic story of Henrietta Lacks, an African-American mother of five from Baltimore who died of cervical cancer at the age of thirty-one in October 1951, can provide important orientation as we move away from the biopolitics of "race" and toward its nano-politics. Cells taken without consent from Lacks's body by Dr. George Gey, a cell biologist at the Johns Hopkins Hospital, were grown in tissue culture and have been used since then in countless scientific experiments all over the world. The cell-line extracted from her cancer, now known as HeLa, was the first human tumor cell-line to be cultivated. It had a number of unusual properties.

The unprecedentedly virulent cells grew rapidly and proliferated, invading adjacent cultures and combining unexpectedly with other organisms in the labs where they were in use. They were soon being marketed as a "research organism" and have proved to be an indispensable tool in the burgeoning biotech industry.

The Lacks case raises important issues about when material of this type extracted from a body can be considered human tissue and the point at which it is to be identified alternatively as a form of property that belongs, not to the person in whose body it began, but to the commercial interests involved in selling it for private profit. The story of HeLa cells is also instructive for the confusion that was created when enzymes that suggested Mrs. Lacks's "blackness" revealed themselves, confounding and perplexing researchers who had assumed her "whiteness" or had, more importantly, failed to think raciologically about her legacy or their own research. This episode can be used to mark the point at which an important threshold in thinking about "race" was crossed. The message conveyed by commerce in HeLa cells exceeds even the old familiar tale in which black patients have sometimes been abused and manipulated by the white doctors employed to treat them. It would appear that race-defying cells, the body's smallest vital component, have become absolutely central to controversies over the limit and character of species life.

At the risk of sounding too anthropocentric, I would suggest that the cultivation of cells outside the body for commercial and other purposes is an epoch-making shift that requires a comprehensive rethinking of the ways we understand and analyze our vulnerable humanity. Like the speculative manipulation of genetic material between various species that has followed it with unpredictable and possibly dangerous results for all human beings, this change suggests a wholly new set of boundaries within which humanity will take shape. The "engineering" of transgenic animals and plants, some of which have supposedly benefited from the insertion of human genes into their DNA, is a related phenomenon that has also been the subject of intense debate about its potentially catastrophic consequences. The international and therefore necessarily "transracial" trade in internal organs and other body parts for transplant, sometimes obtained by dubious means, is another pertinent development. The challenges that have arisen from the manipulation and commerce in all aspects of human fertility, including the vividly contentious issue of whether mothers of one "race" might perversely choose to bear babies of another, represent yet another key change, while a number of recent attempts to patent or hold copyright in organisms, cells, and other elements of life itself would be the final sign that we have to adjust our conceptions of life and our mutable human nature.

All these changes impact upon how "race" is understood. Awareness of the indissoluble unity of all life at the level of genetic materials leads to a stronger sense of the particularity of our species as a whole, as well as to new anxieties that its character is being fundamentally and irrevocably altered. With these symptomatic developments in mind, it is difficult to resist the conclusion that this biotechnological revolution demands a change in our understanding of "race," species, embodiment, and human specificity. In other words, it asks that we reconceptualize our relationship to ourselves, our species, our nature, and the idea of life. We need to ask, for example, whether there should be any place in this new paradigm of life for the idea of specifically *racial* differences.

The well-known and surprisingly popular portrait of human beings as an essentially irrelevant transitory medium for the dynamic agency of their supposedly selfish genes is not the only morally and politically objectionable consequence of emergent, genomic orthodoxy. It, too, has fundamental implications for the coherence of the idea of "race" and its relationship to the increasingly complex patterns of natural variation that will no doubt be revealed in a geographically distributed species and the endlessly varying but fundamentally similar individuals who compose it. The specification of significant differences can only be calculated within specific scales, what the physicist Ilya Prigogine calls "domains of validity." Sadly, however much common sense and popular comprehension of "race" lag behind these developments, they do not mean that ideas of "race" based upon immediate appearance have become instantly redundant, acquiring a residual status that contrasts sharply with the conspicuous power they enjoyed previously in the ages of colonial empires, mass migration, and mass extermination.

As actively de-politicized consumer culture has taken hold, the world of racialized appearances has become invested with another magic. This comes courtesy of developments like the proliferation of ever-cheaper cosmetic surgery and the routine computer enhancement and modification of visual images. These changes, which build upon a long history of technical procedures for producing and accentuating racial differences on film, undermine more than the integrity of raciological representation. They interact with other processes that have added a conspicuous premium to today's planetary traffic in the imagery of blackness. Layer upon layer of easily commodified exotica have culminated in a racialized glamour and contributed an extra cachet to some degree of nonspecific, somatic difference. The perfect faces on billboards and screens and in magazines are no longer exclusively white, but as they lose that uniformity we are being pressed to consider and appreciate exactly what they have become, where they fit in the old hierarchy that is being erased, and what illicit combination of those familiar racial types combined to produce that particular look, that exotic style, or that transgressive stance. The stimulating pattern of this hyper-visibility supplies the signature of a corporate multiculturalism in which some degree of visible difference from an implicit white norm may be highly prized as a sign of timeliness, vitality, inclusivity, and global reach.

A whole new crop of black models, stylists, photographers, and now, thanks to the good offices of Spike Lee, a black advertising agency, have contributed to this change of climate in the meaning of racialized signs, symbols, and bodies. The stardom of prominent iconic figures like Tyson Beckford, Tyra Banks, and, of course, Lee himself supplements the superhuman personalities and conspicuous physical attributes of the latest heroic wave of black athletes who built connections to the emerging planetary market in leisure, fitness, and sports products. In that domain, blackness has proved to be a substantial asset. What Fanon, pondering the iconic stardom of Joe Louis and Jesse Owens, called "the cycle of the bio-logical" was initiated with the mythic figure of The Negro: either unthinkingly lithe and athletic or constitutionally disposed to be lethargic and lazy. That modern cycle may also be thought of as terminating in the space of black metaphysicality. Zygmunt Bauman has argued that the primal scene of postmodern social life in the overdeveloped world is being staged in a distinctive private relation to one's

own corporeality, through a disciplinary custodianship that can be specified as the idea of the body "as task." This has unexpected consequences where the ideal of physical prowess, to which blacks were given a special title in exchange for their disassociation from the mind, assumes an enhanced significance.

It is best to be absolutely clear that the ubiquity and prominence currently accorded to exceptionally beautiful and glamorous but nonetheless racialized bodies do nothing to change the everyday forms of racial hierarchy. The historic associations of blackness with infrahumanity, brutality, crime, idleness, excessive threatening fertility, and so on remain undisturbed. But the appearance of a rich visual culture that allows blackness to be beautiful also feeds a fundamental lack of confidence in the power of the body to hold the boundaries of racial difference in place. It creates anxiety about the older racial hierarchies that made that revolutionary idea of black beauty oxymoronic, just as it requires us to forget the political movement that made its acknowledgment imperative. It is as though these images of nonwhite beauty, grace, and style somehow make the matter of "race" secondary, particularly when they are lit, filtered, textured, and toned in ways that challenge the increasingly baffled observer's sense of where racial boundaries might fall. In this anxious setting, new hatreds are created not by the ruthless enforcement of stable racial categories but from a disturbing inability to maintain them. Conforming enthusiastically to wider social patterns, the surface of black bodies must now be tattooed, pierced, and branded if they are to disclose the deepest, most compelling truths of the privatized ontology within. The words "Thug Life" famously inked onto the eloquent torso of the late Tupac Shakur, like the hexagrams, Oriental characters, cartoon pictures, and other devices sported by a host of stars—Treach, Foxy Brown, and Dennis Rodman, to name only three—conform to this trend and have the additional significance of showing the world how far from the color black these muscled black bodies really are.

It should be clear that the shape-shifting and phenotype-modifying antics that abound in the world of black popular culture did not culminate in the strange case of Michael Jackson. His physical transformation of himself ushered in this new phase of creative possibilities. Playful mut(il)ation did not contradict either his affirmation of an African-American heritage or his well-publicized distaste for Africa itself. Similar patterns enjoy a far more insidious afterlife in the antics of the legions of models, athletes, and performers whose beauty and strength have contributed to the postmodern translation of blackness from a badge of insult into an increasingly powerful but still very limited signifier of prestige. The ongoing activities of this group in the worlds of television, music, sports, fashion, entertainment, and, above all, advertising supply further proof that as far as "race" is concerned, what you see is not necessarily what you get.

All these developments stem from and contribute to the same uncertainties over "race." They help to call the self-evident, obvious authority of familiar racialized appearances, of common-sense racial typologies, into question. Bodies may still be the most significant determinants in fixing the social optics of "race," but black bodies are now being seen—figured and imaged—differently. Thanks to Adobe Photoshop® and similar image-processing technologies, skin tones can be more readily manipulated than the indelibly marked musculatures that sell the sweated and branded products of Tommy Hilfiger, Calvin Klein, Timberland, and

Guess in the glossy pages of overground publications like *Vibe* and *The Source* that trade widely in aspects of black culture but are not primarily addressed to any black reading public. This crisis has ensured that racialized bodies represented as objects—objects among other objects—are never going to be enough to guarantee that racial differences remain what they were when everyone on both sides of the line between white and colored knew what "race" was supposed to be.

These timely occurrences should be placed in the context of the leveling forces of placeless development and commercial planetarization. The meaning and status of racial categories are becoming even more uncertain now that substantial linguistic and cultural differences are being flattened out by the pressures of a global market. Where cultural continuity or overlap is recognized between different racialized groups, the smallest cultural nuances provide a major means of differentiation. Once the course of the mainstream is diverted through marginal, underexploited cultural territory, an emphasis on culture can readily displace previous attention to the receding certainties of "race." In these conditions, the relationship between cultural differences and racial particularity gets complex and fraught. Culture, no less than Mrs. Lacks's valuable cells, becomes akin to a form of property attached to the history and traditions of a particular group and regulated by anyone who dares to speak in its name. This can produce some odd conflicts over the assignment of fragments that resist all disciplinary powers. One small illustration springs to mind from the workings of the British political system. Much to the disgust of the Labour Party's black members of Parliament, Bernie Grant and Paul Boateng, who wanted to place it in other political traditions, some of Bob Marley's music was employed as the curtain raiser for a fringe meeting of the European Movement (UK) at the 1996 Conservative Party conference. The person responsible for this grave affront to Marley's inherent socialism was Sir Teddy Taylor, an eccentric, Euro-skeptic but reggae-loving right-winger who explained to the media that he "thought the song ["Three Little Birds"] summed up the Tory policy on Europe."

The emphasis on culture as a form of property to be owned rather than lived characterizes the anxieties of the moment. It compounds rather than resolves the problems arising from associating "race" with embodied or somatic variation. Indeed, we must be alert to circumstances in which the body is reinvested with the power to arbitrate in the assignment of cultures to peoples. The bodies of a culture's practitioners can be called upon to supply the proof of where that culture fits in the inevitable hierarchy of value. The body may also provide the preeminent basis on which that culture is to be ethnically assigned. The body circulates uneasily through contemporary discussions of how one knows the group to which one belongs and of what it takes to be recognized as belonging to such a collectivity. Differences within particular groups proliferate along the obvious axes of division: gender, age, sexuality, region, class, wealth, and health. They challenge the unanimity of racialized collectivities. Exactly what, in cultural terms, it takes to belong, and, more importantly, what it takes to be recognized as belonging, begin to look very uncertain. However dissimilar individual bodies are, the compelling idea of common, racially indicative bodily characteristics offers a welcome short-cut into the favored forms of solidarity and connection, even if they are effectively denied by divergent patterns in life chances and everyday experience.

Even more pernicious symptoms of the crisis of raciology are all around us. They are more pronounced in Europe now that the racial sciences are no longer muted by the memories of their active complicity in the genocide of European Jews. The special moral and political climate that arose in the aftermath of National Socialism and the deaths of millions was a transitory phenomenon. It has receded with the living memory of those frightful events. The Nazi period constitutes the most profound moral and temporal rupture in the history of the twentieth century and the pretensions of its modern civilization. Remembering it has been integral to the politics of "race" for more than fifty years, but a further cultural and ethical transition represented by war-crimes trials, financial reparations, and a host of national apologies is irreversibly under way. It aims to place this raciological catastrophe securely in an irrecoverable past, what Jean Améry called "the cold storage of history," designed more to be cited or passed en route to other happier destinations rather than deliberately summoned up, inhabited, or mourned in an open-ended manner. Official restitution promotes a sense of closure and may be welcomed as a sign that justice has been belatedly done, but it may also undercut the active capacity to remember and set the prophylactic powers of memory to work against future evils. The effects of trauma may be modified if not moderated by the passage of time. They are also vulnerable to the provision of various forms of compensation: substantive and vacuous, formal and informal, material and symbolic.

This is not a straightforward conflict between a culturally sanctioned public obligation to remember and a private desire to forget the unforgettable. The manner, style, and mood of collective remembrance are absolutely critical issues, and the memory of racial slavery in the New World is not the only history of suffering to have been belittled by the power of corrosive or trivializing commemoration. One small example suffices here. The slaves in Steven Spielberg's courtroom drama *Amistad* arrive at their Cuban auction block fresh from the horrors of the Middle Passage. They are buffed: apparently fit and gleaming with robust good health. They enjoy the worked-out and pumped-up musculature that can only be acquired through the happy rigors of a postmodern gym routine. Against the grain of white supremacy's indifference and denial, the Middle Passage has been deliberately and provocatively recovered, but it is rendered in an impossible and deeply contentious manner that offers only the consolation of tears in place of more challenging and imaginative connections. It may be that those coveted abdominal muscles are now deemed to be an essential precondition for identifying with the superhuman figures of heroes like Spielberg's Joseph Cinqué.

There has never been spontaneous consensus over how to commemorate and memorialize histories of suffering. Significant discrepancies have been apparent, for example, between the ways that African Americans and Ghanaians have approached the conservation of fortified sites of slave-trading activity that have recently become places of pilgrimage and cultural tourism for some of the more affluent daughters and sons of the Atlantic diaspora. In the very same moment that these sharp divisions have appeared inside what we were once urged to see as a single "racial" group, a torrent of images of casual death and conflict have been transmitted instantaneously from all over the African continent. For some, these dismal reports have ushered in nostalgia for the orderly world of colonial empires

and threatened to make savagery something that occurs exclusively beyond the fortified borders of the new Europe. Through genocide in Rwanda and slaughter in Congo and Burundi, civil strife in Liberia, Sierra Leone, and Nigeria, corruption and violence in Kenya, Uganda, Sudan, and Mozambique, government by terror has been associated once again with infrahuman blackness reconstituted in the "half-devil, half-child" patterns favored by older colonial mentalities. Attempts to emphasize that many of the architects of mass killing in Rwanda and Bosnia were educated to the highest standards of the Western humanities have not achieved the same prominence. Placing some of them on trial for war crimes or for the genocidal activities involved in their crimes against humanity has raised more difficult questions about the specificity and uniqueness of earlier mass killing and the central place of the "race-thinking" that has recurrently been featured as a means to justify more recent episodes.

Interestingly, the important work of South Africa's Truth Commission has mobilized a version of the history of Apartheid that accentuates its political affinities as well as its concrete historical connections to the criminal governance of the Nazi period. With these connections underlined, Apartheid's elaborate theories of cultural and tribal difference can be swiftly reduced to the bare bones of raciology that originally warranted them and dispatched Broederbond commissioners back to Europe during the 1930s in pursuit of an appropriate ethnic content for the ideal white culture that was being actively invented.

An even blend of those deceptively bland terms "ethnicity" and "culture" has emerged as the main element in the discourse of differentiation that is struggling to supersede crude appeals to "race" by asserting the power of tribal affiliations. These timely notions circulate in more specialized language, but any sense that they bring greater precision into the task of social division is misleading. The culturalist approach still runs the risk of naturalizing and normalizing hatred and brutality by presenting them as inevitable consequences of illegitimate attempts to mix and amalgamate primordially incompatible groups that wiser, worldlier, more authentically colonial government would have kept apart or left to meet only in the marketplace. The unfolding of recent postcolonial history has sent out a less nostalgic and more challenging message: if the status of "race" can be transformed even in South Africa, the one place on earth where its salience for politics and government could not be denied, the one location where state-sponsored racial identities were openly and positively conducted into the core of a modern civic culture and social relations, then surely it could be changed anywhere. If it is as mutable as that, what then does racial identity comprise?

The widespread appearance of forms of ultranationalist race-thinking that are not easily classified as either biologistic or cultural but which seem to bear the significant imprint of past fascism is another dimension to the crisis of raciology. In Britain, today's patriotic neo-fascists are still undone by the memory of the 39–45 war, torn between their contradictory appeals to the figures of Churchill on one side and Hitler on the other. The French Front Nationale has included a full complement of Holocaust deniers and apologists for colonial brutality, but it also managed to stand black and Jewish candidates in the elections of May 1997. The most prominent of these, Hugette Fatna, the organization's secretary for France's overseas territories, proudly declaimed, "I'm black and proud of it ... I'm a free

woman, and I accept my difference," as though democratic denunciations of her then leader, Jean-Marie Le Pen, as a racist, required her to deny it. In other places, the loquacious veterans of Apartheid's death squads have protested at length that, speaking personally, they are not themselves inclined to antiblack racism. The Italian-born Belgian broadcaster Georges Ruggiu faces a trial for crimes against humanity as a result of being arrested and charged with complicity in the 1994 genocide of Tutsis. His inflammatory programs on Radio Mille Collines famously compared the Hutu assault to the French Revolution. Thus, in their genocidal confrontation with the African proxies of "Anglo-Saxon" geo-political ambition, the francophone killers seemed to have imagined themselves as an extension of the French nation to which they were bound. Gérard Prunier has described this as "the Fashoda syndrome."

The advocates of these unsettling varieties of racialized politics have been forced to become fluent in the technical, anthropological language of ethnicity and culture. Their opinions are also likely to be leavened with mechanistic determinism and neurotic hyper-patriotism. Nonetheless, these obvious ties to past raciologies should not be allowed to obscure the fact that the language produced by this crisis of race-thinking differs from its predecessors. When facing these new phenomena, what we used to be able to call an antiracist opposition must involve more than merely establishing the secret lineage that associates these contemporary groups with their radically evil, authentically fascist antecedents. What Primo Levi, with characteristic precision, referred to as "the silent Nazi diaspora" continues to go about its strategic work, but soon, mobilizing the fragmentary memories of Hitlerism will not be enough to embarrass its activists, never mind defeat them. Nazism and other related versions of populist ultranationalism have found new adherents and, more worryingly, new bands of imitators in all sorts of unlikely locations. The glamour of that particular political style and its Utopian charge will be explored later on. They, too, have increased as emotional, psychological, and historical distance from the events of the Third Reich has grown.

All these factors contribute to a situation in which there are diminishing moral or political inhibitions against once more invoking "race" as a primary means of sorting people into hierarchies and erecting unbridgeable chasms around their discrete collective identities. Why, then, describe this situation as a crisis of raciology rather than its crowning glory? It is a crisis because the idea of "race" has lost much of its common-sense credibility, because the elaborate cultural and ideological work that goes into producing and reproducing it is more visible than ever before, because it has been stripped of its moral and intellectual integrity, and because there is a chance to prevent its rehabilitation. Prompted by the impact of genomics, "race," as it has been defined in the past, has also become vulnerable to the claims of a much more elaborate, less deterministic biology. It is therefore all the more disappointing that much influential recent work in this area loses its nerve in the final furlong and opts to remain ambiguous about whether the idea of "race" can survive a critical revision of the relationship between human beings and their constantly shifting social nature!

Whether it is articulated in the more specialized tongues of biological science and pseudo-science or in a vernacular idiom of culture and common sense, the term "race" conjures up a peculiarly resistant variety of natural difference. It stands

outside of, and in opposition to, most attempts to render it secondary to the overwhelming sameness that overdetermines social relationships between people and continually betrays the tragic predicaments of their common species life. The undervalued power of this crushingly obvious, almost banal human sameness, so close and basically invariant that it regularly passes unremarked upon, also confirms that the crisis of raciological reasoning presents an important opportunity where it points toward the possibility of leaving "race" behind, of setting aside its disabling use as we move out of the time in which it could have been expected to make sense.

There is a danger that this argument will be read as nothing more than a rather old-fashioned plea for disabusing ourselves of the destructive delusions of racism. Injunctions of that kind have been a recurrent feature of some liberal, religious, socialist, and feminist pronouncements on these matters since the term "race" was first coined. While I value that political pedigree, I want to try to be clear about exactly where this line of thought departs from its noble precursors in those traditions that have contributed so extensively to the ideas and the practice of antiracism. All the earlier arguments conform to the same basic architecture. They posit the particular, singular, and specific against the general, universal, and transcendent that they value more highly. In contrast, the approach I favor attempts to break up these unhappy couples. It has less to say about the unanswerable force of claims to singularity and particularity that have fueled ethnic absolutism. Instead, it directs attention toward the other side of these simultaneous equations. We should, it suggests, become concerned once again with the notion of the human into which reluctant specificity has been repeatedly invited to dissolve itself. My position recognizes that these invitations would be more plausible and attractive if we could only confront rather than evade the comprehensive manner in which previous incarnations of exclusionary humanity were tailored to racializing codes and qualified by the operation of colonial and imperial power. In other words, the alternative version of humanism that is cautiously being proposed here simply cannot be reached via any retreat into the lofty habits and unamended assumptions of liberal thinking, particularly about juridical rights and sovereign entitlements. This is because these very resources have been tainted by a history in which they were not able to withstand the biopolitical power of the race-thinking that compromised their boldest and best ambitions. Their resulting failures, silences, lapses, and evasions must become central. They can be reinterpreted as symptoms of a struggle over the boundaries of humanity and then contribute to a counterhistory that leads up to the rough-hewn doorway through which any alternative conception of the human must pass. This can only be attained after a wholesale reckoning with the idea of "race" and with the history of raciology's destructive claims upon the very best of modernity's hopes and resources. A restoration of political culture is the evasive goal of these operations.

Another curious and perplexing effect of the crisis of raciology is a situation in which some widely divergent political interests have been able to collaborate in retaining the concept and reinvesting it with explanatory power. Strange alliances and opportunistic connections have been constructed in the name of ethnic purity and the related demand that unbridgeable cultural differences be identified and respected. This desire to cling on to "race" and go on stubbornly

and unimaginatively seeing the world on the distinctive scales that it has specified makes for odd political associations as well as for less formal connections between raciological thinkers of various hues. In doing battle against all of them and their common desire to retain and reinflate the concept so that it becomes, once again, a central political and historical reference point, we must be very clear about the dimensions of this moment and the significant discrepancies that have arisen between different local settings. We should recognize that "race" has been given a variety of accents. Problems of compatibility and translation have been multiplied by the globalization of culture in which local codes may have to fight against the encroachments of corporate multiculturalism if they are to retain their historic authority and explanatory power. For example, America's distinctive patterns of color consciousness may not be anything other than a fetter on the development of the planetary market in health, fitness, leisure, and sports products mentioned above. Certain common features, like the odd prestige attached to the metaphysical value of whiteness, do recur and continue to travel well, but they too will be vulnerable to the long-term effects of this crisis. Some distinctive local patterns undoubtedly persist, but their anachronistic longevity compounds the problem. Where communication becomes instantaneous, the crisis of racial meaning is further enhanced by the way attachments to the idea of "race" develop unevenly and remain primarily associated with the context of overdevelopment.

We cannot remind ourselves too often that the concept of "race" as it is used in common-sense, everyday language to signify connectedness and common characteristics in relation to type and descent is a relatively recent and absolutely modern invention. Though it would be foolish to suggest that evil, brutality, and terror commence with the arrival of scientific racism toward the end of the eighteenth century, it would also be wrong to overlook the significance of that moment as a break point in the development of modern thinking about humanity and its nature. Even prescientific versions of the logic of "race" multiplied the opportunities for their adherents to do evil freely and justify it to themselves and to others. That problem was compounded once confused and unsystematic race-thinking aspired to become something more coherent, rational, and authoritative. This threshold is important because it identifies the junction point of "race" with both rationality and nationality. It is the beginning of a period in which deference toward science, scientists, and scientific discourses around "race" began to create new possibilities and orchestrate new varieties of knowledge and power centered on the body, what Foucault identifies as "political anatomy."

The story of how this change was influenced by imperatives of colonial trade and government and shaped by growing imperial consciousness, how it was endorsed and then challenged by the developing science of anthropology, discredited by the catastrophic consequences of racial science, silenced by the aftereffects of Nazi genocide only to gain another commanding voice in the wake of Watson and Crick, is a familiar one. But the most recent phases in this process—which we have already seen is not simply and straightforwardly reducible to the resurgence of biological explanations—have not been understood adequately.

Beyond the new racism

Some years ago, a loose group of scholars in which the English philosopher Martin Barker was especially influential began, in recognition of changed patterns in the way the discourse of racial difference was employed in politics, to speak about the emergence of what they called a New Racism. This racism was defined by its strong culturalist and nationalist inclinations. Whereas in the past raciology had been arrogant in its imperial certainty that biology was both destiny and hierarchy, this persuasive new variant was openly uncomfortable with the idea that "race" could be biologically based. Consciousness of "race" was seen instead as closely linked to the idea of nationality. Authentic, historic nations had discrete cultural fillings. Their precious homogeneity endowed them with great strength and prestige. Where large "indigestible" chunks of alien settlement had taken place, all manner of dangers were apparent. Conflict was visible, above all, along cultural lines. Of course, these regrettably transplanted aliens were not identified as inferior, less worthy, or less admirable than their "hosts." They may not have been infrahuman, but they were certainly out of place. The social, economic, and political problems that had followed their mistaken importation could only be solved by restoring the symmetry and stability that flowed from putting them back where they belonged. Nature, history, and geopolitics dictated that people should cleave to their own kind and be most comfortable in the environments that matched their distinctive cultural and therefore national modes of being in the world. Mythic versions of cultural ecology were invented to rationalize the lives of these discrete national and racial identities. The Germans became a people in their forests, whereas the British were a nation whose seafaring activity shaped their essential inner character. In all cases, fragments of self-evident truth nourished the fantasies of blood and belonging, which in turn demanded an elaborate geopolitical cartography of nationality.

Science, nature and cyberculture

Raymond Williams

IDEAS OF NATURE

EDITOR'S INTRODUCTION

I N THIS ESSAY, ORIGINALLY DELIVERED as a lecture, Raymond Williams
presents a brisk account of concepts of nature as they have mutated over
the centuries in the West. He is offering us a historical philology of what he
famously called a 'keyword' – one of the words around which our understanding
of ourselves and the world turn, and which play an important role thereby in the
construction of our society.

Raymond Williams, the most influential figure in the early days of cultural
studies, was a socialist and, unlike most radicals after 1968, retained his sense
that socialism was historically in reach for advanced capitalist nations. This faith
underlies his account of the history of nature-as-a-concept since he is making a
strong case for rejecting what he sees as one of capitalism's key moves, namely
to separate 'man' from nature and think of nature as a resource, or a source
of consolation, or as a model. For Williams human beings and the world they
create are always as 'natural' as anything else (surely he is right about this?)
which means that nature can't be used to name what we spoil or to provide an
image of what we are *really* like. Why this matters for Williams's socialism is
that nature can't be used against the effort to build a society that is fair and
just and inclusive. It means, for instance, that evolution has nothing to say to
morality and politics.

I hope this piece encourages readers to pursue Raymond Williams's other
writings (his *The Country and the City*, for instance, is closely related to this
piece). And it's worth thinking hard about the differences between the arguments
in this essay and those put forward by Bruno Latour in the chapter after next.

Further reading: Franklin *et al.* 2000; Williams 1975, 1980 and 1985; Wilson 1992.

One touch of nature may make the whole world kin, but usually, when we say nature, do we mean to include ourselves? I know some people would say that the other kind of nature—trees, hills, brooks, animals—has a kindly effect. But I've noticed that they then often contrast it with the world of humans and their relationships.

I begin from this ordinary problem of meaning and reference because I want this inquiry to be active, and because I intend an emphasis when I say that the idea of nature contains, though often unnoticed, an extraordinary amount of human history. Like some other fundamental ideas which express mankind's vision of itself and its place in the world, 'nature' has a nominal continuity, over many centuries, but can be seen, in analysis, to be both complicated and changing, as other ideas and experiences change. I've previously attempted to analyse some comparable ideas, critically and historically. Among them were culture, society, individual, class, art, tragedy. But I'd better say at the outset that, difficult as all those ideas are, the idea of nature makes them seem comparatively simple. It has been central, over a very long period, to many different kinds of thought. Moreover it has some quite radical difficulties at the very first stages of its expression: difficulties which seem to me to persist.

Some people, when they see a word, think the first thing to do is to define it. Dictionaries are produced, and, with a show of authority no less confident because it is usually so limited in place and time, what is called a proper meaning is attached. But while it may be possible to do this, more or less satisfactorily, with certain simple names of things and effects, it is not only impossible but irrelevant in the case of more complicated ideas. What matters in them is not the proper meaning but the history and complexity of meanings: the conscious changes, or consciously different uses: and just as often those changes and differences which, masked by a nominal continuity, come to express radically different and often at first unnoticed changes in experience and history. I'd then better say at once that any reasonably complete analysis of these changes in the idea of nature would be very far beyond the scope of a lecture, but I want to try to indicate some of the main points, the general outlines, of such an analysis, and to see what effects these may have on some of our contemporary arguments and concerns.

The central point of the analysis can be expressed at once in the singular formation of the term. As I understand it, we have here a case of a definition of quality which becomes, through real usage, based on certain assumptions, a description of the world. Some of the early linguistic history is difficult to interpret, but we still have, as in the very early uses, these two very different bearings. I can perhaps illustrate them from a well-known passage in Burke:

> In a state of *rude* nature there is no such thing as a people ... The idea of a people is the idea of a corporation. It is wholly artificial; and made, like all other legal fictions, by common agreement. What the particular nature of that agreement was, is collected from the form into which the particular society has been cast.

Perhaps *rude*, there, makes some slight difference, but what is most striking is the coexistence of that common idea, *a state of nature*, with the almost unnoticed because so habitual use of *nature* to indicate the inherent quality of the agreement. That sense of nature as the inherent and essential quality of any particular thing is, of course, much more than accidental. Indeed there is evidence that it is historically the earliest use. In Latin one would have said *natura rerum*, keeping nature to the essential quality and adding the definition of things. But then also in Latin *natura* came to be used on its own, to express the same general meaning: the essential constitution of the world. Many of the earliest speculations about nature seem to have been in this sense physical, but with the underlying assumption that in the course of the physical inquiries one was discovering the essential, inherent and indeed immutable laws of the world. The association and then the fusion of a name for the quality with a name for the things observed has a precise history. It is a central formation of idealist thought. What was being looked for in nature was an essential principle. The multiplicity of things, and of living processes, might then be mentally organized around a single essence or principle: a nature.

Now I would not want to deny, I would prefer to emphasize, that this singular abstraction was a major advance in consciousness. But I think we have got so used to it, in a nominal continuity over more than two millennia, that we may not always realize quite all that it commits us to. A singular name for the real multiplicity of things and living processes may be held, with an effort, to be neutral, but I am sure it is very often the case that it offers, from the beginning, a dominant kind of interpretation: idealist, metaphysical, or religious. And I think this is especially apparent if we look at its subsequent history. From many early cultures we have records of what we would now call nature spirits or nature gods: beings believed to embody or direct the wind or the sea or the forest or the moon. Under the weight of Christian interpretation we are accustomed to calling these gods or spirits pagan: diverse and variable manifestations before the revelation of the one true God. But just as in religion the moment of monotheism is a critical development, so, in human responses to the physical world, is the moment of a singular Nature.

Singular, abstracted and personified

When Nature herself, as people learnt to say, became a goddess, a divine Mother, we had something very different from the spirits of wind and sea and forest and moon. And it is all the more striking that this singular abstracted and often personified principle, based on responses to the physical world, had of course (if the expression may be allowed) a competitor, in the singular, abstracted and personified religious being: the monotheistic God. The history of that interaction is immense. In the orthodox western medieval world a general formula was arrived at, which preserved the singularity of both: God is the first absolute, but Nature is His minister and deputy. As in many other treaties, this relationship went on being controversial. There was a long argument, preceding the revival of systematic physical inquiry—what we would now call science—as to the propriety and then the mode of this inquiry into a minister, with the obvious question of whether the ultimate sovereignty was being infringed or shown insufficient respect. It is an old argument

now, but it is interesting that when it was revived in the nineteenth century, in the arguments about evolution, even men who were prepared to dispense with the first singular principle—to dispense with the idea of God—usually retained and even emphasized that other and very comparable principle: the singular and abstracted, indeed still often and in some new ways personified, Nature.

Perhaps this does not puzzle others as much as it puzzles me. But I might mention at this stage one of its evident practical effects. In some serious argument, but even more in popular controversy and in various kinds of contemporary rhetoric, we continually come across propositions of the form 'Nature is...', or 'Nature shows...', or 'Nature teaches...'. And what is usually apparent about what is then said is that it is selective, according to the speaker's general purpose. 'Nature is...'—what? Red in tooth and claw; a ruthlessly competitive struggle for existence; an extraordinary interlocking system of mutual advantage; a paradigm of interdependence and cooperation.

And 'Nature is' any one of these things according to the processes we select: the food-chain, dramatized as the shark or the tiger; the jungle of plants competing for space and light and air; or the pollinator—the bee and the butterfly—or the symbiote and the parasite; even the scavenger, the population controller, the regulator of food supplies. In what is now seen so often as the physical crisis of our world many of us follow, with close attention, the latest reports from those who are observing and qualified to observe these particular processes and effects, these creatures and things and acts and consequences. And I am prepared to believe that one or other of the consequent generalizations may be more true than the rest, may be a better way of looking at the processes in which we also are involved and on which we can be said to depend. But I am bound to say I would feel in closer touch with the real situation if the observations, made with great skill and precision, were not so speedily gathered—I mean, of course, at the level of necessary generalization—into singular statements of essential, inherent and immutable characteristics; into principles of a singular nature. I have no competence to speak directly of any of these processes, but to put it as common experience: when I hear that nature is a ruthless competitive struggle I remember the butterfly, and when I hear that it is a system of ultimate mutual advantage I remember the cyclone. Intellectual armies may charge each other repeatedly with this or that selected example; but my own inclination is to ponder the effects of the idea they share: that of a singular and essential nature, with consistent and reconcilable laws. Indeed I find myself reflecting at this point on the full meaning of what I began by saying: that the idea of nature contains an extraordinary amount of human history. What is often being argued, it seems to me, in the idea of nature is the idea of man; and this not only generally, or in ultimate ways, but the idea of man in society, indeed the ideas of kinds of societies.

For the fact that nature was made singular and abstract, and was personified, has at least this convenience: that it allows us to look, with unusual clarity, at some quite fundamental interpretations of all our experience. Nature may indeed be a single thing or a force or a principle, but then what these are has a real history. I have already mentioned Nature the minister of God. To know Nature was to know God, although there was radical controversy about the means of knowing: whether by faith, by speculation, by right reason, or by physical inquiry and experiment.

But Nature the minister or deputy was preceded and has been widely succeeded by Nature the absolute monarch. This is characteristic of certain phases of fatalism, in many cultures and periods. It is not that Nature is unknowable: as subjects we know our monarch. But his powers are so great, and their exercise at times so apparently capricious, that we make no pretensions to control. On the contrary we confine ourselves to various forms of petition or appeasement: the prayer against storm or for rain; the superstitious handling or abstention from handling of this or that object; the sacrifice for fertility or the planting of parsley on Good Friday. As so often, there is an indeterminate area between this absolute monarch and the more manageable notion of God's minister. An uncertainty of purpose is as evident in the personified Nature as in the personified God: is he provident or indifferent, settled or capricious? Everyone says that in the medieval world there was a conception of order which reached through every part of the universe, from the highest to the lowest: a divine order, of which the laws of nature were the practical expression. Certainly this was often believed and perhaps even more often taught. In Henry Medwall's play *Nature* or in Rastell's *The Four Elements*, Nature instructs man in his duties, under the eye of God; he can find his own nature and place from the instructions of nature. But in plague or famine, in what can be conveniently called not natural laws but natural catastrophes, the very different figure of the absolute and capricious monarch can be seen appearing, and the form of the struggle between a jealous God and a just God is very reminiscent of the struggle in men's minds between the real experiences of a provident and a destructive 'nature'. Many scholars believe that this conception of a natural order lasted into and dominated the Elizabethan and early Jacobean world, but what is striking in Shakespeare's *Lear*, for example, is the uncertainty of the meaning of 'nature':

> Allow not nature more than nature needs,
> Man's life's as cheap as beast's...
> ... one daughter
> Who redeems nature from the general curse
> Which twain have brought her to.

> That nature, which condemns its origin,
> Cannot be border'd certain in itself...
> ... All shaking thunder...
> Crack nature's moulds, all germens spill at once,
> That make ungrateful man ...

> ... Hear, nature hear; dear goddess, hear...

In just these few examples, we have a whole range of meanings: from nature as the primitive condition before human society; through the sense of an original innocence from which there has been a fall and a curse, requiring redemption; through the special sense of a quality of birth, as in the Latin root; through again the sense of the forms and moulds of nature which can yet, paradoxically, be destroyed by the natural force of thunder; to that simple and persistent form of

the personified goddess, Nature herself. John Danby's analysis of the meanings of 'nature' in *Lear* shows an even wider range.[1]

What in the history of thought may be seen as a confusion or an over-lapping is often the precise moment of the dramatic impulse, since it is because the meanings and the experiences are uncertain and complex that the dramatic mode is more powerful, includes more, than could any narrative or exposition: not the abstracted order, though its forms are still present, but at once the order, the known meanings, and that experience of order and meanings which is at the very edge of the intelligence and the senses, a complex interaction which is the new and dramatic form. All at once nature is innocent, is unprovided, is sure, is unsure, is fruitful, is destructive, is a pure force and is tainted and cursed. I can think of no better contrast to the mode of the singular meaning, which is the more accessible history of the idea.

Yet the simplifying ideas continued to emerge. God's deputy, or the absolute monarch (and real absolute monarchs were also, at least in the image, the deputies of God) were succeeded by that Nature which, at least in the educated world, dominates seventeenth- to nineteenth-century European thought. It is a less grand, less imposing figure: in fact, a constitutional lawyer. Though lip-service is still often paid to the original giver of the laws (and in some cases, we need not doubt, it was more than lip-service), all practical attention is given to the details of the laws: to interpreting and classifying them, making predictions from precedents, discovering or reviving forgotten statutes, and then and most critically shaping new laws from new cases: the laws of nature in this quite new constitutional sense, not so much shaping and essential ideas but an accumulation and classification of cases.

The new idea of evolution

The power of this new emphasis hardly needs to be stressed. Its practicality and its detail had quite transforming results in the world. In its increasing secularism, indeed naturalism, it sometimes managed to escape the habit of singular personification, and nature, though often still singular, became an object, even at times a machine. In its earlier phases the sciences of this emphasis were predominantly physical: that complex of mathematics, physics, astronomy which was called natural philosophy. What was classically observed was a fixed state, or fixed laws of motion. The laws of nature were indeed constitutional, but unlike most real constitutions they had no effective history. In the life sciences the emphasis was on constitutive properties, and significantly, on classifications of orders. What changed this emphasis was of course the evidence and the idea of evolution: natural forms had not only a constitution but a history. From the late eighteenth century, and very markedly in the nineteenth century, the consequent personification of nature changed. From the underlying image of the constitutional lawyer, men moved to a different figure: the selective breeder; Nature the selective breeder. Indeed the habit of personification, which except in rather formal uses had been visibly weakening, was very strongly revived by this new concept of an actively shaping, indeed intervening, force. Natural selection could be interpreted either way, with natural as a simple unemphatic description of a process, or with the implication

of nature, a specific force, which could do something as conscious as select. There are other reasons, as we shall see, for the vigour of the late eighteenth-century and nineteenth-century personifications, but this new emphasis, that nature itself had a history, and so might be seen as an historical, perhaps the historical force, was another major moment in the development of ideas.

It is already evident, if we look at only some of the great personifications or quasi-personifications, that the question of what is covered by nature, what it is held to include, is critical. There can be shifts of interest between the physical and the organic world, and indeed the distinction between these is one of the forms of the shaping inquiry. But the most critical question, in this matter of scope, was whether nature included man. It was, after all, a main factor in the evolution controversy: whether man could be properly seen in terms of strictly natural processes; whether he could be described, for example, in the same terms as animals. Though it now takes different forms, I think this question remains critical, and this is so for discoverable reasons in the history of the idea.

In the orthodox medieval concept of nature, man was, of course, included. The order of nature, which expressed God's creation, included, as a central element, the notion of hierarchy: man had a precise place in the order of creation, even though he was constituted from the universal elements which constituted nature as a whole. Moreover, this inclusion was not merely passive. The idea of a place in the order implied a destiny. The constitution of nature declared its purpose. By knowing the whole world, beginning with the four elements, man would come to know his own important place in it, and the definition of this importance was in discovering his relation to God.

Yet there is all the difference in the world between an idealist notion of a fixed nature, embodying permanent laws, and the same apparent notion with the idea of a future, a destiny, as the most fundamental law of them all. The latter, to put it mildly, is less likely to encourage physical enquiry as a priority; the purpose of the laws, and hence their nature, is already known: that is to say, assumed. And it is then not surprising that it is the bad angel who says, in Marlowe:

Go forward, Faustus, in that famous art
Wherein all Nature's treasure is contained.

What was worrying, obviously, was that in his dealings with nature man might see himself as

Lord and Commander of these elements.

It was a real and prolonged difficulty:

Nature that framed us of four elements
Warring within our breasts for regiment
Doth teach us all to have aspiring minds.

But though this might be so, aspiration was ambiguous: either to aspire to know the order of nature, or to know how to intervene in it, become its commander;

or, putting it another way, whether to learn one's important place in the order of nature, or learn how to surpass it. It can seem an unreal argument. For many millennia men had been intervening, had been learning to control. From the beginning of farming and the domestication of animals this had been consciously done, quite apart from the many secondary consequences as men pursued what they thought of as their normal activities.

The abstraction of man

It is now well enough known that as a species we grew in confidence in our desire and in our capacity to intervene. But we cannot understand this process, indeed cannot even describe it, until we are clear as to what the idea of nature includes, and in particular whether it includes man. For, of course, to speak of man 'intervening' in natural processes is to suppose that he might find it possible not to do so, or to decide not to do so. Nature has to be thought of, that is to say, as separate from man, before any question of intervention or command, and the method and ethics of either, can arise. And then, of course, this is what we can see happening, in the development of the idea. It may at first seem paradoxical, but what we can now call the more secular and more rational ideas of nature depended on a new and very singular abstraction: the abstraction of Man. It is not so much a change from a metaphysical to a naturalist view, though that distinction has importance, as a change from one abstract notion to another, and one very similar in form.

Of course there had been a long argument about the relations between nature and social man. In early Greek thought this is the argument about nature and convention; in a sense an historical contrast between the state of nature and a formed human state with conventions and laws. A large part of all subsequent political and legal theory has been based on some sense of this relation. But then of course it is obvious that the state of nature, the condition of natural man, has been very differently interpreted. Seneca saw the state of nature as a golden age, in which men were happy, innocent and simple. This powerful myth often came to coincide with the myth of Eden: of man before the fall. But sometimes it did not: the fall from innocence could be seen as a fall into nature; the animal without grace, or the animal needing grace. Natural, that is to say, could mean wholly opposite conditions: the innocent man or the mere beast.

In political theory both images were used. Hobbes saw the state of men in nature as low, and the life of pre-social man as 'solitary, poor, nasty, brutish and short'. At the same time, right reason was itself a law of nature, in the rather different constitutive sense. Locke, opposing Hobbes, saw the state of nature as one of 'peace, goodwill, mutual assistance and cooperation'. A just society organized these natural qualities, whereas in Hobbes an effective society had overcome those natural disadvantages. Rousseau saw natural man as instinctive, inarticulate, without property, and contrasted this with the competitive and selfish society of his own day. The point about property has a long history. It was a widespread medieval idea that common ownership was more natural than private property, which was a kind of fall from grace, and there have always been radicals, from the Diggers to Marx,

who have relied on some form of this idea as a programme or as a critique. And indeed it is in this problem of property that many of the crucial questions about man and nature were put, often almost unconsciously. Locke produced a defence of private property based on the natural right of a man to that with which he has mixed his own labour, and many thousands of people believed and repeated this, in periods when it must have been obvious to everybody that those who most often and most fully mixed their labour with the earth were those who had no property, and when the very marks and stains of the mixing were in effect a definition of being propertyless. The argument can go either way, can be conservative or radical. But once we begin to speak of men mixing their labour with the earth, we are in a whole world of new relations between man and nature, and to separate natural history from social history becomes extremely problematic.

I think nature had to be seen as separate from man, for several purposes. Perhaps the first form of the separation was the practical distinction between nature and God: that distinction which eventually made it possible to describe natural processes in their own terms; to examine them without any prior assumption of purpose or design, but simply as processes, or to use the historically earlier term, as machines. We could find out how nature 'worked'; what made it, as some still say, 'tick' (as if Paley's clock were still with us). We could see better how it worked by altering or isolating certain conditions, in experiment or in improvement. Some of this discovery was passively conceived: a separated mind observing separated matter; man looking at nature. But much more of it was active: not only observation but experiment; and of course not only science, the pure knowledge of nature, but applied science, the conscious intervention for human purposes. Agricultural improvement and the industrial revolution follow clearly from this emphasis, and many of the practical effects depended on seeing nature quite clearly and even coldly as a set of objects, on which men could operate. Of course we still have to remind ourselves of some of the consequences of that way of seeing things. Isolation of the object being treated led and still leads to unforeseen or uncared-for consequences. It led also, quite clearly, to major developments in human capacity, including the capacity to sustain and care for life in quite new ways.

But in the idea of nature itself there was then a very curious result. The physical scientists and the improvers, though in different ways, had no doubt that they were working on nature, and it would indeed be difficult to deny that this was so, taking any of the general meanings. Yet at just the first peak of this kind of activity another and now very popular meaning of nature emerged. Nature, in this new sense, was in another and different way all that was not man: all that was not touched by man, spoilt by man: nature as the lonely places, the wilderness.

The natural and the conventional

I want to describe this development in some detail, but because we are still so influenced by it I must first draw attention to the conventional character of this unspoilt nature; indeed the conventional terms in which it is separated out. There are some true wildernesses, some essentially untouched places. As a matter of fact (and of course almost by definition) few people going to 'nature' go to them.

But here some of the earlier meanings of 'Nature' and 'natural' come in as a doubtful aid. This wild nature is essentially peaceful and quiet, you hear people say. Moreover it is innocent; it contrasts with man, except presumably with the man looking at it. It is unspoilt but also it is settled: a kind of primal settlement. And indeed there are places where in effect this is so.

But it is also very striking that the same thing is said about places which are in every sense man-made. I remember someone saying that it was unnatural, a kind of modern scientific madness, to cut down hedges; and as a matter of fact I agreed that they ought not to be cut down. But what was interesting was that the hedges were seen as natural, as parts of nature, though I should imagine everyone knows that they were planted and tended, and would indeed not be hedges if men had not made them so. A considerable part of what we call natural landscape has the same kind of history. It is the product of human design and human labour, and in admiring it as natural it matters very much whether we suppress that fact of labour or acknowledge it. Some forms of this popular modern idea of nature seem to me to depend on a suppression of the history of human labour, and the fact that they are often in conflict with what is seen as the exploitation or destruction of nature may in the end be less important than the no less certain fact that they often confuse us about what nature and the natural are and might be.

It is easy to contrast what can be called the improvers of nature and the lovers or admirers of nature. In the late eighteenth century, when this contrast began to be widely made, there was ample evidence of both kinds of response and activity. But though in the end they can be distinguished, and need to be distinguished, I think there are other and rather interesting relations between them.

We have first to remember that by the eighteenth century the idea of nature had become, in the main, a philosophical principle, a principle of order and right reason. Basil Willey's account of the main bearings of the idea, and of the effects and changes in Wordsworth, cannot, I think, be improved upon.[2] Yet it is not primarily ideas that have a history; it is societies. And then what often seem opposed ideas can in the end be seen as parts of a single social process. There is this familiar problem about the eighteenth century: that it is seen as a period of order, because order was talked about so often, and in close relation to the order of nature. Yet it is not only that at any real level it was a notably disorderly and corrupt period; it is also that it generated, from within this disorder, some of the most profound of all human changes. The use of nature, in the physical sense, was quite remarkably extended, and we have to remember—which we usually don't, because a successful image was imposed on us—that our first really ruthless capitalist class, taking up things and men in much the same spirit and imposing an at once profitable and pauperizing order on them, were those eighteenth-century agrarians who got themselves called an aristocracy, and who laid the real foundations, in spirit and practice (and of course themselves joining in), for the industrial capitalists who were to follow them.

A state of nature could be a reactionary idea, against change, or a reforming idea, against what was seen as decadence. But where the new ideas and images were being bred there was a quite different perspective. It is significant that the successful attack on the old idea of natural law should have been mounted just

then. Not that it didn't need to be attacked; it was often in practice mystifying. But the utilitarians who attacked it were making a new and very much sharper tool, and in the end what had disappeared was any positive conception of a just society, and this was replaced by new and ratifying concepts of a mechanism and a market. That these, in turn, were deduced from the laws of nature is one of the ironies we are constantly meeting in the history of ideas. The new natural economic laws, the natural liberty of the entrepreneur to go ahead without interference, had in its projection of the market as the natural regulator a remnant—it is not necessarily a distortion—of the more abstract ideas of social harmony, within which self-interest and the common interest might ideally coincide. But what is gradually left behind, in the utilitarians, is any shadow of a principle by which a higher justice—to be appealed to against any particular activity or consequence—could be effectively imagined. And so we have this situation of the great interferers, some of the most effective interferers of all time, proclaiming the necessity of non-interference: a contradiction which as it worked itself through had chilling effects on later thinkers in the same tradition, through John Stuart Mill to the Fabians.

For and against improvement

And then it is at just this time, and first of all in the philosophy of the improvers, that nature is decisively seen as separate from men. Most earlier ideas of nature had included, in an integral way, ideas of human nature. But now nature, increasingly, was 'out there', and it was natural to reshape it to a dominant need, without having to consider very deeply what this reshaping might do to men. People talk of order in those cleared estates and those landscaped parks, but what was being moved about and rearranged was not only earth and water but men. Of course we must then say at once that this doesn't imply any previous state of social innocence. Men were more cruelly exploited and imposed on in the great ages of natural law and universal order; but not more thoroughly, for the thoroughness depended on new physical forces and means. Of course it soon happened that this process was denounced as unnatural: from Goldsmith to Blake, and from Cobbett to Ruskin and Dickens, this kind of attack on a new 'unnatural' civilization was powerfully deployed. The negative was clear enough, but the positive was always more doubtful. Concepts of natural order and harmony went on being repeated, against the increasingly evident disorder of society. Other appeals were attempted: to Christian brotherhood and to culture—that new idea of human growth, based on natural analogy. Yet set against the practical ideas of the improvers, these were always insufficient. The operation on nature was producing wealth, and objections to its other consequences could be dismissed as sentimental. Indeed the objections often were, often still are, sentimental. For it is a mark of the success of the new idea of nature—of nature as separated from man—that the real errors, the real consequences, could be described at first only in marginal terms. Nature in any other sense than that of the improvers indeed fled to the margins: to the remote, the inaccessible, the relatively barren areas. Nature was where industry was not, and then in that real but limited sense had very little to say about the operations on nature that were proceeding elsewhere.

Very little to say. But in another sense it had a great deal to say. New feelings for landscape: a new and more particular nature poetry; the green vision of Constable; the green language of Wordsworth and Clare. Thomson in *The Seasons*, like Cobbett on his rural rides, saw beauty in cultivated land. But as early as Thomson, and then with increasing power in Wordsworth and beyond him, there came the sense of nature as a refuge, a refuge from man; a place of healing, a solace, a retreat. Clare broke under the strain, for he had one significant disadvantage; he couldn't both live on the process and escape its products, as some of the others were doing and indeed as became a way of life—this is a very bitter irony—for some of the most successful exploiters. As the exploitation of nature continued, on a vast scale, and especially in the new extractive and industrial processes, the people who drew most profit from it went back, where they could find it (and they were very ingenious) to an unspoilt nature, to the purchased estates and the country retreats. And since that time there has always been this ambiguity in the defence of what is called nature, and in its associated ideas of conservation, in the weak sense, and the nature reserve. Some people in this defence are those who understand nature best, and who insist on making very full connections and relationships. But a significant number of others are in the plainest sense hypocrites. Established at powerful points in the very process which is creating the disorder, they change their clothes at week-ends, or when they can get down to the country; join appeals and campaigns to keep one last bit of England green and unspoilt; and then go back, spiritually refreshed, to invest in the smoke and the spoil.

They would not be able to go undetected so long if the idea they both use and abuse were not, in itself, so inadequate. When nature is separated out from the activities of men, it even ceases to be nature, in any full and effective sense. Men come to project on to nature their own unacknowledged activities and consequences. Or nature is split into unrelated parts: coal-bearing from heather-bearing; downwind from upwind. The real split, perhaps, is in men themselves: men seen, seeing themselves, as producers and consumers. The consumer wants only the intended product; all other products and by-products he must get away from, if he can. But get away—it really can't be overlooked—to treat leftover nature in much the same spirit: to consume it as scenery, landscape, image, fresh air. There is more similarity than we usually recognise between the industrial entrepreneur and the landscape gardener, each altering nature to a consumable form: and the client or beneficiary of the landscaper, who in turn has a view or a prospect to use, is often only at the lucky end of a common process, able to consume because others have produced, in a leisure that follows from quite precise work.

Men project, I said, their own unacknowledged activities and consequences. Into a green and quiet nature we project, I do not doubt, much of our own deepest feeling, our senses of growth and perspective and beauty. But is it then an accident that an opposite version of nature comes to force its way through? Nothing is more remarkable, in the second half of the nineteenth century, than the wholly opposite version of nature as cruel and savage. As Tennyson put it:

A monster then, a dream,
A discord. Dragons of the prime
Which tear each other in the slime.

Those images of tearing and eating, of natural savagery, came to dominate much modern feeling. Disney, in some of his nature films, selects them with what seems an obsessive accuracy. Green nature goes on, in the fortunate places, but within it and all about it is this struggle and tearing, this ruthless competition for the right to live, this survival of the fittest. It is very interesting to see how Darwin's notion of natural selection passed into popular imagery—and by popular I mean the ordinary thoughts and feelings of educated men. 'Fittest', meaning those best adapted to a given and variable environment, became 'strongest', 'most ruthless'. The social jungle, the rat race, the territory-guarders, the naked apes: this, bitterly, was how an idea of man re-entered the idea of nature. A real experience of society was projected, by selective examples, on to a newly alienated nature. Under the veneer of civilization was this natural savagery: from Wells to Golding this could be believed, in increasingly commonplace ways. What had once been a ratification, a kind of natural condonation, of ruthless economic selfishness—the real ideology of early capitalism and of imperialism—became, towards our own day, not only this but a hopelessness, a despair, an end of significant social effort; because if that is what life is like, is naturally like, any idea of brotherhood is futile. Then build another refuge perhaps, clear another beach. Keep out not so much the shark and the tiger (though them when necessary) as other men, the grasping, the predatory, the selfish, the untidy, the herd. Let mid-Wales depopulate and then call it a wilderness area: a wilderness to go to from the jungle of the cities.

Ideas of nature, but these are the projected ideas of men. And I think nothing much can be done, nothing much can even be said, until we are able to see the causes of this alienation of nature, this separation of nature from human activity, which I have been trying to describe. But these causes cannot be seen, in a practical way, by returning to any earlier stage of the idea. In reaction against our existing situation, many writers have created an idea of a rural past: perhaps innocent, as in the first mythology of the Golden Age; but even more organic, with man not separated from nature. The impulse is understandable, but quite apart from its element of fantasy—its placing of such a period can be shown to be continually recessive—it is a serious underestimate of the complexity of the problem. A separation between man and nature is not simply the product of modern industry or urbanism; it is a characteristic of many earlier kinds of organized labour, including rural labour. Nor can we look with advantage to that other kind of reaction, which, correctly identifying one part of the problem in the idea of nature as a mechanism, would have us return to a traditional teleology, in which men's unity with nature is established through their common relation to a creator. That sense of an end and a purpose is in important ways even more alienated than the cold world of mechanism. Indeed the singular abstraction which it implies has much in common with that kind of abstract materialism. It directs our attention away from real and variable relations, and can be said to ratify the separation by making one of its forms permanent and its purpose fixed.

The point that has really to be made about the separation between man and nature which is characteristic of so many modern ideas is that—however hard this may be to express—the separation is a function of an increasing real interaction. It is easy to feel a limited unity on the basis of limited relationships, whether in animism, in monotheism, or in modern forms of pantheism. It is only when the real

relations are extremely active, diverse, self-conscious, and in effect continuous—as our relations with the physical world can be seen to be in our own day—that the separation of human nature from nature becomes really problematic. I would illustrate this in two ways.

In our complex dealings with the physical world, we find it very difficult to recognize all the products of our own activities. We recognize some of the products, and call others by-products; but the slagheap is as real a product as the coal, just as the river stinking with sewage and detergent is as much our product as the reservoir. The enclosed and fertile land is our product, but so are the waste moors from which the poor cultivators were cleared, to leave what can be seen as an empty nature. Furthermore, we ourselves are in a sense products: the pollution of industrial society is to be found not only in the water and in the air but in the slums, the traffic jams, and not these only as physical objects but as ourselves in them and in relation to them. In this actual world there is then not much point in counterposing or restating the great abstractions of Man and Nature. We have mixed our labour with the earth, our forces with its forces too deeply to be able to draw back and separate either out. Except that if we mentally draw back, if we go on with the singular abstractions, we are spared the effort of looking, in any active way, at the whole complex of social and natural relationships which is at once our product and our activity.

The process, that is to say, has to be seen as a whole, but not in abstract or singular ways. We have to look at all our products and activities, good and bad, and to see the relationships between them which are our own real relationships. More clearly than anyone, Marx indicated this, though still in terms of quite singular forces. I think we have to develop that kind of indication. In industry, for example, we cannot afford to go on saying that a car is a product but a scrapyard a by-product, any more than we can take the paint-fumes and petrol-fumes, the jams, the mobility, the motorway, the torn city centre, the assembly line, the time-and-motion study, the unions, the strikes, as by-products rather than the real products they are. But then of course to express this we should need not only a more sophisticated but a more radically honest accounting than any we now have. It will be ironic if one of the last forms of the separation between abstracted Man and abstracted Nature is an intellectual separation between economics and ecology. It will be a sign that we are beginning to think in some necessary ways when we can conceive these becoming, as they ought to become, a single discipline.

But it is even harder than that. If we say only that we have mixed our labour with the earth, our forces with its forces, we are stopping short of the truth that we have done this unequally: that for the miner and the writer the mixing is different, though in both cases real; and that for the labourer and the man who manages his labour, the producer and the dealer in his products, the difference is wider again. Out of the ways in which we have interacted with the physical world we have made not only human nature and an altered natural order; we have also made societies. It is very significant that most of the terms we have used in this relationship—the conquest of nature, the domination of nature, the exploitation of nature—are derived from the real human practices: relations between men and men. Even the idea of the balance of nature has its social implications. If we talk only of singular Man and singular Nature we can compose a general history, but

at the cost of excluding the real and altering social relations. Capitalism, of course, has relied on the terms of domination and exploitation; imperialism, in conquest, has similarly seen both men and physical products as raw material. But it is a measure of how far we have to go that socialists also still talk of the conquest of nature, which in any real terms will always include the conquest, the domination or the exploitation of some men by others. If we alienate the living processes of which we are a part, we end, though unequally, by alienating ourselves.

We need different ideas because we need different relationships.

Nature and Nature's laws lay hid in night.
God said, let Newton be, and all was light.[3]

Now o'er the one half world
Nature seems dead.[4]

Between the brisk confidence and the brooding reflection of those remembered lines we feel our own lives swing. We need and are perhaps beginning to find different ideas, different feelings, if we are to know nature as varied and variable nature, as the changing conditions of a human world.

Notes

1 *Shakespeare's Doctrine of Nature*, London 1949.
2 *The Eighteenth Century Background,* London 1940.
3 Alexander Pope, *Epitaph Intended for Sir Isaac Newton*.
4 *Macbeth*, II, i.

Friedrich A. Kittler

GRAMOPHONE

EDITOR'S INTRODUCTION

KITTLER IS ONE OF THE MOST IMPORTANT historians of modern communications technology, and his work is of interest within cultural studies for two main reasons.

First, he provides a model for working in the field we might call 'history of technologized culture' in which, to put it very bluntly, the history of technology cannot be separated from the history of perception and emotions. What this means, second, is that technology is not developed when particular scientific theories or manufacturing skills or materials become available, but when culture prepares a use and demand for them. At one level technology is an expression of the culture, not an autonomous domain determined by technical invention. His work in this field can be usefully compared to that of Jonathan Crary, listed in the further reading below.

This essay, which is on the invention of the gramophone – a now obsolete technology, but one of real consequence since it begins the modern regime of mechanical reproduction – is a good case in point. According to Kittler, gramophones are invented when a particular theory of the 'soul' had prepared the way for them, and they were invented in a context in which poets and language theorists and researchers played an important role. The book from which this piece is drawn, *Gramophone, Film, Typewriter*, goes on to show how modern communications technology arose out of, and intervened in relations between mothers and children in particular, allowing Kittler to extend our understanding of psychoanalysis through the history of the emergence of mechanical reproduction.

Further reading: Crary 1992 and 2001; Daly 2004; DeLanda 1991; du Gay 1997; Kittler 1990 and 1999; Virilio 1991b.

"Hullo!" Edison screamed into the telephone mouthpiece. The vibrating diaphragm set in motion a stylus that wrote onto a moving strip of paraffin paper. In July 1877, 81 years before Turing's moving paper strip, the recording was still analog. Upon replaying the strip and its vibrations, which in turn set in motion the diaphragm, a barely audible "Hullo!" could be heard.

Edison understood. A month later he coined a new term for his telephone addition: phonograph. On the basis of this experiment, the mechanic Kruesi was given the assignment to build an apparatus that would etch acoustic vibrations onto a rotating cylinder covered with tinfoil. While he or Kruesi was turning the handle, Edison once again screamed into the mouthpiece—this time the nursery rhyme "Mary Had a Little Lamb." Then they moved the needle back, let the cylinder run a second time—and the first phonograph replayed the screams. The exhausted genius, in whose phrase genius is 1 percent inspiration and 99 percent perspiration, slumped back. Mechanical sound recording had been invented. "Speech has become, as it were, immortal."

It was December 6, 1877. Eight months earlier, Charles Cros, a Parisian writer, bohemian, inventor, and absinthe drinker, had deposited a sealed envelope with the Academy of Sciences. It contained an essay on the "Procedure for the Recording and Reproduction of Phenomena of Acoustic Perception" (*Procédé d'enregistrement et de reproduction des phénomènes perçus par l'ouïe*). With great technological elegance this text formulated all the principles of the phonograph, but owing to a lack of funds Cros had not yet been able to bring about its "practical realization." "To reproduce" the traces of "the sounds and noises" that the "to and fro" of an acoustically "vibrating diaphragm" leaves on a rotating disk—that was also the program of Charles Cros.

But once he had been preceded by Edison, who was aware of rumors of the invention, things sounded different. "Inscription" is the title of the poem with which Cros erected a belated monument to honor his inventions, which included an automatic telephone, color photography, and, above all, the phonograph:

Like the faces in cameos
I wanted beloved voices
To be a fortune which one keeps forever,
And which can repeat the musical
Dream of the too short hour;
Time would flee, I subdue it.

The program of the poet Cros, in his capacity as the inventor of the phonograph, was to store beloved voices and all-too-brief musical reveries. The wondrously resistant power of writing ensures that the poem has no words for the truth about competing technologies. Certainly, phonographs can store articulate voices and musical intervals, but they are capable of more and different things. Cros the poet forgets the noises mentioned in his precise prose text. An invention that subverts both literature and music (because it reproduces the unimaginable real they are both based on) must have struck even its inventor as something unheard of.

Hence, it was not coincidental that Edison, not Cros, actually built the phonograph. His "Hullo!" was no beloved voice and "Mary Had a Little Lamb"

no musical reverie. And he screamed into the bell-mouth not only because phonographs have no amplifiers but also because Edison, following a youthful adventure involving some conductor's fists, was half-deaf. A physical impairment was at the beginning of mechanical sound recording—just as the first typewriters had been made by the blind for the blind, and Charles Cros had taught at a school for the deaf and mute.

Whereas (according to Derrida) it is characteristic of so-called Man and his consciousness to hear himself speak and see himself write, media dissolve such feedback loops. They await inventors like Edison whom chance has equipped with a similar dissolution. Handicaps isolate and thematize sensory data streams. The phonograph does not hear as do ears that have been trained immediately to filter voices, words, and sounds out of noise; it registers acoustic events as such. Articulateness becomes a second-order exception in a spectrum of noise. In the first phonograph letter of postal history, Edison wrote that "the articulation" of his baby "was loud enough, just a bit indistinct ... not bad for a first experiment."

Wagner's *Gesamtkunstwerk*, that monomaniacal anticipation of modern media technologies, had already transgressed the traditional boundaries of words and music to do justice to the unarticulated. In *Tristan*, Brangäne was allowed to utter a scream whose notation cut straight through the score. Not to mention *Parsifal*'s Kundry, who suffered from an hysterical speech impairment such as those which were soon to occupy the psychoanalyst Freud: she "gives a loud wail of misery, that sinks gradually into low accents of fear," "utters a dreadful cry," and is reduced to "hoarse and broken," though nonetheless fully composed, garbling. This labored inception of language has nothing to do with operas and dramas that take it for granted that their figures can speak. Composers of 1880, however, are allied with engineers. The undermining of articulation becomes the order of the day.

In Wagner's case this applies to both text and music. The *Rhinegold* prelude, with its infinite swelling of a single chord, dissolves the E-flat major triad in the first horn melody as if it were not a matter of musical harmony but of demonstrating the physical overtone series. All the harmonics of E-flat appear one after the other, as if in a Fourier analysis; only the seventh is missing, because it cannot be played by European instruments. Of course, each of the horn sounds is an unavoidable overtone mixture of the kind only the sine tones of contemporary synthesizers can avoid. Nevertheless, Wagner's musico-physiological dream at the outset of the tetralogy sounds like a historical transition from intervals to frequencies, from a logic to a physics of sound. By the time Schoenberg, in 1910, produced the last analysis of harmony in the history of music, chords had turned into pure acoustics: "For Schoenberg as well as for science, the physical basis in which he is trying to ground all phenomena is the overtone series."

Overtones are frequencies, that is, vibrations per second. And the grooves of Edison's phonograph recorded nothing but vibrations. Intervals and chords, by contrast, were ratios, that is, fractions made up of integers. The length of a string (especially on a monochord) was subdivided, and the fractions, to which Pythagoras gave the proud name *logoi*, resulted in octaves, fifths, fourths, and so on. Such was the logic upon which was founded everything that, in Old Europe, went by the name of music: first, there was a notation system that enabled the transcription of clear sounds separated from the world's noise; and second, a

harmony of the spheres that established that the ratios between planetary orbits (later human souls) equaled those between sounds.

The nineteenth century's concept of frequency breaks with all this. The measure of length is replaced by time as an independent variable. It is a physical time removed from the meters and rhythms of music. It quantifies movements that are too fast for the human eye, ranging from 20 to 16,000 vibrations per second. The real takes the place of the symbolic. Certainly, references can also be established to link musical intervals and acoustic frequencies, but they only testify to the distance between two discourses. In frequency curves the simple proportions of Pythagorean music turn into irrational, that is, logarithmic, functions. Conversely, overtone series—which in frequency curves are simply integral multiples of vibrations and the determining elements of each sound—soon explode the diatonic music system. That is the depth of the gulf separating Old European alphabetism from mathematical-physical notation.

Which is why the first frequency notations were developed outside of music. First noise itself had to become an object of scientific research, and discourses "a privileged category of noises." A competition sponsored by the Saint Petersburg Academy of Sciences in 1780 made voiced sounds, and vowels in particular, an object of research, and inaugurated not only speech physiology but also all the experiments involving mechanical language reproduction. Inventors like Kempelen, Maelzel, and Mical built the first automata that, by stimulating and filtering certain frequency bands, could simulate the very sounds that Romanticism was simultaneously celebrating as the language of the soul: their dolls said "Mama" and "Papa" or "Oh," like Hoffmann's beloved automaton, Olympia. Even Edison's 1878 article on phonography intended such toy mouths voicing the parents' names as Christmas presents. Removed from all Romanticism, a practical knowledge of vowel frequencies emerged.

Continuing these experiments, Willis made a decisive discovery in 1829. He connected elastic tongues to a cogwheel whose cogs set them vibrating. According to the speed of its rotation, high or low sounds were produced that sounded like the different vowels, thus proving their frequency. For the first time pitch no longer depended on length, as with string or brass instruments; it became a variable dependent on speed and therefore, time. Willis had invented the prototype of all square-curve generators, ranging from the bold verse-rhythm experiments of the turn of the century to *Kontakte*, Stockhausen's first electronic composition.

The synthetic production of frequencies is followed by their analysis. Fourier had already provided the mathematical theory, but that theory had yet to be implemented technologically. In 1830, Wilhelm Weber in Göttingen had a tuning fork record its own vibrations. He attached a pig's bristle to one of the tongues, which etched its frequency curves into sooty glass. Such were the humble, or animal, origins of our gramophone needles.

From Weber's writing tuning fork Edouard Léon Scott, who as a Parisian printer was, not coincidentally, an inhabitant of the Gutenberg Galaxy, developed his phonautograph, patented in 1857. A bell-mouth amplified incoming sounds and transmitted them onto a membrane which in turn used a coarse bristle to transcribe them onto a soot-covered cylinder. Thus came into being autographs or handwritings of a data stream that heretofore had not ceased not to write itself.

(Instead, there was handwriting.) Scott's phonautograph, however, made visible what, up to this point, had only been audible and had been much too fast for ill-equipped human eyes: hundreds of vibrations per second. A triumph of the concept of frequency: all the whispered or screamed noises people emitted from their larynxes, with or without dialects, appeared on paper. Phonetics and speech physiology became a reality.

They were especially real in the case of Henry Sweet, whose perfect English made him the prototype of all experimental phonetics as well as the hero of a play. Recorded by Professor F. C. Donders of Utrecht, Sweet was also dramatized by George Bernard Shaw, who turned him into a modern Pygmalion out to conquer all mouths that, however beautiful, were marred by dialect. To record and discipline the dreadful dialect of the flower girl Eliza Doolittle, "Higgins's laboratory" boasts "a phonograph, a laryngoscope, [and] a row of tiny organ pipes with a bellows." In the world of the modern *Pygmalion*, mirrors and statues are unnecessary; sound storage makes it possible "to inspect one's own speech or discourse as in a mirror, thus enabling us to adopt a critical stance toward our products." To the great delight of Shaw, who saw his medium or his readability technologically guaranteed to all English speakers, machines easily solve a problem that literature had not been able to tackle on its own, or had only been able to tackle through the mediation of pedagogy: to drill people in general, and flower girls in particular, to adopt a pronunciation purified by written language.

It comes as no surprise that Eliza Doolittle, all of her love notwithstanding, abandons her Pygmalion (Sweet, a.k.a. Higgins) at the end of the play in order to learn "bookkeeping and typewriting" at "shorthand schools and polytechnic classes." Women who have been subjected to phonographs and typewriters are souls no longer; they can only end up in musicals. Renaming the drama *My Fair Lady*, Rodgers and Hammerstein will throw Shaw's *Pygmalion* among Broadway tourists and record labels. "On the Street Where You Live" is sound.

In any event, Edison, ancestor of the record industry, only needed to combine, as is so often the case with inventions. A Willis-type machine gave him the idea for the phonograph; a Scott-type machine pushed him toward its realization. The synthetic production of frequencies combined with their analysis resulted in the new medium.

Edison's phonograph was a by-product of the attempt to optimize telephony and telegraphy by saving expensive copper cables. First, Menlo Park developed a telegraph that indented a paraffin paper strip with Morse signs, thus allowing them to be replayed faster than they had been transmitted by human hands. The effect was exactly the same as in Willis's case: pitch became a variable dependent on speed. Second, Menlo Park developed a telephone receiver with a needle attached to the diaphragm. By touching the needle, the hearing-impaired Edison could check the amplitude of the telephone signal. Legend has it that one day the needle drew blood—and Edison "recognized how the force of a membrane moved by a magnetic system could be put to work." "In effect, he had found a way to transfer the functions of his ear to his sense of touch."

A telegraph as an artificial mouth, a telephone as an artificial ear—the stage was set for the phonograph. Functions of the central nervous system had been

technologically implemented. When, after a 72-hour shift ending early in the morning of July 16, 1888, Edison had finally completed a talking machine ready for serial production, he posed for the hastily summoned photographer in the pose of his great idol. The French emperor, after all, is said to have observed that the progress of national welfare (or military technology) can be measured by transportation costs. And no means of transportation are more economical than those which convey information rather than goods and people. Artificial mouths and ears, as technological implementations of the central nervous system, cut down on mailmen and concert halls. What Ong calls our secondary orality has the elegance of brain functions. Technological sound storage provides a first model for data streams, which are simultaneously becoming objects of neurophysiological research. Helmholtz, as the perfecter of vowel theory, is allied with Edison, the perfecter of measuring instruments. Which is why sound storage, initially a mechanically primitive affair on the level of Weber's pig bristle, could not be invented until the soul fell prey to science. "O my head, my head, my head," groans the phonograph in the prose poem Alfred Jarry dedicated to it. "All white underneath the silk sky: They have taken my head, my head—and put me into a tea tin!"

Which is why Villiers de l'Isle-Adam, the symbolist poet and author of the first of many Edison novels, is mistaken when, in *Tomorrow's Eve*, he has the great inventor ponder his delay.

> What is most surprising in history, almost unimaginable, is that among all the great inventors across the centuries, not one thought of the Phonograph! And yet most of them invented machines a thousand times more complicated. The Phonograph is so simple that its construction owes nothing to materials of scientific composition. Abraham might have built it, and made a recording of his calling from on high. A steel stylus, a leaf of silver foil or something like it, a cylinder of copper, and one could fill a storehouse with all the voices of Heaven and Earth.

This certainly applies to materials and their processing, but it misses the historical a priori of sound recording. There are also immaterials of scientific origin, which are not so easy to come by and have to be supplied by a science of the soul. They cannot be delivered by any of the post-Abraham candidates whom Villiers de l'Isle-Adam suspects of being able to invent the phonograph: neither Aristotle, Euclid, nor Archimedes could have underwritten the statement that "The soul is a notebook of phonographic recordings" (but rather, if at all, a tabula rasa for written signs, which in turn signify acts of the soul). Only when the soul has become the nervous system, and the nervous system (according to Sigmund Exner, the great Viennese neurophysiologist) so many facilitations (*Bahnungen*), can Delboeuf's statement cease to be scandalous. In 1880, the philosopher Guyau devoted a commentary to it. And this first theory of the phonograph attests like no other to the interactions between science and technology. Thanks to the invention of the phonograph, the very theories that were its historical a priori can now optimize their analogous models of the brain.

Bruno Latour

WAR OF THE WORLDS

EDITOR'S INTRODUCTION

BRUNO LATOUR IS A SEMINAL FIGURE in science studies but his work often has implications for cultural studies as does this polemical essay which is concerned both about the status of nature today and about globalization. It makes the argument that Europe was once committed to a stable and rational account of nature in terms that meant that all social and political differences and agreement were secondary in relation to it. In the end nature was king, and in the end nature was such that all societies would gradually, perhaps by history's cunning, become more rational, that is, more natural. Various forms of liberalism, tolerance and multiculturalism were in the end possible because that account of a shared, rational nature was securely in place.

But it no longer is, Latour argues. Which means that the world has become much less secure: the power of the West is no longer based on its ideology of confident naturalism. Latour does not deplore the loss of what we can call a common scientific ontology, on the contrary. For him the 'modern' idea of rationalized and self-complete nature was always only an interpretation (and perhaps he overplays this line of thought: see Raymond Williams's 'Ideas of Nature' essay above). But he does recognise that its loss places us in a risky global environment, one characterized by 'multinaturalism' and which makes agreement and negotiation all the more difficult.

It's clear enough that this essay is gesturing towards the war of terror that followed September 11 and also towards events such as global warming, which radically shift both our species' relation to the environment which gave us as a species birth and relations between different belief traditions as they developed in human history. What makes Latour's thought especially engaging

is that he begins to offer us a way of seeing these two 'world-historical' events as connected.

Further reading: Gieryn 1999; Harding 1995; Hess 1997; Latour 2004, 2005 and 2006; Ross 1991, 1994 and 1996.

The lesson does not seem to sink in. When did Paul Valéry prophetically observe that, "We have now learned that all civilizations are mortal?" Just after the so-called Great War. Many horrific disasters have passed since, and yet we are still surprised when another attack seems to threaten the precarious forms of life so dear to our hearts. Since September 2001, we go on dialing the same emergency number, 911, and rightly so, since we have entered a state of emergency. We look around frantically to understand why all that we feel is worth fighting for remains so fragile. I read in the news that Hollywood scriptwriters rushed to revise the catastrophist scenarios that suddenly looked obscene in the face of a much harsher reality. In the same way, nihilism used to look like a gold mine when it was applied hypothetically to any value worth its salt. Does such idle criticism not look superficial now that nihilism is truly striking at "us"—at US—putting what we call civilization in great danger of being found hollow? Who needs to add another deconstruction to a heap of broken debris? The courageous iconoclast waving her arm in defiance, so proud of her hammer, ready to break everything with the powerful weapon of critique—down with empires, beliefs, fetishes, ideologies, icons, idols!—does she not look a bit silly now that what she wanted to strike down lies in dust, already smashed to the ground, and by people who do not fit at all the ideal of the critical avant-garde?! What has happened to the critical urge? Has it not overshot its target?

The word "war" is spewing out of every mouth, and although it sounds so disheartening at first there might be an opportunity to seize on these clarion calls. In "emergency" lays a hidden word, "emergent." What is emerging, being "brought to light," by the recent events? To realize that we are in the midst of a war might take us out of the complacency with which so many people imagined an ever more peaceful future, with all the nations converging toward fuzzy modernist ideals. No, Westerners might not be able to modernize the whole planet after all. This does not mean that they are forever locked into the narrow confines of their own civilization, threatened by all others in a war of all against all. It just means that they counted a bit prematurely on possessing a sure principle that could unify the whole world, make one accepted common world. It is not the case that an already existing peaceful union has been savagely shattered. We have merely been reminded that unity has to be made; it is not simply observed. Far from being self evident, unity was never more solid than a future possibility to struggle for. Unity has to be the end result of a diplomatic effort; it can't be its uncontroversial starting point.

My argument in this tricky, prickly piece is that it might after all be better to be at war, and thus to be forced to think about the diplomatic work to be done, than to imagine that there is no war at all and keep talking endlessly about progress, modernity, development—without realizing the price that must be paid

in reaching such lofty goals. So we are at war, aren't we? Fine. But then three questions can finally be raised: who is involved? What are their war aims? And finally, the most important one: what about peace? I will argue that we are not faced with a peace unfairly shattered, nor with a "war of civilizations," but that we have first to fathom that a war of the worlds has been raging all along, throughout the so-called "modern age"—this modern parenthesis. Still, nothing proves we are on the wrong side, and nothing proves either that this war cannot be won. What is sure is that it has to be waged explicitly and not covertly. The worst course would be to act as if there were no war at all, only the peaceful extension of Western natural Reason using its police forces to combat, contain, and convert the many Empires of Evil. That is the mistake those who still believe they are moderns are in danger of making. On the other hand, if we are going to bring the wars of modernization to an end, we cannot afford to declare that all bets are off, that premodern savagery will be met with premodern savagery, that senseless violence will answer senseless violence. No, what is needed is a new recognition of the old war we have been fighting all along—in order to bring about new kinds of negotiation, and a new kind of peace.

The false peace offered by the one nature/many cultures divide

If we are in a state of war, who are the parties engaged in this conflict? In earlier times things looked simpler: despite all their disagreements, their disputes and the diversity of their customs and languages, humans used to share, without even knowing it, a common world, the world of nature, that physical anthropology could describe fairly well. Thus the many diverse cultures known to social and cultural anthropology stood out against a background of natural unity. They could be compared synoptically not unlike the way a museum's white wall helps to bring out the differences between exotic masks hung side by side. There may have been Bantus and Baoules, Finns and Laplanders, Californians and Burgundians, but they all shared a common make-up of genes, neurons, muscles, skeletons, ecosystems and evolution which allowed them to be classed in the same humanity. If cultural differences shined so vividly, this was because the unity of nature provided the common denominator.

This denominator was even more indisputably common when one moved from the world of human nature to the world of non-human nature. The possibility of disagreement among specialists or disciplines certainly remained, but ultimately the world (in the singular) external nature would be enough to bring agreement among them all. Different cultures existed, with their many idiosyncrasies, but at least there was only one nature with its necessary laws. Conflicts between humans, no matter how far they went, remained limited to the representations, ideas and images that diverse cultures could have of a single biophysical nature. To be sure, differences of opinion, disagreements and violent conflicts remained, but they all had their source in the subjectivity of the human mind without ever engaging the world, its material reality, its cosmology or its ontology, which by construction—no! precisely, by nature—remained intangible.

In this blessed era of modernism, differences, in other words, never cut very deep; they could never be fundamental since they did not affect the world itself. Agreement was in principle always possible, if not easy. There always remained the hope that differences of opinion, even violent conflicts, could be eased or alleviated if one only focused a little more on this unifying and pacifying nature and a little less on the divergent, contradictory and subjective representations humans had of it. If, through education, rational debates or careful scrutiny, one succeeded in bringing the one natural and physical reality into the debates, then passions would be calmed. Thus one could always move from passionate diversity to a reassuring and rational agreed upon reality. Even if humanity featured divergent religions, rights, customs and arts, it could always seek solace in this haven of unity and peace offered by science, technology, economics and democracy. Passions may divide us, but we can rely on reason to reunite us. There may be many ways of bringing up children, but there is only one embryo-genesis. Therefore, when disputes occur, we need only to increase the relative share of scientific objectivity, technical efficiency, economic profitability and democratic debate, and the disputes will soon cease.

It is impossible now to realize the extent to which this solution was convenient in solving the problem of the progressive composition of the common world (which is the name I give to politics). For after all, the hard work had already been done, unity had been fully constituted, fitted out from head to foot. The world had been unified, and there remained only the task of convincing a few last recalcitrant people who resisted modernization—and if this failed, well, the leftovers could always be stored among those "values" to be respected, such as cultural diversity, tradition, inner religious feelings, madness, etc. In other words, the leftovers could be gathered together in a museum or a reserve or a hospital and then be turned into more or less collective forms of subjectivity. Their conservation did not threaten the unity of nature since they would never be able to return to make a claim for their objectivity and request a place in the only real world under the only real sun. Like the wives and children of overthrown monarchs, who were locked up in convents for life, they would be forever banned from participating in the serious matters of state.

Anthropologists, curators, physicians, artists could even enjoy the luxury of "respecting" those diverse idiosyncrasies since they never threatened to stake a claim in the order of the world. There were certainly wars, innumerable ones, but there was only one world, which, without hesitation, made it possible to speak of one planet, one universal humanity, the rights of man and of human beings as such. In those not-so-distant times, there could have been no wars of the worlds. Diversity could be handled by tolerance—but of a very condescending sort since the many cultures were debarred from any ontological claim to participate in the controversial definition of the one world of nature. Although there could be many warring parties engaged in local conflicts, one thing was sure: there was only one arbiter, Nature, a known by Reason.

Of course, there remained a slight suspicion that the referee of all the disputes could be biased. Maybe this world in the singular, the world of Science, of Technology, of the Market, Democracy, Humanity, Human Rights—in short the world of the Human—suffered from being a little ethnocentric, if not a trifle imperialist, or even merely American, not to say Yankee... Unification proceeded,

it was all too clear, in a somewhat unfair manner, as though the task of unifying the world had been delegated (although no one had actually delegated anything) to only one of the cultures of the world, the one bearing the imprecise name of the West. However odd, this in itself did not seem shocking to most Westerners and their many clients, because fundamentally "the West" was not a culture "among" others, since it enjoyed a privileged access to nature and its already-accomplished unification. Europeans, Americans, Australians and later Japanese certainly possessed cultural traits which identified them as unique cultural groups, but their access to nature swiftly made these superficial differences disappear. If "Westernization" could be challenged or rejected, "modernization" was beyond doubt the common property of humanity—and even if "modernization" came to be disputed, then "naturalization" could provide another, deeper uncontroversial bedrock common to all.

Thus, surrendering to modernization and naturalization did not mean submitting to any given imperialism or voluntarily imitating a cultural model, but rather coming closer to this fundamental, indisputable source of unification that was to be rooted in a nature known by reason. The solution always was to connect directly to the objective origin of the common world and thus to draw nearer to unity. Neither those who were developing nor those being developed had the feeling that they were surrendering to another people when they respectively disseminated or adopted sciences, technologies, markets and democracy. They were surrendering to modernization, which, because of its break with all cultural inheritances, simply marked the more or less dramatic eruption of nature, indisputable and unifying—as if truth was finally shining through a tear in the colorful screen clumsily painted by the many cultural representations.

There was, however, a little hitch in this peaceful modernist version of politics: nature was as meaningless as it was disenchanted! Herein lies the whole paradox of these strange times we call "modernity"—which retrospectively appear no longer as the motor of history, but increasingly as the partial representation of one historical episode now come to an end. For if nature had the immediate advantage of imparting unification, it also had the serious drawback, in the eyes of its very promoters, of being fundamentally devoid of meaning. Objective facts in their harsh reality could neither be smelled, nor tasted, nor could they provide any truly human signification. The modernists themselves were fully aware of this, and even acknowledged it with a sort of sadomasochistic joy. "The great scientific discoveries," they were glad to say with a shudder, "are incessantly wrenching us from our little village and hurling us into the frightening, infinite spaces of an icy cosmos whose center we no longer occupy." Ultimately, though, this was not a matter of choice: modernization compelled one to mourn the passing of all one's colorful pretensions, one's motley cosmologies, of all the many ways of life with their rich rituals. "Let us wipe away our tears," the modernists liked to declare, "let us become adults at last; humanity is leaving behind its myth-imbued childhood and is stepping into the harsh reality of Science, Technology and the Market. It's a pity but that's the way it is: you can either choose to cling to your diverse cultures, and conflicts will not cease, or, alternatively, you can accept unity and the sharing of a common world, and then, naturally (in every sense of the word), this world will be devoid of meaning. Too bad, love it or leave it." One

may wonder whether one of the many metaphysical origins of the twentieth-century world wars did not consist of this odd way with which the West sought to pacify all conflicts by appealing to a single common world. How long can one survive in peace when torn by this impossible double bind with which modernizers have trapped themselves together with those they have modernized: nature known by reason unifies, but this unification is devoid of meaning?

The irresistible advance of the modernization front had a great advantage, and that was to help define the difference between "us" and "them" as a great, radical break. The term "ethnocentrism" cannot by definition be applied to the West, contrary to what anti- and post-colonialists might claim, since the center was made of nature and not of any particular culture. Although ethnocentrism, like common sense according to Descartes, is of all things in the world the most evenly distributed, and although in establishing relations of trade, domination and avoidance, all peoples and all nations have placed themselves in the center, relegating the others to the periphery, the West, and only the West, was thought to have escaped this fate. Whereas all the others had maintained a fundamental equality between them, in that they were all at the very least peoples, as Lévi-Strauss had often said, this was never the case for the modernists: the others were "peoples" and "cultures," but "we," the Westerners, were only "half" culture, as Roy Wagner has argued. For the first time in history, the West could occupy, alone, the position of undeniable center, without this center having a particular ethnic group as its origin. This was indeed precisely what enabled the difference to be established between "them"—prisoners inside the narrow confines of their cultures, incapable of grasping the unifying principles of nature—and "us," who evidently possessed more or less emphasized cultural traits, but whose hidden strength was to have reached, thanks to Science, Technology and Economics' slow work of erosion, the rock bottom of universality, the hard core of nature, the backdrop of any history. The modernizing West may have been "naturocentric" or "ratiocentric," but never had a political formation been less ethnocentric than it. All the more so, since with truly admirable magnanimity, it gave everybody, whatever his or her ethnic group of origin, the chance to become universal like itself. Through the mediation of scientific objectivity, technical efficiency and economic profitability, anybody could join this fatherland without ancestors, this ethnic group without rituals, this country without borders; this country of reason, able to access unifying nature through the hard work of criticism and rational discussion.

But in the end, the meaning of this existence still remained unsolved. For, the more one belonged to this fatherland without father or mother, the less this belonging had any significance: a strange paradox, which triggered a frantic search throughout the whole planet to discover the generic human being, who, when it was finally found, only led to despair at the sight of what had turned out to be again mere nature: animal, biophysical, genetic, neuronal—at best a sociobiological Darwinian machinery. The solution for diminishing, if not solving, this contradiction between a unifying but senseless nature, on the one hand, and, on the other, cultures packed with meaning but no longer entitled to rule objective reality, was to make the notion of "culture" sacred. Cultures began to be cherished, conserved, respected, reinvented, occasionally even made up from scratch.

But the notion of culture, it should not be forgotten, is relational: ethnic groups do not belong in the same ontological category as cabbages or turnips. Culture is but one of the possible ways of relating to others, one perspective on otherness, and certainly not the only one. Multiculturalism is nothing more than the flipside of what may be termed mononaturalism. The impression of great open-mindedness given by multiculturalism should not hide the price that peoples had to pay for the preservation of their existence in the form of culture. "You possess meaning, perhaps," they were told, "but you no longer have reality, or else you have it merely in the symbolic, subjective, collective, ideological form of mere representations of a world that escapes you, although *we are able to grasp it objectively*. And don't be mistaken, you have the right to cherish your culture, but all others likewise have this same right, and all cultures are valued by us equally." In this combination of respect and complete indifference, we may recognize the hypocritical condescension of cultural relativism so rightly criticized by Donna Haraway. To the eyes of the cultural relativist, those cultural differences make no real difference anyway, since, somewhere, nature continues to unify reality by means of laws that are indisputable and necessary, even if they are not as charming and meaningful as these delightful productions which human whim and arbitrary categories have engendered everywhere.

Let us sum up the situation as it was when modernization was at its height: a) we possessed a privileged, natural world already unified, whatever some humans imprisoned by their own symbolic representations might think; b) the West, alone in not being ethnocentric, contemplated the multiplicity of ways of evading this common world with a simultaneously watchful, dismayed, condescending, tolerant and interested eye; c) in addition, we could profit from the rich diversity provided by many cultures, all comparable, and all of them equally disengaged from the construction of the common natural reality, which was left safely in the hands of culture-free scientists, engineers, economists and democrats; d) as an added bonus, we were offered some sort of peace proposal which presupposed that there could be no conflict whatsoever, no real wars, no reality wars: worlds were never at stake, only the many symbolic representations of the one and only world; unity was already complete; a general increase in the dose of universal nature would bring agreement straight away. Finally, e) since this universal nature had no human meaning, cultural conservatism was indispensable for embellishing, enriching and ornamenting, by means of values and passions, the harsh world of facts and reason—provided, of course, that none of these cultures claimed any ontological pretensions. *Voila*, in a few words, the now vanished world which the alliance of mononaturalism and multiculturalism had proposed. "The one world is ours, the many worlds are yours; and if your disputes are too noisy, may the world of harsh reality come in to pacify your disputes." A peculiar offer of peace, one which had never recognized the existence of a war in the first place!

From mono- to multi-naturalism

Looking retrospectively at the episode of modernization—a few short centuries of violent spasms—one cannot help but be struck by the extent to which it was

peaceful, despite the wars that were unleashed on an ever more staggering scale. This is not a paradox: the West was fundamentally peaceful since disagreements could never go very far. They affected representations, but they never touched the substance, the very fabric of the world. To speak like philosophers, only the "secondary qualities" were at stake, never the "primary qualities." To the Galileos Newtons, Pasteurs, Curies, even to the Oppenheimers, politics always appeared—and still appears to Steven Weinberg—as a violent fire that a little more objective science could always snuff out. However terrifying the conflicts were, Westerners were all convinced that peace was always within arm's reach, just behind the narrow walls of our passions and our representations. How could they define any war aims? There was no war at all. Only the "others" were at war because of the archaic calling of their subjective passions.

Already we have forgotten just how reassuring, gratifying and stabilizing was this feeling of inner peace that the modernists enjoyed: this absolute certainty that there would be wars, but not wars of science; that there were wars in the world, but never wars of the worlds—except in science-fiction stories. For all those great ancestors, there existed no source of conflict that could not be wiped out. Or if it could not be made to disappear, it could always be internalized, psychologized, sunk into the private depth of our inner selves. This is what the West had managed so successfully with "religious peace." Yes, religion is divisive, but no, it does not involve the world, only one's private salvation. Religion had to become a mere culture so that nature could become a true religion—what brings everyone into assent. Living side by side implied no re-negotiation of the common world already constituted, but simply the acceptance of others' eccentricities, opinions and feelings—so long as they remained within the narrow boundaries of their cerebral movie theaters. What a perfect solution: the invention of a tolerant society.

But this solution is no longer available to those who no longer live under the sway of modernism. There are many ways to interpret modernism and its history, but I have become convinced that the best way is to treat "modernism" as an anachronistic interpretation of the events in which the West participated. In this sense the West has never been more modern than the French revolutionaries, in the eyes of Tocqueville and François Furet, have been revolutionary. Modernism has never been anything more than a highly biased interpretation of events with different and sometimes entirely opposite motivations. To be sure, modernism as a theory of what was happening has been active, and sometimes very efficiently, in molding the events, but it was never an accurate account of the strange ways in which the West became entangled with every nation and every living and non-living entity on Earth. How to reconcile, for instance, the war cry for emancipation, progress and detachment from any archaic constraint with the progressive imbroglios of humans and non-humans at an ever-expanding scale that characterizes the West? Which one of these three following phenomena should the anthropologist study most carefully: the self-congratulatory talk of the modernists about becoming at last released from the shackles of the past? The harsh reality of becoming more attached every day to ever more opaque hybrids of law, science, technology, passion and social ties? Or, should she follow instead the perverse ways through which the talk about progress interferes, accelerates, blinds and perturbs the many entanglements of humans and non-humans that are being generated on an

ever-expanding scale? Whichever choice is made, there is no longer any overlap between modernism as an interpretation and the events it purported for so long to interpret. Through the cracks of the call for universal reason now appears a rather monstrous animal that no longer looks like "the West." If it has ceased to be familiar to the eyes of the anthropologist, it has lost also its inner peacefulness and, with it, its complete asymmetric distance from the "others." "They" look a lot like "us" now—and this is why we are finally at war with them, but what sort of battle are we expected to lead?

The slogan invented by journalists a few years ago has been well chosen: "Science Wars" are taking place. What looked at first like a tempest in a teacup has revealed itself as the tiny tell tale sign of a much larger transformation. One way to sum up this sea change is to say that modernity, which had been conceived as the filling up of the world with ever more matters of fact, is now full of what I would like to call states of affairs. Matters of fact were supposed to bring agreement by appealing to the objective nature out there; but instead many of the former facts have become controversial issues that create more dissent than agreements, thus requiring another quasi-legal or quasi-political procedure to bring closure. Facts are no longer the mouth-shutting alternative to politics, but what has to be stabilized instead. To use another etymology, "objects" which had been conceived as wholly exterior to the social and political realm, have become "things" again, that is, in the sense of the mixture of assemblies, issues, causes for concerns, data, law suits, controversies which the words *res, causa, chose, aitia, ding* have designated in all the European languages. While in earlier times, it was still possible to imagine quieting down the turbulent political passions by a solid importation of indisputable facts, the only possibility now seems to add to the turmoil of passions the turmoil generated by hotly disputed states of affairs. The fount of peace no longer exists "out there." In addition, cultures no longer wish to be mere cultures. We are now facing wars of the worlds. Mononaturalism has been replaced by a monster inconceivable only ten years ago: multinaturalism (to use the neologism devised by Eduardo Viveiros de Castro) which has joined in the devilish dance started by multiculturalism—after the latter was blown to pieces along with the hypocritical tolerance it entailed. No one wants to be just tolerated anymore. No one can bear to be just one culture "among others" watched with interest and indifference by the gaze of the naturalizers. Reality is once again becoming the issue at stake.

The conjunction of two words repeated ad nauseam, "globalization" and "fragmentation," constitutes a striking symptom of these changing times. It would be a mistake not to take these "globalloneys" very seriously, for they indicate, respectively, the crisis of unity and the crisis of multiplicity. Contrary to the misconceived impression that contemporary discourses on globalization might give, our age is much less global than it was, say, in 1790, 1848, 1918, 1945, 1968 or 1989, to take a few simple landmarks of particular significance to the Europeans. It was still possible at these different dates to speak of humanity, of the human being, of world unity, of planet Earth, of progress and of world citizens, since we were under the impression of having connected history to the single rational, learned, objective source of unity and peace, the model for which was provided by the natural sciences. Victory was around the corner. Light was seen at the end

of the tunnel. Modernization was about to triumph. "We" were all going to share the same world. Oddly enough, "the" world in the singular never appeared more global, total and in the process of completion, than just before the period when the word "globalization" started ringing in our ears.

Another paradox? No, for when globalization is spoken of nowadays, it is as a fatal danger, a crushing necessity, a tragedy, a passionate commitment, or as a challenge to be taken up. In their positive as much as in their negative renderings, the global or the worldwide are spoken of as a war-like uprising, as a front or a battle which could be lost. Going global or worldwide has become a serious problem to be solved, and is no longer the obvious solution to all conflicts as it was before, during the times of modernization. Even the French, despite their fondness for republican universality, rally "against globalization" and start noisily demanding the right to maintain their "cultural exception"—something that would have been inconceivable even ten years ago! They worship a farmer, José Bové, who brings to Berkeley a smelly Roquefort in order to stop the American imperialistic grab on food production! For the first time, the global is becoming visibly and publicly what is at stake in a merciless war—and no longer the invisible unity to which everybody surreptitiously resorted. Today, in Seattle or Porto Alegre, barricades go up against globalization and its perils: who in the past would have been mad enough to put up barricades against universality? Against nature?

Things look just as bad on the side of multiplicity. While globalization is causing problems for unity, fragmentation is now beginning to make tolerance look equally problematic, if not positively dangerous. Has anyone sufficiently remarked upon the oddness of complaining simultaneously about fragmentation, which allegedly prevents any common world, and about globalization, which is blamed for unifying too rapidly and without negotiation? Because, after all, we ought to be rejoicing: if globalization is dangerous, then long live the fragmentation that shatters its hegemony; but if supposedly post-modern fragmentation is so terrifying, should we not be welcoming globalization with open arms, as something which at last provides unity and common sense? In complaining so unfairly against both globalization and fragmentation, we identify precisely the deep transformation that took us out of modernism and the convenient solution it offered to the problems of unity and multiplicity. Fragmentation shatters mononaturalism; globalization destroys multiculturalism. On both sides, whether the aim is to create multiplicity or unity, opponents, fronts and violent contradictions are finally starting to appear. It is possible to measure the staggering speed of transformation with this tell tale sign: the word "global" no longer sounds at all like "natural," and "fragmented" no longer sounds like "culturally respectable." We have seen the last of tolerance, as Isabelle Stengers provocatively said, along with the hypocritical respect of comparative anthropology, and smug assertions about humanity, human rights and the fact that we are all similar inhabitants of the same world. There is now a war of the worlds. Peace, the hypocritical peace of modernity, is well and truly over.

Donna Haraway

A CYBORG MANIFESTO

EDITOR'S INTRODUCTION

IS THIS REALLY A MANIFESTO? For whom? Whatever the answer, it's an amazing 'blasphemous' call for a profound change of consciousness for everyone – maybe most of all women – living and working in high-tech culture. Donna Haraway's manifesto sits dead-centre within cultural studies in its radical, pleasure-seeking affirmation of an often maligned and feared feature of the contemporary world – technologization. And it also mediates practically enough on women's relation to technoscience.

The essay is usefully read as an exercise in feminist post-structuralism, prefiguring and supplementing queer theory, conceptualizations of the post-human, as well as shadowing the French philosophers Deleuze and Guattari's experimental prescriptions for contemporary thought and living.

In particular, Haraway targets:

1 nature fetishism which finds value in what is natural, where nature is interpreted as the opposite of artifice and technology;
2 organicism which analyses society and culture in terms of organic unities, and where it does not find them, bitterly complains;
3 sexualism for which sex is the best form or replication, and social bonds which are grounded in sex ('blood' ties, filiative associations) are primary;
4 identity thinking for which selves are discrete wholes with specific identities.

It's a cliché: but once you have read and taken in this essay, you won't think the same way about things again.

Further reading: Bukatman 1993; Deleuze and Guattari 1977 and 1988; Fox-Keller 1984; Haraway 2003; Hayles 1999; Penley 1997; Robertson *et al*. 1996.

This essay is an effort to build an ironic political myth faithful to feminism, socialism, and materialism. Perhaps more faithful as blasphemy is faithful, than as reverent worship and identification. Blasphemy has always seemed to require taking things very seriously. I know no better stance to adopt from within the secular-religious, evangelical traditions of United States politics, including the politics of socialist feminism. Blasphemy protects one from the moral majority within, while still insisting on the need for community. Blasphemy is not apostasy. Irony is about contradictions that do not resolve into larger wholes, even dialectically, about the tension of holding incompatible things together because both or all are necessary and true. Irony is about humour and serious play. It is also a rhetorical strategy and a political method, one I would like to see more honoured within socialist-feminism. At the centre of my ironic faith, my blasphemy, is the image of the cyborg.

A cyborg is a cybernetic organism, a hybrid of machine and organism, a creature of social reality as well as a creature of fiction. Social reality is lived social relations, our most important political construction, a world-changing fiction. The international women's movements have constructed 'women's experience', as well as uncovered or discovered this crucial collective object. This experience is a fiction and fact of the most crucial, political kind. Liberation rests on the construction of the consciousness, the imaginative apprehension, of oppression, and so of possibility. The cyborg is a matter of fiction and lived experience that changes what counts as women's experience in the late twentieth century. This is a struggle over life and death, but the boundary between science fiction and social reality is an optical illusion.

Contemporary science fiction is full of cyborgs – creatures simultaneously animal and machine, who populate worlds ambiguously natural and crafted. Modern medicine is also full of cyborgs, of couplings between organism and machine, each conceived as coded devices, in an intimacy and with a power that was not generated in the history of sexuality. Cyborg 'sex' restores some of the lovely replicative baroque of ferns and invertebrates (such nice organic prophylactics against heterosexism). Cyborg replication is uncoupled from organic reproduction. Modern production seems like a dream of cyborg colonization work, a dream that makes the nightmare of Taylorism seem idyllic. And modern war is a cyborg orgy, coded by C^3I, command-control-communication-intelligence, an $84 billion item in 1984's US defence budget. I am making an argument for the cyborg as a fiction mapping our social and bodily reality and as an imaginative resource suggesting some very fruitful couplings. Michel Foucault's biopolitics is a flaccid premonition of cyborg politics, a very open field.

By the late twentieth century, our time, a mythic time, we are all chimeras, theorized and fabricated hybrids of machine and organism; in short, we are cyborgs. The cyborg is our ontology; it gives us our politics. The cyborg is a condensed image of both imagination and material reality, the two joined centres structuring any possibility of historical transformation. In the traditions of 'Western' science

and politics – the tradition of racist, male-dominant capitalism; the tradition of progress; the tradition of the appropriation of nature as resource for the productions of culture; the tradition of reproduction of the self from the reflections of the other – the relation between organism and machine has been a border war. The stakes in the border war have been the territories of production, reproduction, and imagination. This essay is an argument for *pleasure* in the confusion of boundaries and for *responsibility* in their construction. It is also an effort to contribute to socialist-feminist culture and theory in a postmodernist, non-naturalist mode and in the utopian tradition of imagining a world without gender, which is perhaps a world without genesis, but maybe also a world without end. The cyborg incarnation is outside salvation history. Nor does it mark time on an oedipal calendar, attempting to heal the terrible cleavages of gender in an oral symbiotic utopia or post-oedipal apocalypse.

The cyborg is a creature in a post-gender world; it has no truck with bisexuality, pre-oedipal symbiosis, unalienated labour, or other seductions to organic wholeness through a final appropriation of all the powers of the parts into a higher unity. In a sense, the cyborg has no origin story in the Western sense – a 'final' irony since the cyborg is also the awful apocalyptic *telos* of the 'West's' escalating dominations of abstract individuation, an ultimate self untied at last from all dependency, a man in space. An origin story in the 'Western', humanist sense depends on the myth of original unity, fullness, bliss and terror, represented by the phallic mother from whom all humans must separate, the task of individual development and of history, the twin potent myths inscribed most powerfully for us in psychoanalysis and Marxism. Hilary Klein has argued that both Marxism and psychoanalysis, in their concepts of labour and of individuation and gender formation, depend on the plot of original unity out of which difference must be produced and enlisted in a drama of escalating domination of woman/nature. The cyborg skips the step of original unity, of identification with nature in the Western sense. This is its illegitimate promise that might lead to subversion of its teleology as star wars.

The cyborg is resolutely committed to partiality, irony, intimacy, and perversity. It is oppositional, utopian, and completely without innocence. No longer structured by the polarity of public and private, the cyborg defines a technological polis based partly on a revolution of social relations in the *oikos*, the household. Nature and culture are reworked; the one can no longer be the resource for appropriation or incorporation by the other. The relationships for forming wholes from parts, including those of polarity and hierarchical domination, are at issue in the cyborg world. Unlike the hopes of Frankenstein's monster, the cyborg does not expect its father to save it through a restoration of the garden; that is, through the fabrication of a heterosexual mate, through its completion in a finished whole, a city and cosmos. The cyborg does not dream of community on the model of the organic family, this time without the oedipal project. The cyborg would not recognize the Garden of Eden; it is not made of mud and cannot dream of returning to dust. Perhaps that is why I want to see if cyborgs can subvert the apocalypse of returning to nuclear dust in the manic compulsion to name the Enemy. Cyborgs are not reverent; they do not re-member the cosmos. They are wary of holism, but needy for connection – they seem to have a natural feel for united front politics,

but without the vanguard party. The main trouble with cyborgs, of course, is that they are the illegitimate offspring of militarism and patriarchal capitalism, not to mention state socialism. But illegitimate offspring are often exceedingly unfaithful to their origins. Their fathers, after all, are inessential.

I will return to the science fiction of cyborgs at the end of this essay, but now I want to signal three crucial boundary breakdowns that make the following political-fictional (political-scientific) analysis possible. By the late twentieth century in United States scientific culture, the boundary between human and animal is thoroughly breached. The last beachheads of uniqueness have been polluted if not turned into amusement parks – language, tool use, social behaviour, mental events, nothing really convincingly settles the separation of human and animal. And many people no longer feel the need for such a separation; indeed, many branches of feminist culture affirm the pleasure of connection of human and other living creatures. Movements for animal rights are not irrational denials of human uniqueness; they are a clear-sighted recognition of connection across the discredited breach of nature and culture. Biology and evolutionary theory over the last two centuries have simultaneously produced modern organisms as objects of knowledge and reduced the line between humans and animals to a faint trace re-etched in ideological struggle or professional disputes between life and social science. Within this framework, teaching modern Christian creationism should be fought as a form of child abuse.

Biological-determinist ideology is only one position opened up in scientific culture for arguing the meanings of human animality. There is much room for radical political people to contest the meanings of the breached boundary. The cyborg appears in myth precisely where the boundary between human and animal is transgressed. Far from signalling a walling off of people from other living beings, cyborgs signal disturbingly and pleasurably tight coupling. Bestiality has a new status in this cycle of marriage exchange.

The second leaky distinction is between animal-human (organism) and machine. Pre-cybernetic machines could be haunted; there was always the spectre of the ghost in the machine. This dualism structured the dialogue between materialism and idealism that was settled by a dialectical progeny, called spirit or history, according to taste. But basically machines were not self-moving, self-designing, autonomous. They could not achieve man's dream, only mock it. They were not man, an author to himself, but only a caricature of that masculinist reproductive dream. To think they were otherwise was paranoid. Now we are not so sure. Late twentieth-century machines have made thoroughly ambiguous the difference between natural and artificial, mind and body, self-developing and externally designed, and many other distinctions that used to apply to organisms and machines. Our machines are disturbingly lively, and we ourselves frighteningly inert.

Technological determination is only one ideological space opened up by the reconceptions of machine and organism as coded texts through which we engage in the play of writing and reading the world. 'Textualization' of everything in post-structuralist, postmodernist theory has been damned by Marxists and socialist feminists for its utopian disregard for the lived relations of domination that ground the 'play' of arbitrary reading. It is certainly true that postmodernist strategies, like my cyborg myth, subvert myriad organic wholes (for example, the poem, the

primitive culture, the biological organism). In short, the certainty of what counts as nature – a source of insight and promise of innocence – is undermined, probably fatally. The transcendent authorization of interpretation is lost, and with it the ontology grounding 'Western' epistemology. But the alternative is not cynicism or faithlessness, that is, some version of abstract existence, like the accounts of technological determinism destroying 'man' by the 'machine' or 'meaningful political action' by the 'text'. Who cyborgs will be is a radical question; the answers are a matter of survival.

The third distinction is a subset of the second: the boundary between physical and non-physical is very imprecise for us. Pop physics books on the consequences of quantum theory and the indeterminacy principle are a kind of popular scientific equivalent to Harlequin romances as a marker of radical change in American white heterosexuality: they get it wrong, but they are on the right subject. Modern machines are quintessentially microelectronic devices: they are everywhere and they are invisible. Modern machinery is an irreverent upstart god, mocking the Father's ubiquity and spirituality. The silicon chip is a surface for writing; it is etched in molecular scales disturbed only by atomic noise, the ultimate interference for nuclear scores. Writing, power, and technology are old partners in Western stories of the origin of civilization, but miniaturization has changed our experience of mechanism. Miniaturization has turned out to be about power; small is not so much beautiful as pre-eminently dangerous, as in cruise missiles. Contrast the television sets of the 1950s or the news cameras of the 1970s with the television wrist bands or hand-sized video cameras now advertised. Our best machines are made of sunshine; they are all light and clean because they are nothing but signals, electromagnetic waves, a section of a spectrum, and these machines are eminently portable, mobile – a matter of immense human pain in Detroit and Singapore. People are nowhere near so fluid, being both material and opaque. Cyborgs are ether, quintessence.

The ubiquity and invisibility of cyborgs is precisely why these sunshine-belt machines are so deadly. They are as hard to see politically as materially. They are about consciousness – or its simulation. They are floating signifiers moving in pickup trucks across Europe, blocked more effectively by the witch-weavings of the displaced and so unnatural Greenham women, who read the cyborg webs of power so very well, than by the militant labour of older masculinist politics, whose natural constituency needs defence jobs. Ultimately the 'hardest' science is about the realm of greatest boundary confusion, the realm of pure number, pure spirit, C^3I, cryptography, and the preservation of potent secrets. The new machines are so clean and light. Their engineers are sun-worshippers mediating a new scientific revolution associated with the night dream of post-industrial society. The diseases evoked by these clean machines are 'no more' than the minuscule coding changes of an antigen in the immune system, 'no more' than the experience of stress. The nimble fingers of 'Oriental' women, the old fascination of little Anglo-Saxon Victorian girls with doll's houses, women's enforced attention to the small take on quite new dimensions in this world. There might be a cyborg Alice taking account of these new dimensions.

So my cyborg myth is about transgressed boundaries, potent fusions, and dangerous possibilities which progressive people might explore as one part of

needed political work. One of my premises is that most American socialists and feminists see deepened dualisms of mind and body, animal and machine, idealism and materialism in the social practices, symbolic formulations, and physical artefacts associated with 'high technology' and scientific culture. From *One-Dimensional Man* (Marcuse 1964) to *The Death of Nature* (Merchant 1980), the analytic resources developed by progressives have insisted on the necessary domination of technics and recalled us to an imagined organic body to integrate our resistance. Another of my premises is that the need for unity of people trying to resist worldwide intensification of domination has never been more acute. But a slightly perverse shift of perspective might better enable us to contest for meanings, as well as for other forms of power and pleasure in technologically mediated societies.

From one perspective, a cyborg world is about the final imposition of a grid of control on the planet, about the final abstraction embodied in a Star Wars apocalypse waged in the name of defence, about the final appropriation of women's bodies in a masculinst orgy of war. From another perspective, a cyborg world might be about lived social and bodily realities in which people are not afraid of their joint kinship with animals and machines, not afraid of permanently partial identities and contradictory standpoints. The political struggle is to see from both perspectives at once because each reveals both dominations and possibilities unimaginable from the other vantage point. Single vision produces worse illusions than double vision or many-headed monsters. Cyborg unities are monstrous and illegitimate; in our present political circumstances, we could hardly hope for more potent myths for resistance and recoupling. I like to imagine LAG, the Livermore Action Group, as a kind of cyborg society, dedicated to realistically converting the laboratories that most fiercely embody and spew out the tools of technological apocalypse, and committed to building a political form that actually manages to hold together witches, engineers, elders, perverts, Christians, mothers, and Leninists long enough to disarm the state. Fission Impossible is the name of the affinity group in my town. (Affinity: related not by blood but by choice, the appeal of one chemical nuclear group for another, avidity.)

Fractured identities

It has become difficult to name one's feminism by a single adjective – or even to insist in every circumstance upon the noun. Consciousness of exclusion through naming is acute. Identities seem contradictory, partial, and strategic. With the hard-won recognition of their social and historical constitution, gender, race, and class cannot provide the basis for belief in 'essential' unity. There is nothing about being 'female' that naturally binds women. There is not even such a state as 'being' female, itself a highly complex category constructed in contested sexual scientific discourses and other social practices. Gender, race, or class consciousness is an achievement forced on us by the terrible historical experience of the contradictory social realities of patriarchy, colonialism, and capitalism. And who counts as 'us' in my own rhetoric? Which identities are available to ground such a potent political myth called 'us', and what could motivate enlistment in this collectivity? Painful fragmentation among feminists (not to mention among women) along

every possible fault line has made the concept of *woman* elusive, an excuse for the matrix of women's dominations of each other. For me – and for many who share a similar historical location in white, professional middle-class, female, radical, North American, mid-adult bodies – the sources of a crisis in political identity are legion. The recent history for much of the US left and US feminism has been a response to this kind of crisis by endless splitting and searches for a new essential unity. But there has also been a growing recognition of another response through coalition – affinity, not identity.

Chela Sandoval, from a consideration of specific historical moments in the formation of the new political voice called women of colour, has theorized a hopeful model of political identity called 'oppositional consciousness', born of the skills for reading webs of power by those refused stable membership in the social categories of race, sex, or class. 'Women of colour', a name contested at its origins by those whom it would incorporate, as well as a historical consciousness marking systematic breakdown of all the signs of Man in 'Western' traditions, constructs a kind of postmodernist identity out of otherness, difference, and specificity. This postmodernist identity is fully political, whatever might be said about other possible postmodernisms. Sandoval's oppositional consciousness is about contradictory locations and heterochronic calendars, not about relativisms and pluralisms.

Sandoval emphasizes the lack of any essential criterion for identifying who is a woman of colour. She notes that the definition of the group has been by conscious appropriation of negation. For example, a Chicana or US black woman has not been able to speak as a woman or as a black person or as a Chicano. Thus, she was at the bottom of a cascade of negative identities, left out of even the privileged oppressed authorial categories called 'women and blacks', who claimed to make the important revolutions. The category 'woman' negated all non-white women; 'black' negated all non-black people, as well as all black women. But there was also no 'she', no singularity, but a sea of differences among US women who have affirmed their historical identity as US women of colour. This identity marks out a self-consciously constructed space that cannot affirm the capacity to act on the basis of natural identification, but only on the basis of conscious coalition, of affinity, of political kinship. Unlike the 'woman' of some streams of the white women's movement in the United States, there is no naturalization of the matrix, or at least this is what Sandoval argues is uniquely available through the power of oppositional consciousness.

Sandoval's argument has to be seen as one potent formulation for feminists out of the worldwide development of anti-colonialist discourse; that is to say, discourse dissolving the 'West' and its highest product – the one who is not animal, barbarian, or woman; man, that is, the author of a cosmos called history. As orientalism is deconstructed politically and semiotically, the identities of the occident destabilize, including those of feminists. Sandoval argues that 'women of colour' have a chance to build an effective unity that does not replicate the imperializing, totalizing revolutionary subjects of previous Marxisms and feminisms which had not faced the consequences of the disorderly polyphony emerging from decolonization.

Katie King has emphasized the limits of identification and the political/poetic mechanics of identification built into reading 'the poem', that generative core of

cultural feminism. King criticizes the persistent tendency among contemporary feminists from different 'moments' or 'conversations' in feminist practice to taxonomize the women's movement to make one's own political tendencies appear to be the *telos* of the whole. These taxonomies tend to remake feminist history so that it appears to be an ideological struggle among coherent types persisting over time, especially those typical units called radical, liberal, and socialist feminism. Literally, all other feminisms are either incorporated or marginalized, usually by building an explicit ontology and epistemology. Taxonomies of feminism produce epistemologies to police deviation from official women's experience. And of course, 'women's culture', like women of colour, is consciously created by mechanisms inducing affinity. The rituals of poetry, music, and certain forms of academic practice have been pre-eminent. The politics of race and culture in the US women's movements are intimately interwoven. The common achievement of King and Sandoval is learning how to craft a poetic/political unity without relying on a logic of appropriation, incorporation, and taxonomic identification.

The theoretical and practical struggle against unity-through-domination or unity-through-incorporation ironically not only undermines the justifications for patriarchy, colonialism, humanism, positivism, essentialism, scientism, and other unlamented -isms, but *all* claims for an organic or natural standpoint. I think that radical and socialist/Marxist feminisms have also undermined their/our own epistemological strategies and that this is a crucially valuable step in imagining possible unities. It remains to be seen whether all 'epistemologies' as Western political people have known them fail us in the task to build effective affinities.

It is important to note that the effort to construct revolutionary standpoints, epistemologies as achievements of people committed to changing the world, has been part of the process showing the limits of identification. The acid tools of postmodernist theory and the constructive tools of ontological discourse about revolutionary subjects might be seen as ironic allies in dissolving Western selves in the interests of survival. We are excruciatingly conscious of what it means to have a historically constituted body. But with the loss of innocence in our origin, there is no expulsion from the Garden either. Our politics lose the indulgence of guilt with the *naïveté* of innocence. But what would another political myth for socialist feminism look like? What kind of politics could embrace partial, contradictory, permanently unclosed constructions of personal and collective selves and still be faithful, effective — and, ironically, socialist feminist?

I do not know of any other time in history when there was greater need for political unity to confront effectively the dominations of 'race', 'gender', 'sexuality', and 'class'. I also do not know of any other time when the kind of unity we might help build could have been possible. None of 'us' have any longer the symbolic or material capability of dictating the shape of reality to any of 'them'. Or at least 'we' cannot claim innocence from practising such dominations. White women, including socialist feminists, discovered (that is, were forced kicking and screaming to notice) the non-innocence of the category 'woman'. That consciousness changes the geography of all previous categories; it denatures them as heat denatures a fragile protein. Cyborg feminists have to argue that 'we' do not want any more natural matrix of unity and that no construction is whole. Innocence, and the corollary insistence on victimhood as the only ground for insight, has done enough damage. But the

constructed revolutionary subject must give late-twentieth-century people pause as well. In the fraying of identities and in the reflexive strategies for constructing them, the possibility opens up for weaving something other than a shroud for the day after the apocalypse that so prophetically ends salvation history.

Both Marxist/socialist feminisms and radical feminisms have simultaneously naturalized and denatured the category 'woman' and consciousness of the social lives of 'women'. Perhaps a schematic caricature can highlight both kinds of moves. Marxian socialism is rooted in an analysis of wage labour which reveals class structure. The consequence of the wage relationship is systematic alienation, as the worker is dissociated from his (sic) product. Abstraction and illusion rule in knowledge, domination rules in practice. Labour is the pre-eminently privileged category enabling the Marxist to overcome illusion and find that point of view which is necessary for changing the world. Labour is the humanizing activity that makes man; labour is an ontological category permitting the knowledge of a subject, and so the knowledge of subjugation and alienation.

In faithful filiation, socialist feminism advanced by allying itself with the basic analytic strategies of Marxism. The main achievement of both Marxist feminists and socialist feminists was to expand the category of labour to accommodate what (some) women did, even when the wage relation was subordinated to a more comprehensive view of labour under capitalist patriarchy. In particular, women's labour in the household and women's activity as mothers generally (that is, reproduction in the socialist feminist sense), entered theory on the authority of analogy to the Marxian concept of labour. The unity of women here rests on an epistemology based on the ontological structure of 'labour'. Marxist/socialist feminism does not 'naturalize' unity; it is a possible achievement based on a possible standpoint rooted in social relations. The essentializing move is in the ontological structure of labour or of its analogue, women's activity. The inheritance of Marxian humanism, with its pre-eminently Western self, is the difficulty for me. The contribution from these formulations has been the emphasis on the daily responsibility of real women to build unities, rather than to naturalize them.

Catherine MacKinnon's version of radical feminism is itself a caricature of the appropriating, incorporating, totalizing tendencies of Western theories of identity grounding action. It is factually and politically wrong to assimilate all of the diverse 'moments' or 'conversations' in recent women's politics named radical feminism to MacKinnon's version. But the ideological logic of her theory shows how an epistemology and ontology – including their negations – erase or police difference. Only one of the effects of MacKinnon's theory is the rewriting of the history of the polymorphous field called radical feminism. The major effect is the production of a theory of experience, of women's identity, that is a kind of apocalypse for all revolutionary standpoints. That is, the totalization built into this tale of radical feminism achieves its end – the unity of women – by enforcing the experience of and testimony to radical non-being. As for the Marxist/socialist feminist, consciousness is an achievement, not a natural fact. And MacKinnon's theory eliminates some of the difficulties built into humanist revolutionary subjects, but at the cost of radical reductionism.

MacKinnon argues that feminism necessarily adopted a different analytical strategy from Marxism, looking first not at the structure of class but at the

structure of sex or gender and its generative relationship, men's constitution and appropriation of women sexually. Ironically, MacKinnon's 'ontology' constructs a non-subject, a non-being. Another's desire, not the self's labour, is the origin of 'woman'. She therefore develops a theory of consciousness that enforces what can count as 'women's' experience – anything that names sexual violation, indeed, sex itself as far as 'women' can be concerned. Feminist practice is the construction of this form of consciousness; that is, the self-knowledge of a self-who-is-not.

Perversely, sexual appropriation in this feminism still has the epistemological status of labour; that is to say, the point from which an analysis able to contribute to changing the world must flow. But sexual objectification, not alienation, is the consequence of the structure of sex or gender. In the realm of knowledge, the result of sexual objectification is illusion and abstraction. However, a woman is not simply alienated from her product, but in a deep sense does not exist as a subject, or even potential subject, since she owes her existence as a woman to sexual appropriation. To be constituted by another's desire is not the same thing as to be alienated in the violent separation of the labourer from his product.

MacKinnon's radical theory of experience is totalizing in the extreme; it does not so much marginalize as obliterate the authority of any other women's political speech and action. It is a totalization producing what Western patriarchy itself never succeeded in doing – feminists' consciousness of the non-existence of women, except as products of men's desire. I think MacKinnon correctly argues that no Marxian version of identity can firmly ground women's unity. But in solving the problem of the contradictions of any Western revolutionary subject for feminist purposes, she develops an even more authoritarian doctrine of experience. If my complaint about socialist/Marxian standpoints is their unintended erasure of polyvocal, unassimilable, radical difference made visible in anticolonial discourse and practice, MacKinnon's intentional erasure of all difference through the device of the 'essential' non-existence of women is not reassuring.

In my taxonomy, which like any other taxonomy is a re-inscription of history, radical feminism can accommodate all the activities of women named by socialist feminists as forms of labour only if the activity can somehow be sexualized. Reproduction had different tones of meanings for the two tendencies, one rooted in labour, one in sex, both calling the consequences of domination and ignorance of social and personal reality 'false consciousness'.

Beyond either the difficulties or the contributions in the argument of any one author, neither Marxist nor radical feminist points of view have tended to embrace the status of a partial explanation; both were regularly constituted as totalities. Western explanation has demanded as much; how else could the 'Western' author incorporate its others? Each tried to annex other forms of domination by expanding its basic categories through analogy, simple listing, or addition. Embarrassed silence about race among white radical and socialist feminists was one major, devastating political consequence. History and polyvocality disappear into political taxonomies that try to establish genealogies. There was no structural room for race (or for much else) in theory claiming to reveal the construction of the category woman and social group women as a unified or totalizable whole. The structure of my caricature looks like this:

socialist feminism – structure of class // wage labour // alienation
labour, by analogy reproduction, by extension sex, by addition race

radical feminism – structure of gender // sexual appropriation //objectification
sex, by analogy labour, by extension reproduction, by addition race

In another context, the French theorist, Julia Kristeva, claimed that women appeared
as a historical group after the Second World War, along with groups like youth.
Her dates are doubtful; but we are now accustomed to remembering that as
objects of knowledge and as historical actors, 'race' did not always exist, 'class' has
a historical genesis, and 'homosexuals' are quite junior. It is no accident that the
symbolic system of the family of man – and so the essence of woman – breaks up
at the same moment that networks of connection among people on the planet are
unprecedentedly multiple, pregnant and complex. 'Advanced capitalism' is inadequate
to convey the structure of this historical moment. In the 'Western' sense, the end
of man is at stake. It is no accident that woman disintegrates into women in our
time. Perhaps socialist feminists were not substantially guilty of producing essentialist
theory that suppressed women's particularity and contradictory interests. I think
we have been, at least through unreflective participation in the logics, languages,
and practices of white humanism and through searching for a single ground of
domination to secure our revolutionary voice. Now we have less excuse. But in the
consciousness of our failures, we risk lapsing into boundless difference and giving
up on the confusing task of making partial, real connection. Some differences are
playful; some are poles of world historical systems of domination. 'Epistemology'
is about knowing the difference.

The informatics of domination

In this attempt at an epistemological and political position, I would like to
sketch a picture of possible unity, a picture indebted to socialist and feminist
principles of design. The frame for my sketch is set by the extent and importance
of rearrangements in worldwide social relations tied to science and technology.
I argue for a politics rooted in claims about fundamental changes in the nature
of class, race, and gender in an emerging system of world order analogous in its
novelty and scope to that created by industrial capitalism; we are living through
a movement from an organic, industrial society to a polymorphous, information
system – from all work to all play, a deadly game. Simultaneously material and
ideological, the dichotomies may be expressed in the following chart of transitions
from the comfortable old hierarchical dominations to the scary new networks I
have called the informatics of domination:

Representation	Simulation
Bourgeois novel, realism	Science fiction, postmodernism
Organism	Biotic component
Depth, integrity	Surface, boundary
Heat	Noise

Biology as clinical practice	Biology as inscription
Physiology	Communications engineering
Small group	Subsystem
Perfection	Optimization
Eugenics	Population Control
Decadence, *Magic Mountain*	Obsolescence, *Future Shock*
Hygiene	Stress Management
Microbiology, tuberculosis	Immunology, AIDS
Organic division of labour	Ergonomics/cybernetics of labour
Functional specialization	Modular construction
Reproduction	Replication
Organic sex role specialization	Optimal genetic strategies
Biological determinism	Evolutionary inertia, constraints
Community ecology	Ecosystem
Racial chain of being	Neo-imperialism, United Nations humanism
Scientific management in home/factory	Global factory/electronic cottage
Family/market/factory	Women in the Integrated Circuit
Family wage	Comparable worth
Public/private	Cyborg citizenship
Nature/culture	Fields of difference
Co-operation	Communications enhancement
Freud	Lacan
Sex	Genetic engineering
Labour	Robotics
Mind	Artificial Intelligence
Second World War	Star Wars
White capitalist patriarchy	Informatics of domination

This list suggests several interesting things. First, the objects on the right-hand side cannot be coded as 'natural', a realization that subverts naturalistic coding for the left-hand side as well. We cannot go back ideologically or materially. It's not just that 'god' is dead; so is the 'goddess'. Or both are revivified in the worlds charged with microelectronic and biotechnological politics. In relation to objects like biotic components, one must think not in terms of essential properties, but in terms of design, boundary constraints, rates of flows, systems logics, costs of lowering constraints. Sexual reproduction is one kind of reproductive strategy among many, with costs and benefits as a function of the system environment. Ideologies of sexual reproduction can no longer reasonably call on notions of sex and sex role as organic aspects in natural objects like organisms and families. Such reasoning will be unmasked as irrational, and ironically corporate executives reading *Playboy* and anti-porn radical feminists will make strange bedfellows in jointly unmasking the irrationalism.

Likewise for race, ideologies about human diversity have to be formulated in terms of frequencies of parameters, like blood groups or intelligence scores. It is 'irrational' to invoke concepts like primitive and civilized. For liberals and

radicals, the search for integrated social systems gives way to a new practice called 'experimental ethnography' in which an organic object dissipates in attention to the play of writing. At the level of ideology, we see translations of racism and colonialism into languages of development and under-development, rates and constraints of modernization. Any objects or persons can be reasonably thought of in terms of disassembly and reassembly; no 'natural' architectures constrain system design. The financial districts in all the world's cities, as well as the export-processing and free-trade zones, proclaim this elementary fact of 'late capitalism'. The entire universe of objects that can be known scientifically must be formulated as problems in communications engineering (for the managers) or theories of the text (for those who would resist). Both are cyborg semiologies.

One should expect control strategies to concentrate on boundary conditions and interfaces, on rates of flow across boundaries – and not on the integrity of natural objects. 'Integrity' or 'sincerity' of the Western self gives way to decision procedures and expert systems. For example, control strategies applied to women's capacities to give birth to new human beings will be developed in the languages of population control and maximization of goal achievement for individual decision-makers. Control strategies will be formulated in terms of rates, costs of constraints, degrees of freedom. Human beings, like any other component or subsystem, must be localized in a system architecture whose basic modes of operation are probabilistic, statistical. No objects, spaces, or bodies are sacred in themselves; any component can be interfaced with any other if the proper standard, the proper code, can be constructed for processing signals in a common language. Exchange in this world transcends the universal translation effected by capitalist markets that Marx analysed so well. The privileged pathology affecting all kinds of components in this universe is stress – communications breakdown. The cyborg is not subject to Foucault's biopolitics; the cyborg simulates politics, a much more potent field of operations.

This kind of analysis of scientific and cultural objects of knowledge which have appeared historically since the Second World War prepares us to notice some important inadequacies in feminist analysis which has proceeded as if the organic, hierarchical dualisms ordering discourse in 'the West' since Aristotle still ruled. They have been cannibalized. The dichotomies between mind and body, animal and human, organism and machine, public and private, nature and culture, men and women, primitive and civilized are all in question ideologically. The actual situation of women is their integration or exploitation into a world system of production/reproduction and communication called the informatics of domination. The home, workplace, market, public arena, the body itself – all can be dispersed and interfaced in nearly infinite, polymorphous ways, with large consequences for women and others – consequences that themselves are very different for different people and which make potent oppositional international movements difficult to imagine and essential for survival. One important route for reconstructing socialist-feminist politics is through theory and practice addressed to the social relations of science and technology, including crucially the systems of myth and meanings structuring our imaginations. The cyborg is a kind of disassembled and reassembled, postmodern collective and personal self. This is the self feminists must code.

Communications technologies and biotechnologies are the crucial tools recrafting our bodies. These tools embody and enforce new social relations for women worldwide. Technologies and scientific discourses can be partially understood as formalizations, i.e., as frozen moments, of the fluid social interactions constituting them, but they should also be viewed as instruments for enforcing meanings. The boundary is permeable between tool and myth, instrument and concept, historical systems of social relations and historical anatomies of possible bodies, including objects of knowledge. Indeed, myth and tool mutually constitute each other.

Furthermore, communications sciences and modern biologies are constructed by a common move – *the translation of the world into a problem of coding*, a search for a common language in which all resistance to instrumental control disappears and all heterogeneity can be submitted to disassembly, reassembly, investment, and exchange.

In communications sciences, the translation of the world into a problem in coding can be illustrated by looking at cybernetic (feedback-controlled) systems theories applied to telephone technology, computer design, weapons deployment, or data base construction and maintenance. In each case, solution to the key questions rests on a theory of language and control; the key operation is determining the rates, directions, and probabilities of flow of a quantity called information. The world is subdivided by boundaries differentially permeable to information. Information is just that kind of quantifiable element (unit, basis of unity) which allows universal translation, and so unhindered instrumental power (called effective communication). The biggest threat to such power is interruption of communication. Any system breakdown is a function of stress. The fundamentals of this technology can be condensed into the metaphor C^3I, command-control-communication-intelligence, the military's symbol for its operations theory.

In modern biologies, the translation of the world into a problem in coding can be illustrated by molecular genetics, ecology, sociobiological evolutionary theory, and immunobiology. The organism has been translated into problems of genetic coding and read-out. Biotechnology, a writing technology, informs research broadly. In a sense, organisms have ceased to exist as objects of knowledge, giving way to biotic components, i.e., special kinds of information-processing devices. The analogous moves in ecology could be examined by probing the history and utility of the concept of the ecosystem. Immunobiology and associated medical practices are rich exemplars of the privilege of coding and recognition systems as objects of knowledge, as constructions of bodily reality for us. Biology here is a kind of cryptography. Research is necessarily a kind of intelligence activity. Ironies abound. A stressed system goes awry; its communication processes break down; it fails to recognize the difference between self and other. Human babies with baboon hearts evoke national ethical perplexity – for animal rights activists at least as much as for the guardians of human purity. In the US gay men and intravenous drug users are the 'privileged' victims of an awful immune system disease that marks (inscribes on the body) confusion of boundaries and moral pollution.

But these excursions into communications sciences and biology have been at a rarefied level; there is a mundane, largely economic reality to support my claim that these sciences and technologies indicate fundamental transformations in the structure of the world for us. Communications technologies depend on electronics.

Modern states, multinational corporations, military power, welfare state apparatuses, satellite systems, political processes, fabrication of our imaginations, labour-control systems, medical constructions of our bodies, commercial pornography, the international division of labour, and religious evangelism depend intimately upon electronics. Microelectronics is the technical basis of simulacra; that is, of copies without originals.

Microelectronics mediates the translations of labour into robotics and word processing, sex into genetic engineering and reproductive technologies, and mind into artificial intelligence and decision procedures. The new biotechnologies concern more than human reproduction. Biology as a powerful engineering science for redesigning materials and processes has revolutionary implications for industry, perhaps most obvious today in areas of fermentation, agriculture, and energy. Communications sciences and biology are constructions of natural-technical objects of knowledge in which the difference between machine and organism is thoroughly blurred; mind, body, and tool are on very intimate terms. The 'multinational' material organization of the production and reproduction of daily life and the symbolic organization of the production and reproduction of culture and imagination seem equally implicated. The boundary-maintaining images of base and superstructure, public and private, or material and ideal never seemed more feeble.

I have used Rachael Grossman's image of women in the integrated circuit to name the situation of women in a world so intimately restructured through the social relations of science and technology. I used the odd circumlocution, 'the social relations of science and technology', to indicate that we are not dealing with a technological determinism, but with a historical system depending upon structured relations among people. But the phrase should also indicate that science and technology provide fresh sources of power, that we need fresh sources of analysis and political action. Some of the rearrangements of race, sex, and class rooted in high-tech-facilitated social relations can make socialist feminism more relevant to effective progressive politics.

The 'homework economy' outside 'the home'

The 'New Industrial Revolution' is producing a new worldwide working class, as well as new sexualities and ethnicities. The extreme mobility of capital and the emerging international division of labour are intertwined with the emergence of new collectivities, and the weakening of familiar groupings. These developments are neither gender- nor race-neutral. White men in advanced industrial societies have become newly vulnerable to permanent job loss, and women are not disappearing from the job rolls at the same rates as men. It is not simply that women in Third World countries are the preferred labour force for the science-based multinationals in the export-processing sectors, particularly in electronics. The picture is more systematic and involves reproduction, sexuality, culture, consumption, and production. In the prototypical Silicon Valley, many women's lives have been structured around employment in electronics-dependent jobs, and their intimate realities include serial heterosexual monogamy, negotiating childcare, distance from extended kin or most other forms of traditional community, a high

likelihood of loneliness and extreme economic vulnerability as they age. The ethnic and racial diversity of women in Silicon Valley structures a microcosm of conflicting differences in culture, family, religion, education, and language.

Richard Gordon has called this new situation the 'homework economy'. Although he includes the phenomenon of literal homework emerging in connection with electronics assembly, Gordon intends 'homework economy' to name a restructuring of work that broadly has the characteristics formerly ascribed to female jobs, jobs literally done only by women. Work is being redefined as both literally female and feminized, when performed by men or women. To be feminized means to be made extremely vulnerable; able to be disassembled, reassembled, exploited as a reserve labour force; seen less as workers than as servers; subjected to time arrangements on and off the paid job that make a mockery of a limited work day; leading an existence that always borders on being obscene, out of place, and reducible to sex. Deskilling is an old strategy newly applicable to formerly privileged workers. However, the homework economy does not refer only to large-scale deskilling, nor does it deny that new areas of high skill are emerging, even for women and men previously excluded from skilled employment. Rather, the concept indicates that factory, home and market are integrated on a new scale and that the places of women are crucial – and need to be analysed for differences among women and for meanings for relations between men and women in various situations.

The homework economy as a world capitalist organizational structure is made possible by (not caused by) the new technologies. The success of the attack on relatively privileged, mostly white, men's unionized jobs is tied to the power of the new communications technologies to integrate and control labour despite extensive dispersion and decentralizaton. The consequences of the new technologies are felt by women both in the loss of the family (male) wage (if they ever had access to this white privilege) and in the character of their own jobs, which are becoming capital-intensive; for example, office work and nursing.

The new economic and technological arrangements are also related to the collapsing welfare state and the ensuing intensification of demands on women to sustain daily life for themselves as well as for men, children, and old people. The feminization of poverty – generated by dismantling the welfare state, by the homework economy where stable jobs become the exception, and sustained by the expectation that women's wages will not be matched by a male income for the support of children – has become an urgent focus. The causes of various women-headed households are a function of race, class, or sexuality; but their increasing generality is a ground for coalitions of women on many issues. That women regularly sustain daily life partly as a function of their enforced status as mothers is hardly new; the kind of integration with the overall capitalist and progressively war-based economy is new. The particular pressure, for example, on US black women, who have achieved an escape from (barely) paid domestic service and who now hold clerical and similar jobs in large numbers, has large implications for continued enforced black poverty *with* employment. Teenage women in industrializing areas of the Third World increasingly find themselves the sole or major source of a cash wage for their families, while access to land is ever more problematic. These developments must have major consequences in the psychodynamics and politics of gender and race.

Within the framework of three major stages of capitalism (commercial or early industrial, monopoly, multinational) – tied to nationalism, imperialism, and multinationalism, and related to Jameson's three dominant aesthetic periods of realism, modernism, and postmodernism – I would argue that specific forms of families dialectically relate to forms of capital and to its political and cultural concomitants. Although lived problematically and unequally, ideal forms of these families might be schematized as, first, the patriarchal nuclear family, structured by the dichotomy between public and private and accompanied by the white bourgeois ideology of separate spheres and nineteenth-century Anglo-American bourgeois feminism; second, the modern family mediated (or enforced) by the welfare state and institutions like the family wage, with a flowering of afeminist heterosexual ideologies, including their radical versions represented in Greenwich Village around the First World War; and, third, the 'family' of the homework economy with its oxymoronic structure of women-headed households and its explosion of feminisms and the paradoxical intensification and erosion of gender itself. This is the context in which the projections for worldwide structural unemployment stemming from the new technologies are part of the picture of the homework economy. As robotics and related technologies put men out of work in 'developed' countries and exacerbate failure to generate male jobs in Third World 'development', and as the automated office becomes the rule even in labour-surplus countries, the feminization of work intensifies. Black women in the United States have long known what it looks like to face the structural underemployment ('feminization') of black men, as well as their own highly vulnerable position in the wage economy. It is no longer a secret that sexuality, reproduction, family, and community life are interwoven with this economic structure in myriad ways which have also differentiated the situations of white and black women. Many more women and men will contend with similar situations, which will make cross-gender and cross-race alliances on issues of basic life support (with or without jobs) necessary, not just nice.

The new technologies also have a profound effect on hunger and on food production for subsistence worldwide. Rae Lessor Blumberg estimates that women produce about 50 per cent of the world's subsistence food. Women are excluded generally from benefiting from the increased high-tech commodification of food and energy crops, their days are made more arduous because their responsibilities to provide food do not diminish, and their reproductive situations are made more complex. Green Revolution technologies interact with other high-tech industrial production to alter gender divisions of labour and differential gender migration patterns.

The new technologies seem deeply involved in the forms of 'privatization' that Ros Petchesky has analysed, in which militarization, right-wing family ideologies and policies, and intensified definitions of corporate (and state) property as private synergistically interact. The new communications technologies are fundamental to the eradication of 'public life' for everyone. This facilitates the mushrooming of a permanent high-tech military establishment at the cultural and economic expense of most people, but especially of women. Technologies like video games and highly miniaturized televisions seem crucial to production of modern forms of 'private life'. The culture of video games is heavily orientated to individual competition and extraterrestrial warfare. High-tech, gendered imaginations are produced here,

imaginations that can contemplate destruction of the planet and a sci-fi escape from its consequences. More than our imaginations is militarized; and the other realities of electronic and nuclear warfare are inescapable. These are the technologies that promise ultimate mobility and perfect exchange – and incidentally enable tourism, that perfect practice of mobility and exchange, to emerge as one of the world's largest single industries.

The new technologies affect the social relations of both sexuality and of reproduction, and not always in the same ways. The close ties of sexuality and instrumentality, of views of the body as a kind of private satisfaction – and utility maximizing machine, are described nicely in sociobiological origin stories that stress a genetic calculus and explain the inevitable dialectic of domination of male and female gender roles. These sociobiological stories depend on a high-tech view of the body as a biotic component or cybernetic communications system. Among the many transformations of reproductive situations is the medical one, where women's bodies have boundaries newly permeable to both 'visualization' and 'intervention'. Of course, who controls the interpretation of bodily boundaries in medical hermeneutics is a major feminist issue. The speculum served as an icon of women's claiming their bodies in the 1970s; that handcraft tool is inadequate to express our needed body politics in the negotiation of reality in the practices of cyborg reproduction. Self-help is not enough. The technologies of visualization recall the important cultural practice of hunting with the camera and the deeply predatory nature of a photographic consciousness. Sex, sexuality, and reproduction are central actors in high-tech myth systems structuring our imaginations of personal and social possibility.

Another critical aspect of the social relations of the new technologies is the reformulation of expectations, culture, work, and reproduction for the large scientific and technical workforce. A major social and political danger is the formation of a strongly bimodal social structure, with the masses of women and men of all ethnic groups, but especially people of colour, confined to a homework economy, illiteracy of several varieties, and general redundancy and impotence, controlled by high-tech repressive apparatuses ranging from entertainment to surveillance and disappearance. An adequate socialist feminist politics should address women in the privileged occupational categories, and particularly in the production of science and technology that constructs scientific-technical discourses, processes, and objects.

This issue is only one aspect of enquiry into the possibility of a feminist science, but it is important. What kind of constitutive role in the production of knowledge, imagination, and practice can new groups doing science have? How can these groups be allied with progressive social and political movements? What kind of political accountability can be constructed to tie women together across the scientific-technical hierarchies separating us? Might there be ways of developing feminist science/technology politics in alliance with anti-military science facility conversion action groups? Many scientific and technical workers in Silicon Valley, the high-tech cowboys included, do not want to work on military science. Can these personal preferences and cultural tendencies be welded into progressive politics among this professional middle class in which women, including women of colour, are coming to be fairly numerous?

Women in the integrated circuit

Let me summarize the picture of women's historical locations in advanced industrial societies, as these positions have been restructured partly through the social relations of science and technology. If it was ever possible ideologically to characterize women's lives by the distinction of public and private domains – suggested by images of the division of working-class life into factory and home, of bourgeois life into market and home, and of gender existence into personal and political realms – it is now a totally misleading ideology, even to show how both terms of these dichotomies construct each other in practice and in theory. I prefer a network ideological image, suggesting the profusion of spaces and identities and the permeability of boundaries in the personal body and in the body politic. 'Networking' is both a feminist practice and a multinational corporate strategy – weaving is for oppositional cyborgs.

So let me return to the earlier image of the informatics of domination and trace one vision of women's 'place' in the integrated circuit, touching only a few idealized social locations seen primarily from the point of view of advanced capitalist societies: Home, Market, Paid Work Place, State, School, Clinic-Hospital, and Church. Each of these idealized spaces is logically and practically implied in every other locus, perhaps analogous to a holographic photograph. I want to suggest the impact of the social relations mediated and enforced by the new technologies in order to help formulate needed analysis and practical work. However, there is no 'place' for women in these networks, only geometries of difference and contradiction crucial to women's cyborg identities. If we learn how to read these webs of power and social life, we might learn new couplings, new coalitions. There is no way to read the following list from a standpoint of 'identification', of a unitary self. The issue is dispersion. The task is to survive in the diaspora.

Home. Women-headed households, serial monogamy, flight of men, old women alone, technology of domestic work, paid homework, re-emergence of home sweat-shops, home-based businesses and telecommuting, electronic cottage, urban homelessness, migration, module architecture, reinforced (simulated) nuclear family, intense domestic violence.

Market. Women's continuing consumption work, newly targeted to buy the profusion of new production from the new technologies (especially as the competitive race among industrialized and industrializing nations to avoid dangerous mass unemployment necessitates finding ever bigger new markets for ever less clearly needed commodities); bimodal buying power, coupled with advertising targeting of the numerous affluent groups and neglect of the previous mass markets; growing importance of informal markets in labour and commodities parallel to high-tech, affluent market structures; surveillance systems through electronic funds transfer; intensified market abstraction (commodification) of experience, resulting in ineffective utopian or equivalent cynical theories of community; extreme mobility (abstraction) of marketing or financing systems; interpenetration of sexual and labour markets; intensified sexualization of abstracted and alienated consumption.

Paid Work Place. Continued intense sexual and racial division of labour, but considerable growth of membership in privileged occupational categories for many white women and people of colour; impact of new technologies on women's work

in clerical, service, manufacturing (especially textiles), agriculture, electronics; international restructuring of the working classes; development of new time arrangements to facilitate the homework economy (flexi time, part time, over time, no time); homework and out work; increased pressures for two-tiered wage structures; significant numbers of people in cash-dependent populations worldwide with no experience or no further hope of stable employment; most labour 'marginal' or 'feminized'.

State. Continued erosion of the welfare state; decentralizations with increased surveillance and control; citizenship by telematics; imperialism and political power broadly in the form of information-rich/information-poor differentiation; increased high-tech militarization increasingly opposed by many social groups; reduction of civil service jobs as a result of the growing capital intensification of office work, with implications for occupational mobility for women of colour; growing privatization of material and ideological life and culture; close integration of privatization and militarization, the high-tech forms of bourgeois capitalist personal and public life; invisibility of different social groups to each other, linked to psychological mechanisms of belief in abstract enemies.

School. Deepening coupling of high-tech capital needs and public education at all levels, differentiated by race, class, and gender; managerial classes involved in educational reform and refunding at the cost of remaining progressive educational democratic structures for children and teachers; education for mass ignorance and repression in technocratic and militarized culture; growing anti-science mystery cults in dissenting and radical political movements; continued relative scientific illiteracy among white women and people of colour; growing industrial direction of education (especially higher education) by science-based multinationals (particularly in electronics-dependent and biotechnology-dependent companies); highly educated, numerous elites in a progressively bimodal society.

Clinic-hospital. Intensified machine–body relations; renegotiations of public metaphors which channel personal experience of the body, particularly in relation to reproduction, immune system functions, and 'stress' phenomena; intensification of reproductive politics in response to world historical implications of women's unrealized, potential control of their relation to reproduction; emergence of new, historically specific diseases; struggles over meanings and means of health in environments pervaded by high technology products and processes; continuing feminization of health work; intensified struggle over state responsibility for health; continued ideological role of popular health movements as a major form of American politics.

Church. Electronic fundamentalist 'super-saver' preachers solemnizing the union of electronic capital and automated fetish gods; intensified importance of churches in resisting the militarized state; central struggle over women's meanings and authority in religion; continued relevance of spirituality, intertwined with sex and health, in political struggle.

The only way to characterize the informatics of domination is as a massive intensification of insecurity and cultural impoverishment, with common failure of subsistence networks for the most vulnerable. Since much of this picture interweaves with the social relations of science and technology, the urgency of a socialist feminist politics addressed to science and technology is plain. There is much now

being done, and the grounds for political work are rich. For example, the efforts to develop forms of collective struggle for women in paid work should be a high priority for all of us. These efforts are profoundly tied to technical restructuring of labour processes and reformations of working classes. These efforts also are providing understanding of a more comprehensive kind of labour organization, involving community, sexuality, and family issues never privileged in the largely white male industrial unions.

The structural rearrangements related to the social relations of science and technology evoke strong ambivalence. But it is not necessary to be ultimately depressed by the implications of late twentieth-century women's relation to all aspects of work, culture, production of knowledge, sexuality, and reproduction. For excellent reasons, most Marxisms see domination best and have trouble understanding what can only look like false consciousness and people's complicity in their own domination in late capitalism. It is crucial to remember that what is lost, perhaps especially from women's points of view, is often virulent forms of oppression, nostalgically naturalized in the face of current violation. Ambivalence towards the disrupted unities mediated by high-tech culture requires not sorting consciousness into categories of 'clear-sighted critique grounding a solid political epistemology' versus 'manipulated false consciousness', but subtle understanding of emerging pleasures, experiences, and powers with serious potential for changing the rules of the game.

There are grounds for hope in the emerging bases for new kinds of unity across race, gender, and class, as these elementary units of socialist feminist analysis themselves suffer protean transformations. Intensifications of hardship experienced worldwide in connection with the social relations of science and technology are severe. But what people are experiencing is not transparently clear, and we lack sufficiently subtle connections for collectively building effective theories of experience. Present efforts – Marxist, psychoanalytic, feminist, anthropological – to clarify even 'our' experience are rudimentary.

I am conscious of the odd perspective provided by my historical position – a PhD in biology for an Irish Catholic girl was made possible by Sputnik's impact on US national science-education policy. I have a body and mind as much constructed by the post-Second-World-War arms race and Cold War as by the women's movements. There are more grounds for hope in focusing on the contradictory effects of politics designed to produce loyal American technocrats, which also produced large numbers of dissidents, than in focusing on the present defeats.

The permanent partiality of feminist points of view has consequences for our expectations of forms of political organization and participation. We do not need a totality in order to work well. The feminist dream of a common language, like all dreams for a perfectly true language, or perfectly faithful naming of experience, is a totalizing and imperialist one. In that sense, dialectics too is a dream language, longing to resolve contradiction. Perhaps, ironically, we can learn from our fusions with animals and machines how not to be Man, the embodiment of Western *logos*. From the point of view of pleasure in these potent and taboo fusions, made inevitable by the social relations of science and technology, there might indeed be a feminist science.

Sexuality and gender

Simone de Beauvoir

THE INDEPENDENT WOMAN

EDITOR'S INTRODUCTION

LIKE MANY TEACHERS IN CULTURAL STUDIES who've been In the business for many years, whenever I address the question of feminism I have a strong sense that the experiences of current students, and especially women students, are very different from those of my generation. For many, a majority I would say, feminism has become something that can be either rejected or accepted but which is somewhat tangential to their lives. But that wasn't how it was, mainly for women of course but for men too since they had to renegotiate their sense of gender and privilege in relation to feminism.

And this is why I have included Simone de Beauvoir in this anthology. It's an extract from *The Second Sex*, first published in 1949, and the ur-text for what is now often called 'second-wave feminism' (the feminism that emerged as a major political and social movement only in the late 1960s). (Actually it should be 'third-wave feminism', since there is the feminism of the revolutionary enlightenment at the end of the eighteenth century (Mary Wollstonecraft), the politically-orientated 'suffragettes' of around 1900 and then the contemporary feminist movement.)

De Beauvoir's cultural, political and intellectual world now has a particular historical and geographical flavour: it is French, it belongs to existentialism, it shares a faith in and ease of reference to high literary culture and an absence of interest/knowledge in popular culture that has all but disappeared. My hope is that students will read this and think precisely about that difference: how have women changed since de Beauvoir's time and place wherever they are? And my sense is that the rate and shape of that change is uneven today: to read this circa 2008 in the USA or in the South Asian subcontinent or in France or in Latin America will be very different experiences.

Further reading: Grewal 2005; McRobbie 2000; Mohanty 2003; Moi 1992; Shiach 1999; Simons 1999.

According to French law, obedience is no longer included among the duties of a wife, and each woman citizen has the right to vote; but these civil liberties remain theoretical as long as they are unaccompanied by economic freedom. A woman supported by a man—wife or courtesan—is not emancipated from the male because she has a ballot in her hand; if custom imposes less constraint upon her than formerly, the negative freedom implied has not profoundly modified her situation; she remains bound in her condition of vassalage. It is through gainful employment that woman has traversed most of the distance that separated her from the male; and nothing else can guarantee her liberty in practice. Once she ceases to be a parasite, the system based on her dependence crumbles; between her and the universe there is no longer any need for a masculine mediator.

The curse that is upon woman as vassal consists, as we have seen, in the fact that she is not permitted to do anything; so she persists in the vain pursuit of her true being through narcissism, love, or religion. When she is productive, active, she regains her transcendence; in her projects she concretely affirms her status as subject; in connection with the aims she pursues, with the money and the rights she takes possession of, she makes trial of and senses her responsibility. Many women are aware of these advantages, even among those in very modest positions. I heard a charwoman declare, while scrubbing the stone floor of a hotel lobby: "I never asked anybody for anything; I succeeded all by myself." She was as proud of her self-sufficiency as a Rockefeller. It is not to be supposed, however, that the mere combination of the right to vote and a job constitutes a complete emancipation: working, today, is not liberty. Only in a socialist world would woman by the one attain the other. The majority of workers are exploited today. On the other hand, the social structure has not been much modified by the changes in woman's condition; this world, always belonging to men, still retains the form they have given it.

We must not lose sight of those facts which make the question of woman's labor a complex one. An important and thoughtful woman recently made a study of the women in the Renault factories; she states that they would prefer to stay in the home rather than work in the factory. There is no doubt that they get economic independence only as members of a class which is economically oppressed; and, on the other hand, their jobs at the factory do not relieve them of housekeeping burdens. If they had been asked to choose between forty hours of work a week in the factory and forty hours of work a week in the home, they would doubtless have furnished quite different answers. And perhaps they would cheerfully accept both jobs, if as factory workers they were to be integrated in a world that would be theirs, in the development of which they would joyfully and proudly share. At the present time, peasants apart, the majority of women do not escape from the traditional feminine world; they get from neither society nor their husbands the assistance they would need to become in concrete fact the equals of the men. Only those women who have a political faith, who take militant action in the unions, who have confidence in their future, can give ethical meaning to thankless

daily labor. But lacking leisure, inheriting a traditional submissiveness, women are naturally just beginning to develop a political and social sense. And not getting in exchange for their work the moral and social benefits they might rightfully count on, they naturally submit to its constraints without enthusiasm.

It is quite understandable, also, that the milliner's apprentice, the shopgirl, the secretary, will not care to renounce the advantages of masculine support. I have already pointed out that the existence of a privileged caste, which she can join by merely surrendering her body, is an almost irresistible temptation to the young woman; she is fated for gallantry by the fact that her wages are minimal while the standard of living expected of her by society is very high. If she is content to get along on her wages, she is only a pariah: ill lodged, ill dressed, she will be denied all amusement and even love. Virtuous people preach asceticism to her, and, indeed, her dietary regime is often as austere as that of a Carmelite. Unfortunately, not everyone can take God as a lover: she has to please men if she is to succeed in her life as a woman. She will therefore accept assistance, and this is what her employer cynically counts on in giving her starvation wages. This aid will sometimes allow her to improve her situation and achieve a real independence; in other cases, however, she will give up her work and become a kept woman. She often retains both sources of income and each serves more or less as an escape from the other; but she is really in double servitude: to job and to protector. For the married woman her wages represent only pin money as a rule; for the girl who "makes something on the side" it is the masculine contribution that seems extra; but neither of them gains complete independence through her own efforts.

There are, however, a fairly large number of privileged women who find in their professions a means of economic and social autonomy. These come to mind when one considers woman's possibilities and her future. This is the reason why it is especially interesting to make a close study of their situation, even though they constitute as yet only a minority; they continue to be a subject of debate between feminists and antifeminists. The latter assert that the emancipated women of today succeed in doing nothing of importance in the world and that furthermore they have difficulty in achieving their own inner equilibrium. The former exaggerate the results obtained by professional women and are blind to their inner confusion. There is no good reason, as a matter of fact, to say they are on the wrong road; and still it is certain that they are not tranquilly installed in their new realm: as yet they are only halfway there. The woman who is economically emancipated from man is not for all that in a moral, social, and psychological situation identical with that of man. The way she carries on her profession and her devotion to it depend on the context supplied by the total pattern of her life. For when she begins her adult life she does not have behind her the same past as does a boy; she is not viewed by society in the same way; the universe presents itself to her in a different perspective. The fact of being a woman today poses peculiar problems for an independent human individual.

The advantage man enjoys, which makes itself felt from his childhood, is that his vocation as a human being in no way runs counter to his destiny as a male. Through the identification of phallus and transcendence, it turns out that his social and spiritual successes endow him with a virile prestige. He is not divided. Whereas it

is required of woman that in order to realize her femininity she must make herself object and prey, which is to say that she must renounce her claims as sovereign subject. It is this conflict that especially marks the situation of the emancipated woman. She refuses to confine herself to her role as female, because she will not accept mutilation; but it would also be a mutilation to repudiate her sex. Man is a human being with sexuality; woman is a complete individual, equal to the male, only if she too is a human being with sexuality. To renounce her femininity is to renounce a part of her humanity. Misogynists have often reproached intellectual women for "neglecting themselves"; but they have also preached this doctrine to them: if you wish to be our equals, stop using make-up and nail-polish.

This piece of advice is nonsensical. Precisely because the concept of femininity is artificially shaped by custom and fashion, it is imposed upon each woman from without; she can be transformed gradually so that her canons of propriety approach those adopted by the males: at the seashore—and often elsewhere—trousers have become feminine.[1] That changes nothing fundamental in the matter: the individual is still not free to do as she pleases in shaping the concept of femininity. The woman who does not conform devaluates herself sexually and hence socially, since sexual values are an integral feature of society. One does not acquire virile attributes by rejecting feminine attributes; even the transvestite fails to make a man of herself—she is a travesty. As we have seen, homosexuality constitutes a specific attitude: neutrality is impossible. There is no negative attitude that does not imply a positive counterpart. The adolescent girl often thinks that she can simply scorn convention; but even there she is engaged in public agitation; she is creating a new situation entailing consequences she must assume. When one fails to adhere to an accepted code, one becomes an insurgent. A woman who dresses in an outlandish manner lies when she affirms with an air of simplicity that she dresses to suit herself, nothing more. She knows perfectly well that to suit herself is to be outlandish.

Inversely, a woman who does not wish to appear eccentric will conform to the usual rules. It is injudicious to take a defiant attitude unless it is connected with positively effective action: it consumes more time and energy than it saves. A woman who has no wish to shock or to devaluate herself socially should live out her feminine situation in a feminine manner; and very often, for that matter, her professional success demands it. But whereas conformity is quite natural for a man—custom being based on his needs as an independent and active individual—it will be necessary for the woman who also is subject, activity, to insinuate herself into a world that has doomed her to passivity. This is made more burdensome because women confined to the feminine sphere have grossly magnified its importance: they have made dressing and housekeeping difficult arts. Man hardly has to take thought of his clothes, for they are convenient, suitable to his active life, not necessarily elegant; they are scarcely a part of his personality. More, nobody expects him to take care of them himself: some kindly disposed or hired female relieves him of this bother.

Woman, on the contrary, knows that when she is looked at she is not considered apart from her appearance: she is judged, respected, desired, by and through her toilette. Her clothes were originally intended to consign her to impotence, and they have remained unserviceable, easily ruined: stockings get runs, shoes get down at the

heel, light-colored blouses and frocks get soiled, pleats get unpleated. But she will have to make most of the repairs herself; other women will not come benevolently to her assistance and she will hesitate to add to her budget for work she could do herself: permanents, setting hair, make-up materials, new dresses, cost enough already. When they come in after the day's work, students and secretaries always have a stocking with a run to be fixed, a blouse to wash, a skirt to press. A woman who makes a good income will spare herself this drudgery, but she will have to maintain a more complicated elegance; she will lose time in shopping, in having fittings, and the rest. Tradition also requires even the single woman to give some attention to her lodgings. An official assigned to a new city will easily find accommodations at a hotel; but a woman in the same position will want to settle down in a place of her own. She will have to keep it scrupulously neat, for people would not excuse a negligence on her part which they would find quite natural in a man.

It is not regard for the opinion of others alone that leads her to give time and care to her appearance and her housekeeping. She wants to retain her womanliness for her own satisfaction. She can regard herself with approval throughout her present and past only in combining the life she has made for herself with the destiny that her mother, her childhood games, and her adolescent fantasies prepared for her. She has entertained narcissistic dreams; to the male's phallic pride she still opposes her cult of self; she wants to be seen, to be attractive. Her mother and her older sisters have inculcated the liking for a nest: a home, an "interior," of her own! That has always been basic in her dreams of independence; she has no intention of discarding them when she has found liberty by other roads. And to the degree in which she still feels insecure in the masculine universe, she tends to retain the need for a retreat, symbolical of that interior refuge she has been accustomed to seeking within herself. Obedient to the feminine tradition, she will wax her floors, and she will do her own cooking instead of going to eat at a restaurant as a man would in her place. She wants to live at once like a man and like a woman, and in that way she multiplies her tasks and adds to her fatigue.

If she intends to remain fully feminine, it is implied that she also intends to meet the other sex with the odds as favorable as possible. Her most difficult problems are going to be posed in the field of sex. In order to be a complete individual, on an equality with man, woman must have access to the masculine world as does the male to the feminine world, she must have access to the *other;* but the demands of the *other* are not symmetrical in the two symmetrical cases. Once attained, fame and fortune, appearing like immanent qualities, may increase woman's sexual attractiveness; but the fact that she is a being of independent activity wars against her femininity, and this she is aware of. The independent woman—and above all the intellectual, who thinks about her situation—will suffer, as a female, from an inferiority complex; she lacks leisure for such minute beauty care as that of the coquette whose sole aim in life is to be seductive; follow the specialists' advice as she may, she will never be more than an amateur in the domain of elegance. Feminine charm demands that transcendence, degraded into immanence, appear no longer as anything more than a subtle quivering of the flesh; it is necessary to be spontaneously offered prey.

But the intellectual knows that she is offering herself, she knows that she is a conscious being, a subject; one can hardly dull one's glance and change one's

eyes into sky-blue pools at will; one does not infallibly stop the surge of a body that is straining toward the world and change it into a statue animated by vague tremors. The intellectual woman will try all the more zealously because she fears failure; but her conscious zeal is still an activity and it misses its goal. She makes mistakes like those induced by the menopause: she tries to deny her brain just as the woman who is growing older tries to deny her age; she dresses like a girl, she overloads herself with flowers, furbelows, fancy materials; she affects childish tricks of surprised amazement. She romps, she babbles, she pretends flippancy, heedlessness, sprightliness.

[…]

The fact is that men are beginning to resign themselves to the new status of woman; and she, not feeling condemned in advance, has begun to feel more at ease. Today the woman who works is less neglectful of her femininity than formerly, and she does not lose her sexual attractiveness. This success, though already indicating progress toward equilibrium, is not yet complete; it continues to be more difficult for a woman than for a man to establish the relations with the other sex that she desires. Her erotic and affectional life encounters numerous difficulties. In this matter the unemancipated woman is in no way privileged: sexually and affectionally most wives and courtesans are deeply frustrated. If the difficulties are more evident in the case of the independent woman, it is because she has chosen battle rather than resignation. All the problems of life find a silent solution in death; a woman who is busy with living is therefore more at variance with herself than is she who buries her will and her desires; but the former will not take the latter as a standard. She considers herself at a disadvantage only in comparison with man.

A woman who expends her energy, who has responsibilities, who knows how harsh is the struggle against the world's opposition, needs—like the male—not only to satisfy her physical desires but also to enjoy the relaxation and diversion provided by agreeable sexual adventures. Now, there are still many social circles in which her freedom in this matter is not concretely recognized; if she exercises it, she risks compromising her reputation, her career; at the least a burdensome hypocrisy is demanded of her. The more solidly she establishes her position in society, the more ready people will be to close their eyes; but in provincial districts especially, she is watched with narrow severity, as a rule. Even under the most favorable circumstances—where fear of public opinion is negligible—her situation in this respect is not equivalent to man's. The differences depend both on traditional attitudes and on the special nature of feminine eroticism.

Man has easy access to fugitive embraces that are at the worst sufficient to calm his flesh and keep him in good spirits. There have been women—not many—prepared to demand that brothels for females be provided; in a novel entitled *Le-Numéro 17* a woman proposed the establishment of houses where women could resort for "sexual appeasement" through the services of "taxi-boys."[2] It appears that an establishment of this kind formerly existed in San Francisco; the customers were prostitutes, who were highly amused to pay instead of being paid. Their pimps had the place closed. Apart from the fact that this solution is chimerical and hardly desirable, it would doubtless meet with small success, for, as we have seen, woman does not obtain "appeasement" as mechanically as does

the male; most women consider the arrangement hardly conducive to voluptuous abandon. At any rate, this resource is unavailable today.

Another possible solution is to pick up in the street a partner for a night or an hour—supposing that the woman, being of passionate temperament and having overcome all her inhibitions, can contemplate it without disgust—but this solution is much more dangerous for her than for the male. The risk of venereal disease is graver, because it is the man who is responsible for taking precautions against infection; and, however careful she may be, the woman is never wholly protected against the danger of conception. But what is important above all in such relations between strangers—relations that are on a plane of brutality—is the difference in physical strength. A man has not much to fear from the woman he takes home with him; he merely needs to be reasonably on his guard. It is not the same with a woman who takes a man in. I was told of two young women, just arrived in Paris and eager to "see life," who, after a look around at night, invited two attractive Montmartre characters to supper. In the morning they found themselves robbed, beaten up, and threatened with blackmail. A more significant case is that of a woman of forty, divorced, who worked hard all day to support three children and her old parents. Still attractive, she had absolutely no time for social life, or for playing the coquette and going through the customary motions involved in getting an affair under way, which, besides, would have caused her too much bother. She had strong feelings, however, and she believed in her right to satisfy them. So she would occasionally roam the streets at night and manage to scare up a man. But one night, after spending an hour or two in a thicket in the Bois de Boulogne, her lover of the moment refused to let her go: he demanded her name and address, he wanted to see her again, to arrange to live together. When she refused, he gave her a severe beating and finally left her covered with bruises and almost frightened to death.

[...]

For most women—and men too—it is not a mere matter of satisfying erotic desire, but of maintaining their dignity as human beings while obtaining satisfaction. When a male enjoys a woman, when he gives her enjoyment, he takes the position of sole subject: he is imperious conqueror, or lavish donor—sometimes both at once. Woman, for her part, also wishes to make it clear that she subdues her partner to her pleasure and overwhelms him with her gifts. Thus, when she imposes herself on a man, be it through promised benefits, or in staking on his courtesy, or by artfully arousing his desire in its pure generality, she readily persuades herself that she is overwhelming him with her bounty. Thanks to this advantageous conviction, she can make advances without humiliating herself, because she feels she is doing so out of generosity. [...]

Inversely, if the woman who entraps a man likes to imagine that she is giving herself, she who does give herself wants it understood that she also takes. "As for me, I am a woman who takes," a young journalist told me one day. The truth of the matter is that, except in the case of rape, neither one really takes the other; but here woman doubly deceives herself. For in fact a man often does seduce through his fiery aggressiveness, actively winning the consent of his partner. Save exceptionally—Mme de Staël has already been mentioned as one instance—it is otherwise with woman: she can hardly do more than offer herself; for most men

are very jealous of their role. What they want is to arouse a specific excitement in the woman, not to be chosen as the means for satisfying her need in its generality: so chosen, they feel exploited. A very young man once said to me: "A woman who is not afraid of men frightens them." And I have often heard older men declare: "It horrifies me to have a woman take the initiative." If a woman offers herself too boldly, the man departs, for he is intent on conquering. Woman, therefore, can take only when she makes herself prey: she must become a passive thing, a promise of submission. If she succeeds, she will think that she performed this magic conjuration intentionally, she will be subject again. But she risks remaining in the status of unnecessary object if the male disdains her. This is why she is deeply humiliated when he rejects her advances. A man is sometimes angered when he feels that he has lost; however, he has only failed in an enterprise, nothing more. Whereas the woman has consented to make herself flesh in her agitation, her waiting, and her promises; she could win only in losing herself: she remains lost. One would have to be very blind or exceptionally clear-sighted to reconcile oneself to such a defeat.

And even when her effort at seduction succeeds, the victory is still ambiguous; the fact is that in common opinion it is the man who conquers, who *has* the woman. It is not admitted that she, like a man, can have desires of her own: she is the prey of desire. It is understood that man has made the specific forces a part of his personality, whereas woman is the slave of the species. She is represented, at one time, as pure passivity, available, open, a utensil; she yields gently to the spell of sex feeling, she is fascinated by the male, who picks her like a fruit. At another time she is regarded as if possessed by alien forces: there is a devil raging in her womb, a serpent lurks in her vagina, eager to devour the male's sperm.

In any case, there is a general refusal to think of her as simply free. Especially in France the free woman and the light woman are obstinately confused, the term *light* implying an absence of resistance and control, a lack, the very negation of liberty. [...] In America a certain liberty is recognized in woman's sexual activity, an attitude that tends to favor it. But the disdain for women who "go to bed" affected in France by even the men who enjoy their favors paralyzes a great many women who do not. They are horrified by the protests they would arouse, the comment they would cause, if they should.

[...]

If she is proud and demanding, woman meets the male as an adversary, and she is much less well armed than he is. In the first place, he has physical strength, and it is easy for him to impose his will; we have seen, also, that tension and activity suit his erotic nature, whereas when woman departs from passivity, she breaks the spell that brings on her enjoyment; if she mimics dominance in her postures and movements, she fails to reach the climax of pleasure: most women who cling to their pride become frigid. Lovers are rare who allow their mistresses to satisfy dominative or sadistic tendencies; and rarer still are women who gain full erotic satisfaction even from their docility.

There is a road which seems much less thorny for women: that of masochism. When one works all day, struggles, takes responsibilities and risks, it is a welcome relaxation to abandon oneself at night to vigorous caprices. Whether schooled in love or a tyro, woman does in fact very often enjoy annihilating herself for the benefit

of a masterful will. But it is still necessary for her to feel really dominated. It is not easy for one who lives her daily life among men to believe in the unconditional supremacy of the male. I have been told of the case of a woman who was not really masochistic but very "feminine"—that is, who found deep submissive pleasure in masculine arms. She had been married several times since she was seventeen and had had several lovers, always with much satisfaction. After having successfully managed an enterprise in the course of which she had men under her direction, she complained of having become frigid. There was formerly a blissful submission that she no longer felt, because she had become accustomed to dominating over males, and so their prestige had vanished.

When a woman begins to doubt men's superiority, their pretensions serve only to decrease her esteem for them. In bed, at the time when man would like to be most savagely male, he seems puerile from the very fact that he pretends virility, and woman averts her eyes; for he only conjures up the old complex of castration, the shadow of his father, or some such phantasm. It is not always from pride that a mistress refuses to yield to the caprices of her lover: she would fain have to do with an adult who is living out a real moment of his life, not with a little boy telling himself stories. The masochist is especially disappointed: a maternal compliance, annoyed or indulgent, is not the abdication she dreams of. She, too, will have to content herself with ridiculous games, pretending to believe herself dominated and enslaved, or she will pursue men supposed to be "superior" in the hope of finding a master, or she will become frigid.

We have seen that it is possible to avoid the temptations of sadism and masochism when the two partners recognize each other as equals; if both the man and the woman have a little modesty and some generosity, ideas of victory and defeat are abolished: the act of love becomes a free exchange. But, paradoxically, it is much more difficult for the woman than for the man to recognize an individual of the other sex as an equal. Precisely because the male caste has superiority of status, there are a great many individual women whom a man can hold in affectionate esteem: it is an easy matter to love a woman. In the first place, a woman can introduce her lover into a world that is different from his own and that he enjoys exploring in her company; she fascinates and amuses him, at least for a time. For another thing, on account of her restricted and subordinate situation, all her qualities seem like high achievements, conquests, whereas her mistakes are excusable; Stendhal admires Mme de Rênal and Mme de Chasteller in spite of their detestable prejudices. If a woman has false ideas, if she is not very intelligent, clear-sighted, or courageous, a man does not hold her responsible: she is the victim, he thinks—and often with reason—of her situation. He dreams of what she might have been, of what she perhaps will be: she can be credited with any possibilities, because she *is* nothing in particular. This vacancy is what makes the lover weary of her quickly; but it is the source of the mystery, the charm, that seduces him and makes him inclined to feel an easy affection in the first place.

It is much less easy for a woman to feel affectionate friendship for a man, for he *is* what he has made himself, irrevocably. He must be loved as he is, not with reference to his promise and his uncertain possibilities; he is responsible for his behavior and ideas; for him there are no excuses. Fellowship with him is impossible unless she approves his acts, his aims, his opinions. [...] Even though prepared

to compromise, woman will hardly be able to take an attitude of indulgence. For man opens to her no verdant paradise of childhood. She meets him in this world which is their world in common: he comes bearing the gift of himself only. Self-enclosed, definite, decided, he is not conducive to daydreaming; when he speaks, one must listen. He takes himself seriously: if he is not interesting, he bores her, his presence weighs heavily on her. Only very young men can be endued with facile marvels; one can seek mystery and promise in them, find excuses for them, take them lightly: which is one reason why mature women find them most seductive. The difficulty is that, for their part, they usually prefer young women. The woman of thirty is thrown back on adult males. And doubtless she will encounter among them some who will not discourage her esteem and friendship; but she will be lucky if they make no show of arrogance in the matter. When she contemplates an affair or an adventure involving her heart as well as her body, the problem is to find a man whom she can regard as an equal without his considering himself superior.

I will be told that in general women make no such fuss; they seize the occasion without asking themselves too many questions, and they manage somehow with their pride and their sensuality. True enough. But it is also true that they bury in their secret hearts many disappointments, humiliations, regrets, resentments, not commonly matched in men. From a more or less unsatisfactory affair a man is almost sure of obtaining at least the benefit of sex pleasure; a woman can very well obtain no benefit at all. Even when indifferent, she lends herself politely to the embrace at the decisive moment, sometimes only to find her lover impotent and herself compromised in a ridiculous mockery. If all goes well except that she fails to attain satisfaction, then she feels "used," "worked." If she finds full enjoyment, she will want to prolong the affair. She is rarely quite sincere when she claims to envisage no more than an isolated adventure undertaken merely for pleasure, because her pleasure, far from bringing deliverance, binds her to the man; separation wounds her even when supposedly a friendly parting. It is much more unusual to hear a woman speak amicably of a former lover than a man of his past mistresses.

The peculiar nature of her eroticism and the difficulties that beset a life of freedom urge woman toward monogamy. Liaison or marriage, however, can be reconciled with a career much less easily for her than for man. Sometimes her lover or husband asks her to renounce it: she hesitates, like Colette's Vagabonde, who ardently desires the warm presence of a man at her side but dreads the fetters of marriage. If she yields, she is once more a vassal; if she refuses, she condemns herself to a withering solitude. Today a man is usually willing to have his companion continue her work; the novels of Colette Yver, showing young women driven to sacrifice their professions for the sake of peace and the family, are rather outdated; living together is an enrichment for two free beings, and each finds security for his or her own independence in the occupation of the mate. The self-supporting wife emancipates her husband from the conjugal slavery that was the price of hers. If the man is scrupulously well-intentioned, such lovers and married couples attain in undemanding generosity a condition of perfect equality. It may even be the man that acts as devoted servant; thus, for George Eliot, Lewes created the favorable

atmosphere that the wife usually creates around the husband-overlord. But for the most part it is still the woman who bears the cost of domestic harmony.

To a man it seems natural that it should be the wife who does the housework and assumes alone the care and bringing up of the children. The independent woman herself considers that in marrying she has assumed duties from which her personal life does not exempt her. She does not want to feel that her husband is deprived of advantages he would have obtained if he had married a "true woman"; she wants to be presentable, a good housekeeper, a devoted mother, such as wives traditionally are. This is a task that easily becomes overwhelming. She assumes it through regard for her partner and out of fidelity to herself also, for she intends, as we have already seen, to be in no way unfaithful to her destiny as woman. She will be a double for her husband and at the same time she will be herself; she will assume his cares and participate in his successes as much as she will be concerned with her own fate—and sometimes even more. Reared in an atmosphere of respect for male superiority, she may still feel that it is for man to occupy the first place; sometimes she fears that in claiming it she would ruin her home; between the desire to assert herself and the desire for self-effacement she is torn and divided.

There is, however, an advantage that woman can gain from her very inferiority. Since she is from the start less favored by fortune than man, she does not feel that she is to blame a priori for what befalls him; it is not her duty to make amends for social injustice, and she is not asked to do so. A man of good will owes it to himself to treat women with consideration, since he is more favored by fate than they are; he will let himself be bound by scruples, by pity, and so runs the risk of becoming the prey of clinging, vampirish women from the very fact of their disarmed condition. The woman who achieves virile independence has the great privilege of carrying on her sexual life with individuals who are themselves autonomous and effective in action, who—as a rule—will not play a parasitic role in her life, who will not enchain her through their weakness and the exigency of their needs. But in truth the woman is rare who can create a free relation with her partner; she herself usually forges the chains with which he has no wish to load her: she takes toward him the attitude of the amoureuse, the woman in love.

Through twenty years of waiting, dreaming, hoping, the young girl has cherished the myth of the liberating savior-hero, and hence the independence she has won through work is not enough to abolish her desire for a glorious abdication. She would have had to be raised exactly like a boy to be able easily to overcome her adolescent narcissism; but as it is, she continues into adult life this cult of the ego toward which her whole youth has tended. She uses her professional successes as merits for the enrichment of her image; she feels the need for a witness from on high to reveal and consecrate her worth. Even if she is a severe judge of the men she evaluates in daily life, she none the less reveres Man, and if she encounters him, she is ready to fall on her knees.

To be justified by a god is easier than to justify herself by her own efforts; the world encourages her to believe it possible for salvation to be given, and she prefers to believe it. Sometimes she gives up her independence entirely and becomes no more than an amoureuse; more often she essays a compromise; but idolatrous love,

the love that means abdication, is devastating; it occupies every thought, every moment, it is obsessing, tyrannical. If she meets with professional disappointments, the woman passionately seeks refuge in her love; then her frustrations are expressed in scenes and demands at her lover's expense. But her amatory troubles have by no means the effect of redoubling her professional zeal; she is, on the contrary, more likely to be impatient with a mode of life that keeps her from the royal road of a great love. A woman who worked ten years ago on a political magazine run by women told me that in the office they seldom talked about politics but incessantly about love: this one complained that she was loved only for her body to the neglect of her splendid intelligence; that one moaned that only her mind was appreciated, to the neglect of her physical charms. Here again, for woman to love as man does—that is to say, in liberty, without putting her very *being* in question—she must believe herself his equal and be so in concrete fact; she must engage in her enterprises with the same decisiveness. But this is still uncommon, as we shall see.

There is one feminine function that it is actually almost impossible to perform in complete liberty. It is maternity. In England and America and some other countries a woman can at least decline maternity at will, thanks to contraceptive techniques. We have seen that in France she is often driven to painful and costly abortion; or she frequently finds herself responsible for an unwanted child that can ruin her professional life. If this is a heavy charge, it is because, inversely, custom does not allow a woman to procreate when she pleases. The unwed mother is a scandal to the community, and illegitimate birth is a stain on the child; only rarely is it possible to become a mother without accepting the chains of marriage or losing caste. If the idea of artificial insemination interests many women, it is not because they wish to avoid intercourse with a male; it is because they hope that freedom of maternity is going to be accepted by society at last. It must be said in addition that in spite of convenient day nurseries and kindergartens, having a child is enough to paralyze a woman's activity entirely; she can go on working only if she abandons it to relatives, friends, or servants. She is forced to choose between sterility, which is often felt as a painful frustration, and burdens hardly compatible with a career.

Thus the independent woman of today is torn between her professional interests and the problems of her sexual life; it is difficult for her to strike a balance between the two; if she does, it is at the price of concessions, sacrifices, acrobatics, which require her to be in a constant state of tension. Here, rather than in physiological data, must be sought the reason for the nervousness and the frailty often observed in her. It is difficult to determine to what extent woman's physical constitution handicaps her. Inquiry is often made, for example, about the obstacle presented by menstruation. Women who have made a reputation through their publications or other activities seem to attach little importance to it. Is this because, as a matter of fact, they owe their success to their relatively slight monthly indisposition? One may ask whether it is not because, on the contrary, their choice of an active and ambitious life has been responsible for this advantage; the interest woman takes in her maladies tends to aggravate them. Women in sports and other active careers suffer less from them than others, because they take little notice of them. There are certainly organic factors also, and I have seen the most energetic

women spend twenty-four hours in bed each month, a prey to pitiless tortures; but this difficulty never prevented their enterprises from succeeding.

[…]

These facts must not be lost sight of when we judge the professional accomplishments of woman and, on that basis, make bold to speculate on her future. She undertakes a career in a mentally harassing situation and while still under the personal burdens implied traditionally by her femininity. Nor are the objective circumstances more favorable to her. It is always difficult to be a newcomer, trying to break a path through a society that is hostile, or at least mistrustful. In *Black Boy* Richard Wright has shown how the ambitions of a young American Negro are blocked from the start and what a struggle he had merely in raising himself to the level where problems began to be posed for the whites. Negroes coming to France from Africa also find difficulties—with themselves as well as around them— similar to those confronting women.

[…]

What is extremely demoralizing for the woman who aims at self-sufficiency is the existence of other women of like social status, having at the start the same situation and the same opportunities, who live as parasites. A man may feel resentment toward the privileged, but he has solidarity with his class; on the whole, those who begin with equal chances reach about the same level in life. Whereas women of like situation may, through man's mediation, come to have very different fortunes. A comfortably married or supported friend is a temptation in the way of one who is intending to make her own success; she feels she is arbitrarily condemning herself to take the most difficult roads; at each obstacle she wonders whether it might not be better to take a different route. "When I think that I have to get everything by my own brain!" said one little poverty-stricken student to me, as if stunned by the thought. Man obeys an imperious necessity; woman must constantly reaffirm her intention. She goes forward not with her eyes fixed straight ahead on a goal, but with her glance wandering around her in every direction; and her gait is also timid and uncertain. The more she seems to be getting ahead on her own hook—as I have already pointed out—the more her other chances fade; in becoming a bluestocking, a woman of brains, she will make herself unattractive to men in general, or she will humiliate her husband or lover by being too outstanding a success. So she not only applies herself the more to making a show of elegance and frivolity, but also restrains her aspiration. The hope of being one day delivered from taking care of herself, and the fear of having to lose that hope if she assumes this care for a time, combine to prevent her from unreservedly applying herself to her studies and her career.

In so far as a woman wishes to be a woman, her independent status gives rise to an inferiority complex; on the other hand, her femininity makes her doubtful of her professional future. This is a point of great importance. We have seen that girls of fourteen declared to an investigator: "Boys are better than girls; they are better workers." The young girl is convinced that she has limited capacities. Because parents and teachers concede that the girls' level is lower than that of the boys, the pupils readily concede it also; and as a matter of fact, in spite of equal curricula, the girls' academic accomplishment in French secondary schools is much lower. Apart from some exceptions, all the members of a girls' class in philosophy, for

example, stand clearly below a boys' class. A great majority of the girl pupils do not intend to continue their studies, and work very superficially; the others lack the stimulus of emulation. In fairly easy examinations their incompetence will not be too evident, but in a serious competitive test the girl student will become aware of her weaknesses. She will attribute them not to the mediocrity of her training, but to the unjust curse of her femininity; by resigning herself to this inequality, she enhances it; she is persuaded that her chances of success can lie only in her patience and application; she resolves to be as economical as possible of her time and strength—surely a very bad plan.

[...]

In consequence of this defeatism, woman is easily reconciled to a moderate success; she does not dare to aim too high. Entering upon her profession with superficial preparation, she soon sets limits to her ambitions. It often seems to her meritorious enough if she earns her own living; she could have entrusted her lot, like many others, to a man. To continue in her wish for independence requires an effort in which she takes pride, but which exhausts her. It seems to her that she has done enough when she has chosen to do something. "That in itself is not too bad for a woman," she thinks. A woman practicing an unusual profession once said: "If I were a man, I should feel obliged to climb to the top; but I am the only woman in France to occupy such a position: that's enough for me." There is prudence in this modesty. Woman is afraid that in attempting to go farther she will break her back.

It must be said that the independent woman is justifiably disturbed by the idea that people do not have confidence in her. As a general rule, the superior caste is hostile to newcomers from the inferior caste: whites will not consult a Negro physician, nor males a woman doctor; but individuals of the inferior caste, imbued with a sense of their specific inferiority and often full of resentment toward one of their kind who has risen above their usual lot, will also prefer to turn to the masters. Most women, in particular, steeped in adoration for man, eagerly seek him out in the person of the doctor, the lawyer, the office manager, and so on. Neither men nor women like to be under a woman's orders. Her superiors, even if they esteem her highly, will always be somewhat condescending; to be a woman, if not a defect, is at least a peculiarity. Woman must constantly win the confidence that is not at first accorded her: at the start she is suspect, she has to prove herself. If she has worth she will pass the tests, so they say. But worth is not a given essence; it is the outcome of a successful development. To feel the weight of an unfavorable prejudice against one is only on very rare occasions a help in overcoming it. The initial inferiority complex ordinarily leads to a defense reaction in the form of an exaggerated affectation of authority.

Most women doctors, for example, have too much or too little of the air of authority. If they act naturally, they fail to take control, for their life as a whole disposes them rather to seduce than to command; the patient who likes to be dominated will be disappointed by plain advice simply given. Aware of this fact, the woman doctor assumes a grave accent, a peremptory tone; but then she lacks the bluff good nature that is the charm of the medical man who is sure of himself.

Man is accustomed to asserting himself; his clients believe in his competence; he can act naturally: he infallibly makes an impression. Woman does not inspire

the same feeling of security; she affects a lofty air, she drops it, she makes too much of it. In business, in administrative work, she is precise, fussy, quick to show aggressiveness. As in her studies, she lacks ease, dash, audacity. In the effort to achieve she gets tense. Her activity is a succession of challenges and self-affirmations This is the great defect that lack of assurance engenders: the subject cannot forget himself. He does not aim gallantly toward some goal: he seeks rather to make good in prescribed ways. In boldly setting out toward ends, one risks disappointments; but one also obtains unhoped-for results; caution condemns to mediocrity.

We rarely encounter in the independent woman a taste for adventure and for experience for its own sake, or a disinterested curiosity; she seeks "to have a career" as other women build a nest of happiness; she remains dominated, surrounded, by the male universe, she lacks the audacity to break through its ceiling, she does not passionately lose herself in her projects. She still regards her life as an immanent enterprise: her aim is not at an objective but, through the objective, at her subjective success. This is a very conspicuous attitude, for example, among American women; they like having a job and proving to themselves that they are capable of handling it properly; but they are not passionately concerned with the *content* of their tasks.

[...]

There is one category of women to whom these remarks do not apply because their careers, far from hindering the affirmation of their femininity, reinforce it. These are women who seek through artistic expression to transcend their given characteristics; they are the actresses, dancers, and singers. For three centuries they have been almost the only women to maintain a concrete independence in the midst of society, and at the present time they still occupy a privileged place in it. Formerly actresses were anathema to the Church, and the very excessiveness of that severity has always authorized a great freedom of behavior on their part. They often skirt the sphere of gallantry and, like courtesans, they spend a great deal of their time in the company of men; but making their own living and finding the meaning of their lives in their work, they escape the yoke of men. Their great advantage is that their professional successes—like those of men—contribute to their sexual valuation; in their self-realization, their validation of themselves as human beings, they find self-fulfillment as women: they are not torn between contradictory aspirations. On the contrary, they find in their occupations a justification of their narcissism; dress, beauty care, charm, form a part of their professional duties. It is a great satisfaction for a woman in love with her own image to *do* something in simply exhibiting what she *is;* and this exhibition at the same time demands enough study and artifice to appear to be [...] a substitute for action. A great actress will aim higher yet: she will go beyond the given by the way she expresses it; she will be truly an artist, a creator, who gives meaning to her life by lending meaning to the world.

These are rare advantages, but they also hide traps: instead of integrating her narcissistic self-indulgence and her sexual liberty with her artistic life, the actress very often sinks into self-worship or into gallantry; I have already referred to those pseudo-artists who seek in the movies or in the theater only to make a name for themselves that represents capital to exploit in men's arms. The conveniences of masculine support are very tempting in comparison with the risks of a career and

with the discipline implied by all real work. Desire for a feminine destiny—husband, home, children—and the enchantment of love are not always easy to reconcile with the will to succeed. But, above all, the admiration she feels for her ego in many cases limits the achievement of an actress; she has such illusions regarding the value of her mere presence that serious work seems useless. She is concerned above all to put herself in the public eye and sacrifices the character she is interpreting to this theatrical quackery. She also lacks the generous-mindedness to forget herself, and this deprives her of the possibility of going beyond herself; rare indeed are the Rachels, the Duses, who avoid this reef and make their persons the instruments of their art instead of seeing in art a servant of their egos. In her private life, moreover, the bad actress will exaggerate all the narcissistic defects: she will reveal herself as vain, petulant, theatric; she will consider all the world a stage.

Today the expressive arts are not the only ones open to women; many are essaying various creative activities. Woman's situation inclines her to seek salvation in literature and art. Living marginally to the masculine world, she sees it not in its universal form but from her special point of view. For her it is no conglomeration of implements and concepts, but a source of sensations and emotions; her interest in the qualities of things is drawn by the gratuitous and hidden elements in them. Taking an attitude of negation and denial she is not absorbed in the real: she protests against it, with words. She seeks through nature for the image of her soul, she abandons herself to reveries, she wishes to attain her *being*—but she is doomed to frustration; she can recover it only in the region of the imaginary. To prevent an inner life that has no *useful* purpose from sinking into nothingness, to assert herself against given conditions which she bears rebelliously, to create a world other than that in which she fails to attain her being, she must resort to *self-expression*. Then, too, it is well known that she is a chatterer and a scribbler; she unbosoms herself in conversations, in letters, in intimate diaries. With a little ambition, she will be found writing her memoirs, making her biography into a novel, breathing forth her feelings in poems. The vast leisure she enjoys is most favorable to such activities.

But the very circumstances that turn woman to creative work are also obstacles she will very often be incapable of surmounting. When she decides to paint or write merely to fill her empty days, painting and essays will be treated as fancy work; she will devote no more time or care to them, and they will have about the same value. It is often at the menopause that woman decides to take brush or pen in hand to compensate for the defects in her existence; but it is rather late in the day, and for lack of serious training she will never be more than amateurish. Even if she begins fairly early, she seldom envisages art as serious work; accustomed to idleness, having never felt in her mode of life the austere necessity of discipline, she will not be capable of sustained and persistent effort, she will never succeed in gaining a solid technique. She is repelled by the thankless, solitary gropings of work that never sees the light of day, that must be destroyed and done over a hundred times; and as from infancy she has been taught trickery when learning to please, she hopes to "get by" through the use of a few stratagems. [...] Woman is ready enough to *play* at working, but she does not work; believing in the magic virtues of passivity, she confuses incantations and acts, symbolic gestures and effective

behavior. She masquerades as a Beaux-Arts student, she arms herself with her battery of brushes; as she sits before her easel, her eye wanders from the white cloth to her mirror; but the bunch of flowers or the bowl of apples is not going to appear on the canvas of its own accord. Seated at her desk, turning over vague stories in her mind, woman enjoys the easy pretense that she is a writer; but she must come to the actual putting of black marks on white paper, she must give them a meaning in the eyes of others. Then the cheating is exposed. In order to please, it is enough to create mirages; but a work of art is not a mirage, it is a solid object; in order to fashion it, one must know one's business.

It is not because of her gifts and her temperament alone that Colette became a great writer; her pen has often been her means of support, and she has had to have from it the same good work that an artisan expects from his tools. Between *Claudine* and *Naissance du jour* the amateur became a professional, and that transition brilliantly demonstrates the benefits of a severe period of training. Most women, however, fail to realize the problems posed by their desire for communication; and that is what in large part explains their laziness. They always regard themselves as given; they believe that their merits derive from an immanent grace and do not imagine that worth can be acquired by conquest. In order to seduce, they know only the method of showing themselves; then their charm either works or does not work, they have no real hand in its success or failure. They suppose that in analogous fashion it is sufficient for expression, communication, to show what one is; instead of elaborating their work with reflective effort, they rely on spontaneity. Writing or smiling is all one to them; they try their luck, success will come or it will not come. If they are sure of themselves, they take for granted that the book or picture will be a success without effort; if timid, they are discouraged by the least criticism. They are unaware that error may open the way of progress, considering it an irreparable catastrophe, like a malformation. This is why they often show a disastrous petulance: they recognize their faults only with irritation and discouragement instead of learning profitable lessons from them.

[...]

Thus, of the legion of women who toy with arts and letters, very few persevere; and even those who pass this first obstacle will very often continue to be torn between their narcissism and an inferiority complex. Inability to forget themselves is a defect that will weigh more heavily upon them than upon women in any other career, if their essential aim is the abstract affirmation of self, the formal satisfaction of success, they will not give themselves over to the contemplation of the world: they will be incapable of re-creating it in art. Marie Bashkirtsev decided to paint because she wished to become famous; her obsession with fame comes between her and reality. She really does not like to paint: art is only a means; it is not her ambitious and hollow dreams that will reveal to her the import of a color or a face. Instead of giving herself generously to a work she undertakes, woman too often considers it simply as an adornment of her life; the book and the picture are merely some of her inessential means for exhibiting in public that essential reality: her own self. Moreover, it is her own self that is the principal—sometimes the unique—subject of interest to her: Mme Vigée-Lebrun never wearied of putting her smiling maternity on her canvases. The woman writer will still be speaking of herself even when she is speaking about general topics: one cannot read certain

theatrical comment without being informed about the figure and corpulence of its author, on the color of her hair, and the peculiarities of her character.

To be sure, the ego is not always odious. Few books are more thrilling than certain confessions, but they must be honest, and the author must have something to confess. Woman's narcissism impoverishes her instead of enriching her; by dint of doing nothing but contemplate herself, she annihilates herself; even her self-love is stereotyped: she reveals in her writings not her genuine experience, but an imaginary idol built up with clichés. One could hardly reproach her with projecting herself in her novels as did Constant, or Stendhal; but the trouble is that she too often sees her history as a silly fairy tale. With the aid of imaginings the young girl hides from herself the reality that frightens her with its crudity, but it is deplorable that when grown to woman she still immerses the world, her characters, and herself in poetic mists. [...]

It is natural enough for woman to attempt escape from this world where she often feels slighted and misunderstood; but one regrets only that she does not venture upon the audacious flights of a Gérard de Nerval, an Edgar Allan Poe. There are many good reasons for her timidity. To please is her first care; and often she fears she will be displeasing as a woman from the mere fact that she writes; the term *bluestocking*, though threadbare, continues to have disagreeable connotations; she lacks, further, the courage to be displeasing as a writer. The writer of originality, unless dead, is always shocking, scandalous; novelty disturbs and repels. Woman is still astonished and flattered at being admitted to the world of thought, of art—a masculine world. She is on her best behavior; she is afraid to disarrange, to investigate, to explode; she feels she should seek pardon for her literary pretensions through her modesty and good taste. She stakes on the reliable values of conformity; she gives literature precisely that personal tone which is expected of her, reminding us that she is a woman by a few well-chosen graces, affectations, and preciosities. All this helps her excel in the production of best-sellers; but we must not look to her for adventuring along strange ways.

Not that these independent women lack originality in behavior or feelings; on the contrary, some are so singular that they should be locked up; all in all, many of them are more whimsical, more eccentric, than the men whose discipline they reject. But they exercise their genius for oddity in their mode of life, their conversation, and their correspondence; if they undertake to write, they feel overwhelmed by the universe of culture, because it is a universe of men, and so they can only stammer. On the other hand, the woman who may choose to reason, to express herself, in accordance with masculine techniques, will be bent on stifling an originality that she has cause to mistrust; like the woman student, she is very prone to be studious and pedantic; she will imitate male rigor and vigor. She can become an excellent theoretician, can acquire real competence; but she will be forced to repudiate whatever she has in her that is "different." There are women who are mad and there are women of sound method: none has that madness in her method that we call genius.

It is, above all, this reasonable modesty that has hitherto set the limits of feminine talent. Many women have avoided—and now they avoid more and more—the traps of narcissism and false magic; but none have ever trampled upon all prudence in the attempt to *emerge* beyond the given world. In the first place,

there are, of course, many who accept society just as it is; they are pre-eminently the poetesses of the bourgeoisie since they represent the most conservative element in this threatened class. With well-chosen adjectives they evoke the refinements of a civilization referred to as one of "quality"; they exalt the middle-class ideal of well-being and disguise the interests of their class in poetic colors; they orchestrate the grand mystification intended to persuade women to "stay womanly." Ancient houses, sheepfolds and kitchen gardens, picturesque old folks, roguish children, washing, preserving, family parties, toilettes, drawing-rooms, balls, unhappy but exemplary wives, the beauty of devotion and sacrifice, the small discontents and great joys of conjugal love, dreams of youth, the resignation of maturity—these themes the women novelists of England, France, America, Canada, and Scandinavia have exploited to their very dregs; they have thus gained fame and wealth, but have surely not enriched our vision of the world.

Much more interesting are the insurgent females who have challenged this unjust society; a literature of protest can engender sincere and powerful works; out of the well of her revolt George Eliot drew a vision of Victorian England that was at once detailed and dramatic; still, as Virginia Woolf has made us see, Jane Austen, the Brontë sisters, George Eliot, have had to expend so much energy negatively in order to free themselves from outward restraints that they arrive somewhat out of breath at the stage from which masculine writers of great scope take their departure; they do not have enough strength left to profit by their victory and break all the ropes that hold them back. We do not find in them, for example, the irony, the ease of a Stendhal, nor his calm sincerity. Nor have they had the richness of experience of a Dostoyevsky, a Tolstoy: this explains why the splendid *Middlemarch* still is not the equal of *War and Peace*; *Wuthering Heights*, in spite of its grandeur, does not have the sweep of *The Brothers Karamazov*.

Today it is already less difficult for women to assert themselves; but they have not as yet completely overcome the agelong sex-limitation that has isolated them in their femininity. Lucidity of mind, for instance, is a conquest of which they are justly proud but with which alone they would be a little too quickly satisfied. The fact is that the traditional woman is a bamboozled conscious being and a practitioner of bamboozlement; she attempts to disguise her dependence from herself, which is a way of consenting to it. To expose this dependence is in itself a liberation; a clear-sighted cynicism is a defense against humiliations and shame: it is the preliminary sketch of an assumption. By aspiring to clear-sightedness women writers are doing the cause of women a great service; but—usually without realizing it—they are still too concerned with serving this cause to assume the disinterested attitude toward the universe that opens the widest horizons. When they have removed the veils of illusion and deception, they think they have done enough; but this negative audacity leaves us still faced by an enigma, for the truth itself is ambiguity, abyss, mystery: once stated, it must be thoughtfully reconsidered, re-created. It is all very well not to be duped, but at that point all else begins. Woman exhausts her courage dissipating mirages and she stops in terror at the threshold of reality.

It is for this reason that there are, for example, sincere and engaging feminine autobiographies; but none can compare with Rousseau's *Confessions* and Stendhal's *Souvenirs d'égotisme*. We are still too preoccupied with clearly seeing the facts to

try to penetrate the shadows beyond that illuminated circle. "Women never go beyond appearances," said a writer to me. It is true enough. Still amazed at being allowed to explore the phenomena of this world, they take inventory without trying to discover meanings. Where they sometimes excel is in the observation of facts, what is given. They make remarkable reporters; no male journalist has surpassed, for example, Andrée Viollis's reports on Indochina and India. Women are able to describe atmosphere and characters, to indicate subtle relationships between the latter, to make us share in the secret stirrings of their souls. Willa Cather, Edith Wharton, Dorothy Parker, Katherine Mansfield, have clearly and sensitively evoked individuals, regions, civilizations. They rarely create masculine heroes as convincing as Heathcliffe: in man they comprehend hardly more than the male. But they have often aptly described their own inner life, their experience, their own universe; attentive to the hidden substance of things, fascinated by the peculiarities of their own sensations, they present their experience, still warm, through savory adjectives and carnal figures of speech. Their vocabulary is often more notable than their syntax because they are interested in things rather than in the relations of things; they do not aim at abstract elegance, but in compensation their words speak directly to the senses.

Nature is one of the realms they have most lovingly explored. For the young girl, for the woman who has not fully abdicated, nature represents what woman herself represents for man: herself and her negation, a kingdom and a place of exile; the whole in the guise of the other. It is when she speaks of moors and gardens that the woman novelist will reveal her experience and her dreams to us most intimately. Many of them enclose the miracles of sap and season in kettles, vases, garden beds; others do not imprison plants and animals but still endeavor to make them their own through close and loving observation, like Colette or Katherine Mansfield. Few indeed there are who face nature in its nonhuman freedom, who attempt to decipher its foreign meanings, and who lose themselves in order to make union with this other presence: hardly any save Emily Brontë, Virginia Woolf, and Mary Webb at times, venture along those roads Rousseau discovered.

With still more reason we can count on the fingers of one hand the women who have traversed the given in search of its secret dimension: Emily Brontë has questioned death, Virginia Woolf life, and Katherine Mansfield—not very often—everyday contingence and suffering. No woman wrote *The Trial*, *Moby Dick*, *Ulysses*, or *The Seven Pillars of Wisdom*. Women do not contest the human situation, because they have hardly begun to assume it. This explains why their works for the most part lack metaphysical resonances and also anger; they do not take the world incidentally, they do not ask it questions, they do not expose its contradictions: they take it as it is too seriously. It should be said that the majority of men have the same limitations; it is when we compare the woman of achievement with the few rare male artists who deserve to be called "great men" that she seems mediocre. It is not a special destiny that limits her: we can readily comprehend why it has not been vouchsafed her—and may not be vouchsafed her for some time—to attain to the loftiest summits.

Art, literature, philosophy, are attempts to found the world anew on a human liberty: that of the individual creator; to entertain such a pretension, one must first unequivocally assume the status of a being who has liberty. The restrictions

that education and custom impose on woman now limit her grasp on the universe; when the struggle to find one's place in this world is too arduous, there can be no question of getting away from it. Now, one must first emerge from it into a sovereign solitude if one wants to try to regain a grasp upon it: what woman needs first of all is to undertake, in anguish and pride, her apprenticeship in abandonment and transcendence: that is, in liberty.

Notes

1 If that is the word.– TR.
2 The author—whose name I have forgotten, a slip that I see no urgent need of repairing—explains at length how they could be prepared to satisfy all kinds of clients, what regimen they should follow, and so on.

Teresa de Lauretis

UPPING THE ANTI (*SIC*) IN
FEMINIST THEORY

EDITOR'S INTRODUCTION

DE LAURETIS'S ESSAY contributes to the important if now somewhat muted
feminist debate over 'essentialism'. I say 'now somewhat muted' because this
was a debate which raged in theory circles during the 1980s at the point when
one form of feminism (that aimed basically at consolidating women's identities
in terms independent of patriarchy – see the de Beauvoir piece above) gave way
to another (that aimed at opening out possibilities beyond identity-politics). But
it's an essay which I think is worth reading and rereading because this problem
remains at the core of all political and cultural analysis pursued in the interest
of the liberation of a particular social group defined around an 'identity' (rather
than say a structural position, like 'the poor' or 'the old' which needn't involve
content-filled identities at all.)

The debate arose because, for structuralist and post-structuralist thought,
identity is always articulated within a system of differences and is therefore never
fixed. To take a concrete example: a signifier like 'women' which is important
to forming identities (in statements like 'I am a woman') does not, for instance,
refer transparently to a particular kind of body – as if that kind of body were
the essence of 'being-woman'. After all, individuals who do not have a woman's
body can still possess a woman's identity, and structuralists argue that this is
possible just because 'woman' means something, not in relation to any essential
quality of womanhood, but in distinction to other categories like, most obviously
'maleness'.

The debate between essentialists and (post)structuralists had been productively
elaborated during the 1970s, but, in this essay, de Lauretis proposed a new move.
She turns towards what she calls feminism's 'essential differences'. This phrase

brings both sides of the debate together, not in the spirit of synthesis, but to point to the structure of differences in which feminism carries out its work. Feminism's 'essential difference' is to be found in its 'historical specificity' and in the sites, bodies, discourses in and through which women live differently both from men and from each other. De Lauretis further suggests that analysis of feminism's historical specificity has to begin its work not with a category as unnuanced as 'woman' but with the more subtle one of the 'female-embodied social subject'.

By suggesting we might return to the history and cultural formations in which 'women' are constructed, de Lauretis is not so much depriving cultural studies of feminist theory as using cultural studies to make theory less routine.

In a later essay (de Lauretis 1991), which drew upon the theory outlined here to move beyond feminism, de Lauretis coined the phrase 'queer theory' in order to point out the 'difference' – the specificity and disruptiveness – of identities embodied in sexual (and racial) minorities. Though de Lauretis herself abandoned the term 'queer', as it became mainstreamed, this essay can be read as establishing a basis, within feminism, for queer theory itself.

Further reading: Butler 1991 and 2004; de Lauretis 1991 and 1994; Fuss 1989; Gallop 1982; Jardine 1985; Kolmar and Bartkowski 2003; McCann and Kim 2002; Mohanty 2003.

Essentialism and anti-essentialism

Nowadays, the term *essentialism* covers a range of metacritical meanings and strategic uses that go the very short distance from convenient label to buzzword. Many who, like myself, have been involved with feminist critical theory for some time, and who did use the term, initially, as a serious critical concept, have grown impatient with this word – essentialism – time and again repeated with its reductive ring, its self-righteous tone of superiority, its contempt for 'them' – those guilty of it. Yet, few would deny that feminist theory is all about an essential difference, an irreducible difference, though not a difference between woman and man, nor a difference inherent in 'woman's nature' (in woman as nature), but a difference in the feminist conception of woman, women, and the world.

Let us say, then, that there is an essential difference between a feminist and a non-feminist understanding of the subject and its relation to institutions; between feminist and non-feminist knowledges, discourses, and practices of cultural forms, social relations, and subjective processes; between a feminist and a non-feminist historical consciousness. That difference is essential in that it is constitutive of feminist thinking and thus of feminism: it is what makes the thinking feminist, and what constitutes certain ways of thinking, certain practices of writing, reading, imaging, relating, acting, etc., into the historically diverse and culturally heterogeneous social movement which, qualifiers and distinctions notwithstanding, we continue with good reasons to call feminism. Another way to say this is that the essential difference of feminism lies in its historical specificity – the particular conditions of its emergence and development, which have shaped its object and field of

analysis, its assumptions and forms of address; the constraints that have attended its conceptual and methodological struggles; the erotic component of its political self-awareness; the absolute novelty of its radical challenge to social life itself.

But even as the specific, essential difference of feminism may not be disputed, the question of the nature of its specificity or what is of the essence in feminist thought and self-representation has been an object of contention, an issue over which divisions, debates, and polarizations have occurred consistently, and without resolution, since the beginning of that self-conscious critical reflection that constitutes the theory of feminism. The currency of the term 'essentialism' may be based on nothing more than its capacity to circumvent this very question – the nature of the specific difference of feminism – and thus to polarize feminist thought on what amounts to a red herring. I suggest that the current enterprise of 'anti-essentialist' theorists engaged in typologizing, defining and branding various 'feminisms' along an ascending scale of theoretico-political sophistication where 'essentialism' weighs heavy at the lower end, may be seen in this perspective.

This is not to say that there should be no critique of feminist positions or no contest for the practical as well as the theoretical meanings of feminism, or even no appeal for hegemony by participants in a social movement which, after all, potentially involves all women. My polemical point here is that either too much or too little is made of the 'essentialism' imputed to most feminist positions (notably those labelled cultural, separatist or radical, but others as well, whether labelled or not), so that the term serves less the purposes of effective criticism in the ongoing elaboration of feminist theory than those of convenience, conceptual simplification or academic legitimation. Taking a more discerning look at the *essence* that is in question in both *essentialism* and *essential difference*, therefore, seems like a very good idea.

Among the several acceptations of 'essence' (from which 'essentialism' is apparently derived) in the *OED*, the most pertinent to the context of use that is in question here are the following:

> 1. Absolute being, substance in the metaphysical sense; the reality underlying phenomena.
> 2. That which constitutes the being of a thing; that 'by which it is what it is'. In two different applications (distinguished by Locke as *nominal essence* and *real essence* respectively):
> a. of a conceptual entity: The totality of the properties, constituent elements, etc., without which it would cease to be the same thing; the indispensable and necessary attributes of a thing as opposed to those which it may have or not ...
> b. of a real entity: Objective character, intrinsic nature as a 'thing-in-itself'; 'that internal constitution, on which all the sensible properties depend'.

Examples of (*a*), dated from 1600 to 1870, include Locke's statement in the *Essay on Human Understanding*: 'The Essence of a Triangle, lies in a very little compass ... three Lines meeting at three Angles, make up that Essence'; and all the examples given for (*b*), from 1667 to 1856, are to the effect that the essence of a real entity, the 'thing-in-itself', is either unknown or unknowable.

Which of these 'essences' are imputed to feminist 'essentialists' by their critics? If most feminists, however one may classify trends and positions – cultural, radical, liberal, socialist, post-structuralist and so forth – agree that women are made, not born, that gender is not an innate feature (as sex may be) but a socio-cultural construction (and precisely for that reason it is oppressive to women), that patriarchy is historical (especially so when it is believed to have superseded a previous matriarchal realm), then the 'essence' of woman that is described in the writings of many so-called essentialists is not the *real essence*, in Locke's terms, but more likely a *nominal* one. It is a totality of qualities, properties, and attributes that such feminists define, envisage, or enact for themselves (and some in fact attempt to live out in 'separatist' communities), and possibly also wish for other women. This is more a project, then, than a description of existent reality; it is an admittedly feminist project of 're-vision', where the specifications *feminist* and revision already signal its historical location, even as the (re)vision projects itself outward geographically and temporally (universally) to recover the past and to claim the future. This may be utopian, idealist, perhaps misguided or wishful thinking, it may be a project one does not want to be a part of, but it is not essentialist as is the belief in a God-given or otherwise immutable nature of woman.

In other words, barring the case in which woman's 'essence' is taken as absolute being or substance in the traditional metaphysical sense (and this may actually be the case for a few, truly fundamentalist thinkers to whom the term essentialist would properly apply), for the great majority of feminists the 'essence' of woman is more like the essence of the triangle than the essence of the thing-in-itself: it is the specific properties (e.g., a female-sexed body), qualities (a disposition to nurturance, a certain relation to the body, etc.), or necessary attributes (e.g., the experience of femaleness, of living in the world as female) that women have developed or have been bound to historically, in their differently patriarchal sociocultural contexts, which make them women, and not men. One may prefer one triangle, one definition of women and/or feminism, to another and, within her particular conditions and possibilities of existence, struggle to define the triangle she wants or wants to be – feminists do want differently. And in these very struggles, I suggest, consist the historical development and the specific difference of feminist theory, the essence of the triangle.

It would be difficult to explain, otherwise, why thinkers or writers with political and personal histories, projects, needs, and desires as different as those of white women and women of colour, of lesbians and heterosexuals, of differently abled women, and of successive generations of women, would all claim feminism as a major – if not the only – ground of difference; why they would address both their critiques or accusations and their demands for recognition to other women, feminists in particular; why the emotional and political stakes in feminist theorizing should be so high, dialogue so charged, and confrontation so impassioned; why, indeed, the proliferation of typologies and the wide currency of 'essentialism' on one hand, countered by the equally wide currency of the term 'male theory' on the other. It is one of the projects of this paper to up the *anti* in feminist theoretical debates, to shift the focus of the controversy from 'feminist essentialism', as a category by which to classify feminists or feminisms, to the historical specificity, the essential difference of feminist theory itself. To this end I first turn to two essays which

prompted my reflection on the uses of 'essentialism' in current Anglo-American feminist critical writing, Chris Weedon's *Feminist Practice and Poststructuralist Theory*, published in London in 1987, and Linda Alcoff's 'Cultural feminism versus post-structuralism: the identity crisis in feminist theory', published in the spring 1988 issue of *Signs*. Then I will go on to argue that the essential difference of feminist theory must be looked for in the form as well as the contents of its political, personal, critical, and textual practices, in the diverse oppositional stances feminism has taken *vis-à-vis* social and cultural formations, and in the resulting divisions, self-conscious reflection, and conceptual elaboration that constitute the effective history of feminism. And thus a division such as the one over the issue of 'essentialism' only *seems* to be a purely 'internal', intra-feminist one, a conflict within feminism. In fact, it is not.

The notion of an 'essential womanhood, common to all women, suppressed or repressed by patriarchy' recurs in Weedon's book as the mark of 'radical-feminist theory', whose cited representatives are Mary Daly, Susan Griffin, and Adrienne Rich. 'Radical feminist theory' is initially listed together with 'socialist feminist and psychoanalytic feminist theories' as 'various attempts to systematize individual insights about the oppression of women into relatively coherent theories of patriarchy', in spite of the author's statement, on the same page, that radical feminist writers are hostile to theory because they see it as a form of male dominance which co-opts women and suppresses the feminine (Weedon 1987: 6). As one reads on, however, socialist feminism drops out altogether while psychoanalytic feminism is integrated into a new and more 'politically' sophisticated discourse called 'feminist poststructuralism'. Thus, three-fourths of the way through the book, one finds this summary statement:

> For poststructuralist feminism, neither the liberal-feminist attempt to redefine the truth of women's nature within the terms of existing social relations and to establish women's full equality with men, nor the radical-feminist emphasis on fixed difference, realized in a separatist context, is politically adequate. Poststructuralist feminism requires attention to historical specificity in the production, for women, of subject positions and modes of femininity and their place in the overall network of social power relations. In this the meaning of biological sexual difference is never finally fixed ... An understanding of how discourses of biological sexual difference are mobilized, in a particular society, at a particular moment, is the first stage in intervening in order to initiate change.
>
> (1987: 135)

There is more than simple irony in the claim that this late-comer, post-structuralist feminism, dark horse and winner of the feminist theory contest, is the 'first stage' of feminist intervention. How can Weedon, at one and the same time, so strongly insist on attention to historical specificity and social — not merely individual — change, and yet disregard the actual historical changes in Western culture brought about in part, at least, by the women's movement and at least in some measure by feminist critical writing over the past twenty years?

One could surmise that Weedon does not like the changes that have taken place (even as they allow the very writing and publication of her book), or does not consider them sufficient, though that would hardly be reason enough to disregard them so blatantly. A more subtle answer may lie in the apologetic and militant project of her book, a defence of post-structuralism *vis-à-vis* both the academic establishment and the general educated reader, but with an eye to the women's studies corner of the publishing market; whence, one must infer, the lead position in the title of the other term of the couple, feminist practice. For, as the Preface states, 'the aim of this book is to make poststructuralist theory accessible to readers to whom it is unfamiliar, to argue its political usefulness to feminism and to consider its implications for feminist critical practice' (p. vii). Somehow, however, in the course of the book, the Preface's modest claim 'to point to a possible direction for future feminist cultural criticism' (p. vii) is escalated into a peroration for the new and much improved feminist theory called feminist post-structuralism or, indifferently, post-structural feminism.

In the concluding chapter on 'Feminist critical practice' (strangely in the singular, as if among so many feminisms and feminist theories, only one practice could properly be called both feminist and critical), the academic contenders are narrowed down to two. The first is the post-structural criticism produced by British feminists (two are mentioned, E. Ann Kaplan and Rosalind Coward) looking 'at the mechanisms through which meaning is constructed' mainly in popular culture and visual representation; the second is 'the other influential branch of feminist criticism [that] looks to fiction as an expression of an already constituted gendered experience' (p. 152). Reappearing here, the word 'experience', identified earlier on as the basis for radical feminist politics ('many feminists assume that women's experience, unmediated by further theory, is the source of true knowledge', p. 8), links this second branch of feminist (literary) criticism to radical feminist ideology. Its standard-bearers are Americans, Showalter's gynocritics and the 'woman-centred criticism' of Gilbert and Gubar, whose reliance on the concept of authorship as a key to meaning and truth also links them with 'liberal-humanist criticism' (pp. 154–5).

A particular subset of this – by now radical liberal – feminist criticism 'dedicated to constructing traditions' (p. 156) is the one concerned with 'black and lesbian female experience'; here the problems and ideological traps appear most clearly, in Weedon's eyes, and are 'most extreme in the case of lesbian writing and the construction of a lesbian aesthetic' (p. 158). The reference works for her analysis, rather surprisingly in view of the abundance of Black and lesbian feminist writings in the 1980s, are a couple of rather dated essays by Barbara Smith and Bonnie Zimmerman reprinted in a collection edited by Elaine Showalter and, in fact, misnamed *The* New *Feminist Criticism*. But even more surprisingly – or not at all so, depending on one's degree of optimism – it is again post-structuralist criticism that, with the help of Derridean deconstruction, can set all of these writers straight, as it were, as to the real, socially constructed and discursively produced nature of gender, race, class, and sexuality – as well as authorship and experience! Too bad for us that no exemplary post-structuralist feminist works or critics are discussed in this context (Cixous, Kristeva, and Irigaray figure prominently, but as psychoanalytic feminists earlier in the book).

Now, I should like to make it clear that I have no quarrel with post-structuralism as such, or with the fundamental importance for all critical thinking, feminist theory included, or many of the concepts admirably summarized by Weedon in passages such as the following:

> For a theoretical perspective to be politically useful to feminism, it should be able to recognize the importance of the *subjective* in constituting the meaning of women's lived reality. It should not deny subjective experience, since the ways in which people make sense of their lives is a necessary starting point for understanding how power relations structure society. Theory must be able to address women's experience by showing where it comes from and how it relates to material social practices and the power relations which structure them ...
> In this process subjectivity becomes available, offering the individual both a perspective and a choice, and opening up the possibility of political change.
>
> (1987: 8–9)

But while I am in complete agreement that experience is a difficult, ambiguous, and often oversimplified term, and that feminist theory needs to elaborate further 'the relationship between experience, social power and resistance' (p. 8), I would insist that the notion of experience in relation both to social-material practices and to the formation and processes of subjectivity is a feminist concept, not a post-structuralist one (this is an instance of that essential difference of feminism which I want to reclaim from Weedon's all-encompassing 'poststructuralism'), and would be still unthinkable were it not for specifically feminist practices, political, critical, and textual: consciousness raising, the rereading and revision of the canon, the critique of scientific discourses, and the imaging of new social spaces and forms of community. In short, the very practices of those feminist critics Weedon allocates to the 'essentialist' camp. I would also add that 'a theory of the relationship between experience, social power and resistance' is precisely one possible definition of feminist, not of post-structuralist, theory, as Weedon would have it, since the latter does not countenance the notion of experience within its conceptual horizon or philosophical presuppositions; and that, moreover, these issues have been posed and argued by several non-denominational feminist theories in the United States for quite some time: for example, in the works of Biddy Martin, Nancy K. Miller, Tania Modleski, Mary Russo, Kaja Silverman as well as myself, and even more forcefully in the works of feminist theorists and writers of colour such as Gloria Anzaldúa, Audre Lorde, Chandra Mohanty, Cherríe Moraga, and Barbara Smith.

So my quarrel with Weedon's book is about its reductive opposition – all the more remarkable coming from a proponent of deconstruction – of a *lumpen* feminist essentialism (radical-liberal-separatist and American) to a phantom feminist post-structuralism (critical-socialist-psychoanalytic and Franco-British), and with the by-products of such a *parti-pris*: the canonization of a few (in)famous feminists as signposts of the convenient categories set up by the typology, the agonistic narrative structure of its account of 'feminist theories', and finally its failure to contribute to the elaboration of feminist critical thought, however useful the book

may be to its other intended readers, who can thus rest easy in the fantasy that post-structuralism is the theory and feminism is just a practice.

The title of Alcoff's essay, 'Cultural feminism versus post-structuralism: the identity crisis in feminist theory', bespeaks some of the same problems: a manner of thinking by mutually oppositional categories, an agonistic frame of argumentation, and a focus on division, a 'crisis in feminist theory' that may be read not only as a crisis *over* identity, a metacritical doubt and a dispute among feminists as to the notion of identity, but also as a crisis *of* identity, of self-definition, implying a theoretical impasse for feminism as a whole. The essay, however, is more discerning, goes much further than its title suggests, and even contradicts it in the end, as the notion of identity, far from fixing the point of an impasse, becomes an active shifter in the feminist discourse of woman.

Taking as its starting point 'the concept of woman', or rather, its redefinition in feminist theory ('the dilemma facing feminist theorists today is that our very self-definition is grounded in a concept that we must deconstruct and de-essentialize in all of its aspects'), Alcoff finds two major categories of responses to the dilemma, or what I would call the paradox of woman (Alcoff 1988: 406). Cultural feminists, she claims, 'have not challenged the defining of woman but only that definition given by men' (p. 407), and have replaced it with what they believe a more accurate description and appraisal, 'the concept of the essential female' (p. 408). On the other hand, the post-structuralist response has been to reject the possibility of defining woman altogether and to replace 'the politics of gender or sexual difference ... with a plurality of difference where gender loses its position of significance' (p. 407). A third category is suggested, but only indirectly, in Alcoff's unwillingness to include among cultural feminists certain writers of colour such as Moraga and Lorde in spite of their emphasis on cultural identity, for in her view 'their work has consistently rejected essentialist conceptions of gender' (p. 412). Why an emphasis on racial, ethnic, and/or sexual identity need not be seen as essentialist is discussed more fully later in the essay with regard to identity politics and in conjunction with a third trend in feminist theory which Alcoff sees as a new course for feminism, 'a theory of the gendered subject that does not slide into essentialism' (p. 422).

Whereas the narrative structure underlying Weedon's account of feminist theories is that of a contest where one actor successively engages and defeats or conquers several rivals, Alcoff's develops as a dialectic. Both the culturalist and post-structuralist positions display internal contradictions: for example, not all cultural feminists 'give explicitly essentialist formulations of what it means to be a woman' (p. 411), and their emphasis on the affirmation of women's strength and positive cultural roles and attributes has done much to counter images of woman as victim or of woman as male when in a business suit; but insofar as it reinforces the essentialist explanations of those attributes that are part and parcel of the traditional notion of womanhood, cultural feminism may, and for some women does, foster another form of sexist oppression. Conversely, if the post-structuralist critique of the unified, authentic subject of humanism is more than compatible with the feminist project to 'deconstruct and de-essentialize' woman (as Alcoff

puts it, in clearly post-structuralist terms), its absolute rejection of gender and its negation of biological determinism in favour of a cultural-discursive determinism result, as concerns women, in a form of nominalism. If 'woman' is a fiction, a locus of pure difference and resistance to logocentric power, and if there are no women as such, then the very issue of women's oppression would appear to be obsolete and feminism itself would have no reason to exist (which, it may be noted, is a corollary of post-structuralism and the stated position of those who call themselves 'post-feminists'). 'What can we demand in the name of women,' Alcoff asks, 'if "women" do not exist and demands in their name simply reinforce the myth that they do?' (p. 420).

The way out – let me say, the sublation – of the contradictions in which are caught these two mainstream feminist views lies in 'a theory of the subject that avoids both essentialism and nominalism' (p. 421), and Alcoff points to it in the work of a few theorists, 'a few brave souls', whom she rejoins in developing her notion of 'woman as positionality': 'woman is a position from which a feminist politics can emerge rather than a set of attributes that are "objectively identifiable"' (pp. 434–5). In becoming feminist, for instance, women take up a position, a point of perspective, from which to interpret or (re)construct values and meanings. That position is also a politically assumed identity, and one relative to their socio-historical location, whereas essentialist definitions would have woman's identity or attributes independent of her external situation; however, the positions available to women in any socio-historical location are neither arbitrary nor undecidable. Thus, Alcoff concludes,

> If we combine the concept of identity politics with a conception of the subject as positionality, we can conceive of the subject as nonessentialized and emergent from a historical experience and yet retain our political ability to take gender as an important point of departure. Thus we can say at one and the same time that gender is not natural, biological, universal, ahistorical, or essential and yet still claim that gender is relevant because we are taking gender as a position from which to act politically.
>
> (1988: 433)

I am, of course, in agreement with her emphases on issues and arguments that have been central in my work, such as the necessity to theorize experience in relation to practices, the understanding of gendered subjectivity as 'an emergent property of a historicized experience' (p. 431), and the notion that identity is an active construction and a discursively mediated political interpretation of one's history. What I must ask, and less as a criticism of Alcoff's essay than for the purposes of my argument here, is: why is it still necessary to set up two opposing categories, cultural feminism and post-structuralism, or essentialism and anti-essentialism, thesis and antithesis, when one has already achieved the vantage point of a theoretical position that overtakes them or sublates them?

Doesn't the insistence on the 'essentialism' of cultural feminists reproduce and keep in the foreground an image of 'dominant' feminism that is at least reductive, at best tautological or superseded, and at worst not in our interests? Doesn't it feed the pernicious opposition of low versus high theory, a low-grade

type of critical thinking (feminism) that is contrasted with the high-test theoretical grade of a post-structuralism from which some feminists would have been smart enough to learn? As one feminist theorist who's been concurrently involved with feminism, women's studies, psychoanalytic theory, structuralism, and film theory from the beginning of my critical activity, I know that learning to be a feminist has grounded, or embodied, all of my learning and so engendered thinking and knowing itself. That engendered thinking and that embodied, situated knowledge (in Donna Haraway's phrase) are the stuff of feminist theory, whether by 'feminist theory' is meant one of a growing number of feminist critical discourses – on culture, science, subjectivity, writing, visual representation, social institutions, etc. – or, more particularly, the critical elaboration of feminist thought itself and the ongoing (re)definition of its specific difference. In either case, feminist theory is not of a lower grade than that which some call 'male theory', but different in kind; and it is its essential difference, the essence of that triangle, that concerns me here as a theorist of feminism.

Why then, I ask again, continue to constrain it in the terms of essentialism and anti-essentialism even as they no longer serve (but did they ever?) to formulate our questions? For example, in her discussion of cultural feminism, Alcoff accepts another critic's characterization despite some doubt that the latter 'makes it appear too homogeneous and ... the charge of essentialism is on shaky ground' (p. 411). Then she adds:

> In the absence of a clearly stated position on the ultimate source of gender difference, Echols *infers* from their emphasis on building a feminist free-space and woman-centred culture that cultural feminists hold some version of essentialism. I share Echols's *suspicion*. Certainly, *it is difficult to render the views of Richard Daly into a coherent whole without supplying a missing premise* that there is an innate female essence.
>
> (1988: 412; emphasis added)

But why do it at all? What is the purpose, or the gain, of supplying a missing premise (innate female essence) in order to construct a coherent image of feminism which thus becomes available to charges (essentialism) based on the very premise that had to be supplied? What motivates such a project, the suspicion, and the inferences?

Theorizing beyond reconciliation

For a theorist of feminism, the answer to these questions should be looked for in the particular history of feminism, the debates, internal divisions, and polarizations that have resulted from its engagement with the various institutions, discourses, and practices that constitute the social, and from its self-conscious reflection on that engagement; that is to say, the divisions that have marked feminism as a result of the divisions (of gender, sex, race, class, ethnicity, sexuality, etc.) in the social itself, and the discursive boundaries and subjective limits that feminism has defined and redefined for itself contingently, historically, in the process of its engagement with

social and cultural formations. The answer should be looked for, in other words, in the form as well as the contents that are specific to feminist political practices and conceptual elaboration, in the paradoxes and contradictions that constitute the effective history, the essential difference, of feminist thought.

In one account that can be given of that history, feminist theory has developed a series of oppositional stances not only vis-à-vis the wider, 'external' context (the social constraints, legislation, ideological apparati, dominant discourses and representations against which feminism has pitched its critique and its political strategies in particular historical locations), but also, concurrently and interrelatedly, in its own 'internal', self-critical processes. For instance, in the 1970s, the debates on academic feminism versus activism in the United States defined an opposition between theory and practice which led, on the one hand, to a polarization of positions either *for* theory or *against* theory in nearly all cultural practices and, on the other, to a consistent, if never fully successful, effort to overcome the opposition itself. Subsequently, the internal division of the movement over the issue of separatism or 'mainstreaming', both in the academy and in other institutional contexts, recast the practice/theory opposition in terms of lesbian versus heterosexual identification, and of women's studies versus feminist cultural theory, among others. Here, too, the opposition led to both polarization (e.g., feminist criticism versus feminist theory in literary studies) and efforts to overcome it by an expanded, extremely flexible, and ultimately unsatisfactory redefinition of the notion of 'feminist theory' itself.

Another major division and the resulting crucial shift in feminist thought were prompted, at the turn of the decade into the 1980s, by the wider dissemination of the writings of women of colour and their critique of racism in the women's movement. The division over the issue of race versus gender, and of the relative importance of each in defining the modes of women's oppression, resistance, and agency, also produced an opposition between a 'white' or 'Western feminism' and a 'US Third World feminism' articulated in several racial and ethnic hyphenations, or called by an altogether different name (e.g., black 'womanism'). Because the oppositional stance of women of colour was markedly, if not exclusively, addressed to white women in the context of feminism – that is to say, their critique addressed more directly white feminists than it did (white) patriarchal power structures, men of colour or even white women in general – once again that division on the issue of race versus gender led to polarization as well as to concerted efforts to overcome it, at least internally to feminist theoretical and cultural practices. And once again those efforts met with mostly unsatisfactory or inadequate results, so that no actual resolution, no dialectic sublation has been achieved in this opposition either, as in the others. For even as the polarization may be muted or displaced by other issues that come to the fore, each of those oppositions remains present and active in feminist consciousness and, I want to argue, must so remain in a feminist theory of the female-sexed or female-embodied social subject that is based on its specific and emergent history.

Since the mid-1980s, the so-called feminist sex wars (Ruby Rich) have pitched 'pro-sex' feminists versus the anti-pornography movement in a conflict over representation that recast the sex/gender distinction into the form of a paradoxical opposition: sex and gender are either collapsed together, and rendered

both analytically and politically indistinguishable (MacKinnon, Hartsock) or they are severed from each other and seen as endlessly recombinable in such figures of boundary crossing as transsexualism, transvestism, bisexualism, drag and impersonation (Butler), cyborgs (Haraway), etc. This last issue is especially central to the lesbian debate on sadomasochism (*Coming to Power, Against Sadomasochism*), which recasts the earlier divisions of lesbians between the women's liberation movement, with its more or less overt homophobia (Bearchell, Clark), and the gay liberation movement, with its more or less overt sexism (Frye), into the current opposition of radical S/M lesbianism to mainstream-cultural lesbian feminism (Rubin, Califia), an opposition whose mechanical binarism is tersely expressed by the recent magazine title *On Our Backs* punning on the long-established feminist periodical *Off Our Backs*. And here may be also mentioned the opposition pro and against psychoanalysis (e.g., Rose and Wilson) which, ironically, has been almost completely disregarded in these sexuality debates, even as it determined the conceptual elaboration of sexual difference in the 1970s and has since been fundamental to the feminist critique of representation in the media and the arts.

This account of the history of feminism in relation to both 'external' and 'internal' events, discourses, and practices suggests that two concurrent drives, impulses or mechanisms, are at work in the production of its self-representation: *an erotic, narcissistic drive* that enhances images of feminism as difference, rebellion, daring, excess, subversion, disloyalty, agency, empowerment, pleasure and danger, and rejects all images of powerlessness, victimization, subjection, acquiescence, passivity, conformism, femininity; and *an ethical drive* that works towards community, accountability, entrustment, sisterhood, bonding, belonging to a common world of women or sharing what Adrienne Rich has poignantly called 'the dream of a common language'. Together, often in mutual contradiction, the erotic and ethical drives have fuelled not only the various polarizations and the construction of oppositions but also the invention or conceptual imaging of a 'continuum' of experience, a global feminism, a 'house of difference', or a separate space where 'safe words' can be trusted and 'consent' be given uncoerced. And an erotic and an ethical drive may be seen to underlie and sustain at once the possibility of, and the difficulties involved in, the project of articulating a female symbolic. Are these two drives together, most often in mutual contradiction, what particularly distinguishes lesbian feminism, where the erotic is as necessary a condition as the ethical, if not more?

That the two drives often clash or bring about political stalemates and conceptual impasses is not surprising, for they have contradictory objects and aims, and are forced into open conflict in a culture where women are not supposed to be, know, or see themselves as subjects. And for this very reason perhaps, the two drives characterize the movement of feminism, and more emphatically lesbian feminism, its historically intrinsic, essential condition of contradiction, and the processes constitutive of feminist thought in its specificity. As I have written elsewhere, 'the tension of a twofold pull in contrary directions – the critical negativity of its theory, and the affirmative positivity of its politics – is both the historical condition of existence of feminism and its theoretical condition of possibility'. That tension, as the condition of possibility and effective elaboration of feminist theory, is most productive in the kind of critical thinking that refuses to be pulled to either side

of an opposition and seeks instead to deconstruct it, or better, to disengage it from the fixity of polarization in an 'internal' feminist debate and to reconnect it to the 'external' discursive and social context from which it finally cannot be severed except at the cost of repeatedly reducing a historical process, a movement, to an ideological stalemate. This may be the approach of those writers whom Alcoff would call 'brave souls ... attempting to map out a new course' (1988: 407). But that course, I would argue, does not proceed in the manner of a dialectic, by resolving or reconciling the given terms of an opposition – say, essentialism/anti-essentialism or pro-sex/anti-pornography – whether the resolution is achieved discursively (for example, alleging a larger, tactical or political perspective on the issue) or by pointing to their actual sublation in existing material conditions (for example, adducing sociological data or statistical arguments). It proceeds, in my view, by what I call upping the 'anti': by analysing the undecidability, conceptual as well as pragmatic, of the alternative *as given*, such critical works release its terms from the fixity of meaning into which polarization has locked them, and reintroduce them into a larger contextual and conceptual frame of reference; the tension of positivity and negativity that marks feminist discourse in its engagement with the social can then displace the impasse of mere 'internal' opposition to a more complex level of analysis.

Seen in this larger, historical frame of reference, feminist theory is not merely a theory of gender oppression in culture, as both MacKinnon and Rubin maintain, from the respective poles of the sex/gender and pro-sex/anti-pornography debates, and as is too often reiterated in women's studies textbooks; nor is it the essentialist theory of women's nature which Weedon opposes to an anti-essentialist, post-structuralist theory of culture. It is instead a developing theory of the female-sexed or female-embodied social subject, whose constitution and whose modes of social and subjective existence include most obviously sex and gender, but also race, class, and any other significant socio-cultural divisions and representations; a developing theory of the female-embodied social subject that is based on its specific, emergent, and conflictual history.

Note

Another version of this essay was published in *Differences: A Journal of Feminist Cultural Studies* 1 (2) (fall 1989) with the title 'The essence of the triangle or, taking the risk of essentialism seriously: feminist theory in Italy, the US, and Britain'. The essay was initially written for the issue of *Differences* devoted to 'The Essential Difference: Another Look at Essentialism', but then rethought in the context of the project of a book addressing the problem of 'conflicts in feminism'. The two versions have in common the arguments set out in Part I, but then, in Parts II and III, present two quite distinct accounts of what I call the effective history of feminist theory and its specific, essential difference as a developing theory of the female-sexed or female-embodied social subject: there, an account, one possible history of feminist theory in Italy, here one account of feminist theory in North America.

Judith Butler

SUBVERSIVE BODILY ACTS

EDITOR'S INTRODUCTION

IN THIS SELECTION from her important book *Gender Trouble: Feminism and the Subversion of Identity*, Judith Butler makes a strong case for refusing to think of the body as the ground of identity. Traditional concepts of gender assume that (barring a few exceptions) human beings come into the world with one of two kinds of body: a male body or a female one. This distinction is, of course, classically categorized around the presence or absence of a penis. But Butler asks: aren't bodies already inscribed by history and culture? And because they are, she contends that they cannot be conceived as a natural ground for cultural difference.

Having established to her own satisfaction that the body is culturally inscribed, Butler goes on to offer some concrete examples of such inscriptions. She argues, first, that we (in the West?) inscribe or imagine the body as a discrete, tightly bordered thing, and that this has consequences for the kinds of sex acts that are deemed normal, proper, legal. Sex acts like anal sex which involve entries into the body where it is not supposed to be permeable become outlawed. She further argues (following Foucault) that in the difficult perhaps impossible effort to live in the body in these terms, the 'soul' becomes imagined as an emblem of coherence, that is possessing the features absent from messy actual bodies. Souls, then, are inscribed on bodies too, if only as lack.

It's the failure of the body to be whole and enduring that leads to the soul being imagined in terms which make it the prison of the body: for Butler the soul is that which prevents the permeability and instability of the body from being realized. It's a barrier to freedom. She argues that gender too concerns the soul, since it too is a product of a desire for integrity, inscribed on a body but also

more ideal or transcendent than the body. And as such it needs to be continually performed: gender is a 'corporeal style'. But as a performed style, gender is open to parody and improvisation in modes which undo the dominant ways of perceiving male/female difference and the regime of compulsory heterosexuality within which men and women live and have sex together. At this point parodying and mimicking corporeal styles (drag) becomes an act of sexual liberation.

Further reading: Adams and Savran 2002; Bordo 2000; Butler 1993; Faludi 1999; Smith 1992; Solomon-Godeau 1999.

Bodily inscriptions, performative subversions

> "Garbo 'got in drag' whenever she took some heavy glamour part, whenever she melted in or out of a man's arms, whenever she simply let that heavenly-flexed neck … bear the weight of her thrown-back head. … How resplendent seems the art of acting! It is all *impersonation*, whether the sex underneath is true or not."—
> Parker Tyler, "The Garbo Image," quoted in Esther Newton, *Mother Camp*

Categories of true sex, discrete gender, and specific sexuality have constituted the stable point of reference for a great deal of feminist theory and politics. These constructs of identity serve as the points of epistemic departure from which theory emerges and politics itself is shaped. In the case of feminism, politics is ostensibly shaped to express the interests, the perspectives, of "women." But is there a political shape to "women," as it were, that precedes and prefigures the political elaboration of their interests and epistemic point of view? How is that identity shaped, and is it a political shaping that takes the very morphology and boundary of the sexed body as the ground, surface, or site of cultural inscription? What circumscribes that site as "the female body"? Is "the body" or "the sexed body" the firm foundation on which gender and systems of compulsory sexuality operate? Or is "the body" itself shaped by political forces with strategic interests in keeping that body bounded and constituted by the markers of sex?

The sex/gender distinction and the category of sex itself appear to presuppose a generalization of "the body" that preexists the acquisition of its sexed significance. This "body" often appears to be a passive medium that is signified by an inscription from a cultural source figured as "external" to that body. Any theory of the culturally constructed body, however, ought to question "the body" as a construct of suspect generality when it is figured as passive and prior to discourse. There are Christian and Cartesian precedents to such views which, prior to the emergence of vitalistic biologies in the nineteenth century, understand "the body" as so much inert matter, signifying nothing or, more specifically, signifying a profane void, the fallen state: deception, sin, the premonitional metaphorics of hell and the eternal feminine. There are many occasions in both Sartre's and Beauvoir's work where "the body" is figured as a mute facticity, anticipating some meaning that can be attributed only by a transcendent consciousness, understood in Cartesian terms as radically immaterial. But what establishes this dualism for

us? What separates off "the body" as indifferent to signification, and signification itself as the act of a radically disembodied consciousness or, rather, the act that radically disembodies that consciousness? To what extent is that Cartesian dualism presupposed in phenomenology adapted to the structuralist frame in which mind/body is redescribed as culture/nature? With respect to gender discourse, to what extent do these problematic dualisms still operate within the very descriptions that are supposed to lead us out of that binarism and its implicit hierarchy? How are the contours of the body clearly marked as the taken-for-granted ground or surface upon which gender significations are inscribed, a mere facticity devoid of value, prior to significance?

Wittig suggests that a culturally specific epistemic *a priori* establishes the naturalness of "sex." But by what enigmatic means has "the body" been accepted as a *prima facie* given that admits of no genealogy? Even within Foucault's essay on the very theme of genealogy, the body is figured as a surface and the scene of a cultural inscription: "the body is the inscribed surface of events." The task of genealogy, he claims, is "to expose a body totally imprinted by history." His sentence continues, however, by referring to the goal of "history"—here clearly understood on the model of Freud's "civilization"—as the "destruction of the body". Forces and impulses with multiple directionalities are precisely that which history both destroys and preserves through the *entstehung* (historical event) of inscription. As "a volume in perpetual disintegration", the body is always under siege, suffering destruction by the very terms of history. And history is the creation of values and meanings by a signifying practice that requires the subjection of the body. This corporeal destruction is necessary to produce the speaking subject and its significations. This is a body, described through the language of surface and force, weakened through a "single drama" of domination, inscription, and creation. This is not the *modus vivendi* of one kind of history rather than another, but is, for Foucault, "history" in its essential and repressive gesture.

Although Foucault writes, "Nothing in man [*sic*]—not even his body—is sufficiently stable to serve as the basis for self-recognition or for understanding other men [*sic*]", he nevertheless points to the constancy of cultural inscription as a "single drama" that acts on the body. If the creation of values, that historical mode of signification, requires the destruction of the body, much as the instrument of torture in Kafka's *In the Penal Colony* destroys the body on which it writes, then there must be a body prior to that inscription, stable and self-identical, subject to that sacrificial destruction. In a sense, for Foucault, as for Nietzsche, cultural values emerge as the result of an inscription on the body, understood as a medium, indeed, a blank page; in order for this inscription to signify, however, that medium must itself be destroyed—that is, fully transvaluated into a sublimated domain of values. Within the metaphorics of this notion of cultural values is the figure of history as a relentless writing instrument, and the body as the medium which must be destroyed and transfigured in order for "culture" to emerge.

By maintaining a body prior to its cultural inscription, Foucault appears to assume a materiality prior to signification and form. Because this distinction operates as essential to the task of genealogy as he defines it, the distinction itself is precluded as an object of genealogical investigation. Occasionally in his analysis of Herculine, Foucault subscribes to a prediscursive multiplicity of bodily forces

that break through the surface of the body to disrupt the regulating practices of cultural coherence imposed upon that body by a power regime, understood as a vicissitude of "history." If the presumption of some kind of precategorial source of disruption is refused, is it still possible to give a genealogical account of the demarcation of the body as such as a signifying practice? This demarcation is not initiated by a reified history or by a subject. This marking is the result of a diffuse and active structuring of the social field. This signifying practice effects a social space for and of the body within certain regulatory grids of intelligibility.

Mary Douglas' *Purity and Danger* suggests that the very contours of "the body" are established through markings that seek to establish specific codes of cultural coherence. Any discourse that establishes the boundaries of the body serves the purpose of instating and naturalizing certain taboos regarding the appropriate limits, postures, and modes of exchange that define what it is that constitutes bodies:

> ideas about separating, purifying, demarcating and punishing transgressions have as their main function to impose system on an inherently untidy experience. It is only by exaggerating the difference between within and without, above and below, male and female, with and against, that a semblance of order is created.

Although Douglas clearly subscribes to a structuralist distinction between an inherently unruly nature and an order imposed by cultural means, the "untidiness" to which she refers can be redescribed as a region of *cultural* unruliness and disorder. Assuming the inevitably binary structure of the nature/culture distinction, Douglas cannot point toward an alternative configuration of culture in which such distinctions become malleable or proliferate beyond the binary frame. Her analysis, however, provides a possible point of departure for understanding the relationship by which social taboos institute and maintain the boundaries of the body as such. Her analysis suggests that what constitutes the limit of the body is never merely material, but that the surface, the skin, is systemically signified by taboos and anticipated transgressions; indeed, the boundaries of the body become, within her analysis, the limits of the social *per se*. A poststructuralist appropriation of her view might well understand the boundaries of the body as the limits of the socially *hegemonic*. In a variety of cultures, she maintains, there are

> pollution powers which inhere in the structure of ideas itself and which punish a symbolic breaking of that which should be joined or joining of that which should be separate. It follows from this that pollution is a type of danger which is not likely to occur except where the lines of structure, cosmic or social, are clearly defined.
>
> A polluting person is always in the wrong. He [*sic*] has developed some wrong condition or simply crossed over some line which should not have been crossed and this displacement unleashes danger for someone.

In a sense, Simon Watney has identified the contemporary construction of "the polluting person" as the person with AIDS in his *Policing Desire: AIDS, Pornography,*

and the Media. Not only is the illness figured as the "gay disease," but throughout the media's hysterical and homophobic response to the illness there is a tactical construction of a continuity between the polluted status of the homosexual by virtue of the boundary-trespass that *is* homosexuality and the disease as a specific modality of homosexual pollution. That the disease is transmitted through the exchange of bodily fluids suggests within the sensationalist graphics of homophobic signifying systems the dangers that permeable bodily boundaries present to the social order as such. Douglas remarks that "the body is a model that can stand for any bounded system. Its boundaries can represent any boundaries which are threatened or precarious." And she asks a question which one might have expected to read in Foucault: "Why should bodily margins be thought to be specifically invested with power and danger?"

Douglas suggests that all social systems are vulnerable at their margins, and that all margins are accordingly considered dangerous. If the body is synecdochal for the social system *per se* or a site in which open systems converge, then any kind of unregulated permeability constitutes a site of pollution and endangerment. Since anal and oral sex among men clearly establishes certain kinds of bodily permeabilities unsanctioned by the hegemonic order, male homosexuality would, within such a hegemonic point of view, constitute a site of danger and pollution, prior to and regardless of the cultural presence of AIDS. Similarly, the "polluted" status of lesbians, regardless of their low-risk status with respect to AIDS, brings into relief the dangers of their bodily exchanges. Significantly, being "outside" the hegemonic order does not signify being "in" a state of filthy and untidy nature. Paradoxically, homosexuality is almost always conceived within the homophobic signifying economy as *both* uncivilized and unnatural.

The construction of stable bodily contours relies upon fixed sites of corporeal permeability and impermeability. Those sexual practices in both homosexual and heterosexual contexts that open surfaces and orifices to erotic signification or close down others effectively reinscribe the boundaries of the body along new cultural lines. Anal sex among men is an example, as is the radical re-membering of the body in Wittig's *The Lesbian Body*. Douglas alludes to "a kind of sex pollution which expresses a desire to keep the body (physical and social) intact," suggesting that the naturalized notion of "the" body is itself a consequence of taboos that render that body discrete by virtue of its stable boundaries. Further, the rites of passage that govern various bodily orifices presuppose a heterosexual construction of gendered exchange, positions, and erotic possibilities. The deregulation of such exchanges accordingly disrupts the very boundaries that determine what it is to be a body at all. Indeed, the critical inquiry that traces the regulatory practices within which bodily contours are constructed constitutes precisely the genealogy of "the body" in its discreteness that might further radicalize Foucault's theory.

Significantly, Kristeva's discussion of abjection in *The Powers of Horror* begins to suggest the uses of this structuralist notion of a boundary-constituting taboo for the purposes of constructing a discrete subject through exclusion. The "abject" designates that which has been expelled from the body, discharged as excrement, literally rendered "Other." This appears as an expulsion of alien elements, but the alien is effectively established through this expulsion. The construction of the

"not-me" as the abject establishes the boundaries of the body which are also the first contours of the subject. Kristeva writes:

> *nausea* makes me balk at that milk cream, separates me from the mother and father who proffer it. "I" want none of that element, sign of their desire; "I" do not want to listen, "I" do not assimilate it, "I" expel it. But since the food is not an "other" for "me," who am only in their desire, I expel *myself*, I spit *myself out*, I abject *myself* within the same motion through which "I" claim to establish myself.

The boundary of the body as well as the distinction between internal and external is established through the ejection and transvaluation of something originally part of identity into a defiling otherness. As Iris Young has suggested in her use of Kristeva to understand sexism, homophobia, and racism, the repudiation of bodies for their sex, sexuality, and/or color is an "expulsion" followed by a "repulsion" that founds and consolidates culturally hegemonic identities along sex/race/sexuality axes of differentiation. Young's appropriation of Kristeva shows how the operation of repulsion can consolidate "identities" founded on the instituting of the "Other" or a set of Others through exclusion and domination. What constitutes through division the "inner" and "outer" worlds of the subject is a border and boundary tenuously maintained for the purposes of social regulation and control. The boundary between the inner and outer is confounded by those excremental passages in which the inner effectively becomes outer, and this excreting function becomes, as it were, the model by which other forms of identity-differentiation are accomplished. In effect, this is the mode by which Others become shit. For inner and outer worlds to remain utterly distinct, the entire surface of the body would have to achieve an impossible impermeability. This sealing of its surfaces would constitute the seamless boundary of the subject; but this enclosure would invariably be exploded by precisely that excremental filth that it fears.

Regardless of the compelling metaphors of the spatial distinctions of inner and outer, they remain linguistic terms that facilitate and articulate a set of fantasies, feared and desired. "Inner" and "outer" make sense only with reference to a mediating boundary that strives for stability. And this stability, this coherence, is determined in large part by cultural orders that sanction the subject and compel its differentiation from the abject. Hence, "inner" and "outer" constitute a binary distinction that stabilizes and consolidates the coherent subject. When that subject is challenged, the meaning and necessity of the terms are subject to displacement. If the "inner world" no longer designates a topos, then the internal fixity of the self and, indeed, the internal locale of gender identity, become similarly suspect. The critical question is not *how* did that identity become *internalized?* as if internalization were a process or a mechanism that might be descriptively reconstructed. Rather, the question is: From what strategic position in public discourse and for what reasons has the trope of interiority and the disjunctive binary of inner/outer taken hold? In what language is "inner space" figured? What kind of figuration is it, and through what figure of the body is it signified? How does a body figure on its surface the very invisibility of its hidden depth?

From interiority to gender performatives

In *Discipline and Punish* Foucault challenges the language of internalization as it operates in the service of the disciplinary regime of the subjection and subjectivation of criminals. Although Foucault objected to what he understood to be the psychoanalytic belief in the "inner" truth of sex in *The History of Sexuality*, he turns to a criticism of the doctrine of internalization for separate purposes in the context of his history of criminology. In a sense, *Discipline and Punish* can be read as Foucault's effort to rewrite Nietzsche's doctrine of internalization in *On the Genealogy of Morals* on the model of *inscription*. In the context of prisoners, Foucault writes, the strategy has been not to enforce a repression of their desires, but to compel their bodies to signify the prohibitive law as their very essence, style, and necessity. That law is not literally internalized, but incorporated, with the consequence that bodies are produced which signify that law on and through the body; there the law is manifest as the essence of their selves, the meaning of their soul, their conscience, the law of their desire. In effect, the law is at once fully manifest and fully latent, for it never appears as external to the bodies it subjects and subjectivates. Foucault writes:

> It would be wrong to say that the soul is an illusion, or an ideological effect. On the contrary, it exists, it has a reality, it is produced permanently *around*, *on*, *within*, the body by the functioning of a power that is exercised on those that are punished (my emphasis).

The figure of the interior soul understood as "within" the body is signified through its inscription *on* the body, even though its primary mode of signification is through its very absence, its potent invisibility. The effect of a structuring inner space is produced through the signification of a body as a vital and sacred enclosure. The soul is precisely what the body lacks; hence, the body presents itself as a signifying lack. That lack which *is* the body signifies the soul as that which cannot show. In this sense, then, the soul is a surface signification that contests and displaces the inner/outer distinction itself, a figure of interior psychic space inscribed *on* the body as a social signification that perpetually renounces itself as such. In Foucault's terms, the soul is not imprisoned by or within the body, as some Christian imagery would suggest, but "the soul is the prison of the body."

The redescription of intrapsychic processes in terms of the surface politics of the body implies a corollary redescription of gender as the disciplinary production of the figures of fantasy through the play of presence and absence on the body's surface, the construction of the gendered body through a series of exclusions and denials, signifying absences. But what determines the manifest and latent text of the body politic? What is the prohibitive law that generates the corporeal stylization of gender, the fantasied and fantastic figuration of the body? We have already considered the incest taboo and the prior taboo against homosexuality as the generative moments of gender identity, the prohibitions that produce identity along the culturally intelligible grids of an idealized and compulsory heterosexuality. That disciplinary production of gender effects a false stabilization of gender in the interests of the heterosexual construction and regulation of sexuality within

the reproductive domain. The construction of coherence conceals the gender discontinuities that run rampant within heterosexual, bisexual, and gay and lesbian contexts in which gender does not necessarily follow from sex, and desire, or sexuality generally, does not seem to follow from gender—indeed, where none of these dimensions of significant corporeality express or reflect one another. When the disorganization and disaggregation of the field of bodies disrupt the regulatory fiction of heterosexual coherence, it seems that the expressive model loses its descriptive force. That regulatory ideal is then exposed as a norm and a fiction that disguises itself as a developmental law regulating the sexual field that it purports to describe.

According to the understanding of identification as an enacted fantasy or incorporation, however, it is clear that coherence is desired, wished for, idealized, and that this idealization is an effect of a corporeal signification. In other words, acts, gestures, and desire produce the effect of an internal core or substance, but produce this *on the surface* of the body, through the play of signifying absences that suggest, but never reveal, the organizing principle of identity as a cause. Such acts, gestures, enactments, generally construed, are *performative* in the sense that the essence or identity that they otherwise purport to express are *fabrications* manufactured and sustained through corporeal signs and other discursive means. That the gendered body is performative suggests that it has no ontological status apart from the various acts which constitute its reality. This also suggests that if that reality is fabricated as an interior essence, that very inferiority is an effect and function of a decidedly public and social discourse, the public regulation of fantasy through the surface politics of the body, the gender border control that differentiates inner from outer, and so institutes the "integrity" of the subject. In other words, acts and gestures, articulated and enacted desires create the illusion of an interior and organizing gender core, an illusion discursively maintained for the purposes of the regulation of sexuality within the obligatory frame of reproductive heterosexuality. If the "cause" of desire, gesture, and act can be localized within the "self" of the actor, then the political regulations and disciplinary practices which produce that ostensibly coherent gender are effectively displaced from view. The displacement of a political and discursive origin of gender identity onto a psychological "core" precludes an analysis of the political constitution of the gendered subject and its fabricated notions about the ineffable interiority of its sex or of its true identity.

If the inner truth of gender is a fabrication and if a true gender is a fantasy instituted and inscribed on the surface of bodies, then it seems that genders can be neither true nor false, but are only produced as the truth effects of a discourse of primary and stable identity. In *Mother Camp: Female Impersonators in America*, anthropologist Esther Newton suggests that the structure of impersonation reveals one of the key fabricating mechanisms through which the social construction of gender takes place. I would suggest as well that drag fully subverts the distinction between inner and outer psychic space and effectively mocks both the expressive model of gender and the notion of a true gender identity. Newton writes:

> At its most complex, [drag] is a double inversion that says, "appearance is
> an illusion." Drag says [Newton's curious personification] "my 'outside'

appearance is feminine, but my essence 'inside' [the body] is masculine." At the
same time it symbolizes the opposite inversion; "my appearance 'outside' [my
body, my gender] is masculine but my essence 'inside' [myself] is feminine."

Both claims to truth contradict one another and so displace the entire enactment
of gender significations from the discourse of truth and falsity.

The notion of an original or primary gender identity is often parodied
within the cultural practices of drag, cross-dressing, and the sexual stylization
of butch/femme identities. Within feminist theory, such parodic identities have
been understood to be either degrading to women, in the case of drag and cross-
dressing, or an uncritical appropriation of sex-role stereotyping from within the
practice of heterosexuality, especially in the case of butch/femme lesbian identities.
But the relation between the "imitation" and the "original" is, I think, more
complicated than that critique generally allows. Moreover, it gives us a clue to
the way in which the relationship between primary identification—that is, the
original meanings accorded to gender—and subsequent gender experience might
be re-framed. The performance of drag plays upon the distinction between the
anatomy of the performer and the gender that is being performed. But we are
actually in the presence of three contingent dimensions of significant corporeality:
anatomical sex, gender identity, and gender performance. If the anatomy of the
performer is already distinct from the gender of the performer, and both of those
are distinct from the gender of the performance, then the performance suggests
a dissonance not only between sex and performance, but sex and gender, and
gender and performance. As much as drag creates a unified picture of "woman"
(what its critics often oppose), it also reveals the distinctness of those aspects of
gendered experience which are falsely naturalized as a unity through the regulatory
fiction of heterosexual coherence. *In imitating gender, drag implicitly reveals the imitative
structure of gender itself—as well as its contingency*. Indeed, part of the pleasure, the
giddiness of the performance is in the recognition of a radical contingency in the
relation between sex and gender in the face of cultural configurations of causal
unities that are regularly assumed to be natural and necessary. In the place of the
law of heterosexual coherence, we see sex and gender denaturalized by means of a
performance which avows their distinctness and dramatizes the cultural mechanism
of their fabricated unity.

The notion of gender parody defended here does not assume that there is an
original which such parodic identities imitate. Indeed, the parody is *of* the very
notion of an original; just as the psychoanalytic notion of gender identification is
constituted by a fantasy of a fantasy, the transfiguration of an Other who is always
already a "figure" in that double sense, so gender parody reveals that the original
identity after which gender fashions itself is an imitation without an origin. To be
more precise, it is a production which, in effect—that is, in its effect—postures
as an imitation. This perpetual displacement constitutes a fluidity of identities that
suggests an openness to resignification and recontextualization; parodic proliferation
deprives hegemonic culture and its critics of the claim to naturalized or essentialist
gender identities. Although the gender meanings taken up in these parodic styles are
clearly part of hegemonic, misogynist culture, they are nevertheless denaturalized and
mobilized through their parodic recontextualization. As imitations which effectively

displace the meaning of the original, they imitate the myth of originality itself. In the place of an original identification which serves as a determining cause, gender identity might be reconceived as a personal/cultural history of received meanings subject to a set of imitative practices which refer laterally to other imitations and which, jointly, construct the illusion of a primary and interior gendered self or parody the mechanism of that construction.

According to Fredric Jameson's "Postmodernism and Consumer Society," the imitation that mocks the notion of an original is characteristic of pastiche rather than parody:

> Pastiche is, like parody, the imitation of a peculiar or unique style, the wearing of a stylistic mask, speech in a dead language: but it is a neutral practice of mimicry, without parody's ulterior motive, without the satirical impulse, without laughter, without that still latent feeling that there exists something *normal* compared to which what is being imitated is rather comic. Pastiche is blank parody, parody that has lost it humor.

The loss of the sense of "the normal," however, can be its own occasion for laughter, especially when "the normal," "the original" is revealed to be a copy, and an inevitably failed one, an ideal that no one *can* embody. In this sense, laughter emerges in the realization that all along the original was derived.

Parody by itself is not subversive, and there must be a way to understand what makes certain kinds of parodic repetitions effectively disruptive, truly troubling, and which repetitions become domesticated and recirculated as instruments of cultural hegemony. A typology of actions would clearly not suffice, for parodic displacement, indeed, parodic laughter, depends on a context and reception in which subversive confusions can be fostered. What performance will invert the inner/outer distinction and compel a radical rethinking of the psychological presuppositions of gender identity and sexuality? What performance will compel a reconsideration of the *place* and stability of the masculine and the feminine? And what kind of gender performance will enact and reveal the performativity of gender itself in a way that destabilizes the naturalized categories of identity and desire.

If the body is not a "being," but a variable boundary, a surface whose permeability is politically regulated, a signifying practice within a cultural field of gender hierarchy and compulsory heterosexuality, then what language is left for understanding this corporeal enactment, gender, that constitutes its "interior" signification on its surface? Sartre would perhaps have called this act "a style of being," Foucault, "a stylistics of existence." And in my earlier reading of Beauvoir, I suggest that gendered bodies are so many "styles of the flesh." These styles all never fully self-styled, for styles have a history, and those histories condition and limit the possibilities. Consider gender, for instance, as *a corporeal style*, an "act," as it were, which is both intentional and performative, where "*performative*" suggests a dramatic and contingent construction of meaning.

Wittig understands gender as the workings of "sex," where "sex" is an obligatory injunction for the body to become a cultural sign, to materialize itself in obedience to a historically delimited possibility, and to do this, not once or

twice, but as a sustained and repeated corporeal project. The notion of a "project," however, suggests the originating force of a radical will, and because gender is a project which has cultural survival as its end, the term *strategy* better suggests the situation of duress under which gender performance always and variously occurs. Hence, as a strategy of survival within compulsory systems, gender is a performance with clearly punitive consequences. Discrete genders are part of what "humanizes" individuals within contemporary culture; indeed, we regularly punish those who fail to do their gender right. Because there is neither an "essence" that gender expresses or externalizes nor an objective ideal to which gender aspires, and because gender is not a fact, the various acts of gender create the idea of gender, and without those acts, there would be no gender at all. Gender is, thus, a construction that regularly conceals its genesis; the tacit collective agreement to perform, produce, and sustain discrete and polar genders as cultural fictions is obscured by the credibility of those productions—and the punishments that attend not agreeing to believe in them; the construction "compels" our belief in its necessity and naturalness. The historical possibilities materialized through various corporeal styles are nothing other than those punitively regulated cultural fictions alternately embodied and deflected under duress.

Consider that a sedimentation of gender norms produces the peculiar phenomenon of a "natural sex" or a "real woman" or any number of prevalent and compelling social fictions, and that this is a sedimentation that over time has produced a set of corporeal styles which, in reified form, appear as the natural configuration of bodies into sexes existing in a binary relation to one another. If these styles are enacted, and if they produce the coherent gendered subjects who pose as their originators, what kind of performance might reveal this ostensible "cause" to be an "effect"?

In what senses, then, is gender an act? As in other ritual social dramas, the action of gender requires a performance that is *repeated*. This repetition is at once a reenactment and reexperiencing of a set of meanings already socially established; and it is the mundane and ritualized form of their legitimation. Although there are individual bodies that enact these significations by becoming stylized into gendered modes, this "action" is a public action. There are temporal and collective dimensions to these actions, and their public character is not inconsequential; indeed, the performance is effected with the strategic aim of maintaining gender within its binary frame—an aim that cannot be attributed to a subject, but, rather, must be understood to found and consolidate the subject.

Gender ought not to be construed as a stable identity or locus of agency from which various acts follow; rather, gender is an identity tenuously constituted in time, instituted in an exterior space through a *stylized repetition of acts*. The effect of gender is produced through the stylization of the body and, hence, must be understood as the mundane way in which bodily gestures, movements, and styles of various kinds constitute the illusion of an abiding gendered self. This formulation moves the conception of gender off the ground of a substantial model of identity to one that requires a conception of gender as a constituted *social temporality*. Significantly, if gender is instituted through acts which are internally discontinuous, then the *appearance of substance* is precisely that, a constructed identity, a performative accomplishment which the mundane social audience, including the actors themselves,

come to believe and to perform in the mode of belief. Gender is also a norm that can never be fully internalized; "the internal" is a surface signification, and gender norms are finally phantasmatic, impossible to embody. If the ground of gender identity is the stylized repetition of acts through time and not a seemingly seamless identity, then the spatial metaphor of a "ground" will be displaced and revealed as a stylized configuration, indeed, a gendered corporealization of time. The abiding gendered self will then be shown to be structured by repeated acts that seek to approximate the ideal of a substantial ground of identity, but which, in their occasional *dis*continuity, reveal the temporal and contingent groundlessness of this "ground." The possibilities of gender transformation are to be found precisely in the arbitrary relation between such acts, in the possibility of a failure to repeat, a deformity, or a parodic repetition that exposes the phantasmatic effect of abiding identity as a politically tenuous construction.

If gender attributes, however, are not expressive but performative, then these attributes effectively constitute the identity they are said to express or reveal. The distinction between expression and performativeness is crucial. If gender attributes and acts, the various ways in which a body shows or produces its cultural signification, are performative, then there is no preexisting identity by which an act or attribute might be measured; there would be no true or false, real or distorted acts of gender, and the postulation of a true gender identity would be revealed as a regulatory fiction. That gender reality is created through sustained social performances means that the very notions of an essential sex and a true or abiding masculinity or femininity are also constituted as part of the strategy that conceals gender's performative character and the performative possibilities for proliferating gender configurations outside the restricting frames of masculinist domination and compulsory heterosexuality.

Genders can be neither true nor false, neither real nor apparent, neither original nor derived. As credible bearers of those attributes, however, genders can also be rendered thoroughly and radically *incredible*.

Eve Kosofsky Sedgwick

AXIOMATIC

EDITOR'S INTRODUCTION

IN THIS SUBTLE PIECE OF METHODOLOGICAL ground-clearing (or mine-sweeping), part of the introduction to her book *Epistemologies of the Closet*, Eve Sedgwick elaborates some deceptively simple axioms from which gay and lesbian studies might proceed. Of particular interest is her discussion of the Foucauldian claim that 'homosexuality' begins around 1870. What this means, of course, is that individuals who preferred sex with people of their own gender were then for the first time defined or identified as (fundamentally pathological) 'homosexuals'. But, as Sedgwick argues, even as we try to dismantle the category 'homosexual' we are playing a game in which one large model is being replaced with another large model. In this situation it is important to take the banality 'We are all different people' (Axiom 1) very seriously.

This banal proposition contains a pun: we're all different from each other, and we're not always the same ourselves. It is because the first is true that 'allo-identification' (identification with the other) should take place, however rarely it does; and it is because the second is true that the first *can* take place: we cannot simply 'auto-identify' once and for all. Thus same-gender sex, like different-gender sex involves a mixture of both kinds of identification. At a more general level, for Sedgwick, auto-identification requires narratives which try to account for *how* we came to be what we are and, more than that, to establish *what* we are – though, of course, this can never be finally determined. Such narratives can also trigger further identifications by and with others. More particularly, Sedgwick implies, lesbian and gay studies need a particular mix of auto- and allo-identification if they are to remain different from, but not radically other to, each other.

Further reading: Abelove *et al.* 1993; Butler 2004; Edelman 1994 and 2004; Foucault 1980a; Fuss 1991; Halperin 1995; Jagose 1996; Rubin 1975 and 1984; Sedgwick 1987 and 1990; Warner 1993 and 1999; Weeks 1985.

Epistemology of the Closet proposes that many of the major nodes of thought and knowledge in twentieth-century Western culture as a whole are structured – indeed, fractured – by a chronic, now endemic crisis of homo/heterosexual definition, indicatively male, dating from the end of the nineteenth century. The book will argue that an understanding of virtually any aspect of modern Western culture must be, not merely incomplete, but damaged in its central substance to the degree that it does not incorporate a critical analysis of modern homo/heterosexual definition; and it will assume that the appropriate place for that critical analysis to begin is from the relatively decentred perspective of modern gay and antihomophobic theory.

The passage of time, the bestowal of thought and necessary political struggle since the turn of the century have only spread and deepened the long crisis of modern sexual definition, dramatizing, often violently, the internal incoherence and mutual contradiction of each of the forms of discursive and institutional 'common sense' on this subject inherited from the architects of our present culture. The contradictions I will be discussing are not in the first place those between pro-homosexual and anti-homosexual people or ideologies, although the book's strongest motivation is indeed the gay-affirmative one. Rather, the contradictions that seem most active are the ones internal to all the important twentieth-century understandings of homo/heterosexual definition, both heterosexist and antihomophobic. Their outlines and something of their history are sketched in Chapter 1. Briefly, they are two. The first is the contradiction between seeing homo/heterosexual definition on the one hand as an issue of active importance primarily for a small, distinct, relatively fixed homosexual minority (what I refer to as a minoritizing view), and seeing it on the other hand as an issue of continuing, determinative importance in the lives of people across the spectrum of sexualities (what I refer to as a universalizing view). The second is the contradiction between seeing same sex object choice on the one hand as a matter of liminality or transitivity between genders, and seeing it on the other hand as reflecting an impulse of separatism – though by no means necessarily political separatism – within each gender. The purpose of this book is not to adjudicate between the two poles of either of these contradictions, for, if its argument is right, no epistemological grounding now exists from which to do so. Instead, I am trying to make the strongest possible introductory case for a hypothesis about the centrality of this nominally marginal, conceptually intractable set of definitional issues to the important knowledges and understandings of twentieth-century Western culture as a whole.

The word 'homosexual' entered Euro-American discourse during the last third of the nineteenth century – its popularization preceding, as it happens, even that of the word 'heterosexual'. It seems clear that the sexual behaviours, and even for some people the conscious identities, denoted by the new term 'homosexual' and its contemporary variants already had a long, rich history. So, indeed, did a wide range of other sexual behaviours and behavioural clusters. What *was* new from the turn of the century was the world-mapping by which every given person,

just as he or she was necessarily assignable to a male or a female gender, was not considered necessarily assignable as well to a homo- or a hetero-sexuality, a binarized identity that was full of implications, however confusing, for even the ostensibly least sexual aspects of personal existence. It was this new development that left no space in the culture exempt from the potent incoherences of homo/heterosexual definition.

New, institutionalized taxonomic discourses – medical, legal, literary, psychological – centring on homo/heterosexual definition proliferated and crystallized with exceptional rapidity in the decades around the turn of the century, decades in which so many of the other critical nodes of the culture were being, if less suddenly and newly, nonetheless also definitively reshaped. Both the power relations between the genders and the relations of nationalism and imperialism, for instance, were in highly visible crisis. For this reason, and because the structuring of same-sex bonds can't, in any historical situation marked by inequality and contest *between* genders, fail to be a site of intensive regulation that intersects virtually every issue of power and gender, lines can never be drawn to circumscribe within some proper domain of sexuality (whatever that might be) the consequences of a shift in sexual discourse. Furthermore, in accord with Foucault's demonstration, whose results I will take to be axiomatic, that modern Western culture has placed what it calls sexuality in a more and more distinctively privileged relation to our most prized constructs of individual identity, truth, and knowledge, it becomes truer and truer that the language of sexuality not only intersects with but transforms the other languages and relations by which we know.

An assumption underlying the book is that the relations of the closet – the relations of the known and the unknown, the explicit and the inexplicit around homo/heterosexual definition – have the potential for being peculiarly revealing, in fact, about speech acts more generally. But, in the vicinity of the closet, even what *counts* as a speech act is problematized on a perfectly routine basis. As Foucault says: 'there is no binary division to be made between what one says and what one does not say; we must try to determine the different ways of not saying such things … There is not one but many silences, and they are an integral part of the strategies that underlie and permeate discourses' (Foucault 1980a: 27). 'Closetedness' itself is a performance initiated as such by the speech act of a silence – not a particular silence, but a silence that accrues particularity by fits and starts, in relation to the discourse that surrounds and differentially constitutes it. The speech acts that coming out, in turn, can comprise are as strangely specific. And they may have nothing to do with the acquisition of new information. I think of a man and a woman I know, best friends, who for years canvassed freely the emotional complications of each other's erotic lives – the man's eroticism happening to focus exclusively on men. But it was only after one particular conversational moment, fully a decade into this relationship, that it seemed to either of these friends that permission had been given to the woman to refer to the man, in their conversation together, as *a gay man*. Discussing it much later, both agreed they had felt at the time that this one moment had constituted a clear-cut act of coming out, even in the context of years and years beforehand of exchange predicated on the man's *being* gay. What was said to make this difference? Not a version of 'I am gay', which could only have been bathetic between them. What constituted coming out for this man, in

this situation, was to use about himself the phrase 'coming out' – to mention, as if casually, having come out to someone else. (Similarly, a T-shirt that ACT UP sells in New York bearing the text 'I am out, therefore I am', is meant to do for the wearer not the constative work of reporting that s/he *is* out, but the performative work of coming out in the first place.) And the fact that silence is rendered as pointed and performative as speech, in relations around the closet, depends on and highlights more broadly the fact that ignorance is as potent and as multiple a thing there as is knowledge.

Anyone working in gay and lesbian studies, in a culture where same-sex desire is still structured by its distinctive public/private status, at once marginal and central, as *the* open secret, discovers that the line between straining at truths that prove to be imbecilically self-evident, on the one hand, and on the other hand tossing off commonplaces that turn out to retain their power to galvanize and divide, is weirdly unpredictable. In dealing with an open-secret structure, it's only by being shameless about risking the obvious that we happen into the vicinity of the transformative. I have methodically to sweep into one little heap some of the otherwise unarticulated assumptions and conclusions from a long-term project of anti-homophobic analysis. These nails, these scraps of wiring: will they bore or will they shock?

Under the rule that most privileges the most obvious:

Axiom 1: People are different from each other

It is astonishing how few respectable conceptual tools we have for dealing with this self-evident fact. A tiny number of inconceivably coarse axes of categorization have been painstakingly inscribed in current critical and political thought: gender, race, class, nationality, sexual orientation are pretty much the available distinctions. They, with the associated demonstrations of the mechanisms by which they are constructed and reproduced, are indispensable, and they may indeed override all or some other forms of difference and similarity. But the sister or brother, the best friend, the classmate, the parent, the child, the lover, the ex-: our families, loves, and enmities alike, not to mention the strange relations of our work, play, and activism, prove that even people who share all or most of our own positionings along these crude axes may still be different enough from us, and from each other, to seem like all but different species.

Everybody has learned this, I assume, and probably everybody who survives at all has reasonably rich, unsystematic resources of nonce taxonomy for mapping out the possibilities, dangers, and stimulations of their human social landscape. It is probably people with the experience of oppression or subordination who have most *need* to know it; and I take the precious, devalued arts of gossip, immemorially associated in European thought with servants, with effeminate and gay men, with all women, to have to do not even so much with the transmission of necessary news as with the refinement of necessary skills for making, testing, and using unrationalized and provisional hypotheses about what *kinds of people* there are to be found in one's world. The writing of a Proust or a James would be exemplary here: projects precisely of *nonce* taxonomy, of the making and unmaking and remaking

and redissolution of hundreds of old and new categorical imaginings concerning all the kinds it may take to make up a world.

I don't assume that all gay men or all women are very skilled at the nonce-taxonomic work represented by gossip, but it does make sense to suppose that our distinctive needs are peculiarly disserved by its devaluation. For some people, the sustained, foregrounded pressure of loss in the AIDS years may be making such needs clearer: as one anticipates or tries to deal with the absence of people one loves, it seems absurdly impoverishing to surrender to theoretical trivialization or to 'the sentimental' one's descriptive requirements that the piercing bouquet of a given friend's particularity be done some justice. What is more dramatic is that – in spite of every promise to the contrary – every single theoretically or politically interesting project of postwar thought has finally had the effect of delegitimating our space for asking or thinking in detail about the multiple, unstable ways in which people may be like or different from each other. This project is not rendered otiose by any demonstration of how fully people may differ also from themselves. Deconstruction, founded as a very science of *différ(e/a)nce*, has both so fetishized the idea of difference and so vaporized its possible embodiments that its most thoroughgoing practitioners are the last people to whom one would now look for help in thinking about particular differences. The same thing seems likely to prove true of theorists of postmodernism. Psychoanalytic theory, if only through the almost astrologically lush plurality of its overlapping taxonomies of physical zones, developmental stages, representational mechanisms, and levels of consciousness, seemed to promise to introduce a certain becoming amplitude into discussions of what different people are like – only to turn, in its streamlined trajectory across so many institutional boundaries, into the sveltest of metatheoretical disciplines, sleeked down to such elegant operational entities as *the* mother, *the* father, *the* pre-oedipal, *the* oedipal, *the* other or Other. Within the less theorized institutional confines of intra-psychoanalytic discourse, meanwhile, a narrowly and severely normative, difference-eradicating ethical programme has long sheltered under developmental narratives and a metaphorics of health and pathology. In more familiar ways, Marxist, feminist, postcolonial, and other engagé critical projects have deepened understandings of a few crucial axes of difference, perhaps necessarily at the expense of more ephemeral or less global impulses of differential grouping. In each of these enquiries, so much has been gained by the different ways we have learned to deconstruct the category of *the individual* that it is easy for us now to read, say, Proust, as the most expert operator of our modern technologies for dismantling taxonomies of the person. For the emergence and persistence of the vitalizing worldly taxonomic energies on which Proust also depends, however, we have no theoretical support to offer. And these defalcations in our indispensable anti-humanist discourses have apparently ceded the potentially forceful ground of profound, complex variation to humanist liberal 'tolerance' or repressively trivializing celebration at best, to reactionary suppression at worst.

In the particular area of sexuality, for instance, I assume that most of us know the following things that can differentiate even people of identical gender, race, nationality, class, and 'sexual orientation' – each one of which, however, if taken seriously as pure *difference*, retains the unaccounted-for potential to disrupt many forms of the available thinking about sexuality.

- Even identical genital acts mean very different things to different people.
- To some people, the nimbus of 'the sexual' seems scarcely to extend beyond the boundaries of discrete genital acts; to others, it enfolds them loosely or floats virtually free of them.
- Sexuality makes up a large share of the self-perceived identity of some people, a small share of others'.
- Some people spend a lot of time thinking about sex, others little.
- Some people like to have a lot of sex, others little or none.
- Many people have their richest mental or emotional involvement with sexual acts that they don't do, or even don't *want* to do.
- For some people, it is important that sex be embedded in contexts resonant with meaning, narrative, and connectedness with other aspects of their life; for other people, it is important that they not be; to others it doesn't occur that they might be.
- For some people, the preference for a certain sexual object, act, role, zone, or scenario is so immemorial and durable that it can only be experienced as innate; for others, it appears to come late or to feel aleatory or discretionary.
- For some people, the possibility of bad sex is aversive enough that their lives are strongly marked by its avoidance; for others, it isn't.
- For some people, sexuality provides a needed space of heightened discovery and cognitive hyperstimulation. For others, sexuality provides a needed space of routinized habituation and cognitive hiatus.
- Some people like spontaneous sexual scenes, others like highly scripted ones, others like spontaneous-sounding ones that are nonetheless totally predictable.
- Some people's sexual orientation is intensely marked by autoerotic pleasures and histories – sometimes more so than by any aspect of alloerotic object choice. For others the autoerotic possibility seems secondary or fragile, if it exists at all.
- Some people, homo-, hetero-, and bisexual, experience their sexuality as deeply embedded in a matrix of gender meanings and gender differentials. Others of each sexuality do not.

Axiom 2: The study of sexuality is not coextensive with the study of gender; correspondingly, anti-homophobic enquiry is not coextensive with feminist enquiry. But we can't know in advance how they will be different

Sex, gender, sexuality: three terms whose usage relations and analytical relations are almost irremediably slippery. The charting of a space between something called 'sex' and something called 'gender' has been one of the most influential and successful undertakings of feminist thought. For the purposes of that undertaking, 'sex' has had the meaning of a certain group of irreducible, biological differentiations between members of the species *Homo sapiens* who have XX and those who have XY chromosomes. These include (or are ordinarily thought to include) more or less

marked dimorphisms of genital formation, hair growth (in populations that have body hair), fat distribution, hormonal function, and reproductive capacity. 'Sex' in this sense – what I'll demarcate as 'chromosomal sex' – is seen as the relatively minimal raw material on which is then based the social construction of *gender*. Gender, then, is the far more elaborated, more fully and rigidly dichotomized social production and reproduction of male and female identities and behaviours – of male and female *persons* – in a cultural system for which 'male/female' functions as a primary and perhaps model binarism affecting the structure and meaning of many, many other binarisms whose apparent connection to chromosomal sex will often be exiguous or non-existent. Compared to chromosomal sex, which is seen (by these definitions) as tending to be immutable, immanent in the individual, and biologically based, the meaning of gender is seen as culturally mutable and variable, highly relational (in the sense that each of the binarized genders is defined primarily by its relation to the other), and inextricable from a history of power differentials between genders. This feminist charting of what Gayle Rubin refers to as a 'sex/gender system', the system by which chromosomal sex is turned into, and processed as, cultural gender, has tended to minimize the attribution of people's various behaviours and identities to chromosomal sex and to maximize their attribution to socialized gender constructs. The purpose of that strategy has been to gain analytic and critical leverage on the female-disadvantaging social arrangements that prevail at a given time in a given society, by throwing into question their legitimative ideological grounding in biologically based narratives of the 'natural'.

'Sex' is, however, a term that extends indefinitely beyond chromosomal sex. That its history of usage often overlaps with what might, now, more properly be called 'gender' is only one problem. ('I can only love someone of my own sex.' Shouldn't 'sex' be 'gender' in such a sentence? 'M. saw that the person who approached was of the opposite sex.' Genders – insofar as there are two and they are defined in contradistinction to one another – may be said to be opposite; but in what sense is XX the opposite of XY?) Beyond chromosomes, however, the association of 'sex', precisely through the physical body, with reproduction and with genital activity and sensation keeps offering new challenges to the conceptual clarity or even possibility of sex/gender differentiation. There is a powerful argument to be made that a primary (or *the* primary) issue in gender differentiation and gender struggle is the question of who is to have control of women's (biologically) distinctive reproductive capability. Indeed, the intimacy of the association between several of the most signal forms of gender oppression and 'the facts' of women's bodies and women's reproductive activity has led some radical feminists to question, more or less explicitly, the usefulness of insisting on a sex/gender distinction. For these reasons, even usages involving the 'sex/gender system' within feminist theory are able to use 'sex/gender' only to delineate a problematical *space* rather than a crisp distinction. My own loose usage in this book will be to denominate that problematized space of the sex/gender system, the whole package of physical and cultural distinctions between women and men, more simply under the rubric 'gender'. I do this in order to reduce the likelihood of confusion between 'sex' in the sense of 'the space of differences between male and female' (what I'll be grouping under 'gender') and 'sex' in the sense of sexuality.

Table 28.1 Some mappings of sex, gender, and sexuality

Biological Essential Individually immanent	Cultural Constructed Relational

Constructivist Feminist Analysis

chromosomal sex ———————————— gender
gender inequality

Radical Feminist Analysis

chromosomal sex
reproductive relations ———————————— reproductive relations
sexual inequality ———————————— sexual inequality

Foucault-influenced Analysis

chromosomal sex ————— reproduction ————— sexuality

For meanwhile the whole realm of what modern culture refers to as 'sexuality' and *also* calls 'sex' – the array of acts, expectations, narratives, pleasures, identity-formations, and knowledges, in both women and men, that tends to cluster most densely around certain genital sensations but is not adequately defined by them – that realm is virtually impossible to situate on a map delimited by the feminist-defined sex/gender distinction. To the degree that it has a centre or starting point in certain physical sites, acts, and rhythms associated (however contingently) with procreation or the potential for it, 'sexuality' in this sense may seem to be of a piece with 'chromosomal sex': biologically necessary to species survival, tending toward the individually immanent, the socially immutable, the given. But to the extent that, as Freud argued and Foucault assumed, the distinctively sexual nature of human sexuality has to do precisely with its excess over or potential difference from the bare choreographies of procreation, 'sexuality' might be the very opposite of what we originally referred to as (chromosomal-based) sex: it could occupy, instead, even more than 'gender' the polar position of the relational, the social/symbolic, the constructed, the variable, the representational (see Table 28.1). To note that, according to these different findings, *something* legitimately called sex or sexuality is all over the experiential and conceptual map is to record a problem less resolvable than a necessary choice of analytic paradigms or a determinate slippage of semantic meaning; it is rather, I would say, true to quite a range of contemporary worldviews and intuitions to find that sex/sexuality *does* tend to represent the full spectrum of positions between the most intimate and the most social, the most predetermined and the most aleatory, the most physically rooted and the most symbolically infused, the most innate and the most learned, the most autonomous and the most relational traits of being.

If all this is true of the definitional nexus between sex and sexuality, how much less simple, even, must be that between sexuality and gender. It will be an assumption of this study that there is always at least the potential for an analytic distance between gender and sexuality, even if particular manifestations or features of particular sexualities are among the things that plunge women and men most ineluctably into the discursive, institutional, and bodily enmeshments of gender definition, gender relation, and gender inequality. This book will hypothesize that

the question of gender and the question of sexuality, inextricable from one another though they are in that each can be expressed only in terms of the other, are none the less not the same question, that in twentieth-century Western culture gender and sexuality represent two analytic axes that may productively be imagined as being as distinct from one another as, say, gender and class, or class and race. Distinct, that is to say, no more than minimally, but none the less usefully.

It would be a natural corollary to Axiom 2 to hypothesize, then, that gay/lesbian and anti-homophobic enquiry still has a lot to learn from asking questions that feminist enquiry has learned to ask – but only so long as we don't demand to receive the same answers in both interlocutions. In a comparison of feminist and gay theory as they currently stand, the newness and consequent relative underdevelopment of gay theory are seen most clearly in two manifestations. First, we are by now very used to asking as feminists what we aren't yet used to asking as anti-homophobic readers: how a variety of forms of oppression intertwine systematically with each other; and especially how the person who is disabled through one set of oppressions may *by the same positioning* be enabled through others. For instance, the understated demeanour of educated women in our society tends to mark both their deference to educated men and their expectation of deference from women and men of lower class. Again, a woman's use of a married name makes graphic at the same time her subordination as a woman and her privilege as a presumptive heterosexual. Or, again, the distinctive vulnerability to rape of women of all races has become in this country a powerful tool for the racist enforcement by which white people, including women, are privileged at the expense of Black people of both genders. That one is *either* oppressed *or* an oppressor, or that, if one happens to be both, the two are not likely to have much to do with each other, still seems to be a common assumption, however, in at any rate male gay writing and activism, as it hasn't for a long time been in careful feminist work.

Indeed, it was the long, painful realization, *not* that all oppressions are congruent, but that they are *differently* structured and so must intersect in complex embodiments that was the first great heuristic breakthrough of socialist-feminist thought and of the thought of women of colour. This realization has as its corollary that the comparison of different axes of oppression is a crucial task, not for any purpose of ranking oppressions but to the contrary because each oppression is likely to be in a uniquely indicative relation to certain distinctive nodes of cultural organization. The *special* centrality of homophobic oppression in the twentieth century, I will be arguing, has resulted from its inextricability from the question of knowledge and the processes of knowing in modern Western culture at large.

The second and perhaps even greater heuristic leap of feminism has been the recognition that categories of gender and, hence, oppressions of gender can have a structuring force for nodes of thought, for axes of cultural discrimination, whose thematic subject isn't explicitly gendered at all. Through a series of developments structured by the deconstructive understandings and procedures sketched above, we have now learned as feminist readers that dichotomies in a given text of culture as opposed to nature, public as opposed to private, mind as opposed to body, activity as opposed to passivity, etc. etc., are, under particular pressures of culture and history, likely places to look for implicit allegories of the relations of men to women; more, that to fail to analyse such nominally ungendered constructs in

gender terms can itself be a gravely tendentious move in the gender politics of reading. This has given us ways to ask the question of gender about texts even where the culturally 'marked' gender (female) is not present as either author or thematic.

Axiom 3: There can't be an *a priori* decision about how far it will make sense to conceptualize lesbian and gay male identities together. Or separately

The lesbian interpretative framework most readily available at the time this project began was the separatist-feminist one that emerged from the 1970s. According to that framework, there were essentially no valid grounds of commonality between gay male and lesbian experience and identity; to the contrary, women-loving women and men-loving men must be at precisely opposite ends of the gender spectrum. The assumptions at work here were indeed radical ones: most important, the stunningly efficacious re-visioning, in female terms, of same-sex desire as being at the very definitional centre of each gender, rather than as occupying a cross-gender or liminal position between them. Thus, women who loved women were seen as *more* female, men who loved men as quite possibly more male, than those whose desire crossed boundaries of gender. The axis of sexuality, in this view, was not only exactly coextensive with the axis of gender but expressive of its most heightened essence: 'Feminism is the theory, lesbianism is the practice.' By analogy, male homosexuality could be, and often was, seen as the practice for which male supremacy was the theory. A particular reading of modern gender history was, of course, implicit in and in turn propelled by this gender-separatist framework. In accord with, for instance, Adrienne Rich's understanding of many aspects of women's bonds as constituting a 'lesbian continuum', this history, found in its purest form in the work of Lilian Faderman, deemphasized the definitional discontinuities and perturbations between more and less sexualized, more and less prohibited, and more and less gender-identity-bound forms of female same-sex bonding. Insofar as lesbian object-choice was viewed as epitomizing a specificity of female experience and resistance, insofar as a symmetrically opposite understanding of gay male object-choice also obtained, and insofar also as feminism necessarily posited male and female experiences and interests as different and opposed, the implication was that an understanding of male homo/heterosexual definition could offer little or no affordance or interest for any lesbian theoretical project. Indeed, the powerful impetus of a gender-polarized feminist ethical schema made it possible for a profoundly anti-homophobic reading of lesbian desire (as a quintessence of the female) to fuel a correspondingly homophobic reading of gay male desire (as a quintessence of the male).

Since the late 1970s, however, there have emerged a variety of challenges to this understanding of how lesbian and gay male desires and identities might be mapped against each other. Each challenge has led to a refreshed sense that lesbians and gay men may share important though contested aspects of one another's histories, cultures, identities, politics, and destinies. These challenges have emerged from the 'sex wars' within feminism over pornography and S/M, which seemed

to many pro-sex feminists to expose a devastating continuity between a certain, theretofore privileged feminist understanding of a resistant female identity, on the one hand, and on the other the most repressive nineteenth-century bourgeois constructions of a sphere of pure femininity. Such challenges emerged as well from the reclamation and relegitimation of a courageous history of lesbian transgender role-playing and identification. Along with this new historical making-visible of self-defined mannish lesbians came a new salience of the many ways in which male and female homosexual identities had in fact been constructed through and in relation to each other over the last century – by the variously homophobic discourses of professional expertise, but also and just as actively by many lesbians and gay men. The irrepressible, relatively class-non-specific popular culture in which James Dean has been as numinous an icon for lesbians as Garbo or Dietrich has for gay men seems resistant to a purely feminist theorization. It is in these contexts that calls for a theorized axis of sexuality as distinct from gender have developed. And after the anti-S/M, anti-pornography liberal feminist move toward labelling and stigmatizing particular sexualities joined its energies with those of the much longer-established conservative sanctions against all forms of sexual 'deviance', it remained only for the terrible accident of the HIV epidemic and the terrifyingly genocidal overdeterminations of AIDS discourse to reconstruct a category of the pervert capacious enough to admit homosexuals of any gender. The newly virulent homophobia of the 1980s, directed alike against women and men even though its medical pretext ought, if anything, logically to give a relative exemptive privilege to lesbians, reminds urgently that it is more to friends than to enemies that gay women and gay men are perceptible as distinct groups. Equally, however, the internal perspective of the gay movements shows women and men increasingly, though far from uncontestingly and far from equally, working together on mutually anti-homophobic agendas. The contributions of lesbians to current gay and AIDS activism are weighty, not despite, but because of the intervening lessons of feminism. Feminist perspectives on medicine and health-care issues, on civil disobedience, and on the politics of class and race as well as of sexuality have been centrally enabling for the recent waves of AIDS activism. What this activism returns to the lesbians involved in it may include a more richly pluralized range of imaginings of lines of gender and sexual identification.

Thus, it can no longer make sense, if it ever did, simply to assume that a male-centred analysis of homo-heterosexual definition will have no lesbian relevance or interest. At the same time, there are no algorithms for assuming a priori what its lesbian relevance could be or how far its lesbian interest might extend.

Axiom 4: The immemorial, seemingly ritualized debates on nature versus nurture take place against a very unstable background of tacit assumptions and fantasies about both nurture and nature

If there is one compulsory setpiece for the Introduction to any gay-oriented book written in the late 1980s, it must be the meditation on and attempted adjudication of constructivist versus essentialist views of homosexuality. My demurral has two

grounds. The first is that any such adjudication is impossible to the degree that a conceptual deadlock between the two opposing views has by now been built into the very structure of every theoretical tool we have for undertaking it. The second one is already implicit in a terminological choice I have been making: to refer to 'minoritizing' versus 'universalizing' rather than to essentialist versus constructivist understandings of homosexuality. I prefer the former terminology because it seems to record and respond to the question, 'In whose lives is homo/heterosexual definition an issue of continuing centrality and difficulty?' rather than either of the questions that seem to have got conflated in the constructivist/essentialist debate: on the one hand what one might call the question of phylogeny, 'How fully are the meaning and experience of sexual activity and identity contingent on their mutual structuring with other, historically and culturally variable aspects of a given society?'; and on the other what one might call that of ontogeny, 'What is the cause of homo- [or of hetero-] sexuality in the individual?' I am specifically offering minoritizing/universalizing as an *alternative* (though not an equivalent) to essentialist/constructivist, in the sense that I think it can do some of the same analytic work as the latter binarism, and rather more tellingly. I think it may isolate the areas where the questions of ontogeny and phylogeny most consequentially overlap. I also think, as I suggested in Axiom 1, that it is more respectful of the varied proprioception of many authoritative individuals. But I am additionally eager to promote the obsolescence of 'essentialist/constructivist' because I am very dubious about the ability of even the most scrupulously gay-affirmative thinkers to divorce these terms, especially as they relate to the question of ontogeny, from the essentially gay-genocidal nexuses of thought through which they have developed. And beyond that: even where we may think we know the conceptual landscape of their history well enough to do the delicate, always dangerous work of prying them loose from their historical backing to attach to them newly enabling meanings, I fear that the special volatility of postmodern bodily and technological relations may make such an attempt peculiarly liable to tragic misfire. Thus, it would seem to me that gay-affirmative work does well when it aims to minimize its reliance on any particular account of the origin of sexual preference and identity in individuals.

In particular, my fear is that there currently exists no framework in which to ask about the origins or development of individual gay identity that is not already structured by an implicit, trans-individual Western project or fantasy of eradicating that identity. It seems ominously symptomatic that, under the dire homophobic pressures of the last few years, and in the name of Christianity, the subtle constructivist argument that sexual aim is, at least for many people, not a hard-wired biological given but, rather, a social fact deeply embedded in the cultural and linguistic forms of many, many decades is being degraded to the blithe ukase that people are 'free at any moment to' (i.e., must immediately) 'choose' to adhere to a particular sexual identity (say, at a random hazard, the heterosexual) rather than to its other. (Here we see the disastrously unmarked crossing of phylogenetic with ontogenetic narratives.) To the degree – and it is significantly large – that the gay essentialist/constructivist debate takes its form and premises from, and insistently refers to, a whole history of other nature/nurture or nature/culture debates, it partakes of a tradition of viewing culture as malleable relative to nature: that is, culture, unlike nature, is assumed to be the thing that

can be changed; the thing in which 'humanity' has, furthermore, a right or even an obligation to intervene. This has certainly been the grounding of, for instance, the feminist formulation of the sex/gender system described above, whose implication is that the more fully gender inequality can be shown to inhere in human culture rather than in biological nature, the more amenable it must be to alteration and reform. I remember the buoyant enthusiasm with which feminist scholars used to greet the finding that one or other brutal form of oppression was not biological but 'only' cultural! I have often wondered what the basis was for our optimism about the malleability of culture by any one group or programme. At any rate, never so far as I know has there been a sufficiently powerful place from which to argue that such manipulations, however triumphal the ethical imperative behind them, were not a right that belonged to anyone who might have the power to perform them.

The number of persons or institutions by whom the existence of gay people – never mind the existence of *more gay people* – is treated as a precious desideratum, a needed condition of life, is small, even compared to those who may wish for the dignified treatment of any gay people who happen already to exist. Advice on how to make sure your kids turn out gay, not to mention your students, your parishioners, your therapy clients, or your military subordinates, is less ubiquitous than you might think. By contrast, the scope of institutions whose programmatic undertaking is to prevent the development of gay people is unimaginably large. No major institutionalized discourse offers a firm resistance to that undertaking; in the United States, at any rate, most sites of the state, the military, education, law, penal institutions, the church, medicine, mass culture, and the mental health industries enforce it all but unquestioningly, and with little hesitation even at recourse to invasive violence. So for gay and gay-loving people, even though the space of cultural malleability is the only conceivable theatre for our effective politics, every step of this constructivist nature/culture argument holds danger: it is so difficult to intervene in the seemingly natural trajectory that begins by identifying a place of cultural malleability; continues by inventing an ethical or therapeutic mandate for cultural manipulation; and ends in the overarching, hygienic Western fantasy of a world without any more homosexuals in it.

That's one set of dangers, and it is against them, I think, that essentialist understandings of sexual identity accrue a certain gravity. The resistance that seems to be offered by conceptualizing an unalterably *homosexual body*, to the social engineering momentum apparently built into every one of the human sciences of the West, can reassure profoundly. Furthermore, it reaches deeply and, in a sense, protectively into a fraught space of life-or-death struggle that has been more or less abandoned by constructivist gay theory: that is, the experience and identity of gay or proto-gay children. The ability of anyone in the culture to support and honour gay kids may depend on an ability to name them as such, notwithstanding that many gay adults may never have been gay kids and some gay kids may not turn into gay adults. It seems plausible that a lot of the emotional energy behind essentialist historical work has to do not even in the first place with reclaiming the place and eros of Homeric heroes, Renaissance painters, and medieval gay monks, so much as with the far less permissible, vastly more necessary project of recognizing and validating the creativity and heroism of the effeminate boy or tommish girl of

the 1950s (or 1960s or 1970s or 1980s) whose sense of constituting precisely a *gap* in the discursive fabric of the given has not been done justice, so far, by constructivist work.

At the same time, however, just as it comes to seem questionable to assume that cultural constructs are peculiarly malleable ones, it is also becoming increasingly problematical to assume that grounding an identity in biology or 'essential nature' is a stable way of insulating it from societal interference. If anything, the gestalt of assumptions that undergird nature/nurture debates may be in the process of direct reversal. Increasingly it is the conjecture that a particular trait is genetically or biologically based, *not* that it is 'only cultural', that seems to trigger an oestrus of manipulative fantasy in the technological institutions of the culture. A relative depressiveness about the efficacy of social engineering techniques, a high mania about biological control: the Cartesian bipolar psychosis that always underlay the nature/nurture debates has switched its polar assignments without surrendering a bit of its hold over the collective life. And in this unstable context, the dependence on a specified *homosexual body* to offer resistance to any gay-eradicating momentum is tremblingly vulnerable. AIDS, though it is used to proffer every single day to the news-consuming public the crystallized vision of a world after the homosexual, could never by itself bring about such a world. What whets these fantasies more dangerously, because more blandly, is the presentation, often in ostensibly or authentically gay-affirmative contexts, of biologically based 'explanations' for deviant behaviour that are absolutely invariably couched in terms of 'excess', 'deficiency', or 'imbalance' — whether in the hormones, in the genetic material, or, as is currently fashionable, in the foetal endocrine environment. If I had ever, in any medium, seen any researcher or popularizer refer even once to any supposed gay-producing circumstance as the *proper* hormone balance, or the *conducive* endocrine environment, for gay generation, I would be less chilled by the breezes of all this technological confidence. As things are, a medicalized dream of the prevention of gay bodies seems to be the less visible, far more respectable underside of the AIDS-fuelled public dream of their extirpation. In this unstable balance of assumptions between nature and culture, at any rate, under the overarching, relatively unchallenged aegis of a culture's desire that gay people *not be*, there is no unthreatened, unthreatening conceptual home for a concept of gay origins. We have all the more reason, then, to keep our understanding of gay origin, of gay cultural and material reproduction, plural, multi-capillaried, argus-eyed, respectful, and endlessly cherished.

Axiom 5: The historical search for a Great Paradigm Shift may obscure the present conditions of sexual identity

Since 1976, when Michel Foucault, in an act of polemical bravado, offered 1870 as the date of birth of modern homosexuality, the most sophisticated historically oriented work in gay studies has been offering ever more precise datings, ever more nuanced narratives of the development of homosexuality 'as we know it today'. The great value of this scholarly movement has been to subtract from that 'as we know it today' the twin positivist assumptions, first, that there must

be some *transhistorical* essence of 'homosexuality' available to modern knowledge, and, second, that the history of understandings of same-sex relations has been a history of increasingly direct, true knowledge or comprehension of that essence. To the contrary, the recent historicizing work has assumed, first, that the differences between the homosexuality 'we know today' and previous arrangements of same-sex relations may be so profound and so integrally rooted in other cultural differences that there may be no continuous, defining essence of 'homosexuality' to *be* known; and, second, that modern 'sexuality' and hence modern homosexuality are so intimately entangled with the historically distinctive contexts and structures that now count as *knowledge* that such 'knowledge' can scarcely be a transparent window onto a separate realm of sexuality but, rather, itself constitutes that sexuality.

These developments have promised to be exciting and productive in the way that the most important work of history or, for that matter, of anthropology may be: in radically defamiliarizing and denaturalizing not only the past and the distant, but the present. One way, however, in which such an analysis is still incomplete – in which, indeed, it seems to me that it has tended inadvertently to *re*familiarize, *re*naturalize, damagingly reify an entity that it could be doing much more to subject to analysis – is in counterposing against the alterity of the past a relatively unified homosexuality that 'we' *do* 'know today'. It seems that the *topos* of 'homosexuality as we know it today', or even, to incorporate more fully the anti-positivist finding of the Foucauldian shift, 'homosexuality as we *conceive of it* today', has provided a rhetorically necessary fulcrum point for the denaturalizing work on the past done by many historians. But an unfortunate side effect of this move has been implicitly to underwrite the notion that 'homosexuality as we conceive of it today' itself comprises a coherent definitional field rather than a space of overlapping, contradictory, and conflictual definitional forces. Unfortunately, this presents more than a problem of oversimplification. To the degree that power relations involving modern homo/heterosexual definition have been structured by the very tacitness of the double-binding force fields of conflicting definition – to that degree these historical projects, for all their immense care, value, and potential, still risk reinforcing a dangerous consensus of knowingness about the genuinely *un*known, more than vestigially contradictory structurings of contemporary experience.

As an example of this contradiction effect, let me juxtapose two programmatic statements of what seem to be intended as parallel and congruent projects. In the foundational Foucault passage to which I alluded above, the modern category of 'homosexuality' that dates from 1870 is said to be

> characterized … less by a type of sexual relations than by a certain quality of sexual sensibility, a certain way of inverting the masculine and feminine in oneself. Homosexuality appeared as one of the forms of sexuality when it was transposed from the practice of sodomy onto a kind of interior androgyny, a hermaphrodism of the soul. The sodomite had been a temporary aberration; the homosexual was now a species.

In Foucault's account, the unidirectional emergence in the late nineteenth century of 'the homosexual' as 'a species', of homosexuality as a minoritizing identity, is seen as tied to an also unidirectional, and continuing, emergent understanding of

homosexuality in terms of gender inversion and gender transitivity. This understanding appears, indeed, according to Foucault, to underlie and constitute the common sense of the homosexuality 'we know today'. A more recent account by David M. Halperin, on the other hand, explicitly in the spirit and under the influence of Foucault but building, as well, on some intervening research by George Chauncey and others, constructs a rather different narrative – but constructs it, in a sense, *as if it were the same one*:

> Homosexuality and heterosexuality, as we currently understand them, are modern, Western, bourgeois productions. Nothing resembling them can be found in classical antiquity. … In London and Paris, in the seventeenth and eighteenth centuries, there appear … social gathering-places for persons of the same sex with the same socially deviant attitudes to sex and gender who wish to socialize and to have sex with one another. … This phenomenon contributes to the formation of the great nineteenth-century experience of 'sexual inversion', or sex-role reversal, in which some forms of sexual deviance are interpreted as, or conflated with, gender deviance. The emergence of homosexuality out of inversion, the formation of a sexual orientation independent of relative degrees of masculinity and femininity, takes place during the latter part of the nineteenth century and comes into its own only in the twentieth. Its highest expression is the 'straight-acting and -appearing gay male', a man distinct from other men in absolutely no other respect besides that of his 'sexuality'.
>
> (Halperin 1989: 8–9)

Halperin offers some discussion of why and how he has been led to differ from Foucault in discussing 'inversion' as a stage that in effect preceded 'homosexuality'. What he does not discuss is that his reading of 'homosexuality' as 'we currently understand' it – his presumption of the reader's common sense, present-tense conceptualization of homosexuality, the point from which all the thought experiments of differentiation must proceed – is virtually the opposite of Foucault's. For Halperin, what is presumed to define modern homosexuality 'as we understand' it, in the form of the straight-acting and -appearing gay male, is gender intransitivity; for Foucault, it is, in the form of the feminized man or virilized woman, gender transitivity.

What obscures this difference between two historians, I believe, is the underlying structural congruence of the two histories: each is a unidirectional narrative of supersession. Each one makes an overarching point about the complete conceptual alterity of earlier models of same-sex relations. In each history one model of same-sex relations is superseded by another, which may again be superseded by another. In each case the superseded model then drops out of the frame of analysis. For Halperin, the power and interest of a post-inversion notion of 'sexual orientation independent of relative degrees of masculinity and femininity' seem to indicate that that notion must necessarily be seen as superseding the inversion model; he then seems to assume that any elements of the inversion model still to be found in contemporary understandings of homosexuality may be viewed as mere historical remnants whose process of withering away, however protracted, merits no analytic attention. The end point of Halperin's narrative differs from that of Foucault, but

his proceeding does not: just as Halperin, having discovered an important *intervening* model, assumes that it must be a *supervening* one as well, so Foucault had already assumed that the nineteenth-century intervention of a minoritizing discourse of sexual identity in a previously extant, universalizing discourse of 'sodomitic' sexual acts must mean, for all intents and purposes, the eclipse of the latter.

This assumption is significant only if – as I will be arguing – the most potent effects of modern homo/heterosexual definition tend to spring precisely from the inexplicitness or denial of the gaps *between* long-coexisting minoritizing and universalizing, or gender-transitive and gender-intransitive, understandings of same-sex relations. If that argument is true, however, then the enactment performed by these historical narratives has some troubling entailments. For someone who lives, for instance, as I do, in a state where certain acts called 'sodomy' are criminal regardless of the gender, never mind the homo/heterosexual 'identity', of the persons who perform them, the threat of the juxtaposition *on* that prohibition against *acts* of an additional, unrationalized set of sanctions attaching to *identity* can only be exacerbated by the insistence of gay theory that the discourse of acts can represent nothing but an anachronistic vestige. The project of the present book will be to show how issues of modern homo/heterosexual definition are structured, not by the supersession of one model and the consequent withering away of another, but instead by the relations made possible by the unrationalized coexistence of different models during the times they do coexist. This project does not involve the construction of historical narratives alternative to those that have emerged from Foucault and his followers. Rather, it requires a reassignment of attention and emphasis within those valuable narratives – attempting, perhaps, to denarrativize them somewhat by focusing on a performative space of contradiction that they both delineate and, themselves performative, pass over in silence. I have tended, therefore, in these chapters not to stress the alterity of disappeared or now-supposed-alien understandings of same-sex relations but instead to invest attention in those unexpectedly plural, varied, and contradictory historical understandings whose residual – indeed, whose renewed – force seems most palpable today. My first aim is to denaturalize the present, rather than the past – in effect, to render less destructively presumable 'homosexuality as we know it today'.

Axiom 6: The paths of allo-identification are likely to be strange and recalcitrant. So are the paths of auto-identification

What would make a good answer to implicit questions about someone's group-identification across politically charged boundaries, whether of gender, of class, of race, of sexuality, of nation? It could never be a version of 'But everyone *should* be able to make this identification.' Perhaps everyone should, but everyone does not, and almost no one makes more than a small number of very narrowly channelled ones. (A currently plausible academic ideology, for instance, is that everyone in a position of class privilege *should* group-identify across lines of class; but who hasn't noticed that of the very few US scholars under fifty who have been capable of doing so productively, and over the long haul, most also 'happen to have been'

red diaper babies?) If the ethical prescription is explanatory at all – and I have doubts about that – it is anything but a full explanation. It often seems to me, to the contrary, that what these implicit questions really ask for is narrative, and of a directly personal sort. When I have experimented with offering such narrative, in relation to this ongoing project, it has been with several aims in mind. I wanted to disarm the categorical imperative that seems to do so much to promote cant and mystification about motives in the world of politically correct academia. I wanted to try opening channels of visibility – towards the speaker, in this case – that might countervail somewhat against the terrible one-directionality of the culture's spectacularizing of gay men, to which it seems almost impossible, in any powerful gay-related project, not also to contribute. I meant, in a sense, to give hostages, though the possible thud of them on the tarmac of some future conflict is not something I can contemplate. I also wanted to offer (though on my own terms) whatever tools I could with which a reader who needed to might begin unknotting certain overdetermined impactions that inevitably structure these arguments. Finally, I have come up with such narrative because I desired and needed to, because its construction has greatly interested me, and what I learned from it has often surprised me.

A note appended to one of these accounts suggested an additional reason: 'Part of the motivation behind my work on it', I wrote there, 'has been a fantasy that readers or hearers would be variously – in anger, identification, pleasure, envy, "permission", exclusion – stimulated to write accounts "like" this one (whatever that means) of their own, and share those' (Sedgwick 1987: 137). My impression, indeed, is that some readers of that essay have done so. An implication of that wishful note was that it is not only identifications *across* definitional lines that can evoke or support or even require complex and particular narrative explanation; rather, the same is equally true of any person's identification with her or his 'own' gender, class, race, sexuality, nation. I think, for instance, of a graduate class I taught a few years ago in gay and lesbian literature. Half the students in the class were men, half women. Throughout the semester all the women, including me, intensely uncomfortable with the dynamics of the class and hyperconscious of the problems of articulating lesbian with gay male perspectives, attributed our discomfort to some obliquity in the classroom relations between ourselves and the men. But by the end of the semester it seemed clear that we were in the grip of some much more intimate dissonance. It seemed that it was among the group of women, all feminists, largely homogeneous in visible respects, that some nerve of individually internal difference had been set painfully, contagiously atremble. Through a process that began, but *only* began, with the perception of some differences among our most inexplicit, often somewhat uncrystallized sexual self-definitions, it appeared that each woman in the class possessed (or might, rather, feel we were possessed by) an ability to make one or more of the other women radically and excruciatingly doubt the authority of her own self-definition as a woman; as a feminist; and as the positional subject of a particular sexuality.

I think it probable that most people, especially those involved with any form of politics that touches on issues of identity – race, for instance, as well as sexuality and gender – have observed or been part of many such circuits of intimate denegation, as well as many circuits of its opposite. The political or pedagogical

utility or destructiveness of those dissonant dynamics is scarcely a given, though perhaps it must always be aversive to experience them. Such dynamics – the denegating ones along with the consolidating ones – are not epiphenomenal to identity politics, but constitute it. After all, to identify *as* must always include multiple processes of identification *with*. It also involves identification *as against*; but even did it not, the relations implicit in *identifying with* are, as psychoanalysis suggests, in themselves quite sufficiently fraught with intensities of incorporation, diminishment, inflation, threat, loss, reparation, and disavowal. For a politics like feminism, furthermore, effective moral authority has seemed to depend on its capacity for conscientious and non-perfunctory enfoldment of women alienated from one another in virtually every other relation of life. Given this, there are strong political motives for obscuring any possibility of differentiating between one's identification *as* (a woman) and one's identification *with* (women very differently situated – for bourgeois feminists, this means radically less privileged ones). At least for relatively privileged feminists of my generation, it has been an article of faith, and a deeply educative one, that to conceive of oneself as a woman at all must mean trying to conceive oneself, over and over, as if incarnated in ever more palpably vulnerable situations and embodiments. The costs of this pressure toward mystification – the constant reconflation, as one monolithic act, of *identification with/as* – are, I believe, high for feminism, though its rewards have also been considerable. (Its political efficacy in actually broadening the bases of feminism is still, it seems to me, very much a matter of debate.) *Identification with/as* has a distinctive resonance for women in the oppressively tidy dovetailing between old ideologies of women's traditional 'selflessness' and a new one of feminist commitment that seems to begin with a self but is legitimated only by wilfully obscuring most of its boundaries.

For better and for worse, mainstream, male-centred gay politics has tended not to be structured as strongly as feminism has by that particular ethical pressure. Yet, there is a whole different set of reasons why a problematics of *identification with/as* seems to be distinctively resonant with issues of male homo/heterosexual definition. *Between Men* tried to demonstrate that modern, homophobic constructions of male heterosexuality have a conceptual dependence on a distinction between men's *identification* (with men) and their *desire* (for women), a distinction whose factitiousness is latent where not patent. The (relatively new) emphasis on the 'homo-', on the dimension of sameness, built into modern understandings of relations of sexual desire within a given gender, has had a sustained and active power to expose that factitiousness, to show how close may be the slippage or even the melding between identification and desire. Thus, an entire social region of the vicarious becomes peculiarly charged in association with homo-heterosexual definition. I will argue that processes of homosexual attribution and identification have had a distinctive centrality, in this century, for many stigmatized but extremely potent sets of relations involving projective chains of vicarious investment: sentimentality, kitsch, camp, the knowing, the prurient, the arch, the morbid.

There may, then, be a rich and conflictual salience of the vicarious embedded within gay definition. I don't point out to offer an excuse for the different, openly vicariating cathexis from outside that motivates this study; it either needs or, perhaps, can have none. But this in turn may suggest some ways in which the particular obliquities of my approach to the subject may bias what I find there. I

can say generally that the vicarious investments most visible to me have had to do with my experiences as a woman; as a fat woman; as a non-procreative adult; as someone who is, under several different discursive regimes, a sexual pervert; and, under some, a Jew. To give an example: I've wondered about my ability to keep generating ideas about 'the closet', compared to a relative inability, so far, to have new ideas about the substantive differences made by post-Stonewall imperatives to rupture or vacate that space (this, obviously, despite every inducement to thought provided by the immeasurable value of 'out' liberatory gay politics in the lives around me and my own). May it not be influenced by the fact that my own relation, as a woman, to gay male discourse and gay men echoes most with the pre-Stonewall gay self-definition of (say) the 1950s? — something, that is, whose names, where they exist at all, are still so exotically coarse and demeaning as to challenge recognition, never mind acknowledgement; leaving, in the stigma-impregnated space of refused recognition, sometimes also a stimulating ether of the unnamed, the lived experiment.

PART SEVEN

Consumption and the market

Theodor Adorno and Max Horkheimer

THE CULTURE INDUSTRY
Enlightenment as mass deception

EDITOR'S INTRODUCTION

ADORNO AND HORKHEIMER'S ESSAY, published in the mid-1940s, remains the classic denunciation of the 'culture industry'. It offers a vision of a society that has lost its capacity to nourish true freedom and individuality – as well as the ability to represent the real conditions of existence. Adorno and Horkheimer believe this loss results from the fact that cultural production has moved from an artisanal stage, which depended on individual effort and required little or no investment, to an industrial stage. For them, the modern culture industry produces safe, standardized products geared to the larger demands of the capitalist economy. It does so by representing 'average' life for purposes of pure entertainment or distraction as seductively and realistically as possible. Thus, for them, Hollywood movies, radio, mass-produced journalism and advertising are only different at the most superficial level. Furthermore, the culture industry has become so successful that 'art' and 'life' are no longer wholly separable – which is the theme later theorists of postmodernity took from the essay. (See Jameson 1990.) Of course 'high' art still exists as 'mass culture's' opposite, but for Adorno, in a famous phrase, these are two halves of a whole that do not add up.

Debate about the essay continues, but it is important to remember the situation in which it was written. The Second World War had not quite ended, and Adorno and Horkheimer were refugees from Nazi Germany living in the USA. Hitler's totalitarianism (with its state control of cultural production) and the American market-system are fused in their thought – all the more easily because, for them as members of the German (or rather the secularized German-Jewish) bourgeoisie, high culture, particularly drama and music, is a powerful vehicle of civil values. It is also worth emphasizing that when this essay was written the

cultural industry was less variegated than it was to become during the 1960s in particular. Hollywood, for instance, was still 'vertically integrated' so that the five major studios owned the production, distribution and exhibition arms of the film business between them; television was still in its infancy; the LP and the single were unknown; the cultural market had not been broken into various demographic sectors – of which, in the 1950s, the youth segment was to become the most energetic. This helps explain how Adorno and Horkheimer neglect what was to become central to cultural studies: the ways in which the cultural industry, while in the service of organized capital, also provides the opportunities for all kinds of individual and collective creativity and decoding.

Further reading: Adorno 1991; Berman 1989; Connerton 1980; Gunster 2004; Jameson 1990; Jay 1984a; Jenkins *et al.* 2003; Kracauer 1995; Pensky 1997.

The sociological theory that the loss of the support of objectively established religion, the dissolution of the last remnants of precapitalism, together with technological and social differentiation or specialization, have led to cultural chaos is disproved every day; for culture now impresses the same stamp on everything. Films, radio and magazines make up a system which is uniform as a whole and in every part. Even the aesthetic activities of political opposites are one in their enthusiastic obedience to the rhythm of the iron system. The decorative industrial management buildings and exhibition centres in authoritarian countries are much the same as anywhere else. The huge gleaming towers that shoot up everywhere are outward signs of the ingenious planning of international concerns, towards which the unleashed entrepreneurial system (whose monuments are a mass of gloomy houses and business premises in grimy, spiritless cities) was already hastening. Even now the older houses just outside the concrete city centres look like slums, and the new bungalows on the outskirts are at one with the flimsy structures of world fairs in their praise of technical progress and their built-in demand to be discarded after a short while like empty food cans. Yet the city housing projects designed to perpetuate the individual as a supposedly independent unit in a small hygienic dwelling make him all the more subservient to his adversary – the absolute power of capitalism. Because the inhabitants, as producers and as consumers, are drawn into the centre in search of work and pleasure, all the living units crystallize into well-organized complexes. The striking unity of microcosm and macrocosm presents men with a model of their culture: the false identity of the general and the particular. Under monopoly all mass culture is identical, and the lines of its artificial framework begin to show through. The people at the top are no longer so interested in concealing monopoly: as its violence becomes more open, so its power grows. Movies and radio need no longer pretend to be art. The truth that they are just business is made into an ideology in order to justify the rubbish they deliberately produce. They call themselves industries; and when their directors' incomes are published, any doubt about the social utility of the finished products is removed.

Interested parties explain the culture industry in technological terms. It is alleged that because millions participate in it, certain reproduction processes

are necessary that inevitably require identical needs in innumerable places to be satisfied with identical goods. The technical contrast between the few production centres and the large number of widely dispersed consumption points is said to demand organization and planning by management. Furthermore, it is claimed that standards were based in the first place on consumers' needs, and for that reason were accepted with so little resistance. The result is the circle of manipulation and retroactive need in which the unity of the system grows ever stronger. No mention is made of the fact that the basis on which technology acquires power over society is the power of those whose economic hold over society is greatest. A technological rationale is the rationale of domination itself. It is the coercive nature of society alienated from itself. Automobiles, bombs, and movies keep the whole thing together until their levelling element shows its strength in the very wrong which it furthered. It has made the technology of the culture industry no more than the achievement of standardization and mass production, sacrificing whatever involved a distinction between the logic of the work and that of the social system. This is the result not of a law of movement in technology as such but of its function in today's economy. The need which might resist central control has already been suppressed by the control of the individual consciousness. The step from the telephone to the radio has clearly distinguished the roles. The former still allowed the subscriber to play the role of subject, and was liberal. The latter is democratic: it turns all participants into listeners and authoritatively subjects them to broadcast programmes which are all exactly the same. No machinery of rejoinder has been devised, and private broadcasters are denied any freedom. They are confined to the apocryphal field of the 'amateur', and also have to accept organization from above. But any trace of spontaneity from the public in official broadcasting is controlled and absorbed by talent scouts, studio competitions and official programmes of every kind selected by professionals. Talented performers belong to the industry long before it displays them; otherwise they would not be so eager to fit in. The attitude of the public, which ostensibly and actually favours the system of the culture industry, is a part of the system and not an excuse for it. If one branch of art follows the same formula as one with a very different medium and content; if the dramatic intrigue of broadcast soap operas becomes no more than useful material for showing how to master technical problems at both ends of the scale of musical experience — real jazz or a cheap imitation; or if a movement from a Beethoven symphony is crudely 'adapted' for a film soundtrack in the same way as a Tolstoy novel is garbled in a film script: then the claim that this is done to satisfy the spontaneous wishes of the public is no more than hot air. We are closer to the facts if we explain these phenomena as inherent in the technical and personnel apparatus which, down to its last cog, itself forms part of the economic mechanism of selection. In addition there is the agreement — or at least the determination — of all executive authorities not to produce or sanction anything that in any way differs from their own rules, their own ideas about consumers, or above all themselves.

In our age the objective social tendency is incarnate in the hidden subjective purposes of company directors, the foremost among whom are in the most powerful sectors of industry — steel, petroleum, electricity, and chemicals. Culture monopolies are weak and dependent in comparison. They cannot afford to neglect

their appeasement of the real holders of power if their sphere of activity in mass society (a sphere producing a specific type of commodity which anyhow is still too closely bound up with easygoing liberalism and Jewish intellectuals) is not to undergo a series of purges. The dependence of the most powerful broadcasting company on the electrical industry, or of the motion picture industry on the banks, is characteristic of the whole sphere, whose individual branches are themselves economically interwoven. All are in such close contact that the extreme concentration of mental forces allows demarcation lines between different firms and technical branches to be ignored. The ruthless unity in the culture industry is evidence of what will happen in politics. Market differentiations such as those of A and B films, or of stories in magazines in different price ranges, depend not so much on subject matter as on classifying, organizing, and labelling consumers. Something is provided for all so that none may escape; the distinctions are emphasized and extended. The public is catered for with a hierarchical range of mass-produced products of varying quality, thus advancing the rule of complete quantification. Everybody must behave (as if spontaneously) in accordance with his previous determined and indexed level, and choose the category of mass product turned out for his type. Consumers appear as statistics on research organization charts, and are divided by income groups into red, green, and blue areas; the technique is that used for any type of propaganda.

How formalized the procedure is can be seen when the mechanically differentiated products prove to be all alike in the end. That the difference between the Chrysler range and General Motors products is basically illusory strikes every child with a keen interest in varieties. What connoisseurs discuss as good or bad points serve only to perpetuate the semblance of competition and range of choice. The same applies to the Warner Brothers and Metro Goldwyn Mayer productions. But even the differences between the more expensive and cheaper models put out by the same firm steadily diminish: for automobiles, there are such differences as the number of cylinders, cubic capacity, details of patented gadgets; and for films there are the number of stars, the extravagant use of technology, labour, and equipment, and the introduction of the latest psychological formulas. The universal criterion of merit is the amount of 'conspicuous production' of blatant cash investment. The varying budgets in the culture industry do not bear the slightest relation to factual values, to the meaning of the products themselves. Even the technical media are relentlessly forced into uniformity. Television aims at a synthesis of radio and film, and is held up only because the interested parties have not yet reached agreement, but its consequences will be quite enormous and promise to intensify the impoverishment of aesthetic matter so drastically, that by tomorrow the thinly veiled identity of all industrial culture products can come triumphantly out into the open, derisively fulfilling the Wagnerian dream of the *Gesamtkunstwerk* – the fusion of all the arts in one work. The alliance of word, image, and music is all the more perfect than in *Tristan* because the sensuous elements which all approvingly reflect the surface of social reality are in principle embodied in the same technical process, the unity of which becomes its distinctive content. This process integrates all the elements of the production, from the novel (shaped with an eye to the film) to the last sound effect. It is the triumph of invested capital, whose title as absolute master is etched deep into the hearts of the dispossessed

in the employment line; it is the meaningful content of every film, whatever plot the production team may have selected.

The whole world is made to pass through the filter of the culture industry. The old experience of the movie-goer, who sees the world outside as an extension of the film he has just left (because the latter is intent upon reproducing the world of everyday perceptions), is now the producer's guideline. The more intensely and flawlessly his techniques duplicate empirical objects, the easier it is today for the illusion to prevail that the outside world is the straightforward continuation of that presented on the screen. This purpose has been furthered by mechanical reproduction since the lightning takeover by the sound film.

Real life is becoming indistinguishable from the movies. The sound film, far surpassing the theatre of illusion, leaves no room for imagination or reflection on the part of the audience, who are unable to respond within the structure of the film, yet deviate from its precise detail without losing the thread of the story; hence the film forces its victims to equate it directly with reality. The stunting of the mass-media consumer's powers of imagination and spontaneity does not have to be traced back to any psychological mechanisms; he must ascribe the loss of those attributes to the objective nature of the products themselves, especially to the most characteristic of them, the sound film. They are so designed that quickness, powers of observation, and experience are undeniably needed to apprehend them at all; yet sustained thought is out of the question if the spectator is not to miss the relentless rush of facts. Even though the effort required for his response is semi-automatic, no scope is left for the imagination. Those who are so absorbed by the world of the movie — by its images, gestures, and words — that they are unable to supply what really makes it a world, do not have to dwell on particular points of its mechanics during a screening. All the other films and products of the entertainment industry which they have seen have taught them what to expect; they react automatically. The might of industrial society is lodged in men's minds. The entertainments manufacturers know that their products will be consumed with alertness even when the customer is distraught, for each of them is a model of the huge economic machinery which has always sustained the masses, whether at work or at leisure — which is akin to work. From every sound film and every broadcast programme the social effect can be inferred which is exclusive to none but is shared by all alike. The culture industry as a whole has moulded men as a type unfailingly reproduced in every product. All the agents of this process, from the producer to the women's clubs, take good care that the simple reproduction of this mental state is not nuanced or extended in any way.

The art historians and guardians of culture who complain of the extinction in the West of a basic style-determining power are wrong. The stereotyped appropriation of everything, even the inchoate, for the purposes of mechanical reproduction surpasses the rigour and general currency of any 'real style', in the sense in which cultural *cognoscenti* celebrate the organic precapitalist past. No Palestrina could be more of a purist in eliminating every unprepared and unresolved discord than the jazz arranger in suppressing any development which does not conform to the jargon. When jazzing up Mozart he changes him not only when he is too serious or too difficult but when he harmonizes the melody in a different way, perhaps more simply, than is customary now. No medieval builder can have

scrutinized the subjects for church windows and sculptures more suspiciously than the studio hierarchy scrutinizes a work by Balzac or Hugo before finally approving it. No medieval theologian could have determined the degree of the torment to be suffered by the damned in accordance with the *ordo* of divine love more meticulously than the producers of shoddy epics calculate the torture to be undergone by the hero or the exact point to which the leading lady's hemline shall be raised. The explicit and implicit, exoteric and esoteric catalogue of the forbidden and tolerated is so extensive that it not only defines the area of freedom but is all-powerful inside it. Everything down to the last detail is shaped accordingly. Like its counterpart, avant-garde art, the entertainment industry determines its own language, down to its very syntax and vocabulary, by the use of anathema. The constant pressure to produce new effects (which must conform to the old pattern) serves merely as another rule to increase the power of the conventions when any single effect threatens to slip through the net. Every detail is so firmly stamped with sameness that nothing can appear which is not marked at birth, or does not meet with approval at first sight. And the star performers, whether they produce or reproduce, use this jargon as freely and fluently and with as much gusto as if it were the very language which it silenced long ago. Such is the ideal of what is natural in this field of activity, and its influence becomes all the more powerful, the more technique is perfected and diminishes the tension between the finished product and everyday life. The paradox of this routine, which is essentially travesty, can be detected and is often predominant in everything that the culture industry turns out. A jazz musician who is playing a piece of serious music, one of Beethoven's simplest minuets, syncopates it involuntarily and will smile superciliously when asked to follow the normal divisions of the beat. This is the 'nature' which, complicated by the ever-present and extravagant demands of the specific medium, constitutes the new style and is a 'system of non-culture, to which one might even concede a certain "unity of style" if it really made any sense to speak of stylized barbarity'.

The universal imposition of this stylized mode can even go beyond what is quasi-officially sanctioned or forbidden; today a hit song is more readily forgiven for not observing the thirty-two beats or the compass of the ninth than for containing even the most clandestine melodic or harmonic detail which does not conform to the idiom. Whenever Orson Welles offends against the tricks of the trade, he is forgiven because his departures from the norm are regarded as calculated mutations which serve all the more strongly to confirm the validity of the system. The constraint of the technically conditioned idiom which stars and directors have to produce as 'nature' so that the people can appropriate it, extends to such fine nuances that they almost attain the subtlety of the devices of an avant-garde work as against those of truth. The rare capacity minutely to fulfil the obligations of the natural idiom in all branches of the culture industry becomes the criterion of efficiency. What and how they say it must be measurable by everyday language, as in logical positivism. The producers are experts. The idiom demands an astounding productive power, which it absorbs and squanders. In a diabolical way it has overreached the culturally conservative distinction between genuine and artificial style. A style might be called artificial which is imposed from without on the refractory impulses of a form. But in the culture industry every

element of the subject matter has its origin in the same apparatus as that jargon whose stamp it bears. The quarrels in which the artistic experts become involved with sponsor and censor about a lie going beyond the bounds of credibility are evidence not so much of an inner aesthetic tension as of a divergence of interests. The reputation of the specialist, in which a last remnant of objective independence sometimes finds refuge, conflicts with the business politics of the church, or the concern which is manufacturing the cultural commodity. But the thing itself has been essentially objectified and made viable before the established authorities began to argue about it. Even before Zanuck acquired her, St Bernadette was regarded by her latter-day hagiographer as brilliant propaganda for all interested parties. That is what became of the emotions of the character. Hence the style of the culture industry, which no longer has to test itself against any refractory material, is also the negation of style. The reconciliation of the general and particular, of the rule and the specific demands of the subject matter, the achievement of which alone gives essential, meaningful content to style, is futile because there has ceased to be the slightest tension between opposite poles: these concordant extremes are dismally identical; the general can replace the particular, and vice versa.

Nevertheless, this caricature of style does not amount to something beyond the genuine style of the past. In the culture industry the notion of genuine style is seen to be the aesthetic equivalent of domination. Style considered as mere aesthetic regularity is a romantic dream of the past. The unity of style not only of the Christian Middle Ages but of the Renaissance expresses in each case the different structure of social power, and not the obscure experience of the oppressed in which the general was enclosed. The great artists were never those who embodied a wholly flawless and perfect style, but those who used style as a way of hardening themselves against the chaotic expression of suffering, as a negative truth. The style of their works gave what was expressed that force without which life flows away unheard. Those very art forms which are known as classical, such as Mozart's music, contain objective trends which represent something different to the style which they incarnate. As late as Schoenberg and Picasso, the great artists have retained a mistrust of style, and at crucial points have subordinated it to the logic of the matter. What Dadaists and Expressionists called the untruth of style as such triumphs today in the sung jargon of a crooner, in the carefully contrived elegance of a film star, and even in the admirable expertise of a photograph of a peasant's squalid hut. Style represents a promise in every work of art. That which is expressed is subsumed through style into the dominant forms of generality, into the language of music, painting, or words, in the hope that it will be reconciled thus with the idea of true generality. This promise held out by the work of art that it will create truth by lending new shape to the conventional social forms is as necessary as it is hypocritical. It unconditionally posits the real forms of life as it is by suggesting that fulfilment lies in their aesthetic derivatives. To this extent the claim of art is always ideology too. However, only in this confrontation with tradition of which style is the record can art express suffering. That factor in a work of art which enables it to transcend reality certainly cannot be detached from style; but it does not consist of the harmony actually realized, of any doubtful unity of form and content, within and without, of individual and society; it is to be found in those features in which discrepancy appears: in the necessary failure of the passionate

striving for identity. Instead of exposing itself to this failure in which the style of the great work of art has always achieved self-negation, the inferior work has always relied on its similarity with others – on a surrogate identity.

In the culture industry this imitation finally becomes absolute. Having ceased to be anything but style, it reveals the latter's secret: obedience to the social hierarchy. Today aesthetic barbarity completes what has threatened the creations of the spirit since they were gathered together as culture and neutralized. To speak of culture was always contrary to culture. Culture as a common denominator already contains in embryo that schematization and process of cataloguing and classification which bring culture within the sphere of administration. And it is precisely the industrialized, the consequent, subsumption which entirely accords with this notion of culture. By subordinating in the same way and to the same end all areas of intellectual creation, by occupying men's senses from the time they leave the factory in the evening to the time they clock in again the next morning with matter that bears the impress of the labour process they themselves have to sustain throughout the day, this subsumption mockingly satisfies the concept of a unified culture which the philosophers of personality contrasted with mass culture.

The culture industry perpetually cheats its consumers of what it perpetually promises. The promissory note which, with its plots and staging, it draws on pleasure is endlessly prolonged; the promise, which is actually all the spectacle consists of, is illusory: all it actually confirms is that the real point will never be reached, that the diner must be satisfied with the menu. In front of the appetite stimulated by all those brilliant names and images there is finally set no more than a commendation of the depressing everyday world it sought to escape. Of course works of art were not sexual exhibitions either. However, by representing deprivation as negative, they retracted, as it were, the prostitution of the impulse and rescued by mediation what was denied. The secret of aesthetic sublimation is its representation of fulfilment as a broken promise. The culture industry does not sublimate; it represses. By repeatedly exposing the objects of desire, breasts in a clinging sweater or the naked torso of the athletic hero, it only stimulates the unsublimated fore-pleasure which habitual deprivation has long since reduced to a masochistic semblance. There is no erotic situation which, while insinuating and exciting, does not fail to indicate unmistakably that things can never go that far. The Hays Office [the film censor of the time] merely confirms the ritual of Tantalus that the culture industry has established anyway. Works of art are ascetic and unashamed; the culture industry is pornographic and prudish. Love is downgraded to romance. And, after the descent, much is permitted; even licence as a marketable speciality has its quota bearing the trade description 'daring'. The mass production of the sexual automatically achieves its repression. Because of his ubiquity, the film star with whom one is meant to fall in love is from the outset a copy of himself. Every tenor voice comes to sound like a Caruso record, and the 'natural' faces of Texas girls are like the successful models by whom Hollywood has typecast them. The mechanical reproduction of beauty, which reactionary cultural fanaticism wholeheartedly serves in its methodical idolization of individuality, leaves no room for that unconscious idolatry which was once essential to beauty. The triumph over beauty is celebrated by humour – the *Schadenfreude* that every successful deprivation calls forth. There is laughter because there is nothing to

laugh at. Laughter, whether conciliatory or terrible, always occurs when some fear passes. It indicates liberation either from physical danger or from the grip of logic. Conciliatory laughter is heard as the echo of an escape from power; the wrong kind overcomes fear by capitulating to the forces which are to be feared. It is the echo of power as something inescapable. Fun is a medicinal bath. The pleasure industry never fails to prescribe it. It makes laughter the instrument of the fraud practised on happiness. Moments of happiness are without laughter; only operettas and films portray sex to the accompaniment of resounding laughter. But Baudelaire is as devoid of humour as Hölderlin. In the false society laughter is a disease which has attacked happiness and is drawing it into its worthless totality. To laugh at something is always to deride it, and the life in which, according to Bergson, laughter breaks through the barrier, is actually an invading barbaric life, self-assertion prepared to parade its liberation from any scruple when the social occasion arises. Such a laughing audience is a parody of humanity. Its members are monads, all dedicated to the pleasure of being ready for anything at the expense of everyone else. Their harmony is a caricature of solidarity. What is fiendish about this false laughter is that it is a compelling parody of the best, which is conciliatory. Delight is austere: *res severa verum gaudium*. The monastic theory that not asceticism but the sexual act denotes the renunciation of attainable bliss receives negative confirmation in the gravity of the lover who with foreboding commits his life to the fleeting moment. In the culture industry, jovial denial takes the place of the pain found in ecstasy and in asceticism. The supreme law is that they shall not satisfy their desires at any price; they must laugh and be content with laughter. In every product of the culture industry, the permanent denial imposed by civilization is once again unmistakably demonstrated and inflicted on its victims. To offer and to deprive them of something is one and the same. This is what happens in erotic films. Precisely because it must never take place, everything centres upon copulation. In films it is more strictly forbidden for an illegitimate relationship to be admitted without the parties being punished than for a millionaire's future son-in-law to be active in the labour movement. In contrast to the liberal era, industrialized as well as popular culture may wax indignant at capitalism, but it cannot renounce the threat of castration. This is fundamental. It outlasts the organized acceptance of the uniformed seen in the films which are produced to that end, and in reality. What is decisive today is no longer puritanism, although it still asserts itself in the form of women's organizations, but the necessity inherent in the system not to leave the customer alone, not for a moment to allow him any suspicion that resistance is possible. The principle dictates that he should be shown all his needs as capable of fulfilment, but that those needs should be so predetermined that he feels himself to be the eternal consumer, the object of the culture industry. Not only does it make him believe that the deception it practises is satisfaction, but it goes further and implies that, whatever the state of affairs, he must put up with what is offered. The escape from everyday drudgery which the whole culture industry promises may be compared to the daughter's abduction in the cartoon: the father is holding the ladder in the dark. The paradise offered by the culture industry is the same old drudgery. Both escape and elopement are predesigned to lead back to the starting point. Pleasure promotes the resignation which it ought to help to forget.

Amusement, if released from every restraint, would not only be the antithesis of art but its extreme role. The Mark Twain absurdity with which the American culture industry flirts at times might be a corrective of art. The more seriously the latter regards the incompatibility with life, the more it resembles the seriousness of life, its antithesis; the more effort it devotes to developing wholly from its own formal law, the more effort it demands from the intelligence to neutralize its burden. In some revue films, and especially in the grotesque and the funnies, the possibility of this negation does glimmer for a few moments. But of course it cannot happen. Pure amusement in its consequence, relaxed self-surrender to all kinds of associations and happy nonsense, is cut short by the amusement on the market: instead, it is interrupted by a surrogate overall meaning which the culture industry insists on giving to its products, and yet misuses as a mere pretext for bringing in the stars. Biographies and other simple stories patch the fragments of nonsense into an idiotic plot. We do not have the cap and bells of the jester but the bunch of keys of capitalist reason, which even screens the pleasure of achieving success. Every kiss in the revue film has to contribute to the career of the boxer, or some hit song expert or other whose rise to fame is being glorified. The deception is not that the culture industry supplies amusement but that it ruins the fun by allowing business considerations to involve it in the ideological clichés of a culture in the process of self-liquidation. Ethics and taste cut short unrestrained amusement as 'naïve' – naïveté is thought to be as bad as intellectualism – and even restrict technical possibilities. The culture industry is corrupt; not because it is a sinful Babylon but because it is a cathedral dedicated to elevated pleasure. On all levels, from Hemingway to Emil Ludwig, from Mrs Miniver to the Lone Ranger, from Toscanini to Guy Lombardo, there is untruth in the intellectual content taken ready-made from art and science. The culture industry does retain a trace of something better in those features which bring it close to the circus, in the self-justifying and nonsensical skill of riders, acrobats and clowns, in the 'defence and justification of physical as against intellectual art'. But the refuges of a mindless artistry which represent what is human as opposed to the social mechanism are being relentlessly hunted down by a schematic reason which compels everything to prove its significance and effect. The consequence is that the nonsensical at the bottom disappears as utterly as the sense in works of art at the top.

In the culture industry the individual is an illusion not merely because of the standardization of the means of production. He is tolerated only so long as his complete identification with the generality is unquestioned. Pseudo individuality is rife: from the standardized jazz improvization to the exceptional film star whose hair curls over her eye to demonstrate her originality. What is individual is no more than the generality's power to stamp the accidental detail so firmly that it is accepted as such. The defiant reserve or elegant appearance of the individual on show is mass-produced like Yale locks, whose only difference can be measured in fractions of millimetres. The peculiarity of the self is a monopoly commodity determined by society; it is falsely represented as natural. It is no more than the moustache, the French accent, the deep voice of the woman of the world, the Lubitsch touch: finger prints on identity cards which are otherwise exactly the same, and into which the lives and faces of every single person are transformed by the power of the

generality. Pseudo-individuality is the prerequisite for comprehending tragedy and removing its poison: only because individuals have ceased to be themselves and are now merely centres where the general tendencies meet, is it possible to receive them again, whole and entire, into the generality. In this way mass culture discloses the fictitious character of the 'individual' in the bourgeois era, and is merely unjust in boasting on account of this dreary harmony of general and particular. The principle of individuality was always full of contradiction. Individuation has never really been achieved. Self-preservation in the shape of class has kept everyone at the stage of a mere species being. Every bourgeois characteristic, in spite of its deviation and indeed because of it, expressed the same thing: the harshness of the competitive society. The individual who supported society bore its disfiguring mark; seemingly free, he was actually the product of its economic and social apparatus. Power based itself on the prevailing conditions of power when it sought the approval of persons affected by it. As it progressed, bourgeois society did also develop the individual. Against the will of its leaders, technology has changed human beings from children into persons. However, every advance in individuation of this kind took place at the expense of the individuality in whose name it occurred, so that nothing was left but the resolve to pursue one's own particular purpose. The bourgeois whose existence is split into a business and a private life, whose private life is split into keeping up his public image and intimacy, whose intimacy is split into the surly partnership of marriage and the bitter comfort of being quite alone, at odds with himself and everybody else, is already virtually a Nazi, replete both with enthusiasm and abuse; or a modern city-dweller who can now imagine friendship only as a 'social contact': that is, as being in social contact with others with whom he has no inward contact. The only reason why the culture industry can deal so successfully with individuality is that the latter has always reproduced the fragility of society. On the faces of private individuals and movie heroes put together according to the patterns on magazine covers vanishes a pretence in which no one now believes; the popularity of the hero models comes partly from a secret satisfaction that the effort to achieve individuation has at last been replaced by the effort to imitate, which is admittedly more breathless. It is idle to hope that this self-contradictory, disintegrating 'person' will not last for generations, that the system must collapse because of such a psychological split, or that the deceitful substitution of the stereotype for the individual will of itself become unbearable for mankind. Since Shakespeare's *Hamlet*, the unity of the personality has been seen through as a pretence. Synthetically produced physiognomies show that the people of today have already forgotten that there was ever a notion of what human life was. For centuries society has been preparing for Victor Mature and Mickey Rooney. By destroying they come to fulfil.

C.L.R. James

WHAT IS ART?

EDITOR'S INTRODUCTION

THE FOLLOWING PIECE IS AN EXTRACT from C.L.R. James's wonderful
book *Beyond a Boundary* (first published in 1963): part memoir, part cricket
history, part treatise on aesthetics, part nostalgia for a certain British culture.
James was born in Trinidad in 1901, emigrated to England in the 1930s, lived
in the States in the postwar period and, after having been deported, returned to
Britain after a short period back in Trinidad in the late 1950s. He was a Marxist
activist and labour organizer for much of his life, long aligned to Trotskyite
groups, but he was also an original political theorist, a cricket journalist (for the
Manchester Guardian among other newspapers), a key anticolonialist organizer,
and a pathbreaking historian, whose account of the Caribbean slave trade first
revealed the degree to which the slaves themselves engineered their freedom. In
any expanded account of the roots of contemporary cultural studies his intellectual
work should hold a prominent place.

Here James argues that cricket is an art, with aesthetic values as rich as
sculpture or theatre or painting. The case he makes needs little elucidation: it
is clearly and powerfully presented. But his argument may read oddly in the
context of today's cultural studies which has pretty much refused to engage the
question of the aesthetic, seeing it as bound to (and a support of) the reductive
division between high and low or between colonizer and colonized since, it is
usually assumed, aesthetic values are embedded most firmly in Western high art.
With any luck, James can help us think otherwise. And in *Beyond a Boundary*,
he actually argues that the collective life around Trinidadian cricket, that is a life
centred around an aesthetic practice, helped simultaneously to politicize him as

a boy, helped to give him a sense of what a classless society would look like and (more controversially) to accept the values of the old-style British public school ('stiff upper lip', 'the game for the game's sake', 'it doesn't matter whether you win or lose' and so on) which may provide a basis for an ethics which is both aesthetically committed and politically just.

It's a daring and original argument, then and now: the whole book is essential reading (but it does help to know or learn something about cricket, which some believe is the world's most popular game (forget soccer) since it is a cult among the over a billion inhabitants of the South Asian subcontinent).

Further reading: Arbena and Lafrance 2002; Becker 1982; Brennan 1997; Buhle 1988; Eagleton 1990; Gumbrecht 2006; James 1993; Kelley 2002; Lazarus 1999; Miller 1992.

I have made great claims for cricket. As firmly as I am able and as is here possible, I have integrated it in the historical movement of the times. The question remains: What is it? Is it mere entertainment or is it an art? Mr. Neville Cardus (whose work deserves a critical study) is here most illuminating, not as subject but as object. He will ask: 'Why do we deny the art of a cricketer, and rank it lower than a vocalist's or a fiddler's? If anybody tells me that R. H. Spooner did not compel a pleasure as aesthetic as any compelled by the most cultivated Italian tenor that ever lived I will write him down a purist and an ass.' He says the same in more than one place. More than any sententious declaration, all his work is eloquent with the aesthetic appeal of cricket. Yet he can write in his autobiography: 'I do not believe that anything fine in music or in anything else can be understood or truly felt by the crowd.' Into this he goes at length and puts the seal on it with 'I don't believe in the contemporary idea of taking the arts to the people: let them seek and work for them.' He himself notes that Neville Cardus, the writer on cricket, often introduces music into his cricket writing. Never once has Neville Cardus, the music critic, introduced cricket into his writing on music. He finds this 'a curious point'. It is much more than a point, it is not curious. Cardus is a victim of that categorization and specialization, that division of the human personality, which is the greatest curse of our time. Cricket has suffered, but not only cricket. The aestheticians have scorned to take notice of popular sports and games—to their own detriment. The aridity and confusion of which they so mournfully complain will continue until they include organized games *and the people who watch them* as an integral part of their data. Sir Donald Bradman's technical accomplishments are not on the same plane as those of Yehudi Menuhin. Sir John Gielgud in three hours can express adventures and shades in human personality which are not approached in three years of Denis Compton at the wicket. Yet cricket is an art, not a bastard or a poor relation, but a full member of the community.

The approach must be direct. Too long has it been impressionistic or apologetic, timid or defiant, always ready to take refuge in the mysticism of metaphor. It is a game and we have to compare it with other games. It is an art and we have to compare it with other arts.

Cricket is first and foremost a dramatic spectacle. It belongs with the theatre, ballet, opera and the dance.

In a superficial sense all games are dramatic. Two men boxing or running a race can exhibit skill, courage, endurance and sharp changes of fortune; can evoke hope and fear. They can even harrow the soul with laughter and tears, pity and terror. The state of the city, the nation or the world can invest a sporting event with dramatic intensity such as is reached in few theatres. When the democrat Joe Louis fought the Nazi Schmelling the bout became a focus of approaching world conflict. On the last morning of the 1953 Oval Test, when it was clear that England would win a rubber against Australia after twenty years, the nation stopped work to witness the consummation.

These possibilities cricket shares with other games in a greater or lesser degree. Its quality as drama is more specific. It is so organized that at all times it is compelled to reproduce the central action which characterizes all good drama from the days of the Greeks to our own: two individuals are pitted against each other in a conflict that is strictly personal but no less strictly representative of a social group. One individual batsman faces one individual bowler. But each represents his side. The personal achievement may be of the utmost competence or brilliance. Its ultimate value is whether it assists the side to victory or staves off defeat. This has nothing to do with morals. It is the organizational structure on which the whole spectacle is built. The dramatist, the novelist, the choreographer, must *strive* to make his individual character symbolical of a larger whole. He may or may not succeed. The runner in a relay race must take the plus or minus that his partner or partners give him. The soccer forward and the goalkeeper may at certain rare moments find themselves sole representatives of their sides. Even the baseball-batter, who most nearly approaches this particular aspect of cricket, may and often does find himself after a fine hit standing on one of the bases, where he is now dependent upon others. The batsman facing the ball does not merely represent his side. For that moment, to all intents and purposes, he is his side. This fundamental relation of the One and the Many, Individual and Social, Individual and Universal, leader and followers, representative and ranks, the part and the whole, is structurally imposed on the players of cricket. What other sports, games and arts have to aim at, the players are given to start with, they cannot depart from it. Thus the game is founded upon a dramatic, a human, relation which is universally recognized as the most objectively pervasive and psychologically stimulating in life and therefore in that artificial representation of it which is drama.

The second major consideration in all dramatic spectacles is the relation between event (or, if you prefer, contingency) and design, episode and continuity, diversity in unity, the battle and the campaign, the part and the whole. Here also cricket is structurally perfect. The total spectacle consists and must consist of a series of individual, isolated episodes, each in itself completely self-contained. Each has its beginning, the ball bowled; its middle, the stroke played; its end, runs, no runs, dismissal. Within the fluctuating interest of the rise or fall of the game as a whole, there is this unending series of events, each single one fraught with immense possibilities of expectation and realization. Here again the dramatist or movie director has to strive. In the very finest of soccer matches the ball for long periods is in places where it is impossible to expect any definite

alteration in the relative position of the two sides. In lawn tennis the duration of the rally is entirely dependent upon the subjective skill of the players. In baseball alone does the encounter between the two representative protagonists approach the definitiveness of the individual series of episodes in cricket which together constitute the whole.

The structural enforcement of the fundamental appeals which all dramatic spectacle must have is of incalculable value to the spectator. The glorious uncertainty of the game is not anarchy. It would not be glorious if it were not so firmly anchored in the certainties which must attend all successful drama. That is why cricket is perhaps the only game in which the end result (except where national or local pride is at stake) is not of great importance. Appreciation of cricket has little to do with the end, and less still with what are called 'the finer points', of the game. What matters in cricket, as in all the arts, is not finer points but what everyone with some knowledge of the elements can see and feel. It is only within such a rigid structural frame that the individuality so characteristic of cricket can flourish. Two batsmen are in at the same time. Thus the position of representative of the side, though strictly independent, is interchangeable. In baseball one batter bats at a time. The isolated events of which both games consist is in baseball rigidly limited. The batter is allowed choice of three balls. He must hit the third or he is out. If he hits he must run. The batter's place in the batting order is fixed—it cannot be changed. The pitcher must pitch until he is taken off and when he is taken off he is finished for that game. (The Americans obviously prefer it that way.) In cricket the bowler bowls six balls (or eight). He can then be taken off and can be brought on again. He can bowl at the other end. The batting order is interchangeable. Thus while the principle of an individual representing the side at any given moment is maintained, the utmost possible change of personnel compatible with order is allowed. We tend to take these things for granted or not to notice them at all. In what other dramatic spectacle can they be found built-in? The greatness of the great batsman is not so much in his own skill as that he sets in motion all the immense possibilities that are contained in the game as structurally organized.

Cricket, of course, does not allow that representation or suggestion of specific relations as can be done by a play or even by ballet and dance. The players are always players trafficking in the elemental human activities, qualities and emotions—attack, defence, courage, gallantry, steadfastness, grandeur, ruse. This is no drawback. Punch and Judy, *Swan Lake*, pantomime, are even less particularized than cricket. They depend for their effect upon the technical skill and creative force with which their exponents make the ancient patterns live for their contemporaries. Some of the best beloved and finest music is created out of just such elemental sensations. We never grow out of them, of the need to renew them. Any art which by accident or design gets too far from them finds that it has to return or wither. They are the very stuff of human life. It is of this stuff that the drama of cricket is composed.

If the drama is very limited in range and intricacy there are advantages. These need not be called compensating, but they should not be ignored. The long hours (which so irritates those who crave continuous excitement), the measured ritualism and the varied and intensive physical activity which take place within it, these

strip the players of conventional aspects, and human personality is on view long enough and in sufficiently varied form to register itself indelibly. I mention only a few—the lithe grace and elegance of Kardar leading his team on to the field; the unending flow of linear rhythm by which Evans accommodated himself to returns from the field; the dignity which radiates from every motion of Frank Worrell; the magnificence and magnanimity of Keith Miller. There are movie stars, world-famous and rightly so, who mumble words and go through motions which neither they nor their audience care very much about. Their appeal is themselves, how they walk, how they move, how they do anything or nothing, so long as they are themselves and their particular quality shines through. Here a Keith Miller met a Clark Gable on equal terms.

The dramatic content of cricket I have purposely pitched low—I am concerned not with degree but kind. In addition to being a dramatic, cricket is also a visual art. This I do not pitch low at all. The whole issue will be settled here.

The aestheticians of painting, especially the modern ones, are the great advocates of 'significant form', the movement of the line, the relations of colour and tone. Of these critics, the most consistent, the clearest (and the most widely accepted), that I know is the late Mr. Bernhard Berenson. Over sixty years ago in his studies of the Italian Renaissance painters he expounded his aesthetic with refreshing clarity. The merely accurate representation of an object, the blind imitation of nature, was not art, not even if that object was what would commonly be agreed upon as beautiful, for example a beautiful woman. There was another category of painter superior to the first. Such a one would not actually reproduce the object as it was. Being a man of vision and imagination, the object would stimulate in him impulses, thoughts, memories visually creative. These he would fuse into a whole and the result would be not so much the object as the totality of the visual image which the object had evoked in a superior mind. That, too, Mr. Berenson excluded from the category of true art (and was by no means isolated in doing so): mere reproduction of objects, whether actually in existence or the product of the sublimest imaginations, was 'literature' or 'illustration'. What then was the truly artistic? The truly artistic was a quality that existed in its own right, irrespective of the object represented. It was the line, the curve, its movement, the drama it embodied as painting, the linear design, the painterly tones and values taken as a whole: this constituted the specific quality of visual art. Mr. Berenson did not rank colour very high; the head of a statue (with its human expression) he could usually dispense with. It was the form as such which was significant.

Mr. Berenson was not at all cloudy or mystifying. He distinguished two qualities which could be said to constitute the significance of the form in its most emphatic manifestation.

The first he called 'tactile values'. The idea of tactile values could be most clearly grasped by observing the manner in which truly great artists rendered the nude human body. They so posed their figures, they manipulated, arranged, shortened, lengthened, foreshortened, they so articulated the movements of the joints that they stimulated the tactile consciousness of the viewer, his specially artistic sense. This significance in the form gave a higher coefficient of reality to the object represented. Not that such a painting looked more real, made the object more

lifelike. That was not Mr. Berenson's point. Significant form makes the painting life-giving, life-enhancing, *to the viewer*. Significant form, or 'decoration', to use his significant personal term, sets off physical processes in the spectator which give to him a far greater sense of the objective reality before him than would a literal representation, however accurate.[1] Mr. Berenson does not deny that an interesting subject skilfully presented in human terms can be interesting as illustration. He does not deny that such illustration can enhance significant form. But it is the form that matters. Mr. John Berger of the *New Statesman*, ardent propagandist of socialist realism in art, claims that what is really significant in Michelangelo is his bounding line. The abstract artists get rid of the object altogether and represent only the abstract form, the line and relations of line. If I understand Mr. Berger aright he claims that all the great representational paintings of the past live and have lived only to the degree that their form is significant—that, however, is merely to repeat Mr. Berenson.

The second characteristic of significant form in Mr. Berenson's aesthetic is the sense of 'movement'.

We have so far been wandering in chambers where as cricketers we are not usually guests. Fortunately, the aesthetic vision now focuses on territory not too far distant from ours. In his analysis of 'movement' Mr. Berenson discussed the artistic possibilities and limitations of an athletic event, a wrestling match. His exposition seems designed for cricket and cricketers, and therefore must be reproduced in full.

> Although a wrestling match may, in fact, contain many genuinely artistic elements, our enjoyment of it can never be quite artistic: we are prevented from completely realizing it not only by our dramatic interest in the game, but also, granting the possibility of being devoid of dramatic interest, by the succession of movements being too rapid for us to realize each completely, and too fatiguing, even if realizable. Now if a way could be found of conveying to us the realization of movement without the confusion and the fatigue of the actuality, we should be getting out of the wrestlers more than they themselves can give us—the heightening of vitality which comes to us whenever we keenly realize life, such as the actuality itself would give us, *plus* the greater effectiveness of the heightening brought about by the clearer, intenser and less fatiguing realization. This is precisely what the artist who succeeds in representing movement achieves: making us realize it as we never can actually, he gives us a heightened sense of capacity, and whatever is in the actuality enjoyable, he allows us to enjoy at our leisure. In words already familiar to us, he *extracts the significance of movements*, just as, in rendering tactile values, the artist extracts the corporal significance of objects. His task is, however, far more difficult, although less indispensable: it is not enough that he should extract the values of what at any given moment is an actuality, as is an object, but what at no moment really is—namely, movement. He can accomplish his task in only one way, and that is by so rendering the one particular movement that we shall be able to realize all other movements that the same figure may make. "He is grappling with his enemy now," I say of my wrestler. "What a pleasure to be

able to realize in my own muscles, on my own chest, with my own arms and legs, the life that is in him as he is making his supreme effort! What a pleasure, as I look away from the representation, to realize in the same manner, how after the contest his muscles will relax, and the rest trickle like a refreshing stream through his nerves!" All this I shall be made to enjoy by the artist who, in representing any one movement, can give me the logical sequence of visible strain and pressure in the parts and muscles.

Now here all of us, cricketers and aesthetics, are on familiar ground. I submit that cricket does in fact contain genuinely artistic elements, infinitely surpassing those to be found in wrestling matches. In fact it can be said to comprise most of those to be found in all other games.

I submit further that the abiding charm of cricket is that the game has been so organized that the realization of movement is completely conveyed despite the confusion and fatigue of actuality.

I submit finally that without the intervention of any artist the spectator at cricket extracts the significance of movement and of tactile values. He experiences the heightened sense of capacity. Furthermore, however the purely human element, the literature, the illustration, in cricket may enhance the purely artistic appeal, the significant form at its most unadulterated is permanently present. It is known, expected, recognized and enjoyed by tens of thousands of spectators. Cricketers call it style.

From the beginning of the modern game this quality of style has been abstracted and established in its own right, irrespective of results, human element, dramatic element, anything whatever except itself. It is, if you will, pure decoration. Thus we read of a player a hundred years ago that he was elegance, all elegance, fit to play before the Queen in her parlour. We read of another that he was not equal to W. G. except in style, where he surpassed The Champion. In *Wisden* of 1891 A. G. Steel, a great player, a great judge of the game and, like so many of those days, an excellent writer, leaves no loophole through which form can escape into literature:

> The last-named batsman, when the bowling was very accurate, was a slow scorer, *but* always a treat to watch. If the present generation of stone-wall cricketers, such as Scotton, Hall, Barlow, A. Bannerman, nay even Shrewsbury, possessed such beautiful ease of style the tens of thousands that used to frequent the beautiful Australian ground would still flock there, instead of the hundred or two patient gazers on feats of Job-like patience that now attend them.

In 1926 H. L. Collins batted five hours for forty runs to save the Manchester Test and Richard Binns wrote a long essay to testify among much else that Collins was never dull because of his beautiful style. There is debate about style. Steel's definition clears away much cumbersome litter about left shoulder forward and straight bat: 'no flourish, but the maximum of power with the minimum of exertion'. If the free-swinging off-drive off the front foot has been challenged by the angular jerk through the covers off the back foot, this last is not at all

alien to the generation which has experienced Cubism in posters and newspaper advertisements.

We are accustomed in cricket to speak of beauty. The critics of art are contemptuous of the word. Let us leave it aside and speak of the style that is common to the manifold motions of the great players, or most of them. There are few picture galleries in the world which effectively reproduce a fraction of them—I am sticking to form and eschewing literature and illustration. These motions are not caught and permanently fixed for us to make repeated visits to them. They are repeated often enough to become a permanent possession of the spectator which he can renew at will. And having held our own with the visitor from the higher spheres, I propose to take the offensive.

And first I meet Mr. Berenson on his own ground, so to speak. Here is John Arlott, whose written description of cricket matches I prefer to all others, describing the bowling action of Maurice Tate.

> You would hardly have called Maurice Tate's physique graceful, yet his bowling action remains—and not only for me—as lovely a piece of movement as even cricket has ever produced. He had strong, but sloping shoulders; a deep chest, fairly long arms and—essential to the pace bowler—broad feet to take the jolt of the delivery stride and wide hips to cushion it. His run-in, eight accelerating and lengthening strides, had a hint of scramble about it at the beginning, but, by the eighth stride and well before his final leap, it seemed as if his limbs were gathered together in one glorious wheeling unity. He hoisted his left arm until it was pointing straight upwards, while his right hand, holding the ball, seemed to counter-poise it at the opposite pole. Meanwhile, his body, edge-wise on to the batsman, had swung its weight back on to the right foot: his back curved so that, from the other end, you might see the side of his head jutting out, as it were, from behind his left arm. Then his bowling arm came over and his body turned; he released the ball at the top of his arm-swing, with a full flick of the wrist, and then plunged through, body bending into that earth-tearing, final stride and pulling away to the off side.
>
> All these things the textbook will tell you to do: yet no one has ever achieved so perfectly a co-ordination and exploitation of wrist, shoulders, waist, legs and feet as Maurice Tate did. It was as if bowling had been implanted in him at birth, and came out—as the great arts come out—after due digestion, at that peak of greatness which is not created—but only confirmed—by instruction.

Because most people think always of batting when they think of cricket as a visual art another description of a bowler in action will help to correct the unbalance.

> From two walking paces Lindwall glides into the thirteen running strides which have set the world a model for rhythmic gathering of momentum for speed-giving power. Watching him approach the wicket, Sir Pelham Warner was moved to murmur one word, "Poetry!"

The poetry of motion assumes dramatic overtones in the last couple of strides. A high-lifted left elbow leads Lindwall to the line. The metal plate on his right toe-cap drags through the turf and across the bowling crease as his prancing left foot thrusts directly ahead of it, to land beyond the popping crease. This side-on stretch brings every ounce of his thirteen stone into play as his muscular body tows his arm over for the final fling that shakes his shirtsleeve out of its fold. In two more strides his wheeling follow-through has taken him well to the side of the pitch. Never had plunging force and science formed so deadly an alliance.

We may note in passing that the technique of watching critically, i.e. with a conception of all the factors that have contributed to the result, can be as highly developed and needs as many years of training in cricket as in the arts. But I do not want to emphasize that here.

What is to be emphasized is that whereas in the fine arts the image of tactile values and movement, however effective, however magnificent, is permanent, fixed, in cricket the spectator sees the image constantly re-created, and whether he is a cultivated spectator or not, has standards which he carries with him always. He can re-create them at will. He can go to see a game hoping and expecting to see the image re-created or even extended. You can stop an automobile to watch a casual game and see a batsman, for ever to be unknown, cutting in a manner that recalls the greatest exponents of one of the most difficult movements in cricket. Sometimes it is a total performance branching out in many directions by a single player who stamps all he does with the hallmark of an individual style—a century by Hutton or Compton or Sobers. It can be and often is a particular image—Hammond's drive through the covers. The image can be a single stroke, made on a certain day, which has been seen and never forgotten. There are some of these the writer has carried in his consciousness for over forty years, some in fact longer, as is described in the first pages of this book. On the business of setting off physical processes and evoking a sense of movement in the spectator, followers of Mr. Berenson's classification would do well to investigate the responses of cricket spectators. The theory may be thereby enriched, or may be seen to need enrichment. To the eye of a cricketer it seems pretty thin.

It may seem that I am squeezing every drop out of a quite casual illustration extracted from Mr. Berenson's more comprehensive argument. That is not so. Any acquaintances with his work will find that he lavishes his most enthusiastic praise on 'Hercules Strangling Antaeus' by Pollaiuolo, and the same artist's 'David Striding Over the Head of the Slain Goliath'. In more than one place 'The Gods Shooting [arrows] at a Mark' and the 'Hercules Struggling With a Lion', drawings by Michelangelo, are shown to be for him the ultimate yet reached in the presentation of tactile values and sense of movement, with the consequent life-giving and life-enhancing stimulation of the spectator. Mr. Berenson, in the books I have mentioned, nowhere analyses this momentous fact: the enormous role that elemental physical action plays in the visual arts throughout the centuries, at least until our own. Why should he believe that Michelangelo's projected painting of the soldiers surprised when bathing would have produced the greatest masterpiece

of figure art in modern times? I have been suggesting an answer by implication in describing what W. G. brought from pre-Victorian England to the modern age. I shall now state it plainly.

If we stick to cricket it is not because of any chauvinism. The analysis will apply to all games. After a thorough study of bull-fighting in Spain, Ernest Haas, the famous photographer, does not ignore the violence, the blood, the hovering presence of death, the illustration. Aided by his camera, his conclusion is: 'The bull fight is pure art. The spectacle is all motion… . Motion, the perfection of motion, is what the people come to see. They come hoping that this bull-fight will produce the perfect flow of motion.' Another name for the perfect flow of motion is style, or, if you will, significant form.

Let us examine this motion, or, as Mr. Berenson calls it, movement. Where the motive and directing force rests with the single human being, an immense variety of physical motion is embraced within four categories. A human being places himself physically in some relation of contact or avoidance (or both) with another human being, with an animal, an inanimate object, or two or more of these. He may extend the reach and force of his arms or feet with a tool or device of some kind. He propels a missile. He runs, skips, jumps, dives, to attain some objective which he has set himself or others have set for him. In sport there is not much else that he can do, and in our world human beings are on view for artistic enjoyment only on the field of sport or on the entertainment stage. In sport cricket leads the field. The motions of a batter in baseball, a player of lawn tennis, hockey, golf, all their motions added together do not attain the sum of a batsman's. The batsman can shape to hit practically round the points of the compass. He can play a dead bat, pat for a single, drive along the ground; he can skim the infielders; he can lift over their heads; he can clear the boundary. He can cut square with all the force of his wrists, arms and shoulders, or cut late with a touch as delicate as a feather. He can hit to long-leg with all his force or simply deflect with a single motion. He can do most of these off the front foot or the back. Many of them he can do with no or little departure from his original stance. The articulation of his limbs is often enough quite visible, as in the use of the wrists when cutting or hooking. What is not visible is received in the tactile consciousness of thousands who have themselves for years practiced the same motion and know each muscle that is involved in each stroke. And all this infinite variety is from one base, stable and fixed, so that each motion in its constituent parts can be observed in its detail and in its entirety from start to finish.

The batsman propels a missile with a tool. The bowler does the same unaided. Within the narrow territory legally allowed to him there is, as Mr. Arlott on Tate has shown, a surprising variety of appeal. He may bowl a slow curve or fast or medium, or he may at his pleasure use each in turn. There have been many bowlers whose method of delivery has seemed to spectators the perfection of form, irrespective of the fate which befell the balls bowled. Here, far more than in batting, the repetition conveys the realization of movement despite the actuality. Confusion is excluded by the very structure of the game.

As for the fieldsmen, there is no limit whatever to their possibilities of running, diving, leaping, falling forward, backwards, sideways, with all their energies concentrated on a specific objective, the whole completely realizable by the alert

spectator. The spontaneous outburst of thousands at a fierce hook or a dazzling slip-catch, the ripple of recognition at a long-awaited leg-glance, are as genuine and deeply felt expressions of artistic emotion as any I know.

You will have noted that the four works of art chosen by Mr. Berenson to illustrate movement all deal with some physical action of the athletic kind. Mr. Berenson calls the physical process of response mystical.[2] There I refuse to go along any further, not even for the purpose of discussion. The mystical is the last refuge, if refuge it is. Cricket, in fact any ball game, to the visual image adds the sense of physical co-ordination, of harmonious action, of timing. The visual image of a diving fieldsman is a frame for his rhythmic contact with the flying ball. Here two art forms meet.

I believe that the examination of the stroke, the brilliant piece of fielding, will take us through mysticism to far more fundamental considerations than mere life-enhancing. We respond to physical action or vivid representation of it, dead or alive, because we are made that way. For unknown centuries survival for us, like all other animals, depended upon competent and effective physical activity. This played its part in developing the brain. The particular nature which became ours did not rest satisfied with this. If it had it could never have become human. The use of the hand, the extension of its powers by the tool, the propulsion of a missile at some objective and the accompanying refinements of the mechanics of judgment, these marked us off from the animals. Language may have come at the same time. The evolution may have been slow or rapid. The end result was a new species which preserved the continuity of its characteristics and its way of life. Sputnik can be seen as no more than a missile made and projected through tools by the developed hand.

Similarly the eye for the line which is today one of the marks of ultimate aesthetic refinement is not new. It is old. The artists of the caves of Altamira had it. So did the bushmen. They had it to such a degree that they could reproduce it or, rather, represent it with unsurpassed force. Admitting this, Mr. Berenson confines the qualities of this primitive art to animal energy and an exasperated vitality. That, even if true, is totally subordinate to the fact that among these primitive peoples the sense of form existed to the degree that it could be consciously and repeatedly reproduced. It is not a gift of high civilization, the last achievement of noble minds. It is exactly the opposite. The use of sculpture and design among primitive peoples indicates that the significance of the form is a common possession. Children have it. There is no need to adduce further evidence for the presupposition that the faculty or faculties by which we recognize significant form in elemental physical action is native to us, a part of the process by which we have become and remain human. It is neither more nor less mystical than any other of our faculties of apprehension. Neither do I see an 'exasperated vitality' in the work of the primitive artists. The impression I get is that the line was an integral part of co-ordinated physical activity, functional perhaps, but highly refined in that upon it food or immediate self-preservation might depend.

Innate faculty though it might be, the progress of civilization can leave it unused, suppress its use, can remove us from the circumstances in which it is associated with animal energy. Developing civilization can surround us with circumstances and conditions in which our original faculties are debased or refined, made more

simple or more complicated. They may seem to disappear altogether. They remain part of our human endowment. The basic motions of cricket represent physical action which has been the basis not only of primitive but of civilized life for countless centuries. In work and in play they were the motions by which men lived and without which they would perish. The Industrial Revolution transformed our existence. Our fundamental characteristics as human beings it did not and could not alter. The bushmen reproduced in one medium not merely animals but the line, the curve, the movement. It supplied in the form they needed a vision of the life they lived. The Hambledon men who made modern cricket did the same. The bushmen's motive was perhaps religious, Hambledon's entertainment. One form was fixed, the other had to be constantly re-created. The contrasts can be multiplied. That will not affect the underlying identity. Each fed the need to satisfy the visual artistic sense. The emphasis on style in cricket proves that without a shadow of doubt; whether the impulse was literature and the artistic quality the result, or vice-versa, does not matter. If the Hambledon form was infinitely more complicated it rose out of a more complicated society, the result of a long historical development. Satisfying the same needs as bushmen and Hambledon, the industrial age took over cricket and made it into what it has become. The whole tortured history of modern Spain explains why it is in the cruelty of the bullring that they seek the perfect flow of motion. That flow, however, men since they have been men have always sought and always will. It is an unspeakable impertinence to arrogate the term 'fine art' to one small section of this quest and declare it to be culture. Luckily, the people refuse to be bothered. This does not alter the gross falsification of history and the perversion of values which is the result.

Lucian's Solon tells what the Olympic Games meant to the Greeks. The human drama, the literature, was as important to them as to us. No less so was the line, the curve, the movement of the athletes which inspired one of the greatest artistic creations we have ever known— Greek sculpture. To this day certain statues baffle the experts: are they statues of Apollo or are they statues of athletes? The games and sculpture were 'good' arts and popular. The newly fledged democracy found them insufficient. The contrast between life under an ancient landed aristocracy and an ancient democratic regime was enormous. It can be guessed at by what the democracy actually achieved. The democracy did not neglect the games or sculpture. To the contrary. The birth of democracy saw the birth of individualism in sculpture. Immense new passions and immense new forces had been released. New relations between the individual and society, between individual and individual, launched life on new, exciting and dangerous ways. Out of this came the tragic drama. After a long look at how the creation of the Hambledon men became the cornerstone of Victorian education and entertainment, I can no longer accept that Peisistratus encouraged the dramatic festival as a means of satisfying or appeasing or distracting the urban masses on their way to democracy. That would be equivalent to saying that the rulers of Victorian England encouraged cricket to satisfy or appease or distract the urban masses on their way to democracy. The Victorian experience with cricket suggests a line of investigation on the alert for signs both more subtle and more tortuous. It may be fruitful to investigate whether Peisistratus and his fellow rulers did not need the drama for themselves before it became a national festival. That at any rate is what happened to the Victorians.

The elements which were transformed into Greek drama may have existed in primitive form, quite apart from religious ceremonial—there is even a tradition that peasants played primitive dramas. However that may be, the newly fledged Greek democrat found his need for a fuller existence fulfilled in the tragic drama. He had no spate of books to give him distilled, concentrated and ordered views of life. The old myths no longer sufficed. The drama recast them to satisfy the expanded personality. The end of democracy is a more complete existence. Voting and political parties are only a means. The expanded personality and needs of the Victorian aspiring to democracy did not need drama. The stage, books, newspapers, were part of his inheritance. The production of these for democracy had already begun. What he needed was the further expansion of his aesthetic sense. Print had long made church walls and public monuments obsolescent as a means of social communication. Photography would complete the rout of painting and sculpture, promoting them upstairs. The need was filled by organized games.

Cricket was fortunate in that for their own purposes the British ruling classes took it over and endowed it with money and prestige. On it men of gifts which would have been remarkable in any sphere expended their powers—the late C. B. Fry was a notable example. Yet even he submitted to the prevailing aesthetic categories and circumscribed cricket as a 'physical' fine art. There is no need so to limit it. It is limited in variety of range, of subject-matter. It cannot express the emotions of an age on the nature of the last judgment or the wiping out of a population by bombing. It must repeat. But what it repeats is the original stuff out of which everything visually or otherwise artistic is quarried. The popular democracy of Greece, sitting for days in the sun watching *The Oresteia;* the popular democracy of our day, sitting similarly, watching Miller and Lindwall bowl to Hutton and Compton—each in its own way grasps at a more complete human existence. We may some day be able to answer Tolstoy's exasperated and exasperating question: What is art?—but only when we learn to integrate our vision of Walcott on the back foot through the covers with the outstretched arm of the Olympic Apollo.

Notes

1 If I do Mr. Berenson any injustice it can be corrected in the reprint of his history, third edition, 1954, and his *Des Arts Visuels* (Esthétique et Histoire), Paris, 1953, where the original thesis is restated. (I am not being pedantic. In these metaphysical matters you can misplace a comma and be thereby liable to ten thousand words of aesthetic damnation.)

2 Mr. Berenson's aesthetics do not by any means exhaust the subject. Mr. Adrian Stokes, for example, on Michelangelo, is suggestive of much that is stimulating to any enquiry into the less obvious origins of a game like cricket. Further I find it strange that (as far as I know) so ardent an apostle of mass culture and non-representational art as Sir Herbert Read has never probed into the question whether the physical modes so beloved by Michelangelo and the physical movements of popular sports and games so beloved by the millions do not appeal to the 'collective unconscious' more powerfully than the esoteric forms of, for example, Mr. Henry Moore. The difficulty here, it seems to me, is not merely the habit of categorizing into higher and lower. The aesthetics of cricket demand first that you master the game, and, preferably, have played it, if not well, at least in good company. And that is not the easy acquisition outsiders think it to be.

Dick Hebdige

SUBCULTURE AND STYLE

EDITOR'S INTRODUCTION

NO CULTURAL STUDIES BOOK has been more widely read than Dick Hebdige's 1979 *Subculture: The Meaning of Style*, from which this essay is taken. It brought a unique and supple blend of Althusser, Gramsci and semiotics (as propounded by Barthes and the 'Prague School') to bear on the world of, or at any rate near to, the young British academics and students who first became immersed in cultural studies. That was the world of 'subcultures' more visible in Britain than anywhere else: teds, skinheads, punks, Bowie-ites, hippies, dreads...

For Hebdige two Gramscian terms are especially useful in analysing subcultures: conjuncture and specificity. Subcultures form in communal and symbolic engagements with the larger system of late industrial culture; they're organized around, but not wholly determined by age and class, and are expressed in the creation of styles. These styles are produced within specific historical and cultural 'conjunctures'; they are not to be read as simply resisting hegemony or as magical resolutions to social tensions – as earlier theorists had supposed. Rather subcultures cobble together (or hybridize) styles out of the images and material culture available to them in the effort to construct identities which will confer on them 'relative autonomy' within a social order fractured by class, generation, work etc.

In his later work, Hebdige (1988) was to rework his method, admitting that he had underestimated the power of commercial culture to appropriate, and indeed, to produce, counter-hegemonic styles. Punk, in particular, was a unique mixture of an avant-garde cultural strategy, marketing savvy and working-class transgression produced in the face of a section of British youth's restricted access to consumer markets. The line between subculture as resistance and commercial

culture as both provider of pleasures and an instrument of hegemony is in fact very hard to draw – especially when youth markets are in question.

It would be particularly interesting to apply Hebdige's methods to ask the question: do fans of high-culture now make up a subculture? And then to inquire about whether the kind of analysis he brought to bear works as well outside of Britain, in Japan say, which proliferates subculture like no other nation on earth (see Lipsitz *et al.* 2004). Or are we talking about 'post subcultures' there (see Muggleton 2004)? Russell Potter's essay on hip-hop in this anthology begins to suggest that in the US, we need to think rather differently about black subcultures at least.

Further reading: Bennett 2004; Clarke *et al.* 1976; Cohen 1980; Gelder and Thornton 1997; Hebdige 1979, 1988; Hills 2002; Lipsitz 1990; Lipsitz *et al.* 2004; Muggleton and Weinzierl 2004.

> I managed to get about twenty photographs, and with bits of chewed bread I pasted them on the back of the cardboard sheet of regulations that hangs on the wall. Some are pinned up with bits of brass wire which the foreman brings me and on which I have to string coloured glass beads. Using the same beads with which the prisoners next door make funeral wreaths, I have made star-shaped frames for the most purely criminal. In the evening, as you open your window to the street, I turn the back of the regulation sheet towards me. Smiles and sneers, alike inexorable, enter me by all the holes I offer… They watch over my little routines.
>
> (Genet, 1966a)

In the opening pages of *The Thief's Journal*, Jean Genet describes how a tube of vaseline, found in his possession, is confiscated by the Spanish police during a raid. This 'dirty, wretched object', proclaiming his homosexuality to the world, becomes for Genet a kind of guarantee – 'the sign of a secret grace which was soon to save me from contempt'. The discovery of the vaseline is greeted with laughter in the record-office of the station, and the police 'smelling of garlic, sweat and oil, but … strong in their moral assurance' subject Genet to a tirade of hostile innuendo. The author joins in the laughter too ('though painfully') but later, in his cell, 'the image of the tube of vaseline never left me'.

> I was sure that this puny and most humble object would hold its own against them; by its mere presence it would be able to exasperate all the police in the world; it would draw down upon itself contempt, hatred, white and dumb rages.
>
> (Genet, 1967)

I have chosen to begin with these extracts from Genet because he more than most has explored in both his life and his art the subversive implications of style. I shall be returning again and again to Genet's major themes: the status

and meaning of revolt, the idea of style as a form of Refusal, the elevation of crime into art (even though, in our case, the 'crimes' are only broken codes). Like Genet, we are interested in subculture – in the expressive forms and rituals of those subordinate groups – the teddy boys and mods and rockers, the skinheads and the punks – who are alternately dismissed, denounced and canonized; treated at different times as threats to public order and as harmless buffoons. Like Genet also, we are intrigued by the most mundane objects – a safety pin, a pointed shoe, a motor cycle – which, none the less, like the tube of vaseline, take on a symbolic dimension, becoming a form of stigmata, tokens of a self-imposed exile. Finally, like Genet, we must seek to recreate the dialectic between action and reaction which renders these objects meaningful. For, just as the conflict between Genet's 'unnatural' sexuality and the policemen's 'legitimate' outrage can be encapsulated in a single object, so the tensions between dominant and subordinate groups can be found reflected in the surfaces of subculture – in the styles made up of mundane objects which have a double meaning. On the one hand, they warn the 'straight' world in advance of a sinister presence – the presence of difference – and draw down upon themselves vague suspicions, uneasy laughter, 'white and dumb rages'. On the other hand, for those who erect them into icons, who use them as words or as curses, these objects become signs of forbidden identity, sources of value. Recalling his humiliation at the hands of the police, Genet finds consolation in the tube of vaseline. It becomes a symbol of his 'triumph' – 'I would indeed rather have shed blood than repudiate that silly object' (Genet, 1967).

The meaning of subculture is, then, always in dispute, and style is the area in which the opposing definitions clash with most dramatic force. Much of the available space in this book will therefore be taken up with a description of the process whereby objects are made to mean and mean again as 'style' in subculture. As in Genet's novels, this process begins with a crime against the natural order, though in this case the deviation may seem slight indeed – the cultivation of a quiff, the acquisition of a scooter or a record or a certain type of suit. But it ends in the construction of a style, in a gesture of defiance or contempt, in a smile or a sneer. It signals a Refusal. I would like to think that this Refusal is worth making, that these gestures have a meaning, that the smiles and the sneers have some subversive value, even if, in the final analysis, they are, like Genet's gangster pin-ups, just the darker side of sets of regulations, just so much graffiti on a prison wall.

Even so, graffiti can make fascinating reading. They draw attention to themselves. They are an expression both of impotence and a kind of power – the power to disfigure (Norman Mailer calls graffiti – 'Your presence on their Presence ... hanging your alias on their scene' (Mailer, 1974)). In this book I shall attempt to decipher the graffiti, to tease out the meanings embedded in the various post-war youth styles. But before we can proceed to individual subcultures, we must first define the basic terms. The word 'subculture' is loaded down with mystery. It suggests secrecy, masonic oaths, an Underworld. It also invokes the larger and no less difficult concept 'culture'. So it is with the idea of culture that we should begin.

From culture to hegemony

Culture

> Culture: cultivation, tending, in Christian authors, worship; the action or practice of cultivating the soil; tillage, husbandry; the cultivation or rearing of certain animals (e.g. fish); the artificial development of microscopic organisms, organisms so produced; the cultivating or development (of the mind, faculties, manners), improvement or refinement by education and training; the condition of being trained or refined; the intellectual side of civilization; the prosecution or special attention or study of any subject or pursuit.
>
> (Oxford English Dictionary)

Culture is a notoriously ambiguous concept as the above definition demonstrates. Refracted through centuries of usage, the word has acquired a number of quite different, often contradictory, meanings. Even as a scientific term, it refers both to a process (artificial development of microscopic organisms) and a product (organisms so produced). More specifically, since the end of the eighteenth century, it has been used by English intellectuals and literary figures to focus critical attention on a whole range of controversial issues. The 'quality of life', the effects in human terms of mechanization, the division of labour and the creation of a mass society have all been discussed within the larger confines of what Raymond Williams has called the 'Culture and Society' debate (Williams, 1961). It was through this tradition of dissent and criticism that the dream of the 'organic society' – of society as an integrated, meaningful whole – was largely kept alive. The dream had two basic trajectories. One led back to the past and to the feudal ideal of a hierarchically ordered community. Here, culture assumed an almost sacred function. Its 'harmonious perfection' (Arnold, 1868) was posited against the Wasteland of contemporary life.

The other trajectory, less heavily supported, led towards the future, to a socialist Utopia where the distinction between labour and leisure was to be annulled. Two basic definitions of culture emerged from this tradition, though these were by no means necessarily congruent with the two trajectories outlined above. The first – the one which is probably most familiar to the reader – was essentially classical and conservative. It represented culture as a standard of aesthetic excellence: 'the best that has been thought and said in the world' (Arnold, 1868), and it derived from an appreciation of 'classic' aesthetic form (opera, ballet, drama, literature, art). The second, traced back by Williams to Herder and the eighteenth century (Williams, 1976), was rooted in anthropology. Here the term 'culture' referred to a

> ... particular way of life which expresses certain meanings and values not only in art and learning, but also in institutions and ordinary behaviour. The analysis of culture, from such a definition, is the clarification of the meanings and values implicit and explicit in a particular way of life, a particular culture.
>
> (Williams, 1965)

This definition obviously had a much broader range. It encompassed, in T. S. Eliot's words,

> ... all the characteristic activities and interests of a people. Derby Day, Henley Regatta, Cowes, the 12th of August, a cup final, the dog races, the pin table, the dart-board, Wensleydale cheese, boiled cabbage cut into sections, beetroot in vinegar, 19th Century Gothic churches, the music of Elgar... .
>
> <div align="right">(Eliot, 1948)</div>

As Williams noted, such a definition could only be supported if a new theoretical initiative was taken. The theory of culture now involved the 'study of relationships between elements in a whole way of life' (Williams, 1965). The emphasis shifted from immutable to historical criteria, from fixity to transformation:

> ... an emphasis [which] from studying particular meanings and values seeks not so much to compare these, as a way of establishing a scale, but by studying their modes of change to discover certain general causes or 'trends' by which social and cultural developments as a whole can be better understood.
>
> <div align="right">(Williams, 1965)</div>

Williams was, then, proposing an altogether broader formulation of the relationships between culture and society, one which through the analysis of 'particular meanings and values' sought to uncover the concealed fundamentals of history; the 'general causes' and broad social 'trends' which lie behind the manifest appearances of an 'everyday life'.

In the early years, when it was being established in the Universities, Cultural Studies sat rather uncomfortably on the fence between these two conflicting definitions – culture as a standard of excellence, culture as a 'whole way of life' – unable to determine which represented the most fruitful line of enquiry. Richard Hoggart and Raymond Williams portrayed working-class culture sympathetically in wistful accounts of pre-scholarship boyhoods (Leeds for Hoggart (1958), a Welsh mining village for Williams (1960)) but their work displayed a strong bias towards literature and literacy and an equally strong moral tone. Hoggart deplored the way in which the traditional working-class community – a community of tried and tested values despite the dour landscape in which it had been set – was being undermined and replaced by a 'Candy Floss World' of thrills and cheap fiction which was somehow bland *and* sleazy. Williams tentatively endorsed the new mass communications but was concerned to establish aesthetic and moral criteria for distinguishing the worthwhile products from the 'trash'; the jazz – 'a real musical form' – and the football – 'a wonderful game' – from the 'rape novel, the Sunday strip paper and the latest Tin Pan drool' (Williams, 1965). In 1966 Hoggart laid down the basic premises upon which Cultural Studies were based:

> First, without appreciating good literature, no one will really understand the nature of society; second, literary critical analysis can be applied to certain social phenomena other than 'academically respectable' literature (for example,

the popular arts, mass communications) so as to illuminate their meanings for individuals and their societies.

(Hoggart, 1966)

The implicit assumption that it still required a literary sensibility to 'read' society with the requisite subtlety, and that the two ideas of culture could be ultimately reconciled was also, paradoxically, to inform the early work of the French writer, Roland Barthes, though here it found validation in a method — semiotics — a way of reading signs (Hawkes, 1977).

Barthes: Myths and signs

Using models derived from the work of the Swiss linguist Ferdinand de Saussure Barthes sought to expose the *arbitrary* nature of cultural phenomena, to uncover the latent meanings of an everyday life which, to all intents and purposes, was 'perfectly natural'. Unlike Hoggart, Barthes was not concerned with distinguishing the good from the bad in modern mass culture, but rather with showing how *all* the apparently spontaneous forms and rituals of contemporary bourgeois societies are subject to a systematic distortion, liable at any moment to be dehistoricized, 'naturalized', converted into myth:

> The whole of France is steeped in this anonymous ideology: our press, our films, our theatre, our pulp literature, our rituals, our Justice, our diplomacy, our conversations, our remarks about the weather, a murder trial, a touching wedding, the cooking we dream of, the garments we wear, everything in everyday life is dependent on the representation which the bourgeoisie *has and makes us have* of the relations between men and the world.
>
> (Barthes, 1972)

Like Eliot, Barthes' notion of culture extends beyond the library, the opera-house and the theatre to encompass the whole of everyday life. But this everyday life is for Barthes overlaid with a significance which is at once more insidious and more systematically organized. Starting from the premise that 'myth is a type of speech', Barthes set out in *Mythologies* to examine the normally hidden set of rules, codes and conventions through which meanings particular to specific social groups (i.e. those in power) are rendered universal and 'given' for the whole of society. He found in phenomena as disparate as a wrestling match, a writer on holiday, a tourist-guide book, the same artificial nature, the same ideological core. Each had been exposed to the same prevailing rhetoric (the rhetoric of common sense) and turned into myth, into a mere element in a 'second-order semiological system' (Barthes, 1972). (Barthes uses the example of a photograph in *Paris-Match* of a Negro soldier saluting the French flag, which has a first and second order connotation: (1) a gesture of loyalty, but also (2) 'France is a great empire, and all her sons, without colour discrimination, faithfully serve under her flag'.)

Barthes' application of a method rooted in linguistics to other systems of discourse outside language (fashion, film, food, etc.) opened up completely new

possibilities for contemporary cultural studies. It was hoped that the invisible seam between language, experience and reality could be located and prised open through a semiotic analysis of this kind: that the gulf between the alienated intellectual and the 'real' world could be rendered meaningful and, miraculously, at the same time, be made to disappear. Moreover, under Barthes' direction, semiotics promised nothing less than the reconciliation of the two conflicting definitions of culture upon which Cultural Studies was so ambiguously posited – a marriage of moral conviction (in this case, Barthes' Marxist beliefs) and popular themes: the study of a society's total way of life.

This is not to say that semiotics was easily assimilable within the Cultural Studies project. Though Barthes shared the literary preoccupations of Hoggart and Williams, his work introduced a new Marxist 'problematic' which was alien to the British tradition of concerned and largely un-theorized 'social commentary'. As a result, the old debate seemed suddenly limited. In E. P. Thompson's words it appeared to reflect the parochial concerns of a group of 'gentlemen amateurs'. Thompson sought to replace Williams' definition of the theory of culture as 'a theory of relations between elements in a whole way of life' with his own more rigorously Marxist formulation: 'the study of relationships in a whole way of *conflict*'. A more analytical framework was required; a new vocabulary had to be learned. As part of this process of theorization, the word 'ideology' came to acquire a much wider range of meanings than had previously been the case. We have seen how Barthes found an 'anonymous ideology' penetrating every possible level of social life, inscribed in the most mundane of rituals, framing the most casual social encounters. But how can ideology be 'anonymous', and how can it assume such a broad significance? Before we attempt any reading of subcultural style, we must first define the term 'ideology' more precisely.

Ideology: A lived *relation*

In the *German Ideology*, Marx shows how the basis of the capitalist economic structure (surplus value, neatly defined by Godelier as 'Profit ... is unpaid work' (Godelier, 1970)) is hidden from the consciousness of the agents of production. The failure to see through appearances to the real relations which underlie them does not occur as the direct result of some kind of masking operation consciously carried out by individuals, social groups or institutions. On the contrary, ideology by definition thrives *beneath* consciousness. It is here, at the level of 'normal common sense', that ideological frames of reference are most firmly sedimented and most effective, because it is here that their ideological nature is most effectively concealed. As Stuart Hall puts it:

> It is precisely its 'spontaneous' quality, its transparency, its 'naturalness', its refusal to be made to examine the premises on which it is founded, its resistance to change or to correction, its effect of instant recognition, and the closed circle in which it moves which makes common sense, at one and the same time, 'spontaneous', ideological and *unconscious*. You cannot learn, through common sense, *how things are*: you can only discover *where they fit* into the existing scheme

of things. In this way, its very taken-for-grantedness is what establishes it as a medium in which its own premises and presuppositions are being rendered *invisible* by its apparent transparency.

<div align="right">(Hall, 1977)</div>

Since ideology saturates everyday discourse in the form of common sense, it cannot be bracketed off from everyday life as a self-contained set of 'political opinions' or 'biased views'. Neither can it be reduced to the abstract dimensions of a 'world view' or used in the crude Marxist sense to designate 'false consciousness'. Instead, as Louis Althusser has pointed out:

> ... ideology has very little to do with 'consciousness'... . It is profoundly *unconscious*... . Ideology is indeed a system of representation, but in the majority of cases these representations have nothing to do with 'consciousness': they are usually images and occasionally concepts, but it is above all as *structures* that they impose on the vast majority of men, not via their 'consciousness'. They are perceived-accepted-suffered cultural objects and they act functionally on men via a process that escapes them.

<div align="right">(Althusser, 1969)</div>

Although Althusser is here referring to structures like the family, cultural and political institutions, etc., we can illustrate the point quite simply by taking as our example a physical structure. Most modern institutes of education, despite the apparent neutrality of the materials from which they are constructed (red brick, white tile, etc.) carry within themselves implicit ideological assumptions which are literally structured into the architecture itself. The categorization of knowledge into arts and sciences is reproduced in the faculty system which houses different disciplines in different buildings, and most colleges maintain the traditional divisions by devoting a separate floor to each subject. Moreover, the hierarchical relationship between teacher and taught is inscribed in the very lay-out of the lecture theatre where the seating arrangements – benches rising in tiers before a raised lectern – dictate the flow of information and serve to 'naturalize' professorial authority. Thus, a whole range of decisions about what is and what is not possible within education have been made, however unconsciously, before the content of individual courses is even decided.

These decisions help to set the limits not only on what is taught but on *how* it is taught. Here the buildings literally *reproduce* in concrete terms prevailing (ideological) notions about what education *is* and it is through this process that the educational structure, which can, of course, be altered, is placed beyond question and appears to us as a 'given' (i.e. as immutable). In this case, the frames of our thinking have been translated into actual bricks and mortar.

Social relations and processes are then appropriated by individuals only through the forms in which they are represented to those individuals. These forms are, as we have seen, by no means transparent. They are shrouded in a 'common sense' which simultaneously validates and mystifies them. It is precisely these 'perceived-accepted-suffered cultural objects' which semiotics sets out to 'interrogate' and decipher. All aspects of culture possess a semiotic value, and the most taken-for-

granted phenomena can function as signs: as elements in communication systems governed by semantic rules and codes which are not themselves directly apprehended in experience. These signs are, then, as opaque as the social relations which produce them and which they re-present. In other words, there is an ideological dimension to every signification:

> A sign does not simply exist as part of reality – it reflects and refracts another reality. Therefore it may distort that reality or be true to it, or may perceive it from a special point of view, and so forth. Every sign is subject to the criteria of ideological evaluation.... . The domain of ideology coincides with the domain of signs. They equate with one another. Whenever a sign is present, ideology is present too. Everything ideological possesses a semiotic value.
>
> (Volosinov, 1973)

To uncover the ideological dimension of signs we must first try to disentangle the codes through which meaning is organized. 'Connotative' codes are particularly important. As Stuart Hall has argued, they '... cover the face of social life and render it classifiable, intelligible, meaningful' (Hall, 1977). He goes on to describe these codes as 'maps of meaning' which are of necessity the product of selection. They cut across a range of potential meanings, making certain meanings available and ruling others out of court. We tend to live inside these maps as surely as we live in the 'real' world: they 'think' us as much as we 'think' them, and this in itself is quite 'natural'. All human societies *reproduce* themselves in this way through a process of 'naturalization'. It is through this process – a kind of inevitable reflex of all social life – that *particular* sets of social relations, *particular* ways of organizing the world appear to us as if they were universal and timeless. This is what Althusser means when he says that 'ideology has no history' and that ideology in this general sense will always be an 'essential element of every social formation' (Althusser and Balibar, 1968).

However, in highly complex societies like ours, which function through a finely graded system of divided (i.e. specialized) labour, the crucial question has to do with which specific ideologies, representing the interests of which specific groups and classes will prevail at any given moment, in any given situation. To deal with this question, we must first consider how power is distributed in our society. That is, we must ask which groups and classes have how much say in defining, ordering and classifying out the social world. For instance, if we pause to reflect for a moment, it should be obvious that access to the means by which ideas are disseminated in our society (i.e. principally the mass media) is *not* the same for all classes. Some groups have more say, more opportunity to make the rules, to organize meaning, while others are less favourably placed, have less power to produce and impose their definitions of the world on the world.

Thus, when we come to look beneath the level of 'ideology-in-general' at the way in which specific ideologies work, how some gain dominance and others remain marginal, we can see that in advanced Western democracies the ideological field is by no means neutral. To return to the 'connotative' codes to which Stuart Hall refers we can see that these 'maps of meaning' are charged with a potentially explosive significance because they are traced and re-traced along the lines laid

down by the *dominant* discourses about reality, the *dominant* ideologies. They thus tend to represent, in however obscure and contradictory a fashion, the interests of the dominant groups in society.

To understand this point we should refer to Marx:

> The ideas of the ruling class are in every epoch the ruling ideas, i.e. the class which is the ruling *material* force of society is at the same time its ruling *intellectual* force. The class which has the means of material production at its disposal, has control at the same time over the means of mental production, so that generally speaking, the ideas of those who lack the means of mental production are subject to it. The ruling ideas are nothing more than the ideal expression of the dominant material relationships grasped as ideas; hence of the relationships which make the one class the ruling class, therefore the ideas of its dominance.
>
> (Marx and Engels, 1970)

This is the basis of Antonio Gramsci's theory of *hegemony* which provides the most adequate account of how dominance is sustained in advanced capitalist societies.

Hegemony: The moving equilibrium

> Society cannot share a common communication system so long as it is split into warring classes.
>
> (Brecht, *A Short Organum for the Theatre*)

The term hegemony refers to a situation in which a provisional alliance of certain social groups can exert 'total social authority' over other subordinate groups, not simply by coercion or by the direct imposition of ruling ideas, but by 'winning and shaping consent so that the power of the dominant classes appears both legitimate and natural' (Hall, 1977). Hegemony can only be maintained so long as the dominant classes 'succeed in framing all competing definitions within their range' (Hall, 1977), so that subordinate groups are, if not controlled, then at least contained within an ideological space which does not seem at all 'ideological': which appears instead to be permanent and 'natural', to lie outside history, to be beyond particular interests (see *Social Trends*, no. 6, 1975).

This is how, according to Barthes, 'mythology' performs its vital function of naturalization and normalization and it is in his book *Mythologies* that Barthes demonstrates most forcefully the full extension of these normalized forms and meanings. However, Gramsci adds the important proviso that hegemonic power, precisely *because* it requires the consent of the dominated majority, can never be permanently exercised by the same alliance of 'class fractions'. As has been pointed out, 'Hegemony ... is not universal and "given" to the continuing rule of a particular class. It has to be won, reproduced, sustained. Hegemony is, as Gramsci said, a "moving equilibrium" containing relations of forces favourable or unfavourable to this or that tendency' (Hall and Jefferson, 1976a).

In the same way, forms cannot be permanently normalized. They can always be deconstructed, demystified, by a 'mythologist' like Barthes. Moreover commodities can be symbolically 'repossessed' in everyday life, and endowed with implicitly oppositional meanings, by the very groups who originally produced them. The symbiosis in which ideology and social order, production and reproduction, are linked is then neither fixed nor guaranteed. It can be prised open. The consensus can be fractured, challenged, overruled, and resistance to the groups in dominance cannot always be lightly dismissed or automatically incorporated. Although, as Lefebvre has written, we live in a society where '... objects in practice become signs and signs objects and a second nature takes the place of the first – the initial layer of perceptible reality' (Lefebvre, 1971), there are, as he goes on to affirm, always 'objections and contradictions which hinder the closing of the circuit' between sign and object, production and reproduction.

We can now return to the meaning of youth subcultures, for the emergence of such groups has signalled in a spectacular fashion the breakdown of consensus in the post-war period. In the following chapters we shall see that it is precisely objections and contradictions of the kind which Lefebvre has described that find expression in subculture. However, the challenge to hegemony which subcultures represent is not issued directly by them. Rather it is expressed obliquely, in style. The objections are lodged, the contradictions displayed (and, as we shall see, 'magically resolved') at the profoundly superficial level of appearances: that is, at the level of signs. For the sign-community, the community of myth-consumers, is not a uniform body. As Volosinov has written, it is cut through by class:

> Class does not coincide with the sign community, i.e. with the totality of users of the same set of signs of ideological communication. Thus various different classes will use one and the same language. As a result, differently oriented accents intersect in every ideological sign. Sign becomes the arena of the class struggle.
>
> (Volosinov, 1973)

The struggle between different discourses, different definitions and meanings within ideology is therefore always, at the same time, a struggle within signification: a struggle for possession of the sign which extends to even the most mundane areas of everyday life. To turn once more to the examples used in the Introduction, to the safety pins and tubes of vaseline, we can see that such commodities are indeed open to a double inflection: to 'illegitimate' as well as 'legitimate' uses. These 'humble objects' can be magically appropriated; 'stolen' by subordinate groups and made to carry 'secret' meanings: meanings which express, in code, a form of resistance to the order which guarantees their continued subordination.

Style in subculture is, then, pregnant with significance. Its transformations go 'against nature', interrupting the process of 'normalization'. As such, they are gestures, movements towards a speech which offends the 'silent majority', which challenges the principle of unity and cohesion, which contradicts the myth of consensus. Our task becomes, like Barthes', to discern the hidden messages inscribed in code on the glossy surfaces of style, to trace them out as 'maps of

meaning' which obscurely re-present the very contradictions they are designed to resolve or conceal.

Academics who adopt a semiotic approach are not alone in reading significance into the loaded surfaces of life. The existence of spectacular subcultures continually opens up those surfaces to other potentially subversive readings. Jean Genet, the archetype of the 'unnatural' deviant, again exemplifies the practice of resistance through style. He is as convinced in his own way as is Roland Barthes of the ideological character of cultural signs. He is equally oppressed by the seamless web of forms and meanings which encloses and yet excludes him. His reading is equally partial. He makes his own list and draws his own conclusions:

> I was astounded by so rigorous an edifice whose details were united against me. Nothing in the world is irrelevant: the stars on a general's sleeve, the stock-market quotations, the olive harvest, the style of the judiciary, the wheat exchange, the flower-beds, ... Nothing. This order... had a meaning – my exile.
>
> (Genet, 1967)

It is this alienation from the deceptive 'innocence' of appearances which gives the teds, the mods, the punks and no doubt future groups of as yet unimaginable 'deviants' the impetus to move from man's second 'false nature' (Barthes, 1972) to a genuinely expressive artifice; a truly subterranean style. As a symbolic violation of the social order, such a movement attracts and will continue to attract attention, to provoke censure and to act, as we shall see, as the fundamental bearer of significance in subculture.

No subculture has sought with more grim determination than the punks to detach itself from the taken-for-granted landscape of normalized forms, nor to bring down upon itself such vehement disapproval. We shall begin therefore with the moment of punk and we shall return to that moment throughout the course of this book. It is perhaps appropriate that the punks, who have made such large claims for illiteracy, who have pushed profanity to such startling extremes, should be used to test some of the methods for 'reading' signs evolved in the centuries-old debate on the sanctity of culture.

Justin Lewis

PUBLIC ARTS FUNDING
Who benefits?

EDITOR'S INTRODUCTION

JUSTIN LEWIS'S CRITIQUE of public art policy in Britain in the 1980s remains very relevant to cultural studies, in particular because it outlines clear criteria for cultural value from a cultural policy perspective. As Lewis makes clear, public funding for the arts disproportionately benefits the rich and educated. While this in itself may not be grounds for complaint since arts funding bodies may not be aiming to redistribute cultural goods (let alone wealth), it is a problem insofar as extending *access* to the arts is routinely one of the declared aims of the policy behind the allocation of public arts funding. So in its own terms it tends to be a failure.

Lewis makes two main arguments here, one of which, though often repeated, remains quite controversial. First he contends that no art form or genre (opera, pop music, theatre, television soaps) has a particular value inherent to itself; its value is attributed to it from outside and is thence 'contingent' on social circumstances. It follows from this that criteria of value can be debated and agreed upon, and that these might properly involve economic and other social factors and goals. Cultural policy needs to have a sense of these criteria so as to direct public support rationally and for the wider community benefit.

This essay predates the current interest in creative industries and the enormous amount of work done on the economic benefit of cultural development by economists and others (Caves 2002; Throsby 2000) but it remains a very lucid and useful piece for thinking through the public issues involved.

Further reading: Bennett *et al.* 1999; Bourdieu 1986; Caves 2002; Frow 1995; Hartley 2005; Hesmondhalgh 2002; Lewis 1990 and 1991; Maxwell 2001; Throsby 2000.

The traditional arts audience

The link between education and artistic values spelt out in the previous chapter has direct and predictable social consequences. The people who benefit from the public funding of art are, overwhelmingly, the educated middle class.

The evidence for this is indisputable. Those who attempt to sustain the mythology that art is accessible to everyone – and many still do – justify it with anecdotes and 'personal experiences' of arts audiences. Nevertheless, all the surveys and audience profiles carried out in recent years reveal the same thing; namely that the barriers to most people's participation in consumption of publicly funded art are class and education.

Education and class are, of course, closely linked. Apart from being a defining characteristic in itself, education will largely determine a person's occupational class. This is reflected by surveys of arts audiences, where the indices of class and education consistently divide arts attenders from non-attenders.

Before going any further, I want to make it quite clear that what I am referring to are those artistic activities that are endowed with aesthetic value by our dominant culture. These are the scholarly arts, characterized by the high levels of cultural competence required to understand them. They will tend to be, appropriately enough, tied to particular cultural institutions such as theatres and art galleries. In the realm of music, public subsidy tends to support classical music, opera, and, most recently, jazz; rather than, say, music hall, independent pop music, samba, contemporary African music, or brass bands. Performance art will focus on theatres and drama companies at the 'literary end' of the genre, rather than pantomime, television, film, and radio. Dance means ballet and contemporary dance. It does not, on the whole, mean break dancing, tap dancing, or tea dances. Visual arts funding is more likely to go into art galleries than into places in which people live, work, or take their leisure. Subsidy for film and cinema, through the British Film Institute, will support the production and performance of 'art movies', rather than the films most people want to go and see.

There are, of course, exceptions to this, usually funded by local authorities and Regional Arts Associations. [...] They remain, however, very much exceptions. The bulk of arts funding is allocated according to the traditional definitions of value.

Audience research

There are, broadly speaking, three kinds of surveys on arts audiences: general or focused population surveys, user surveys, and qualitative research. Taken together they provide us with a fairly clear picture of the traditional arts audience.

General or focused population surveys

These are surveys based on short interviews with particular samples of the population. These samples will either be broadly representative of the general population, in terms of basic socio-demographic variables such as age, sex, education, occupational

Table 32.1 Social grade, education, and arts attendance (%)

	Social grade					Terminal education age			
	Total	AB	C1	C2	DE	19 plus	17 or 18	16 or less	Still in education
Sample	5874	822	1340	1745	1967	578	726	4201	330
Events attended:									
Theatre	26	49	38	21	13	54	37	20	35
Plays	19	43	28	13	8	49	28	12	33
Musicals	14	29	22	10	7	31	20	11	18
Pantomime/ children's shows	21	26	24	21	16	30	24	19	20
Ballet	5	13	7	3	2	5	8	3	6
Contemporary dance	3	5	4	2	1	9	3	1	6
Opera	4	11	5	2	2	13	5	2	3
Classical music	10	27	13	5	4	29	15	6	9
Jazz	7	11	10	5	4	13	9	5	15
Art galleries/ exhibitions	18	35	28	14	9	42	25	13	27

Source: British Market Research Bureau *Survey of Arts Attendance in Great Britain*, The Arts Council of Great Britain, 1986.

class, etc., or they will be more specifically aimed at particular sections of the population, such as unemployed people or Afro-Caribbean people in Brixton.

These surveys are most useful in identifying who does and does not attend arts venues or events. The table below, taken from a 1986 British Market Research Bureau survey for the Arts Council, highlights the class and educational background of traditional arts audiences. The more education you have received, or the higher your 'social grade', the more likely you are to show an interest in the traditional arts.

The member of classes A or B (professional and managerial) is 4 times more likely to go to the theatre, 4 times more likely to go to an art gallery or exhibition, 5 times more likely to go to watch contemporary dance, 5½ times more likely to go to the opera and over 6 times more likely to go to a ballet or classical concert than a member of classes D and E (semi-skilled or unskilled manual workers).

The statistics on educational background show exactly the same pattern. If there is one factor that identifies the arts attender more than any other, it is taking part in further education (in the survey this is defined as beyond the age of 19). The figures show that this group, above all others, are the prolific arts attenders.

The only events that attract an even spread of social/educational backgrounds are pantomimes and children's shows. These activities, significantly, are endowed with less artistic value than the others, and are less likely to receive public funding.

A focused population survey (based on samples of women in Deptford, black people in Brixton and unemployed people in Dalston) carried out by Comedia in the same year (1986), makes a similar point. The survey divided the sample into two educational groups: those with 'O' levels or higher educational qualifications, and those with CSEs or no qualifications. The more traditionally artistic a cultural activity, the more it is dominated by the educationally qualified group.

Pierre Bourdieu's work in France analyses these links in relation to musical taste. Using complex survey data, he is able 'to distinguish three zones of taste which roughly correspond to educational levels and social classes'. These are

Table 32.2 Art or entertainment visited in the previous month (%)

	Up to CSE	'O' level plus
Art gallery	3.5	22
Theatre	3.5	20
Live music	12	31
Cinema	27	47
Nightclub/disco	21	26
Social club	10	6
Bingo	9	2.5

Source: J. Lewis *et al.*, *Art – Who Needs It?*, Comedia, 1987.

identified as legitimate taste, 'middle-brow' taste and 'popular' taste. The types of music preferred by the highly educated people with legitimate taste are given high aesthetic value and will tend to be publicly subsidized, while the 'popular' aesthetic is given less value and left to the commercial sector.

The 'legitimate' group are obviously comfortable with the high level of cultural competence required to enjoy the world of the traditional arts while the 'middle-brow' group will only be on the periphery of that world. The more involved an audience becomes in the arts, the more exclusive it becomes. It follows, then, that the educational and class divide is even greater amongst frequent arts attenders. A survey by NOP for the Society of West End Theatres (SWET) found that amongst the 11 per cent of the population who went frequently to the theatre (3 or more times in the previous year), those from social classes A and B were *10 times* more likely to be in this group than members of classes D and E.

Similarly, these surveys reveal the socially homogeneous nature of the 'arts attenders' group. The British Market Research Bureau survey found that, for example, opera-goers were also likely to go to art galleries, ballet, etc. In other words, the person with the cultural competence necessary to indulge in one 'high' or 'legitimate' art form is also equipped to indulge in others. The existence of this cultural clique demonstrates how coherent the dominant system of aesthetic value is. It applies across most 'high' art forms and features the same educational links.

Is there anything else that characterizes the arts user or attender? Here, survey results are a little less consistent. Overall, men and women are fairly equally represented. Audiences tend to be white – although it is difficult to tell how much this is simply due to the disadvantaged position of black people in social class and educational terms. Do black people abstain from arts attendance because they tend to be working class or because of the dominance of white cultural forms? There will, of course, be no general answer, as the interplay of race and class will work in a variety of different ways, with a range of cultural effects.

Age differences, on the other hand, tend to vary with art forms. The British Market Research Bureau survey found that 'the median age of attenders would be: opera 53; ballet 49; classical music 44; musicals 47; art galleries/exhibitions 44; theatre 42; plays 42; pantomime/children's shows 34; contemporary dance 34; and jazz 30'. Others surveys have found similar differences, which probably have more to do with fashion than any acquired cultural competence. The Broadcasting Research Unit's (BRU) analysis of cinema audiences, for example, suggests that cinema-going is very much a young person's pastime. [...]

The age range of arts attenders also conforms to other patterns of leisure: young and middle-aged people tend to go out more often than the elderly, and their presence at arts events reflects this.

User surveys

User surveys are normally carried out by venues in order to find out more about their audience. Amongst other things, they confirm the existence of educational and class barriers (and barriers are very much what they are, if access depends upon education and the cultural competence that education brings).

A survey at the Institute of Contemporary Arts (ICA) revealed that only 3 per cent of the people who went there were 'blue collar' workers, while as many as 60 per cent were actually involved in the arts in some way themselves. A survey by the British Film Institute (BFI) found that half the members of the National Film Theatre had occupations described as management, professional, or 'intellectual', as opposed to the 8 per cent who had manual or clerical jobs, three-quarters of the sample had experience of higher education, and half of them read the *Guardian*. Both surveys also showed that their audiences were regular attenders: about half the ICA survey had visited the Institute at least seven times in the previous year, while the NFT members averaged 35 films a year.

A survey of arts and leisure services in Islington, carried out by Comedia in 1987, involved a range of user surveys. These were carried out at both traditional arts venues, such as the King's Head Theatre, and popular arts venues, such as the Thatch Irish music club, the Holloway Road Odeon, and a black music record shop. Accordingly, they found that 70 per cent of the King's Head Theatre audience had a degree or a diploma, compared with only 19 per cent at the Holloway Odeon (the local cinema), 14 per cent at the record shop and 8 per cent at the Irish music club. The only venue, in other words, with an audience characterized by a high level of education was also the only one to receive public funding. It is not thought appropriate to fund the more popular and accessible venues, whose work is not legitimated by the dominant cultural aesthetics. This reflects Bourdieu's distinction between the (publicly funded) 'legitimate' arts audience and the (commercially funded) popular arts audience.

Another good example of this is revealed in the BRU's study of cinema audiences. Most cinemas are, of course, commercial. There are, however, 37 Regional Film Theatres (RFTs) around Britain, showing independent, foreign, and 'art' movies. The BRU's survey of the RFT audiences shows them to be overwhelmingly middle class. Nearly 80 per cent of them were members of social classes A and B or students, as compared to the more even social spread attending ordinary commercial cinemas. Over half the RFT audience, indeed, were involved in full-time education.

They also found that, as opposed to those attending ordinary commercial cinemas, the 'specialist film audience is media-rich: they are theatre goers, art gallery habitués, disco maniacs and clubbers. The commercial audience seems less concerned with such frenetic activity'.

Qualitative research

Quantitative surveys have established who makes up the audience for the arts. In order to discover the attitudes and motivations that lie behind these statistics, it is necessary to do more qualitative research. The most common form of qualitative research is the group discussion. The group's make-up will depend upon the researcher's particular interests: it may consist of people who do or who don't attend arts events, or it may consist of members of a particular socio-demographic grouping, such as working-class women or young Afro-Caribbean men. Alternatively, qualitative research can involve one-to-one interviews, with, say, people who live on a particular housing estate.

Qualitative research is often an extremely rich source of information. It allows us to explore issues in some depth (such as the value of the artistic experience or what constitutes that experience). [...] But here the question is what light such research throws upon the educational divide between those who benefit from public arts subsidy and those who do not.

The degree of alienation most working-class (particularly young) people feel from traditional art forms is clearly revealed. A young working-class discussion group in the north-east defined the arts attender as 'one of them' rather than 'one of us': 'Theatre goers? Someone well off. Not just your ordinary worker ... we're North-Easters, it's a class thing'. The same report went on to point out that members of younger working-class discussion groups saw the arts not only as middle class, but as too 'intellectual':

> younger and less sophisticated people felt alienated by the whole idea of attending a classical concert – they felt they would not fit in with the 'middle class' or 'intellectual' audience, and that they would feel foolish and bored because they had no idea of how to select or appreciate the music.

This alienation is felt by young and old alike, although it is expressed in different ways. A report based on a mixed-age group of working-class people demonstrates how, while younger respondents will tend to be more assertive, both age groups are articulating similar feelings:

> The 'high culture' arts of opera, ballet or Shakespeare plays were never mentioned spontaneously. When introduced to the discussions, apart from two people who had actually attended, the older people became slightly defensive – 'they are just for visitors and tourists', 'too busy for that sort of thing', 'ordinary people just want a cinema and somewhere to go for special treats'. The younger people seemed amazed that they should even be asked about such things, 'if you're middle class you might want something different', 'we just want the video in my street', 'that's for posh people'.

These feelings are even more pronounced when faced with the possibility of getting involved and participating in artistic activity. A study based on interviews with women living in council estates in the London Borough of Ealing showed this total lack of confidence:

Many of the interviewees wouldn't contemplate an activity which could be easily defined as 'art'. The results of their efforts would be tangible and, as such, readily available for criticism, which would expose them to possible ridicule or patronage. It was much more frequently the case that people said 'Oh, no, I couldn't do that' than 'I wouldn't like to do that.'

It is interesting that people's *desire* is distinguished from their perceived ability: in other words, regardless of whether I *want* to get involved in artistic activity, I am simply not able to.

This clarifies the notion of 'cultural competence'. The qualitative research I have referred to shows how real that notion is. Cultural competence is what you need to appreciate or participate in 'art', it is something you acquire if you're middle-class, 'intellectual' or 'posh'. The lack of this cultural competence makes 'art' inappropriate or something quite frightening.

Public funding: theory and practice

I have argued that the aesthetic value system governing arts funding is ultimately arbitrary. That is the nature of any value system: value is attributed to something, it is not part of its essence. There is nothing essentially valuable about gold. We give it value because we have associated value – in this case – with rarity, and with the jewellery we turn gold into.

Once a value system is in place, of course, it seems no longer arbitrary. In the case of art, it is supported by an education and class system which makes it both appropriate and coherent. It is, for all that, not something permanent or impossible to change.

The social consequences of our aesthetic value system are usually disregarded. Public money is spent without any consideration of social or cultural needs. At worst, [...] 'such a policy actually represents ... the redistribution of wealth from the working classes to subsidise the institutions of the upper classes'; at best, it provides state support for middle-class entertainment and middle-class aesthetics.

The social and cultural goals of our funding institutions are, in fact, fairly democratic. The problem is that they bear very little relation to the reality of their funding. The Arts Council of Great Britain operates under a Royal Charter, granted in 1967. This Charter states that two of the Arts Council's main objectives are:

a) to develop and improve the knowledge, understanding and practice of the arts; and,
b) to increase the accessibility of the arts to the public throughout Great Britain.

Luke Rittner, introducing the Arts Council's 1985/6 Annual Report, argues that the 'growth and development of Britain's cultural life is vital in this post industrial era', the clear implication being that this is what the Arts Council is about.

The Minister for the Arts, Richard Luce, echoed these sentiments when he said that 'the arts cannot exist in a vacuum or be insulated from the outside

world. Their interest must be to encourage the maximum public participation in their affairs'.

This is all highly laudable. The Arts Council is reaching out to the British public, enhancing cultural life and the general good. Luke Rittner again:

> Today, the arts can no longer be described as an elitist minority interest... something has changed in Britain. The arts are being pushed up the agenda by the sheer weight of public demand for the joy and exhilaration the arts can provide.

This is also, unfortunately, highly disingenuous. A look at those bodies to which the Arts Council actually gives money is like looking at a directory of high art. It goes to theatres, art galleries, orchestras, contemporary dance and ballet companies, opera companies, poetry societies, and other scholarly pursuits. In 1985/6, it gave out approximately £100 million. Out of this, only a fraction went to activities that were *even potentially* popular or against the traditional grain: just under £16 million went to Regional Arts Associations, while less than £200,000 went to 'community arts' and £3,000 was spread amongst 30 different carnivals.

The British Film Institute, however good their intentions might be, sustain a similar set of aesthetic values. As I have already suggested, the Broadcasting Research Unit study of film audiences indicates that the cultural competence required to watch a BFI funded film production or to go to a Regional Film Theatre makes them a middle-class preserve. The ordinary 'commercial' cinemas on the other hand, attract a comparatively broad cross-section of the public, yet they receive no subsidy at all. It is not that they don't need it – the annual audience for British cinema declined from 1,640 million to 73 million between 1946 and 1986, with hundreds of cinemas closing down – it is that they are not deemed *worthy* of it.

Even in a 'mass medium' such as television, the BBC, a public corporation, has adopted a similarly elitist set of values. Radio stations Three and Four are heavily subsidized by the TV licence fee for the benefit of a small middle-class audience (particularly for Radio Three, the classical music station). The popular music station, Radio One, gets a far bigger audience and substantially less money. This is justified in 'the public interest' – yet what is being referred to is not 'the public' at all, but the educated middle-class public. Moreover, the argument that Radio Three *needs* more money than Radio One, despite its small audience, is quite spurious. Radio Three does not need to invest in music production – but it does. Radio One could also invest in production, but it does not.

On a more local level, the Arts Council devolved responsibility for some of the less expensive local or regional arts activities in the late 1970s to the Regional Arts Associations (RAAs). The RAAs, despite the rather paltry percentage of funds they receive from the Arts Council's budget, will often see themselves as the flagships for democratic culture. Their rather meagre existence is seen to balance the 'legitimate' artistic activities the Arts Council spends most of its money on. Local authorities, who are major arts funders in Britain, will often adopt a similar outlook, seeking to provide for the needs of their local communities.

On the whole, despite a host of democratic intentions, RAAs and local authorities tend to spend most of their money on much the same kinds of

activity as the Arts Council. There are some notable exceptions to this, and, as I have already promised, I shall be looking at these in detail in the chapters that follow. Nevertheless, the audience for the more 'community based' initiatives they support tends to be, once again, highly educated and middle-class. There have been three recent studies of the audience for and participants in these more locally or 'community' based activities in London. They have all indicated that attempts to bridge the educational divide have usually failed. Local authorities and RAAs invariably focus upon the traditional arts, while attempts to move into less traditional areas (such as video or mural painting) have often been couched within the aesthetics of cultural competence.

The stated aims and objectives of our major arts and cultural institutions are not really the problem. What they actually *do*, on the other hand, is elitist and discriminatory. It is no good claiming to promote access, or to spend money in the name of 'the growth and development of Britain's cultural life', if the aesthetic values you have chosen to adopt inevitably favour the educationally privileged and the better off.

The gap between the goals of our arts and cultural institutions and their achievements is their undoing. The true nature of their aesthetic value system is hidden beneath the rhetoric of art for all. It is a pretence, unconsciously sustained by the influential 'arts' lobby — by marching under the banner of universal access we are able to *pretend* to ourselves and everyone else that these contradictions do not exist. What is so extraordinary is that politicians and people from both the left and the right have been confused and intimidated by this myth for so long.

A new set of values

Where does this leave the principle of 'art for all'? It is, in a general theoretical sense, a fairly uncontentious proposition, based upon the best ideals of public funding in general — whether health-care or national defence. Everyone is, in theory, free to go to an art gallery or the theatre. Unfortunately we are not totally free agents, but socially constructed ones. Our actions are limited and shaped by our social environment.

If this democratic principle is to become a reality, we need to establish an artistic value system that promotes this principle, rather than one that flies in the face of it. This must be worked out in the context of the complex set of economic and cultural conditions in which we live.

Any evaluation of art that does not work within the possibilities and limits of our existing culture (in its broadest sense) and society, is bound to run into difficulties justifying itself. There would be no point in supplying hospitals with units to tackle outbreaks of smallpox, since the harsh reality of smallpox has disappeared from our shores. Health-care needs to be geared to the prevention and cure of accidents and diseases that people actually suffer. (The analogy is a useful one, because of the difficult question of medical research and development. This is expensive and of no immediate benefit to anyone — yet it is vital for the future of health-care. The same function exists within art — a point I shall take up again later.)

Most traditional arts funding is gloriously inappropriate to the leisure trends in Britain today. As Mulgan and Worpole write:

> The shift towards greater spending on cultural hardware (TV sets, VCRs, hi-fi, etc.) as opposed to services has also meant that entertainment is increasingly located in the home. The growth in take away catering, canned beer, has gone hand in hand with the decline in audiences for cinema, football matches and pubs. The privatisation of pleasure – driven by basic economics – has become a fundamental issue, whilst traditions of civic, municipal, and public cultures are being swept away. In their place, fragmented cultures are being formed by the market – specialised TV channels for consumption in the home, and specialised 'life-style' based entertainments in the city centres. When television is available at around 2p an hour, why bother with the expense and trouble of travelling to the city centre (most local theatres and cinemas have long disappeared), going out to eat, risking increasingly violent streets and arranging for child care?

This is a process to be engaged with, not ignored. It also opens up the question of value. What is wrong with a home-based mass culture? What, of value, will the free market fail to secure if left to its own devices? This, in the current economic climate, is the question public funders must answer.

The traditional aesthetics of cultural competence would respond by suggesting that the 'difficult' art forms that are currently funded – opera, contemporary dance, art exhibitions, etc. – are of value partly because of their complexity, but they are too expensive and/or too unpopular to survive in the free market. They therefore need public subsidy for their value to be sustained. This, in the context of the cultural inequalities inherent within these traditional values, is rather a lame response.

Why is this response so unconvincing? I have already detailed the disastrous consequences once such a value system becomes a public policy, but there are many other reasons for its inadequacy. It is an aesthetics steeped in nostalgia for the old traditional forms. While there is nothing wrong with a little nostalgia, an aesthetics informed by it is unlikely to breed anything truly innovative or dynamic. It is also a form of public intervention precipitated by commercial failure, a system whereby the worthiness of the recipients is partly measured by their unpopularity. It is one thing to criticize the free market for equating popularity with cultural value, but quite another to adopt an inverted version of this crude formula. Such a position does not question the logic of the free market, it simply turns it upside down. Faced with such a limited choice of positions, you have to admit that at least the free marketeers have a majority on their side!

This leads us to the most profound flaw in our current system of cultural funding. Inscribed within it is the idea that the popular domain organized by the free market – the commercial culture that most of us consume – is an arena where notions of public intervention do not apply. It is as if the culture promoted by the commercial cultural industries is too rigid, too mundane, or too 'low' to be worth thinking about, and that aesthetic value can only be pursued outside this commercial world. This is an extraordinarily inept basis for a cultural strategy. It is like one

party on the far left addressing themselves only to the limitations of another party on the far left – you are destined to a life meddling on the sidelines.

If we accept the idea that we need a culture that reaches beyond the confines of the free market, a culture that includes practices and forms that a commercial system will not automatically provide, then two things follow. We must, first of all, clearly articulate a set of cultural values that the free market is or is not providing. We should then try to understand how the free market operates in relation to these cultural values. Can certain cultural values be promoted by regulating or strategically investing in the commercial culture? If not, which other cultural forms is it most appropriate to promote? Only by answering these questions can we develop a cultural strategy worthy of the name, instead of the ill-conceived mixture of pragmatism and prejudice that has guided us until now.

The question of 'cultural value' is difficult but unavoidable. Our cultural values, after all, constitute the guiding principles of our cultural policy. I shall, in the following paragraphs, offer six broad areas of 'cultural value' that allow us to address the shortcomings of the free market. While they may be developed, contested or refuted (although they are not, in an abstract sense, particularly controversial) they are, in one form or another, a necessary cornerstone for building a new cultural strategy.

The value of diversity

'The market alone', write Mulgan and Worpole, 'for all its dynamism and concern to meet unmet wants, is incapable of sustaining diversity except on its own terms.' Taste will be at worst dictated by, at best be geared to the economics of production. This, in the age of home-based entertainment, is bound to work against artistic diversity, for two basic economic reasons. Firstly, the economies of scale in the production process apply to culture as much as anything else. It is generally more profitable to produce a small range of products for a lot of people than a diverse range for a number of small groups of people. Secondly, those groups with limits on their disposable income, such as the unemployed, or with restrictions on ways of spending it, the disabled for example, will be more or less ignored by the process of cultural production. They are not, unlike other segmented markets, able to sustain the economics of production.

The free-market culture is much more likely to diversify at the 'upper' ends of the market. Middle-class people are likely to have enough disposable income to support cultural products with a more limited appeal. This is why 'quality' newspapers such as the *Guardian* or the *Daily Telegraph* survive with a much lower print run than tabloids such as the *Sun* and the *Mirror*. The former have middle-class readers with lots of money while the latter have working-class readers with rather less. This means that it is possible to sell the 'quality' papers at a higher price, while charging advertisers more (per paper) in order to reach this smaller but more affluent market. The laws of the free market guarantee that market segmentation benefits those with high levels of disposable income.

The value of innovation

The free market suppresses artistic innovation, because it is easier and cheaper to do without it. Innovation is an expensive business – it involves that area of activity known in industry as 'research and development'. This means allocating resources to activities that may spend most of the time producing little of value, in the hope that it will result in something new or something better.

Innovation also involves taking enormous commercial risks. A business will usually invest in a formula that is tried and tested – whether it is a pop group, a play, or a film – because it will be able to predict with reasonable safety that it will be successful. Investment in something new and different is like plunging into the unknown.

The freedom to innovate is valued within the dominant system of aesthetic value, and artists are often grant-aided so that they might have this freedom. Innovation does not necessarily mean complexity, however. During the late 1970s and early 1980s, the British music industry went through one of its most artistically creative periods, with a range of different styles emerging from the seeds sown by 'punk' and 'new wave' music. This had very little to do with the major record companies and was certainly not publicly subsidized. It involved small groups, independent record labels or promoters, using cheap available technology and taking commercial risks to support new musical styles. Although cheap technology reduced the amount of money required to finance such ventures, most of this activity involved self-exploitation, and most of it, on a commercial level, failed. Some new bands and new styles did, nevertheless, break through. Once a 'market' for their music was established, the major record companies moved in and either bought them up or promoted similar bands. Innovation, in this instance, was subsidized by the enthusiasm and energy of people prepared to behave in a decidedly non-commercial manner. This, in a free market, happens very rarely indeed.

The value of art in the environment

The public and private sectors have always been reluctant to introduce questions of artistic and environmental value in their cost benefit analyses. The shabby and ugly developments that comprise most city centres in Britain is their legacy. This is because employing craftspeople, artists, and planners is expensive. The cost can only realistically be borne by public agencies.

The role of art in architecture and the environment is not a simple one. It involves, as John Willet puts it, ensuring a 'good relationship between artist, patron (and/or architect) and the affected public'. The value of art in improving the environment is part of civic culture, whether it is Eduardo Paolozzi's mosaics that decorate Tottenham Court Road tube station in Central London, the 'Rainbow Room' murals that adorn part of Southampton General Hospital, or the work of the Seattle Arts Commission in North America. The work in Seattle, like other cities in the US, is based upon the 'percentage for the arts' idea. This involves the local state ensuring that a certain percentage (say 1 per cent) of money spent on new development goes towards an artistic input.

The value of social pleasure

Art is one amongst many other leisure activities that involves what we can call 'social pleasure'. Audience research consistently reinforces the importance of activities as a social experience:

> As an extension of the desire for 'escapism' and 'entertainment' there were many indications, especially from women, that one of the main pleasures of attending an event is the *'treat'* of an evening out. For most this involved careful planning, taking time to get dressed up and the excitement of a change of scene, together with the luxury of indulging money on personal enjoyment.
>
> In many cases it is not so much the particular cultural product (this or that film) on offer which is the key factor in attracting people to a project so much as a more general sense of whether or not the place offers a friendly, welcoming and enjoyable ambience in which to meet other people and have a pleasurable social experience. This factor is important to all the groups interviewed, but appears to be particularly important to women, given their particular experience of isolation in the home. The projects that offer this kind of social forum draw considerable praise in this respect – where it is lacking it is a distinct cause of negative comment and dissatisfaction.

The trend towards home-based entertainment is eradicating a culture based on social pleasure. Going to the pictures, to the theatre, or to the dance hall, exist only as memories for many people. The social and cultural consequences of this are summed up by a woman in a discussion group in Islington:

> It's no life though, is it ... I get bored to tears. I often say I feel like an old granny sitting in here. You get frustrated with yourself because, I think my life is passing and I am just sitting indoors watching television ... you might say you are prisoners in your own home ... I really get depressed indoors ... look at me ... shut in here I am like an old granny. You must be at your husband all the time.... . When you look back and think what you used to be able to do ... your social life ... it's finished.

The reasons for the post-war decline in these activities are complex. What is clear is that the free market is incapable of providing most people with the social pleasure of art. Removing the many barriers – whether fear of the streets at night, lack of transport facilities, or lack of confidence, requires strategic public investment.

The value of creative expression

The creative experience is usually achieved by *participating* in the artistic process itself – although it can also be part of its consumption. The value of this self-expression has been described many times by people working in various arts projects up and

down the country. It is summed up by a group of young people from the Albany
Basement Drama Project in Deptford:

> 'You change as a person ... I was quiet, I was shy, I've got more confidence
> now and I've got a bigger mouth and a bigger voice ...'

> 'It gives you encouragement and expands your whole life ...'

> 'It's just a feeling that you've achieved something ...'

> 'You're a person who's actually done something that other people find
> pleasurable ...'

This kind of grass-roots participation usually takes place outside the commercial
cultural world. It is invariably supported by public money rather than the free
market. The group Graeae, for example, wrote eloquently of the importance of
public funding (in this case, from the GLC) for people with disabilities:

> This company would have collapsed without GLC funding ... if it goes people
> with disabilities are back to square one after a brief period of a more fulfilled
> lifestyle ... our voice must not be stifled again through lack of money ... thanks
> for helping us this far.

The artistic experience, in this sense, is not only about acquiring cultural competence,
but about personal development and the broadening of horizons.

The economic value of art

The 'cultural industries' approach to artistic production is an attempt to place it
in an economic context. At the same time, organizations such as the Arts Council,
under pressure to justify their public subsidy, have been forced to stress the economic
importance of the arts. Chapter 7 will be devoted to a critical look at the use of
culture as an economic strategy. In the meantime, it is worth summarizing the
main arguments used to justify cultural funding in economic terms

a) The arts are a cost-effective form of employment. They will tend to be labour-
 intensive (labour comprising 60–70 per cent of major performing arts companies'
 total budgets) and will, therefore, only require comparatively low capital costs.
 They will often raise at least a proportion of their own income. The 1987 study
 of *Arts Centres in the United Kingdom* by the Policy Studies Institute, calculates that
 Art Centres raise, on average, 40 per cent of their own income (this includes 3
 per cent from sponsorship and donations).
b) The arts cross-subsidize education and broadcasting, providing educational resources
 and facilities (such as theatre in education, school visits, etc.), training actors and
 musicians for broadcasting and sometimes directly subsidizing the broadcasting
 of theatrical or musical productions.

c) Subsidy to particular parts of artistic industries can both enrich them and increase their economic viability. The British music industry, for example, was made more interesting and more profitable by the 'subsidy' provided by independent record labels. These non-profit or loss-making concerns functioned as a research and development wing of the music industry, keeping the industry one step ahead of its competitors. Other artistic industries can be made more economically self-sufficient by the provision of 'seed money' at strategic points in the sector. A cultural industry may not be profitable because a particular point in the economic chain may not be working efficiently. Investment in the distribution and marketing of independent video or community publishing are examples of strategic intervention in sectors that have been too production orientated to be efficient.

d) Art and culture are seen as important features in the development of tourism. Cities such as Glasgow and Bradford have spent money on cultural facilities to attract tourists (who will spend money in the city, not only on art and entertainment, but on subsidiary industries such as catering) and company investment (on the basis that Glasgow or Bradford is a nice place to live). At a national level, foreign tourists spend most of their money on VAT-rated goods and services, which provides a direct financial yield to the Treasury, as well as creating employment in subsidiary industries. Surveys suggest that the arts in Britain are a major reason for their coming.

Promoting a new set of values

This set of values (diversity, innovation, social pleasure, participation, the environment, and economic generation) provides a complex but coherent basis for funding the arts in Britain. Like all values they are not innocent. They need to be incorporated into mechanisms that ensure the creation of a diverse, innovative, environmental and social culture for everyone, regardless of income or education. This is something that the dominant aesthetic value system, in a society where access to 'cultural competence' is granted only to the privileged minority, is incapable of doing. As Alan Tomkins (borrowing from Bourdieu) writes:

> The cultural field is an analogous form of economy where agents are endowed with specific cultural 'capitals' arising from educational opportunity where one class (the dominant) possesses the 'cultural capital' and another (the dominated) does not.

Changing the nature of this 'cultural economy' means using a set of values that are incorporated within the social and cultural realities of Britain today. The values I have put forward have, for this reason, been developed within a clearly defined social and cultural context, rather than the abstract notion of 'excellence' based upon cultural competence. I have tried to define the role of public funding clearly in relation to the commercial artistic industries, by analysing what the free market can and cannot offer. The six values I have laid out are not particularly controversial – the Arts establishment pays lip service to all of them at some time

or another. What is more controversial is that they should be thought through and developed, free of the traditional value system, to manifest the principle of art for all. Not an easy task: as Alan Plater says, 'Once a tradition is established in the UK it takes a deal of shifting'.

It entails a radical restructuring of our whole system of arts funding, through the Arts Council, local authorities, broadcasting, and other artistic agencies. This involves more than simply asserting the right principles. The few RAAs and local authorities that have attempted to promote a more accessible and wide-ranging culture have, on the whole, failed. This is because they have failed to establish a thoroughgoing *value system* to define and evaluate what they do — often by apparently abandoning any value system at all, in a mishmash of social targeting of 'underserved' groups (ethnic minorities, people with disabilities, etc.) within a framework of traditional artistic values.

The task is, unfortunately, more complicated than simply asserting a new set of artistic values. Translating these values into funding strategies requires whole new ways of thinking. What, exactly, *do* you fund or support, and how do you set about it?

I shall, in the chapters that follow, address these questions. I shall endeavour, wherever possible, to base proposals on concrete examples of work going on in Britain today. I shall be looking at a wide range of groups, organizations, and agencies all over Britain that are, in one way or another, achieving some of the objectives I have set out. Their experiences are invaluable, and I make no excuse for referring to them throughout the rest of the book.

The popular culture I will be advocating is not a 'majority' culture ruled by the lowest common denominator. This is what the free market offers. It is an exciting, innovative, varied, and enriching culture, promoted by public investment. Popular involvement needs to be nurtured and stimulated, so that it provides a thriving basis for diverse cultural developments. When William Morris, in a letter to the *Daily Chronicle* in 1883, wrote that

> No one can tell us now what form that art will take; but as it is certain that
> it will not depend on the whim of a few persons, but on the will of all, so it
> may be hoped that it will at least not lag behind the will of past ages, but will
> outdo the art of the past...

he was, with hindsight, a little too optimistic. The aim of this book is to root the spirit of this optimism within the complexities of the cultural world.

Russell A. Potter

HISTORY – SPECTACLE – RESISTANCE

EDITOR'S INTRODUCTION

RUSSELL POTTER'S ESSAY (a chapter from his book *Spectacular Vernaculars: Hip-Hop and the Politics of Postmodernism*) needs to be read alongside the Hebdige and Gilroy pieces in this anthology. In many ways it's a theoretically and methodologically simpler contribution than theirs, and in part that is because it is making the case that hip-hop has been able to mount resistance to the hegemonic culture In the States. One reason that it can make this case in terms that are much less nuanced than those that Hebdige proposes for British subcultures is that the division between white and African-American cultures goes much deeper and is much more entrenched than class (or even ethnic) divisions in the UK. Indeed race divisions are absolutely central to US past, present and future in ways that outsiders often don't see because they are routinely officially unacknowledged. The whole Gramscian vocabulary of articulation, hegemony, negotiation, appropriation breaks down in the face of this history of African-Americans in the US. And the de Certeauian analysis of tactical resistance quickly reaches its limits, as becomes clear in this essay too.

Russell Potter's essay was written in the early 1990s, and hip-hop has moved on since then. At one level it's become more mainstream; it's hybridized itself with other genres – soul, raga and so on; it's internationalized itself; it's geographized itself, with London and Southern rap becoming genres all of their own; it's reorganized itself around the dramatic transformation of the record business in the wake of digitalization and the download not least by channelling more power and autonomy to the producers who are now the kings of commercial rap music in particular; it's become more distant from the street and school cultures in which it is still nourished, and, with producers like Wu Tang's RZA

it has aestheticized itself too. But the appeal and project that Potter describes and theorizes remains in place.

Further reading: Chang 2005; Flores 2000; Gilroy 1987; Lipsitz 1994; Negus 1999; Rose 1994.

> We have seen that there is a way in which postmodernism replicates or reproduces—reinforces the logic of consumer capitalism; the more significant question is whether there is also a way in which it resists that logic. But that is a question we must leave open.
>
> Fredric Jameson

1. Tactics of Resistance

Jameson's question has been the starting point for numerous analyses of the problematics of consumer culture, most of which work from within a theoretical/ philosophical network of texts. Only a few of these analyses pay much attention to material culture, and fewer still have founded their arguments on the specific historical experience of African-Americans in contemporary culture. Yet, I would argue, the history of African-American cultures provides the most astonishing and empowering account of resistance, and of a resistance which from its earliest days has consisted of strategies for forming and sustaining a culture *against* the dominant, using materials at hand. Deprived by the Middle Passage and slavery of a unified cultural identity, African-American cultures have mobilized, via a network of localized sites and nomadic incursions, cultures of the *found*, the *revalued*, the *used*—and cultures moreover which have continually transfigured and transformed objects of *consumption* into sites of *production*.

 This remaking, this *revaluation*, is especially evident in hip-hop; through its appropriation of the detritus of "pop" culture and use of the African-American tradition of Signifyin(g), it hollows out a fallout shelter where the ostensible, "official" significance of words and pictures is made shiftable, mutable, unreliable. A television jingle for a breakfast cereal, a drum break from Booker T and the MG's, the William Tell overture, a speech by Huey Newton or Louis Farrakhan—all these are intermingled and layered together in a musical fusion that transforms and transposes, in the process constructing its own internal modes of Signifyin(g). These modes are not only constructed, but endlessly form and repeat an "open," *reconstructable* structure—since the rhythm track, the words, or the mix of Funkadelic may be sampled by digital underground, which in turn will be sampled by Craig G, which in turn will be sampled by. ... Hip-hop audiences do not, at any rate, merely *listen*—passive reception is no longer possible. Layer upon layer—one to dance to, one to think on, one to add to the din. Hip-hop itself is not merely *music* (though it is certainly that); it is a cultural recycling center, a social heterolect, a field of contest, even a form of psychological warfare. When a jeep loaded with speakers powered by a bank of car batteries blasts "Gangsta Gangsta" over the lawns of the "vanilla suburbs" of the "chocolate cities" (the phrases are George Clinton's) it is not to sell ice cream.

Of course, hip-hop itself is continually commodified by the music industry, "made safe" (it's only a song) for the masses, recycled yet again into breakfast-cereal ditties and public service announcements. Yet this commodification frequently backfires, transvalued before it even reaches the streets; commercial hip-hop jingles are re-recycled into lyrical and political metaphors, as when the Goats rap,

> I was turning, now I'm done turning other cheeks
> You had ya time to beef, now let Madd like speak
> Ya just a Honey nut, Honey Nut Cheerio
> I pour some rhymes in and now you're soggy, yo!

In tropes such as these, Signifyin(g) draws from jingles, newspaper headlines, and slogans in the same way that vernacular discourse for centuries has made use of the locally available (street names, political slogans, folkloric aphorisms)—as texts from and against which to mark a *difference*. However much fire commercial applications—such as Kool-Aid's use of Naughty by Nature's "Hip-Hop Hooray" beat—borrow from the music, the vernacular reservoir is in no danger of drying up.

Such verbal (and necessarily *cultural*) recycling may not, by itself be or be thought of as an act of resistance, of course. When a farmer in a hardscrabble rural economy reclaims parts from one tractor to repair another, or a kindergarten class makes puppets out of discarded milk cartons, these are hardly actions that trouble either the economic base or the ideology of consumer capitalism. Yet this does not at all preclude the mobilization of such acts, their deployment as tactics against the dominant modes of production and consumption. Again, De Certeau:

> A practice of the order constructed by others redistributes its space; it creates at least a certain play in that order, a space for maneuvers of unequal forces…what is there called "wisdom" (*sabedoria*) may be defined as a stratagem…innumerable ways of playing and filing the other's game (*jouer/déjouer le jeu d'autre*), that is, the space instituted by others, characterize the subtle, stubborn, resistant activity of groups which, since they lack their own space, have to get along with a network of already established forces and representations. People have to make do with what they have. In these combatants' stratagems, there is a certain art of placing one's blows.

While certain of De Certeau's observations are inapplicable here (certainly African-American cultures do not "lack their own space," though the space(s) they do occupy are themselves 'vernacular' in the sense that they are often zones abandoned by white and middle-class residents, and isolated via police curfews, bank and insurance company redlining, and even in many cases physical barricades), I think he is quite right in describing a certain tactical position which many disenfranchised classes, races, genders, and sexualities have occupied (not by choice), and have used to their collective advantage. When, in *Lola Leroy*, a trip to the market turned into an underground news broadcast, when a nineteenth-century quilting bee turned into a Women's Suffrage meeting, when an Oakland block party turned into a Black Panther rally, when a New York City power outage turned into a riot—in

all these instances, disenfranchised groups have made use of vernacular spaces and technologies. Hip-hop, armed with electricity (back in the day, pirated from a city light pole), cheap turntables, makeshift amps, and used records, was bricolage with a vengeance, and the fact that this bricolage has in its turn been commodified does not interrupt but in a crucial sense *fuels* its own appropriative resistance, rendering it both more urgent and more richly supplied with 'recyclables.'

The doubleness, the anxiety of authenticity which haunts such acts of bricolage within African-American culture—and indeed, in the wake of the cultural violence of the Middle Passage, almost *everything* has had to be constructed from fragments of both the "African" and the "American"—is in this way intensified to the "breaking" point with hip-hop. Every past commodification—of blues, of rock-n-roll, or jazz, and of hip-hop itself—haunts the musical mix, sometimes in person (a digital sample), sometimes only as a "ghost" or trace (a passing act of Signifyin(g) on some past text). It is hard to think of anything less distinctively "black" than Kraftwerk's "Trans-Europe Express," Queen's "We Will Rock You," or Frank Zappa's "Tiny Umbrellas"—yet each in its turn has been claimed by DJs and used to make distinctive and lasting contributions to hip-hop. At the same time, ample samples of distinctive moments in the history of black musical expression, from Monk to Hendrix to Bootsy Collins, have always been central to the hip-hop aesthetic. It is not what you take, it is the attitude with which you take it (and what you do *with* it) that situates hip-hop within black diasporic traditions.

In any case, hip-hop artists and audiences function in a way that obviates any one-way model of production and consumption, and form instead a high-speed dialectical network, in which producers consume, consumers produce, and today's "anotha level" is tomorrow's old school. To put it another way, hip-hop is not merely a critique of capitalism, it is a counter-formation that takes up capitalism's gaps and contradictions and creates a whole new mode, a whole new economics. It is a mode that, inevitably, exercises a huge attraction on capitalistic machines, since it seems to promise a virtually endless source of new waves on which corporate surfers can try their luck (not to mention an attractive source of income for tracks that record companies already own)—and yet it can also drown them in the tide or leave them caught in some suddenly motionless backwater. And, unlike the days when a Pat Boone cover could clock more sales than a Little Richard original, the lid is off the old musical apartheid; record companies have had no lasting success with Vanilla Ice and his ilk, and have at least been forced to deal with the artists who created the artform. There has been exploitation, to be sure, but the deal is on, and rappers who have learned the ins and outs of the business have been able to gain both financial reward and increased creative control.

This of course ups the ante in some ways, putting the burden on rappers and producers themselves to navigate the sometimes treacherous waters of self-commodification, responsible for creating the product, though far from fully enfranchised in its success. For their part, rappers make few apologies for being 'out to get theirs,' and the status-conferring power of commodities such as jewelry or expensive cars has long been verbal and visual stock-in-trade. Nonetheless, there is a strong ethic against 'selling out,' which for most rappers is not a matter of sales figures but of playing too hard for what Gang Starr calls 'mass appeal.' It is fine if a record sells well, and a large white audience *per se* does nothing to de-

authenticate a rap record. "Selling out" is about attitude, about 'hardness,' about a refusal of stasis, predictability, or music that is too easy to listen to. As Chuck D intones in "The Sticka," "Every now and then, I think people wanna hear something from us nice and easy. But there's just one thing, you see, we never ever do nothing nice and easy. We always gotta do it hard, and rough." This hardness is hard in more ways than one—for starters, it is "hard" to define. But it is a central part of the hip-hop aesthetic, this sense of "here's where I'm coming from, take it or leave it." Even rappers who have a fairly R&B-flavored, radio-friendly sound, still have that attitude; conversely, when rappers who lack attitude try to put on a "hard" exterior—such as MC Hammer—they lose the reciprocal respect of the core audience. This may or may not translate into lower sales—and for that matter, the same goes for the "hardest" hard attitude—but there is often a remarkable degree of consensus among rap's audiences. This consensus is at times powerful enough to irrevocably damage an artist's reputation, and spell doom for his or her current or future recordings, however well-promoted and bankrolled by the music industry.

The "core" of this hardcore audience, too, may be hard to define—and it is certainly not readily delimited by race. The tremendous commercial success of "gangsta" rap in 1994 showcased all angles of the 'attitude' question, as it demonstrated that the most hardcore sounds often had the broadest audience— with stellar sales for artists such as Dr. Dre, Snoop Doggy Dogg, and Ice Cube—even as the industry hurriedly launched a stream of would-be gangsta rappers, most of whom shot their way straight into the cutout bins. "Can't bury rap like you buried jazz," Ice Cube intones, and yet with his spectacular refusal of commodification, he sells two million records: "I'm platinum, bitch, and I didn't have to sell out." Far from being a mere screen or surface-level add-on, attitude ultimately demonstrates the substance of style. If 'style' were only that, the record industry ought to be able to produce it on demand, but it has not. Added to the ostentatious criticism that the music industry levels against itself in places like the pages of *Billboard* magazine (recently rife with articles denouncing gangsta rap), the industry's frustration at not being able to find its way to the street without a guide Dogg is to a large extent symptomatic of its hypocrisy, and of the economics of the spectacle in general.

It is hardly news, after all, that the same large television, film, and music industries which so readily take up the cry against 'violence' effectively increase the value of the goods they market by doing so. The industry has in fact learned a few new tricks about reverse marketing from hip-hop's *own* strategies; the more vehemently a record is denounced, the more a certain kind of authenticity attaches to it, the more fervently it is desired. Leaving aside the more well-known case of Ice-T (whose controversial *Cop Killer* record, whatever else it was, was *not* a hip-hop album), there are numerous other cases where negative publicity added measurable market value. Paris, a radical political rapper from Oakland, encountered difficulties with Time-Warner (corporate parent of Tommy Boy, to whom Paris was contracted for his second album) over the featured cut "Bush Killa" and the accompanying cover concept (which featured an armed Paris crouching in the shrubbery, ready to assassinate a smiling President Bush). Paris was released from his Tommy Boy contract and took the record to two other labels, both of which rejected it out

of fears similar to those expressed by Time-Warner's lawyers (that the song could violate laws against "threats of assault upon federal officials"). Finally, Paris released the album himself on his own Scarface Records, and despite the fact that in the course of the delays Bush was voted out of office, advance orders climbed from 75,000 to 200,000 on the strength of the publicity surrounding what was now known as a "banned" record. In the end, Paris's established reputation enabled him to profit from the attempt at censorship (and indeed set an example followed by Ice-T in his break with Time-Warner a few months later).

Of course, however one reads these events—whether one chooses to see them as the rappers *using* the industry or vice versa—there remains a more material threat in terms of what such pressure might mean for less well-established artists. KMD, for one, a group with a widely-respected debut album, saw their sophomore effort summarily dropped by Elektra after an article in *Billboard* criticized the racial politics of its cover artwork. Thanks to the acquisition of several major hip-hop labels by large corporations in the mid-'80s, only two substantial independent labels—Priority and Profile—could offer artists an alternative to corporate ways and means. The music industry's policy of acquiring successful independent labels has led to an economic re-colonization of the music, against which rappers continue to struggle; in a strictly economic sense, it is at least as important that Ice Cube's million-selling records are on Priority as that they are militant and uncompromisingly hardcore. If hip-hop wants to make a serious challenge to the forces of commodification, it needs to do more than simply make lyrical resistance; to date, few rappers have acted on this necessity with the degree of awareness of, say, Isaac Hayes or James Brown, both of whom backed their calls for musical and cultural black self-reliance with industry savvy and their own business organizations. Paris's independent release, Ice-T's move to Priority, and the formation of independently managed subsidiaries suggest that such awareness is on the rise.

Nonetheless, the large record companies do serve some of the interests of rap artists; as the only entities with sufficiently deep pockets to sustain the cost of signing numerous new acts, they bring a lot of new talent into the pool, though admittedly a lot of dross as well. Veteran rapper Chuck D describes their attitude: "what's goin' on through rap music, is, sign anybody you can find, and throw it up on the wall, and what sticks sticks, and what doesn't will slide off into obscurity." However clumsily, this process offers one route for new rappers to gain access to the market. Small labels, in contrast, can only promote a relatively small pool of artists, and if too many new acts bomb, the solvency of the whole company may be on the line. The narrow pathway to nationwide distribution is one reason why hip-hop acts often have a difficult time getting a good contract, good promotion and distribution, and getting their albums released in a timely manner. While hip-hop is finely tuned to the issues of the moment, the record industry frequently bumps back an album for months at a time in search of a more auspicious set of competing releases, a delay which in some cases reduces the impact of their message or stylistic innovations.

A still deeper difficulty underlying all of the marketing problems with hip-hop is the fact that its central black urban audience has only a fraction of the buying power of predominantly white suburban listeners. Alternatives to purchase,

whether listening to the radio, dubbing tapes for friends, or buying lower-priced bootlegs, are a necessary part of rap's urban circulation, but none of them add to sales figures, giving more affluent fans a distortedly high influence on the artists and albums the music industry considers "successful." Partly in response to this, and partly as an alternative to the clogged and crooked pipeline of major-label success, there exists a burgeoning underground hip-hop scene in many major cities, where artists with self-produced tapes are able to get club and radio play sufficient to sustain their artistic and financial needs. Underground success can sometimes lead to label contracts, but even if it does not, it is often worn as a badge of honor. To use Paul Gilroy's "wavelength" metaphor, underground rap is on a very low frequency; its sound may not be heard as widely, but it is heard more intensely, and has a powerful though often unseen influence on hip-hop as a whole.

Hip-hop's loose "posses," "families," and "crews" are another counter-hegemonic structure, one that often bridges the major-label, independent, and underground scenes. Rappers and DJs who have enjoyed major-label success frequently do everything they can to nurture new talent, and are among the biggest (and most powerful) fans of the underground scene. Whenever possible, these artists give guest spots to unsigned mentors, and in many cases they have been able to negotiate record contracts for these same mentors. It is a linked chain of community that cleaves close to the black vernacular ethos of friendship; if you are "down with" another artist, you become a link on that chain. Record companies, for their own motives, are receptive to these chains, since often their A&R departments aren't as strong with rap as with other genres of music, and this structure gives them a free connection to other potential successes. At other times, though, the posse ethos takes record labels down a dead-end street; not *everybody's* sister-in-law or second cousin is an unrecognized genius. Whatever its commercial analogues, however, this collective ethos is one of the central and recurrent features of hip-hop, and whatever disses are exchanged on the mic, almost every rap album has a page-long list of shouts and props.

Finally, it is important to note the double valences of hip-hop's overall success in the 1980s. However the process of commodification may have skewed the development of rap, rappers and DJs themselves have generally managed to stay one step ahead, setting new trends which the industry only belatedly apprehends. And, in creating the first generation of hip-hop superstars, the industry has also ended up supporting those artists' work, including their music, live shows, and their own internal industry projects. The answer to the question "who's commodifying whom?" is as dialectically unresolvable as Apache and Nikki D's "Who Freaked Who?" Many rappers see their profits as a payback from a corrupt system; Chuck D has his own model of his ties with Sony Music, saying "I try to do my best to stick 'em. I say, well, they're the ones to stick up more than anybody"—or as Sir Mix-a-Lot puts it, "I'm the pimp, and the ho's the system."

2. History as Resistance

In his pioneering study of black culture in the United Kingdom, *There Ain't No Black in the Union Jack*, Paul Gilroy sets forth three key themes around which the resistances mobilized by black expressive culture have been deployed: a critique of work, a critique of the state, and

> A passionate belief in the importance of history and the historical process. This is presented as an antidote to the suppression of historical and temporal perception under late capitalism.

This third point is, I think, crucial; in the increasingly amnesiac world of bourgeois American culture, history itself is, in potential at least, a form of resistance. Much of suburban America presents a landscape singularly devoid of history; everything is new or at least remodeled. The educational process does little to foreground historical consciousness; for the most part, the past is presented as an arbitrary series of dates and events, with little evident relevance to the present. Even and especially when it comes to contemporary events, suburbia retains a thick buffer of reference; the events in the inner cities that replay themselves over television screens are as remote—perhaps more remote—than the Vietnam war. What little use capitalism has for history is by way of connotative associations with isolated historical synecdoches: Crazy Horse Malt Liquor, Ajax detergent, King Arthur flour.

In stark contrast to this de-historicization, this leveling of the past that bourgeois consumers habitually ingest, hip-hop, as rapper Michael T. Miller insists, is "a vehicle for the telling of history," and more: a vehicle for telling the repressed and suppressed histories of African-American culture. The central histories at stake, inevitably are recent—the worsening situation in the cities under Reagan's funding cuts, crime, drugs, police brutality, and U.S. militarism abroad—but they also extend b(l)ackwards through the years of hope and frustration in the '60s and '70s (Paris's "The Days of Old") back to the experience of slavery and the Middle Passage (Public Enemy's "Can't Truss It"). And, unlike high school textbooks that alienate historical events from their cultural contexts, the urban griots of hip-hop offer visceral, first-person histories, complete with sound effects, street dialogue, and samples that re-invoke the affective *presence* of the past. As the "tour guide" voiceover on Ice Cube's "How to Survive in South Central" puts it, "Ain't nothin' like the shit you saw on TV!"

Finally, with all the other histories it re-tales, hip-hop offers its *own* history, whether through didactic raps such as Ice-T's "Body Rock" or Subsonic 2's "Unsung Heroes of Hip Hop" or via the ongoing and infinitely extendable dialectic of "diss" and "payback" tracks (e.g., the battle between Marley Marl's Juice Crew and Boogie Down Productions, which began with "The Bridge" and BDP's "The Bridge is Over" in 1986 and continued through numerous personal paybacks ranging from Roxanne Shanté's "Have a Nice Day" (1987) to MC Lyte's "Steady Fuckin'" (1993). Even in a track not explicitly identified as a "payback" or "answer" rap, the numerous instances of Signifyin(g) on previous rappers' turns of phrase, combined with the verbal "shouts" thrown out to peers and heroes, continue to

build a complex historical web of influence, confluence, and effluence; it is not so much that hip-hop *tells* history, it's that it is history; drop the needle anywhere and you will find lyrical vectors to every other site on the hip-hop map.

The points of reference in hip-hop's histories, however, as often musical than verbal, and while the vast bulk of samples date to the '70s, many rappers have reached back to such '60s funk and R&B pioneers as the Meters, Book T. and the MG's, Rufus Thomas, and Otis Redding; the rapper Laquan even reaches back to 1937 to sample the opening line of a blues by the legendary Robert Johnson. The recycling of these samples resituates them in a postmodern milieu even as it invokes the past; many hip-hop DJs pick a sample precisely *because* it is obscure, though others are just as ready to sample a trademark riff (Naughty by Nature's OPP for instance, which is built around substantial samples from the Jackson Five's "ABC"). In many cases, DJ raids upon the music of previous generations reach back well before their own birthdates, such that their own search for sounds becomes a kind of genealogical *research*; as a fringe benefit, many older listeners may first be drawn to a rap by the familiarity of the sampled material.

To see just how revolutionary these continuing raids upon the sound archives of black history are, one has only to listen to a few hours of heavily-formatted "oldies" programming on any of the hundreds of stations across the country that support it. On "oldies" radio, James Brown's 1960's (or George Clinton's 1970's) are nowhere to be heard; instead, listeners are inundated with a top-ten "pop" chart wave, over which they can surf safely without wondering what they are missing. Garry and the Pacemakers, the Beatles, the Byrds, the Hollies, the Four Seasons, Crosby, Stills, and Nash, James Taylor, Jefferson Airplane—the "oldies" playlists falsify not only the aural archive of the past they pretend to represent, but even the actual sounds of pop radio in the decades they "recreate"; from the mid-'60s through to the dawn of Album-Oriented Rock in the mid-'70s, AM radio was a multicultural crossroads—at least when compared to '80s and '90s format-driven radio.

In the face of this homogenized, safety-sealed version of history, hip-hop brings back the musical past that many white and middle-class listeners have conveniently forgotten. And, to the soundtrack of this historical incursion, it adds powerful beats and rhymes that draw listeners into the Signified situation, pushing the limits of connotation to make language come undone in a zipless fuck of aural frenzy:

> Step to this, as the derelict re-animates
> No jim hat as my mouth ejaculates
> I states mumbo, I speaks jumbo
> Phonetics are a phonograph of rhyme, ya petro…
>
> 3rd Bass, "Derelicts of Dialect"

Reanimating "dead" sounds, bringing repressed histories back to vivid life, hip-hop sustains a profound historical consciousness, all of which serves to frame contemporary struggles within a continuum of African-American history.

Look at an inner city hood—South Bronx, South Side of Chicago, South Central L.A.—and you'll see a place marked—*pockmarked*—with history. Vacant warehouses and factories testify to a lost industrial base and the shattered dream

of the "great migration" north and west; hole-filled streets testify to a declining tax base accelerated by bank and insurance company redlining. At the same time, liquor stores and convenience stores at every corner testify to yet another generation of immigrants who are enjoying a slice of the American pie that many African-Americans are still denied; in this context, Ice Cube's threat to burn Korean grocery stores "to a cinder" becomes suddenly comprehensible. Overhead, police helicopters flash the streets with searchlights, giving the residents of broken-down bungalows and row houses a free soundtrack to *Apocalypse Now* (minus the Wagner). The underlying logic is clear enough: *history* is a burden to be borne; those who can afford to have already dispensed with theirs.

All this leads up to the question of the contemporary, with which, despite its deep historical roots, hip-hop is most concerned. Again, there exists a kind of media apartheid; black issues, black interests, black perspectives are hard to find on cable TV (outside of BET and a few shows on Fox); the news media pander to white paranoia and present the inner cities as a landscape of criminals, carjackers, and drug fiends, to which the comfortable residents of Simi Valley (or Westchester county, or any other suburb of a large urban area) respond by voting for more police revenues and stiffer jail sentences (this despite the fact the mandatory prison terms (most for drug-related offenses) have made the United States the most incarcerating nation on the planet, both per capita and in overall numbers). Against this protected bourgeois enclave, [...] hip-hop offers a different drama, one in which the ghetto, like a chaos-ridden post-colonial nation (Somalia, anyone?) is under siege by police that act more like an occupying army than "peace officers," in which life moves at a literally "breakneck" pace ("with cocaine, my success came speedy," raps Ice-T), roaring down the streets in a low rider, equally on the lookout for police and other gangs.

If there's a contemporary analogy, it may well be Northern Ireland. Just as Ulster Protestants and Ulster Catholics, though inhabiting the same "nation," have different histories, different remembered grudges, different holy days, different neighborhoods, and different rationales for their paramilitary forces, inner-city blacks and Latinos inhabit a concrete and psychic territory that is less familiar to many white Americans than the surface of the moon. Hip-hop, at least, offers two revolutionary possibilities: (1) by getting inner-city kids to see the cost of endless gang warfare and black-on-black crime, they can unite them in opposition to the larger power-structures of racism; and (2) insofar as young white listeners come to hip-hop looking for an analog to their own alienation, these listeners will get a dose of "ghetto consciousness" that will give them a far better understanding of the politics of race and class than many college educations.

"The race that controls the past, controls the living present," declaims a voice (Louis Farrakhan's?) at the beginning of Public Enemy's *Fear of a Black Planet*, and true to this insight, hip-hop fights its battle on both fronts, making insurrections against both the homogenized past and the safety-coated present. Even in tracks that don't contain obvious political references, the recursion of sampled sounds and the linguistic slippage of Signifyin(g) at least *disorient* the listener, forcing her or him to recheck their "bearings," just as the heavy bass and booming drums have the often-underestimated virtue of *irritating* those who don't want to hear the message they carry. And, on hip-hop's home territories, the music gives a

soundtrack to the everyday ups and downs of life, even though in the inner cities random killings, police raids, and poverty *are* everyday.

3. The hip-hop continuum: refabricating the prefabricated

Given the continual struggle against commodification that hip-hop has had to fight, how has it managed to endure? One answer, albeit a tentative one, is offered by Hal Foster in his collection, *Recodings: Art, Spectacle, Cultural Politics*. Unlike so many art critics, Foster is well attuned to cultural and political issues, and he departs from other critics of modernism in finding political valences where others have seen only a *flight* from the political. Foster takes a cold hard look at bourgeois culture's tendencies towards appropriation and recuperation of subcultures. Foster knows better than David Samuels the implication of "violent black youth" being transformed from a threat into a commodity; since bourgeois culture craves difference, appropriating subcultural forms and turning them into commodities solves two problems in one blow. For example, as Dick Hebdige has delineated in *Subculture*, while "punk" in the United Kingdom was, for a brief shining moment, a thoroughgoing high-voltage attack on everything respectable (in becoming which, of course, it made appropriations of its own), it was not long before studded leather jackets, dark glasses, and bleached and spiked hair made a miraculous journey across the Atlantic, where, stripped of their cultural significance, they neatly took the place of faded jeans, rock t-shirts, and ponytails as handy-dandy markers for American youth in search of a quick fix of rebellion.

For Samuels, the popularity of rap is nothing but a rerun of this appropriative commodification—his problem was he never saw the sequel. Foster, along with his awareness of the rapidity with which commodity culture dismantles and re-assembles subcultural signs, sees the flipside of such a move: robbing the mythmakers. Whether performed in the name of "recovering" the "original" context of the commodified sign, or "to break apart the abstracted, mythical sign and…reinscribe it in a countermythical system," such reappropriation emerges as not merely *a*, but *the* tactic of resistance. Hebdige notes the appropriations via which punk invented itself—from glam-rock, the mods, and the more militant West Indian club scenes—and Foster acknowledges the power of subsequent re-reappropriations, such as those via which elements of punk style have resurfaced again and again (even forming a central element in the early Def Jam recordings of artists such as the Beastie Boys and Public Enemy).

Hip-hop recognizes what Samuels does not: there is no "unfabricated" community, no "essential" blackness outside of the continual, *tactical* enactment of blackness. When Chuck D raps about brothers going "under color," he's Signifyin(g) a move *beyond* the merely under*cover*; he's talking about the erasure of identity. Whereas the ideology of bourgeois consumerism takes "black" as a quality that, while always symbolically dislocated (by the spectacular "black underclass") from middle-class status, remains intact despite the (all too rare) achievement of status (e.g., *The Cosby Show*), Chuck D insists that blackness is something that has to be *made*, whose making cannot be negotiated without taking on the ideologies

and myths of race. And this is not because there is no authentic "blackness," but rather because within the African-American dialectics of identity that hip-hop moves, authenticity and constructivism are not antagonistic but mutually resonant. Black Americans have always had to *make something out of nothing*, to make use of materials *at hand;* they have not been as heavily influenced by the ideology of the "lone creative genius" for whom "originality" is always such an obsession. A look at the acknowledgments on a typical hip-hop album demonstrates a collectivity that is larger than (and indeed, sustains) the specific agonistic stances of one or another rapper or DJ. In a collective work such as hip-hop, there is in a sense no singular "author," however many instigators of discourse there may be; rather, there is a cast of characters: Flavor Flav and Chuck D, Humpty-Hump and Shock-G, Professor X and Professor Griff. None of these would be substantial without their costumes, without their enactment: Flavor Flav's clocks, Humpty's nose, or Professor X's ankh-emblazoned leather hat. Yet this does not at all prevent these "stagings" from being "serious" (another rather Eurocentric standard); despite the fact that his big nose is plastic, Humpty can still cut a rap ("No Nose Job") about how cosmetic surgery is used to erase blackness:

> They say the whiter, the righter; yeah, well that's tough
> Sometimes I think that I'm not black enough

Hip-hop *stages* the difference of blackness, and its staging is both the Signifyin(g) of its constructedness *and* the site of its production of the *authentic*.

In this staging, hip-hop follows in the tradition of the blues, jazz, and jump blues ("rock-n-roll"), exchanging the unreal "real" for the "real" production of the constructed. From the Red Hot Jazz Babies to Sun Ra's Space Arkestra, from Cab Calloway to George Clinton, this staging has always had its costumes, its lingo, its poses. And, as with these other artforms, the insurrectionary aspect of this "act" has been that it has forced Euro-American culture to take stock of its own costumes, lingo, and poses—that is, to see "whiteness" as a quality; it is not surprising, in this light, that many young white kids in this century have turned to black culture to get culture, to search for identities. The logic of the "same"—of the white, middle-class world as a norm which never has to account for itself—is called violently into question by the Signification of difference, and this Signification has never been played as far to (and beyond) the limit as it has been by hip-hop culture. Indeed, part of the attraction of hip-hop for many white fans is precisely that it brings difference and identity back into play, while for black fans there can be the compensatory sense that blackness is restored to the apex of the cultural pyramid. Critiques of the historical 'errors' or conflation of Afrocentric rappers are beside the point, as the mythic history at stake here is—just as with its Eurocentric counterparts—not an effect of "actual" history (as if such history could be wholly recovered) but an imaginary genealogy whose point is a sense of cultural continuity, unity, and pride.

For, as Paul Gilroy makes compellingly clear, 'whiteness' and 'blackness' have both been *constructed*, though often via polarizing dialectics that have justified injustice and rationalized racism. If people are to recover a sense of identity that is both usable and relevant, they must of course know and understand this bitter

history, but they must also gain the license to forge cultural links and empowering narratives. England, after all, had no sound historical evidence upon which to hook its genealogy to Aeneas and the martyred city of Troy, and yet it did so—and gave itself a mythology otherwise lost in the collision of its Saxon and Norman pasts. Inhabitants of black diasporic cultures have repeatedly created mythic pasts and Utopian futures, drawing on African, Judaic, Islamic, Christian, and secular histories, and to try to invalidate such creations by an appeal to historical accuracy is wildly hypocritical. At the same time, critics such as Gilroy are right, I believe, in criticizing versions of Pan-African particularism which fall into the same error as the most disreputable Eurocentrism—that of assuming that some 'pure' identity exists which could be assumed *without* taking account of its imbrication within other cultural histories and myths, from which, indeed, so much richness and complexity derives.

The Afrocentrism of hip-hop, in any case, should not be overly generalized; many rappers, even when adopting African names, dress, and icons, are as conscious of the *construction* of this identity as any '70s funk band suiting up in its bell-bottomed 'space cowboy' outfits. Others, while they may joke at times about their dress, are absolutely serious in their call for a separatist black nationalist order. For these Afrocentric rappers, particularly X-Clan, the use of African beats and Egyptian headgear, constructed or not, are signs of a self-conscious 'step blackwards' that picks up where Garveyism and the Nation of Islam left off; "African" consciousness forms the ethical center of these rappers' rhyming practice. Hip-hop reflects the whole range of Afrocentrisms, ranging from the didactically particularist to the playfully constructivist, and indeed includes rappers whose message partakes of other paradigms altogether, such as KRS-One's tactically-modified humanism or Michael Franti's eschewal of the roped-off models of culture implicit in some strains of identity politics. There is even, in the House of Pain, a historical reclamation of the (no less diasporically conflicted) Irish-American identity as a site of resistance.

Yet if there is no pure blackness, does that mean, as Michel Foucault claimed, that there is 'no *soul* of (or *in*) revolt'? If postmodernity reconfigures identity, is resisting consumption tantamount to shattering images in an infinite house of mirrors? Not necessarily. The vernacular conjunction of forces that enabled the uprisings in LA, (whether in 1965 or 1992) shattered more than glass, and the cultural "noise" of hip-hop has done more than simply given Tipper Gore an earache. In this 'society of the spectacle,' as Guy Debord has dubbed it, cultural myths rise and fall in an almost operatic struggle upon the electronic stages of television, radio, and compact disks. The myth of the 'concerned' liberal white goes toe-to-toe with hip-hop's carnivalesque mirroring of his/her own stereotypes; the Goats' "Uncle Scam" runs drug cartels, wars, and drive-by shootings like booths at an amusement park. If images of Willie Horton scared middle-class Americans into voting for George Bush, the images and words of Ice Cube, putting his gat in the mouth of Uncle Sam and shooting "'til his brains hang out'" will scare them more, and this fear in turn will inspire laughter (as when Cube, on *Predator*, samples the voice of a young white girl in a talkshow audience and loops the results "I'm scared...I'm scared...I'm scared").

Exploding myths via exaggeration, hyperbole, and the carnivalesque may not be the strategy of sober-minded politicians, but in the hands of rappers it

is a powerful tool; Queen Latifah isn't kidding when she says M.C. stands for "microphone commando." And, in a time of the stagnation and indeed the reversal of civil rights and economic gains won during the struggles of the 1960s, even progressive sober-minded political agendas sound like the ditherings of pre-'60s "Uncle Toms," as the rhetoric of Malcolm X is suddenly contemporary again. If white kids, in Ice Cube's phrase, "eavesdrop" on hip-hop, the message they get will not only dramatize this scandalous history (as invisible to many suburban whites as the initial struggles of the SCLC in the deep south), but call on them to declare, as in the old union song, which side they are on. Ice-T, in his caustic prophesy "Race War," predicts that in the coming struggle a lot of white kids will be "down with the Africans," just as many blacks (he implies) will be more loyal to class position than to race ("down with the Republicans").

If consumer capitalism were to succeed in making even these kinds of dire warnings into titillating products on a par with adventure movies (and indeed, the increasing isolation of white and black worlds makes such confusion likely), then indeed the grounds for resistance would seem slight. Yet the African-American experience is rich with occasions where the self-conscious *return* to roots—whether blues tonality, West African rhythms, or the oral tradition of the Dozens, has marked a successful revolt in both stylistic and cultural terms. Indeed, were it not for the success of these revolts (each of which has taken place during a time of social and economic setbacks), there would be no distinct African-American culture alive today. In a symbolic reopening of the old assimilationist/separatist dichotomy, hip-hop demonstrates not only that an insistence on *difference* is both vital and sustainable, but that perhaps the agonistic tension between spectacular subjectivities is precisely the psychic engine needed to create and maintain difference against a hegemonic consumer culture.

There are hazards here—among them the romanticization of underclass status and the all-too-readily-granted *symbolic* "superiority" that have again and again marked white responses to African-American culture—but also a recognition. A recognition that in a crucial sense, the old "American dream" of an *undifferentiated* society never was and never will be, that aesthetics never breathed apart from questions of power, that in fact all of us, whoever "we" are, are situated by and within African-American culture—this is the recognition which hip-hop militantly throws back "in your face," and which necessarily works to undermine the strategies with which whites have distanced themselves from the urgent problems of the inner cities. It is no coincidence that in 1991, the song "From a Distance," a pseudo-folkie love anthem, waxed lyrical about how peaceful and harmonious everything looks "from a distance"; what went unsaid was that the distant eye of this song was implicitly *white*, and that the problems that passed before its pathetic gaze were those of urban America, postcolonial Africa, and the Middle East (where a new crusade against the Infidel was fanning nationalist sentiments in the United States).

At that same historical moment, rappers, reflecting urban discontent and a lack of sympathy with Bush's "Desert Storm," took a far more oppositional series of tactics. Public Enemy linked the experience of the Middle Passage to the "holocaust still goin' on" in the cities with "Can't Truss It," and produced a guerilla song and video staging the assassination of Arizona Governor Edward

Meecham (an unreformed racist and opponent of the Martin Luther King, Jr. holiday). The Disposable Heroes of Hip-Hoprisy attacked Bush's Gulf war policy with "The Winter of the Long Hot Summer," as well as corporate consumer culture in "Television: Drug of a Nation." Not to be outdone, Ice Cube delivered his sharpest raps against the U.S. government on his album *Death Certificate*, whose cover featured the body of "Uncle Sam" laid out in a morgue with a toe tag, and whose lyrics inveighed against Bush's patriotic rhetoric:

> Now in 91, he wanna tax me
> I remember, the son of a bitch used ta ax me
> And hang me by a rope till my neck snap
> Now the sneaky motherfucka wanna ban rap
> And put me under dirt or concrete
> But I can see through a white sheet
> Cos you the devil in drag;
> You can burn your cross, well I'll burn your flag
> Try to gimme the HIV, so I can stop makin' babies like me
> And you're givin' dope to my people, chump
> Just wait till we get over that hump
> Cos yo ass is grass, cos Imma blas'
> Can't bury rap like you buried jazz
> Cos we stopped bein' whores, stopped doin' floors
> So bitch you can fight your own wars
>
> So if you see a man in red, white, an' blue
> Bein' chased by the Lench Mob crew
> It's a man who deserves to buckle
> I wanna kill Sam cos he ain't my motherfuckin' uncle...

Not since the heady days of the late '60s and early '70s, when cuts like Edwin Starr's "War," the Last Poet's "White Man's Got a God Complex," and the James Brown's "Funky President" provided the soundtrack for the political trials of the Black Panthers, had such a potent dose of lyrical dynamite been tossed at the feet of the U.S. government. Many African-Americans, indeed, perceived the situation in 1991 as a war on two fronts: against Iraq in the Persian Gulf (and the U.S. attacks on civilian areas in an Islamic country touched a nerve with many inside and outside the 5% nation) and against black youth in the inner cities (the 'Nam-like overtones of the constant sound of helicopters was not lost on a South Central Los Angeles which was home to many black veterans).

Eric B. and Rakim dramatize this sense of the ghetto as a war zone in their 1992 track "Casualties of War":

> Casualties of war, as I approach the barricade
> Where is the enemy, who do I invade?

The scene here could be '65, '68, or '91; the barricade could be in Watts, Saigon, Paris, or Basra. The political dislocation of the African-American, called upon for

combat to defend the very freedoms that were eroding at home, was dramatized by the cases of black veterans of Desert Storm, many of whom returned home only to face greater violence than that of the "war," wounded in drive-by shootings, or (in one much publicized case) killed in what at first appeared to be random gunfire.

Shortly after the media-hyped "victory" in the Persian Gulf, the urgencies of race overtook the spectacle of American militarism abroad. The brutal beating of black motorist Rodney King by a number of L.A.P.D. officers had stirred outrage when it was first televised, and King's name had already been added to hip-hop recitations of the victims of racist violence; what distinguished King's case was, as an A.C.L.U. spokesperson remarked, not that it happened, but that it was *taped*. For years, arguably ever since Grandmaster Flash's "The Message" in 1982, hip-hop had spoken of the increasing tensions in the cities, where opportunities were shrinking and the "war on drugs" was in effect a "war" on black youth. There was apprehension as the verdict approached early in 1992, and in the uprising that followed the not guilty verdicts, the old Panther slogan (revived by rappers) once again sounded loud and clear: "we've come for what's ours." The LA uprising, in fact, was the first multicultural urban revolt of its kind, as a substantial number of the participants were Latinos—and indeed, west coast rap had for some years reflected the new ethnic mix via the careers of rappers such as Kid Frost (the 'Hispanic Causing Panic') and Mellow Man Ace (the 'brother with two tongues'). This was a revolt foretold by hip-hop, fueled by its rhetoric, and which in its turn fueled the radical agenda and symbolic intensity of the raps that have followed in its wake. From Ice-T and Black Uhuru's "Tip of the Iceberg," which made a groundbreaking alliance between old-school political reggae (as opposed to dancehall) and hip-hop, to Ice Cube's album *The Predator*, which featured dialogue of Ice Cube going door-to-door killing off members of the L.A.P.D. jury along with the officers they acquitted, the hip-hop response has been one of redoubled rage, and the rage is still smoldering; as Ice-T puts it "the fire is out but the coals are still hot."

Could one quantify the degree to which hip-hop has been responsible for a new black radicalism, and the extent to which this radicalism played a role in the LA uprising? In this complex and contradictory world of American race relations, there will never be a revolt-o-meter fine-tuned enough, but at the very least, hip-hop has served as a means of *communicating* political solidarity, not only in the United States but in the Caribbean and the United Kingdom as well. As Paul Gilroy has amply documented, the 'underground' dancehall scene in West Indian neighborhoods in England for years served as part of a tripartite sounding-board for the African diaspora; American R&B traveled to West Kingston and became Ska; Ska traveled to England and gave rise to Two Tone, which in turn traveled back to Jamaica and the United States. In these cultural nomadisms, not only the music but the critique of racism, or colonialism, and (implicitly) of capitalism (especially in the United Kingdom, where pirate radio and blank-label pressings created a truly underground scene) made its way through the diaspora, linking communities whose common interests might otherwise not have come together. Insofar as a perceived common set of interests is a first step towards a more revolutionary consciousness, hip-hop has been a crucial factor in shaping the cultural landscape of resistance.

And yet it has done more: the 1980s were a critical decade in U.S. race relations, but the worst symptoms of the crisis were hidden from the view of middle- and upper-class whites. The media, treating drugs and crime as *causes* rather than *symptoms* of urban blight, combined with Reagan-Bush rhetoric to recast black (and Hispanic) urban America as a land of pushers and killers; white television viewers saw only a parade of such characters (often in arrests every bit as staged as a Broadway musical—as when L.A.P.D. Chief Gates invited Nancy Reagan and a cadre of local and national TV cameras over for some fruit salad and a tour of a "coke house" bust). This spectacle—the Willie-Hortonizing of black America—brought calls for longer prison terms, more cops, and a mysterious silence on the part of many white political activists as to the increasing violations of civil rights. The older generation of black leaders looked impotent; even as the rights they fought for were eroded by the Reagan court, the economic ills of their communities were worsened still more by the sixty percent cutback in urban aid under Reagan. Of the senior generation, only Jesse Jackson retained credibility (and never more than among rappers; Melle Mell's "Jesse!" has a pioneering place among political raps). Yet after Jackson's rebuff in 1988 from the new Democratic "centrists," it became clear that the Democrats, too, were joining in the rush to the right. For young African-Americans and Hispanic Americans living in the tattered ruins of the inner cities, 1988 was the first of a series of "long hot summers," and the urgency and militancy of much political rap increased proportionately at just this time—most notably, 1988 was the year that a loose agglomeration of Los Angeles hip-hoppers once known as World Class Wrekin' Cru re-launched their career as N.W.A. (Niggaz wit' Attitude) and caught the ears of white and blacks alike off guard with the no-holds-barred militancy of "Fuck tha Police."

In a spectacular society, filled with flower-waving cheerleaders at Reagan election rallies and syrupy video sunsets that could advertise the Republican Party as easily as they could "breakfast at McDonald's," hip-hop made spectacular resistances. Its strategy has been that it is just as effective to pump up the volume, to magnify (and distort) the image of white America's fears as it is to displace them with accurate descriptions of urban reality (though these two strategies often work together, and the strategic mix varies widely from artist to artist). Yet the fact that rappers play with these stereotypes in a way that has a certain tactical effect of white listeners and viewers is not evidence that hip-hop has "sold out" to white audiences. Indeed, only a privileged white audience could conceive of the notion that the spectacle was all being done for their benefit. On the contrary, for many rappers the primary function of this spectacularized Signifyin(g) is to reclaim via a combination of collective anger (and laughter) the inheritance of *difference* that lies at the center of African-American self-knowledge. How to know oneself without measuring with the oppressor's ruler? How to maintain dignity and a sense of historical place in the face of the pressures of assimilation? In large part, hip-hop, like jazz and the blues before it, serves this kind of inner function at least as much as it serves to produce an agenda for others. In the funhouse reflections of hip-hop, as through black comedy such as *In Living Color* or the monologues of Paul Mooney, there is compensation for the distortions perpetrated by white stereotypes, and a whole school of rappers—Digital Underground, the Pharcyde, DEL the Funkie Homosapien, and Funkdoobiest—mix funky bass lines with comedy

skits, wild rhymes, and "in" jokes to produce a vernacular funk that carries on the tradition started by George Clinton in the early '70s.

This P-Funk (as in Parliament) school, as it is often called, makes some political points, but most of its energy is directed inward; its central locus is in the BASS register, and its wordplay and images make verbal art out of scatological references. After all, "funk" still carries its olfactory connotations, and what can be "funkier" than a "booty"? Similarly, the so-called underground school makes a virtue of its anti-commercialism and seeks to sustain ghetto audiences without any concessions to radio airplay, buppies, or heavy dance beats. On one level, "underground" connotes uncommercial, even as it invokes the underground railway of slavery days. Yet there are also humorous metaphorical linkages: Das EFX raps about hangin' around in "da sewer" and filmed a segment of *Yo! MTV Raps!* from an underground tunnel in New York City; they also broke the first big rap on diarrhea ("Looseys"). The magazine *Rap Pages* recently did a nationwide survey of the "underground," and documented the increasing movement towards an inward-facing, funky, and resolutely hardcore hip-hop scene—a scene that already marks the beginnings of another bop-like turn away from commodification.

The underground sound is certainly one reason why, despite the commercialization of hip-hop, new artists and new sounds continue to evolve completely outside the industry's official A&R proving grounds. Hardcore rap is another; while associated in the popular press with a monolithic "gangsta" outlook, hardcore rappers in fact have laid claim to a wide variety of ground, ranging from Public Enemy's almost didactic political and social raps to Big Daddy Kane's lyrical fantasies of himself as a super-sexed Luther Vandross, to Dr. Dre's threatening yet laid-back paybacks against his former hip-hop allies. Jazz-influenced (and influencing) rap, touted in 1993 with Guru's *Jazzmatazz* and Greg Osby's *3-D Lifestyles*, has in face been around for a while, at least since the Dream Warriors' debut back in 1990, and continues to grow both via live bands (e.g., the Brand New Heavies, or Freestyle Fellowship's in-house "Underground Railway Band") and samples (the digable planets' use of Sonny Rollins). And, all along, rap's broadest influences have been on dance music, not only with "New Jack Swing" but with a new generation of musicians who have crossed over from R&B *into* hip-hop, such as Mary J. Blige. It is no longer possible to take the diverse agglomeration of music that falls under "hip-hop" and make sweeping statements, whether of praise or condemnation.

Media and public spheres

Stuart Hall

ENCODING, DECODING

EDITOR'S INTRODUCTION

STUART HALL'S INFLUENTIAL ESSAY offers a densely theoretical account of how messages are produced and disseminated, referring particularly to television. He suggests a four-stage theory of communication: production, circulation, use (which here he calls distribution or consumption) and reproduction. For him each stage is 'relatively autonomous' from the others. This means that the coding of a message *does* control its reception but not transparently – each stage has its own determining limits and possibilities. The concept of relative autonomy allows him to argue that polysemy is not the same as pluralism: messages are not open to any interpretation or use whatsoever – just because each stage in the circuit limits possibilities in the next.

In actual social existence, Hall goes on to argue, messages have a 'complex structure of dominance' because at each stage they are 'imprinted' by institutional power-relations. Furthermore, a message can only be received at a particular stage if it is recognizable or appropriate – though there is space for a message to be used or understood at least somewhat against the grain. This means that power-relations at the point of production, for example, will loosely fit those at the point of consumption. In this way, the communication circuit is also a circuit which reproduces a pattern of domination.

This analysis allows Hall to insert a semiotic paradigm into a social framework, clearing the way both for further textualist and ethnographic work. His essay has been particularly important as a basis on which fieldwork like David Morley's has proceeded.

Further reading: Hall 1977 and 1980; Morley 1980 and 1989.

Traditionally, mass-communications research has conceptualised the process of communication in terms of a circulation circuit or loop. This model has been criticised for its linearity — sender/message/receiver — for its concentration on the level of message exchange and for the absence of a structured conception of the different moments as a complex structure of relations. But it is also possible (and useful) to think of this process in terms of a structure produced and sustained through the articulation of linked but distinctive moments — production, circulation, distribution, consumption, reproduction. This would be to think of the process as a 'complex structure in dominance', sustained through the articulation of connected practices, each of which, however, retains its distinctiveness and has its own specific modality, its own forms and conditions of existence.

The 'object' of these practices is meanings and messages in the form of sign-vehicles of a specific kind organised, like any form of communication or language, through the operation of codes within the syntagmatic chain of a discourse. The apparatuses, relations and practices of production thus issue, at a certain moment (the moment of 'production/circulation') in the form of symbolic vehicles constituted within the rules of 'language'. It is in this discursive form that the circulation of the 'product' takes place. The process thus requires, at the production end, its material instruments — its 'means' — as well as its own sets of social (production) relations — the organisation and combination of practices within media apparatuses. But it is in the *discursive* form that the circulation of the product takes place, as well as its distribution to different audiences. Once accomplished, the discourse must then be translated — transformed, again — into social practices if the circuit is to be both completed and effective. If no 'meaning' is taken, there can be no 'consumption'. If the meaning is not articulated in practice, it has no effect. The value of this approach is that while each of the moments, in articulation, is necessary to the circuit as a whole, no one moment can fully guarantee the next moment with which it is articulated. Since each has its specific modality and conditions of existence, each can constitute its own break or interruption of the 'passage of forms' on whose continuity the flow of effective production (that is, 'reproduction') depends.

Thus while in no way wanting to limit research to 'following only those leads which emerge from content analysis', we must recognise that the discursive form of the message has a privileged position in the communicative exchange (from the viewpoint of circulation), and that the moments of 'encoding' and 'decoding', though only 'relatively autonomous' in relation to the communicative process as a whole, are *determinate* moments. A 'raw' historical event cannot, *in that form*, be transmitted by, say, a television newscast. Events can only be signified within the aural-visual forms of the televisual discourse. In the moment when a historical event passes under the sign of discourse, it is subject to all the complex formal 'rules' by which language signifies. To put it paradoxically, the event must become a 'story' before it can become a *communicative event*. In that moment the formal sub-rules of discourse are 'in dominance', without, of course, subordinating out of existence the historical event so signified, the social relations in which the rules are set to work or the social and political consequences of the event having been signified in this way. The 'message form' is the necessary 'form of appearance' of the event in its passage from source to receiver. Thus the transposition into and

out of the 'message form' (or the mode of symbolic exchange) is not a random 'moment', which we can take up or ignore at our convenience. The 'message form' is a determinate moment; though, at another level, it comprises the surface movements of the communications system only and requires, at another stage, to be integrated into the social relations of the communication process as a whole, of which it forms only a part.

From this general perspective, we may crudely characterise the television communicative process as follows. The institutional structures of broadcasting, with their practices and networks of production, their organised relations and technical infrastructures, are required to produce a programme. Production, here, constructs the message. In one sense, then, the circuit begins here. Of course, the production process is not without its 'discursive' aspect: it, too, is framed throughout by meanings and ideas: knowledge-in-use concerning the routines of production, historically defined technical skills, professional ideologies, institutional knowledge, definitions and assumptions, assumptions about the audience and so on frame the constitution of the programme through this production structure. Further, though the production structures of television originate the television discourse, they do not constitute a closed system. They draw topics, treatments, agendas, events, personnel, images of the audience, 'definitions of the situation' from other sources and other discursive formations within the wider socio-cultural and political structure of which they are a differentiated part. Philip Elliott has expressed this point succinctly, within a more traditional framework, in his discussion of the way in which the audience is both the 'source' and the 'receiver' of the television message. Thus – to borrow Marx's terms – circulation and reception are, indeed, 'moments' of the production process in television and are reincorporated, via a number of skewed and structured 'feedbacks', into the production process itself. The consumption or reception of the television message is thus also itself a 'moment' of the production process in its larger sense, though the latter is 'predominant' because it is the 'point of departure for the realisation' of the message. Production and reception of the television message are not, therefore, identical, but they are related: they are differentiated moments within the totality formed by the social relations of the communicative process as a whole.

At a certain point, however, the broadcasting structures must yield encoded messages in the form of a meaningful discourse. The institution–societal relations of production must pass under the discursive rules of language for its product to be 'realised'. This initiates a further differentiated moment, in which the formal rules of discourse and language are in dominance. Before this message can have an 'effect' (however defined), satisfy a 'need' or be put to a 'use', it must first be appropriated as a meaningful discourse and be meaningfully decoded. It is this set of decoded meanings which 'have an effect', influence, entertain, instruct or persuade, with very complex perceptual, cognitive, emotional, ideological or behavioural consequences. In a 'determinate' moment the structure employs a code and yields a 'message': at another determinate moment the 'message', via its decodings, issues into the structure of social practices. We are now fully aware that this re-entry into the practices of audience reception and 'use' cannot be understood in simple behavioural terms. The typical processes identified in positivistic research on isolated elements – effects, uses, 'gratifications' – are themselves framed by structures of

understanding, as well as being produced by social and economic relations, which shape their 'realisation' at the reception end of the chain and which permit the meanings signified in the discourse to be transposed into practice or consciousness (to acquire social use value or political effectivity).

Clearly, what we have labelled in the diagram (below) 'meaning structures 1' and 'meaning structures 2' may not be the same. They do not constitute an 'immediate identity'. The codes of encoding and decoding may not be perfectly symmetrical. The degrees of symmetry – that is, the degrees of 'understanding' and 'misunderstanding' in the communicative exchange – depend on the degrees of symmetry/asymmetry (relations of equivalence) established between the positions of the 'personifications', encoder-producer and decoder-receiver. But this in turn depends on the degrees of identity or non-identity between the codes which perfectly or imperfectly transmit, interrupt or systematically distort what has been transmitted. The lack of fit between the codes has a great deal to do with the structural differences of relation and position between broadcasters and audiences, but it also has something to do with the asymmetry between the codes of 'source' and 'receiver' at the moment of transformation into and out of the discursive form. What are called 'distortions' or 'misunderstandings' arise precisely from the *lack of equivalence* between the two sides in the communicative exchange. Once again, this defines the 'relative autonomy', but 'determinateness', of the entry and exit of the message in its discursive moments.

The application of this rudimentary paradigm has already begun to transform our understanding of the older term, television 'content'. We are just beginning to see how it might also transform our understanding of audience reception, 'reading' and response as well. Beginnings and endings have been announced in communications research before, so we must be cautious. But there seems some ground for thinking that a new and exciting phase in so-called audience research, of a quite new kind, may be opening up. At either end of the communicative chain the use of the semiotic paradigm promises to dispel the lingering behaviourism which has dogged mass-media research for so long, especially in its approach to content. Though we know the television programme is not a behavioural input, like a tap on the kneecap, it seems to have been almost impossible for traditional

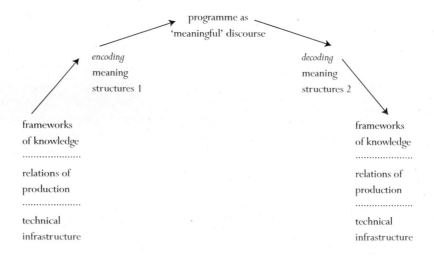

researchers to conceptualise the communicative process without lapsing into one or other variant of low-flying behaviourism. We know, as Gerbner has remarked, that representations of violence on the television screen 'are not violence but messages about violence': but we have continued to research the question of violence, for example, as if we were unable to comprehend this epistemological distinction.

The televisual sign is a complex one. It is itself constituted by the combination of two types of discourse, visual and aural. Moreover, it is an iconic sign, in Peirce's terminology, because 'it possesses some of the properties of the thing represented'. This is a point which has led to a great deal of confusion and has provided the site of intense controversy in the study of visual language. Since the visual discourse translates a three-dimensional world into two-dimensional planes, it cannot, of course, *be* the referent or concept it signifies. The dog in the film can bark but it cannot bite! Reality exists outside language, but it is constantly mediated by and through language: and what we can know and say has to be produced in and through discourse. Discursive 'knowledge' is the product not of the transparent representation of the 'real' in language but of the articulation of language on real relations and conditions. Thus there is no intelligible discourse without the operation of a code. Iconic signs are therefore coded signs too – even if the codes here work differently from those of other signs. There is no degree zero in language. Naturalism and 'realism' – the apparent fidelity of the representation to the thing or concept represented – is the result, the effect, of a certain specific articulation of language on the 'real'. It is the result of a discursive practice.

Certain codes may, of course, be so widely distributed in a specific language community or culture, and be learned at so early an age, that they appear not to be constructed – the effect of an articulation between sign and referent – but to be 'naturally' given. Simple visual signs appear to have achieved a 'near-universality' in this sense: though evidence remains that even apparently 'natural' visual codes are culture-specific. However, this does not mean that no codes have intervened; rather, that the codes have been profoundly *naturalised*. The operation of naturalised codes reveals not the transparency and 'naturalness' of language but the depth, the habituation and the near-universality of the codes in use. They produce apparently 'natural' recognitions. This has the (ideological) effect of concealing the practices of coding which are present. But we must not be fooled by appearances. Actually, what naturalised codes demonstrate is the degree of habituation produced when there is a fundamental alignment and reciprocity – an achieved equivalence – between the encoding and decoding sides of an exchange of meanings. The functioning of the codes on the decoding side will frequently assume the status of naturalised perceptions. This leads us to think that the visual sign for 'cow' actually *is* (rather than *represents*) the animal, cow. But if we think of the visual representation of a cow in a manual on animal husbandry – and, even more, of the linguistic sign 'cow' – we can see that both, in different degrees, are *arbitrary* with respect to the concept of the animal they represent. The articulation of an arbitrary sign – whether visual or verbal – with the concept of a referent is the product not of nature but of convention, and the conventionalism of discourses requires the intervention, the support, of codes. Thus Eco has argued that iconic signs 'look like objects in the real world because they reproduce the conditions (that is, the codes) of perception in the viewer'. These 'conditions of perception'

are, however, the result of a highly coded, even if virtually unconscious, set of operations – decodings. This is as true of the photographic or televisual image as it is of any other sign. Iconic signs are, however, particularly vulnerable to being 'read' as natural because visual codes of perception are very widely distributed and because this type of sign is less arbitrary than a linguistic sign: the linguistic sign, 'cow', possesses *none* of the properties of the thing represented, whereas the visual sign appears to possess *some* of those properties.

This may help us to clarify a confusion in current linguistic theory and to define precisely how some key terms are being used in this article. Linguistic theory frequently employs the distinction 'denotation' and 'connotation'. The term 'denotation' is widely equated with the literal meaning of a sign: because this literal meaning is almost universally recognised, especially when visual discourse is being employed, 'denotation' has often been confused with a literal transcription of 'reality' in language – and thus with a 'natural sign', one produced without the intervention of a code. 'Connotation', on the other hand, is employed simply to refer to less fixed and therefore more conventionalised and changeable, associative meanings, which clearly vary from instance to instance and therefore must depend on the intervention of codes.

We do *not* use the distinction – denotation/connotation – in this way. From our point of view, the distinction is an *analytic* one only. It is useful, in analysis, to be able to apply a rough rule of thumb which distinguishes those aspects of a sign which appear to be taken, in any language community at any point in time, as its 'literal' meaning (denotation) from the more associative meanings for the sign which it is possible to generate (connotation). But analytic distinctions must not be confused with distinctions in the real world. There will be very few instances in which signs organised in a discourse signify *only* their 'literal' (that is, near-universally consensualised) meaning. In actual discourse most signs will combine both the denotative and the connotative *aspects* (as redefined above). It may, then, be asked why we retain the distinction at all. It is largely a matter of analytic value. It is because signs appear to acquire their full ideological value – appear to be open to articulation with wider ideological discourses and meanings – at the level of their 'associative' meanings (that is, at the connotative level) – for here 'meanings' are *not* apparently fixed in natural perception (that is, they are not fully naturalised), and their fluidity of meaning and association can be more fully exploited and transformed. So it is at the connotative *level* of the sign that situational ideologies alter and transform signification. At this level we can see more clearly the active intervention of ideologies in and on discourse: here, the sign is open to new accentuations and, in Voloshinov's terms, enters fully into the struggle over meanings – the class struggle in language. This does not mean that the denotative or 'literal' meaning is outside ideology. Indeed, we could say that its ideological value is strongly *fixed* – because it has become so fully universal and 'natural'. The terms 'denotation' and 'connotation', then, are merely useful analytic tools for distinguishing, in particular contexts, between not the presence or absence of ideology in language but the different levels at which ideologies and discourses intersect.

The level of connotation of the visual sign, of its contextual reference and positioning in different discursive fields of meaning and association, is the point

where *already coded* signs intersect with the deep semantic codes of a culture and take on additional, more active ideological dimensions. We might take an example from advertising discourse. Here, too, there is no 'purely denotative', and certainly no 'natural', representation. Every visual sign in advertising connotes a quality, situation, value or inference, which is present as an implication or implied meaning, depending on the connotational positioning. In Barthes's example, the sweater always signifies a 'warm garment' (denotation) and thus the activity or value of 'keeping warm'. But it is also possible, at its more connotative levels, to signify 'the coming of winter' or 'a cold day'. And, in the specialised sub-codes of fashion, the sweater may also connote a fashionable style of *haute couture* or, alternatively, an informal style of dress. But set against the right visual background and positioned by the romantic sub-code, it may connote 'long autumn walk in the woods'. Codes of this order clearly contract relations for the sign with the wider universe of ideologies in a society. These codes are the means by which power and ideology are made to signify in particular discourses. They refer signs to the 'maps of meaning' into which any culture is classified; and those 'maps of social reality' have the whole range of social meanings, practices, and usages, power and interest 'written in' to them. The connotative levels of signifiers, Barthes remarked, 'have a close communication with culture, knowledge, history, and it is through them, so to speak, that the environmental world invades the linguistic and semantic system. They are, if you like, the fragments of ideology.'

The so-called denotative *level* of the televisual sign is fixed by certain, very complex (but limited or 'closed') codes. But its connotative *level*, though also bounded, is more open, subject to more active *transformations*, which exploit its polysemic values. Any such already constituted sign is potentially transformable into more than one connotative configuration. Polysemy must not, however, be confused with pluralism. Connotative codes are *not* equal among themselves. Any society or culture tends, with varying degrees of closure, to impose its classifications of the social and cultural and political world. These constitute a *dominant cultural order*, though it is neither univocal nor uncontested. This question of the 'structure of discourses in dominance' is a crucial point. The different areas of social life appear to be mapped out into discursive domains, hierarchically organised into *dominant or preferred meanings*. New, problematic or troubling events, which breach our expectancies and run counter to our 'commonsense constructs', to our 'taken-for-granted' knowledge of social structures, must be assigned to their discursive domains before they can be said to 'make sense'. The most common way of 'mapping' them is to assign the new to some domain or other of the existing 'maps of problematic social reality'. We say *dominant*, not 'determined', because it is always possible to order, classify, assign and decode an event within more than one 'mapping'. But we say 'dominant' because there exists a pattern of 'preferred readings'; and these both have the institutional/political/ideological order imprinted in them and have themselves become institutionalised. The domains of 'preferred meanings' have the whole social order embedded in them as a set of meanings, practices and beliefs: the everyday knowledge of social structures, of 'how things work for all practical purposes in this culture', the rank order of power and interest and the structure of legitimations, limits and sanctions. Thus to clarify a 'misunderstanding' at the connotative level, we must refer, *through*

the codes, to the orders of social life, of economic and political power and of ideology. Further, since these mappings are 'structured in dominance' but not closed, the communicative process consists not in the unproblematic assignment of every visual item to its given position within a set of prearranged codes, but of *performative rules* – rules of competence and use, of logics-in-use – which seek actively to *enforce* or *pre-fer* one semantic domain over another and rule items into and out of their appropriate meaning-sets. Formal semiology has too often neglected this practice of *interpretative work*, though this constitutes, in fact, the real relations of broadcast practices in television.

In speaking of *dominant meanings*, then, we are not talking about a one-sided process 'which governs how all events will be signified. It consists of the 'work' required to enforce, win plausibility for and command as legitimate a *decoding* of the event within the limit of dominant definitions in which it has been connotatively signified. Terni has remarked:

> By the word *reading* we mean not only the capacity to identify and decode a certain number of signs, but also the subjective capacity to put them into a creative relation between themselves and with other signs: a capacity which is, by itself, the condition for a complete awareness of one's total environment.

Our quarrel here is with the notion of 'subjective capacity', as if the referent of a televisional discourse were an objective fact but the interpretative level were an individualised and private matter. Quite the opposite seems to be the case. The televisual practice takes 'objective' (that is, systemic) responsibility precisely for the relations which disparate signs contract with one another in any discursive instance, and thus continually rearranges, delimits and prescribes into what 'awareness of one's total environment' these items are arranged.

This brings us to the question of misunderstandings. Television producers who find their message 'failing to get across' are frequently concerned to straighten out the kinks in the communication chain, thus facilitating the 'effectiveness' of their communication. Much research which claims the objectivity of 'policy-oriented analysis' reproduces this administrative goal by attempting to discover how much of a message the audience recalls and to improve the extent of understanding. No doubt misunderstandings of a literal kind do exist. The viewer does not know the terms employed, cannot follow the complex logic of argument or exposition, is unfamiliar with the language, finds the concepts too alien or difficult or is foxed by the expository narrative. But more often broadcasters are concerned that the audience has failed to take the meaning as they – the broadcasters – intended. What they really mean to say is that viewers are not operating within the 'dominant' or 'preferred' code. Their ideal is 'perfectly transparent communication'. Instead, what they have to confront is 'systematically distorted communication'.

In recent years discrepancies of this kind have usually been explained by reference to 'selective perception'. This is the door via which a residual pluralism evades the compulsions of a highly structured, asymmetrical and non-equivalent process. Of course, there will always be private, individual, variant readings. But 'selective perception' is almost never as selective, random or privatised as the concept suggests. The patterns exhibit, across individual variants, significant clusterings. Any

new approach to audience studies will therefore have to begin with a critique of 'selective perception' theory.

It was argued earlier that since there is no necessary correspondence between encoding and decoding, the former can attempt to 'pre-fer' but cannot prescribe or guarantee the latter, which has its own conditions of existence. Unless they are wildly aberrant, encoding will have the effect of constructing some of the limits and parameters within which decodings will operate. If there were no limits, audiences could simply read whatever they liked into any message. No doubt some total misunderstandings of this kind do exist. But the vast range must contain *some* degree of reciprocity between encoding and decoding moments, otherwise we could not speak of an effective communicative exchange at all. Nevertheless, this 'correspondence' is not given but constructed. It is not 'natural' but the product of an articulation between two distinct moments. And the former cannot determine or guarantee, in a simple sense, which decoding codes will be employed. Otherwise communication would be a perfectly equivalent circuit, and every message would be an instance of 'perfectly transparent communication'. We must think, then, of the variant articulations in which encoding and decoding can be combined. To elaborate on this, we offer a hypothetical analysis of some possible decoding positions, in order to reinforce the point of 'no necessary correspondence'.

We identify *three* hypothetical positions from which decodings of a televisual discourse may be constructed. These need to be empirically tested and refined. But the argument that decodings do not follow inevitably from encodings, that they are not identical, reinforces the argument of 'no necessary correspondence'. It also helps to deconstruct the commonsense meaning of 'misunderstanding' in terms of a theory of 'systematically distorted communication'.

The first hypothetical position is that of the *dominant-hegemonic position*. When the viewer takes the connoted meaning from, say, a television newscast or current affairs programme full and straight, and decodes the message in terms of the reference code in which it has been encoded, we might say that the viewer is *operating inside the dominant code*. This is the ideal-typical case of 'perfectly transparent communication' – or as close as we are likely to come to it 'for all practical purposes'. Within this we can distinguish the positions produced by the *professional code*. This is the position (produced by what we perhaps ought to identify as the operation of a 'metacode') which the professional broadcasters assume when encoding a message which has *already* been signified in a hegemonic manner. The professional code is 'relatively independent' of the dominant code, in that it applies criteria and transformational operations of its own, especially those of a technico-practical nature. The professional code, however, operates *within* the 'hegemony' of the dominant code. Indeed, it serves to reproduce the dominant definitions precisely by bracketing their hegemonic quality and operating instead with displaced professional codings which foreground such apparently neutral-technical questions as visual quality, news and presentational values, televisual quality, 'professionalism' and so on. The hegemonic interpretations of, say, the politics of Northern Ireland, or the Chilean *coup* or the Industrial Relations Bill are principally generated by political and military elites: the particular choice of presentational occasions and formats, the selection of personnel, the choice of images, the staging of debates are selected and combined through the operation of

the professional code. How the broadcasting professionals are able *both* to operate with 'relatively autonomous' codes of their own *and* to act in such a way as to reproduce (not without contradiction) the hegemonic signification of events is a complex matter which cannot be further spelled out here. It must suffice to say that the professionals are linked with the defining elites not only by the institutional position of broadcasting itself as an 'ideological apparatus' but also by the structure of *access* (that is, the systematic 'over-accessing' of selective elite personnel and their 'definition of the situation' in television). It may even be said that the professional codes serve to reproduce hegemonic definitions specifically by *not overtly* biasing their operations in a dominant direction: ideological reproduction therefore takes place here inadvertently, unconsciously, 'behind men's backs'. Of course, conflicts, contradictions and even misunderstandings regularly arise between the dominant and the professional significations and their signifying agencies.

The second position we would identify is that of the *negotiated code* or position. Majority audiences probably understand quite adequately what has been dominantly defined and professionally signified. The dominant definitions, however, are hegemonic precisely because they represent definitions of situations and events which are 'in dominance' (*global*). Dominant definitions connect events, implicitly or explicitly, to grand totalisations, to the great syntagmatic views-of-the-world: they take 'large views' of issues: they relate events to the 'national interest' or to the level of geopolitics even if they make these connections in truncated, inverted or mystified ways. The definition of a hegemonic viewpoint is, first, that it defines within its terms the mental horizon, the universe, of possible meanings, of a whole sector of relations in a society or culture; and, second, that it carries with it the stamp of legitimacy – it appears coterminous with what is 'natural', 'inevitable', 'taken for granted' about the social order. Decoding within the *negotiated version* contains a mixture of adaptive and oppositional elements: it acknowledges the legitimacy of the hegemonic definitions to make the grand significations (abstract), while, at a more restricted, situational (situated) level, it makes its own ground rules – it operates with exceptions to the rule. It accords the privileged position to the dominant definitions of events while reserving the right to make a more negotiated application to 'local conditions', to its own more *corporate* positions. This negotiated version of the dominant ideology is thus shot through with contradictions, though these are only on certain occasions brought to full visibility. Negotiated codes operate through what we might call particular or situated logics: and these logics are sustained by their differential and unequal relation to the discourses and logics of power. The simplest example of a negotiated code is that which governs the response of a worker to the notion of an Industrial Relations Bill limiting the right to strike or to arguments for a wages freeze. At the level of the 'national interest' economic debate the decoder may adopt the hegemonic definition, agreeing that 'we must all pay ourselves less in order to combat inflation'. This, however, may have little or no relation to his or her willingness to go on strike for better pay and conditions or to oppose the Industrial Relations Bill at the level of shop-floor or union organisation. We suspect that the great majority of so-called 'misunderstandings' arise from the contradictions and disjunctures between hegemonic-dominant encodings and negotiated-corporate decodings.

It is just these mismatches in the levels which most provoke defining elites and professionals to identify a 'failure in communications'.

Finally, it is possible for a viewer perfectly to understand both the literal and the connotative inflection given by a discourse but to decode the message in a *globally* contrary way. He or she detotalises the message in the preferred code in order to retotalise the message within some alternative framework of reference. This is the case of the viewer who listens to a debate on the need to limit wages but 'reads' every mention of the 'national interest' as 'class interest'. He or she is operating with what we must call an *oppositional code*. One of the most significant political moments (they also coincide with crisis points within the broadcasting organisations themselves, for obvious reasons) is the point when events which are normally signified and decoded in a negotiated way begin to be given an oppositional reading. Here the 'politics of signification' – the struggle in discourse – is joined.

Note

This article is an edited extract from 'Encoding and Decoding in Television Discourse', CCCS Stencilled Paper no. 7.

Nancy Fraser

RETHINKING THE PUBLIC SPHERE
A contribution to the critique of actually
existing democracy

EDITOR'S INTRODUCTION

O N THE FACE OF IT, NANCY FRASER'S ESSAY belongs more to social or critical theory than to cultural studies as usually conceived. Nonetheless, as a canny and persuasive critique of Jürgen Habermas's concept of the 'bourgeois public sphere' it finds its place in an anthology like this, just because Habermas's work, like that of Adorno, Benjamin, Williams or Bhabha, provides a theoretical sub-stratum for contemporary cultural studies.

In his *Structural Transformations of the Public Sphere*, Habermas argued that the eighteenth-century world of London coffee-houses and clubs provided new occasions for free exchange of discourse as if between equals, and that from such exchanges emerged the possibility of reformist, egalitarian public debate, opinion forming as well as, indirectly, governance. Fraser engages this idea critically, arguing that there never was, and never should be just one 'public sphere' but rather a number of public spheres. What is at stake, for her, is not just discourse-exchange, but how stratified such publics should be, and how closely each is tied to the institutions of decision making.

Further reading: Calhoun 1992; Crossley 2004; Laclau 1994; McGuigan 1996; Warner 2002.

Today in the United States we hear a great deal of ballyhoo about 'the triumph of liberal democracy' and even 'the end of history'. Yet there is still quite a lot to object to in our own actually existing democracy, and the project of a critical theory of the limits of democracy in late-capitalist societies remains as relevant

as ever. In fact, this project seems to me to have acquired a new urgency at a time when 'liberal democracy' is being touted as the *ne plus ultra* of social systems for countries that are emerging from Soviet-style state socialism, Latin American military dictatorships and southern African regimes of racial domination.

Those of us who remain committed to theorising the limits of democracy in late-capitalist societies will find in the work of Jürgen Habermas an indispensable resource. I mean the concept of 'the public sphere', originally elaborated in his 1962 book, *The Structural Transformation of the Public Sphere*, and subsequently resituated but never abandoned in his later work.

The political and theoretical importance of this idea is easy to explain. Habermas's concept of the public sphere provides a way of circumventing some confusions that have plagued progressive social movements and the political theories associated with them. Take, for example, the longstanding failure in the dominant wing of the socialist and Marxist tradition to appreciate the full force of the distinction between the apparatuses of the state, on the one hand, and public arenas of citizen discourse and association, on the other. All too often it was assumed in this tradition that to subject the economy to the control of the socialist state was to subject it to the control of the socialist citizenry. Of course, that was not so. But the conflation of the state apparatus with the public sphere of discourse and association provided ballast to processes whereby the socialist vision became institutionalised in an authoritarian-statist form instead of in a participatory-democratic form. The result has been to jeopardise the very idea of socialist democracy.

A second problem, albeit one that has so far been much less historically momentous and certainly less tragic, is a confusion one encounters at times in contemporary feminisms. I mean a confusion that involves the use of the very same expression 'the public sphere' but in a sense that is less precise and less useful than Habermas's. This expression has been used by many feminists to refer to everything that is outside the domestic or familial sphere. Thus 'the public sphere' on this usage conflates at least three analytically distinct things: the state, the official economy of paid employment and arenas of public discourse. Now it should not be thought that the conflation of these three things is a merely theoretical issue. On the contrary, it has practical political consequences when, for example, agitational campaigns against misogynist cultural representations are confounded with programmes for state censorship or when struggles to deprivatise housework and child care are equated with their commodification. In both these cases the result is to occlude the question of whether to subject gender issues to the logic of the market or the administrative state is to promote the liberation of women.

The idea of 'the public sphere' in Habermas's sense is a conceptual resource that can help overcome such problems. It designates a theatre in modern societies in which political participation is enacted through the medium of talk. It is the space in which citizens deliberate about their common affairs, and hence an institutionalised arena of discursive interaction. This arena is conceptually distinct from the state; it is a site for the production and circulation of discourses that can in principle be critical of the state. The public sphere in Habermas's sense is also conceptually distinct from the official economy; it is not an arena of market relations but rather one of discursive relations, a theatre for debating and deliberating rather than for

buying and selling. Thus this concept of the public sphere permits us to keep in view the distinctions among state apparatuses, economic markets, and democratic associations, distinctions that are essential to democratic theory.

For these reasons I am going to take as a basic premise for this essay that something like Habermas's idea of the public sphere is indispensable to critical social theory and democratic political practice. I assume that no attempt to understand the limits of actually existing late-capitalist democracy can succeed without in some way or another making use of it. I assume that the same goes for urgently needed constructive efforts to project alternative models of democracy.

If you will grant me that the general idea of the public sphere is indispensable to critical theory, then I shall go on to argue that the specific form in which Habermas has elaborated this idea is not wholly satisfactory. On the contrary, I contend that his analysis of the public sphere needs to undergo some critical interrogation and reconstruction if it is to yield a category capable of theorising the limits of actually existing democracy.

Let me remind you that the subtitle of *Structural Transformation* is 'An Inquiry into a Category of Bourgeois Society'. The object of the inquiry is the rise and decline of a historically specific and limited form of the public sphere, which Habermas calls the 'liberal model of the bourgeois public sphere'. The aim is to identify the conditions that made possible this type of public sphere and to chart their devolution. The upshot is an argument that under altered conditions of late-twentieth-century 'welfare state mass democracy', the bourgeois or liberal model of the public sphere is no longer feasible. Some new form of public sphere is required to salvage that arena's critical function and to institutionalise democracy.

Oddly, Habermas stops short of developing a new, post-bourgeois model of the public sphere. Moreover, he never explicitly problematises some dubious assumptions that underlie the bourgeois model. As a result, we are left at the end of *Structural Transformation* without a conception of the public sphere that is sufficiently distinct from the bourgeois conception to serve the needs of critical theory today.

That, at any rate, is the thesis I intend to argue. To make my case, I shall proceed as follows: I shall begin by juxtaposing Habermas's account of the structural transformation of the public sphere with an alternative account that can be pieced together from some recent revisionist historiography. Then I shall identify four assumptions underlying the bourgeois conception of the public sphere, as Habermas describes it, that this newer historiography renders suspect. Next in the following sections I shall examine each of these assumptions in turn. Finally, I shall draw together some strands from these critical discussions that point toward an alternative, post-bourgeois conception of the public sphere.

The public sphere: alternative histories, competing conceptions

Let me begin by sketching highlights of Habermas's account of the structural transformation of the public sphere. According to Habermas, the idea of a public sphere is that of a body of 'private persons' assembled to discuss matters of 'public concern' or 'common interest'. This idea acquired force and reality in early modern

Europe in the constitution of 'bourgeois public spheres' as counterweights to absolutist states. These publics aimed to mediate between society and the state by holding the state accountable to society via publicity. At first this meant requiring that information about state functioning be made accessible so that state activities would be subject to critical scrutiny and the force of public opinion. Later it meant transmitting the considered 'general interest' of 'bourgeois society' to the state via forms of legally guaranteed free speech, free press and free assembly, and eventually through the parliamentary institutions of representative government.

According to Habermas, the full utopian potential of the bourgeois conception of the public sphere was never realised in practice. The claim to open access in particular was not made good. Moreover, the bourgeois conception of the public sphere was premised on a social order in which the state was sharply differentiated from the newly privatised market economy; it was this clear separation of society and state that was supposed to underpin a form of public discussion that excluded 'private interests'. But these conditions eventually eroded as non-bourgeois strata gained access to the public sphere. Then 'the social question' came to the fore, society was polarised by class struggle, and the public fragmented into a mass of competing interest groups. Street demonstrations and back-room, brokered compromises among private interests replaced reasoned public debate about the common good. Finally, with the emergence of welfare-state mass democracy, society and the state became mutually intertwined; publicity in the sense of critical scrutiny of the state gave way to public relations, mass-mediated staged displays and the manufacture and manipulation of public opinion.

Now let me juxtapose to this sketch of Habermas's account an alternative account that I shall piece together from some recent revisionist historiography. Briefly, scholars like Joan Landes, Mary Ryan and Geoff Eley contend that Habermas's account idealises the liberal public sphere. They argue that, despite the rhetoric of publicity and accessibility, the official public sphere rested on, indeed was importantly constituted by, a number of significant exclusions. For Landes, the key axis of exclusion is gender; she argues that the ethos of the new republican public sphere in France was constructed in deliberate opposition to that of a more woman-friendly salon culture that the republicans stigmatised as 'artificial', 'effeminate', and 'aristocratic'. Consequently, a new, austere style of public speech and behaviour was promoted, a style deemed 'rational', 'virtuous', and 'manly'. In this way masculinist gender constructs were built into the very conception of the republican public sphere, as was a logic that led, at the height of Jacobin rule, to the formal exclusion of women from political life (Landes 1988). Here the republicans drew on classical traditions that cast femininity and publicity as oxymorons; the depth of such traditions can be gauged in the etymological connection between 'public' and 'pubic', a graphic trace of the fact that in the ancient world possession of a penis was a requirement for speaking in public.

Extending Landes's argument, Geoff Eley contends that exclusionary operations were essential to liberal public spheres not only in France but also in England and Germany and that in all these countries gender exclusions were linked to other exclusions rooted in processes of class formation. In all these countries, he claims, the soil that nourished the liberal public sphere was 'civil society', the emerging new congeries of voluntary associations that sprung up in what came to be known

as 'the age of societies'. But this network of clubs and associations – philanthropic, civic, professional and cultural – was anything but accessible to everyone. On the contrary, it was the arena, the training ground and eventually the power base of a stratum of bourgeois men who were coming to see themselves as a 'universal class' and preparing to assert their fitness to govern. Thus the elaboration of a distinctive culture of civil society and of an associated public sphere was implicated in the process of bourgeois class formation; its practices and ethos were markers of 'distinction' in Pierre Bourdieu's sense, ways of defining an emergent elite, of setting it off from the older aristocratic elites it was intent on displacing on the one hand and from the various popular and plebeian strata it aspired to rule on the other. Moreover, this process of distinction helps explain the exacerbation of sexism characteristic of the liberal public sphere; new gender norms enjoining feminine domesticity and a sharp separation of public and private spheres functioned as key signifiers of bourgeois difference from both higher and lower social strata. It is a measure of the eventual success of this bourgeois project that these norms later became hegemonic, sometimes imposed on, sometimes embraced by, broader segments of society.

There is a remarkable irony here, one that Habermas's account of the rise of the public sphere fails fully to appreciate. A discourse of publicity touting accessibility, rationality and the suspension of status hierarchies is itself deployed as a strategy of distinction. Of course, in and of itself this irony does not fatally compromise the discourse of publicity; that discourse can be, indeed has been, differently deployed in different circumstances and contexts. Nevertheless, it does suggest that the relationship between publicity and status is more complex than Habermas intimates, that declaring a deliberative arena to be a space where extant status distinctions are bracketed and neutralised is not sufficient to make it so.

Moreover, the problem is not only that Habermas idealises the liberal public sphere but also that he fails to examine other, non-liberal, non-bourgeois, competing public spheres. Or rather, it is precisely because he fails to examine these other public spheres that he ends up idealising the liberal public sphere. In the case of elite bourgeois women, this involved building a counter civil society of alternative, woman-only, voluntary associations, including philanthropic and moral-reform societies. In some respects, these associations aped the all-male societies built by these women's fathers and grandfathers, yet in other respects the women were innovating, since they creatively used the heretofore quintessentially 'private' idioms of domesticity and motherhood precisely as springboards for public activity. Meanwhile, for some less privileged women, access to public life came through participation in supporting roles in male-dominated working-class protest activities. Still other women found public outlets in street protests and parades. Finally, women's rights advocates publicly contested both women's exclusion from the official public sphere and the privatisation of gender politics.

Even in the absence of formal political incorporation through suffrage, there were a variety of ways of accessing public life and a multiplicity of public arenas. Thus the view that women were excluded from the public sphere turns out to be ideological; it rests on a class- and gender-biased notion of publicity, one which accepts at face value the bourgeois public's claim to be *the* public. The bourgeois public was never *the* public. On the contrary, virtually contemporaneous with

the bourgeois public there arose a host of competing counter-publics, including nationalist publics, popular peasant publics, elite women's publics, and working-class publics. Thus there were competing publics from the start, not just in the late nineteenth and twentieth centuries, as Habermas implies (Ryan 1990).

Moreover, not only was there always a plurality of competing publics, but the relations between bourgeois publics and other publics were always conflictual. Virtually from the beginning, counter-publics contested the exclusionary norms of the bourgeois public, elaborating alternative styles of political behaviour and alternative norms of public speech. Bourgeois publics in turn excoriated these alternatives and deliberately sought to block broader participation. As Eley puts it, 'the emergence of a bourgeois public was never defined solely by the struggle against absolutism and traditional authority, but ... addressed the problem of popular containment as well. The public sphere was always constituted by conflict' (Eley 1992).

In general, this revisionist historiography suggests a much darker view of the bourgeois public sphere than the one that emerges from Habermas's study. The exclusions and conflicts that appeared as accidental trappings from his perspective become constitutive in the revisionists' view. The result is a gestalt switch that alters the very meaning of the public sphere. We can no longer assume that the bourgeois conception of the public sphere was simply an unrealised utopian ideal; it was also a masculinist ideological notion that functioned to legitimate an emergent form of class rule. Therefore, Eley draws a Gramscian moral from the story: the official bourgeois public sphere is the institutional vehicle for a major historical transformation in the nature of political domination. This is the shift from a repressive mode of domination to a hegemonic one, from rule based primarily on acquiescence to superior force to rule based primarily on consent supplemented with some measure of repression. The important point is that this new mode of political domination, like the older one, secures the ability of one stratum of society to rule the rest. The official public sphere, then, was, and indeed is, the prime institutional site for the construction of the consent that defines the new, hegemonic mode of domination.

What conclusions should we draw from this conflict of historical interpretations? Should we conclude that the very concept of the public sphere is a piece of bourgeois, masculinist ideology so thoroughly compromised that it can shed no genuinely critical light on the limits of actually existing democracy? Or should we conclude rather that the public sphere was a good idea that unfortunately was not realised in practice but retains some emancipatory force? In short, is the idea of the public sphere an instrument of domination or a utopian ideal?

Well, perhaps both, but actually neither. I contend that both of those conclusions are too extreme and unsupple to do justice to the material I have been discussing. Instead of endorsing either one of them, I want to propose a more nuanced alternative. I shall argue that the revisionist historiography neither undermines nor vindicates *the* concept of the public sphere *simpliciter*, but that it calls into question four assumptions that are central to the *bourgeois, masculinist* conception of the public sphere, at least as Habermas describes it. These are as follows:

- The assumption that it is possible for interlocutors in a public sphere to bracket status differentials and to deliberate *as if* they were social equals; the

assumption, therefore, that societal equality is not a necessary condition for political democracy

- The assumption that the proliferation of a multiplicity of competing publics is necessarily a step away from, rather than toward, greater democracy, and that a single, comprehensive public sphere is always preferable to a nexus of multiple publics
- The assumption that discourse in public spheres should be restricted to deliberation about the common good, and that the appearance of private interests and private issues is always undesirable
- The assumption that a functioning democratic public sphere requires a sharp separation between civil society and the state.

Let me consider each of these in turn.

Open access, participatory parity and social equality

Habermas's account of the bourgeois conception of the public sphere stresses its claim to be open and accessible to all. Indeed, this idea of open access is one of the central meanings of the norm of publicity. Of course, we know both from revisionist history and from Habermas's account that the bourgeois public's claim to full accessibility was not in fact realised. Women of all classes and ethnicities were excluded from official political participation on the basis of gender status, while plebeian men were formally excluded by property qualifications. Moreover, in many cases women and men of radicalised ethnicities of all classes were excluded on racial grounds.

What are we to make of this historical fact of non-realisation in practice of the bourgeois public sphere's ideal of open access? One approach is to conclude that the ideal itself remains unaffected, since it is possible in principle to overcome these exclusions. And in fact, it was only a matter of time before formal exclusions based on gender, property and race were eliminated.

This is convincing enough as far as it goes, but it does not go far enough. The question of open access cannot be reduced without remainder to the presence or absence of formal exclusions. It requires us to look also at the process of discursive interaction within formally inclusive public arenas. Here we should recall that the bourgeois conception of the public sphere requires bracketing inequalities of status. This public sphere was to be an arena in which interlocutors would set aside such characteristics as differences in birth and fortune and speak to one another as if they were social and economic peers. The operative phrase here is 'as if'. In fact, the social inequalities among the interlocutors were not eliminated but only bracketed.

But were they really effectively bracketed? The revisionist historiography suggests they were not. Rather, discursive interaction within the bourgeois public sphere was governed by protocols of style and decorum that were themselves correlates and markers of status inequality. These functioned informally to marginalise women and members of the plebeian classes and to prevent them from participating as peers.

Here we are talking about informal impediments to participatory parity that can persist even after everyone is formally and legally licensed to participate. That these constitute a more serious challenge to the bourgeois conception of the public sphere can be seen from a familiar contemporary example. Feminist research has documented a syndrome that many of us have observed in faculty meetings and other mixed-sex deliberative bodies: men tend to interrupt women more than women interrupt men; men also tend to speak more than women, taking more turns and longer turns; and women's interventions are more often ignored or not responded to than men's. In response to the sorts of experiences documented in this research, an important strand of feminist political theory has claimed that deliberation can serve as a mask for domination. Theorists like Jane Mansbridge have argued that

> the transformation of 'I' into 'we' brought about through political deliberation can easily mask subtle forms of control. Even the language people use as they reason together usually favours one way of seeing things and discourages others. Subordinate groups sometimes cannot find the right voice or words to express their thoughts, and when they do, they discover they are not heard. [They] are silenced, encouraged to keep their wants inchoate, and heard to say 'yes' when what they have said is 'no.'

> (Mansbridge 1990: 127)

Mansbridge rightly notes that many of these feminist insights into ways in which deliberation can serve as a mask for domination extend beyond gender to other kinds of unequal relations, like those based on class or ethnicity.

Here I think we encounter a very serious difficulty with the bourgeois conception of the public sphere. In so far as the bracketing of social inequalities in deliberation means proceeding as if they don't exist when they do, this does not foster participatory parity. On the contrary, such bracketing usually works to the advantage of dominant groups in society and to the disadvantage of subordinates. In most cases it would be more appropriate to *unbracket* inequalities in the sense of explicitly thematising them – a point that accords with the spirit of Habermas's later communicative ethics.

The misplaced faith in the efficacy of bracketing suggests another flaw in the bourgeois conception. This conception assumes that a public sphere is or can be a space of zero degree culture, so utterly bereft of any specific ethos as to accommodate with perfect neutrality and equal ease interventions expressive of any and every cultural ethos. But this assumption is counterfactual, and not for reasons that are merely accidental. In stratified societies, unequally empowered social groups tend to develop unequally valued cultural styles. The result is the development of powerful informal pressures that marginalise the contributions of members of subordinated groups both in everyday contexts and in official public spheres. Moreover, these pressures are amplified, rather than mitigated, by the peculiar political economy of the bourgeois public sphere. In this public sphere the media that constitute the material support for the circulation of views are privately owned and operated for profit. Consequently, subordinated social groups

usually lack equal access to the material means of equal participation. Thus political economy enforces structurally what culture accomplishes informally.

If we take these considerations seriously, then we should be led to entertain serious doubts about a conception of the public sphere that purports to bracket, rather than to eliminate, structural social inequalities. We should question whether it is possible even in principle for interlocutors to deliberate *as if* they were social peers in specifically designated discursive arenas when these discursive arenas are situated in a larger societal context that is pervaded by structural relations of dominance and subordination.

What is at stake here is the autonomy of specifically political institutions *vis-à-vis* the surrounding societal context. Now one salient feature that distinguishes liberalism from some other political-theoretical orientations is that liberalism assumes the autonomy of the political in a very strong form. Liberal political theory assumes that it is possible to organise a democratic form of political life on the basis of socioeconomic and socio-sexual structures that generate systemic inequalities. For liberals, then, the problem of democracy becomes the problem of how to insulate political processes from what are considered to be non-political or pre-political processes, those characteristic, for example, of the economy, the family, and informal everyday life. The problem for liberals is thus how to strengthen the barriers separating political institutions that are supposed to instantiate relations of equality from economic, cultural and socio-sexual institutions that are premised on systemic relations of inequality. Yet the weight of circumstance suggests that to have a public sphere in which interlocutors can deliberate as peers, it is not sufficient merely to bracket social inequality. Instead, a necessary condition for participatory parity is that systemic social inequalities be eliminated. This does not mean that everyone must have exactly the same income, but it does require the sort of rough equality that is inconsistent with systemically generated relations of dominance and subordination. *Pace* liberalism, then, political democracy requires substantive social equality.

I have been arguing that the bourgeois conception of the public sphere is inadequate in so far as it supposes that social equality is not a necessary condition for participatory parity in public spheres. What follows from this for the critique of actually existing democracy? One task for critical theory is to render visible the ways in which societal inequality infects formally inclusive existing public spheres and taints discursive interaction within them.

Equality, diversity and multiple publics

So far I have been discussing what we might call 'intrapublic relations', that is, the character and quality of discursive interactions within a given public sphere. Now I want to consider what we might call 'interpublic relations', that is, the character of interactions among different publics.

Let me begin by recalling that Habermas's account stresses the singularity of the bourgeois conception of the public sphere, its claim to be *the* public arena, in the singular. In addition, his narrative tends in this respect to be faithful

to that conception, since it casts the emergence of additional publics as a late development signalling fragmentation and decline. This narrative, then, like the bourgeois conception itself, is informed by an underlying evaluative assumption, namely, that the institutional confinement of public life to a single, overarching public sphere is a positive and desirable state of affairs, whereas the proliferation of a multiplicity of publics represents a departure from, rather than an advance toward, democracy. It is this normative assumption that I now want to scrutinise. In this section I shall assess the relative merits of a single, comprehensive public versus multiple publics in two kinds of modern societies: stratified and egalitarian multicultural societies.

First, let me consider the case of stratified societies, by which I mean societies whose basic institutional framework generates unequal social groups in structural relations of dominance and subordination. I have already argued that in such societies, full parity of participation in public debate and deliberation is not within the reach of possibility. The question to be addressed here then is: What form of public life comes closest to approaching that ideal? What institutional arrangements will best help narrow the gap in participatory parity between dominant and subordinate groups?

I contend that in stratified societies, arrangements that accommodate contestation among a plurality of competing publics better promote the ideal of participatory parity than does a single, comprehensive, overarching public. This follows from the argument of the previous section. There I argued that it is not possible to insulate special discursive arenas from the effects of societal inequality and, that where societal inequality persists, deliberative processes in public spheres will tend to operate to the advantage of dominant groups and to the disadvantage of subordinates. Now I want to add that these effects will be exacerbated where there is only a single, comprehensive public sphere. In that case, members of subordinated groups would have no arenas for deliberation among themselves about their needs, objectives, and strategies. They would have no venues in which to undertake communicative processes that were not, as it were, under the supervision of dominant groups. In this situation they would be less likely than otherwise to 'find the right voice or words to express their thoughts' and more likely than otherwise 'to keep their wants inchoate'. This would render them less able than otherwise to articulate and defend their interests in the comprehensive public sphere. They would be less able than otherwise to expose modes of deliberation that mask domination by, in Mansbridge's words, 'absorbing the less powerful into a false "we" that reflects the more powerful'.

This argument gains additional support from revisionist historiography of the public sphere, up to and including that of very recent developments. This historiography records that members of subordinated social groups – women, workers, peoples of colour, and gays and lesbians – have repeatedly found it advantageous to constitute alternative publics. I propose to call these *subaltern counterpublics* in order to signal that they are parallel discursive arenas where members of subordinated social groups invent and circulate counter-discourses to formulate oppositional interpretations of their identities, interests and needs. Perhaps the most striking example is the late-twentieth-century US feminist subaltern counter-

public, with its variegated array of journals, bookstores, publishing companies, film and video distribution networks, lecture series, research centres, academic programmes, conferences, conventions, festivals and local meeting places. In this public sphere, feminist women have invented new terms for describing social reality, including 'sexism', 'the double shift', 'sexual harassment' and 'marital, date and acquaintance rape'. Armed with such language, we have recast our needs and identities, thereby reducing, although not eliminating, the extent of our disadvantage in official public spheres.

Let me not be misunderstood. I do not mean to suggest that subaltern counter-publics are always necessarily virtuous. Some of them, alas, are explicitly anti-democratic and anti-egalitarian, and even those with democratic and egalitarian intentions are not always above practising their own modes of informal exclusion and marginalisation. Still, in so far as these counter-publics emerge in response to exclusions within dominant publics, they help expand discursive space. In principle, assumptions that were previously exempt from contestation will now have to be publicly argued out. In general, the proliferation of subaltern counter-publics means a widening of discursive contestation, and that is a good thing in stratified societies.

I am emphasising the contestatory function of subaltern counter-publics in stratified societies in part to complicate the issue of separatism. In my view, the concept of a counter-public militates in the long run against separatism because it assumes a *publicist* orientation. In so far as these arenas are *publics*, they are by definition not enclaves, which is not to deny that they are often involuntarily enclaved. After all, to interact discursively as a member of public, subaltern or otherwise, is to aspire to disseminate one's discourse to ever widening arenas. Habermas captures well this aspect of the meaning of publicity when he notes that, however limited a public may be in its empirical manifestation at any given time, its members understand themselves as part of a potentially wider public, that indeterminate, empirically counterfactual body we call 'the public at large'. The point is that in stratified societies, subaltern counter-publics have a dual character. On the one hand, they function as spaces of withdrawal and regroupment; on the other hand, they also function as bases and training grounds for agitational activities directed toward wider publics. It is precisely in the dialectic between these two functions that their emancipatory potential resides. This dialectic enables subaltern counter-publics partially to offset, although not wholly to eradicate, the unjust participatory privileges enjoyed by members of dominant social groups in stratified societies.

So far I have been arguing that, although in stratified societies the ideal of participatory parity is not fully realisable, it is more closely approximated by arrangements that permit contestation among a plurality of competing publics than by a single, comprehensive public sphere. Of course, contestation among competing publics supposes interpublic discursive interaction. How, then, should we understand such interaction? Geoff Eley suggests that we think of the public sphere (in stratified societies) as 'the structured setting where cultural and ideological contest or negotiation among a variety of publics takes place'. This formulation does justice to the multiplicity of public arenas in stratified societies by expressly acknowledging the presence and activity of 'a variety of publics'. At the same

time, it also does justice to the fact that these various publics are situated in a single 'structured setting' that advantages some and disadvantages others. Finally, Eley's formulation does justice to the fact that in stratified societies the discursive relations among differentially empowered publics are as likely to take the form of contestation as that of deliberation.

Let me now consider the relative merits of multiple publics versus a single public for egalitarian, multicultural societies. By 'egalitarian societies' I mean non-stratified societies, societies whose basic framework does not generate unequal social groups in structural relations of dominance and subordination. Egalitarian societies, therefore, are societies without classes and without gender or racial divisions of labour. However, they need not be culturally homogeneous. On the contrary, provided such societies permit free expression and association, they are likely to be inhabited by social groups with diverse values, identities and cultural styles, and hence to be multicultural. My question is: Under conditions of cultural diversity in the absence of structural inequality, would a single, comprehensive public sphere be preferable to multiple publics?

To answer this question, we need to take a closer look at the relationship between public discourse and social identities. *Pace* the bourgeois conception, public spheres are not only arenas for the formation of discursive opinion; in addition, they are arenas for the formation and enactment of social identities. This means that participation is not simply a matter of being able to state propositional contents that are neutral with respect to form of expression. Rather, as I argued in the previous section, participation means being able to speak in one's own voice, and thereby simultaneously to construct and express one's cultural identity through idiom and style. Moreover, as I also suggested, public spheres themselves are not spaces of zero-degree culture, equally hospitable to any possible form of cultural expression. Rather, they consist in culturally specific institutions, including, for example, various journals and various social geographies of urban space. These institutions may be understood as culturally specific rhetorical lenses that filter and alter the utterances they frame; they can accommodate some expressive modes and not others.

It follows that public life in egalitarian, multicultural societies cannot consist exclusively in a single, comprehensive public sphere. That would be tantamount to filtering diverse rhetorical and stylistic norms through a single, overarching lens. Moreover, since there can be no such lens that is genuinely culturally neutral, it would effectively privilege the expressive norms of one cultural group over others and thereby make discursive assimilation a condition for participation in public debate. The result would be the demise of multiculturalism (and the likely demise of social equality). In general, then, we can conclude that the idea of an egalitarian, multicultural society only makes sense if we suppose a plurality of public arenas in which groups with diverse values and rhetoric participate. By definition, such a society must contain a multiplicity of publics.

However, this need not preclude the possibility of an additional, more comprehensive arena in which members of different, more limited publics talk across lines of cultural diversity. On the contrary, our hypothetical egalitarian, multicultural society would surely have to entertain debates over policies and issues affecting everyone. The question is: Would participants in such debates share enough

in the way of values, expressive norms, and therefore protocols of persuasion to lend their talk the quality of deliberations aimed at reaching agreement through giving reasons?

In my view, this is better treated as an empirical question than as a conceptual question. I see no reason to rule out in principle the possibility of a society in which social equality and cultural diversity coexist with participatory democracy. I certainly hope there can be such a society. That hope gains some plausibility if we consider that, however difficult it may be, communication across lines of cultural difference is not in principle impossible, although it will certainly become impossible if one imagines that it requires bracketing of differences. Granted, such communication requires multicultural literacy, but that, I believe, can be acquired through practice. In fact, the possibilities expand once we acknowledge the complexity of cultural identities. *Pace* reductive, essentialist conceptions, cultural identities are woven of many different strands, and some of these strands may be common to people whose identities otherwise diverge, even when it is the divergences that are most salient. Likewise, under conditions of social equality, the porousness, outer-directedness and open-endedness of publics could promote intercultural communication. In addition, the unbounded character and publicist orientation of publics allows people to participate in more than one public and it allows memberships of different publics partially to overlap. This in turn makes intercultural communication conceivable in principle. All told, then, there do not seem to be any conceptual (as opposed to empirical) barriers to the possibility of a socially egalitarian, multicultural society that is also a participatory democracy. But this will necessarily be a society with many different publics, including at least one public in which participants can deliberate as peers across lines of difference about policy that concerns them all.

In general, I have been arguing that the ideal of participatory parity is better achieved by a multiplicity of publics than by a single public. This is true both for stratified societies and for egalitarian, multicultural societies, albeit for different reasons. In neither case is my argument intended as a simple post-modern celebration of multiplicity. Rather, in the case of stratified societies, I am defending subaltern counter-publics formed under conditions of dominance and subordination. In the other case, by contrast, I am defending the possibility of combining social equality, cultural diversity and participatory democracy.

What are the implications of this discussion for a critical theory of the public sphere in actually existing democracy? Briefly, we need a critical political sociology of a form of public life in which multiple but unequal publics participate. This means theorising about the contestatory interaction of different publics and identifying the mechanisms that render some of them subordinate to others.

Public spheres, common concerns and private interests

I have argued that in stratified societies, like it or not, subaltern counter-publics stand in a contestatory relationship to dominant publics. One important object of such interpublic contestation is the appropriate boundaries of the public sphere.

Here the central questions are: What counts as a public matter? What, in contrast, is private? This brings me to a third set of problematic assumptions underlying the bourgeois conception of the public sphere, namely, assumptions concerning the appropriate scope of publicity in relation to privacy.

Let me remind you that it is central to Habermas's account that the bourgeois public sphere was to be a discursive arena in which 'private persons' deliberated about 'public matters'. There are several different senses of 'private' and 'public' in play here. 'Public', for example, can mean, first, state-related; second, accessible to everyone; third, of concern to everyone; and, fourth, pertaining to a common good or shared interest. Each of these corresponds to a contrasting sense of 'private'. In addition, there are two other senses of 'private' hovering just below the surface here: fifth, pertaining to private property in a market economy; and, sixth, pertaining to intimate domestic or personal life, including sexual life.

I have already talked at length about the sense of 'public' as open or accessible to all. Now I want to examine some of the other senses, beginning with the third point, of concern to everyone. This is ambiguous between what objectively affects or has an impact on everyone as seen from an outsider's perspective, and what is recognised as a matter of common concern by participants. The idea of a public sphere as an arena of collective self-determination does not sit well with approaches that would appeal to an outsider's perspective to delimit its proper boundaries. Thus it is the second, participants' perspective that is relevant here. Only participants themselves can decide what is and what is not of common concern to them. However, there is no guarantee that all of them will agree. For example, until quite recently, feminists were in the minority in thinking that domestic violence against women was a matter of common concern and thus a legitimate topic of public discourse. The great majority of people considered this issue to be a private matter between what was assumed to be a fairly small number of heterosexual couples (and perhaps the social and legal professionals who were supposed to deal with them). Then feminists formed a subaltern counter-public from which we disseminated a view of domestic violence as a widespread systemic feature of male-dominated societies. Eventually, after sustained discursive contestation, we succeeded in *making* it a common concern.

The point is that there are no naturally given, *a priori* boundaries here. What will count as a matter of common concern will be decided precisely through discursive contestation. It follows that no topics should be ruled off limits in advance of such contestation. On the contrary, democratic publicity requires positive guarantees of opportunities for minorities to convince others that what in the past was not public in the sense of being a matter of common concern should now become so.

What, then, of the sense of 'publicity' as pertaining to a common good or shared interest? This is the sense that is in play when Habermas characterises the bourgeois public sphere as an arena in which the topic of discussion is restricted to the 'common good' and in which discussion of 'private interests' is ruled out. This is a view of the public sphere that we would today call civic-republican, as opposed to liberal-individualist. Briefly, the civic-republican model stresses a view of politics as people reasoning together to promote a common good that transcends the mere sum of individual preferences. The idea is that through deliberation the members of the public can come to discover or create such a common good. In

the process of their deliberations, participants are transformed from a collection of self-seeking, private individuals into a public-spirited collectivity, capable of acting together in the common interest. On this view, private interests have no proper place in the political public sphere. At best, they are the pre-political starting point of deliberation, to be transformed and transcended in the course of debate.

This civic-republican view of the public sphere is in one respect an improvement over the liberal-individualist alternative. Unlike the latter, it does not assume that people's preferences, interests and identities are given exogenously in advance of public discourse and deliberation. It appreciates, rather, that preferences, interests and identities are as much outcomes as antecedents of public deliberation; indeed, they are discursively constituted in and through it. However, the civic-republican view contains a very serious confusion, one that blunts its critical edge. This view conflates the ideas of deliberation and the common good by assuming that deliberation must be deliberation *about* the common good. Consequently, it limits deliberation to talk framed from the standpoint of a single, all-encompassing 'we', thereby ruling claims of self-interest and group interest out of order. Yet, as Jane Mansbridge has argued, this works against one of the principle aims of deliberation, namely, to help participants clarify their interests, when those interests turn out to conflict. 'Ruling self-interest [and group interest] out of order makes it harder for any participant to sort out what is going on. In particular, the less powerful may not find ways to discover that the prevailing sense of "we" does not adequately include them' (Mansbridge 1990: 131).

In general, there is no way to know in advance whether the outcome of a deliberative process will be the discovery of a common good in which conflicts of interest evaporate as merely apparent or the discovery that conflicts of interest are real and the common good is chimerical. But if the existence of a common good cannot be presumed in advance, then there is no warrant for putting any strictures on what sorts of topics, interests and views are admissible in deliberation.

This argument holds even in the best-case scenario of societies whose basic institutional frameworks do not generate systemic inequalities; even in such relatively egalitarian societies, we cannot assume in advance that there will be no real conflicts of interest. How much more pertinent, then, the argument is to stratified societies, which are traversed with pervasive relations of inequality. After all, when social arrangements operate to the systemic profit of some groups of people and to the systemic detriment of others, there are prima facie reasons for thinking that the postulation of a common good shared by exploiters and exploited may well be a mystification. Moreover, any consensus that purports to represent the common good in this social context should be regarded with suspicion, since this consensus will have been reached through deliberative processes tainted by the effects of dominance and subordination.

In general, critical theory needs to take a harder, more critical look at the terms 'private' and 'public'. These terms, after all, are not simply straightforward designations of societal spheres; they are cultural classifications and rhetorical labels. In political discourse they are powerful terms frequently deployed to delegitimate some interests, views, and topics and to valorise others.

This brings me to two other senses of 'private', which often function ideologically to delimit the boundaries of the public sphere in ways that disadvantage subordinate

social groups. These are the fifth sense, pertaining to private property in a market economy, and the sixth sense, pertaining to intimate domestic or personal life, including sexual life. Each of these senses is at the centre of a rhetoric of privacy that has historically been used to restrict the universe of legitimate public contestation.

The rhetoric of domestic privacy would exclude some issues and interests from public debate by personalising and/or familiarising them; it casts these as private, domestic or personal, familial matters in contradistinction to public, political matters. The rhetoric of economic privacy, in contrast, would exclude some issues and interests from public debate by economising them; the issues in question here are cast as impersonal market imperatives or as 'private' ownership prerogatives or as technical problems for managers and planners, all in contradistinction to public, political matters. In both cases, the result is to enclave certain matters in specialised discursive arenas and thereby to shield them from broadly based debate and contestation. This usually works to the advantage of dominant groups and individuals and to the disadvantage of their subordinates. If wife-battering, for example, is labelled a 'personal' or 'domestic' matter and if public discourse about it is channelled into specialised institutions associated with, say, family law, social work, and the sociology and psychology of 'deviance', then this serves to reproduce gender dominance and subordination. Similarly, if questions of workplace democracy are labelled 'economic' or 'managerial' problems and if discourse about these questions is shunted into specialised institutions associated with, say, 'industrial relations' sociology, labour law, and 'management science', then this serves to perpetuate class (and usually also gender and race) dominance and subordination.

This shows once again that the lifting of formal restrictions on public-sphere participation does not suffice to ensure inclusion in practice. On the contrary, even after women and workers have been formally licensed to participate, their participation may be hedged by conceptions of economic privacy and domestic privacy that delimit the scope of debate. These notions, therefore, are vehicles through which gender and class disadvantages may continue to operate subtextually and informally, even after explicit, formal restrictions have been rescinded.

Strong publics, weak publics: on civil society and the state

Let me turn now to my fourth and last assumption underlying the bourgeois conception of the public sphere, namely, the assumption that a functioning democratic public sphere requires a sharp separation of civil society and the state. This assumption is susceptible to two different interpretations, according to how one understands the expression 'civil society'. If one takes that expression to mean a privately ordered, capitalist economy, then to insist on its separation from the state is to defend classical liberalism. The claim would be that a system of limited government and *laissez-faire* capitalism is a necessary precondition for a well-functioning public sphere.

We can dispose of this (relatively uninteresting) claim fairly quickly by drawing on some arguments of the previous sections. I have already shown that participatory

parity is essential to a democratic public sphere and that rough socio-economic equality is a precondition of participatory parity. Now I need only add that *laissez-faire* capitalism does not foster socio-economic equality and that some form of politically regulated economic reorganisation and redistribution is needed to achieve that end. Likewise, I have also shown that efforts to 'privatise' economic issues and to cast them as off-limits with respect to state activity impede, rather than promote, the sort of full and free discussion built into the idea of a public sphere. It follows from these considerations that a sharp separation of (economic) civil society and the state is not a necessary condition for a well-functioning public sphere. On the contrary and *pace* the bourgeois conception, it is precisely some sort of interimbrication of these institutions that is needed.

However, there is also a second, more interesting interpretation of the bourgeois assumption that a sharp separation of civil society and the state is necessary to a working public sphere, one that warrants more extended examination. In this interpretation, 'civil society' means the nexus of non-governmental or 'secondary' associations that are neither economic nor administrative. We can best appreciate the force of the claim that civil society in this sense should be separate from the state if we recall Habermas's definition of the liberal public sphere as a 'body of private persons assembled to form a public'. The emphasis here on 'private persons' signals (among other things) that the members of the bourgeois public are not state officials and that their participation in the public sphere is not undertaken in any official capacity. Accordingly, their discourse does not eventuate in binding, sovereign decisions authorising the use of state power; on the contrary, it eventuates in 'public opinion', critical commentary on authorised decision-making that transpires elsewhere. The public sphere, in short, is not the state; it is rather the informally mobilised body of non-governmental discursive opinion that can serve as a counterweight to the state. Indeed, in the bourgeois conception, it is precisely this extra-governmental character of the public sphere that confers an aura of independence, autonomy and legitimacy on the 'public opinion' generated in it.

Thus the bourgeois conception of the public sphere supposes the desirability of a sharp separation of (associational) civil society and the state. As a result, it promotes what I shall call *weak publics*, publics whose deliberative practice consists exclusively in opinion formation and does not also encompass decision-making. Moreover, the bourgeois conception seems to imply that an expansion of such publics' discursive authority to encompass decision-making as well as opinion-making would threaten the autonomy of public opinion, for then the public would effectively become the state, and the possibility of a critical discursive check on the state would be lost.

That, at least, is suggested by Habermas's initial formulation of the bourgeois conception. In fact, the issue becomes more complicated as soon as we consider the emergence of parliamentary sovereignty. With that landmark development in the history of the public sphere, we encounter a major structural transformation, since a sovereign parliament functions as a public sphere *within* the state. Moreover, sovereign parliaments are what I shall call *strong publics*, publics whose discourse encompasses both opinion formation and decision-making. As a locus of public deliberation culminating in legally binding decisions (or laws), parliament was to

be the site for the discursive authorisation of the use of state power. With the achievement of parliamentary sovereignty, therefore, the line separating (associational) civil society and the state is blurred.

Clearly, the emergence of parliamentary sovereignty and the consequent blurring of the separation between (associational) civil society and the state represents a democratic advance over earlier political arrangements. This is because, as the terms 'strong public' and 'weak public' suggest, the force of public opinion is strengthened when a body representing it is empowered to translate such 'opinion' into authoritative decisions. At the same time, there remain important questions about the relation between parliamentary strong publics and the weak publics to which they are supposed to be accountable. In general, these developments raise some interesting and important questions about the relative merits of weak and strong publics and about the respective roles that institutions of both kinds might play in a democratic and egalitarian society.

One set of questions concerns the possible proliferation of strong publics in the form of self-managing institutions. In self-managed workplaces, child-care centres or residential communities, for example, internal institutional public spheres could be arenas both of opinion formation and decision-making. This would be tantamount to constituting sites of direct or quasi-direct democracy, wherein all those engaged in a collective undertaking would participate in deliberations to determine its design and operation. However, this would still leave open the relationship between such internal public spheres cum decision-making bodies and those external publics to which they might also be deemed accountable. The question of that relationship becomes important when we consider that people affected by an undertaking in which they do not directly participate as agents may none the less have a stake in its modus operandi; they therefore also have a legitimate claim to a say in its institutional design and operation.

Here we are again broaching the issue of accountability. What institutional arrangements best ensure the accountability of democratic decision-making bodies (strong publics) to *their* external, weak, or, given the possibility of hybrid cases, weaker publics? Where in society are direct democracy arrangements called for, and where are representative forms more appropriate? How are the former best articulated with the latter? More generally, what democratic arrangements best institutionalise co-ordination among different institutions, including co-ordination among their various complicated publics? Should we think of central parliament as a strong super-public with authoritative discursive sovereignty over basic societal ground rules and co-ordination arrangements? If so, does that require the assumption of a single weak(er) external super-public (in addition to, not instead of, various other smaller publics)? In any event, given the inescapable global interdependence manifest in the international division of labour within a single shared planetary biosphere, does it make sense to understand the nation state as the appropriate unit of sovereignty?

I do not know the answers to most of these questions, and I am unable to explore them further in this essay. However, the possibility of posing them, even in the absence of full, persuasive answers, enables us to draw one salient conclusion: any conception of the public sphere that requires a sharp separation between (associational) civil society and the state will be unable to imagine the

forms of self-management, interpublic co-ordination and political accountability that are essential to a democratic and egalitarian society. The bourgeois conception of the public sphere, therefore, is not adequate for contemporary critical theory. What is needed, rather, is a post-bourgeois conception that can permit us to envision a greater role for (at least some) public spheres than mere autonomous opinion formation removed from authoritative decision-making. A post-bourgeois conception would enable us to think about strong *and* weak publics, as well as about various hybrid forms. In addition, it would allow us to theorise the range of possible relations among such publics, which would expand our capacity to envision democratic possibilities beyond the limits of actually existing democracy.

Janice A. Radway

THE INSTITUTIONAL MATRIX OF
ROMANCE

EDITOR'S INTRODUCTION

IN THIS ESSAY (a section of the first chapter of her book *Reading the Romance*), Janice Radway offers an analysis of the institutions in which the romance is produced. Asking the question: 'what makes romances so popular?' she argues that it cannot simply be answered in terms of the pleasure the romance genre offers readers or the desires it satisfies. After all, a business intervenes between texts and their readers.

By sketching a history of the mass-market publishing industry she shows how it has become increasingly sophisticated and specialized as it attempts to reduce the risks that are so great a part of all cultural businesses. Modern popular romance develops as a genre through a series of strategic decisions by publishers. Yet it is important to emphasize that Radway does not conceive of romance readers as cultural dupes. For her, romance reading occurs in a tripartite structure in which readers' pleasure/choice, the publishing industry, and the writer each play a part in determining textual production.

Further reading: Cohn 1990; Dricoll 2002; Fuchs 2004; Jenkins 1992; Jenkins and Tulloch 1995; Long 2003; Modleski 1982 and 1987; Radway 1984 and 1999; Schwartz 1989.

Like all other commercial commodities in our industrial culture, literary texts are the result of a complicated and lengthy process of production that is itself controlled by a host of material and social factors. Indeed, the modern mass-market paperback was made possible by such technological innovations as the rotary magazine press and

synthetic glue as well as by organisational changes in the publishing and bookselling industries. One of the major weaknesses of the earlier romance critique has been its failure to recognise and take account of these indisputable facts in its effort to explain the genre's growing popularity. Because literary critics tend to move immediately from textual interpretation to sociological explanation, they conclude easily that changes in textual features or generic popularity must be the simple and direct result of ideological shifts in the surrounding culture. Thus, because she detects a more overtly misogynist message at the heart of the genre, Ann Douglas can argue in her widely quoted article 'Soft-porn culture' that the coincidence of the romance's increasing popularity with the rise of the women's movement must point to a new and developing backlash against feminism. Because that new message is there in the text, she reasons, those who repetitively buy romances must experience a more insistent need to receive it again and again.

Although this kind of argument sounds logical enough, it rests on a series of tenuous assumptions about the equivalence of critics and readers and ignores the basic facts about the changing nature of book production and distribution in contemporary America. Douglas's explanatory strategy assumes that purchasing decisions are a function *only* of the content of a given text and of the needs of readers. In fact, they are deeply affected by a book's appearance and availability as well as by potential readers' awareness and expectations. Book buying, then, cannot be reduced to a simple interaction between a book and a reader. It is an event that is affected and at least partially controlled by the material nature of book publishing as a socially organised technology of production and distribution.

The apparent increase in the romance's popularity may well be attributable to women's changing beliefs and needs. However, it is conceivable that it is equally a function of other factors as well, precisely because the romance's recent success *also* coincides with important changes in book production, distribution, advertising and marketing techniques. In fact, it may be true that Harlequin Enterprises can sell 168 million romances not because women suddenly have a greater need for the romantic fantasy but because the corporation has learned to address and overcome certain recurring problems in the production and distribution of books for a mass audience. If it can be shown that romance sales have been increased by particular practices newly adopted within the publishing industry, then we must entertain the alternative possibility that the apparent need of the female audience for this type of fiction may have been generated or at least augmented artificially. If so, the astonishing success of the romance may constitute evidence for the effectiveness of commodity packaging and advertising and not for actual changes in readers' beliefs or in the surrounding culture. The decision about what the romance's popularity constitutes evidence for cannot be made until we know something more about recent changes in paperback marketing strategies, which differ substantially from those that have been used by the industry for almost 150 years.

Standard book-marketing practices can be traced, in fact, to particular conceptions of the book and of the act of publication itself, both of which developed initially as a consequence of the early organisation of the industry. The output of the first American press, established at Cambridge, Massachusetts, in 1639, was largely the ecclesiastical work of learned gentlemen of independent means who could afford to pay the printer to issue their books. Limitation of authorship to those

with sufficient capital occurred generally throughout the colonies because most of the early presses were owned by combined printer-publishers who charged authors a flat fee for typesetting and distribution and a royalty for each book sold. Because it was the author who financed publication and thus shouldered the risk of unsold copies, the printer-publisher had relatively little interest in seeing that the book appealed to previously known audience taste. As a result, authors exerted almost total control over their works, which were then conceived as the unique products of their own individual intellects. Publication was concomitantly envisioned as the act of publicly issuing an author's ideas, an act that could be accomplished by the formal presentation of even one copy of those ideas for public review. In the early years of the printing industry, therefore, the *idea* of publication was not tied to the issue of sales or readership. As long as the work was presented in the public domain, it was considered published, regardless of whether it was read or not.

Of course, authors did concern themselves with readers, not least because they stood to lose a good deal if their books failed to sell. However, the problem was not a major one because the literate reading community was small and because publication itself was carried out on a local scale. The author very often knew who his readers were likely to be and could tailor his offering to their interests and tastes. Indeed, it was not uncommon for an early American writer to finance publication by soliciting contributions from specific, known subscribers whom he made every effort to please. It was thus relatively easy to match individual books with the readers most likely to appreciate the sentiments expressed within them.

Thus the concept of the book as a unique configuration of ideas conceived with a unique hypothetical audience in mind developed as the governing conception of the industry. Publishers prided themselves on the diversity of their offerings and conceived the strength of an individual house to be its ability to supply the American reading public with a constant stream of unique and different books. In addition, they reasoned further that because publishing houses issued so many different kinds of works, each of which was intended for an entirely different public, it was futile to advertise the house name itself or to publicise a single book for a heterogeneous national audience. In place of national advertising, then, publishers relied on editors' intuitive abilities to identify the theoretical audiences for which books had been conceived and on their skills at locating real readers who corresponded to those hypothetical groups. Throughout the nineteenth century and indeed well into the twentieth, authors, editors and publishers alike continued to think of the process of publication as a personal, discrete and limited act because they believed that the very particularity and individuality of books destined them for equally particular and individual publics.

Despite the continuing domination of this attitude, the traditional view of book publishing was challenged, even if only tentatively, in the early years of the nineteenth century by an alternative view which held that certain series of books could be sold successfully and continuously to a huge, heterogeneous, preconstituted public. Made possible by revolutionary developments in technology and distribution and by the changing character of the reading audience itself, this new idea of the book as a saleable commodity gradually began to alter the organisation of the editorial process and eventually the conception of publishing itself. Although this new view of the book and of the proper way to distribute it was at first associated

only with a certain kind of printer-publisher, it was gradually acknowledged and later grudgingly used by more traditional houses when it became clear that readers could be induced to buy quite similar books again and again.

The specific technological developments that prepared the way for the early rationalisation of the book industry included the improvement of machine-made paper, the introduction of mechanical typesetting and more sophisticated flatbed presses, and the invention of the Napier and Hoe cylinder press. The inventions of the steamboat and the railroad and the extension of literacy – especially to women – combined to establish publishing as a commercial industry with the technical capacity to produce for a mass audience by 1830. What this meant was that commercially minded individuals began to enter the business with the sole purpose of turning a profit.

The first production scheme designed specifically to mass produce cheap paperbound books and to utilise the magazine distribution system was not mounted until 1937 when Mercury Publications created American Mercury Books. In fact, according to Frank Schick, American Mercury was the first paperbound book series to employ magazine distribution successfully. Packaged to look like magazines, these books were sold at newsstands and, like periodicals, remained available only for a month. American Mercury's practices, which stressed the ephemerality of this literature, clearly differentiated this publishing venture from more traditional book production, which continued to focus on the establishment of a line of diverse books of lasting worth to be kept constantly in print on a backlist and in stock at the better retail establishments. Although the company at first published a variety of titles, by 1940 the editors had decided to concentrate on mysteries in the interest of establishing better control over their market. The new series, called Mercury Mysteries, differentiated its remarkably similar covers and titles by numbering each book for the reader's convenience.

The publishers of American Mercury Books hoped to sell their paperbacks in large quantities to readers who already knew their mystery magazines. Those magazines enabled the editors to take note of reader opinion and to gauge preferences that they then sought to match in their manuscript selection. In effect, American Mercury tried to control both its audience *and* the books produced especially for that group. Despite this successful formalisation of category publishing, the relatively small size of the American Mercury venture has prevented it from being credited with the mass-market paperback revolution. Although that honour is usually awarded to Robert de Graff for his founding of Pocket Books in 1939, his scheme introduced no new conceptual innovations to the industry. Like the editors at American Mercury, de Graff thought of the book as a commodity to be sold, relied on the magazine system of distribution and gradually turned to category publication. Still, it was de Graff's ability to institute this system on a large scale that set the stage for the romance's rise to dominance within the mass-market industry. To understand exactly how and why the romance has become so important in commodity publishing, it is necessary to understand first how the economics of paperback publishing and distribution created the industry's interest in the predictability of sales.

In the years immediately preceding de Graff's entry into the field, major improvements had been made in both printing and binding techniques. The invention

of magazine rotary presses made high-speed production runs possible and profitable. Although the new machinery was very expensive, the cost was borne largely by the printers themselves who were, by tradition, independent from publishing firms. Because the printers had to keep the costly presses operating twenty-four hours a day to guarantee a return on their initial investment, they pressured de Graff and his competitors at Avon, Popular Library and Dell to schedule production tightly and regularly. This practice led to a magazine-like monthly production schedule similar to American Mercury's, a practice that fitted nicely with de Graff's intention to distribute his books through the magazine network. The regularisation of production further enabled the printers to buy large quantities of paper at lower rates without also having to pay to store it indefinitely. The publishers benefited in turn because they could sell their books at much lower prices.

Surprisingly enough, the invention of synthetic glue also helped to add speed to the publication of the mass-market paperback. Traditional book binding is accomplished by hand or machine sewing of folded signatures of paper to create the finished book. Even when carried out mechanically, the process is both expensive and time-consuming. 'Perfect' binding is an alternative procedure in which single leaves of paper are gathered together, cut uniformly, and then glued to the spine of the cover. The first adhesives used in the process of perfect binding were animal glues that were not only slow to dry but, once dried, were so inflexible that bindings often cracked, releasing individual pages. The glues made it necessary for a printer to obtain sufficient storage space for drying the perfect-bound books. The invention of quick-drying synthetic glues eliminated most of these problems. Fast-setting adhesives necessitated assembly-line procedures that simultaneously accelerated the whole production process and obviated the need for costly storage. The new binding machines were expensive but, once again, the printers shouldered the enormous costs and passed much of the benefit on to the publishers.

Together with the rotary presses, then, perfect binding and synthetic glues made possible the production of huge quantities of books at a very low cost per unit and contributed to the acceleration and regularisation of the acquisition and editorial processes. The consequent emphasis on speed caused the paperback publishers to look with favour on category books that could be written to a fairly rigid formula. By directing their potential writers to create in this way, mass-market houses saved the time and expense of editing unique books that had as yet not demonstrated their ability to attract large numbers of readers.

The particular step taken by de Graff that made this production of vast numbers of books financially feasible was his decision to utilise the extensive magazine distribution network that had developed during the past thirty years. De Graff reasoned that if he was actually to sell the large quantities of books he could now produce so effortlessly, he would have to place books in the daily paths of many more Americans. Because he was aware of the relative lack of bookstores in the United States and of the general population's feeling that those establishments were intimidating and inhospitable, he concluded that books would have to be marketed somewhere else if they were to be sold on a grand scale. He turned to the American News Company, which had a virtual monopoly on the national distribution of magazines and newspapers, because it counted among its clients many thousands of newsstands, drugstores, candy stores and even food outlets. De

Graff felt sure that if confronted with attractively packaged and very inexpensive books at these establishments, the American magazine reader could be persuaded to become a paperback book purchaser. The phenomenal sales of his first ten titles proved him right.

Despite the advantages it offered, however, magazine distribution also posed substantial problems. De Graff and his early competitors soon discovered that few of their new book retailers knew anything about books. Uneasy about purchasing materials they might not be able to sell, these individuals at first resisted efforts to get them to stock paperback books. To overcome their hesitation, de Graff and his counterparts at other houses proposed that the entire risk of unsold books be shouldered by the publishing firms themselves. As a result, they permitted all retail outlets to return any unsold books or to certify that the books themselves had been destroyed.

The returns policy had the desired effect in that it convinced retailers that they could not be harmed by stocking paperbacks, but it proved extremely troublesome to the publishers themselves. Because they had no way to track simultaneously progressing returns and new print orders or to shift the returns from one outlet to another, many publishers found themselves sending a book through a second printing to accommodate demand, only to discover later, after all returns were completed, that eventual total sales were less than the first print order. The resulting overproduction was very costly and caused the mass-market publishers to search for ways to make book sales more predictable. It was thus that category literature suggested itself as a means of gauging how a new version of an already proved type of book might perform in the market.

Category or formulaic literature has been defined most often by its standard reliance on a recipe that dictates the essential ingredients to be included in each new version of the form. It therefore permits an editor to direct and control book creation in highly specific ways. It is worth emphasising, however, that the category literature is *also* characterised by its consistent appeal to a regular audience.

Not only does this kind of production obviate the need to set print orders solely on the basis of blind intuition, but it also reduces the difficulties of designing a proper advertising campaign. By relying on the subscription lists of related periodicals and on sales figures of earlier offerings in the genre, category publishers can project potential sales with some certainty. At the same time, they can use the periodicals for a specific advertising strategy and thus avoid the difficulty and expense of mounting a national effort in the hope of ferreting out the proper audience by chance.

To understand the importance of the fact that category publishing makes book advertising manageable, it is necessary to know that publishers have argued for years that books cannot be marketed or advertised as are other commodities. Because every book is individual and unique, the industry has maintained, all publishers must 'start from scratch' in the effort to build an audience for them. Assuming, therefore, that the discreteness of books necessitated that each be advertised individually, publishers concluded that the enormous expense of advertising an entire month's offering ruled out the process entirely. Furthermore, because they believed that the variety of books offered by each firm made the creation of a single image of the house impossible, they also concluded that potentially less

expensive national advertising of the house imprint would do nothing for the sales of individual books. Thus the publishing industry's advertising budget has been remarkably small for many years. The situation did not change until the 1970s when corporate takeovers of independent houses by large communications conglomerates resulted in the infusion of huge amounts of capital, some of which was directed to advertising budgets. However, before explaining how and why this has occurred and its relevance to our investigation of the romance, it is necessary to return to the early years of the third paperback revolution to trace the growing importance of the romance genre within the mass-market industry.

Although the early paperback publishers relied initially on proven hardcover bestsellers to guarantee large sales, they soon found that an insufficient number of these were available to supply the demand for cheap, paper-covered books. Wary of producing huge quantities of a title that had not yet demonstrated its saleability, these mass-market houses slowly began to rely on books that were examples of categories already proven to be popular with the reading public. The trend really began with the mystery or detective story that developed as the first dominant category in modern mass-market publishing. The genre was particularly well suited for semi-programmed issue because the writer–publisher–audience relationship had been formalised in the 1920s with the establishment of the pulps like *Black Mask*, *Dime Detective*, *Detective Story* and *Detective Fiction Weekly*. They helped to establish a generic orthodoxy which would then guide continuous novel production in hardcover format. Paperback mystery publishing developed simply as an extension of an already established literary practice.

Unfortunately, mystery popularity declined throughout the 1950s. Although the genre occasionally gained back the readers it lost, several publishers none the less began to look elsewhere for new material that they could sell on an even more regular and predictable basis. Troubled by this variability in mystery sales, Gerald Gross at Ace Books recalled the consistent reprint success of Daphne du Maurier's *Rebecca*. Wondering whether its long-standing popularity (it had been published first in 1938) indicated that it struck a universal chord in female readers, he attempted to locate previously published titles resembling du Maurier's novel, which he hoped to issue in a 'gothic' series. He settled upon Phyllis Whitney's *Thunder Heights*, which he then published in 1960 as the first title in his 'gothic' line.

Since Gross and other gothic publishers were not simply inserting mass-produced reading matter into a previously formalised channel of communication as had been done with paperback mysteries, it is necessary to ask why they were almost immediately successful in establishing the gothic romance as a particular category and in creating a growing demand for new titles. Their success cannot be attributed to the mere act of offering a new product to an audience already identified and therefore 'controlled' by the fact of its common subscription to the same magazines. Although confession and romance periodicals had been supplying love stories for faithful readers since their first appearance in the 1920s, these pulps were designed for a working-class audience. Because book reading has always been correlated with high education and income levels, it seems probable that the gothic's extraordinary paperback success was the result of the publishers' ability to convert and then repetitively reach middle-class women. Although one might suspect that these publishers relied on the middle-class trade magazines – such

as *Good Housekeeping* or the *Ladies' Home Journal* — to identify and retain its new audience, in fact, this does not appear to have been the case. Publishers used very little advertising to promote the sales of the early gothics.

What, then, accounts for the immediate success of the category? The achievement has much to do with the special characteristics of its audience, that is, with the unique situation of women in American society. The principal problem facing the publisher in a heterogeneous, modern society is finding an audience for each new book and developing a method for getting that book to its potential readers. By utilising the magazine distribution network, paperback publishers substantially increased their chances of finding buyers. But the use of this network proved especially significant for those paperback houses that were newly interested in female readers because it made available for book distribution two outlets almost always visited on a regular basis by women, the local drugstore and the food supermarket. Even the growing number of women who went to work in the 1960s continued to be held responsible for child care and basic family maintenance, as were their counterparts who remained wholly within the home. Consequently, the publishers could be sure of regularly reaching a large segment of the adult female population simply by placing the gothics in drug and food stores. At the same time, they could limit advertising expenditures because the potential or theoretical audience they hoped to attract already had been gathered for them. The early success of the gothic genre is a function of the *de facto* but none the less effective concentration of women brought about by social constraints on their placement within society. This concentration had the overall effect of limiting their diffusion throughout social space. In turn, this limitation guaranteed that, as a potential book-buying public, American women were remarkably easy to reach.

The popularity of gothic romances increased throughout the decade of the 1960s. While American college students were beginning to protest against American involvement in Vietnam and a gradually increasing number of feminists vociferously challenged female oppression, more and more women purchased novels whose plots centred on developing love relationships between wealthy, handsome men and 'spunky' but vulnerable women. The audience for gothics grew to such proportions that by the early 1970s works of top gothic authors outsold the works of equivalent writers in all other categories of paperback fiction, including mysteries, science fiction and Westerns. A typical Whitney or Holt paperback issued by Fawcett began with a first printing of 800,000 copies. Although most of the category's authors sold nowhere near that number, when taken together the gothic novels released by no fewer than eight paperback houses constituted an enormous total output.

This extraordinary sales success of gothics established them as a true cultural phenomenon and qualified them for endless analysis and satire in the news media. Many articles on 'How to write a gothic' can be found in the Sunday supplements and popular magazines of the period, attesting to widespread awareness of the phenomenon, if less than universal approbation of it.

The increased publicity notwithstanding, sales of gothic romances dropped off gradually between 1972 and 1974. Returns increased to such an extent that many houses cut back their gothic output. When asked to explain the decline in popularity, former publishers of gothics equivocate. Some feel that the market

had simply been saturated, while others suspect that the growing visibility of the feminist movement and increasing openness about female sexuality led to a greater tolerance if not desire for stories with explicit sexual encounters. All seem to agree, however, that the nature of romance publishing changed dramatically in April 1972, when Avon Books issued *The Flame and the Flower* by Kathleen Woodiwiss.

Because Woodiwiss had sent her unsolicited manuscript to Avon without the usual agent introduction, it landed on the 'slush pile', usually considered an absolute dead end in contemporary publishing. Inexplicably, it was picked up by executive editor Nancy Coffey, who was looking for something to get her through a long weekend. As she tells the story, she could not put the manuscript down. She returned to Avon enthusiastically determined to get the book into print. Coffey eventually convinced others and the book was released in April as an Avon Spectacular. Although Woodiwiss's novel, like the gothics, followed the fortunes of a pert but feminine heroine, it was nearly three times as long as the typical gothic, included more explicit descriptions of sexual encounters and near rapes, and described much travel from place to place. Despite the differences, it ended, as did all gothics, with the heroine safely returned to the hero's arms.

A paperback original, *The Flame and the Flower* was given all the publicity, advertising and promotion usually reserved for proven bestsellers. Such originals had been issued continuously in small quantities throughout the early years of mass-market history, but concentration on them was not widespread for the simple reason that it cost more to pay out an advance to an author and to advertise an unknown book than to buy reprint rights to an already moderately successful hardback. Avon, however, under the direction of Peter Meyer, had begun to experiment with originals and different advertising campaigns in the mid-1960s. When Coffey agreed to publish *The Flame and the Flower* without previous hardcover exposure, she was simply following a practice that had become fairly common within her firm. The house's extraordinary success with Woodiwiss's novel soon caused industry-wide reconsideration of the possibilities of paperback originals as potential bestsellers. When Avon followed this success with two more bestseller romances in 1974, the industry was convinced not only of the viability of the original but also of the fact that a new category had been created. Within the trade, the genre was dubbed the 'sweet savage romance' after the second entrant in the field, Rosemary Roger's *Sweet Savage Love*.

Once Avon had demonstrated that original romances could be parlayed into ready money, nearly every other mass-market house developed plans to issue its own 'sweet savage romances', 'erotic historicals', 'bodice-rippers' or 'slave sagas', as they were variously known throughout the industry. Virtually all recognised, as Yvonne McManus of Major Books did, that 'Avon ha[d] smartly created a demand through heavy advertising and promotion'. As she commented further, 'it … invented its own new trend, which is clever paperback publishing'.

Although a few houses have developed bestsellers in the 'sweet savage' category, Avon has been most successful at identifying the house imprint with this kind of romance and has established close ties with its audience by compiling a mailing list from its fan letters. Several publishers have attempted to develop other sorts of romances with the idea of creating a series or 'line' that they hope to associate in readers' minds with the house name. The creation of 'line' fiction is one

more example of the familiar attempt to identify a permanent base audience in order to make better predictions about sales and to increase profit. The growing proliferation and success of such schemes, often modelled after Avon's informal techniques or the more elaborate operations of Harlequin Enterprises, makes them an extremely important development in romance publishing specifically and in mass-market paperback publishing generally. Before assessing several of the most important of these, it will be helpful to mention two further developments, one in general publishing, the other in bookselling, that help to explain why so many paperback houses not only have found the romance market attractive but also have been able to appeal to it successfully.

The most significant development in American publishing in the twentieth century has been the assumption of control of once privately owned houses by vast communications conglomerates. Begun in 1960 with the Random House 'absorption' of Knopf and continued in 1967 when the Radio Corporation of America (RCA) purchased Random House, the merger trend has left only a few houses intact. In 1967, for instance, the Columbia Broadcasting System (CBS) acquired Holt, Rinehart & Winston and then later purchased Praeger Publishers, Popular Library and Fawcett Publications. Xerox has assumed control of Ginn & Company, R. R. Bowker and the trade periodical, *Publishers Weekly*. Dell is owned by Doubleday and Company, as is the Literary Guild. Gulf and Western has acquired both Simon & Schuster and Pocket Books. Although by no means exhaustive, this litany at least makes clear that the first impact of the merger trend has been the union of hardcover and mass-market paperback companies within a single corporate structure. Despite the fact that most individual houses have retained editorial control over what they produce, it is also apparently true that greater attention is paid to their profit-and-loss statements by corporate headquarters than the houses used to devote to them themselves.

It is not hard to understand why 'attention to the bottom line' has begun to dominate the publishing process when one considers that, despite increased profit consciousness within the mass-market segment of the industry, publishing remained a small, informally organised business well into the 1970s. Once referred to as 'seat-of-the-pants' publishing by its critics and supporters alike, the American industry continued to make decisions about manuscript selection, print orders and advertising campaigns on the basis of editors' intuitions, ignoring the availability of the computer and the development of sophisticated market-research techniques. Much of the reluctance to adopt these highly mechanical procedures can be traced to the lingering vision of publishing as the province of literary gentlemen seriously devoted to the 'cause' of humane letters. Editors worried that, if profit became the principal goal, publishers would be reluctant to sponsor the first novel of a promising young writer because its financial failure would be virtually guaranteed.

In recently assessing the impact of corporate takeovers on publishing, Thomas Whiteside has observed that the 'business was indeed riddled with inefficiency'. 'Sluggish management, agonizingly slow editorial and printing processes, creaky and ill-coordinated systems of book distribution and sales, skimpy advertising budgets, and … inadequate systems of financing', he claims, 'prevented many publishers from undertaking major long-range editorial projects that they knew were necessary to their companies' future well-being.' Traditionally a low-profit industry, trade-

book publishing was also characterised by widely varying profits because each house's fortunes fluctuated rapidly in concert with its failure or success at selling its monthly list. When the corporate managers of the new conglomerates began to scrutinise the houses' financial practices and performances, they were appalled. Most responded by forcing the publishers to adopt the procedures long familiar to the corporate world: 'efficient accounting systems, long-range planning, elimination of waste, and unnecessary duplication of services'.

Although it seems obvious that conglomerate control has had the effect of forcing trade publishers to do away almost completely with 'mid-level' books – those that perform only moderately well in both the market and in critical opinion – it has had the additional effect of providing the paperback houses with large sums of money. This has enabled them to pay huge fees for the reprint rights to bestselling novels; it has also permitted them to devote a great deal of financial attention to planning category sales by commissioning market-research studies and to the advertising of the new 'lines' created as their consequence. The logic behind this kind of financial manoeuvre is grounded on the assumption that if paperback sales can be made more predictable and steady, the newly acquired mass-market section of a conglomerate can be used to balance out the necessarily unpredictable operation of the trade process.

Corporate takeovers have had the effect, then, of adding to the pressure on paperback houses to devote increasing amounts of time and money to category sales. At the same time, because reprint rights have grown enormously expensive, it has been necessary for them to place even more emphasis on the acquisition of original manuscripts. To avoid the difficulties of training inexperienced writers and the expense of introducing their works on an individual basis to new audiences, paperback publishers have consequently tended to seek out originals that fit closely within category patterns. They believe it is easier to introduce a new author by fitting his or her work into a previously formalised chain of communication than to establish its uniqueness by locating a special audience for it. The trend has proven so powerful, in fact, that as of 1980, 40 to 50 per cent of nearly every house's monthly releases were paperback originals. The conglomerates' quest for financial accountability has had another effect besides that of increasing the emphasis on category publishing with its steady, nearly guaranteed sales. Their overwhelming interest in predictability has also helped to forge an important link between the now more profit-minded paperback houses and the increasingly successful bookstore chains, B. Dalton, Bookseller and Waldenbooks. Together, these two developments have led to even greater industry interest in romantic novels and the women who purchase them.

Indeed, while the recent history of paperback publishing has been dominated by the rise to prominence of the blockbuster bestseller, it has also been characterised by this slow but inexorable transformation of the business from a relatively small, informally run enterprise still focused on the figure of the author and the event of book *reading* into a consumer-oriented industry making use of the most sophisticated marketing and advertising techniques to facilitate simple commodity exchange. The extraordinary popularity of the romance is in part a function of this transformation, since those very techniques have been applied most energetically to this kind of category literature. Although publishers cannot explain adequately why marketing

research was applied to romances rather than to spy thrillers or Westerns, it seems likely that the decision was influenced by two factors.

First, female readers constitute more than half of the book-reading public. More money is to be made, it seems, by capturing a sizeable portion of that large audience than by trying to reach nearly all of a smaller one. At the same time, women are remarkably available as a book-buying public in the sense that their social duties and habits make them accessible to publishers on a regular basis. The possibility of easy and extensive distribution to an audience inadvertently gathered for them by other forces thus tends to justify the mass production of romances. Currently, one-quarter to one-third of the approximately four hundred paperback titles issued each month are original romances of one kind or another. Almost all of the ten largest paperback houses include a fair proportion of romance fiction as part of their monthly releases. In addition, Harlequin now claims that its million-dollar advertising campaigns reach one out of every ten women in America and that 40 per cent of those reached can usually be converted into Harlequin readers. The huge sales figures associated with romance fiction seem to be the result of this all-important ability to get at a potential audience.

Second, romance novels obviously provide a reading experience enjoyable enough for large numbers of women so that they wish to repeat that experience whenever they can. To conclude, however, that the increasing domination of the paperback market by the romance testifies automatically to some *greater* need for reassurance among American women is to make an unjustified leap in logic. It is also to ignore the other evidence demonstrating that the domination is the consequence of a calculated strategy to make the largest profit possible by appealing to the single most important segment of the book-buying public. The romance's popularity must be tied closely to these important historical changes in the book publishing industry as a whole.

None the less, that popularity is also clearly attributable to the peculiar fact that much of book reading and book buying in America is carried on by women. Many observers of women and book publishing alike have concluded that middle-class women are book readers because they have both the necessary money and the time. They have the time, certainly, because, until recently, social custom kept them out of the full-time paid labour force and in the home where their primary duties involved the care and nurture of the family and, in particular, children. Because children are absent from the home for part of the day after the first several years, the reasoning proceeds, their mothers have blocks of time that can be devoted to the activity of reading.

Although not all women readers are represented by these conditions, it seems highly likely that they do provide the background for the majority of women who are romance readers. Actual demographic statistics are closely guarded within the competitive publishing industry by executives who often insist that romances are read by a broad cross section of the American female population. Still, both Harlequin and Silhouette have indicated repeatedly that the majority of their readers fall within the twenty-five to forty-five age group. If this is true, the meaning of the romance-reading experience may be closely tied to the way the act of reading fits within the middle-class mother's day and the way the story itself addresses anxieties, fears and psychological needs resulting from her social and familial

position. It is to these questions that we must turn, keeping in mind all the while that burgeoning sales do not necessarily imply increasing demand or need. Publishers and the profit motive must be given their due in any effort to explain the popularity of the romance or to understand its significance as a historical and cultural phenomenon. It should also be kept in mind that despite its relative success at gauging general audience interest, semi-programmed issue cannot yet guarantee perfect fit between all readers' expectations and the publisher's product.

Jodi Dean

THE NET AND MULTIPLE REALITIES

EDITOR'S INTRODUCTION

JODI DEAN'S ESSAY ON THE INTERNET, the public sphere and democracy begins from the observation that responses to the net have taken two quite different, indeed opposing lines: 1) it creates too much public sphere, that is it extends our capacity to communicate with one another way past the degree where that capacity can have orderly and progressive outcomes; and 2) it is in the process of destroying the public sphere since basically the net consists of masses of solitary people independently staring at computer monitors.

Both these responses depend on a notion of the public sphere as developed by the German social theorist Jürgen Habermas, who believes that open public discussion can further the enlightened, democratic ideal (and which is explored in more depth in the piece by Nancy Fraser collected in this anthology). But Dean uses the contradictory critique of the net to argue that we should not think of the new communication networks that it opens up in terms of the public sphere at all.

What we have, instead, is something she calls 'communicative capitalism'. And as a form of communicative capitalism, the net is not best thought of as a 'virtual space' (that is old-school thinking on this issue as almost all internet scholars agree) or of a place even where 'multiple realities' meet (she seems to be referencing Bruno Latour here) but rather as a 'democracy without a public' which forms a massive site of conflict, since, for Dean as for Marxists of old, capitalism produces conflict in its very structure, notably between those it enriches and those it (relatively) impoverishes.

The net becomes a 'zero institution' – an institution which is not an institution but which nonetheless stands for (rather than is) a particular kind of social

order — where voices are heard outside knowable channels of communication and reception and which is home to new 'neodemocratic' politics of resistance caught in globalized, networked, hyper-capitalism.

Neodemocracy has yet to be fully theorized but it may well take the form of mutating, provisional alliances between individuals and groups who may share common ground only in some causes, moving from issue to issue, from cause to cause, theorizing connections between the issues and causes as it goes, positioned against the hegemony of the nation-state, using the net's anonymity and absence of publicity as camouflage and fire brush to fire up larger constituencies.

Further reading: Anderson *et al.* 2002; Dean 2002; Habermas 1991; Hansen and Lenoir 2004; Keane 2003.

What is the public sphere? What kind of political architecture does it involve?

Most generally put, the public sphere is the site and subject of liberal democratic practice. That is to say, in political theory it is posited as that space within which people deliberate over matters of common concern, matters that are contested and about which it seems necessary to reach a consensus.

We see versions of this notion of the public sphere at work in legal distinctions between public and private spheres, where public refers to the state and private refers to the market and the family. Likewise, invocations of some sort of public are frequent in newspaper and campaign rhetoric. From public opinion polls to statements like 'the public was outraged to learn' and 'the public has a right to know,' we find an idea of the public as that general audience whose opinions matter, as those folks whose agreement or disagreement could change the course of elections or make or break a play, movie, or television show.

To be sure, political theory provides varying conceptualizations of the public sphere. Hannah Arendt, for example, offers a notion of the public sphere rooted in her understanding of the politics of ancient Greece. For her, what is important about the public sphere is that it is a place of freedom and contestation separate from the demands of work and the necessities of bare life. In contrast, Richard Sennett reads the public sphere more aesthetically, in terms of practices of self-presentation and display. When I speak of the public sphere, I have in mind the work of Jürgen Habermas. His book, *The Structural Transformation of the Public Sphere*, has been vastly influential in numerous fields from sociology and political science to cultural studies and communications theory. So, I use Habermas's conception because of its widespread impact, presuming that most normative invocations of the public have something like this in mind.

In *The Structural Transformation of the Public Sphere* not only does Habermas trace the emergence of the notion of the public in key Enlightenment political theories, but also he looks at the material emergence of a sphere of private persons coming together as a public in the 18th century in German Tischgesellschaften, English coffee houses, and French salons. What Habermas finds in these new associations

are a set of political norms crucial for democratic practice. First, there was disregard for social status, a fundamental parity among all participants such that the authority of the better argument could win out over social hierarchy. Second, new areas of questioning and critique were opened up as culture itself was produced as a commodity to be consumer. Third, the newly emerging public was established as open and inclusive in principle. That is to say, anyone could have access to that which was discussed in the public sphere. These abstractions lead Habermas, fourth, to conceptualize the public sphere in terms of the public use of reason.

So, we have a set of norms: equality, transparency, inclusivity, rationality. These norms apply to actions within the public sphere. But what is the public sphere? What is its architecture more basically? I break this down into the following components: site, goal, means, norms, and vehicle. What Habermas has in mind with his account of the public sphere, and what tends to be assumed, even if only tacitly in invocations of the notion of the public, are actors meeting face to face according to legal or rational deliberative procedures in order to come to agreement on a matter of national interest. The actors tend to be conceptualized as free and rational agents, as citizens who make rational choices about their interests, who have looked into various alternatives and made a coherent, explicable choice. Their deliberations with others are thought of, again, in terms of rational discussions if not exactly between friends then at least not between enemies or even strangers. These are people who simply disagree on the matter at hand but share enough common conceptions to have a discussion – and this makes sense, of course, given that the site is already the nation.

Now, this conception of the public sphere has come under all sorts of good criticisms – it never existed, it excluded women, it was built on the backs of the working class. Habermas himself has changed his mind about key aspects of it, even though he still thinks that the norms of the public sphere are those crucial for deliberative democracy. But, even as the details of the concept have been heavily criticized, the concept is still widely used and championed. Indeed, communication as well as political theorists are likely to take it as axiomatic that something like the public sphere is necessary for democratic politics (Nicholas Garnham, Nancy Fraser, Lauren Berlant). Many current uses of the idea of the public try to avoid the criticisms of the concept by adding an 's.' So, they talk about subaltern counter publics and the like, trading on the normative currency of the concept while trying to avoid its exclusionary dimensions. As an aside, let me add that these attempts to save the concept by adding an 's' to it are worthless: if the groups all have the same norms, then they are part of one public in the Habermasian sense; if they don't have the same norms, if they are exclusive, partial, oriented around specific concerns and interests, then they are not publics but different sorts of groups, interest groups, say. This is important because, to use the example of identity politics, it is precisely the exclusivity of the group that is crucial for its group-ness; it isn't supposed to be a public at all.

Anyway, back to argument, the public sphere has been particularly championed or particularly reinvigorated today because of the emergence of new communication technologies. Habermas himself thinks that 'the phenomenon of a world public sphere' is today 'becoming politically reality for the first time in a cosmopolitan matrix of communication.' Folks familiar with Net hype from the early nineties

will no doubt recall the emphasis on the information superhighway and the town halls for millions. I recently came across an article from ICANN expert Michael Froomkin arguing that the Internet Standards process not only follows but provides empirical validation of Habermas's account of the communicative justification of action norms. And, it seems like we even have a version of this when folks treat the Net as the 'commons' (Noam Chomsky, Hardt and Negri).

Computer-mediated interactions, then, seem to many to materialize aspirations long associated with the public sphere. Indeed, contemporary technoculture itself sometimes seems a machinery produced by the very ideals inspiring democracy. Clearly, advances in computer-mediated interaction provide ever greater numbers of people with access to information. No longer a privilege of the elite, information is available to anyone with a computer. Similarly, more people have opportunities to register their thoughts and opinions in political discussions than ever before. Chatrooms, cybersalons, and ezines are just some of the new electronic spaces in which people can participate as equals in processes of collective will formation. Describing the early nineties ecstasy over the possibilities of computer democracy, Hubertus Buchstein writes, *If one accepts the claims of the optimists, the new technology seems to match all the basic requirements of Habermas's normative theory of the democratic public sphere: it is a universal, anti-hierarchical, complex, and demanding mode of interaction. Because it offers universal access, uncoerced communication, freedom of expression, an unrestricted agenda, participation outside of traditional political institutions and generates public opinion through processes of discussion, the Internet looks like the most ideal speech situation.*

But is the Net really a public sphere? Does the notion of a public sphere help us think better about networked communications?

What's wrong with this picture?

As I already said, I don't think the Net is anything like a public sphere. To explain why, I'm going to do two things. First, I'm going to consider how public sphere norms appear in cybertheory. They appear in two completely opposed ways – as cyberia's lack and as its excess. Second, because of this weird oscillation, I'm going to broaden the frame of analysis to consider what interests are served by thinking of the Net in terms of a public sphere. Put in old-fashioned terms, I'm going to consider the problem of configuring the Net as a public sphere as one that can be addressed through ideology critique. That is, the characterization of networked communication as lacking public sphere norms on the one hand, and as plagued by a surfeit of these norms, on the other, tells us a lot about the ideology materialized in the Internet. And I will argue that it is an ideology of publicity in the service of communicative capitalism.

Lack, or why doesn't the Net look more like the public sphere

Now, I'm sure that we can all immediately think of all sorts of common complaints about the Net that rely on the idea that the Net needs to be more like a public

sphere. For example, early complaints that the Net was dominated by young, white, American, men echoed the critique of the bourgeois public sphere for excluding women, ethnic and racial minorities, and the working class. Here, the key issue was inclusion: all that cyberspace needed to really be the public sphere was to be more inclusive. Likewise, as larger and less experienced cohorts of newbies were brought online, hostile environment concerns emerged: was cyberspace too sexist, too racist, too offensive? Did it operate according to norms of equality and rationality, decency and civility? And, if it didn't what sorts of architectures might better secure these norms?

But these are only some of the most general ways that networked communications link up with the idea of the public sphere. I'm actually more interested in how deep down the assumptions are encoded. So, let's consider a passage from the introduction to *Resisting the Virtual Life*. There, James Brook and Iain Boal write that:

> virtual technologies are pernicious when their simulacra of relationships are deployed societywise as substitutes for face-to-face interactions, which are inherently richer than mediated interactions. Nowadays, the monosyllabic couch potato is joined by the information junkie in passive admiration of the little screen; this passivity is only refined and intensified by programmed 'interactivity'

This sort of criticism is rooted in the assumption that the Net should be more like a public sphere, that the faults of the Net are those points at which it fails to achieve public sphereness. Its basic point is that the Net lacks what it needs to be a proper public sphere.

Where do we see this? We see this in their worry about 'subsitution,' one, and in their concomitant displacement of the Net by television, two.

1 Brook and Boal worry that networked interactions will substitute for face-to-face interactions. For them, face-to-face interactions are somehow more natural and hence better than actions that are not face-to-face. But, face-to-face here (and I will go ahead with the bold claim that this is the case in absolutely any invocation of face-to-face interactions) needs to be understood as purely an imaginary object, as a fantasy that in fact relies on its opposition to 'mediated interactions' for it claim to be 'inherently richer.' All interactions are mediated; there is no pure, immediate, fully-present, fully-transparent encounter. But, by worrying that computer mediated interactions will "substitute" for face-to-face ones, they can occlude this fact. And, this occlusion, this naturalization and idealization of face-to-face interactions in effect produces the subject of these interactions as an embodied individual richly interconnected with significant others in significant, real, relationships – none of which, presumably, are mediated at all. So, the worry about substitution in effect produces the individuated agent of the public sphere.

2 Notice, that in their emphasis on face-to-face interactions in contrast to the simulacra of technologically mediated relationships, Brook and Boal associate unity with allegedly natural interactions and fragmentation with technology:

the person (that they created through the opposition between face-to-face and mediation) is alone, passively consuming information in front of a screen. But this is weird – what happened to the technologically mediated relationship? Now the person in their account is totally alone. The interaction is completed displaced by the screen. And, clearly, the screen is really a television screen, not a computer screen at all – this is clear with their reference to the monosyllabic couch potato. And, this displacement lets them treat the person in front of the screen as a junkie, as an information addict, injected with stuff. So, the Net is not a vehicle for rational discussion at all: it's television, injecting banalities into passive consumer-junkies. So, in a nutshell, we can read Brooks and Boal as faulting the Net for lacking key components of the public sphere: individuated agents as the vehicle for discussion and rational, active participants in a reasonable, worthwhile exchange.

Excess or ohmygod! The Net is the Public Sphere!

But this is just one side of the coin. Other commentators on computer mediated interaction see the Net as being too much like the public sphere – it realizes the ideals of the public, and that's precisely the problem with it. Consider Esther Dyson. In a 1998 article in *Brill's Content* she complained that the Net:

> allows all kinds of people to enter the conversation. There are still reliable and unreliable sources, but for now, as people move onto the Net, they tend to lose their common sense and believe all kinds of crazy tales and theories. Unfortunately, we as a society haven't learned 'Net literacy' yet. We take a story's appearance online, as well as in print, as proof that it has been subjected to rigorous journalistic standards, but there's so much stuff out there that no one has the time to contradict all the errors.

Now, Dyson doesn't specify which conversation she has in mind, so it's hard to be sure what she's trying to protect here. Presumably, she's thinking about something like the public sphere, something in which 'we as a society' participate, something that requires a 'common' sense. What might such an all-inclusive conversation look like? Dyson's horror at the thought of 'all kinds of people' entering it tells us, first, that the possibility of an inclusive public sphere conjures up anxieties around truth and trust; and, second, that what she defends as the public sphere relies on a conception of rational debate that excludes all but the reasonable few. Who exactly loses their common sense and believes crazy theories because of a cruise on the Web? Dyson suggests that it must be those who are ignorant and unsophisticated, those of us who don't have authorities to tell us what to believe. Moreover, she suggests, in light of the underlying epistemology of the public sphere, that there is one truth and that there are experts out there who know this truth and who should be empowered to enlighten the rest of us. This of course flies in the face of important research on knowledge networks, situated knowledges, and the structures that authorize what is to count with knowledge in specific domains. Moreover, it fails to grasp precisely the epistemological purchase of truth conditions

in cyberia: given the competing conceptions of the Real meeting and clashing on the Web, the authorizations previously presumed to attach to one set of knowledge claims (assumed by those with control over dominant institutions of knowledge production) are seen in all their actual conflict with competing claims. And, this isn't a relativist position – this is a position that emphasizes precisely that point of conflict that Dyson rejects with her emphasis on consensus. (I should add, if not an aside, then at least an advertisement for my book on alien abduction here.)

So, for Dyson, the problem with the Net is the very excesses that make it a public sphere – everyone is included: ohmygod! People who are ignorant are out there not knowing what to think; all sorts of opinions are out there – ohmygod! authority is undermined. There is too much equality! Too much inclusivity! In fact, Dyson's point seems to boil down to the problem that there are too many different opinions and ideas out there on the Net. But too many for what? What is the criterion according to which one can assess too many or too few? I suggest that the criterion, yet again, is the consensus that is the goal of discussion in the public sphere. Precisely because she presupposes that the Net is something like a public sphere, Dyson can worry about too many opinions – she thinks there needs to be agreement.

Finally, notice that in both the cases of lack and excess, the invocation of the public, or, the territorialization of the Net, of cyberia, as a public functions so as to authorize regulatory interventions. Too little security, too little trust to be able to know that one is dealing with rational, fully individuated agents? Better install some sorts of mechanisms that can let us know who one is, codes that will warrant the other person as a responsible subject. Too many opinions? Too many voices? Better put in filters so that the real authorities can be recognized. But if cyberia really is the public sphere, if it really does let in all the voices and opinions and give equal access to all within its domain, what is the problem? Put somewhat differently, why exactly is it a nightmare of inclusion? What is the base line from which this is measured? The answer, of course, is global capital, or in a term I take from Paul Passavant, communicative capitalism. These regulatory interventions are invoked and pursued so as to make the Net safe for commercial exchange, to protect the intranets of financial markets, establish the trust necessary for consumer confidence in online transactions, and to make appear as a public sphere what is clearly the material basis of the global economy.

Lack? Excess? It must be ideology: publicity as the ideology of technoculture (or, it's the economy, stupid)

So, since we have these two contradictory renderings of the Net as not enough of a public sphere and as too much of a public sphere, what do we do? We treat the public sphere as an ideological construct and subject it to ideology critique. Publicity is the ideology of technoculture. It is what makes communicative capitalism seem natural, unavoidable. It provides the matrix that tells us how to think, what to see, what to desire. It gives us the protocols by which to engineer our reality – and I mean engineer here in a completely material sense. Publicity is materialized in contemporary technoculture. I'll set this out in a bit more detail.

Technoculture is often heralded for the ways it enhances democracy by realizing norms of publicity. From virtual town halls to the chat and opining of apparently already politicized netizens, computer mediated interaction has been proffered as democracy's salvation (as if all that we ever lacked was information or access). New technologies seem to solve the old republican worry about whether deliberative democracy can work in societies too big for face-to-face discussion. In technoculture we can have the privilege and convenience of democracy without the unsightly mess as millions and millions of people participate in a great big public sphere.

Or, at least that's the fantasy. New media present themselves for and as a democratic public. They present themselves for a democratic public in their eager offering of information, access, and opportunity. They present themselves as a democratic public when the very fact of networked communications comes to mean democratization, when expansions in the infrastructure of the information society are assumed to be enactments of a demos. But, as is becoming increasingly clear, the expansion and intensification of communication and entertainment networks yields not democracy but something else entirely – communicative capitalism.

In communicative capitalism, what has been heralded as central to enlightenment ideals of democracy takes material form in new technologies. Access, information, and communication, as well as open networks of discussion and opinion formation are conditions for rule by the public that seem to have been realized through global telecommunications. But instead of leading to more equitable distributions of wealth and influence, instead of enabling the emergence of a richer variety in modes of living and practices of freedom, the deluge of screens and spectacles undermines political opportunity and efficacy for most of the world's peoples. As Saskia Sassen's research on the impact of economic globalization on sovereignty and territoriality makes clear, the speed, simultaneity, and interconnectivity of electronic telecommunications networks produce massive distortions and concentrations of wealth. Not only does the possibility of super-profits in the finance and services complex lead to hypermobility in capital and the devalorization of manufacturing, but financial markets themselves acquire the capacity to discipline national governments. Similarly, within nations like the US, the proliferation of media has been accompanied by a shift in political participation. Rather than actively organized in parties and unions, politics has become a domain of financially mediated and professionalized practices centered on advertising, public relations, and the means of mass communication. Indeed, with the commodification of communication, more and more domains of life seem to have been reformatted in terms of market and spectacle as if the valuation itself had been rewritten in binary code. Bluntly put, the standards of a finance and consumption-driven entertainment culture set the very terms of democratic governance today. In effect, changing the system, organizing against and challenging communicative capitalism, seems to require strengthening the system: how else to get out the message than to raise the money, buy the television time, register the domain names, build the websites, and craft the accessible, user-friendly, spectacular message? Democracy demands publicity.

So, we're at an impasse: the ideal of the public works simultaneously to encode democratic practice and market global technoculture. Precisely those technologies that materialize a promise of full political access and inclusion drive an economic formation whose brutalities render democracy worthless for the majority of people.

The meme: publicity is to technoculture what liberalism is to capitalism. It's the ideology that constitutes the truth conditions of global, information age capital. Publicity is what makes today's communicative capitalism seem perfectly natural.

The ideal of publicity configures the Net as a consensual space. Not only does this pathologize all sorts of interactions long part of computer mediated communication – sex, porn, games, banal chatter – but it completely occludes the way that the Net is the key infrastructural element of the global economy. We see this totally clearly in all those ICANN statements that emphasize the importance of competition on the Net. Competition is associated with the public good, with what is best for all people. It's that same weird thing that appears in all third way rhetoric: the market is public; the market registers and serves the public interest. Market competition as public good thus displaces attention from the actual antagonisms, the actual conflict going on in the world in various forms and spaces. The Net is one of the spaces where this conflict rages in full-force. When we talk about the Net as a public sphere, we displace attention from this conflict.

So, if the Net is not the public sphere, what is it? Is it just a tool or a medium?

Not if by that one means to employ a model of technology that is not always already a materialization of particular ideologies, beliefs, aspirations. Is the Net better understood in terms of virtual reality. Absolutely not: not only is it real in the sense that real people use it, remaining within their bodies and retaining their physical capacities, but it is a very real component of the economic formation that now impacts the entire planet. To emphasize its virtuality displaces attention from its economic role. As the conference title states, the Net is clearly beyond fantasy.

Ok, a third try, perhaps the Net is best understood as a site at which multiple realities converge. Again, absolutely not. Indeed, it strikes me that the idea of multiple realities is one of the most pernicious today. There is one reality. It is a site of conflict. It is multiple to the extent that there are multiple approaches to it, but each of these approaches as political effects, effects that reach far beyond those that allegedly accept a particular reality. I'll consider this from a different angle: to claim that there are multiple realities is to fall in to traps similar to those that affect those who see the Net as a public sphere. It is to avoid acknowledging the conflicts and antagonisms manifest within, pervading, and structuring the Net. Instead of conflict, one just shifts or jumps from reality to reality – like Lola in Tom Tykwer's *Run, Lola, Run*.

Now, sometimes I err on the side of the claim that the Net is nothing at all – that all of contemporary society should be understood as cyberia, as awash in a sea of flows and links and networks such that to isolate one communicative infrastructure on the basis of technology alone makes no sense. I actually tend to think this. But, it is nevertheless the case that the Net generally and the Web more specifically play a key role in configuring the contemporary communicative capitalist imaginary. It is a site of conflict over the meaning, practice, and shape of

the global. To that extent, how and what it represents is inseparable from what it does. Put somewhat differently, it is the architecture for communicative capitalism, both as an order establishing itself and as an order being resisted.

Consequently, I suggest that theoretically speaking we understand the Net as a 'zero institution.' This term comes from Levi-Strauss as explained by Slavoj Žižek. Levi-Strauss calls 'zero institution' that empty signifier that itself has no determinate meaning but that signifies the presence of meaning. It is an institution that has no positive function at all – its only function is to signal the actuality of social institutions as opposed to pre-institutional chaos. In political theory terms, I think of this as like Machiavelli's Prince or Rousseau's Legislator. As institutions they signify the beginning or founding of something, marking that instance of transformation from the chaotic period prior to the founding. They don't do anything in the government or figure in the constitution. Back to Levi Strauss, reference to the 'zero institution' enables all members of the tribe to think of themselves as members of the same tribe, even when they are radically split, even when their very representations of what the tribe is are radically antagonistic to one another. Žižek views the nation as a kind of zero-institution, adding that sexual difference should also be understood as a zero-institution. Whereas the nation is the zero-institution of society's unity, sexual difference is the zero institution of society's split or fundamental antagonism.

I think of the Web as a zero institution: it enables myriad conflicting constituencies to understand themselves as part of the same global structure even as they disagree over what the architecture of this structure should entail. Indeed, the Web is a particularly powerful form of zero institution insofar as its basic elements seem a paradoxical combination of singularity and collectivity, collision and convergence. It brings together both the unity and split, both the hope and the antagonism, the imaginary and the Real in one site. The fundamental constitutive antagonisms of communicative capitalism are alive and present, cursing through and structuring the Web in diverse, protean, and evolving networks. As the nation has collapsed as a zero institution capable of standing in symbolically for the possibility of social institutions (and we see this collapse all over the place, from the crisis of sovereignty engendered by the WTO, to the crises in the Balkans, to the conflicts over migration and immigration, to the dismantling of the welfare state) and as global economic structures have made their presence felt all the more strongly, the Web has emerged as that zero institution signifying institutionality as such. Likewise, as sexual difference has both been complicated by myriad other differences (sexuality, race, ethnicity, etc.) and as experimentation and blurring and proliferation of sexual difference has thrown into disarray the very possibility of the term, the Web – precisely as a site where all these differences emerge, mutate, and link up into and through networks – seems to take on this aspect of the zero institution as well. Hence, conflict over configuring the Web is at the same time a conflict over the configuration of the world of unity and difference.

So, representationally, the Web is a zero institution. It provides an all-encompassing space in which social antagonism is simultaneously expressed and obliterated. It is a global space in which everyone can recognize themselves as connected to everyone else, as linked to everything that matters. At the same time, it is a space of conflicting networks and networks of conflict so deep and

fundamental that even to speak of consensus or convergence seems an act of violence. So, the Web is communicative capitalism's imaginary of uncontested, yet competitive, global flow. And, it is the Real of communicative capitalism, configuring the networks and flows and markets and gambles of the global market. All this is naturalized on, rendered as the nature of, the Web.

I want to anticipate an objection at this point: someone might be thinking that my argument up to this point is to pessimistic, that I'm overplaying the whole communicative capitalism card and underplaying the importance of non-commercial forms of networked interaction. After all, not just corporations are on the Web. All sorts of activists use the Web – as WTO protest organizing makes perfectly clear. And, aren't we in the midst of a dotcom meltdown? Haven't the commercial applications of the Web been proven not just economically but also ideationally bankrupt?

My response is that the dotcom meltdown in no way should be read in terms of the demise of communicative capitalism. The introduction of commercially viable new technologies is always accompanied by phases of proliferation and meltdown as the new technology establishes itself. At points in the early to mid 80s, as Commodore, Atari and other early pc companies collapsed, many thought that the personal computer was going the way of the 8 track player. But, instead, it was a period of consolidation that relied on the efforts of precisely those companies that died in the struggle, that fought the good fight. In a more cynical vein, one might speculate that the consumer oriented period of the late nineties was really part of a strategy to naturalize the Web, to make it a part of everyday life, like banking, even as the real beneficiary was global capital. Importantly, though, the presence of activists proves my point: the Web is a site of conflict. And, I think it is important to emphasize this conflictual, contested dimension of the Web.

Now, I have recently been totally inspired in this regard by some fabulous empirical work by Richard Rogers and Noorjes Marres. Their research opens-up new ways of thinking about democratic politics post-public. Rogers and Marres have developed a set of software tools in conjunction with a research project on 'issue-fication' on the Web. In effect, these tools provide new imaginings of democracy as they enable material practices that navigate differently through cyberia, practices that do not follow, reproduce, or presuppose the architecture of the public sphere. By following the movement of issues on the Web, Rogers and Marres have been able to identify 'issue networks' that are neither publics nor actors. Networks are the flows of communication and contestation that turn matters into issues. For example, using their 'netlocator' software to check the Web for information presented by television media as a spectacle regarding French farmers in the streets, they discover a radically different political configuration: the farmers are absent. What the Web tells them, Rogers and Marres write, is *that the farmers are not farmers, but an organizational figuration that moves from the national to the global and from the political-ideological to the issue-activist. It is quite an organized picture, whereby neither farmers, nor 'phoney farmers,' nor 'a bunch of disorganized anarchists' make up the protests, but a professional national-international network.*

As they follow issues on the Web, rather than in more massified media, Rogers and Marres avoid some of the major problems of publicity in technoculture. They are not in the business of trying to decide which actors are worthy, which actors

count as actors. They don't decide which knowledge has authority – they let the Web decide. They don't presume a public or an audience in advance. Contestation, argument over issues, is at the center of their analysis – not some fantasy of unity or dream of consensus. Furthermore, although Rogers and Marres treat the Web as a communications medium, they don't romanticize the connections it enables – they politicize them, investigating and challenging the practices of linking employed in issue networks. In fact, their research on the influence of .coms and .govs in 'issue-fication' clarifies the ways in which all links are not equal. The configurations of networks change as various players enter or leave the network, as they strategically link to specific sites within the network, and as certain sites lose or gain in prominence. Additionally, Rogers and Marres demonstrate the difference in attention cycles between issues on the Web and news in the media. I find this a powerful challenge to an idea of 'real time' that has become limited to the time it takes to type a sentence, refresh a screen, or write and email before AOL cuts off the connection. (So, you can tell, I'm a fan.)

What sort of democracy is without publics? If we take Rogers and Marres' advice and 'follow the issues,' we get, not exactly a set of democratic norms and procedures, not a democratic public sphere, but more or less democratic configurations that we might think of as 'neo-democracies.' Neo-democracies are configured through contestation and conflict. They reject the fantasy of a public and instead work from the antagonisms that animate political life.

Public Sphere, Neo-democracies,
Site Nation, Web as zero-institution,
Goal Consenus (Legitimation), Contestation,
Means Procedures (legal, rational), Networked conflict,
Norms Inclusivity, Duration,
Equality, Hegemony,
Transparency, Decisiveness,
Rationality, Credibility,
Vehicle Actors, Issues

The public sphere was a formation tied to the nation. Given the challenges to national sovereignty under globally communicative capitalism, this spatiality limits our political imagination as it fails to acknowledge the new conditions of politics, knowledge, and affiliation today. As a beginning point, then, neo-democracies should be understood as situated in a different zero-institution, the Web. Just like the nation, the Web is a zero-institution that posits the possibility of institutionality over chaos. Unlike the nation and like sexual difference, the Web uses the very presence of conflict and antagonism to signify institutionality. Paradoxically perhaps, contestation itself signifies collectivity. And this is what thinking about the Web in terms of a public overlooks.

As theorized by Habermas, the public sphere has been the site of political legitimation, that locus of discussion and debate over matters of common concern. But, as a sphere the telos of which is consensus, the public posits a fantasy of unity that covers over the fundamental antagonisms dividing social and political life. In contrast, neo-democratic networks are contestatory networks, networks

of engagement around issues of vital concern to their constituents. These net-works accept that democracy is animated by a split: they thrive on this split, acknowledging the committed endeavors of those engaged in struggle. By focusing on contestation instead of legitimation, then, neo-democracy acknowledges the unavoidable antagonisms of political life. This is especially important today as Third Wave advocates seek to obscure the reality of the fundamental cleavages wrought by the new economy and as the ideology of publicity tells us that communicative capitalism is really about competition – not conflict.

I fully acknowledge that some may find this emphasis on conflict obscene when millions around the world are victims of various forms of military, state, economic, and domestic violence. But, precisely this perception of 'distant violence' has to be rejected: power is always accompanied by an obscene, excessive supplement. Disavowing the ways that privilege enables some of us to inhabit zones of protection while violence remains 'elsewhere,' then, distorts and limits democratic politics even as it contributes to the production of spectacles for communicative capitalism's media machine. As Aida Hozic argues: "Perhaps the most important aspect of the construction of war zones by and through the media is their de-contextualization from other, global, political and economic trends. There are no economic crises in war zones, only humanitarian. There is no politics in war zones, only the perennial struggle of good and evil. War zones are zones precisely because they are cut-off from the rest of the world, internally homogenized and externally policed. Violence is thus fetishized, turned into an object separate from 'body politic' and, as such, voyeuristically adored."

Clearly, then, neo-democratic politics will not be a politics rooted in figuring out the best sorts of procedures and decision rules for political deliberation. Instead, it acknowledges in advance the endless morphing variety of political tools and tactics. What is crucial to these tactics, however, is whether they open up opportunities for contestation. Not all tactics are equal – those that are part of a neo-democratic arsenal are those that challenge rather than reinforce communicative capitalism.

The norms articulated together by the notion of the public were important to utopian imaginings of democracy. Unfortunately, they have been coopted by a communicative capitalism that has turned them into their opposite. For this reason, it may well be necessary to abandon them – if only to realize them. Hence, instead of prioritizing inclusivity, equality, transparency, and rationality, neo-democratic politics emphasizes duration, hegemony, decisiveness, and credibility.

Any transformative politics today will have to grapple with the speed of global telecommunications and the concomitant problems of data glut and information dumping. Instead of giving into the drive for spectacle and immediacy that plagues an audience oriented news cycle, the issue networks of neo-democracy work to maintain links among those specifically engaged with a matter of concern. This is not, needless to say, a return to the technocratic rule of the experts. Rather, it builds from the extensions of access, information, and know-how enabled by networked communications and uses them to value various strengths, perspectives, and knowledges developed by people of varying degrees of interest and expertise. Put somewhat differently, the valuation of duration as opposed to inclusion prioritizes the interest and engagement brought to bear on an issue rather than inclusion for its own sake. Not everyone knows. Not every opinion matters. What does

matter is commitment and engagement by people and organizations networked around contested issues.

If contestation and antagonism are at the core of democratic politics, then not every view or way of living is equal. What I mean is that the very notion of a fundamental antagonism involves a political claim on behalf of some modes of living and against others. These other views, then, are in no way equal – calling them that makes no sense; it basically misses the point of contestation, namely, winning. Usually, in a contested matter, one doesn't want the other view to coexist happily somewhere, one wants to defeat it. (Examples from US politics might be guns or prayer in public schools. Each side wants to prevent the other side from practicing what it believes or values.) Accordingly, neo-democratic politics are struggles for hegemony. They are partisan, fought for the sake of people's most fundamental beliefs, identities, and practices. Admittedly, at one level my emphasis on hegemony seems simply a description of politics in technoculture – yes, that's what's going on, a struggle for hegemony. I emphasize it, though, out of a conviction that the democratic left has so emphasized plurality, inclusivity, and equality, that it has lost the partisan will to name and fight against an enemy.

The replacing of transparency by decisiveness follows from the critique of publicity as ideology. The politics of the public sphere has been based on the idea that power is always hidden and secret. But clearly this is not the case today. We know full well that corporations are destroying the environment, employing slave labor, holding populations hostage to their threats to move their operations to locales with cheaper labor. All sorts of horrible political processes are perfectly transparent today. The problem is that people don't seem to mind, that they are so enthralled by transparency – look the chemical corporation really is trying, look they have totally explained what happened – that we have lost our will to fight. With this in mind them, neo-democracy emphasizes the importance of affecting outcomes. Thus, fully aware that there is always more information available and that this availability is ultimately depoliticizing, neo-democratic politics prioritizes decisiveness. Of course, the outcomes of decisions cannot be predicted in advance. Of course, they can be rearticulated in all sorts of perverse and unexpected way. But the only way out of communicative capitalism's endless reflexive circuits of discussion is through decisive action. For many, the ever increasing protests against the World Bank and the G8 have been remarkable precisely as these instances of decisive action that momentarily disrupt the flow of things and hint at the possibility of alternatives to communicative capitalism.

Similarly, the neo-democratic politics mapped by issue networks highlights the contemporary priority of credibility over rationality. The ideal of rationality linked to the public sphere highlighted a single set of particular attributes and competences, raising them to the category of the universal. That native knowledges, feminine strengths, and folk remedies, say, were occluded from this rationality has been well documented in recent decades. What we see on the Web, moreover, is the clash of these different levels and styles of knowledge production. What the issue networks show us is how credibility is managed, who is credible to whom, in what articulations, and under what circumstances.

Finally, the key to this imagining of neo-democracy is focusing on issues, not actors. Given the wide acceptance of the critique of the subject, the proliferation

of cites to Nietzsche's dictum, 'there is no doer behind the deed,' the ongoing experiments with identity and subjectivity throughout technoculture, and the recognition that decisions and actors are always already embedded in networks and systems, it makes sense for critical democratic theory to 'follow the issues.' Although this may not seem like such a radical move – after all, don't all the 'concerned citizens' interviewed on television during presidential elections complain that the candidates don't talk enough about the issues – given the emphasis on identity that has been so prominent in work inspired by the new social movements, it is not an insignificant one. Indeed, it seems to me that a democratic theory built around the notion of issue networks could avoid the fantasy of unity that has rendered publicity in technoculture so profoundly depoliticizing. It recognizes that fissures, antagonism, is what gives democracy its political strength (something Machiavelli recognized long ago). Democracy, then, may well be a secondary quality that emerges as an effect or a result of other practices, but that can never be achieved when aimed at directly.

Reimagining democracy under conditions of global technoculture is a project that is just beginning. The repercussions of the challenge global financial markets pose to state sovereignty as well as the broader crisis of representation occasioned by the proliferation and expansion of global networks are only now starting to be addressed. One vision, that of communicative capitalism, should not be allowed to provide the matrix through which this reimagining occurs. For the sake of democracy, it's time to abandon the public.

Bibliography

Abbas, A. 1997. *Hong Kong: Culture and the Politics of Disappearance*. Minneapolis, MN: University of Minnesota Press.

Abbas, A., Erni, J. and Dissanayake, W. (eds) 2004. *Internationalizing Cultural Studies: An Anthology*. Oxford: Blackwell.

Abelove, H., Barale, M.A. and Halperin, D.M. (eds) 1993. *The Lesbian and Gay Studies Reader*. New York: Routledge.

Abercrombie, N., Hill, S. and Turner, B.S. 1980. *The Dominant Ideology Thesis*. London: George Allen and Unwin.

Adams, R. and Savran, D. 2002. *The Masculinity Studies Reader*. Oxford: Blackwell.

Addison, W. 1953. *English Fairs and Markets*. London: Batsford.

Adorno, T.W. 1967. *Prisms*, trans. S. and S. Weber. London: Neville Spearman.

—— 1991. *The Culture Industry: Selected Essays on Mass Culture*, ed. with intro. J.M. Bernstein. London: Routledge.

Agamben, G. 1998. *Homo Sacer: Sovereign Power and Bare Life*. Stanford, CA: Stanford University Press.

Ahearne, J. 1996. *Michel De Certeau: Interpretation and Its Other*. Stanford, CA: Stanford University Press.

Allen, T. 1994. *The Invention of the White Race*. London: Verso.

Althusser, L. 1969. *For Marx*. London: Allen Lane.

Althusser, L. and Balibar, E. 1968. *Reading Capital*. London: New Left Books.

Amin, S. 1989. *Eurocentrism*, trans. R. Moore. New York: Monthly Review Press.

Anderson, B. 2001. *Imagined Communities: Reflections on the Origin and Spread of Nationalism*, new edition. New York: Verso.

Anderson, J., Dean, J. and Lovink, G. (eds) 2006. *Reformatting Politics: Networked Communications and Global Civil Society*. London: Routledge.

Ang, I. 1985. *Watching Dallas: Soap Opera and the Melodramatic Imagination*. London: Methuen.

—— 1991. *Desperately Seeking the Audience*. London: Routledge.

—— 2001. *On Not Speaking Chinese: Living between Asia and the West*. London: Routledge.

Anzaldúa, G. and Moraga, C. (eds) 1982. *This Bridge is Called My Back: Writings of Radical Women of Color*. New York: Kitchen Table, Women of Color Press.

Appadurai, A. (ed.) 1986. *The Social Life of Things: Commodities in Cultural Perspective*. Cambridge: Cambridge University Press.

—— 1996. *Modernity at Large: Cultural Dimensions of Globalization*. Minneapolis, MN: University of Minnesota Press.

—— 2001. 'Grassroots Globalization and the Research Imagination', *Globalization*, ed. A. Appadurai. Durham, NC: Duke University Press.

Arbena, J. and Lafrance, D.G. (eds) 2002. *Sport and the Caribbean*. New York: SR Books.

Arendt, H. 1958. *The Human Condition*. Chicago, IL: University of Chicago Press.

Attali, J. 1985. *Noise: The Political Economics of Music*, trans. B. Massumi. Minneapolis, MN: University of Minnesota Press.

Bachelard, G. 1969. *The Poetics of Space*, trans. M. Jolas. Boston, MA: Beacon.

Baker, H., Diawara, M. and Lindeborg, R. (eds) 1996. *Black British Cultural Studies: A Reader*. Chicago, IL: Chicago University Press.

Bakhtin, M. 1981. *The Dialogic Imagination*. Austin, TX: University of Texas Press.

—— 1987. *Rabelais and his World*. Bloomington, IN: Indiana University Press.

—— 1986. *Speech, Genres, and Other Late Essays*. Austin, TX: University of Texas Press.

Balakrishnan, G. and Aronowitz, S. (eds) 2003. *Debating Empire*. London: Verso.

Balibar, E. 1991. 'The Nation-Form: History and Ideology', in *Race, Nation, Class: Ambiguous Identities*, eds E. Balibar and I. Wallerstein. London: Verso.

Barber, C.L. 1980. *Shakespeare's Festive Comedies: A Study of Dramatic Form and its Relation to Social Custom*. Princeton, NJ: Princeton University Press.

Barthes, R. 1972. *Mythologies*. London: Jonathan Cape.

—— 1975. *The Pleasure of the Text*. New York: Hill.

—— 1977. *Image, Music, Text*. London: Fontana.

Baudrillard, J. 1995. *Simulacra and Simulation*. Ann Arbor, MI: University of Michigan Press.

Baumann, Z. 2001. *The Individualized Society*. Cambridge: Polity Press

Beck, U. 1992. *Risk Society: Towards a New Modernity*. London: Sage.

Beck, U. and Beck-Gernscheim, E. 2002. *Individualization: Institutionalized Individualism and its Social and Political Consequences*. London: Sage.

Becker, H. 1978. 'Arts and Crafts', *American Journal of Sociology*, 83: 864–70.

—— 1982. *Art Worlds*. Berkeley, CA: University of California Press.

Beebe, R., Fulbrook, D. and Saunders, B. (eds) 2002. *Rock over the Edge: Transformations in Popular Music Culture*. Durham, NC: Duke University Press.

Bell, D. 1973. *Coming of Postindustrial Society*. New York: Basic Books.

Belsey, C. 1980. *Critical Practice*. London and New York: Methuen.

—— 1982. 'Re-reading the Great Tradition', in *Rereading English*, ed. P. Widdowson. London: Methuen.

Benjamin, W. 1969. *Illuminations*. New York: Schocken Books.

—— 1970. *Understanding Brecht*. London: NLB.

—— 1978. *Reflections*. New York: Harcourt Brace Jovanovich.

—— 1979. *One Way Street*. London: NLB.

Bennett, A. 2004. *After Subcultures*. London: Palgrave.

Bennett, T. 1986. 'The Politics of "the Popular" and Popular Culture', in *Popular Culture and Social Relations*, eds T. Bennett, C. Mercer and J. Woollacott. Milton Keynes: Open University Press.

—— 1990. *Outside Literature*. London: Routledge.

—— 1992a. 'Putting Policy into Cultural Studies', in *Cultural Studies*, eds L. Grossberg, C. Nelson and P. Treichler. New York: Routledge.

—— 1992b. 'Coming out of English: From Cultural Studies to Cultural Policy Studies', in *Beyond the Disciplines: The New Humanities*, ed. K.K. Ruthven Canberra: Australian Academy of the Humanities.

—— 1998. *Culture: A Reformer's Science*. St Leonards, NSW: Allen & Unwin.

Bennett, T. and Woollacott, J. 1988. *Bond and Beyond: The Political Career of a Popular Hero*. London: Macmillan.

Bennett, T., Emmison, M. and Frow, J. 1999. *Accounting for Tastes: Australian Everyday Cultures*. Cambridge: Cambridge University Press.

Bennett, T., Grossberg, L. and Morris, M. 2005. *New Keywords: A Vocabulary of Culture and Society*. Oxford: Blackwell.

Berger, M. 1996. *White Lies: Race and the Myths of Whiteness*. New York: Farrar, Straus and Giroux.

Berlant, L. 1997. *The Queen of America goes to Washington City: Essays on Sex and Citizenship*. Durham, NC: Duke University Press.

Berman, M. 1982. *All that is Solid Melts into Air: the Experience of Modernity*. New York: Simon and Schuster.

Berman, R.A. 1989. *Modern Culture and Critical Theory: Art, Politics and the Legacy of the Frankfurt School*. Madison, WI: University of Wisconsin Press.

Beverley, J. 1999. *Subalterneity and Representation: Arguments in Cultural Theory*. Durham, NC: Duke University Press.

Beynon, L. 2004. 'Dilemmas of the Heart: Rural Working Women and their Hopes for the Future', in *On the Move: Women in Rural-to-Urban Migration in Contemporary China*, eds A. Gaetano and T. Jacka. New York: Columbia University Press.

Bhabha, H.K. 1986. 'The Other Question: Difference, Discrimination and the Discourse of Colonialism', in *Literature, Politics and Theory: Papers from the Essex Conference 1976–1984*, eds F. Barker, P. Hulme and M. Iversen. London: Methuen.

—— (ed.) 1990. *Nation and Narration*. London: Routledge.

—— 1994. *The Location of Culture*. New York: Routledge.

Blanchot, M. 1987. 'Everyday speech', *Yale French Studies*, 73: 12–20.

Bloch, E. 1988. *The Utopian Function of Art and Literature: Selected Essays*, trans. J. Zipes and F. Mecklenberg. Cambridge, MA: The MIT Press.

Boddy, W. 1990. 'The Seven Dwarfs and the Money Grubbers: the Public Relations Crisis of US Television in the late 1950s', in *Logics of Television: Essays in Cultural Criticism*, ed. P. Mellencamp. Bloomington, IN: Indiana University Press.

—— 1985. '"The Shining Centre of the Home": Ontologies of Television in the "Golden Age"', in *Television in Transition*, eds P. Drummond and R. Paterson. London: BFI.

Bordo, S. 2000. *The Male Body: A New Look at Men in Public and in Private*. New York: Farrar, Straus and Giroux.

Borg, C., Buttigieg, J. and Mayo, P. 2003. *Gramsci and Education*. Portland, OR: Rowman and Littlefield.

Bourdieu, P. 1986. *Distinction. A Social Critique of the Judgement of Taste*, trans. R. Nice. Cambridge, MA: Harvard University Press.

—— 1990. *In Other Words: Essays Towards a Reflexive Sociology*, trans. M. Adamson. Stanford, CA: Stanford University Press.

—— 1993. *The Field of Cultural Production: Essays on Art and Literature*. Cambridge: Polity Press.

Boyd-Barrett, O. 1977. 'Mass Communication in Cross-Cultural Contexts: the Case of the Third World', in *Mass Communication and Society*, eds J. Curran, M. Gurevitch and J. Woollacott. Milton Keynes: Open University Press.

—— 1982. 'Cultural Dependency and the Mass Media', in *Culture, Society and the Media*, eds M. Gurevitch, T. Bennett, J. Curran and J. Woollacott. London: Methuen.

Brantlinger, P. 1990. *Crusoe's Footsteps: Cultural Studies in Britain and America*. New York: Routledge.

Brennan, T. 1997. *At Home in the World*. Cambridge, MA: Harvard University Press.

—— 2006. *Wars of Position: The Cultural Politics of Left and Right*. New York: Columbia University Press.

Brunsdon, C. 1990. 'Television: Aesthetics and Audience', in *Logics of Television: Essays in Cultural Criticism*, ed. P. Mellencamp. Bloomington, IN: Indiana University Press.

Brunsdon, C. and Morley, D. 1978. *Everyday Television: Nationwide*. London: BFI.

Buckingam, D. 1987. *Public Secrets: EastEnders and its Audience*. London: BFI.

Buck-Morss, S. 1989. *The Dialectics of Seeing: Walter Benjamin and the Arcades Project*. Cambridge, MA: MIT Press.

Buhle, P. 1988. *C.L.R. James: The Artist as Revolutionary*. London: Verso.

Bukatman, S. 1993. *Terminal Identity*. Durham, NC: Duke University Press.

Burchell, G., Gordon, C. and Miller, P. (eds) 1991. *The Foucault Effect: Studies in Governmentality*. London: Harverster/Wheatsheaf.

Burgin, V. 1990. 'Paranoic Space', *New Formations*, 1(2): 61–75.

Butler, J. 1991. *Gender Trouble: Feminism and the Subversion of Identity*. New York: Routledge.

—— 1993. *Bodies that Matter: On the Discursive Limits of 'Sex'*. New York: Routledge.

—— 1996. *Excitable speech: Contemporary Scenes of Politics*. New York: Routledge.

—— 1997. *The Psychic Life of Power: Theories in Subjection*. Stanford, CA: Stanford University Press.

—— 2004. *Undoing Gender*. London: Routledge.

Calhoun, C. (ed.) 1992. *Habermas and the Public Sphere*. Cambridge, MA: The MIT Press.

Carby, H. 1986a. 'Sometimes it jus' bes' dat way', *Radical America*, 20: 9–22.

—— 1986b. '"On the Threshold of Woman's Era": Lynching, Empire, and Sexuality in Black Feminist Theory', in *'Race,' Writing and Difference*, ed. H.L. Gates. Chicago, IL: University of Chicago Press.

Case, S.-E., Brett, P. and Foster, S. (eds) 1995. *Cruising the Performative: Interventions in the Representation of Ethnicity, Nationality, and Sexuality*. Bloomington, IN: University of Indiana Press.

Caughie, J. 1984. 'Television Criticism: "A Discourse in Search of an Object"', *Screen*, 25(4): 109–20.

Caves, R. 2002. *Creative Industries: Contracts between Art and Commerce*. Cambridge, MA: Harvard University Press.

Caygill, H. 1998. *Walter Benjamin: The Colour of Experience*. London: Routledge.

CCCS (Centre for Contemporary Cultural Studies) 1981. *Unpopular Education: Schooling and Social Democracy in England since 1944*. London: Hutchinson.

—— 1982. *The Empire Strikes Back: Race and Racism in 70s Britain*. London: Hutchinson.

Chabram, A. 1990. 'Chicana/o Studies as Oppositional Ethnography', *Cultural Studies*, 4(3): 228–47.

Chakrabarty, D. 2000. *Provincialising Europe*. Princeton, NJ: Princeton University Press.

Chang, J. 2005. *Can't Stop Won't Stop: A History of the Hip-Hop Generation*. New York: St Martin's Press.

Chatterjee, P. 1993a. *Nationalist Thought and the Colonial World*. Minneapolis, MN: University of Minnesota Press.

—— 1993b. *The Nation and its Fragments: Colonial and Postcolonial Histories*. Princeton, NJ: Princeton University Press.

Chaturvedi, V. 2000. *Mapping Subaltern Studies and the Postcolonial*. London: Verso.

Cheah, P. and Robbins, B. (eds) 1998. *Cosmopolitics: Thinking and Feeling Beyond the Nation*. Minneapolis, MN: University of Minnesota Press.

Chen, K.-H. 1998. *Trajectories: Inter-Asia Cultural Studies*. London: Routledge.

Chen, N., Clark, C., Gottschang, S. and Jeffery, L. (eds) 2001. *China Urban: Ethnographies of Contemporary Culture*. Durham, NC: Duke University Press.

Chow, R. 1995. *Primitive Passions: Visuality, Sexuality, Ethnography, and Contemporary Chinese Cinema*. New York: Columbia University Press.

—— 1998. *Ethics after Idealism: Theory, Culture, Ethnicity, Reading*. Bloomington, IN: Indiana University Press.

Christian, B. 1987. 'The Race for Theory', *Cultural Critique*, 6: 51–63.

Clarke, J. 1991. *Old Times and New Enemies*. New York: Routledge.

Clarke, J., Hall, S., Jefferson, T. and Roberts, B. 1976. 'Subcultures, Cultures and Class', in *Resistance through Rituals: Youth Subcultures in Post-War Britain*, eds S. Hall and T. Jefferson. London: Hutchinson.

Clifford, J. 1988. *The Predicament of Culture*. Cambridge, MA: Harvard University Press.

—— 1997. *Routes*. Cambridge, MA: Harvard University Press.

Clifford, J. and Marcus, G.E. (eds) 1986. *Writing Culture: The Poetics and Politics of Ethnography*, Berkeley, CA: University of California Press.

Clifford, J. and Dhareshwar, V. 1989. *Traveling Theories: Traveling Theorists*. Santa Cruz, CA: Centre for Cultural Studies.

Cohen, P. 1980. 'Subcultural Conflict and Working-class Community', in *Culture, Media, Language*, eds S. Hall, D. Hobson, A. Lowe and P. Willis. London: Hutchinson.

Cohn, J. 1988. *Romance and the Erotics of Property: Mass Market Fiction for Women*. Durham, NC: Duke University Press.

—— 1990. *Romance and the Erotics of Property: Mass-market Fiction for Women*. Durham, NC: Duke University Press.

Colebrook, C. 2000. *Deleuze*. London: Routledge.

Collins, J. 1989. *Uncommon Cultures: Popular Culture and Post-Modernism*. New York: Routledge.

—— 1995. *Architectures of Excess: Cultural Life in the Information Age*. New York: Routledge.

Collins, R., Garnham, N. and Locksley, G. 1988. *The Economics of Television: The UK Case*. London: Sage Publications.

Connerton, P. 1980. *The Tragedy of Enlightenment: An Essay on the Frankfurt School*, Cambridge: Cambridge University Press.

Connor, S. 1992. *Theory and Cultural Value*. Oxford: Blackwell.

Couldry, N. 2000. *Inside Culture: Re-Imagining the Method of Cultural Studies*. London: Sage.

—— 2004. *MediaSpace*. London: Routledge.

Coward, R. 1984. *Female Desire: Women's Sexuality Today*. London: Paladin.

Crane, D., Kawashima, N. and Kawasaki, K. (eds) 2002. *Global Culture: Media, Arts, Policy, and Globalization*. New York: Routledge.

Crary, J. 1992. *Techniques of the Observer: On Vision and Modernity in the 19th Centrury*. Cambridge, MA: MIT Press.

—— 2001. *Suspensions of Perceptions: Attention, Spectacle, and Modern Culture*. Cambridge, MA: MIT Press.

Crossley, N. (ed.) 2004. *After Habermas: New Perspectives on the Public Sphere*. Oxford: Blackwell.

Cunningham, H. 1980. *Leisure in the Industrial Revolution*. London: Croom Helm.

Cunningham, S. 1992. *Framing Culture: Culture and Policy in Australia*. Sydney: Allen & Unwin.

Curran, J. 1977. 'Capitalism and Control of the Press, 1800–1975', in *Mass Communication and Society*, eds J. Curran, M. Gurevitch and J. Woollacott. London: Edwin Arnold.

Curran, J. and Gurevitch, M. (eds) 1991. *Mass Media and Society*. London: Edwin Arnold.

Daly, N. 2004. *Literature, Technology, and Modernity, 1860–2000*. Cambridge: Cambridge University Press.

Davies, I. 1995. *Cultural Studies and Beyond: Fragments of Empire*. London: Routledge.

Davis, M. 1992. *City of Quartz: Excavating the Future in Los Angeles*. New York: Verso.

Dean, J. 2002. *Publicity's Secret: How Technoculture Capitalizes on Democracy*. Ithaca, NY: Cornell University Press.

de Beauvoir, S. 1973. *The Second Sex*. New York: Vintage.

de Certeau, M. 1984. *The Practice of Everyday Life*. Berkeley, CA: University of California Press.

—— 1986. *Heterologies: Discourse on the Other*. Manchester: Manchester University Press.

Delanda, M. 1991. *War in the Age of Intelligent Machines*. Cambridge: Zone Books.

de Lauretis, T. 1987. *Technologies of Gender: Essays on Theory, Film and Fiction*. Bloomington, IN: Indiana University Press.

—— 1991. 'Queer Theory: Lesbian and Gay Sexualities', *Differences: A Journal of Feminist Cultural Studies*, 3(2), special issue.

—— 1994. *The Practice of Love: Lesbian Sexuality and Perverse Desire*. Bloomington, IN: University of Indiana Press.

Deleuze, G. and Guattari, F. 1977. *Anti-Oedipus: Capitalism and Schizophrenia*. New York: Viking.

—— 1988. *A Thousand Plateaus: Capitalism and Schizophrenia*, London: Athlone Press.

Deleuze, G. and Parnet, C. 1983. *On the Line*. New York: Semiotext(e).

Denning, M. 2004. *Culture in the Age of Three Worlds*. London: Verso.

Dickson, D. 1988. *The New Politics of Science*. Chicago, IL: University of Chicago Press.

Dimock, W. and Gilmore, M. (eds) 1994. *Rethinking Class: Literary Studies and Social Formations*. New York: Columbia University Press.

Donald, J. 1992. *Sentimental Education: Schooling, Popular Culture and the Regulation of Liberty*. London: Verso.

Doty, A. 1993. *Making Things Perfectly Queer: Interpreting Mass Culture*. Minneapolis, MN: University of Minnesota Press.

Doyle, B. 1989. *English and Englishness*. London: Routledge.

Dreyfus, H.L. and Rabinow, P. 1983. *Michel Foucault: Beyond Structuralism and Hermeneutics*, 2nd edition. With an Afterword by and an Interview with Michel Foucault. Chicago, IL: University of Chicago Press.

Driscoll, C. 2002. *Girls: Feminine Adolescence in Popular Culture and Cultural Theory*. New York: Columbia University Press.

du Gay, P. 1996. *Consumption and Identity at Work*. London: Sage.

—— 1997. *Doing Cultural Studies: The Story of the Sony Walkman*. Culture, Media and Identities. London: Sage.

—— 2000a. 'Representing "Globalization": Notes on the Discursive Ordering of Economic Life', in *Without Guarantees: In Honour of Stuart Hall*, eds P. Gilroy, L. Grossberg and A. McRobbie. London: Verso.

—— 2000b. *In Praise of Bureaucracy: Weber, Organization, Ethics*. London and Thousand Oaks, CA: Sage.

During, S. 1987. 'Postmodernism and Postcolonialism Today', *Textual Practice*, 1(1): 58–86.

—— 1989. 'What was the West', *Meanjin*, 48(4): 759–76.

—— 1992. 'Postcolonialism and Globalisation', *Meanjin*, 51(2): 339–53.

—— 2004. *Cultural Studies: A Critical Introduction*. London: Routledge.

—— 2006. 'Is Cultural Studies a Discipline? Does it Matter?', *Cultural Politics*, 2(2).

Dworkin, D. 1992. *Views Beyond the Border Country: Raymond Williams and Cultural Politics*. London: Routledge.

—— 1997. *Cultural Marxism in Postwar Britain: History, the New Left, and the Origins of Cultural Studies*. London and Durham, NC: Duke University Press.

Dwyer, K. 1979. 'The Dialogic of Ethnology', *Dialectical Anthropology*, 4(October): 205–24.

Dyer, R. 1979. *Stars*. London: BFI.

—— 1997. *White*. London: Routledge.

Eagleton, T. 1990. *The Ideology of the Aesthetic*. Oxford: Blackwell.

—— 1991. *Ideology: An Introduction*. London: Verso.

Edelman, L. 1994. *Homographesis: Essays in Gay Literary and Cultural Theory*. New York: Routledge.

—— 2004. *No Future: Queer Theory and the Death Drive*. Durham, NC: Duke University Press.

Eley, G. 1992. 'Nations, Publics, and Political Cultures: Placing Habermas in the Nineteenth Century', in *Habermas and the Public Sphere*, ed. C. Calhoun. Cambridge, MA: The MIT Press.

Emerson, C. 2000. *The First Hundred Years of Mikhail Bakhtin*. Princeton, NJ: Princeton University Press.

Entwistle, H. 1979. *Antonio Gramsci: Conservative Schooling for Radical Politics*. London: Routledge.

Erni, J. 2004. *Asian Media Studies: Politics of Subjectivities*. Oxford: Blackwell.

Faludi, S. 1999. *Stiffed: The Betrayal of the American Man*. New York: W. Morrow and Co.

Fan, C. 2004. 'Out to the City and Back to the Village: the Experience and Contributions to Rural Women's Migration from Sichuan and Anhui', in *On the Move: Women in Rural-to-Urban Migration in Contemporary China*, eds A. Gaetano and T. Jacka. New York: Columbia University Press.

Fanon, F. 1967a. *The Wretched of the Earth.* Harmondsworth: Penguin.

—— 1967b. *Black Skin, White Masks*. New York: Grove Press.

Faure, A. 1978. *Paris Carême-prenant*. Paris: Hachette.

Featherstone, M. 1993. 'Global and Local Cultures', in *Mapping the Futures: Local Cultures, Global Change*, eds Jon Bird. London: Routledge.

Febvre, L and Martin, H.-G. 1984. *The Coming of the Book: The Impact of Printing 1450–1800*. London: Verso.

Ferguson, M. and Golding, P. (eds) 1997. *Cultural Studies in Question*. London: Sage.

Ferris, D.S. (ed.) 2004. *The Cambridge Companion to Walter Benjamin*. Cambridge: Cambridge University Press.

Fiske, J. 1987a. 'British Cultural Studies and Television', in *Channels of Discourse: TV and Contemporary Crticism*, ed. R.C. Allen. Chapel Hill, NC and London: University of North Carolina Press.

—— 1987b. *Television Culture*. London: Methuen.

Fiske, J. and Hartley, J. 1978. *Reading Television*. London: Methuen.

Flores, J. 2000. *From Bomba to Hip-Hop: Puerto Rican Popular Culture and Latino Identity*. New York: Columbia University Press.

Fox-Keller, E. 1984. *Reflections on Gender and Science*. New Haven, CT: Yale University Press.

Foucault, M. 1970. *The Order of Things: An Archeology of the Human Sciences*. London: Tavistock.

—— 1980a. *History of Sexuality*. New York: Pantheon.

—— 1980b. *Power/Knowledge: Selected Interviews and Other Writings 1972–1977*. New York: Pantheon.

—— 1986. 'Of Other Spaces', *Diacritics*, 16: 22–7.

—— 1988. *Politics, Philosophy, Culture: Interviews and Other Writings 1977–1984*, ed. with intro. L.D. Kritzman. London: Routledge.

Frank, W.A. 1991. 'For a Sociology of the Body', in *The Body: Social Process and Cultural Theory*, eds M. Featherstone, M. Hepworth and B.S. Turner. London: Sage.

Franklin, S., Lury, C. and Stacey, J. (eds) 2000. *Global Nature, Global Culture*. London: Sage.

Freud, S. 1954. *Sigmund Freud's Letters to Wilhelm Fliess, Drafts and Notes*, eds M. Bonaparte, A. Freud and E. Kris; trans. E. Masbacher and J. Strachey. New York: Basic Books.

—— 1963. 'General Remarks on Hysterical Attacks', in *Dora: An Analysis of a Case of Hysteria*, trans. D. Bryan. New York: Macmillan.

—— 1974. 'Studies on Hysteria', in *Pelican Freud Library* 3, ed. A. Richards; trans. J. Strachey and A. Strachey. Harmondsworth: Penguin.

Friedman, J. 1994. *Cultural Identity and Global Process*. London: Sage.

Frith, S. 1988. *Music for Pleasure*. Cambridge: Polity.

—— 1996. *Performing Rites: The Aesthetics of Popular Music*. Cambridge, MA: Harvard University Press.

Frith, S. and McRobbie, A. 1978. 'Rock and Sexuality', *Screen Education*: 28.

Frow, J. 1991. 'Michel de Certeau and the Practice of Representation', *Cultural Studies*, 5(1): 52–60.

—— 1995. *Cultural Studies and Cultural Value*. Oxford: Clarendon Press.

Frow, J. and Morris, M. (eds) 1993. *Australian Cultural Studies: A Reader*. Sydney: Allen & Unwin.

Fuchs, B. 2004. *Romance*. London: Routledge.

Fuss, D. 1989. *Essentially Speaking: Feminism, Nature and Difference*. New York: Routledge.

—— (ed.) 1991. *Inside/Out: Lesbian Theories, Gay Theories*. New York: Routledge.

Gaetano, A. 2004. 'Filial Daughters, Modern Women: Migrant Domestic Workers in Post-Mao Beijing', in *On the Move: Women in Rural-to-Urban Migration in Contemporary China*, eds A. Gaetano and T. Jacka. New York: Columbia University Press.

Gallop, J. 1982. *The Daughter's Seduction: Feminism and Psychoanalysis*. Ithaca, NY: Cornell University Press.

Garber, M., Matlock, J. and Walkowitz, R. (eds) 1993. *Media Spectacles*. New York: Routledge.

Garber, M., Walkowitz, R. and Franklin, P. (eds) 1996. *Fieldwork: Sites in Literary and Cultural Studies*. New York: Routledge.

Garnham, N. 1990. *Capitalism and Communication: Global Culture and the Politics of Information*. London: Sage.

Garnham, N. and Williams, R. 1980. 'Pierre Bourdieu and the Sociology of Culture: An Introduction', *Media, Culture and Society*, 2: 209–23.

Garratt, S. 1990. 'Teenage Dreams', in *On Record: Rock, Pop and the Written Word*, eds S. Frith and A. Goodwin. London and New York: Routledge.

Gates Jr., H.L. (ed.) 1987. 'Authority (White) Power and the (Black) Critic: It's All Greek to Me', *Cultural Critique*, 7: 19–47.

Gelder, K. and Thornton, S. (eds) 1997. *The Subcultures Reader*. London: Routledge.

Gibian, P. (ed.) 1997. *Mass Culture and Everyday Life*. London: Routledge.

Giddens, T. 1990. *The Consequences of Modernity*. Stanford, CA: Stanford University Press.

—— 1991. *Modernity and Self-Identity: Self and Society in the Late Modern Age*. Cambridge: Polity Press.

—— 1992. *The Transformation of Intimacy: Sexuality, Love and Eroticism in Modern Societies*. Stanford, CA: Stanford University Press.

Gieryn, T.F. 1999. *Cultural Boundaries of Science: Credibility on the Line*. Chicago, IL: University of Chicago Press.

Gilroy, P. 1982. 'Against Ethnic Absolutism', in *Cultural Studies*, eds L. Grossberg, C. Nelson and P. Treichler. New York: Routledge.

—— 1987. *There Ain't No Black in the Union Jack: The Cultural Politics of Race and Nation*. London: Hutchinson.

—— 1994. *The Black Atlantic: Modernity and Double Consciousness*. London: Verso.

—— 2000. *Against Race: Imagining Political Culture Beyond the Color Line*. Cambridge, MA: Harvard University Press.

Ginsburg, F.D. and Rapp, R. (eds) 1995. *Conceiving the New World Order: The Global Politics of Reproduction*. Berkeley, CA: University of California Press

Gitlin, T. 1983. *Inside Prime Time*. New York: Pantheon.

Godelier, M. 1970. 'Structure and Contradiction in "'Capital'"', in *Structuralism: A Reader*, ed. M. Lane. London: Jonathan Cape.

Goffman, E. 1973. *The Presentation of Self in Everyday Life*. New York: Overlook Press.

Goldberg, D.T. (ed.) 1994. *Multiculturalism: A Critical Reader*. Oxford: Blackwell.

Golding, P. and Murdock, G. 1990. 'Screening out the Poor', in *The Neglected Audience*, eds J. Willis and T. Wollen. London: BFI.

Graff, G. 1987. *Professing Literature: An Institutional History*. Chicago, IL: University of Chicago Press.

—— 1993. *Beyond the Culture Wars: How Teaching the Conflicts Can Revitalize American Education*. New York: W.W. Norton.

Gramsci, A. 1971. *Selections from the Prison Notebooks*, eds and trans. Q. Hoare and G. Nowell Smith. London: Lawrence and Wishart.

—— 1975. *Quaderni del carceri*. Turin: Finaudi.

—— 1978. *Selections from the Political Writings*, ed. and trans. Q. Hoare. London: Lawrence and Wishart.

Gray, A. 1987. 'Behind Closed Doors: Video Recorders in the Home', in *Boxed In: Women and Television*, eds H. Baehr and G. Dyer. London: Pandora.

Grewal, I. 2005. *Transnational America: Feminisms, Diasporas, Neoliberalisms*. Durham, NC: Duke University Press.

Griffin, J.H. 1961. *Black Like Me*. New York: NAL.

Grossberg, L. 1987. 'The In-difference of Television', *Screen*, 28(2): 28–45.

—— 1988. 'Wandering Audiences, Nomadic Critics', *Cultural Studies*, 2(3): 377–91.

—— 1992. *We Gotta Get Out of This Place*. New York: Routledge.

—— 1997. *Dancing in Spite of Myself: Essays on Popular Culture*. Durham, NC and London: Duke University Press.

—— 1998. 'Cultural Studies vs. Political Economy: is Anybody Else Bored with this Debate?', in *Cultural Theory and Popular Culture: A Reader*, 2nd edition, ed. J. Storey. London: Prentice Hall.

—— 2005. *Caught in the Crossfire: Kids, Politics, and America's Future*. Boulder, CO: Paradigm Publishing.

Grossberg, L., Nelson, C. and Treichler, P. (eds) 1992. *Cultural Studies*. New York: Routledge.

Guha, R. 1983. 'The Prose of Counter-Insurgency', in R. Guha (ed) *Subaltern Studies*, 2. New Delhi: Oxford University Press.

—— 1987. 'Chandra's Death', in *Subaltern Studies*, 5. New Delhi: Oxford University Press.

Guillory, J. 1993. *Cultural Capital: the Problem of Literary Canon Formation*. Chicago, IL: University of Chicago Press.

Gumbrecht, H.U. 2006. *In Praise of Athletic Beauty*. Cambridge, MA: Harvard University Press.

Gunew, S. 1990. 'Denaturalizing Cultural Nationalism: Multicultural Readings of "Australia"', in *Nation and Narration*, ed. H. Bhabha. London: Routledge.

Gunster, S. 2004. *Capitalizing on Culture: Critical Theory for Cultural Studies. Cultural Spaces*. Toronto: University of Toronto Press.

Habermas, J. 1987. *The Philosophical Discourse of Modernity: Twelve Lectures*. Cambridge, MA: The MIT Press.

—— 1991. *The Structural Transformation of the Public Sphere: An Inquiry into a Category of Bourgeois Society*. Cambridge, MA: The MIT Press.

Hall, S. 1977. 'Culture, the Media and the "Ideological Effect"', in *Mass Communication and Society*, eds J. Curran, M. Gurevitch and J. Woollacott. London: Edwin Arnold.

—— 1980. 'Cultural Studies and the Centre: Some Problematics and Problems', in *Culture, Media, Language: Working Papers in Cultural Studies, 1972–79*, eds S. Hall, D. Hobson, A. Love and P. Willis. London: Hutchinson.

—— 1981a. 'Notes on Deconstructing the Popular', in *People's History and Socialist Theory*, ed. R. Samuel. London: Routledge and Kegan Paul.

—— 1981b. 'Two Paradigms in Cultural Studies', in *Culture, Ideology and Social Process*, ed. T. Bennett. London: Batsford.

—— 1988. *The Hard Road to Renewal: Thatcherism and the Crisis of the Left*. London: Verso.

—— 1990. 'The Emergence of Cultural Studies and the Crisis of the Humanities', *October*, 53: 11–23.

—— 1991. 'The Local and the Global: Globalisation and Ethnicity', in *Culture, Globalization, and the World-System*, ed. A. King. London: Macmillan.

—— 1996. 'The New Ethnicities', in *Stuart Hall: Critical Dialogues in Cultural Studies*, eds D. Morley and K.-H. Chen. London: Routledge.

Hall, S. and Jefferson, T. (eds). 1976. *Resistance through Rituals: Youth Subcultures in Post-War Britain*. London: Hutchinson.

Hall, S. and Whannel, P. 1964. *The Popular Arts*. London: Hutchinson.

Hall, S., Gilroy, P., Grossberg, L. and McRobbie, A. 2000. *Without Guarantees: In Honour of Stuart Hall*. London: Verso

Hall, S., Critcher, C., Jefferson, T., Clarke, J. and Roberts, B. 1979. *Policing the Crisis: Mugging, the State, and Law and Order*. London: Macmillan.

Halperin, D. 1989. *One Hundred Years of Homosexuality*. London and New York: Routledge.

—— 1995. *Saint Foucault: Towards a Gay Hagiography*. New York: Oxford University Press.

Hannerz, U. 1996. *Transnational Connections: Culture, People, Places*. London: Routledge.

Hansen, M.B.N. and Lenoir, T. 2004. *New Philosophy for New Media*. Cambridge, MA: MIT Press.

Haraway, D. 1988. 'Situated Knowledge', *Feminist Studies*, 14(3): 575–99.

—— 1991. *Simians, Cyborgs, and Women: the Reinvention of Nature*. New York: Routledge.

—— 1997. *Modest-Witness@Second-Millennium.FemaleMan©-Meets-OncoMouse™: Feminism and Technoscience*. New York: Routledge.

—— 2003. *The Companion Species Manifesto: Dogs, People, and Significant Otherness*. Boston, MA: Prickly Paradigm Press.

—— 2004. *The Haraway Reader*. New York: Routledge.

Harding, S. 1995. *The "Racial" Economy of Science: Towards a Democratic Future*. Bloomington, IN: Indiana University Press.

Hardt, M. and Negri, A. 2000. *Empire*. Cambridge, MA: Harvard University Press.

—— 2004. *Multitude*. New York: Penguin.

Hardt, M and Virno, P. (eds) 1996. *Radical Thought in Italy: A Potential Politics*. Minneapolis, MN: University of Minnesota Press.

Harootunian, H.D. 2000. *History's Disquiet: Modernity, Cultural Practice, and the Question of Everyday Life*. New York: Columbia University Press.

Harris, D. 1992. *From Class Struggle to the Politics of Pleasure: The Effects of Gramscianism on Cultural Studies*. London: Routledge.

Hartley, J. 1983. 'Encouraging Signs: Television and the Power of Dirt, Speech and Scandalous Categories', *Australian Journal of Cultural Studies*, 1(2): 62–82.

—— 1992. *Tele-ology: Studies in Television*. London: Routledge.

—— 1996. *Popular Reality*. London: Edward Arnold.

—— (ed.) 2005. *Creative Industries*. Oxford: Blackwell.

Hartmann, W. 1976. *Der Historische Festzug: Seine Entstehung und Entwicklung im 19. und 20. Jahrhunderts*, Studien zur Kunst des 19. Jahrhunderts, 35: Munich: Prestel.

Harvey, D. 1985. *Consciousness and the Urban Experience*. Oxford: Basil Blackwell.

—— 1989. *The Condition of Postmodernity*. Oxford: Blackwell.

—— 2001. *Spaces of Capital, Towards a Critical Geography*. London: Routledge.

Hawkes, T. 1977. *Semiotics and Structuralism*. London: Methuen.

Hayles, N.K. 1999. *How we Became Posthuman: Virtual Bodies in Cybernetics, Literature and Informatics*. Chicago, IL: University of Chicago Press.

Hayward, P. 1990. 'How ABC Capitalised on Cultural Logic: The Moonlighting Story', in *The Media Reader*, eds M. Alvarado and J.O. Thompson. London: BFI.

Heath, S. and Skirrow, G. 1977. 'Television: a World in Action', *Screen*, 18(2): 7–59.

Hebdige, D. 1979. *Subculture: The Meaning of Style*. London: Methuen.

—— 1988. *Hiding in the Light: Images and Things*. London: Routledge.

Hechter, M. 1974. *Internal Colonialism: The Celtic Fringe in British National Development, 1536–1966*. Berkeley, CA: University of California Press.

Hellekson, K. and Busse, K. 2006. *Fan Fiction and Fan Communities in the Age of the Internet*, Jefferson, NC: McFarlane and Co.

Hesmondhalgh, D. 2002. *The Cultural Industries*. London: Sage.

Hess, D.J. 1997. *Science Studies: An Advanced Introduction*. New York: New York University Press.

Hills, M. 2002. *Fan Cultures*. London: Routledge.

Highmore, B. 2001. *Everyday Life and Cultural Theory*. London: Routledge.

—— 2005. *Cityscapes: Cultural Readings in the Material and Symbolic City*. London: Palgrave.

—— 2006. *Michel de Certeau*. Cambridge: Continuum.

Hirsch, M. and Fox Keller, E. (eds) 1990. *Conflicts in Feminism*. London: Routledge.

Hobsbawm, E. and Ranger, T. (eds) 1983. *The Invention of Tradition*. New York: Columbia University Press.

Hobson, D. 1982. *Crossroads: The Drama of a Soap Opera*. London: Methuen.

Hoggart, R. 1958. *The Uses of Literary*. Harmondsworth: Penguin. First published 1957.

—— 1966. 'Literature and Society', *The American Scholar*, 35: 277–89.

Holquist, M. 2002. *Dialogism*. London: Routledge.

Holub, R. 1992. *Antonio Gramsci: Beyond Marxism and Postmodernism*. London: Routledge.

Hunter, I. 1988. *Culture and Government: The Emergence of Literary Education*. London: Macmillan.

—— 1994. *Rethinking the School: Subjectivity, Bureaucracy and Criticism*. Sydney: Allen & Unwin.

—— 1996. 'Literary Theory in Civil Life', *South Atlantic Quarterly*, 95(4): 1099–134.

Hunter, I., Meredyth, D., Smith, B. and Stokes, G. (eds) 1991. *Accounting for the Humanities: The Language of Culture and the Logic of Government*. Brisbane: Institute for Cultural Policy Studies, Griffith University.

Huntingdon, S. 1997. *The Clash of Civilisations: Remaking of World Order*. New York: Touchstone.

Huyssen, A. 1986. *After the Great Divide*. Bloomington, IN: Indiana University Press.

Inda, J.X. 2005. *Anthropologies of Modernity: Foucault, Governmentality, and Life Politics*. Berkeley, CA: University of California Press.

Irigaray, L. 1985. *The Sex Which is not One*. Ithaca, NY: Cornell University Press.

Iwabuchi, K., Muecke, S. and Thomas, M. 2004. *Rogue Flows: Trans-Asian Cultural Traffic*. Hong Kong: University of Hong Kong Press.

Iyer, P. 1989. *Video Night in Kathmandu: And other Reports from the Not-So-Far East*. New York: Vintage.

Jacka, E. 1994. 'Research Audiences: A Dialogue between Cultural Studies and Social Science', *Media Information Australia*, 73.

—— 2005. 'Finding a Place: Negotiations of Modernization and Globalization among Rural Women in Beijing', *Critical Asian Studies*, 37(1): 51–74.

Jagose, A. 1996. *Queer Theory*. Melbourne: University of Melbourne Press.

James, C.L.R. 1993. *Beyond a Boundary*, Durham, NC: Duke University Press.

Jameson, F. 1990. *Postmodernism or the Cultural Logic of Late Capitalism*. Durham, NC: Duke University Press.

—— 1992. *The Geopolitical Aesthetic: Cinema and Space in the World System*. Bloomington, IN: University of Indiana Press.

—— 1993. 'On Cultural Studies', *Social Text*, 34: 17–52.

JanMohamed, A. and Lloyd, D. 1987. 'Introduction: Towards a Theory of Minority Discourse', *Cultural Critique*, Spring: 65–82.

Jardine, A. 1985. *Gynesis: Configurations of Woman and Modernity*. Ithaca, NY: Cornell University Press.

Jarvis, S. 1998. *Adorno: A Critical Introduction*. London: Routledge.

Jay, M. 1973. *The Dialectical Imagination: A History of the Frankfurt School and the Institute of Social Research 1923–50*. London: Heinemann Educational Books.

—— 1984a. *Adorno*. Cambridge, MA: Harvard University Press.

—— 1984b. *Marxism and Totality: The Adventures of a Concept from Lukács to Habermas*. Berkeley, CA: University of California Press.

Jeffords, S. 1994. *Hard Bodies: Hollywood Masculinity in the Reagan Era*. New Brunswick, NJ: Rutgers University Press.

Jenkins, H. 1992. *Textual Poachers: Television Fans and Participatory Culture*. New York: Routledge.

—— 2006a. *Convergence Culture*. New York: New York University Press.

——2006b. *Fans, Bloggers, and Gamers*. New York: New York University Press.

Jenkins, H. and Tulloch, J. 1995. *Science Fiction Audiences: Watching Dr Who and Star Trek*. London: Routledge.

Jenkins, H., McPherson, T. and Shattuc, J. (eds) 2003. *Hop on Pop: The Politics and Pleasures of Popular Culture*. Durham, NC: Duke University Press.

Jensen, K.B. 1995. *The Social Semiotics of Mass Communication*. London: Sage.

Johnson, R. 1987. 'What is Cultural Studies Anyway?', *Social Text*, 6(1): 38–90.

Jones, P. 1994. 'The Myth of "Raymond Hoggart": On "Founding Fathers" and Cultural Policy', *Cultural Studies*, 8(3): 394–416.

—— 2004. *Raymond Williams's Sociology of Culture: A Critical Reconstruction*. London: Palgrave.

Kaplan, A. and Pease, D.E. (eds) 1993. *Cultures of United States Imperialism*. Durham, NC: Duke University Press.

Kaplan, C. 1986. *Sea Changes: Essays on Culture and Feminism*. London: Verso.

Kappeler, S. 1986. *The Pornography of Representation*. Minneapolis, MN: University of Minnesota Press.

Katz, E. and Liebes, T. 1985. 'Mutual Aid in the Decoding of Dallas: Preliminary Notes from a Cross-Cultural Study', in *Television in Transition: Papers from the First International Television Studies Conference*, eds P. Drummond and R. Paterson. London: BFI.

Keane, J. 2003. *Global Civil Society?* Cambridge: Cambridge University Press.

Kelley, R.D.G. 2002. *Freedom Dreams: The Black Radical Imagination*. Boston, MA: Beacon Press.

Kipnis, L. 1993. *Ecstasy Unlimited: On Sex, Capital, Gender, and Aesthetics*. Minneapolis, MN: University of Minnesota Press.

Kittler, F. 1990. *Discourse Networks 1800/1900*. Stanford, CA: University of Stanford Press.

—— 1999. *Gramophone, Film, Typewriter*. Palo Alto, CA: Stanford University Press.

Kolmar, W. and Bartkowski, F. (eds) 2003. *Feminist Theory: A Reader*. New York: McGraw Hill.

Kracauer, S. 1995. *The Mass Ornament: Weimer Essays*. Cambridge, MA: Harvard University Press.

Lacan, J. 1988. *The Seminars of Jacques Lacan, 1954–55*. Cambridge: Cambridge University Press.

Laclau, E. 1977. *Politics and Ideology in Marxist Theory*. London: New Left Books.

—— (ed.) 1994. *The Making of Political Identities*. London: Verso.

Laclau, E. and Mouffe, C. 1985. *Hegemony and Social Strategy: Towards a Radical Democratic Politics*. London: Verso.

Laing, S. 1986. *Representations of Working-class Life, 1959–64*. London: Macmillan.

Landes, J. 1988. *Women and the Public Sphere in the Age of the French Revolution*. Ithaca, NY: Cornell University Press.

Langton, M. 1993. *Well I Heard it on the Radio and I Saw it on the Television*. Sydney: Australian Film Commission.

Lash, S and Urry, J. 1987. *The End of Organized Capitalism*. Madison, WI: University of Wisconsin Press.

—— 1994. *Economics of Signs and Space*. London: Sage.

Latour, B. 2004. *Politics of Nature: How to Bring the Sciences into Democracy*. Cambridge, MA: Harvard University Press.

—— (ed.) 2005. *Making Things Public: Atmospheres of Democracy*. Cambridge, MA: MIT Press.

—— 2006. *We Have Never Been Modern*. Cambridge, MA: Harvard University Press.

Lazarus, N. 1999. *Nationalism and Cultural Practice in the Postcolonial World*. Cambridge: Cambridge University Press.

Leal, O.F. 1990. 'Popular Taste and Erudite Repertoire: the Place and Space of Television in Brazil', *Cultural Studies*, 4(1): 19–29.

Lears, T.J. 1983. 'From Salvation to Self-realisation: Advertizing and the Therapeutic Roots of Consumer Culture, 1880–1930', in *The Culture of Consumption: Critical Essays in American History, 1880–1980*, eds R.W. Fox and T.J. Lears. New York: Pantheon.

Lefebvre, H. 1971. *Everyday Life in the Modern World*. London: Allen Lane.

—— 1991a. *Critique of Everyday Life*, Vol. 1. London: Verso.

—— 1991b. *The Production of Space*. Oxford: Blackwell.

—— 1995. *Introduction to Modernity*. London: Verso.

Levine, L. 1988. *Highbrow/Lowbrow: The Emergence of Cultural Hierarchy in America*. Cambridge, MA: Harvard University Press.

Levy, P. 1997. *Collective Intelligence: Mankind's Emerging World in Cyberspace*. New York: Plenum Press.

Lewis, J. 1990. *Art, Culture and Enterprise: The Politics of Art and the Cultural Industries*. New York: Routledge.

—— 1991. *The Ideological Octopus*. New York: Routledge.

Lewis, J. and Miller, T. 2002. *Critical Cultural Policy Studies: A Reader*. Oxford: Blackwell.

Liebes, T. and Katz, E. *The Export of Meaning: Cross-cultural Readings of Dallas*. Cambridge: Polity Press.

Lipsitz, G. 1990. *Time Passages: Collective Memory and American Popular Culture*. Minneapolis, MN: University of Minnesota.

—— 1994. *Dangerous Crossroads: Popular Music, Postmodernism, and the Poetics of Place*. London: Verso.

Lipsitz, G., Maira, S. and Soep, E. (eds) 2004. *Youthscapes: The Popular, The National, The Global*. Philadelphia, PA: University of Pennsylvania Press.

Long, E. 2003. *Book Clubs: Women and the Uses of Reading in Everyday Life*. Chicago, IL: University of Chicago Press.

Lowe, L. 1996. *Immigrant Acts: On Asian American Cultural Politics*. Durham, NC: Duke University Press.

Löwy, M. 1979. *George Lukács: From Romantic to Bolshevic*. London: Verso.

Lukács, G. 1971. *History and Class Consciousness*. Cambridg, MA: MIT Press.

Lurie, C. 1996a. *Consumer Culture*. Cambridge: Polity Press.

—— 1996b. *Cultural Rights: Technology, Legality and Personality*. London: Routledge.

MacCabe, C. 1981. 'Memory, Phantasy, Identity: *Days of Hope* and the Politics of the Past', in *Popular Television and Film*, eds T. Bennett, C. Mercer and J. Woollacott. London: BFI.

McCann, C.R. and Kim, S.-K. (eds) 2002. *Feminist Theory Reader: Local and Global Perspectives*. London: Routledge.

McClintock, A. 1994. 'The Angel of Progress: Pitfalls of the Term "Postcolonialism"', in *Colonial Discourse/Postcolonial Theory*, eds F. Barker, P. Hulme and M. Iversen. Manchester: Manchester University Press.

—— 1995. *Imperial Leather: Race, Gender and Sexuality in the Colonial Context*. London: Routledge.

McGuigan, J. 1992. *Cultural Populism*. London: Routledge.

—— 1996. *Culture and the Public Sphere*. London: Routledge.

MacKinnon, C. 1987. *Feminism Unmodified: Discourses of Life and Law*. Cambridge, MA: Harvard University Press.

McRobbie, A. 1980. 'Settling Accounts with Subcultures', *Screen Education*, 34: 37–49.

—— 1984. 'Dance and Social Fantasy', in A. McRobbie and M. Nava. London: Macmillan.

—— 1994. *Postmodernism and Popular Culture*. London: Routledge.

—— 1996. 'Looking Back at New Times and its Critics', in *Stuart Hall: Critical Dialogues in Cultural Studies*, eds D. Morley and K.-H. Chen. London: Routledge.

—— 2000. *Feminism and Youth Culture*, 2nd edition. London: Routledge.

—— 2005. *The Uses of Cultural Studies: A Textbook*. London: Sage.

Mamdani, M. 1996. *Citizen and Subject: Contemporary Africa and the Legacy of Late Colonialism*. Princeton, NJ: Princeton University Press.

Man, C.-S. 2001. 'Exploitation, Exit, and Familism: Economic Retreatism of the Migrant Workers in the Pearl River Delta', Mphil thesis, Chinese University of Hong Kong.

Mandel, E. 1978. *Late Capitalism*. London: Verso.

Mansbridge, J. 1990. 'Feminism and Democracy', *The American Prospect*, 1.

Marcus, G. 1986. *Lipstick Traces: A Secret History of the Twentieth Century*. Cambridge, MA: Harvard University Press.

Marcus, G. and Fischer, M. 1986. *Anthropology as Cultural Critique*. Chicago, IL: University of Chicago Press.

Marcuse, H. 1964. *One-dimensional Man*. Boston, MA: Beacon Press.

Marx, K. and Engels, F. 1970. *The German Ideology*. London: Lawrence and Wishart.

Massey, D. 1994. *Space, Place and Gender*. Cambridge: Polity Press.

Mattelart, A. 1991. *Advertising International: The Privatisation of Public Space*, trans. M. Chanan. Comedia, London and New York: Routledge.

Maxwell, R. 2001. *Culture Works: The Political Economy of Culture*. Minneapolis, MN: University of Minnesota Press.

Meehan, E.R. 1988. 'Technical Capability vs. Corporate Imperatives: Towards a Political Economy of Cable Television and Information Diversity', in *The Political Economy of Information*, eds V. Mosco and J. Wasko. Madison, WI: University of Wisconsin Press.

—— 1990. 'Why We Don't Count: the Commodity Audience', in *Logics of Television: Essays in Cultural Criticism*, ed. P. Mellencamp. Bloomington, IN and London: Indiana University Press.

Mercer, K. 1987. 'Black Hair/Style Politics', *New Formations*, 3: 33–54.

—— 1994. *Welcome to the Jungle: New Positions in Black Cultural Studies*. New York: Routledge.

Merchant, C. 1980. *The Death of Nature: Women, Ecology and the Scientific Revolution*. San Francisco, CA: Harper & Row.

Michaels, E. 1994. *Bad Aboriginal Art: Traditions, Media and Technological Horizons*. Sydney: Allen & Unwin.

Miller, D. 1992. 'The Young and the Restless in Trinidad: a Case of the Local and the Global in Mass Consumption', in *Consuming Technologies*, eds R. Silverstone and E. Hirsch. London: Routledge.

Miller, D. and Slater, D. 2000. *The Internet: An Ethnographic Approach*. Oxford: Berg.

Miller, T. 1993. *The Well-Tempered Self: Citizenship, Culture and the Postmodern Subject*. Baltimore, MD: Johns Hopkins University Press.

—— 1996. 'Cultural Citizenship and Technologies of the Subject: Or, Where Did You Go, Paul Dimaggio?', *Culture and Policy*, 7(1): 141–56.

—— (ed.) 2001. *A Companion to Cultural Studies*. Oxford: Blackwell.

Miller, T. and Yudice, G. 2002. *Cultural Policy*. London: Sage.

Minh-ha, T.T. 1989. *Woman, Native, Other: Writing Postcoloniality and Feminism*. Bloomington, IN: Indiana University Press.

Mitchell, T. 1988. *Colonizing Egypt*. Cambridge: Cambridge University Press.

Miyoshi, M. 1991. *Off Centre: Power and Culture: Relations between Japan and the United States*. Cambridge, MA: Harvard University Press.

Modleski, T. 1982. *Loving with a Vengeance: Mass-Produced Fantasies for Women*. Hamden, CT: Archon Books.

—— 1983. 'The Rythms of Reception: Daytime Television and Women's Work', in *Regarding Television. Critical Approaches: An Anthology*, ed. E.A. Kaplan. Frederick, MD: University Publications of America.

—— (ed.) 1987. *Studies in Entertainment: Critical Approaches to Mass Culture*. Bloomington, IN: University of Indiana Press.

Mohanty, C.T. 2003. *Feminism Without Borders: Decolonizing Theory, Practicing Solidarity*. Durham, NC: Duke University Press.

Moi, T. 1992. *Feminist Theory and Simone De Beauvoir*. Oxford: Blackwell.

Morley, D. 1980. *The 'Nationwide' Audience: Structure and Decoding*, BFI Televison Monographs, 11, London: The British Film Institute.

—— 1986. *Family Television: Cultural Power and Domestic Leisure*. London: Commedia.

—— 1989a. 'Changing Paradigms in Audience Studies', in *Remote Control: Television, Audiences, and Cultural Power*, eds E. Seiter, H. Morchers, G. Kreutzner, and E.-M. Warth. London: Routledge.

—— 1989b. *Remote Control: Television, Audiences, and Cultural Power*, eds. E. Seiter, H. Morchers, G. Kreutzner, and E.-M. Warth. London: Routledge.

—— 1990. 'Behind the Ratings: the Politics of Audience Research', in *The Neglected Audience*, eds J. Willis and T. Wollen. The Broadcasting Debate, 5. London: BFI.

—— 1992. *Television, Audiences, and Cultural Studies*. London: Routledge.

—— 2000. *Home Territories: Media, Mobility and Identity*. London: Routledge.

Morley, D. and Chen, K.-H. 1996. *Stuart Hall: Critical Dialogues in Cultural Studies*. London: Routledge.

Morley, D. and Robins, K. 1995. *Spaces of Identity: Global Media, Electronic Landscapes and Cultural Boundaries*. London: Routledge.

Morris, M. 1988 *The Pirate's Fiancée: Feminism, Reading, Postmodernism*. London: Verso.

—— 1990. 'Banality in Cultural Studies', in *Logics of Television: Essays in Cultural Criticism*, ed. P. Mellencamp. Bloomington, IN and Indianapolis, IN: Indiana University Press.

—— 1992. 'A Gadfly Bites Back', *Meanjin*, 51(3): 545–51.

—— 1998. *Too Soon Too Late: History in Popular Culture*. Bloomington, IN: Indiana University Press.

Morson, G. and Emerson, C. 1991. *Mikhail Bakhtin: Creation of a Prosaics*. Stanford, CA: Stanford University Press.

Mouffe, C. (ed.) 1979. *Gramsci and Marxist Theory*. London: Routledge.

—— 1994. 'For a Politics of Nomadic Identity', in *Traveller's Tales: Narratives of Home and Displacement*, eds G. Robertson, M. Mash, L.Tickner, J. Bird, B. Curtis and T. Putnam London: Routledge.

Muckerji, C. and Schudson, M. (eds) 1991. *Rethinking Popular Culture: Contemprary Perspecitves in Cultural Studies*. Berkeley, CA: University of California Press.

Muggleton, D. and Weinzierl, R. 2004. *The Post-Subcultures Reader*. Oxford: Berg.

Mulhern, F. 2000. *Culture/Metaculture*. The New Critical Idiom. London: Routledge.

Murray, S. and Quellette, L. (eds) 2004. *Reality TV: Remaking Television Culture*. New York: New York University Press.

Naficy, H. 1999. *Home, Exile, Homeland: Film, Media, and the Politics of Place*. New York: Routledge.

Nairn, T. 1977. *The Break-up of Britain: Crisis and Neo-Nationalism*. London: New Left Review Books.

Naremore, J. and Brantlinger, P. (eds) 1991. *Modernity and Mass Culture*. Bloomington, IN: Indiana University Press.

Nava, M. 1987. 'Consumerism and its Contradictions', *Cultural Studies*, 1(2): 204–10.

Negus, K. 1999. *Music Genres and Corporate Cultures*. London: Routledge.

Nelson, C. and Gaonkar, D.P. (eds) 1996. *Disciplinarity and Dissent in Cultural Studies*. New York: Routledge.

Newcomb, H. 1986. 'American Television Criticism 1970–1985', *Critical Studies in Communication*, 3: 217–28.

Newton, E. 1979. *Mother Camp: Female Impersonators in America*. Chicago, IL: University of Chicago Press.

Ong, A. 1999. *Flexible Citizenship: The Cultural Logics of Transnationality*. Durham, NC: Duke University Press.

—— 2003. *Buddha is Hiding: Refugees, Citizenship, the New America*. Berkeley, CA: University of California Press.

O'Regan, T. 1992. '(Mis)taking Policy: Notes on the Cultural Policy Debate', *Cultural Studies*, 6(3): 409–23.

Paras, E. 2006. *Foucault 2.0: Beyond Power and Knowledge*. New York: The Other Press.

Parker, A., Russo, M., Somer, D. and Yaeger, P. (eds) 1992. *Nationalisms and Sexualities*. New York: Routledge.

Patton, P. (ed.) 1996. *Deleuze: A Critical Reader*. Oxford: Blackwell.

Payne, M. 1997. *Reading Knowledge: An Introduction to Barthes, Foucault, and Althusser*. Oxford: Blackwell.

Penley, C. 1997. *NASA/TREK: Popular Science and Sex in America*. New York: Verso.

Penley, C. and Ross, A. (eds) 1991. *Technoculture*. Minneapolis, MN: University of Minnesota Press.

Penley, C. and Willis, S. (eds) 1993. *Male Trouble*. Minneapolis, MN: University of Minnesota Press.

Pensky, M. 1993. *Melancholy Dialectics: Walter Benjamin and the Play of Mourning*. Amherst, MA: University of Massachusetts Press.

—— 1997. *The Actuality of Adorno: Critical Essays on Adorno and the Postmodern*. Albany, NY: State University of New York.

Petro, P. 1986. 'Mass Culture and the Feminine: the "Place" of Television in Film Studies', *Cinema Journal*, 25(3): 5–21.

Pillement, G. 1972. *Paris en Fête*. Paris: Grasset.

Plant, S. 1992. *The Most Radical Gesture*. London: Routledge.

Poole, M. 1984. 'The Cult of the Generalist: British Television Criticism 1936–83', *Screen*, 25(2): 41–61.

Pope, D. 1977. *The Making of Modern Advertising*. New York: Basic Books.

Poulot, D. 1994. 'Identity as Self-discovery: the Eco-museum in France', in *Museum Culture: Histories, Discourses, Spectacles*, eds D. Sherman and I. Rogoff. Minneapolis, MN: University of Minnesota Press.

Prendegast, C. (ed.) 1995. *Cultural Materialism: On Raymond Williams*. Minneapolis, MN: University of Minnesota Press.

Proctor, J. 2004. *Stuart Hall*. London: Routledge.

Rabinach, A. 1985. 'Benjamin, Bloch and Modern Jewish Messianism', *New German Critique*, 17: 78–125.

Radway, J. 1984. *Reading the Romance: Women, Patriarchy and Popular Literature*. Chapel Hill, NC: University of North Carolina Press.

—— 1988. 'Reception Study: Ethnography and the Problems of Dispersed Audiences and Monadic Subjects', *Cultural Studies*, 2(3): 359–76.

—— 1999. *A Feeling for Books: The Book-Of-The-Month Club, Literary Taste, and Middle-Class Desire*. Durham, NC: University of North Carolina Press.

Rai, A. 1994. 'An American Raj in Filmistan: Images of Elvis in Indian Films', *Screen*, 35(1): 51, 66, 67, 75.

Rajchman, J. 2000. *The Deleuze Connections*. Cambridge, MA: The MIT Press.

Reich, R. 1991. *The Work of Nations: Preparing Ourselves for 21st Century Capitalism*. New York: Vintage.

Rigby, B. 1991. *Popular Culture in Modern France: A Study of Cultural Discourse*. London: Routledge.

Robbins, B. (ed.) 1990. *Intellectuals: Aesthetics, Politics, Academics*. Minneapolis, MN: University of Minnesota Press.

—— 1993a. *Secular Vocations: Intellectuals, Professionalism, Culture*. London: Verso.

—— 1993b. *The Phantom Public Sphere*. Minneapolis, MN: University of Minnesota Press.

Robbins, D. 1991. *The Work of Pierre Bourdieu*. Milton Keynes: Open University Press.

Robbins, K. 1983. *The Eclipse of a Great Power: Modern Britain 1870–1975*. London: Longman.

Roberts, K., Cook, F.G., Clark, S.G. and Semeonoff, E. (eds) 1977. *The Fragmentary Class Structure*. London: Heinemann.

Robertson, G., Mash, M., Tickner, L., Bird, J., Curtis, B. and Putnam, T. (eds) 1996. *Future Natural: Nature/Science/Culture*. London: Routledge.

Robertson, R. 1992. *Globalization: Social Theory and Global Culture*. London: Sage.

Rodinson, M. 1978. *Islam and Capitalism*. Austin, TX: University of Texas Press.

Roediger, D. 1991. *The Wages of Whiteness: Race and the Making of the American Working Class*. London: Verso.

—— 1994. *Towards the Abolition of Whiteness: Essays on Race, Politics and Working Class History*. London: Verso.

Rojek, C. 2001. *Celebrity. Focus on Contemporary Issues*. London: Reaktion.

Rose, N. 1990. *Governing the Soul: The Shaping of the Private Self*. London: Routledge.

—— 1993. 'Government, Authority and Expertise in Advanced Liberalism', *Economy and Society*, 22(3): 283–99.

Rose, T. 1994. *Black Noise: Rap Music and Black Culture in Contemporary America*. Music/Culture. Hanover, NH: University Press of New England.

Ross, A. 1988. 'The Work of Nature in the Age of Electronic Emission', *Social Text*, 18: 116–28.

—— 1989. *No Respect: Intellectuals and Popular Culture*. London: Routledge.

—— 1990. 'Defenders of the Faith and the New Class', in *Intellectuals: Aesthetics, Politics, Academics*, ed. B. Robbins. Minneapolis, MN: University of Minnesota Press.

—— 1991. *Strange Weather: Culture, Science and Technology in the Age of Limits*. London: Verso.

—— 1994. *The Chicago Gangster Theory of Life: Nature's Debt to Society*. London: Verso.

—— (ed.) 1996. *Science Wars*. Durham, NC: Duke University Press.

Rubin, G. 1975. 'The Traffic in Women: Notes on the Political Economy of Sex', in *Toward an Anthropology of Women*, ed. R.R. Reiter. New York: Monthly Review Press.

—— 1984. 'Thinking Sex: Notes for a Radical Theory of the Politics of Sexuality', in *Pleasure and Danger: Exploring Female Sexuality*, ed. C. Vance. Boston, MA: Routledge and Kegan Paul.

Ryan, M. 1990. *Women in Public: Between Banners and Ballots, 1825–1880*. Baltimore, MD: Johns Hopkins University Press.

Said, E. 1990. 'Third World Intellectuals and Metropolitan Culture', *Raritan*, 9(3): 27–50.

—— 2002. *Reflections on Exile and other Essays*. Cambridge, MA: Harvard University Press.

—— 2003. *Culture and Resistance: Conversations with Edward Said*. Boston, MA: South End Press.

Sarich, V. and Miele, F. 2004. *Race: The Reality of Human Differences*. Boulder, CO: Westview Press.

Scheff, T.J. 1979. *Catharsis in Healing, Ritual and Drama*. Berkeley, CA: University of California Press.

Schivelsbusch, W. 1986. *The Railway Journey: The Industrialization of Time and Space in the 19th Century*. London: Berg.

Schneider, C. and Wallis, B. (eds) 1988. *Global Television*. New York: Wedge Press.

Schwartz, B. 1989. 'Popular Culture: the Long March', *Cultural Studies*, 3(2): 250–5.

Sedgwick, E.K. 1987. 'A Poem is Being Written', *Representations*, 17: 110–43.

—— 1990. *Epistemology of the Closet*. Berkeley, CA: University of California Press.

—— 1993a. *Tendencies*. Durham, NC: Duke University Press.

—— 1993b. 'Queer Performativity: Henry James's *Art of the Novel*', *GLQ: A Journal of Lesbian and Gay Studies*, 1(1): 1–16.

Seiter, E., Borchers, H., Kreutzner, G. and Warth, E. (eds) 1989. *Remote Control: Television, Audiences, and Cultural Power*. London: Routledge.

Seton-Watson, H. 1977. *Nations and States*. Boulder, CO: Westview Press.

Shiach, M. (ed.) 1999. *Feminism and Cultural Studies*. Oxford: Oxford University Press.

Shields, R. 1999. *Lefebvre, Love and Struggle: Spatial Dialectics*. London: Routledge.

Shohat, E. and Stam, R. 1994. *Unthinking Eurocentricism: Multiculturalism and the Media*. London: Routledge.

Sidro, A. 1979. *Le Carnaval de Nice et ses Fous*. Nice: Éditions Serre.

Simons, M.A. 1999. *Beauvoir and the Second Sex: Feminism, Race, and the Origins of Existentialism*. Portland, OR: Rowman and Littlefield.

Smith, A. 1980. *The Geopolitics of Information: How Western Culture Dominates the World*. London: Faber.

—— 1990. 'Towards a Global Culture?', in *Global Culture: Nationalism, Globalization and Modernity*, ed. M. Featherstone. London: Sage.

Smith, G. (ed.) 1988. *On Walter Benjamin: Critical Essays and Recollections*. Cambridge, MA: MIT Press.

Smith, P. 1992. 'Vas', in *Feminisms*, eds R. Warhol and D. Price Herndl. New Brunswick, NJ: Rutgers University Press.

Snitow, A., Stansell, C. and Thompson, S. (eds) 1983. *The Powers of Desire: The Politics of Sexuality*. New York: Monthly Review Press.

Sobchack, V. (ed.) 1996. *The Persistence of History: Cinema, Television, and the Modern Event*. New York: Routledge.

Solomon-Godeau, A. 1999. *Male Trouble: A Crisis in Representation*. London: Thames and Hudson.

Sontag, S. 1982. *A Susan Sontag Reader*. New York: Farrar, Straus and Giroux.

Spigel, L. 1988. 'Installing the Television Set: Popular Discourses on Television and Domestic Space, 1948–1955', *Camera Obscura*, 16(August): 11–47.

—— 1990. 'Television in the Family Circle: the Popular Reception of a New Medium', in *Logics of Television: Essays in Cultural Criticism*, ed. P. Mellencamp. Bloomington, IN: Indiana University Press.

Spigel, L. and Olsson, J. (eds) 2004. *Television After TV: Essays on a Medium in Transition*. Durham, NC: Duke University Press.

Spivak, G.C. 1988a. *In Other Worlds*. London: Routledge.

—— 1988b. 'Can the Subaltern Speak?', in *Marxism and the Interpretation of Culture*, eds C. Nelson and L. Grossberg. Urbana, IL: University of Illinois Press.

—— 1990. *The Postcolonial Critic: Interviews, Strategies, Dialogues*, ed. S. Harasym. London: Routledge.

—— 1993. *Outside in the Teaching Machine*. London: Routledge.

—— 1998. 'Cultural Talks in the Hot Peace, Revisiting the "Global Village"', in *Cosmopolitics: Thinking and Feeling Beyond the Nation*, ed. B. Robbins. Minneapolis, MN: University of Minnesota Press.

Stafford, A. 2004. *Roland Barthes, Phenomenon and Myth: An Intellectual Biography*. Edinburgh: University of Edinburgh Press.

Stallybrass, P. and White, A. 1986. *The Politics and Poetics of Transgression*. London: Methuen.

Steele, T. 1997. *The Emergence of Cultural Studies, 1945–65: Cultural Politics, Adult Education and the English Question*. London: Lawrence and Wishart.

Stewart, S. 1991. *Crimes of Writing: Problems in the Containment of Representation*. New York: Oxford University Press.

Story, J. (ed.) 1994. *Cultural Theory and Popular Culture: A Reader*, 2nd edition. London: Prentice Hall.

Stratton, J. and Ang, I. 1996. 'On the Impossibility of a Global Cultural Studies', in *Stuart Hall: Critical Dialogues in Cultural Studies*, eds D. Morley and K.-H. Chen. London: Routledge.

Swartz, D. 1998. *Culture and Power: The Sociology of Pierre Bourdieu*. Chicago, IL: University of Chicago Press.

Sussman, G. and Lent, J.A. (eds) 1991. *Transnational Communications: Wiring the Third World*. Newbury Park, CA: Sage.

Taylor, E. 1990. *Prime-time Families: Television Culture in Postwar America*. Berkeley, CA: University of California Press.

Thomas, H. and Ahmed, J. (eds) 2004. *Cultural Bodies: Ethnography and Theory*. London: Blackwell.

Thompson, E.P. 1968. *The Making of the English Working Class*. Harmondsworth: Penguin. First published in 1963.

Thompson, J.B. 1984. 'Symbolic Violence: Language and Power in the Writings of Pierre Bourdieu', in *The Theory of Ideology*. Cambridge: Polity Press.

Thornton, S. 1995. *Club Cultures: Music, Media and Subcultural Capital*. Oxford: Polity Press.

Throsby, D. 2000. *Economics and Culture*. Cambridge: Cambridge University Press.

Tomaseli, K. 1992. 'From Resistance to Policy Research', *Text*, 1.

Tomlinson, J. 1991. *Cultural Imperialism*. London: Pinter Publishers.

—— 1994. 'Mass Communications and the Idea of a Global Public Sphere', *The Journal of International Communication*, 1: 2.

Touraine, A. 1971. *Postindustrial Society*, trans. L. Mayhew. New York: Random House.

Tsing, A.L. 2004. *Friction: An Ethnography of Global Connection*. Princeton, NJ: Princeton University Press.

Tulloch, J. 1990. *Television Drama*. London: Routledge.

Tulloch, J. and Moran, A. 1986. *Quality Soap: A Country Practice*. Sydney: Currency.

Turner, G. 1996. *British Cultural Studies*, 2nd edition. London: Routledge.

Urry, J. 2002. *The Tourist Gaze*, 2nd edition. London: Sage.

Urry, J. and Lash, S. 1987. *The End of Organised Capitalism*. Cambridge: Polity Press.

Virilio, P. 1991a. *The Lost Dimension*. New York: Semiotext[e].

—— 1991b. *The Aesthetics of Disappearance*. New York: Semiotext[e].

Virno, P. 2004. *A Grammar of the Multitude: For an Analysis of Contemporary Forms of Life*. New York: Semiotext(e).

Volosinov, V.N. 1973, *Marxism and the Philosophy of Language*, London: Seminar Press.

Wacquant, L. and Bourdieu, P. 2005. *Bourdieu and Democratic Politics: The Mystery of Ministry*. Cambridge: Polity Press.

Wallace, M. 1990. *Invisibility Blues: From Pop to Theory*. London: Verso.

Wallerstein, I. 1974. *The Modern World-system*, 2 vols. New York: Academic Press.

—— 1979. *The Capitalist World Economy*. Cambridge: Cambridge University Press.

—— 1990. 'Culture as the Ideological Background of the Modern World System', *Theory, Culture and Society*, 2–3.

Warner, M. 1990. *The Letters of the Republic: Publication and the Public Sphere*. Cambridge, MA: Harvard University Press.

—— 1992. 'The Mass Public and the Mass Subject', in *Habermas and the Public Sphere*, ed. C. Calhoun. Cambridge, MA: MIT Press.

—— (ed.) 1993. *Fear of a Queer Planet: Queer Politics and Social Theory*. Minneapolis, MN: University of Minnesota Press.

—— 1999. *The Trouble with Normal: Sex, Politics and the Ethics of Queer Life*. New York: The Free Press.

—— 2002. *Publics and Counterpublics*. Cambridge: Zone Books.

Watney, S. 1987. *Policing Desire: Pornography, AIDS, and the Media*. Minneapolis, MN: University of Minnesota Press.

Webster, D. 1988. *Looka Yonder: The Imaginary America of Popular Culture*. London: Routledge/ Commedia.

Weedon, C. 1987. *Feminist Practice and Poststructuralist Theory*. Oxford: Blackwell.

Weeks, J. 1985. *Sexuality and its Discontents*. London: Routledge and Kegan Paul.

Weigel, S. 1996. *Body- and Image-Space: Re-reading Walter Benjamin*. London: Routledge.

White, A. 1982. 'Pigs and Pierrots: Politics of Transgression in Modern Fiction', *Raritan*, II(2) (Fall): 51–70.

—— 1983. 'The Dismal Sacred Word: Academic Language and the Social Reproduction of Seriousness', *Literature/Teaching/Politics*, 2(4): 4–15.

Williams, L. 1990. *Hard Core: Power, Pleasure and the "Frenzy of the Visible"*. New York: Pandora.

Williams, P. 1998. *Seeing a Colour-Blind Future*. New York: Farrar, Straus and Giroux.

Williams, R. 1960. *Culture and Society: 1780–1950*. Harmondsworth: Penguin. First published in 1958.

—— 1965. *The Long Revolution.* Harmondsworth: Penguin. First published in 1961.

—— 1974. *Television: Technology and Cultural Form*. London: Fontana.

—— 1975. *The Country and the City*. Oxford: Oxford University Press.

—— 1977. *Marxism and Literature*. New York: Oxford University Press.

—— 1980. *Problems in Materialism and Culture*. London: Verso.

—— 1985. *Keywords*, revised edition. Oxford: Oxford University Press.

—— 1989. *The Politics of Modernism*. London: Verso.

Williamson, J. 1978. *Decoding Advertisements: Ideology and Meaning in Advertising*. London: Marion Boyers.

—— 1986. *Consuming Passions: The Dynamics of Popular Culture*. London: Marion Boyers.

Willis, E. 1986. 'Feminism, Moralism and Pornography', in *Caught Looking: Feminism, Pornography and Censorship*, eds B. Jaker, N. Hunter, K.-E. O'Dair, A. Tallmer. New York: Caught Looking.

Willis, P. 1977. *Learning to Labour: How Working Class Kids Get Working Class Jobs*. New York: Columbia University Press.

Willis, S. 1991. *A Primer for Daily Life*. London: Routledge.

Wilson, A. 1992. *The Culture of Nature: North American Landscape from Disney to Exxon Valdez*. Cambridge: Blackwell.

Wilson, R. and Dissanayake, W. (eds) 1996. *Global/Local: Cultural Production and the Transnational Imaginary*. Durham, NC: Duke University Press.

Wimsatt, W. 2001. *Bomb the Suburbs*. Chicago, IL: Soft Skull Press.

Wolf, E. 1982. *Europe and the People without History*. Berkeley, CA: University of California Press.

Wollen, P. 1993. *Raiding the Icebox*. London: Verso.

—— 1994. 'The Cosmopolitan Ideal in the Arts', in *Travellers' Tales: Narratives of Home and Displacement*, eds G. Robertson, M. Mash, L. Tickner, J. Bird, B. Curtis and T. Putnam. London: Routledge.

Wright, G. and Rabinow, P. 1982. 'Spatialization of Power: a Discussion of the Work of Michel Foucault', and 'Interview: Space, Knowledge and Power', *Skyline*, 1: 14–20.

Wright, J. 1979. *Britain in the Age of Economic Management*, Oxford: Oxford University Press.

Yan, Y. 2003. *Private Life under Socialism: Love, Intimacy, and Family in a Chinese Village*. Stanford, CA: Stanford University Press.

Yudice, G. 2004. *The Expediency of Culture: Uses of Culture in the Global Era*. Durham, NC: Duke University Press.

Žižek, S. 1986. *The Sublime Object of Ideology*. Lincoln, NE: University of Nebraska Press.

Index

The end of chapter notes are not included in the index